THE STORY OF MODERN ART

THE STORY OF
Modern Art

BY SHELDON CHENEY

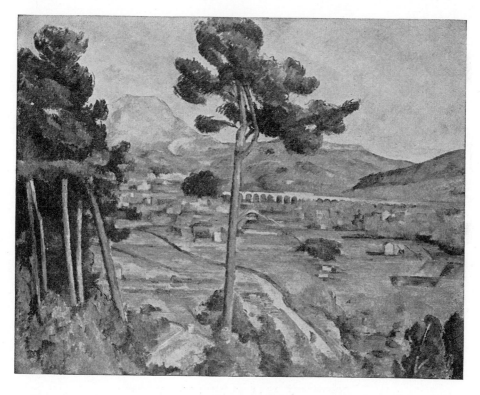

NEW YORK · THE VIKING PRESS

1956

FIRST PUBLISHED IN NOVEMBER 1941
SECOND PRINTING MARCH 1945
THIRD PRINTING SEPTEMBER 1945
FOURTH PRINTING MAY 1947
FIFTH PRINTING JULY 1950
SIXTH PRINTING JANUARY 1956

PUBLISHED ON THE SAME DAY IN THE
DOMINION OF CANADA BY THE MACMILLAN COMPANY OF CANADA LIMITED

FOREWORD AND ACKNOWLEDGMENTS

THIS book is a narrative account of the development of the art that is in the mid-twentieth century called modern. It is, so far as possible, factual and tangible. Special pains have been taken to illustrate the text amply with pictures by the many painters who have contributed to the development of modernism.

I came to the decision to write such a book one night in a prosperous city of Pennsylvania two or three years ago. A museum director had invited me to speak on modern art before an audience trained, it was clear from the gallery exhibits, to judge paintings and sculptures realistically, for their likeness to nature, their literary cleverness, and their smoothness of finish. After I had talked and had shown my slides, the director paused for a cordial word. "That," he said, "was what I wanted my people to hear. We'll want you down again." He added, equally sincerely: "For my part I still think modern art is all a racket." He felt that we understood each other perfectly.

At about that time a patron of the arts in Chicago had organized a movement and was spending her money freely to combat the advance of modernism. Under a banner inscribed "Sanity in Art" she had rallied the forces of conservatism, and she was financing shows of pictures illustrating her thesis that painting "is more closely related to literature than to music." In showing photographically true pictures and story-pictures she had the support of a hundred artists baffled by modernism. She was thinking of modern art not as a racket but as a blight destroying the sweetness and light exemplified in Victorian art.

Pondering upon the blindness, as I saw it, of these two influential figures, the one a museum director, the other a patron, and perceiving over their shoulders the army of gallery-goers who find security and solace in the old art, I resolved to seek a new approach to the understanding of modernism. Most people still, I recognized, see and read pictures, where the moderns believe that one should see and experience them. For the "reading" public, paradoxically, most books about the new art (including my own) were mystifying and alienating. The writers assumed a capacity for formal experience, and they belittled those properties of art dear to the reader's heart and mind: story interest, naturalistic fidelity, pathos, message.

The only way to reach these people—the form-blind—seemed to be to go back and show how the artists who created modern art came to abandon

the old art; to tell biographically and chronologically the story of modernism, leading the reader, as it were, along the life-trail of each of the great revolutionaries, arriving with each, eventually, at the realization of values beyond the realistic, the sentimental, the literary. The reader steeped in realism may still reject the flaming canvases of van Gogh as extreme and anarchistic; but after reading the story of van Gogh's sacrifice of all else in life for attainment of a form-quality, he must thenceforth admit the existence of a property in art beyond his previous knowledge. Thus the way is opened to recognition of the whole bundle of components, formal and mystic, brought in by the moderns.

Two books of mine have dealt with modernism, in the critic's way. A *Primer of Modern Art*, first published in 1924 and frequently reprinted, is an introduction to the subject, abounding in examples, analyses, and—I am afraid—argument. *Expressionism in Art*, published in 1934, was written especially for students and artists; it is an attempt to analyse the nature of the "form" that typically gives character to the modern work of art. In neither book did I go into what I then considered the side issues of artist-biography and history. Now, remembering especially my museum director and the "Sanity in Art" crusader, I have attempted this concrete narrative, a complete story in chronological order.

The present book deals with the art of painting alone. In developing the narrative I was not a little surprised to find that the record of invention, of what might be called the intention of the modern artist, places the painters consistently before the sculptors, the architects, and the other creative designers. Discovering, when I began to set the record of modern sculpture into my framework, that the ideas and innovations invariably came after the similar ones of the painters—discovering, in short, that the story of painting is the original creative story—I decided to render the account in terms of the lives and works of the painters only. The decision made it possible to devote the full count of 373 illustrations to the one art.

In better times I should have thought it necessary to go to Paris and Munich and Berlin to gather the main run of illustrations; but reluctantly, and understandably, I have omitted that errand. Fortunately many of the European masterpieces of modernism have been brought to America. Several museums and schools, moreover, have made extensive collections of photographs of representative paintings. These institutions have been courteous and co-operative when I have asked the privilege of reproduction. In the end, fewer than a dozen scheduled pictures have been omitted.

In other times I should have felt it obligatory too that I go to the sources in the matter of the journals and letters of foreign artists. As it is, instead of making my own translations of excerpts, I have leaned more heavily than usual, by permission, upon other men's work. Among translators Walter Pach has been especially kind, permitting quotation from his edition of Delacroix's *Journal* (Covici-Friede, New York, 1937) and from letters translated by him for his excellent *Ingres* (Harper & Brothers, New York, 1939). To the Houghton Mifflin Company, Boston, I am indebted for permission to quote at some length from the letters of Vincent van Gogh, as translated under the editorship of Irving Stone for the remarkable and revealing book *Dear Theo*. For minor van Gogh excerpts I am indebted to George Slocombe's *Rebels of Art* (Arts & Decoration Book Society, New York, 1939) and to the Museum of Modern Art's catalogue of its van Gogh exhibition. The Museum of Modern Art has also courteously permitted quotation of a few lines from an essay by Jean Cassou appearing in its catalogue *Masters of Popular Painting*, and of a translation of Corot's five-line autobiography, from its Corot-Daumier catalogue.

For translations of materials concerning Cézanne I am especially indebted to *Paul Cézanne* by Gerstle Mack (Alfred A. Knopf, New York, 1935) and to *Paul Cézanne: His Life and Art* by Ambroise Vollard (Crown Publishers, New York, 1937). Excerpts from Gauguin's writings are in some cases translated from the French versions, in others taken from Van Wyck Brooks's translation of *Paul Gauguin's Intimate Journals* (Boni & Liveright, New York, 1921) or from *Gauguin*, by John Rewald (The Hyperion Press, Paris and New York, 1938); with a few lines from *The Life of Paul Gauguin* by Robert Burnett (Oxford University Press, New York, 1937). The quotations from Constable are from the pages of C. R. Leslie's *Memoirs of the Life of John Constable, R.A.*, still the best biography after a hundred years. A few lines are quoted from E. G. Underwood's admirable *A Short History of French Painting*.

The excerpts from manifestos are in most cases from the original documents. The quotation from Guillaume Apollinaire's *Æsthetic Meditations*, upon cubism, is from the translation by Mrs. Charles Knoblauch as it appeared in the *Little Review*, spring 1922. Other brief statements are taken from the writings of Whistler, from Théodore Duret's *Manet and the French Impressionists* (J. B. Lippincott Company, Philadelphia, 1910), from *Nineteenth-Century Painting* by John Rothenstein (John Lane, London, 1932), from *Cubists and Post-Impressionism* by Arthur

Jerome Eddy (A. C. McClurg & Company, Chicago, 1919), and from M. T. H. Sadler's introduction to *The Art of Spiritual Harmony* by Wassily Kandinsky (Constable & Company, London, 1914). A statement by Hilla Rebay on non-objective art is reprinted from a catalogue of the Solomon R. Guggenheim Collection by permission of the author. A few lines from an article by Élie Faure are reprinted from *Twice a Year,* 1940–1941, by permission of the editor, Dorothy Norman. The excerpts about neo-impressionism are translated from documents collected in Paul Signac's *D'Eugène Delacroix au Néo-Impressionnisme*, in the *Écrits d'Artistes* series. To the publishers, editors, and authors of these books I express indebtedness and gratitude.

Many institutions have aided generously with illustrations. The Extension Division of the Metropolitan Museum of Art has lent me photographs not otherwise available, and the Museum's Department of Public Relations has provided photographs of works in the Museum's galleries. The School of the Fine Arts of Yale University also generously opened its photograph files to me. An exceptional number of illustrations has come from the Museum of Modern Art, where the staff has been patient and courteous in meeting my requests. The Art Institute of Chicago has similarly co-operated, as has the M. H. deYoung Memorial Museum, San Francisco. Many of the photographs of German paintings, so difficult to come by in these times, have been lent by Curt Valentin of the Buchholz Gallery, New York, and Karl Nierendorf of the Nierendorf Gallery, New York. Others who have kindly supplied fugitive prints are Pierre Matisse, the Knoedler Galleries, the Durand-Ruel Galleries, J. B. Neumann of the New Art Circle, and Bertram D. Wolfe. The Oxford University Press, acting for the Phaidon Press, and the Hyperion Press each courteously permitted four reproductions from its publications, and the Studio Publications one.

To the scores of others—museum directors, dealers, and private collectors—who have co-operated by permitting reproduction of works in their custody or possession, I can say here only a general thank-you. Their names appear in the captions under the pictures. In the long and sometimes fatiguing process of collecting the hundreds of photographs, I have met with not a single refusal: a notable instance of co-operation and kindly consideration in a world not too kindly or co-operative. If there is some measure of repute due for preparation of such a book, I hope the reader will credit it in part to these many helpers, named and unnamed.

Westport, Connecticut. September 1941 S. C.

CONTENTS

NOTE ON ILLUSTRATIONS

The serial list of illustrations, customary in shorter books, is omitted, because a list of 373 separate entries would be useless for reference purposes. The picture titles and the artists' names are instead included in the general index at the end of the volume.

The illustration on the title-page is CÉZANNE: Landscape. 1885-1887. *Metropolitan Museum of Art.*

THE STORY OF MODERN ART

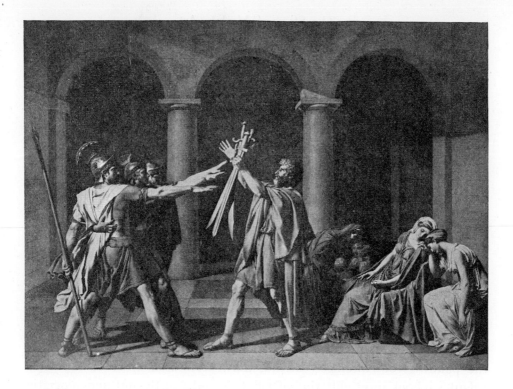

I: END OF AN ERA

THE Convention that met in the name of revolution January 17, 1793, voted to send Louis XVI of France to the guillotine. Among the republican leaders who came forward to support the decree of regicide was a socially conscious artist named Jacques-Louis David, forty-five years old, a painter.

For several years before the flames leaped up openly and destructively in 1789, the fires of revolution had smouldered in France. Those who had lighted and tended these fires, a handful of carefully subversive intellectuals and a horde of desperate peasants and slum democrats, had been

DAVID: The Oath of the Horatii. 1784. *Louvre*

heartened by the spectacle of an America made free by rebellion (though there the arts had not been concerned in or affected by the event). In France the court and the landowning aristocracy had continued to pile up fuel. The King, and above all his Queen, Marie Antoinette, flaunted their extravagances in the faces of the malcontents. The aristocrats lived luxuriously and frivolously, while the national debt soared. Taxes multiplied and hatred grew.

In May 1789, the third-estate deputies of the States-General bound themselves to secure a constitution for France, in the celebrated Oath of the Tennis Court. In July the Bastille was stormed and burned. In October the mob marched on Versailles and brought the King, a virtual prisoner, back to Paris in its wake. For two years the republic with prisoner-monarchs was in the shaping. Then an abortive attempt of the King and Queen to escape relit the fires. Swiftly there came the "deluge" so lightly prophesied by La Pompadour. Among the stern republicans sitting in judgment with Danton, Marat, and Robespierre was the artist David.

Some time since, the pupils of this David, it was reported, had stoned the paintings of Antoine Watteau, most celebrated artist of the *fêtes-galantes* school, most glittering of painters, and courtly and undemocratic. It is likely that the youthful art students no more than threw bread-pellets at *The Embarkation for Cythera*, the painter's sublimation of the exquisite dalliance of the courtiers, in the gallery of the Louvre. Nevertheless they were metaphorically stoning Watteau, and their open derision was a symbol of the passing of the art that had most truly represented the kings. It seemed to mean that one major cycle of art was passing and that the young French painters were entering upon the first phase of another. Their master was already an artist with a following, he had challenged the authority of the painters of frivolities, he had made the right choice politically in alining himself with the uncompromising and bitter leaders of the Assembly. Now the fanatics of the Revolution rewarded him by appointing him national dictator in the field of art.

It was perhaps the grandest opportunity ever presented to an artist-dictator. The old art was dead so far as he might wish it dead. France had been for more than a century the unrivalled art-producing nation of Europe, creator of styles and mentor of artists everywhere. A single forceful genius might have turned the stream of culture into wholly new and creative, and sufficiently democratic, channels. Two or three geniuses might have closed then the history of the Renaissance spirit in painting and sculp-

ture and architecture. They might, in short, have initiated Modern art.

The art students who stoned a masterpiece of Watteau, by way of signalizing the passing of an *ancien régime* of painting, were showing off, in the needless and perhaps cruel way that young artists have. For Watteau too had been an artist, a member of the least accepted group in society, the member who when he is most himself, most the genius, is most misunderstood, most likely to be stoned by the mob. Watteau, seemingly the tangible reflection of his age and environment, had been, really, the perfect example of the artist misfitted to society. He had been restless, discontented, even vaguely rebellious, and he had struggled with most of the problems that are the artist's common lot under kings or democrats: money troubles, client troubles, jealousies, and unfair criticism (with wasting disease finally added to his lot). David and the Revolution were to do nothing to help the artist in these matters. The genius was to remain a suspected rebel and an outcast; the painter and the sculptor were to be considered eccentrics and misfits in society.

Perhaps it was some extension of this grotesque truth, this perversity, that made the changes in art in 1789–1795 fall into a pattern not deeply related to the epochal political and economic shifts. Politically the Revolution marked an overturn as great as any in the course of history. Socially and economically the results were hardly less determining. The kings began their withdrawal from history. In France the aristocracy was permanently weakened and for a time banished, and the way was opened for the rise of the bourgeoisie. The economic consequences for the artist were enormous. The creative opportunities for the artist were enormous, too. At that moment he was free to initiate, to set out upon a new slope, a vista miraculously opening into the future before him. Perversely art, in the name of Modernism, took a side road, not even a main road, back into the past.

When Duccio and Cimabue and their Sienese and Florentine fellows, building on the stiff and formal Byzantine painting, had introduced the humanist note into Italian art, to be followed by Masaccio, Leonardo, and others ardent with the scientific spirit, a new and epochal movement had been initiated in European culture. Its impulse was partly out of classic Rome and Greece—and therefore the name "Renaissance"—but its aims and its expressiveness were fresh enough, in relation to the civilization of the time and the place, to define a major art era. It was an epochal turn of the dial. Europe was for five centuries committed to a course of art

within the realistic canon (as distinguished, broadly, from the formalized, unreal, and decorative art of the Orient).

The wave of the Renaissance, of the art that thus had its rise in thirteenth-century Siena and fourteenth-century Florence, flowed over all of Italy, rising to successive crests in Florence, Rome, and Venice. Minor tides of creative painting, pushed in from the same sources, were to be marked in the northern countries; and, within the ebbing wave, in the run-out Bolognese and Neapolitan schools of the seventeenth century, and in the interwoven baroque or rococo adventures. The flow had touched France repeatedly. Poussin so felt the Renaissance impulse that he became an expatriate in Italy, reviving purest classicism. A century later the Watteau-Boucher development might well have marked the last creative surge of the Renaissance tide in Europe—a surge with little of strength behind it, but vitalized by an artificial, fluttering sort of surface animation. By 1789 even that last wavelet was subsiding, though Fragonard still was painting. In general the wave of the Renaissance seemed spent.

But David in his youthful days, as a student in Italy, had been caught and hopelessly moulded by two impulses that survived, in a debased way, from the originally creative tide—its classic formalism and its scientific realism. In Rome two industrious Germans had set a trap for impressionable young artists. Rather they had reset the trap which had again and again served to lure art students from creative paths and to weaken Renaissance art. Johann Joachim Winckelmann had rediscovered Roman sculpture (which he mistook for Greek), and he had published in 1764 his monumental *History of Ancient Art*; he had proclaimed, furthermore, that "the only means by which we can become truly great is imitation of the ancients." A dryly talented painter, Anton Raphael Mengs, resident in Rome, spread the gospel and was invited to paint at any number of the courts of Europe. (Casanova met Mengs at the Spanish court in 1769 and put him down as "a pompous ass"—and that, today, seems like pretty good art criticism.) Before 1789 even the French Royal Academy had returned to pure classicism as an ideal. And every young art student of Paris coveted the Prix de Rome.

David, who had been a pupil of the typical *fêtes-galantes* painter Boucher, went over early to the studio of Joseph-Marie Vien, Paris's leading classicist, failed three times to win the prize, but was successful the very year Vien was appointed head of the French Academy at Rome. David must have had in him some of the stuff of a revolutionary in art

when he left for Rome in 1775, for he promised his Parisian intimates that "the art of the ancients will not seduce me; it lacks passion and fire."

He was soon tamed. He sent back to the Paris exhibitions a succession of works, at first with typical Boucher marginal bits—goddesses with chubby breasts and cherubs with rosy buttocks—but in "noble" compositions handled with increasing classic restraint and chill. The subjects were largely from Roman history; republicanism was implicit in *The Oath of the Horatii*, which created a sensation at the Salon of 1785. Although purchased by Louis XVI, it was doubtless the more kept in mind by the revolutionaries who were to come into power a few years later. A lesson of stern, even fanatic patriotism was easily read in his interpretation, exhibited in 1789, of Brutus unflinching as he views the bodies of his sons slain as conspirators against the Roman Republic. David had already made himself the natural choice for a dictatorship of art under republican "incorruptibles."

The artist was, no doubt, suspect in some radical quarters, for he had received favours at the hands of the now-imprisoned King, and he had been honoured (after what he felt was undue delay) by the Royal Academy; though he had been offended because the Queen preferred Vigée-Lebrun's prettified portraiture to his academic sort. He had, however, been solidly republican in his themes, and the chance of his *Brutus* being on show at the very hour the conflagration started—with art students turned republican *gardes* ushering the public into the galleries—led to talk of him as "the Painter of the Revolution." The Jacobins commissioned him to paint the first official propaganda picture, the monumental *Oath of the Tennis Court*. It was he who designed the republican costumes, in the Greek fashion, and he planned the revolutionary pageants and processions. He was appointed dictator of art in 1792.

As the rush of events accelerated, toward the Terror, David became political leader too, turning heart and soul Jacobin. He had always been a theorist, with hard and severe ideas. He readily became an extremist, beside Danton, then Marat, then Robespierre. He not only voted for the execution of Louis XVI; in his famous portrait of Barère, the patriot who spoke the principal oration against the monarch, he lettered in, on the railing under the speaker's hand, the opening lines of the speech that ended: "The tree of liberty could not grow were it not watered with the blood of kings." On October 16, 1793, as the tumbrel conveying Marie Antoinette to the guillotine stopped outside his window, David made a

pen-sketch of her, sitting stiffly upright in the cart, her hands tied behind her, unkempt, ugly, like any harridan who has had her day—one of the most horrible documents of art. It is also supposed that David signed the warrant that sent his fellow-painter Hubert Robert to prison. (Robert had been keeper of the King's pictures, a sort of early curator of the galleries of the Louvre, and he had been a known favourite of noble buyers of art. He escaped the guillotine when another was taken from Saint-Lazare Prison in his stead through a likeness of name.) David refused, too, his intercession to save from the guillotine the sister of his artist-friend Carle Vernet, a beautiful woman who had sat to David himself for her portrait within the year.

Recognition of this implacable will, this inflexibility of character, is necessary to understanding of David's iron rule over the arts, once he had been designated by the Assembly to bring painting into the service of the citizens and the revolutionary state. His confidence in the rightness of his painting method was as absolute as the ruthlessness of Marat and Robespierre in advancing their ideals of republicanism through seas of blood. Great as was his talent as artist, within academic limits, he was even more the schoolmaster, the rigid disciplinarian, the iron theorist.

David needed to take only nominal measures for suppression of the old *fêtes-galantes* painting, in the tradition of Watteau and Boucher. The coquettish, effeminate, and often erotic thing went out almost automatically with the disappearance of the court and the aristocrats. Fragonard alone of the courtly masters survived; he had once done David a signal favour, and so happily escaped persecution—and besides, he now had turned sober and dull, and was, without success, trying to bridle his muse in the service of prosaic republican virtue. If there were left any other vestiges of the playtime art of the queens and dandies and courtesans, David had them swept out. To that extent there is truth in the frequently repeated statement that David "arrested the corruption of art and gave it firmness and purity." Henceforward, rococo was dead in Europe.

One painter, Mme. Marie-Anne-Elisabeth Vigée-Lebrun, was of the glittering court but had escaped the nervous excesses and erotic implications of Watteau's followers. She had substituted a hardly less shallow type of pretty portraiture, of a flattering surface loveliness, thus abundantly pleasing the Queen and the court ladies. Years later she was to look back to the day when Marie Antoinette picked up her brush for her and call it the happiest memory of her life. She had fled from France with-

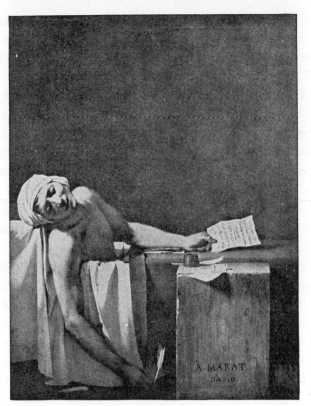

DAVID: The Death of Marat. 1793. *Brussels Museum*

out awaiting the sound of the rolling tumbrels—and it is not David's fault if her progeny continued endlessly to repeat her specialties, the perpetually adolescent girl and the never-failing mother-with-child theme.

One artist alone, of all those popular in the final years of the monarchy, Jean-Baptiste Greuze, carried on uninterruptedly into the republican era. He had once been officially a court painter, but later he had specialized in anecdotal painting and lower-class subjects. He had spent forty years, indeed, extolling the virtues of bourgeois families and peasant maidens— with his vastly popular *The Village Bride, The Morning Prayer, The Peaceful Home, The Girl with Doves,* and *The Broken Pitcher.* Moreover, he was known personally as a stolid, peace-loving man (already disciplined by a shrewish and unfaithful wife). He was certainly not a fellow to help or hinder the Revolution. The officials simply stripped him of his pension and his belongings, then left him alone. He gave up anecdote painting

and the lachrymose appeal, and tried to paint patriotic pictures, in a chastened classic style, but in vain. He drifted down to his grave. So little was he remembered that in 1805 there were only two mourners at his funeral.

The Royal Academy, which had been the court-protected citadel of "serious" art for a century and a half, David unceremoniously suppressed. Everybody agreed that politically this was right and logical. As a move for the good of art, the action could be applauded too, for it was a blow against bureaucracy and regimentation. Presumably "system," favouritism, and repression were to give way before freedom of expression, equality of all artists, and a fraternal communism. The illogic of it lay in the fact that the Royal Academy had led in preparing France for the neo-classicism which David was accrediting as the only style of the Revolution. The Academy had fostered the classic ideal from the day of its founding. When the old classicism had all but died of rhetoric and anæmia, the Academy had taken up the neo-classicism of Mengs and the antiquarian Romans. Even great artists such as Watteau and Greuze had been elected to membership in "inferior" categories; full membership was reserved for "historical painters"—in the dry classical style.

David spoke eloquently to the Convention when he proposed suppression of the Academy, saying: "In humanity's name, in the name of justice, in the name of a vital art—above all, for the sake of youth—let us put an end to all injurious academies; they cannot be permitted to exist under a free society of men." Thus was uttered a battle-cry of modernism, finely stressing freedom, youth, a vital art. But from that day in August 1793, when the despotism of the Academy was lifted, for some thirty years David's own despotism shackled French art. The chains were very little different, were still those of a chill neo-classicism. His iron-bound rules hindered free experiment and excluded from official shows all that adventurous youth might hazard toward creation of another style. Vitality they forbade. For thirty years all the natural revolutionaries of painting were to be homeless in France, so far as the dictator and the officially favoured artists could manage it.

The sum of it is that Jacques-Louis David, in the name of revolution, of freedom, extended the authority of "the grand manner," revived a type of painting that deserved to be permanently dead, and postponed the insurgency in art that was to mark the transition from Renaissance into modern usage. Certainly he saw the Revolution and the passing of the *ancien régime* as opportunity. But his mind was tight, small, filled with the

conception of culture gained from the Italianized Germans of Rome. He returned revolutionary France full into a retrogressive international movement. He missed whatever inspiration to creativeness might have been found in stupendous social change. He missed the challenge to art implied in Europe's great experiment in democracy. He built a monument not to a new spirit, not to a new France, but to his own brand of revivalism, to his narrow eclecticism. He brought to art another, a minor renaissance.

Robespierre, who had done more than any other, in line with his duties as reformer, to satiate the Parisian mob's lust for blood, was himself guillotined in July 1794. David, who had been his devoted supporter, was imprisoned. He served two sentences totalling seven months, and his powers as dictator of art were taken from him. Having renounced all political interests, however, he was released, the Terror being ended.

His influence seemed to have waned hardly at all, and not many years later his paintings attracted the favourable attention of a rising military officer named Napoleon Bonaparte. With the crowning of Napoleon in 1804 came the elevation of David to the post and title of *Premier Peintre de l'Empereur*. If not quite a dictatorship this time, the position enabled David to re-establish the classic code, partly through domination of the Academy—which had been revived, under Napoleon's decree, as a branch of the National Institute back in 1795—partly through the school he himself founded. He also established himself as dictator of fashions in dress and in architectural decoration, answering Napoleon's demand for a new style with the adaptation of classic forms known as "Empire." The clinging classic tunic served the beauties of the day well enough, though for common citizens' wear the innovations proved as unsuitable as had the togas revived briefly in republican days. The architectural style never progressed beyond interiors.

The quality of David as painter very little matters. He was a thoroughly good portraitist, in the hardened realistic tradition. A few of the revolutionary propaganda pictures are excellent as illustrational realism: *The Death of Marat*, with its direct treatment and faithfully correct detail, must have thrilled thousands of patriots, and it remains today a vivid record of a historic incident.

Two sides of David's character are illuminated by his own words about the picture. When the news of Marat's assassination at the gentle hand of Charlotte Corday was brought to the Convention, Guiraud at the end of his eulogy turned dramatically and asked: "David, where art thou? . . .

There is a picture to be made." In reporting completion of the picture, David said to the Convention: "The people asked for their murdered leader back again. They longed to see once more the features of their greatest friend. They cried out to me: 'David, take up thy brush, avenge Marat, so that the enemy may blanch when he sees the contorted face of him who was martyred for his love of freedom.' I heard the People's voice and I obeyed." In this, no doubt, there was sincerity; but there is an inescapable air of rhetoric and demagogism too. The artist was less fortunate in his monumental all-classic pieces and in the huge commemorative record-pictures done for the revolutionary government and for Napoleon.

David served all later French art to its profit by his insistence upon exact draughtsmanship and solid construction. But his gifts were coldly intellectual, and his conception of pictorial construction was static and shallow (based as it was on the ideals of sculptural bas-reliefs). He knew well how to compose a series of forms on the flat, but as regards the feeling for "form" in a picture, in the modern sense, as of something plastically alive, he was unenlightened. Géricault and Delacroix, who follow him in time though on the tangent road of romanticism, paint a few pictures showing intuitive reaching for formal ends, for arrangement of plastic elements to induce in the spectator an ordered formal experience. Canvases of theirs (and certain ones of David's Spanish contemporary Goya) may be shown as akin, at least distantly, to works of Whistler and Manet, who were to study "arranging" in the sixties, and to the post-impressionists of the eighties. But David himself is innocent of any tampering with nature's arrangement of the plastic elements. Note, for instance, how utterly wrong, from the point of view of modern, formally living art, are the over-detailing in the lower left corner of the *Portrait of Pope Pius VII* and the forwardness of the hand there. To cover that corner is to increase the rhythmic values immeasurably, though not to bring them to the pitch of formal simplification or of plastic unity found in Titian's not dissimilar but superb *Pope Paul III* or in certain of Cézanne's formally constructed portraits.

In 1799 David's co-worker Baron François Gérard painted a portrait of Letizia Buonaparte, mother of Napoleon I. It may stand as typical of the paintings of one of the two groups into which David's followers fell. The one group was composed of those who accepted and painted in accordance with the dicta of the master; the other was composed of those followers

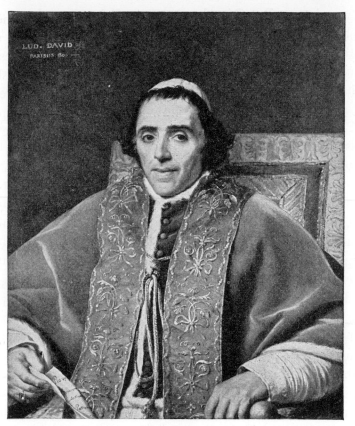

DAVID: Portrait of Pope Pius VII. 1805. *Louvre*
(Courtesy Metropolitan Museum of Art)

who outwardly accepted the rules, assuming the mantle of classicism, but then failed to repress fully their natural independence and feeling for the colourfulness of life.

Gérard accepted the rules and mostly practised within them, and was duly rewarded with rich commissions under both the Empire and the Restoration. The portrait of the mother of Napoleon is typical, not only of his work but of David's school, because it wholly and utterly suppresses the human and emotional characteristics of the sitter, presenting her posed among classic symbols, in impeccably correct drawing—a colourless, academic, bloodless exercise. The woman is known to us, from the biographies, as a spirited and lusty Corsican, with a dash of the primitive in her, who thought nothing of thrashing the potential world-conqueror

when he was sixteen. But Gérard manages to fit her into classic garments, to show her with refined face and an aristocratically slender body disposed with classic grace. A column and a bust of her emperor-son in the Roman manner are added to complete the specious production.

This instance might stand for the whole output of the colder, more obedient group of David's fellows and pupils, particularly for the canvases of Girodet and of Guérin, from which all that is warm in life—and all that is warming and melodious in the painting medium—has been emptied out.

Gérard was somewhat moved, apparently, by Mme. Récamier, and his portrait of her is more appealing than David's celebrated one. He relaxed a little the severity of drawing, he warmed his colouring, and he muted the ascetic tone, partly by showing the famous *salonnière* in a clinging tunic, a little slipped off at the shoulders and scarcely covering the bosom (which, after all, is not without classic precedent).

It was Pierre-Paul Prud'hon who especially made himself the type figure of the second group of David's followers, those who professed orthodox classicism but continually found themselves impelled to express their own feelings, or to warm up their medium. Prud'hon chose literary-historical subjects—the salons of those years simply reeked with "treatments" of Alcestis and Electra, of Priam and Achilles, of Brutus and the Horatii, of Manlius Torquatus, and of Psyche and Cupid and Diana—but somehow he escaped the frigid drawing and the windiness of his contemporaries. He was willing to be Greek but he simply could not exercise David's Spartan discipline. He returned French art a little toward emotional expressiveness and toward freedom of experiment. There is even implicit in his paintings a relish for nature, which is at the far pole from David's ideal of a statuary-inspired art. Prud'hon's nudes are as warm and melting and delicious as any since Correggio, and wholesomely so, without the erotic note struck by Watteau and Boucher or the frivolous one of Fragonard. But Prud'hon when he escaped the bounds of Davidian classicism failed to display more than a tentative revolutionary energy. He had not the stature of a leader.

After David had survived the kaleidoscopic changes of French governmental history of the years 1789–1814, he was exiled—it proved to be for the rest of his life—in 1816. He had helped in the founding and rise of the first Republic. In disfavour briefly during the republican decline, he had easily gone over to Napoleon the Consul, and as easily to the support

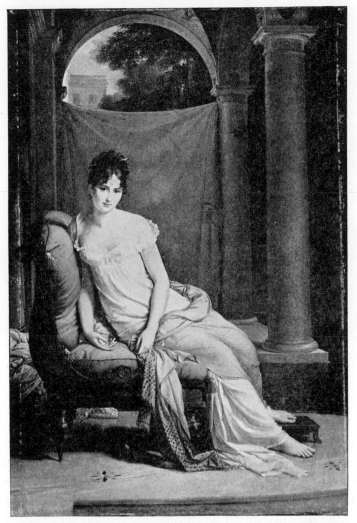

GÉRARD: Portrait of Mme. Récamier. 1802. *Carnavalet Museum, Paris*
(Courtesy M. H. DeYoung Memorial Museum, San Francisco)

of Napoleon the Emperor. By studied evasion, he managed to escape prosecution or retaliation at the hands of the Bourbons during the brief restoration of 1814. When Napoleon triumphantly returned for the Hundred Days, David signed the act intended to banish the Bourbons finally. After Waterloo the restored Louis XVIII proved less forgiving than before, proscribed David as a regicide, and exiled him. From 1816 to the day of his death in 1825 he resided in Brussels.

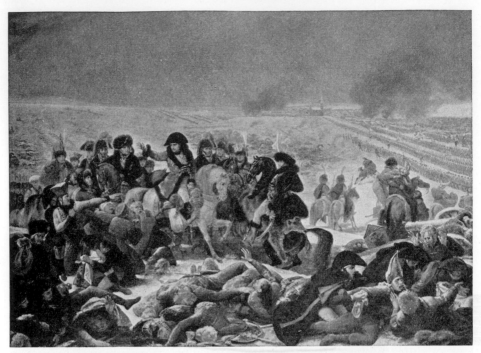

GROS: The Battle of Eylau. 1807. *Collection of Mme. René Antonin, Toulouse*
(Courtesy Metropolitan Museum of Art)

Curiously, David in Brussels was able to guide, through his lieutenants, the course of French art for a decade longer. Chief of his helpers, once a pupil, was Antoine-Jean, Baron Gros. He was decidedly of those who accepted the rules of classicism but internally warred with them. In his later years he did his best to be elevated, pure, and remote. But he never quite got over his early passion for Rubens, the most heated and un-classical of master-painters.

Falling heir to the dictator's mantle when the leader was exiled, Gros took seriously the duty of stamping out any individuality the young paint-ers at David's studio-school might have. He fretted under the necessity of this repressive business, which was against his instincts and quite out of keeping with his own brief escape from authority ten years earlier. When his pupils were inclined to rebel too, asking why they could not take the road Gros had started upon, reminding him that he had added almost Rubenesque colour and animation to his Napoleonic war pictures, he

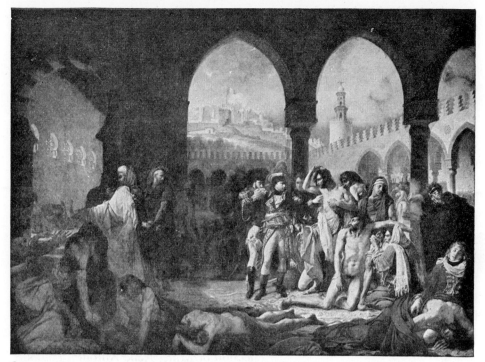

GROS: Napoleon and His Plague-Stricken Soldiers at Jaffa. 1804. *Louvre*
(Alinari photo)

cried out: "It is not I who speak to you—it is David, David, yes, eternally
David!" Then he went back to prove by words the superiority of the
disciplined brush, of the severe line and definite contour, of noble subject
and serene mood.

To the end the dictator's messages from Brussels continued to be
peremptory and specific. Gros settled down resignedly to years of teach-
ing which, his heart told him, was unsound and hurtful. One day he
penned a note saying that, since he could not bear to betray all that was
supportable to him in life, he had resolved to put an end to himself. He
laid the note with his cane and his cravat on the bank of a stream running
into the Seine, and drowned himself in shallow water. This was the man
who seemed destined, if one judge by *The Battle of Eylau* and *Napoleon
and His Plague-Stricken Soldiers at Jaffa*, to be the first great romantic
painter of France. But individuality had failed; discipline, out of a stronger
will, had intervened. Despite the fact that Gros's battle pictures were

superior to David's in all the points that were to be important to a succeeding modernism, the man himself was kept under a shadow.

If the romanticists of the next generation owed something to him, it was for values found in his earlier rather than in his later works. *The Battle of Eylau* (1807), a record-picture of Napoleon's wars, exhibits the controlled movement, the drama, and something of the colourfulness that might have afforded safe models for the school of Delacroix a quarter-century later, when pictorial movement unfortunately became more nervous and the drama and colour less focused.

When he died in 1825 David had practically controlled French art through thirty-two years. He had turned back the revolutionary spirit. He had diverted insurgent effort into a cramped revivalism, had re-established a style already near exhaustion. There were gains to be marked up on the credit side of his record. Something of the eternally good quality of classicism, its care for design and its pictorial poise, had been maintained along with the neo-classic evils of hardness, frigidity, and pomposity. He had killed the debased French rococo and had outlawed (though not stamped out) sentimental-anecdotal realism. He had been, in his own right, a solidly accomplished realistic portraitist, and at times an excellent historical illustrator.

But in relation to the art that was to come, that was to constitute or even to herald modernism, he had been a deterring rather than a constructive figure. He had returned, in his dictator's choice, to forms and methods that came to mark him, historically, as representative of the end of an era. Victor Hugo was to say, a generation later, that David himself was "the guillotine of French art." That is romanticism speaking. If David had literally sent to the guillotine certain artists surviving from the courtly days—some with talents perhaps as great as his own—he had equally thwarted those of his later contemporaries, such as Gros, who showed signs of pushing forward into romantic expression. Even before his death, however, Paris had been stirred by a strangely unorthodox and appealing bit of romantic extravagance.

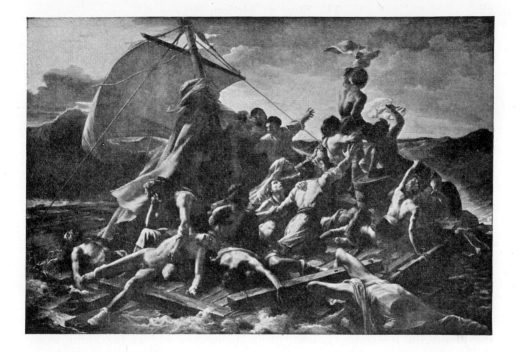

II: THE CHALLENGE OF THE
ROMANTICS—AND GOYA

In 1819, while Baron Gros was holding David's school as a citadel in
defence of the older virtues, there appeared at the Salon a picture that
created a sensation with public and critics by reason of its novelty and the
excitement implicit in both its theme and the realistic handling. It was
entitled *The Raft of the Medusa*, and the painter's name was given as
Théodore Géricault. The public was, if not delighted, at least interested
and excited. The critics were outraged. The painting failed to be classic
on every count. The theme was neither dignified nor ancient. Here was,
rather, an up-to-the-minute journalistic illustration of an incident kept
alive in the public mind by newspaper controversy. The figures had no like-

GÉRICAULT: The Raft of the Medusa. 1819. *Louvre* (Alinari photo)

ness to ancient sculpture. Indeed they were animated, interwoven, feverishly active. There was no serenity, no repose, no lofty sentiment.

Some time before, a raft with one hundred and forty-nine survivors of the abandoned French ship *Medusa* had been set adrift on the ocean. Picked up with only fifteen men still living, with evidences of cannibalism, it had become a frightful symbol and a club for attacking officialdom. The disaster had been due to some official's error, and there was the usual search for a scapegoat, there were charges and countercharges, followed by the public with avid interest.

Obviously no serious, well-brought-up painter would have had anything to do with a subject so immediately exciting, so horrible. Obviously it could not be handled with proper remoteness, with temperateness, with circumspection. But at last a man had arrived at mastery of the painting medium who had done with classic calm and Spartan coldness. Théodore Géricault had made up his mind to be himself at any cost—even his unpleasant self—to express his own emotion, to deny neo-classicism and David and the Institute. He had got his insurgency a little, no doubt, from Baron Gros, whose early idol Rubens he had copied. Then inexplicably he had developed a liking for Caravaggio, the violent and tragic realist of Naples, and for Salvator Rosa, the Byronic adventurer and painter-bandit who had been a wild man of Italian art in the seventeenth century. But mostly it was his own temperament that was to blame. He was an individualist, a born rebel, a romantic, the first in classic France. He is the first true digressionist of our story.

The romantics were to be principals in one of the great battles of art history, in the decade 1820–1830, during which they were to displace the classicists as the recognized revolutionary group. The difference between the two parties seemed more clean-cut and more important then than some decades later. The post-impressionists, for instance, were to point out during the nineties that romanticism and classicism were variants within a large art species and not themselves major species, both being, as commonly practised, within the general Renaissance true-to-nature representationalism. The difference was one of method or approach.

Roughly, the romantic artist, individualistic by temperament, emotionally impulsive, caring for the fire and movement and variety of life, tries to put into his canvas a warm and glowing reflection of his feelings or a stirring record of an event emotionally significant. He works in the two directions of exciting subject and animated medium. In the matter of

medium, he utilizes colour generously, even dramatically—where the classicist had paled down his colours, arriving at a soothing and lifeless greyness; and he utilizes movement, both by showing figures "on the move" and by the technical device of emphasizing diagonals and interweaving the figures in a sort of motion-pattern—where the ideal of the classicists had been that of a few figures separately set out, postured, as in sculpture, in a composition static and grave.

For a young man in his twenties, Géricault had an extraordinary success. *The Raft of the Medusa* was acclaimed by the public. It had the immediacy of appeal which, in his rebellion against classic remoteness, the painter had intended. It excited, it provoked discussion, it shocked. But the artist was disappointed because all the excitement and discussion concerned the case of the *Medusa* and not the art of his picture. Where there was opinion about the method and the choice of subject, among artists and critics, the verdict was almost unanimous in condemning Géricault. He was so disappointed that he said he would never paint again. By a fortunate chance he at that moment went to England.

Géricault had come up against an obstacle which has had to be met by many a rebellious artist along the road travelled by the founders of modern art. If the revolutionary grasps at subjects that are thrilling, in the newspaper or cinema sense, or if his romanticism takes a turn toward utopian ideals, with consequent emphasis upon immediate, contrasting social horrors—in either case he learns that there is a certain disability in journalistic themes, that there is danger in subject matter about which controversies revolve, about which passions automatically rise. That Géricault, having met the danger in exhibiting his first picture, in 1819, should have understood it after the one experience is additional reason for counting him a forerunner of the moderns. For it was to become clear one hundred years later—in so far as any matter of art theory may be said ever to become clear—that a controversial theme, an immediate cause-picture which starts the mind reasoning or sets it arguing or protesting, destroys the conditions under which art as such may be enjoyed. The intellect awakens, and intervenes before the picture registers with that deeper faculty which may be termed the æsthetic sense.

The appeal of art, the moderns were to point out, is not realistic—does not exist to recall to the mind, by photographically correct or only "reasonably" distorted images, what has been known to the eye—nor ethical, nor intellectual. It speaks to the observer at some deeper level of conscious-

ness. Some people, going the whole way, to the opposite pole from intellectual understanding, would have all proper response to art a *spiritual* activity. In any case, the angrily aroused conscious mind acts as a bar to deeper response, and the *Medusa* induced mental rather than æsthetic excitement.

The first showing of *The Raft of the Medusa* was, historically, a landmark, identifying the exact point at which a new *method* of art appeared in France. But it was not a mark identifying the main turn into a modern slope. In the final analysis the picture is both melodramatic and photographically illustrational. Its accurate illustrational content—Géricault interviewed survivors, hired one of them (the ship's carpenter) to build a replica of the raft, and bought corpses from a hospital, keeping them in his studio for such extended study that the neighbours rose in indignation —links it to realism as well as to journalism. That again puts it out of line with the course of modern art, which is, above all else, anti-realistic, a reversal of the current of painting that took its direction at the beginning of the Renaissance under the excitement about scientific vision, exact observation, and the rule of reason.

Géricault never painted another picture in the vein of *The Raft of the Medusa*. He wisely left journalism aside. He in no sense gave up movement as a pictorial asset (though the actually tortured forms do not reappear). Colour remained, and the school he helped found was to be known as one of "colourists." In this particular the English were to help immensely.

When Géricault went to England, it was in the cause of adventure, not in the search of art. No Frenchman would ever have dreamed he would find art in Britain. But adventure might be found there, as in any barbarian country. As an adventurer Géricault had already had a career. Restless, passionate, sensitive, he had been unruly as a pupil and rebellious as a man. His art schooling had ended when a bucket of water with which he had intended to douse a fellow-student was emptied instead over the master of the studio, the famous classicist Guérin. Enraged for the hundredth time at the erratic youth, the master had turned him out, shouting after him: "Besides, your paintings are those of a madman!"

Tiring of Parisian life, Géricault had joined the King's army. Then, embittered in a love affair, he had gone to Florence and Rome, where art seemed to offer the only possible surcease from suffering. Before Michelangelo, he said, he had stood trembling. Having (in W. Gaunt's words)

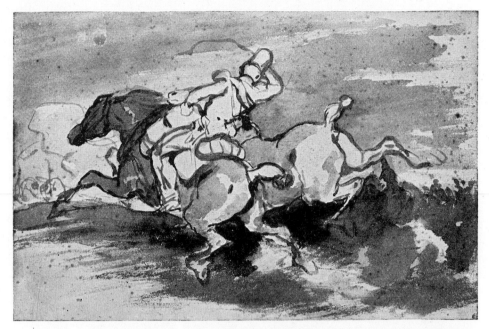

GÉRICAULT: Mounted Hussar Racing. Pen and Bistre Wash Drawing. *Paul J. Sachs Collection, Fogg Art Museum, Cambridge*

"decided on a life of penance and dissipation," he returned to Paris and cast about for a way of art suited to his daring and to his black moods. The story of the *Medusa* had seemed to afford the proper material.

In England he found adventure too, often rewarding, but at one time so little so that he attempted suicide. What matters to art is that after interesting himself in British racing, he painted some of his finest pictures, somewhat in imitation of James Ward, and that he saw the paintings of Constable and Turner. The freedom, the freshness, the movement in the canvases of those insular masters afforded the perfect contrast to the academic "machines" of the French Salon exhibitions. Here were men who apparently never had heard of David and the necessity to be rigorous, Roman, and remote. For once a Frenchman went back to France (after three years) with praise for the art and the artists he had encountered across the Channel.

Géricault disappears quickly from the story. After two more years of extravagant and erratic living he dies, at the age of thirty-three, partly from an injury sustained when thrown from a horse, partly from dissipa-

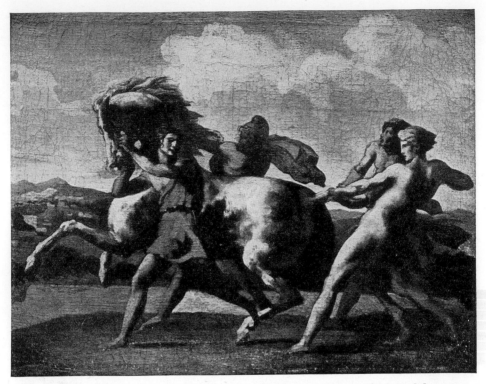

GÉRICAULT: Study for the Race of the Riderless Horse. *Rouen Museum*
(Courtesy M. H. DeYoung Memorial Museum, San Francisco)

tion, and partly—if his friends are right—from the melancholia which had
been chronic with him because he was born a romanticist. He leaves too
few pictures to merit a place in the front rank of the masters or to establish
him as leader of the romantic movement. But his had been the first effective
insurgency against the classicists; he had served to bring before his French
confreres the innovations of Constable and Turner; and he had left a very
few pictures which, in later estimation, went beyond the romantic formula,
touching on territory more properly assigned to the post-impressionists. A
Cross-Country Run, in the Smith College Museum of Art, and the sketches
for *The Race of the Riderless Horse* add to the romantic freedom and
animation then so novel some of the values of form-organization, volume
manipulation, and spatial rhythm more especially associated with the
generation of Cézanne. As a portraitist Géricault surpassed both David

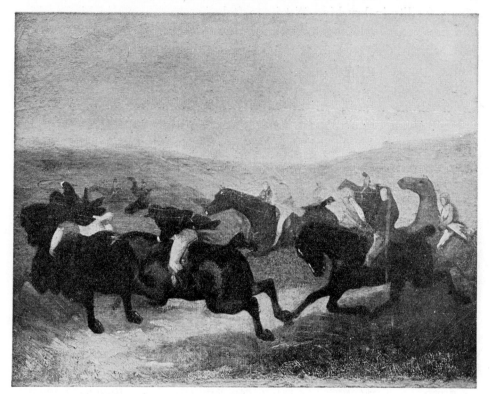

GÉRICAULT: A Cross-Country Run. About 1822.
Smith College Museum of Art, Northampton

and Delacroix. The surviving canvases from a series painted at an asylum for the insane are among the most understanding and accomplished portraits of the nineteenth century. But the hand of this truly great painter was stilled by death in 1824.

Romanticism was ill served a second time when an English painter living and working in Paris, Richard Parkes Bonington, was similarly and tragically cut off at the age of twenty-six. Bonington flashed across the scene of French art during the years 1823–1828. For a moment he was recognized as the artist most likely to initiate a movement that would carry painting into fresh, even revolutionary fields. Trained to proficiency in water-colour before he went to Paris to live, during his teens, he combated the muddiness of traditional oil painting, carried over something of clarity and sparkle from the water-colour medium, and added an extraor-

dinary facility in brushing. A trip to Italy in 1822 awoke in him a vision of atmospheric loveliness to be transferred to canvas. A virtuoso in the ease with which he set down his impressions, he too often had the virtuoso's fault of hasty and not quite solid achievement, of elegance of handling without adequate substance. With a little more of study, with a little deeper understanding, he might have taken his place with Constable and Turner.

He died of tuberculosis a month before his twenty-seventh birthday, and had he lived longer, it may be that he would have matured and ripened, and so claimed a primary place historically. His early brilliance had been such that he was hailed by his fellow-students in Paris, and by their master, Gros. He was honoured, beside Constable, with a gold medal at the Salon of 1824. An occasional landscape of his seems to foreshadow the freshness of the Barbizon painters, and about some of the seascapes there is an almost Whistlerian touch. He failed, however, to measure up to the stature of Géricault.

Constable had sent three canvases from London to the Paris Salon of 1824, and many French artists were able to confirm at first hand what Géricault had so enthusiastically reported, that isolated English painters had already developed a way of painting free of Davidian neo-classicism, based upon a fresh approach to nature, and utilizing colour and movement in unprecedented ways. Six other Englishmen were represented in that Salon. But a greater revelation awaited those French artists and students who were to cross to London in the following year or two, for they had yet to meet the most wayward and inspiring of the English rebels, Turner.

Eugène Delacroix, the French youth who was a close friend of Bonington, was destined to become the leader of the romantic movement of the following decade, and is oftenest spoken of as the founder of French romanticism. Like Géricault he was of a restless nature, and he had survived every sort of boyhood casualty, barely escaping with his life from assaults by disease, fire, and poison, and miraculously living to tell how he was nearly drowned, then nearly hanged (all excellent background for an avowed romantic).

In his later childhood in Paris, fatherless, he was left much alone, developing an introspective and dreamy temperament; and his otherworldliness was increased by summer visits with cousins who lived in an old Norman abbey. As a sensitive schoolboy he wandered in the galleries of the Louvre and chose his own masters; he was drawn especially to the Venetians and to Rubens.

GÉRICAULT: The Mad Assassin. About 1822. *Museum of Fine Arts, Ghent*
(Courtesy M. H. DeYoung Memorial Museum, San Francisco)

At Guérin's studio he became a student beside Géricault, and although less rebellious he failed to please the classic master. When, in 1819, Géricault's *Raft of the Medusa* was shown in the Salon, Delacroix was so excited that, in his own words, he "ran like a madman through the streets of Paris." In 1822 he saw his own first notable painting accepted and hung at the Salon, and made the centre for renewed controversy. *Dante's Bark* showed Dante and Virgil passing over Acheron in a boat surrounded by the damned. The subject might have passed even among the classicists;

the episode had been chosen from literature, and at least Virgil was Roman. But the treatment was imaginative, lively, colourful, essentially unclassic.

Guérin led the attack for the conservatives—"absurd, exaggerated, detestable." But a more liberal classicist, Baron Gros, remembered his youth and threw his weight on the side of the young insurgent, even mentioning "Rubens come back." He secured for the picture a gilt frame (which Delacroix had not been able to afford) and he had the exhibit moved up to a better position in the main hall. The old-time dictator, David, when he saw the picture, was startled. He said: "Where does that come from? I don't know that touch." And well he might find the touch both strange and disturbing.

Perhaps *Dante's Bark* was more modern than even Delacroix, or David, was aware. In letting himself go (the picture was painted in a feverish burst of excitement, in a ferment of emotion and inspiration) the young painter entered a realm of free expression not attained by any other of his major works. At one stroke he cut through every rule of academic classicism. The one picture opened a vista into a far future in which artists would be concerned with long-forgotten or wholly new plastic means; for, intuitively, Delacroix had touched upon such devices as volume tensions and plane manipulation, which were greatly to concern the modernists of the latter half of the century. (A modern master would, no doubt, point out that, considered in the light of twentieth-century standards, *Dante's Bark* offers rather a confused experience to the eye, and particularly that the central mass of figures is over-heavy and too far forward in the spatial field. But the picture has its main and minor movements, and a rhythm in its organization. It is expressive, not merely imitative.)

Dante's Bark was like a bombshell dropped among the exhibits of the sleepy academicians. Where the lone Géricault had been effectively driven off, three years earlier, Delacroix was found to be a tenacious fighter for his ideas and a resourceful antagonist. Moreover, a younger generation weary of being taught the pallid formula of classicism rallied to his side. Writers came forward to proclaim war upon the conservatives of French literature; they were finding the run-out classic verse as tedious and lifeless as Guérin's and Girodet's pictures, and they had been strangely moved by the poems of the Englishman Byron and the German Goethe. Thenceforward it was to be war. The word "romanticism" was inscribed in scarlet upon the new party's banners.

Delacroix, being something less than a genius as painter, though shrewd

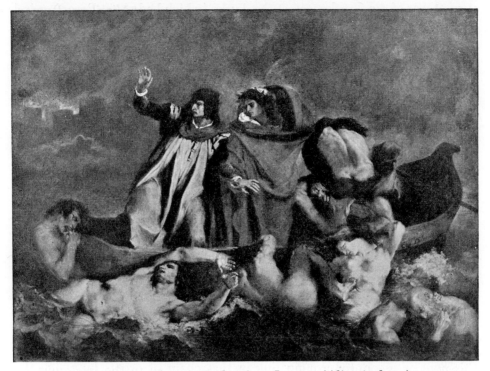

DELACROIX: Dante's Bark. 1822. Louvre (Alinari photo)

and dogged as a leader, was in one respect brother to David. He dreamed in terms of "restoring" qualities lost out of the art of painting, not in terms of the dawn of a new era. He foresaw the glory of Rubens reborn, the colour of Titian and Veronese revived, the symphonic movement of Tintoretto again achieved, perhaps even a second coming of the stormy Michelangelo. His story mainly continues that of revival and rebirth, rather than of new seed planted toward a different flowering.

The second picture by Delacroix did not disappoint his followers. Shown at the Salon of 1824, *The Massacre of Chios* seemed to carry forward the cause of romanticism. Certainly it fed fuel to the raging controversy. The conservatives dubbed it "The Massacre of Painting" and reviled the artist as a barbarian and an apostle of ugliness. As a matter of fact the picture reverted a little to the ground of the classicists: the foreground figures are carefully grouped and set out—even to the point of posturing—and line and contour are more relied upon. But on all other counts the picture is romantic. The theme is immediate, an incident of the

current war of the Greeks against the Turks (which had so set Byron's mind afire). The appeal is frankly emotional, with the wounded men, the panic-stricken children, and the despairing women grouped at the moment of attack, the moment of massacre. In the composition there is abundance of movement, and colour is used dramatically.

At this same Salon of 1824, it will be remembered, Constable was represented by three paintings. Delacroix already had absorbed much from the Englishmen, through his fellow-student Soulier, who had been English-taught, from the Fieldings, from his close friend Bonington, and from Géricault's example. As early as 1823 he had put down a reference to "a sketch by Constable—an admirable bit, unbelievably fine." Now, having sent *The Massacre of Chios* to the Louvre for the Salon showing, Delacroix got access to the Constables there awaiting hanging. He was so enchanted, so overcome by the luminosity and the freedom of handling in the English artist's pictures that he could not rest until he had got permission to retouch his own entry. So, before the Salon's opening day, *The Massacre of Chios* was submitted to a repainting that brought new light and heightened colour into the canvas. Since Delacroix was to be leader of the recognized revolutionary party in French art during the following thirty years, this may be accounted a main link in that chain of events by which the luminism of the English innovators, Constable and Turner, entered into French impressionism and so ultimately into post-impressionism.

The chronicles of romanticism are absorbing—even fascinating when set down by the pen of a Gautier or a Musset—by reason of the flaming spirit and the outrageous actions of the young men of the movement. It was Gautier who introduced the scarlet waistcoat to be flaunted by the young rebel wherever he was likely to meet a pillar of classicism, at the Salons, at the Opéra, at the Comédie when romantic plays were having their *premières*. (At the opening of Victor Hugo's *Hernani* in 1830 there was almost a pitched battle, with actual duels following, from which the romantics in their scarlet waistcoats and pale green breeches came away victors.) There was pamphleteering and there were café meetings, from which, perhaps, the whole picturesque and dubious Bohemianism of latter-day French art might be traced. Temperament became rife; the true sort went into the opening of new paths of freedom for the arts; the bastard sort fostered Bohemian licence and artistic dissipation. In painting there was less true progress, after Géricault's death and Delacroix's early innovations, than in literature and the theatre art.

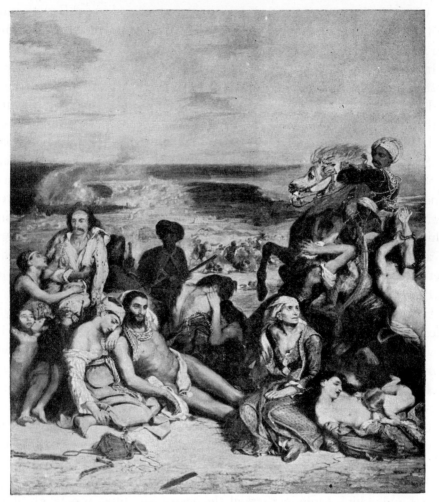

DELACROIX: The Massacre of Chios. 1824. Louvre

Romanticism as practised was a varied phenomenon, ranging from can-
vases that gave pleasure in new and warming ways to mere records of
picturesque scenes, abnormal faces, and exciting events. It is said that there
are 11,397 definitions of the word "romantic"; but so far as painting is
concerned they might all be dismissed for one that stresses individuality in
approach, emotion in contemplation of the subject, a devotion to strange
examples (instead of the classic normal or average), and a presentation
exciting by virtue of its movement and colour. Magnificence and grandeur

were, no doubt, aims. The half-way marks of adventure, pageantry, and rhetoric were sometimes attained. Oftener the output sank to the level of the strange or the novel or the sentimentally effective.

In short, romanticism in painting, once it had cleared the way of classic obstructions and passed on the gains of fresh colouring and vibrating light, had just about completed its service to modernism. No painter appeared with the talent of Géricault, dead in 1824. Delacroix repeated his successes and was increasingly popular with the public, especially through *The Death of Sardanapalus* of 1827, *Liberty Guiding the People*, a patriotic piece, superficially stirring but not a little theatrical and unreal, of 1830, and a long line of Oriental pieces, which date from 1832, when the artist went to Morocco. It seemed as if, after a youthful burst of creative painting, which had carried him to the first courses of a modern and original way of art, Delacroix had intellectualized his gains, reverted to tradition sufficiently to bring him within the Renaissance outline, and lost his originality in the business of painting romantic illustrations.

He also, no doubt, suffered from what may be termed the disability of the romanticist practising in a realistic era. He could not release the imagination beyond "reasonable" limits. He could not go on to explore those realms of distortion of nature, of experiment in the architecture of picture-making, which had seemed to be touched upon in *Dante's Bark*. He became less modern as an artist, as time went on. He was a canny career-maker, even refusing to marry because marriage, or any serious emotional attachment, might interfere with his career. The classicists, to be sure, remained for many years in control of the Institute and the École, and they shamelessly cried down his work and withheld the official honours so richly due him. Only in 1857, at the age of fifty-nine, was he elected to the Institute.

The preceding thirty-three years, since the showing of *The Massacre of Chios*, had seen the complete popular triumph of romanticism, then the too usual compromise of the "revolutionary" party with the academic groups, and finally the rise of a new revolutionary group in the realists led by Courbet. The cycle of romanticism was complete. It had ended in "escape" art, as the realists, wholesomely addicted to nature and crying for an art unashamed of life, were quick to point out.

Delacroix had been as guilty as anyone of diverting the romantic current toward escapist pastures. The ultimate dilemma of the romanticist is that if he renounces immediately dramatic subjects as too journalistic, if he

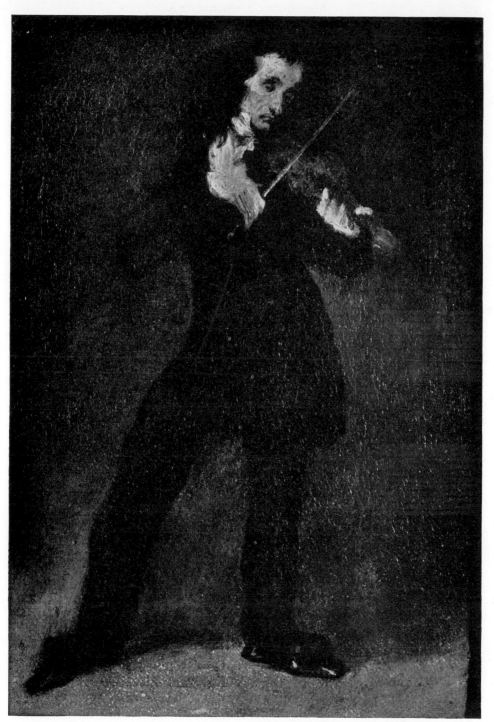
DELACROIX: Paganini. *Phillips Memorial Gallery, Washington*

avoids the controversial and the sensational in the life around him, he must turn to fiction or to the long ago and the far away for subjects. Having sworn above all to be heated and colourful and exciting, he turns inevitably to material from two sources, literature and exotic lands. French art became so preoccupied with pictures drawn from these two sources, in the romantic period, that there was ample ground, by the decade 1840–1850, for the charge that the painters had withdrawn from the common life, had built themselves—in the overworked phrase—an ivory tower.

Delacroix himself painted numerous literary pictures, retelling incidents from Shakespeare, Scott, and Byron, and from Goethe; and from the time of his visit to Morocco he specialized in Oriental subjects. Colour, movement, novelty were there at his disposal, ready made—and indeed his *Femmes d'Alger dans Leur Appartement* and his several portrayals of Arabs hunting lions[1] are among the richest works from his brushes. The lesser men of the movement followed this lead and produced an endless procession of pictures dealing with Eastern courts, harem life, and desert battles. Searchers for the exotic and for "local colour" sometimes went no farther afield than Venice, or perhaps Spain. A cult of the picturesque grew up, and even local ruins of abbeys and prisons yielded subjects.

In England and Germany the vogue was rather for the literary subject; the escape was more into medievalism and illustration of romantic tales, and less to existing exotic lands. (The word "romantic" comes from the old French adjective *roman*, applied to what are termed today the Romance languages or vernaculars, and from the *romans* or tales written therein. These tales were fictitious and usually of adventure, love, and military exploits. Beyond the literary implications of the word there is a troubadourish odour to it.)

The artist, too, the experimental one at any rate, was "escaping" in a different sense: fleeing a place and a time that seemed to have little use for him. The democratic revolution had essentially failed. The Bourbons now had been restored. France was a curious disunited nation, with the bourgeoisie and their pinnacled success-men, the industrialists, continuously gaining power. The court might somewhat weakly encourage artists, but always the safe, uncreative ones. The original painter was on his own, and unwanted—for nothing is more strange and suspect to the bourgeois than an original, a creative artist. The painter was taking his difficult place in

[1] But it is only necessary to see Rubens's *The Lion Hunt* in the Hermitage, Leningrad, to know that the great Fleming's composition is superior in all soundly romantic qualities.

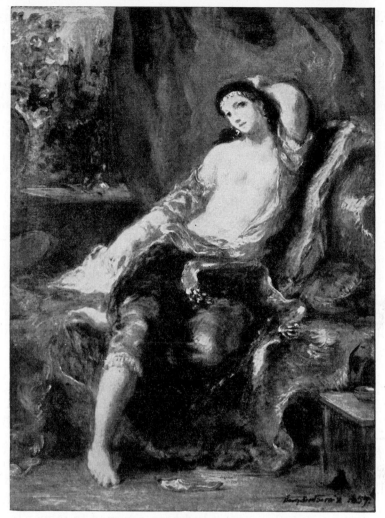

DELACROIX: An Algerian Woman. 1857
Collection of Edward G. Robinson, Beverly Hills, California

competitive capitalistic society. Large pictures, except for a few bought each year by the Government for the museums (and the ones with glamorous female nudes suitable for barrooms), were left on the artist's hands. Portrait painting was his bread-and-butter work. In this period, too, the disillusion that comes after idealistic wars won in vain was over France.

Delacroix, nevertheless, broke the power of David and gave an example of free use of colour and movement, going on to painting that is sensuous

and even tumultuous. He also served well as preceptor. Again and again his sayings summed up the situation and the need with incisive and epigrammatic patness. His *Journal* is one of the richest first-hand documents in the history of art. As an individualist he felt that "Style depends wholly and only upon the free and original expression of the artist's particular qualities." He never attempted to force his own "style" upon anyone else, and he consistently refused to teach. He said: "Grey is the enemy of all painting. . . . Let us banish from our palettes all earth colours." Again, "the finest works of art," he wrote, "are those expressing the pure fantasy of the artist. Hence the inferiority of the French schools of painting and of sculpture, which have always placed study of the model above the expression of the feeling dominating the painter or the sculptor. The French have been preoccupied with questions of style or method. . . . Their love of reason in everything is responsible. . . ."

Thus he dismissed not only David but virtually the entire French tradition; and, despite almost passionate admiration for the Venetians and for Michelangelo, he refused steadfastly to visit Italy—"as a matter of principle." He felt kinship to the masters of the North, Rubens and Rembrandt, and, in literature, to the German Goethe and the English Shakespeare and Byron. There are historians who count romanticism—particularly the sort that goes beyond the 1830 meaning, adding imaginative far-riding significance—as a Northern development, not congenial to the French or Southern intelligence. In so far as he served to bring the freedom and warmth of this way of art into a France frozen in rationalism and classicism, Delacroix served to put his country in position to dominate the art story of the following hundred years. Really it is he and not David who may be considered the true child of the French Revolution, albeit he came thirty years late, after the country had been returned to monarchism.

The authoritarian opposition to romanticism increased rather than diminished after the early sensational showings of the works of Géricault and Delacroix and their obvious success with the public. Perhaps it was the appearance of a leader greater than David that revived the hopes and steeled the hearts of the conservatives. It was in the year 1824, the year of *The Massacre of Chios* and of Constable's coming, that Jean-Auguste-Dominique Ingres returned to Paris after eighteen years spent in Italy. He showed at the Salon, in 1824, his *Vow of Louis XIII*, an academic exercise in imitation of the Florentine Christian masters, depicting the kneeling

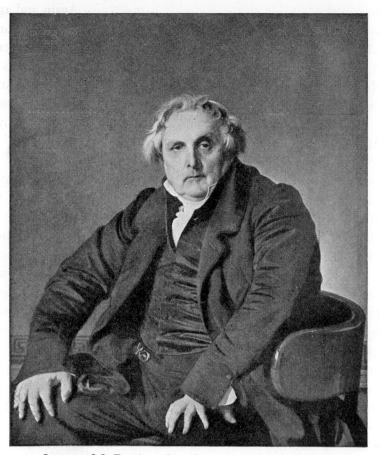

INGRES: M. Bertin. 1832. Louvre (Alinari photo)

king offering his crown and sceptre to the Madonna. The painting made a great success with a section of the public and with the critics, and it was like a rallying-cry to the frightened classic painters. Ingres was immediately elevated to the Institute and to the Legion. He hardly had to wait for David's death in 1825 to take over the mantle of dictator.

Ingres was immeasurably a greater artist than David. It is true that he showed often that he could be a very bad painter indeed, dry, pedantic, pompous; but, judged by his finest canvases and drawings, nearly all to be found among his early works—for his powers degenerated, perhaps from too much Italian study—he emerges as the towering figure of the French neo-classic school. He showed, as David failed to do, a talent for placing

the figure in the canvas, at times attaining to an architectural structure, a symmetry of parts, reminiscent of Poussin (a quality to be prized and widely debated from Cézanne's time on).

In a little group of portraits done as early as 1805–1807 he accomplished as much as can be accomplished within the austere, intellectually controlled, neo-classic formula. Despite the photographic attention to unimportant detail, to natural textures, and the clothing's wrinkles and seams and buttons, the *Mlle. Rivière* and *La Belle Zélie* and *The Painter Granet* live, both as likenesses and as pictorial organizations. There is more than a hint of plastic orchestration, of spatial arrangement. The feeling for the quality is not very deep, and it disappears almost entirely from Ingres's later work, though an exception might be made of the *M. Bertin* of 1832, and perhaps of *Turkish Women at the Bath* of 1862. Indeed, about all the painter succeeds in accomplishing after 1824, through his leadership of the academies, is to prolong the productiveness of the French neo-classicists, side by side with the romanticists—so that in the fifties, when Courbet attacks the romantic escapists, he will be under necessity to fight also the older but somewhat less senile neo-classicists.

David had talked much of classic purity and clarity. It was Ingres who made his paintings surpassingly pure and clear. He went beyond the Romans to the Greeks. If he liked Raphael, he nevertheless became enamoured of Giotto and the Italian primitives. He renounced colour, denied its creative importance (that, of course, is frightfully unmodern), and he put extraordinary emphasis upon line. He has been called the world's greatest draughtsman. A certain unmistakable harmony in his paintings is resident in the linear relationships. He pinned his faith on emphasis of contours, of the graceful, bounding line, of the caressing line (and so, of course, the nude female body was the most agreeable of subjects).

Since, from 1830 to 1940, there were to be continuously painters claiming to be moderns for hardly better reasons than their neglect of correct drawing, Ingres's influence was to be partly on the profitable side. He said: "Drawing is the probity of art." Again he said: "Of the four quarters that constitute painting, drawing contains three and a half." How little he understood colour in the modern sense, as having plastic vitality, is evident from his saying that "no great draughtsman has ever failed to find colours exactly suited to the needs of his drawing," and that "colour adds adornment to the painting, but it is only the attiring-woman of art, rendering

INGRES: Mlle. Rivière. 1805. Louvre
(Archives Photographiques)

more pleasing the inner perfections." He even advises: "Study the flowers
to discover pleasing colours for your draperies."

In 1834, offended over the popular gains made by the romantics and
bitterly disappointed that his fellow-academicians and the critics had turned
on him when he exhibited his *Martyrdom of St. Symphorien,* Ingres vowed
never to show at the Salon again and to leave France for good. He com-

promised to the extent of accepting the directorship of the Government's French School in Rome. He stayed in Italy six years, and he did not show officially in Paris for twenty-one years—when, 'way up in Courbet's time, he was given a series of galleries for a retrospective show at the World's Exposition of 1855. He exhibited a consecutive series of works produced over a period of fifty years, and he was hailed again by officialdom and by the majority of critics as the glorious upholder of the sacred traditions of French art.

Even a conservative, a typical school man and academician, may tower above the schools as they are. Ingres once told a student: "Don't go to the École. . . . That is a place where men are ruined. When one can do nothing else one has to adopt such an expedient; but one should not go there save with one's ears well closed, and without looking left or right."

Ingres in a letter to Édouard Gatteaux in 1836, explaining his reasons for leaving Paris and the art circle there, writes: "Babylon! Babylon! The arts? People no longer want to have anything to do with the arts. . . . What is there to do in such barbarous times, what remains for an artist who still believes in the Greeks and the Romans? He must retire. That is what I am doing. Not one more brushstroke for this public that has so little feeling for the art that is noble."

This artist who eschewed colour and glorified the severe, expressive line was a natural target for Delacroix, who glorified colour and never properly learned to draw. "Ingres," said Delacroix, "is a Chinaman lost in Athens." As a matter of fact Delacroix and the romantics had at first been inclined to praise *The Vow of Louis XIII*, perhaps because in being Raphaelesque it came over a little way from Davidian coldness and colourlessness; and once, at least, Delacroix spoke of "Ingres *charmant*." But on his side Ingres was shocked by *The Massacre of Chios* and joined those who called Delacroix an apostle of ugliness. The two men, unmistakably the two giants of French art during the first forty years of the nineteenth century, fought and reviled each other through two decades. If he arrived at a gathering where Delacroix was, Ingres sniffed, remarked that he smelled brimstone, and withdrew. When finally, in 1857, Delacroix was made a member of the Academy, Ingres exclaimed: "Now the wolf is in the sheepfold!"

It was Delacroix who, seeing the retrospective exhibition of Ingres's paintings at the Exposition of 1855, summed up, not without a touch of malice, the classic master's contribution: "The complete expression of an incomplete intelligence." Toward the future, not without its effect upon

any modern body of art that might develop, Ingres left a gallery of paintings characterized by "irreproachable drawing" and with just enough of architectural or plastic knowing to get them attention when the true pioneers of modernism were seeking their bearings.

On April 16, 1828, there died in France, at Bordeaux, a foreign artist, a refugee from Spain, who was greater than either Ingres or Delacroix. Francisco Goya had nothing to do with the controversies and the changes in art in the country of his refuge, where, out of the crossing strains of English, French, and Spanish influences, modern painting was to be born; but he left paintings and prints which curiously foretold Manet and Cézanne, Redon and Rivera. Incidentally, in those major fields to be abandoned by the moderns, realism and romanticism, he had excelled all those who were to come after him. His portraits are more pulsingly alive and "real" than those of Courbet, who self-consciously added "Realist" after his name. And the Spanish war pictures and the prints of bullfights are more intense, emotional, and stirring than are Delacroix's most romantic action-pictures.

At a moment in that historic year 1824, Goya had had a perhaps fleeting influence upon the impressionable Delacroix. On April 7 the French romanticist entered a note in his *Journal*: "Worked on the little *Don Quixote*. . . . Superb ideas for that subject. Caricatures in Goya's manner." He added a more surprising notation a few paragraphs down: "The people of the present time: Michelangelo and Goya."

It is likely that Delacroix knew Goya's work only in print form. He had examined the Goyas, he noted, "at my studio." No other reference to the Spanish artist appears up to October, when the *Journal* lapses for a period of more than seven years. He is known to have copied in ink the Goya etchings of the *Caprices* series. But the enthusiasm is only one of many. Three days after linking the names of Michelangelo and Goya, Delacroix is speculating that "a strange thing, and a very beautiful one, would be to join Michelangelo's style with that of Velazquez." And in the same breath, as it were, he goes on about Giorgione, and Leonardo—and Géricault. The Goya enthusiasm probably faded as quickly as a hundred others recorded in the *Journal*. "The little group in stone by G. enchants me. It would be enchanting to do some." "Bear well in mind those heads by M. . . . All this is what I have always been seeking."

That dallying and that negative uncertainty lie like a curse upon the

young Frenchmen of the twenties—at the far pole from the assurance and purpose of the iron-willed and affirmative Goya.

It is supposed that shortly after the writing of those notes, the man Goya himself climbed the stairs to Delacroix's studio. Of that meeting little is known. The old Spanish veteran of painting had escaped from intolerable conditions in Madrid, upon the pretext of taking the cure at French resorts. He had made up his mind to remain in exile for the few remaining years of his life, and curiosity had brought him to Paris, where he made a round of calls upon the celebrated French painters of the day.

In 1824 he could hardly have been more than a shadow of himself. He was then seventy-eight years old, deaf, lame, gouty, crabbed. He had been born in Aragon in 1746, had lived through brawls, scandals, and academic art training, had buckled down about 1785 to creative painting, had become (in the historic year 1789) official court painter at Madrid, had served the despicable Bourbon King Charles IV, and the equally despicable María Luisa. Later he had gone over easily to the French invader, Napoleon's brother, then returned just as easily to the restored Spanish line, to Ferdinand VII.

As painter he had so towered over his fellows that no other Spanish name is known to art students for a half-century on either side of him. He had been a reckless lover, a musician, a fighter, a libertine, and so he had been perfectly at home with María Luisa and the circle of courtesans, in a society that took its sensualism neat. He had retained his independence as artist, however, mercilessly showing the King and Queen as they were, satirizing the churchmen, castigating the militarists.

The list of his attainments as painter is extraordinary. For sheerest realism—perhaps the most masterly realism in the history of art—he excelled in portraiture, of which there are 430 known examples—in depicting native life and custom (especially life and custom at the bull-ring); and in reporting the hideous and barbarous facts of war. The portraits include such different masterpieces as the tender and appealing studies of children, the maliciously exact and penetrating likenesses of María Luisa, and the celebrated and vividly lovely full-length nude of the Duchess of Alba. The bull-fight pictures are extraordinary "Spanish scene" art. The war pictures are terribly truthful, full of horror, butchery, and lust. To the list must be added religious pictures, about evenly divided between reverent devotional pieces and satire upon religion or exposés of the corrupt clergy; numberless routine cartoons for tapestries; fantasies, as set down particularly in the

GOYA: The Divided Bull-Ring. *Metropolitan Museum of Art*

series of etchings, Los Caprichos, and in a series of mural paintings in his home; routine celebrative and historical pictures, social comment, miniatures, and caricatures.

Goya practised more than "mere realism." He brought to culmination the centuries-long search for scientific truth of statement, but beyond that he often went over into the territory of the founders of expressionist painting. In guessing the importance of plastic structure, in intuitively grasping the rhythmic or formal means that gave interior life to a picture, he went beyond Delacroix and Ingres; and he surpassed all those other painters whom he ceremoniously called upon in Paris in his old age, in 1824.

Goya died without immediate artistic heirs. If there had been one artist who, in his lifetime, had detected within his pictures the marks of an art beyond realism, who had followed his innovations, Goya would loom as the first in the line of succession leading to Cézanne and Seurat and Munch. But Goya finds no understanding follower until Manet recog-

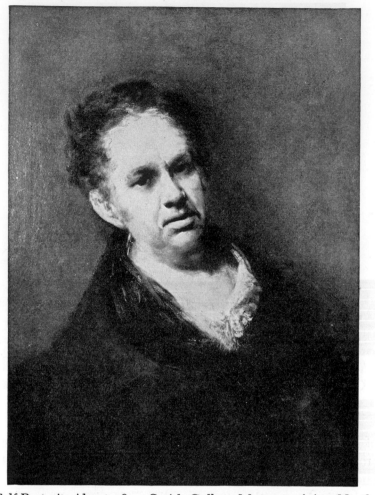

Goya: Self-Portrait. About 1810. Smith College Museum of Art, Northampton

nizes his stature in the sixties—and Manet is influenced, at first, more by his realistic than by his formalistic achievements. If his pictures influenced Daumier, as some historians have inferred, then Goya's name is closer to the line leading into the modern tradition; but Daumier was a beginning student and only twenty when Goya died at Bordeaux.

Goya left some excellent test-works of modernism. It cannot be repeated too often that the formal values—which are, most conspicuously, the distinguishing mark of modern art works—are a built-in element and not the whole work; nor does a high proportion of formal excellence need to im-

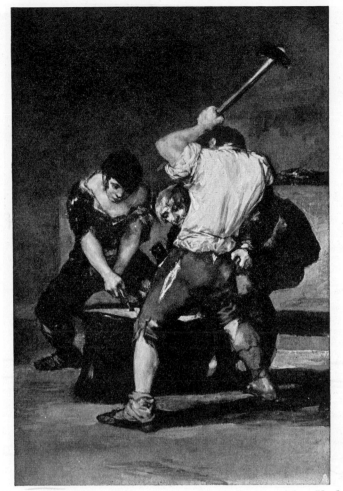

GOYA: The Forge. About 1820. *Frick Collection, New York*
(Photo copyright, Frick Collection, New York)

pair, for instance, the psychologic or even the visual truthfulness of a portrait. As an example, Goya painted his own portrait, and either the version in the Prado, Madrid, or the one at Smith College, Northampton, might be used to illustrate his superiority over Courbet as *realist*. There are strength, vividness, aliveness. But there is only a hint of a knowledge of structure, of placing the head in the picture space, which lifts other of the artist's works into a special, modern category.

Finer as pictorial art, because Goya definitely orchestrates the several plastic means, because he adds fundamental picture-building to an interest

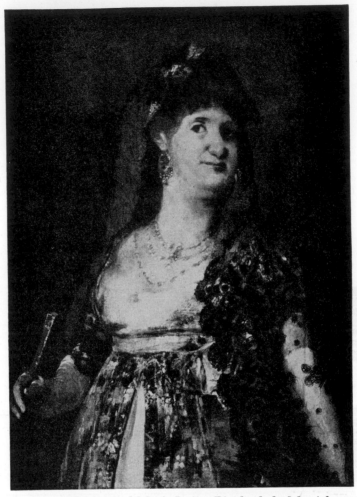

GOYA: Portrait of María Luisa. *Pinakothek, Munich*
(Courtesy The Hispanic Society of America)

in character, is the portrait of María Luisa at Munich. Here is the gross
and cunning harlot-queen—to the life—a fishwife if she were not decked
out regally; shallowness, evil, carnal selfishness supremely indicated. It is
psychologic portraiture at its best. But note the abstract structure, the way
in which the plastic elements build up rhythmically, and the perfect "set"
of the figure in the picture space. The pattern and texture effects (which
both Ingres and Delacroix used objectively, ornamentally, and as varia-
tion) are here employed for movement value: the opulent patterning

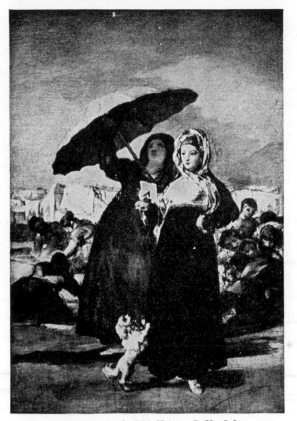

GOYA: Young Girls Walking. *Lille Museum*

brings forward the left side of the figure, rounds the abdomen, helps carry the observer's eye from the fan along the far line of bosom and shoulder to the head, and serves to turn in the edge of the headdress. These are devices to be laboriously rediscovered by Whistler, Cézanne, Gauguin, and the neo-impressionists.

Even more advanced as plastic organization is the *Young Girls Walking*, at Lille, wherein there is fine feeling for rhythm and counter-rhythm of movement, and for plastic weight. If Daumier gained from Goya at some unrecorded meeting with his paintings, it should have been from this simplified and sculptural composition.

Goya, himself of peasant origin, painted the peasants and the workers (and the common soldier rather than the Emperor or the dashing officer),

and is thus a painter of the common people, a pioneer in still another direction, before Courbet and Daumier and Millet. *The Forge*, in the Frick collection, is cunningly composed, with sculptural largeness, and it breathes vitality and vigour, as does so much of Goya's painting; and is "common" in theme. The bullring pictures might be instanced to prove that Goya painted with a freedom and a freshness not permitted in France in his time (which was exactly David's time). *The Divided Bull-Ring* in the Metropolitan Museum, beyond its air of freshness, spontaneous action, and excitement, is characterized by a notably sensitive and intricate formal structure.

Goya was scornful of over-linear painting. The academicians, he said, "always talk about lines, never about masses. But where does one see lines in nature?" And he came near expressing a modernist's view when he added: "I see only masses in light and masses in shadow, planes that come forward and planes in recession, projections and hollowed places." He painted in tone, not line, in planes and volumes, in broad masses of dark and light, with sparing local colour. But sometimes he lightened or livened shadows with points and shreds of colour, almost in broken-colour technique.

When Goya died in 1828, no French artist had yet expressed himself more than fleetingly in the modern language of art. By common consent Paris was the capital of the Western world of art, and no one ever doubted that the next epochal development, the emergence of a post-Renaissance, post-realistic school, would occur there. But so far, since 1800 (or 1789), native art had been almost wholly revivalist, not original and creative. It might be said that David and the neo-classicists cleared the field where modern art was to grow; Géricault and Delacroix fertilized it; but Goya and three strange Englishmen in separate corners of the field planted the first seeds toward the flowering.

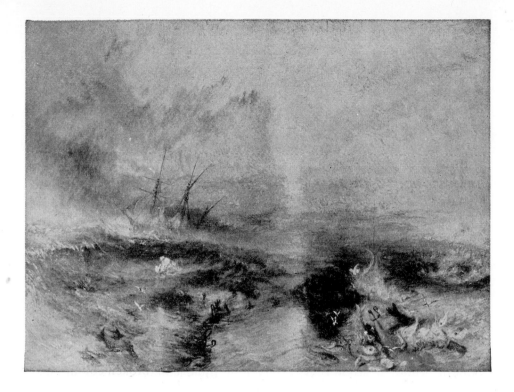

III: THREE STRANGE ENGLISHMEN

WILLIAM BLAKE once wrote, when recalled from his accustomed dream life to face what other men call reality: "I am laid by in a corner as if I did not exist . . . but I laugh at Fortune and go on and on." It might be the motto of four out of five of the creative rebels of modernism.

Only one of the three strange Englishmen who foreran the modern school of art actually was laid by during his lifetime: Blake, the most obscure and the most modern. While living he was hardly accorded the name "artist," and upon his death his works disappeared into an obscurity

TURNER: The Slave Ship. 1840. *Museum of Fine Arts, Boston*

that lasted three-quarters of a century. The other two, Constable and
Turner, knew success during their lifetimes, the one rather fitfully, the
other in a grand if stormy way. But afterward English art continued its
unoriginal, unmodern course as if no one of the three had ever lived. Each
in his way a genius and a discoverer, the three prophetic figures remained
strangers in British art until their paintings had been appreciated and
their influence absorbed abroad—so that a century later a new art was
brought to England from France, by painters who freely acknowledged
their debt to the creative island masters.

These artists, Constable, Blake, Turner, were the great independents
of the early nineteenth century; greater than any of the French; great and
independent as Goya was great and independent; as Daumier would be in
France a generation later. They all together could not make a school, shape
a movement. Each was separated from the others, each in his own way
diverging from the old Renaissance current, each foreshadowing a certain
part of the means that the later French school would combine, assimilate,
and give forth to Europe as the post-realistic style.

In the world of art it is necessary that there come, every so often, a
generation of painters which—to distort a saying familiar to artists—mixes
its paints with freedom. Otherwise the copyists and the academicians pre-
vail, conformity flourishes, art dies. Before 1776 and 1789 England had
known more of freedom than any other land. The idea went back to the
Magna Charta and to the tradition of a parliament of the Commons. The
rebelling American patriots had been Englishmen of a sort, and the French
had learned, politically, from the British, as in the case of Voltaire. It is not
surprising, then, that while David was returning French art to a kind of
slavery to the past, the English within two decades gave birth to three free
painters.

Freedom is only a beginning, and even three free artists may fail to
found a native school. But obliquely England served Western art well by
the example of those rebel artists. Géricault, stirred by the qualities in
English painting that matched his own dreams and desires, contrived,
perhaps with Bonington's aid, that the Englishmen should be shown at the
Paris Salon of 1824. Géricault died before the exhibition doors were open.
But something of the English way of art then entered the French con-
sciousness, and for a generation *les Anglais* were destined to be talked
about, to be fought over, whenever the young French painters threshed
out problems of theory or method. Particularly the English idioms were

adapted or even copied by the young romantics in their experimentation toward an art free, colourful, and imaginative.

Constable was prime agent in this fecundation of French painting. He influenced immediately Delacroix and his circle, then the soberer men who were to make Barbizon celebrated, and ultimately the impressionists (though that would be in the eighteen-seventies, long after his death).

Through the full span of a generation before 1820 there had been no interchange between the countries. The unpleasant episodes of the Bastille and the guillotine had shocked and alienated the British, and the following Napoleonic wars had found the two nations actual enemies in the field. It was only when Napoleon was finally put away on the isle of St. Helena in 1815 that the road was opened again to intercourse. The French, who had never had reason to think they could learn from the English in matters of art, were slow to recognize that their supposed progress during the Revolution and the Empire had been retrogression instead. As seen later, in perspective, their painters were, after two decades of the new century, twenty years behind the times. A Géricault might lift a torch toward the new way, in a *Raft of the Medusa*; but it was Constable and Turner who must be studied.

Delacroix spoke of Constable as "*homme admirable, une des gloires anglaises,*" and he praised inordinately the lightness and freshness of Constable's landscapes. Above all it was the movement, the vibration, the vitality of *light*—an animating illumination that filled the canvas. There was, moreover, that matter of experiment. In France art had been regimented, bound in rules, and rendered colourless and static. It was startling to discover that painters elsewhere had freely experimented.

In earlier times English art had not known a great deal of freedom and invention. Up to, say, 1789, painting in the insular kingdom had been, except for Hogarth's contribution, a succession of styles in imitation of foreign fashions, in only one of which the native product had been distinguishable from alien origins. In ornate portraiture alone the English painters had surpassed their teachers, and that is a genre not very deep or very important. British landscape painting was still obviously derived from Claude or from the Dutch masters. By the opening of the nineteenth century, however, the British landscapists were showing independence of observation and a distinctive way of statement, particularly in the medium of water-colour.

In 1800 John Constable was twenty-four years old; Turner was twenty-

five. At that time the one was a timid, backward student. The other was a youthful prodigy, independent, audacious, already an Associate of the Royal Academy.

John Constable was of the late-blooming variety of artist. He plodded along for years learning his trade, took advice seriously, and formed his own style slowly. Fortunately born, never having to meet the necessity of gaining a living from his pictures, he could follow a whim or a technical lead as long as it interested him. When he became interested in *light* in landscape painting—and possibly it was a landscape by Rubens that first spurred him in this direction—he found the motive for a lifelong work. He searched for ways of conveying the impression of circumambient light and of flickering light. He painted many a dull, academic, over-detailed landscape, even after he had learned how, in his sketches, to set down something of the fleeting freshness of rain-drenched woods, or the evanescent light-dark effects of fields under scudding storm clouds. But in his less laboured, less monumental works he arrived at an individual way of conveying his delight and excitement over nature's moods and movements.

Constable emotionally felt and spontaneously recorded outdoor effects. For that alone he might be called the first modern landscapist. Before him there had been only the studio-concocted picture in which elements taken from nature had to be fitted into a known scheme, a traditional composition. Landscape was compounded of symbolic trees, a stock sky (one of three or four possible types), and a foreground with cows or nymphs or shepherds. It is certain that Constable earlier than any other (excepting, of course, the Chinese) deserved fully the name impressionist.

The Landscape with Windmill at Worcester, for example, is a miracle of spontaneity and atmospheric freshness, considering the date of its production. One can understand how the Frenchmen, trained to Poussin and Claude, not yet fully recovered from Davidian anæmia, must have been startled, then delighted by such pictures. Its emotional immediacy would seem to bring Constable within the definition of "romantic." There was something of the opulent brush and of warm colour about Constable that contrasted eloquently with the thinned line and pale tonalities of Gérard and Girodet and Ingres, and made him temperamentally an ally of the youth group.

Even up to his late years Constable showed a strange duality of tem-

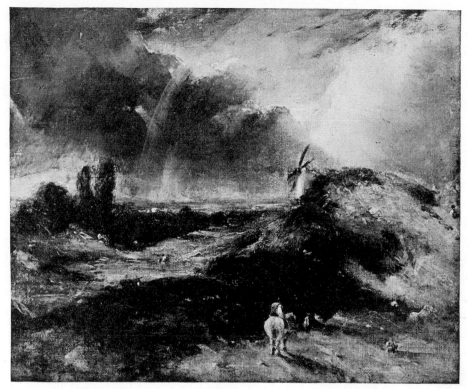

CONSTABLE: Landscape with Windmill. *Worcester Art Museum*

perament. Conservative in all else, he showed independence in his art-judgments. Even-tempered, plodding, calm-mannered, he was passionate about the one matter of painting, especially of light in painting. Orthodoxly trained in his art, he remained orthodox in his appreciation of the respectable masters. His devotion to Claude was hardly less than an obsession. As late as November 1823, long after *The Haywain* had been painted, he wrote to his wife, when he was on a visit to Sir George Beaumont: "I am now going to breakfast before the *Narcissus* of Claude. How enchanting and lovely it is; far, very far surpassing any other landscape I ever beheld." In a letter a week later he exclaimed: "The Claudes, the Claudes, are all, all, I can think of here! . . . I do not wonder at your being jealous of Claude. If anything could come between our love, it is him." He owes also to Rubens and to Canaletto (who had painted in England between 1746 and 1753, and had influenced several of Constable's predecessors). He even defended strongly the study of older painters and advocated copying

their works. "A self-taught artist," he said, "is one taught by a very ignorant person."

But somewhere he had gained for himself a vision of *freshness* brought into painting. He stubbornly resisted pressure to bring him back to the tradition of brown trees and static composition. "There is room enough," he said, "for one natural painter." It was Sir George who pointed out to him that his greens were not to be found in a painting by Gaspard Poussin that happened to be by them. "But suppose," said Constable, "Gaspard could rise from his grave, do you think he would know his own picture in its present state? Or if he did, should we not find it difficult to persuade him that somebody had not smeared tar or cart grease over its surface and then wiped it imperfectly off?" Continuing in his stubborn resistance— which was costing him patrons and election to the Academy—he abolished the brown tree in landscape, and initiated the modern study of the effect of light.

Light—in two separate aspects. First, that the canvas shall be full of light, space filled with light. Large skies with moving clouds, bursts of light that flood from sky down over meadow and hill, light that *surrounds* the trees, so that the observer feels it behind as well as before: all this he accomplished. This might be called light in the large.

Second—in the small—the shimmer and flicker of light must be caught and fixed. Light must vibrate, even in shadows. This is a matter of a certain way of getting the paint, the colour, onto the canvas. Constable developed a method of building up hues, of juxtaposing dots or shreds of colour, a sort of incipient form of the "divisionism" or "broken colour" of the impressionists of the seventies and the neo-impressionists of the eighties.

Constable's awareness of the clouds, the wind, and the light of the sky is supposed to have come from an experience outside the field of art. His father had been a miller, and the son, when convinced that he had failed as an art student, went back discouraged to his home in East Anglia. There he spent a year as a worker in the mill. To a miller the weather was every-thing. When Constable returned to the business of being a painter, he became peculiarly the painter of weather. Wind, rain, storm, sunshine live in his pictures as they had lived in no artist's creations before. There is again a foreshadowing of the ideals of the impressionists, who counted the scene of less importance, the *aspect* of it at a certain time of day, in a cer-tain quality of light, of more importance.

It was *The Haywain*, Constable's first "mature" work, painted when he

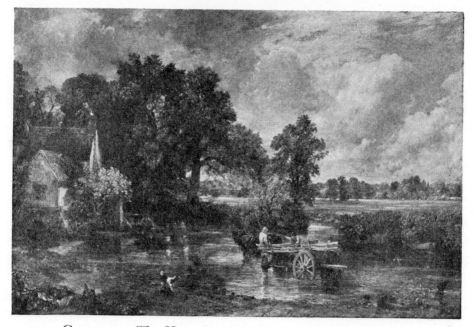

CONSTABLE: The Haywain. 1821. *National Gallery, London*

was well past forty years of age, and exhibited at the Royal Academy in 1821, that most won the French romantics at the Paris Salon of 1824. The English, who had been unmoved and inattentive, were surprised that the painters and critics of Paris could be so stirred, even excited, by a mere matter of a new art method. But Constable's name became as much a storm signal in Parisian art circles as Géricault's had been in 1819 and Delacroix's in 1822. The neo-classicists took notice only to condemn the Englishman's pictures: they "lacked idealism" and were "meaningless." Constable, when told of the criticism, was undisturbed. Borrowing a phrase of Northcote's, he said: "These Parisians know no more of nature than their cab-horses do of meadows." But Delacroix was as enthusiastic as Géricault had been, and the younger men trooped after him.

Among the admiring youths might have been seen a shy, dreamy fellow who had nothing to say for or against Constable—being neither classicist nor romanticist—an art student who simply drank in the nature-beauty of the English master's paintings. This was the young Corot. He will go to Italy to paint for three years, just after this experience, and he will not succeed in finding himself amid the confusing English, French, and Italian

influences for quite some time. As a matter of fact he will not succeed in
selling a picture for a further period of fourteen years. He is destined,
nevertheless, to have popular success in later life, chiefly through paintings
characterized by shimmering light; some of his less popular, less lyric pic-
tures arc destined to be links between Constable and the impressionists;
and throughout his works one might find just Constable's idiom of little
patches of red toning up the generally green colour scheme.

While Constable was going on to even more revolutionary experiments,
in that range of pictures between sketches and museum pieces, and while
he was carrying the larger works to an even greater degree of luminosity—
The Leaping Horse is a sort of culmination—the French were busy absorb-
ing the influence of *The Haywain;* and not a few of the younger men risked
a journey to London to study the Englishmen on their own ground. Dela-
croix himself was among the pilgrims. He spent half the year 1825 in
England.

Some of the visitors were impressed most with the *naturalness* of Con-
stable's pictures (one need not look too intently into the crystal to see an
emerging French *plein-air* school). Others, especially the followers of Géri-
cault and pure romanticism, noted the movement, the animation, of Eng-
lish canvases. Even Lawrence and Wilkie came in for praise, and, of
course, Turner. But most of all it was colour that seemed to the French-
men the outstanding, the exciting element in English art.

Delacroix asked Constable how he achieved so much of freshness in his
colouring. His own recording of the answer survives: "Constable said that
the superiority of the green of his meadows is due to the fact that it is made
up of a multitude of different greens. What causes the lack of intensity and
lack of liveliness in verdure as seen in the general run of landscapes is that
they are painted in one uniform tint." And Delacroix cannily adds: "What
Constable said about the green of the meadows is applicable to all the
other colours." The French critic Nodier had earlier said, in regard to *The
Haywain*: "Seen near by it is all broad daubs of poorly laid colours, so coarse
and rough that they offend the touch as well as the sight. Seen from a
few steps away it is a picturesque scene of water, air, and sky." Thus was
revealed the secret of colouring supposedly discovered by Monet and
Pissarro in the seventies. The retina of the eye will at a distance from the
canvas register a single colour from hues that, examined at close range,
are seen as gobs or points or shreds of raw unmixed colour, and find a
richer, liver hue than if the colours were mixed before spreading on the

canvas. The intuitive feeling for this richness or vividness may be instanced in earlier history, in Velazquez and Goya, in Guardi and Watteau. With Constable it becomes consciously the basis of a system of paint application. From Corot to Manet and Pissarro it grows until it appears in the seventies as a full-fledged "scientific" way of painting.

In England after 1824 a certain number of critics and the majority of painters continued to find Constable's landscape "careless," even "nasty." Except for three or four patrons, he remained a stranger to his own people after the French had reformed their romanticism along the line he had indicated. He was deprived of the honour of becoming a full member of the Royal Academy until 1829. He had coveted the place apparently not for himself but for the pleasure it would have afforded his wife. Theirs had been a late marriage, delayed because she was higher born. They had wed, had children, and been exceptionally happy for a dozen years.

In 1828 she sickened and died. Neither honours nor work consoled him, nor did he go on to increased success. Listlessness, despair, a sense of frustration, overtook him. Of the R.A. membership he said only that "solitary" he could not enjoy it. He died ten years later, in 1837, at the age of sixty-one. He was so little esteemed as artist that when his accumulated paintings were auctioned in 1838, one hundred and forty lots, including fourteen of his major pictures, brought only slightly more than two thousand guineas.

But across the Channel his paintings were hanging in the Louvre. He had been pleased, a letter written to his wife shows, when the French authorities, finding his paintings popular at that historic Salon, had moved his pictures from "very respectable positions" to a position of honour, two prime places in the principal room. Many years after his death, when the National Gallery in London was rearranged, the English gave him similar places of honour. To this day pilgrims go to enjoy *The Haywain* and some of the "minor" impressionistic works. Constable himself would doubtless suggest that they simply give themselves up uncritically to the peculiar beauty that is his, remembering his saying that the fine qualities of each artist are unique, neither gaining nor losing by having or lacking virtues that other artists, in comparison, may have.

In that spirit, judging by no predilection or formula, the pilgrim may open the way to fullest enjoyment, sweetest loss of self in each experience of variable art. But then, beyond the special Constable fresh beauty, he may be reminded that this serious, modest painter put forward the art of

painting technically, in a foreign land that was to be the scene of the next epochal advance; and that in addition to the virtues common to the paintings of many artists of his time, Constable offered, in a few pictures, at least hints of artificial manipulation of planes and volumes in the interest of an affecting plastic order, of a sort to be deeply prized by the century-end moderns. The version of *The Leaping Horse* in the Victoria and Albert Museum, London, is to be noted especially as of that sort.

Constable's mature works are all of the time of David and Ingres, and almost any one of them might be instanced to indicate the greater naturalness of the Englishman. Beyond that, there are three special qualities that mark the artist's modernness. First is the fullness of lighting, combined with what may be called a pattern of locally educed shimmering light (contrived partly by edging leaves with streaks of white paint, known as Constable's "snow" among detractors of his painting). This phase is sufficiently illustrated in *The Haywain*, the historic picture of the 1824 Salon. Second, there is the fresh spontaneity, born of the quick eye and of an emotional response to nature's moods, resulting in the first sustained series of landscape "impressions" in the history of Western art, exampled in *The Landscape with Windmill* at Worcester. Third, there is the rarer attainment of a deeper formal order, of plastic organization, to be detected in *The Leaping Horse*.

The French painters who ventured to visit England after the Salon of 1824 were surprised to find there a second master so imaginative and brilliant that Constable's pictures seemed positively tame in comparison. The wild Turner, "the great pyrotechnist," startled the English as well as the French. All British painting up to his time seemed earthbound and pale beside his imaginative flights and chromatic orgies. He would indeed have seemed exotic and reckless in any gallery of any land before the twentieth century. For controlled use of extravagant colour, he is still a master unsurpassed; but in his late years, even his disciples admit, he did "go wild." How much besides luminous colour was copied from him in the re-forming French painting of 1830–1860 is problematic. Nor are the critics yet through with the controversy, which had its beginning as early as 1800, as to whether Turner's works were "a lamentable proof of genius losing itself in affectation and absurdity" (the London *Times*, 1803) or showed "more of that sublime faculty which we denominate genius than any other of the pictorial claimants" (the London *Morning Post*, 1802); whether Turner

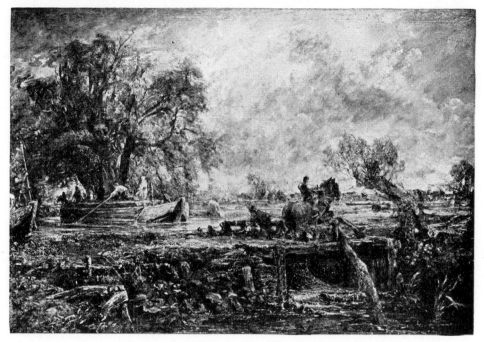

Constable: The Leaping Horse. 1824. *Victoria and Albert Museum*
(Crown copyright reserved)

"created the whole modern intention" and was "the supreme poet that colour has yet given to the world" (Haldane Macfall, 1912) or "demonstrates both the lyric grandeur of the English soul and the impotence of English painting to communicate it" (Élie Faure, 1924).

Joseph Mallord William Turner was born in lower-class London in 1775, son of a barber who had been a peasant before he set up his shop in Maiden Lane. His mother had a strain of madness and was to die in an asylum. The boy never was properly educated, intellectually; he was undisciplined, roamed at will, and skimped all other schooling to indulge his proclivity to drawing.

Before the age of eighteen he was making money by means of his pencil, and at twenty he was an established artist with a studio of his own. He had sent acceptable water-colours to the Royal Academy exhibitions since his fifteenth year. The Academy accepted a first oil painting when he was twenty-one. At twenty-four he was elected an Associate R.A. From that time on he was a storm centre in British art—not that he said much or entered into controversy personally, but because each new picture of

TURNER: Falls of the Rhine, Schaffhausen. 1806. *Museum of Fine Arts, Boston*

his was likely to be provocative, breaking the rules of "good" painting, introducing even greater audacities of colour (this was still the era of the brown tree), and jumping unaccountably from one "style" to another.

His success, in spite of his originality and audacity, was due to his ability to do the usual and the academic thing supremely well when he chose to curb his imagination. At thirty he had more than equalled the English landscapists, had gone on to surpass the Dutch masters (excepting perhaps Ruisdael), and had challenged the supremacy of Claude. Financially he was so successful by the time he was twenty-five that his father then gave up the barbering business and became a sort of combined housekeeper and business agent for the painter son. The artist never had a real home, nor wife and children, nor an ordered environment, and probably never gave a thought to all that he was missing, so consumed was he by the passion for painting. Perhaps he could not have left 20,000 works at his death if he had been normally social.

Turner's story is separate from the story of British art, as it is separate from the narrative sequence of modern art, partly by reason of the man's unsocial nature and stand-offish ways. To one of his temperament the founding of a school, or even association in a movement, was unthinkable.

The force of his genius could not be overlooked; even the Royal Academy capitulated, elevating him to full membership in 1802, when he was twenty-seven. But very truly he was in the Academy, not of it. Æsthetically he went his own way, a lone giant. He attended an occasional Academy meeting if the whim took him; but it did not seem to him that academies and the like had anything to do with the thing that was the passion of his life, art. When he had been elected to membership he refused to pay the usual calls upon the officials, expected of every initiate. If they admired his paintings enough to elect him, that was all right, but they need not expect him to be grateful.

Constable, in June 1813, wrote a long letter to his wife-to-be saying that he had dined with the Royal Academy, in the council room, and had sat next to Turner. His whole description of the event is this: "I was a good deal entertained with Turner. I always expected to find him what I did. He is uncouth but has a wonderful range of mind." When others reported meetings with Turner they were likely to be as non-committal; unless, indeed, they had been annoyed or goaded to the point of explosion. He was silent, even taciturn, morose at times, close in money matters, shrewd, tasteless, slovenly in dress (as Delacroix noted in his *Journal*). In anger he could be as tempestuous as the skies he created.

It is not to be wondered at that he had no followers. Even the easy-going Constable, working a lifetime on the very problems of light which Turner was solving in similar if more brilliant ways, could find no ground for intercourse or for a common approach. It was far easier for the French, remote from the person of Turner, seeing his canvases dispassionately, to be inspired, to analyse his revolutionary technique, to profit by his discoveries and his flaming example.

In Turner they found, of course, the perfect romantic. He was supremely individualistic, passionately expressive, deeply dramatic. He was not limited, like Delacroix, in either his talent for drawing or his imaginative range. His colour was no less than gorgeous.

In being romantic he was not escapist. He found subjects on every hand. Aside from the exotic, far-away landscapes and the legendry so important to the other romantics, his vision discovered exciting material in the quiet English countryside, at the fishermen's wharves, in fighting ships, even in a railway train. When he went to France in 1809 and 1819 he found beauties theretofore unsuspected in the Norman fields and villages (the time was still decades before Barbizon); and in the Alps he made paintings

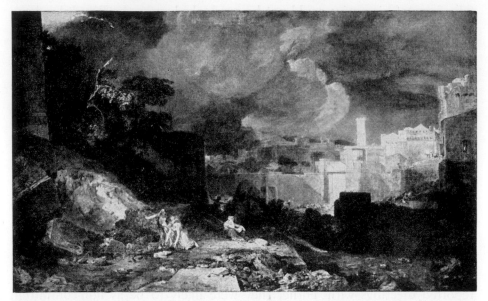

TURNER: The Tenth Plague of Egypt. 1802. National Gallery, Millbank, London

that are sheer lyric poetry or drama, in the very territory where native artists were producing pretty and correct topographical transcripts.

Long afterward scholars were to attempt to list Turner's works in some kind of apprehensible period arrangement. But his erratic sort of insurgency is the hardest to bound and to classify. After a flight into sheerest imaginative expression he would return to the study of an old master, or perhaps to a second-rate painter such as Salvator Rosa or the younger Cozens, and never rest until he equalled that man's painting; then was off again on his own unaccountable flights, using what he wanted of assimilated method or vision.

"All that is vital in modern art was born out of the revelation of Turner," wrote Haldane Macfall during the second decade of the twentieth century. Yet to ask when Turner became modern, in the twentieth-century sense, must seem silly to anyone acquainted with the bulk of his paintings. There are works of the years 1802–1805 which have something of the architectonic structure of Poussin; and they seem, on second examination, to possess, in their studied plane arrangement, the germ of cubism. Cézanne might have found inspiration for his experiments with tilted and overlapping planes in the English artist's *The Tenth Plague of Egypt*, of 1802, or in

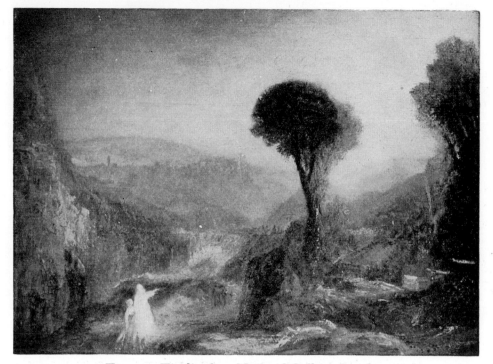

TURNER: Tivoli. 1840. *National Gallery, London*

the *Bonneville, Savoy,* of 1803. In later years, when architectural or geo-metrical means were to be all but excluded from his paintings while he attempted magnificently to bring down the grandeur, the movement, and the mystery of the elements, in storms of light and flames of colour, the plane arrangement seemed to, and often did, disappear. But in the great Alpine paintings, *The Falls of the Rhine at Schaffhausen* and *Snowstorm, Mt. Cenis,* an eye trained to detect major and minor plastic rhythms will find a formal structure both stable and delicately adjusted.

There are pictures in oil and in water-colour that seem at first glance to illustrate perfectly the transition from "solid" painting to the special Turnerian method of losing forms in a tissue of atmospheric variation. But directly one has thought, upon this evidence, to mark the date of a change in the artist's style, one is confused by the fact that the transitional pictures may be of 1810 or 1820 or even 1840. The *Tivoli,* which seems perfectly to illustrate the combination of Poussinesque classical qualities with a new

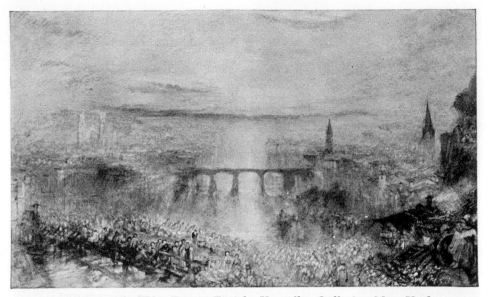

TURNER: The Fête-Day at Zürich. *Knoedler Galleries, New York*

lyricism of vibrating light, is dated 1840. *The Fête-Day at Zürich* is of a much earlier period and is no less insubstantial and shimmering in aspect.

There is no doubt that the technique of luminous statement which links Turner with the 1870 impressionists was well mastered before 1820; and it is likely that Turner was inspired to his earliest innovations in this direction by the experiences of his first Continental journey, in 1802 or 1803, when he sketched in France, in the Swiss Alps and Savoy, and as far as the Valley of Aosta. A second journey permitted him to travel far into Italy; to tarry along the golden shores of the Northern lakes, and in the hills about Rome, and along the glamorous Bay of Naples.

It was in the thirties and the early forties, however, that Turner produced the long series of brilliantly chromatic pictures which were to remain the most daringly colourful exhibits in the galleries of the Western world until, about 1890, French impressionism became popular and respectable. And let it be noted that no impressionist has become a master with the stature of Turner. This Englishman of the early nineteenth century still fulfils, as well as any artist, Cézanne's ideal of a painter "making of impressionism an art solid and durable like that of the museum masters." It is because Turner links with Cézanne and the expressionists, as

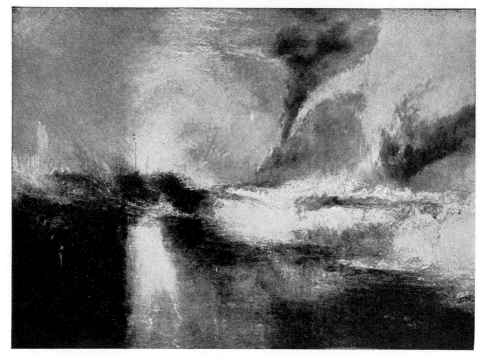

TURNER: Rockets and Blue Lights
(Courtesy Knoedler Galleries, New York)

well as with the impressionists, that his works belong in histories of modern
art, more fully than Constable's or Goya's or Delacroix's.

A quarter-century after Turner's death, upon the occasion of the opening
of a liberal gallery in London, the radical painters of the school of Paris
acknowledged their debt to Turner. In an open letter, signed by Monet,
Pissarro, Degas, and Renoir among others, they said: "A group of French
painters, united in the same æsthetic aims . . . applying themselves with
passion to the rendering of form in movement as well as the fugitive phe-
nomena of light, cannot forget that they have been preceded in this path by
a great master of the English school, the illustrious Turner." But where the
French school was obsessed with the problems of light scientifically under-
stood and rendered, Turner had taken visual observance as a starting point
and a stimulus and added the greater glory of colour out of his imaginative
or spiritual vision.

When the unconvinced academic painters of his day complained that

Turner dissipated the forms of nature in a haze of light, he rejoined: "Indistinctness is my forte." The statement is as misleading today as the painter intended it to be then. He would, at criticism or attempted analysis, snap out anything that would end comment or put analysts on the wrong track. He said himself that he aimed "to put the critics off the scent." He wanted not to be interfered with, especially by the realists. He had no respect for the truth of nature if it limited truth to his inner pictorial vision. In the matter of the disposition of forms in paintings, he might lose individual *forms*, as seen in nature, for the achievement of architectural *form*—quite in the post-impressionist sense. He grasped intuitively at those means around which a theory of plastic organization was to be developed by the groups of century-end moderns.

Certain water-colours are filled with the "movement in the canvas" which is so precious to the moderns, as distinguished from depicted natural movement, and examination of the placing of the main volume units in the pictorial field will indicate that Turner used the volumes, whether building cubes or the masses of mountain or clouds, to induce movement, in expressionist fashion. Each picture "builds up" into a coherent plastic whole. *The Fighting Téméraire Tugged to Her Last Berth to Be Broken Up* is one of the great oil paintings in which Turner used exceptional cunning in the placing of volumes within a picture apparently all atmosphere and glow, a typical sunset picture.

Scores of the water-colours, even when seemingly ethereal and glamorous, when the delight is at first the sensuous one of opalescent colour and vaporous movement, turn out in the end to have firm anchors in the solidity of half-hidden volumes. Beyond the tissue is a stable plastic structure. Hidden but not lost is the path for the eye, marked by volumes in tension, by plane arrangement, by colour vibration. Decades later Whistler was to discover, apparently from Japanese prints, the essentially "modern" device of accenting or "weighting" a figure or an object at the very front of the picture field, indicating a starting point for the observer's eye, anchoring the pictorial structure. Whistler used the device tellingly when he set out to escape realist formulas in his "arrangements." But Turner had been before him, as indicated in many sketches. It may be added that the prophecy and example of "nocturnes" and "harmonies" is also to be found in Turner's minor works.

Turner lived until 1851. His late work was, in many instances, loose and

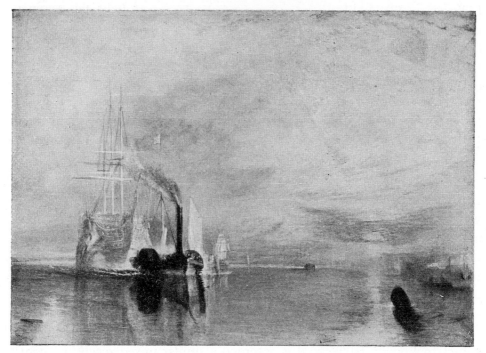

TURNER: The Fighting Téméraire Tugged to Her Last Berth to Be Broken Up.
1839. *National Gallery, London*

structureless, like his life. He had become more than ever the recluse, drinking heavily, dropping from sight for long periods, appearing at his combined gallery and home only to look silently at his works, then to disappear again. At some time he bought a second, a hide-out home, and with it he bought, apparently, the woman who had owned it; for he lived with her for a period of years—and she never learned his name or that he was both rich and famous. His few acquaintances at the taverns knew him as an impoverished naval officer, and called him Admiral Booth, from his housekeeper's name.

Turner had in him, obvious then, a good deal of his peasant father's tastelessness and boorishness, a little of his mother's madness. Nevertheless, it was the poet in him that impelled his last request. Near death, he asked his housekeeper to push his bed to the window. She raised the blind, the sun shone upon him, and his spirit went out to meet the light.

In contrast to the self-imposed obscurity of the later years, the secretive

hiding from the world, there was a great funeral procession, and a crowded ceremony in St. Paul's. He was put to rest, as he requested, in the Cathedral, beside Joshua Reynolds. It was found that his will stipulated that a thousand pounds be expended for a monument there. But practically his entire fortune was left to the public, including more than 19,000 art works from his own hand. Immodestly he made conditions about the placing of the works he bequeathed to the National Gallery, and he required that the nation erect and maintain certain "Turner Galleries."

Thus his legacy, like so much else in his life, though it gave to the public to be preserved for ever some of the most gorgeous of English creative paintings, was touched by ignoble sentiment and jealous conceit. It was years and years before the British people and British authorities were able to forgive the man his shortcomings and to accept the artist as one of the immortals. By that time it was too late for British painters to be influenced by one who had been in their very midst, the greatest forerunner of the creative moderns of the period 1840–1940. At the moment of Turner's death England drops out of the story of modern art, except for another interlude when an American-born painter, French-trained, comes to London to live and is accorded a similar mixed reception, compounded of genuine admiration and stinging resentment, and passes without affecting essentially British painting.

If Turner, after his death, was rejected by the British as influence or inspiration, another and stranger artist, no less to be claimed as kin by the twentieth-century moderns, was equally denied, in life as well as in death. His obscurity was such that the Royal Academy never exhibited more than a few drawings from his hand, and his paintings were long considered as curiosities rather than as painter's art. Nor did William Blake enter into the early development of modern art, except possibly when some stray drawing or illustrated book of his fell by chance into the hands of, possibly, a Cézanne or a Ryder or a Redon, and thus unknown stirred the imagination of one of those who shaped post-realist art.

In all save colour, in all that concerns the use of line, plane, and volume for plastic rhythm, and in mystic reach, Blake is closer to twentieth-century progressive painting than any other artist out of England. He also is closer in exaggeration of nature. But he is as little of the story of the consecutive shaping and unfolding of a modern art of painting as was El Greco or Breughel, or any other of the giants who, removed in time from the

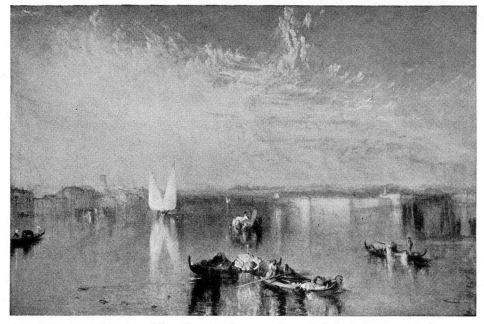

TURNER: Venice: The Campo Santo. 1842. *Toledo Museum of Art*

moderns, grasped the formal means and the unrealistic idioms which are accounted today the essential signs of the new painting. Blake was a fore-runner of the French symbolists and of the German expressionists, and he lived well into the nineteenth century; but the two groups were destined to come, make their contributions, and lose their identities in the full flow of twentieth-century painting before the forward-reaching nature of his art would be recognized.

A few men of his time saw something more than strangeness or madness in Blake's designs, and somehow he earned a living in the London of Gainsborough, Romney, and Lawrence; but his slender reputation did not save him from poverty and burial in an unmarked grave. In 1824 Charles Lamb wrote a letter to Bernard Barton which suggests the esteem in which Blake was held by a very few discerning men: "Blake is a real name, I assure you, and a most extraordinary man if he be still living. He is the Robert Blake whose wild designs accompany a splendid folio edition of the *Night Thoughts*. . . . He paints in water-colours marvellous strange pictures, visions of his brain." And of Blake's poems he writes: "I never read them . . . but there is one to a tiger, which I have heard recited,

which is glorious, but, alas! I have not the book; for the man is flown, whither I know not—to Hades or a Mad House. I look on him as one of the most extraordinary persons of the age."

Yet Lamb miscalled him *Robert* Blake, and knew not that the creator of "marvellous strange pictures, visions," was in his own London, all but starving in two bare rooms, but content because daily he saw persons dear to him, it might be Socrates or Shakespeare or Milton, or angels. He died three years after Lamb wrote of him, in 1827, in his seventieth year. On his deathbed he coloured one of his most characteristic designs, *The Ancient of Days*, showing God leaning down from heaven and laying out with gold compasses the boundaries of the world. The design had come to him in a vision, seen at the head of the staircase in his own house.

The time of his birth, the appearance of prints, paintings, and books, the material struggles and the strange happiness he found with his wife Catherine, the time of his passing: these are details of little significance. What counts still is the great and beautiful spirit of the man, and the individualistic poems and pictures he left. Spiritually he was a truly religious man, unbigoted, loving life and people, a mystic finding companionship with the angels and the prophets, and ecstasy in God, as had the medieval saints. His poems and his pictures are original and prophetic, apocalyptic and elemental.

He ran counter to the expiring current of Renaissance art, counter to realism and scientific statement. Equally he opposed the fashionable ornateness of "the portrait manufacturers" who were England's leading artists. In that one particular he was like Constable and Turner (who were nearly twenty years younger). He even attacked the revered Reynolds, saying that the great master of portraiture had been "hired by Satan to depress art." The famous and successful artists of his time were the perfect representatives and mirrors of a materialistic era, and Blake fought a lifelong battle against materialism, rationalism, and conformity. He withdrew into a spiritual realm, lived more with Dante, Milton, and the figures of Christian legendry. But he reached forward as well as backward. He was visionary in his seeing—and strangely modern in his technique.

There was little of the ascetic about him; he delighted in the physical world; but he rightly avowed that it is nothing unless one detect the eternal in it. One can, he said, find the eternal in the least or the greatest manifestation of nature, and that is God. By creating art, with God's order in it, one adds to the sum of infinite beauty accessible to man. He took

BLAKE: The Conversion of Saul. Water-colour. *Huntington Library and Art Gallery, San Marino, California*

literally Jesus's admonition that the rich cannot get to heaven, and he never complained of his poverty unless the pinch was such that he and Catherine lacked food or the materials for their work. He had rich spiritual companionships, and he could hardly tell his wife from the angels.

Blake produced innumerable small works of art touched by a sense of

BLAKE: Plagues of the Egyptians: Death or Pestilence. Water-colour.
Museum of Fine Arts, Boston

majestic order. His contribution is not showy, opulent, sumptuous, like
Turner's; but it is no less splendid and radiant in its quieter way. The flame
of his genius burned steadily, but it was a spiritual rather than an emotional
flame. Whether he neglected larger painting because, in the improvidence
and poverty that surrounded him, he could seldom afford canvas and
paints, or because he preferred a certain remoteness and delicate effects,
cannot now be known. The great body of his works is in water-colours,
drawings, black-and-white engravings, and colour engravings.

His challenge to the realists was that of a Cézanne or a Kandinsky.
Man's perceptions, he said, take in more than the senses can discover. It
is fool's play to copy what the eye has seen. The "world of vegetation"
which artists have come to treat as the only reality is but a small part of
the real world; and all that is ordered and beautiful in it is but a poor

BLAKE: The Morning Stars Sang Together, and All the Sons of God Shouted for Joy. Water-colour. About 1820. *Pierpont Morgan Library, New York*

reflection of the inner verities known to the spiritual man. It is the artist's business to see beyond the physical envelope of the world, beyond "this vegetable glass of nature," to the rhythms, the realities, of the soul, of the cosmos. Above all, the artist must be a spiritual man, and his religion and his art must be one, indivisible.

Blake put reverence, mystical suggestion, and a profound feeling for order into his pictures, as have few artists in history. In his own time and

BLAKE: The Repose of the Holy Family on the Flight into Egypt. Water-
colour. 1806. *Metropolitan Museum of Art*

for a century after, he was stigmatized as a creator of disorderly and mad
compositions, of wretched and nonsensical designs. In an era of realism he
had grasped at abstraction and symbolism. Although he was one of the
very great masters of line drawing, he used that gift in the service of
"distorted" images, quite as another great master of draughtsmanship,
Pablo Picasso, was to do a century later. In any comparison of Blake with
the moderns of the twentieth century, however, the reservation should
be made that whereas the latter often denied the importance of subject
matter, finding justification for "the new art" in the mastery of a new way
of formal statement, Blake fused his means of expression and what his

BLAKE: Then a Spirit Passed before My Face. Engraved illustration, *Book of Job*. 1825. (Courtesy New York Public Library)

mind and imagination had to say. "He who does not imagine in stronger and better lineaments, and in stronger and better light than his perishing and mortal eye can see, does not imagine at all."

That he was prophetic of the modern plastic means, that he had formal vitality and rhythmic order, that he put great stress upon expression and very little upon imitation, becomes evident from any one of a hundred works, say *The Morning Stars Sang Together* or *Then a Spirit Passed before My Face* or others of the *Book of Job* illustrations. In these

the simplifications, the Michelangelesque largeness, the purposeful wrest-
ing of the pictorial elements away from the natural background are beau-
tifully accomplished. The pillar-like figure of God in the second of these
is a perfect example of the pictorial convention serving at once the sub-
jective and the formal purposes of the artist. Remoteness, majesty, and
impersonality are bestowed upon the figure as protagonist in the drama;
no less the pillar-like element is made the dominating unit of the rhythmic
formal scheme, the central "sun" about which the other elements revolve.

Blake went beyond to works in which one can detect those very means
which became objects of feverish research fifty and a hundred years later.
The little water-colour, *The Repose of the Holy Family on the Flight into
Egypt,* in the Metropolitan Museum, illustrates incidentally several of the
means by which the expressionist artist induces "movement in the can-
vas." Overlapping planes to "step back the eye"; volume tensions; even a
certain amount of patterning or texture interest to bring forward areas that
might otherwise sink too deep: all these devices, as known to modern
students of plastic orchestration, are evident in the one picture. Crossing
and interpenetrating planes and other contrapuntal means are to be de-
tected in *The Conversion of Saul,* in the Huntington Library collection.

Blake once wrote that "Painting, Poetry, and Music are the three Powers
in Man of conversing with Paradise which the Flood did not sweep away."
There are not many modern painters who speak in terms of Paradise and
the Flood, but a considerable number have concluded that the mysterious
undefinable "form" they have sought to fix in their picture-fields is an
echo of some eternally valid cosmic rhythm or spatial order. They are
driven to explain their work in mystical terms, and it is likely that they
will more and more claim as their own that artist who above all others
revealed his mysticism in pictorial terms.

Strangest of the three strange painters of England who enter, at the
very beginning, the story of modern art, Blake is, in both his mystic ap-
proach and his foreshadowing of modern technical means, most akin to
the latest generation of moderns. He was strange to England because he
was not only out of his time but in a sense out of time altogether. As
Horace Shipp has put it, Blake saw the materials of his art "not in the
light of time but by some oblique ray of eternity"; and after his death
"the clouds of materialism closed in behind his passing."

IV: ESCAPE FROM PARIS; COROT AND
THE BARBIZON BROTHERHOOD

IN EARLY May 1839, the English painter Turner, *en route* from London to Switzerland, is said to have paused in Paris and to have entered this terse comment in his journal: "Tuesday, modern paintings at the Louvre, very poor."

Strollers in the palatial galleries of the Louvre that day would have remarked without surprise the stocky, peasant-like Englishman, a little red of nose, a little unkempt of person, and of forbidding address. Art galleries draw the strangest people, and there was nothing in Turner's appearance, at sixty-four, to suggest that he was the greatest living painter, and a good art critic to boot.

COROT: The Bridge at Mantes. About 1869. *Louvre* (Archives Photographiques)

"Modern paintings at the Louvre, very poor. . . ." It might be the verdict upon an era. France, though looked to as the very centre of art production in Europe ever since Louis XIV and Colbert had set about their projects of aggrandizement in the mid-seventeenth century, had never developed a French school, with a group of masters, in the sense in which one spoke of an Italian school, a Flemish school, or even a German school. Poussin had been an expatriate and Claude Lorrain half alien. Perhaps the glittering court painters, from Watteau to Fragonard, might qualify; but if they had led a school, it had been founded on something less than inspiration and sincerity. Certainly it had gone down to oblivion at the hands of Liberty and the implacable David. There had been, since 1789, David's neo-classicists, just now, exactly a half-century later, rallied again around Ingres and still talking of Greek purity. There was the opposition group, Delacroix's followers, calling themselves romanticists and driven to their final refuges in literary painting and Orientalism. The talked-of things in Paris, in 1839, would be the variations within these two groups, by the imitators and pupils of Ingres, by the followers of Delacroix. Not yet had France turned up a leader to put art upon the road to a different expression. Not yet would Turner, or any other visitor, find French "modern" paintings touched with the freshness, spontaneity, and livingness of the best of Goya or Constable, or of Turner himself.

The great news of the year would be that the master Ingres, after a further five years of exile in Rome, had decided to return to Paris. "The Rome of other days that used to be so generous, so liberal to art, simply exists no longer!" So he exclaims in a letter dated 1839. "It is no longer the Rome I used to know"; and in 1840 he comes back to his own capital, where he had been treated so badly. It is, unfortunately, an instance of the master of a style that is transient (and a master unyielding and a bit querulous) driven from one inhospitable environment to another. Paris will be as galling as Rome has been, what with the romantics still popular and youth restless both politically and artistically.

The picture of the Paris of the artists would not be complete without notice of a peasant youth arriving there in this winter of 1839–1840, a young art student named Courbet, who will after a few years take it upon himself to challenge classicism and romanticism alike, in the name of realism. It is he who, in the view of century-end historians, extinguishes the last hopes of the *Ingristes* and appropriates what is useful in Delacroix for the future of art.

But in 1839 there are certain signs, not easily read, pointing to emergence of a modern spirit, and to leadership by the French. Returned recently to France after many *Wanderjahre* spent in Italy, still an uncertain painter perhaps, and certainly still a failure, since at forty-three he has not sold a picture, is Corot, who will add to realism something that Courbet will always lack. (In fact, Corot *does* see angels and fairies, where Courbet truculently and with a swagger says they are not.) A younger man, with Corot's assistance and blessing, will found a school, which he will call Barbizon, within a year or two, and it will be the first French group-development to draw adherents (both patrons and imitating painters) from all over Europe and America. Its young founder is Théodore Rousseau, now twenty-seven years old. He has been honoured once, a landscape of his having been accepted for hanging in the Salon of 1834; but that immediate success has warned the academicians of a possible competitor, and of a heretical talent. Rousseau is now an outsider, and will not be admitted again until 1849. It is he who will bring together Daubigny, Dupré, Diaz, and Millet, in the Barbizon brotherhood.

These will all be excellent painters, as the phrase goes. But not one will paint pictures to match those of a youthful cartoonist named Honoré Daumier, who in 1839–1840 is known only as an accomplished lithographer and a brilliant journalistic commentator in crayon upon political and social affairs. It will be another ten years before he turns seriously to painting; and from then until forty years after his death his reputation as painter will be obscured because critics and public alike prefer first the academic and romantic things, then the truths of nature as put down by the Barbizon men. Daumier will be, nevertheless, the first great French independent of the modern movement. It is he who will go beyond all the labels, "classic," "romantic," "realistic"; who will, intuitively, use the devices of the moderns, and treat the life they treat, who will inspire, more than any other painter, the beginner Cézanne. In the two decades from 1840 to 1860, however, it is not Daumier but Corot and the Barbizon men who will seem to have made history; and indeed they are not without influence upon all later progress.

A simple, good man was Camille Corot, content with little, asking nothing more of the world than that he be permitted to paint without interruption. Some say he was good to the point of stupidity. Should any man, if he were less than naïve, when he had reached the age of fifty, still

ask permission of his parents when he went out of an evening? Would any man still set up his easel every morning, and paint happily, when after thirty years of calling himself artist he had not sold a single picture? Fortunately an indulgent though reluctant father, after discovering that it was useless to keep the dreamy boy chained to "the business," gave him an allowance sufficient for modest wants and for travel and study in France and Italy; fortunately because in the end Corot the painter served France and art well; and, before the end, pleased and astonished his father by making literally tubs of money, and by bringing home the decoration of the Legion of Honour.

Corot's biography is one of the simplest in the records of art. His mother, of Swiss origin, had set up a successful milliner's business in Paris, and was helped by her husband. Over the shop in the Rue du Bac, Jean-Baptiste-Camille was born in July 1796. A great many years later he was asked to write his biography, and this is what he set down: "I was at the college of Rouen up to my eighteenth year. After that I passed eight years in trade. Not being able to stand that any longer I became a landscape painter—pupil of Michallon. When he died I entered the studio of Victor Bertin. After that I launched out all on my own, studying nature— *et voilà*." (As a matter of fact he spent only *three* years as clerk in drapers' shops, measuring and selling cloth; but doubtless it seemed to the youth, secretly an artist already, eight.)

Victor Bertin, the teacher mentioned, was a classicist, devoted to Ingres and reverent toward Poussin. Thus when Corot set out for Italy in 1825 he had experienced the two influences most likely to be useful to a landscapist destined to contribute to the march of modernism. He had learned something of the mysterious, not to say mathematical, form-values in Poussin's masterpieces, and he had been introduced, at the important Salon of 1824, to Constable's innovations. He did not rush after the Englishmen as did Delacroix and the frank romantics, and in the end he is less beholden to them than are Rousseau and Daubigny and the impressionists. But a certain freshness, even some technical devices, and a buttressing for his resolve, unique in France so far, to let nature be his guide: all this may be credited to Constable. Curiously enough Corot's first Salon picture, in 1827, was hung between a Constable and a Bonington.

It was in the autumn of 1825 that he made his way in leisurely fashion to the Swiss lakes and the Alps, and so down into Italy, arriving in Rome

COROT: Town on a Cliff. About 1827. *Smith College Museum of Art, Northampton*

in November. He did not hurry to see the Raphaels, as every well-trained French student was supposed to do. Instead he painted landscapes, or oftener than not townscapes: the ruins of Rome, the Vatican gardens, the suburban hills and villas with their dark masses of cypress, their olive groves, and their vistas across low-lying fields.

For nearly two decades the happy wanderer, spending years in Italy, other years in the French countryside, fails to find himself. Almost at the very beginning, however, there is something like a flash of genius. Corot paints a series of architectural views, in rather earthy but not dull colours, guided by a vision of mathematical harmony to be gained through manipulation of volumes and planes. Some of these little studies might easily have served, years later, as inspiration for the plane arrangements of Picasso and Braque. But neither the public nor the critics found anything of interest in them. Corot soon passed to other types of painting, landscapes mostly, a few portraits, occasional nudes. He does, however, revert to the Roman architectural subjects, re-creating, even in his studio at Ville d'Avray as late as 1850, a view of the Forum or a Tiber scene.

By 1835 there is a hint of the softer lyrical charm that will be more fully expressed in the melting landscapes of the sixties. There is, for instance, in certain of the Italian landscapes an unmistakable blending of Poussin-like formalism with the impressionistic sparkle of Constable's nature studies. In the forties Corot's handling hardens again, and the classical influence prevails, in a considerable series of almost severe land-

scapes with figures. There is also a period of figure studies in which the example of Ingres is suggested, as is so beautifully illustrated in the portrait *Mme. Charmois*, of about 1845.

Although Corot is often classed with the romantics, on account of his poetic approach to nature and his method of free painting in tone, with little dependence upon line, he remains esentially classic in spirit. Nothing could be more repugnant to him than the nervous sampling of life, and the heat and vehemence, of Delacroix and his followers, and their search for the exceptional and the eccentric. By temperament Corot is calm, sweet-spirited, a harmonist. His pictures are apart from the struggle, the contention, the theatrical action that have fascinated Delacroix and Géricault. When he comes back to Poussin, to constructed landscape and an occasional mythological figure, he is again spiritually at home. He breathes tranquillity and composure.

In 1846 Corot was awarded the Cross of the Legion of Honour. His father, having achieved the rank of captain in the National Guard, thought at first that the decoration had been meant for him. Convinced finally that it was for Camille, he remarked: "The boy seems to have talent, after all"; and he doubled "the boy's" allowance. About this time Corot again changed his approach to his art. He became less interested in Italy, whither he had made a third journey in 1843, and turned wholeheartedly to French landscape. Perhaps Rousseau and the forming Barbizon group had an effect on him. The rather stiff trees of his earlier pictures begin to move, and the atmosphere is lighter, stirred by breezes. Thus at the age of fifty he begins the work that is to give him his world-wide reputation, that is the truest Corot, popular and poetic, ethereal and mysterious.

It was in this period, after his fiftieth birthday, that he first sold one of his pictures. He pretended to be inconsolable. "Up to this time," he said, "I have had a complete collection of Corots, and now, alas, it has been broken!"

The Barbizon innovation of going out of doors to paint landscapes was not altogether new to Corot. And he did not take too seriously the injunctions of the laborious and literal Rousseau, the anatomist of nature. Mood, feeling, a musician's understanding saved Corot from the general Barbizon literalness—though he is often enough mentioned as one of the brotherhood. Edmond About might have said of Corot rather than of Rousseau that he led the landscape artists "into a land of promise, where the trees had leaves, where the rivers were liquid, where the figures of men

COROT: Mme. Charmois. About 1845. Louvre (Archives Photographiques)

and of animals were no longer wooden." It was he who carried with him everywhere the poems of Virgil and of Theocritus. "Nature," he said, "is eternal beauty." Nature, poetry, music . . .

During the following twenty years the pictures of Corot became so fluid, so vaporous, that a populace demanding misty sentiment simply revelled in them. Before long the poet-painter of Ville d'Avray was scoring one of the most remarkable popular successes known to art history. During the eighteen-fifties and the eighteen-sixties he turned out hundreds of canvases in which routine motifs and certain idioms of handling are repeated

endlessly, all unmistakably from the one artist's brushes (though now, eighty years after, there are, it is said, as many false Corots as real ones), and all conforming to the demand for glamorously soft nature scenes, preferably with a vaporous nymph or a hazy shepherdess dropped in here and there.

At Ville d'Avray, in the cottage given to him by his father back in his student days, Corot lived a life of almost idyllic peacefulness, visited by his sister or by those artist friends who were as devoted to nature as he. It was a life of simple contentment, of unbroken reveries, far from the distractions of Paris. There is every reason to believe that the landscapes he painted are the sincere and truthful expression of the prevailing mood of his life at this period. He was regularly up before dawn to experience the coming of the morning light, as it caught in a luminous net the fields wet with dew, touching the river with silver, then rose, then gold. At twilight he was sure he saw nymphs playing at the edge of the wood. Yet he repeated his ethereal effects so often, played so excessively the dawn and twilight music, that when there came an unsentimental generation—as a reaction to Victorian languishing romanticism—Corot was in danger of being relegated, *in toto*, to the limbo of the too sweet, too tender, too feminine effusions of the nineteenth century.

But Corot, let it be recorded, has been readmitted to the company of the leaders, even by the Puritans of modernism. Partly it is because his early architectural landscapes hovered on the threshold of cubism (and indeed realized a mathematical loveliness that the doctrinaire cubists did not); more especially because in his figure pieces he equalled the arrangements of Manet and foreshadowed something of Degas and van Gogh; and even, it came to be acknowledged, because he embedded a structural rhythm, a formal architecture, to be detected in many, though by no means all, of the diaphanous landscapes. Sometimes, beyond the wilfully atmospheric surface effect may be found a fully adjusted plastic design, partly a heritage, no doubt, from his study of Poussin, but no less a link with the moderns.

A compact architecture, a play of volume and space, of plane and texture, of dark-light and of colours, as sensitively adjusted and as mathematical as music, is, in a fugitive way, hidden within the glamorous veil of silvery blues, luminous greys, and muted golden light. The nymph or the shepherdess, seemingly so negligently added, is found to be a formal accent, placed cunningly to afford the observer a visual starting point. The

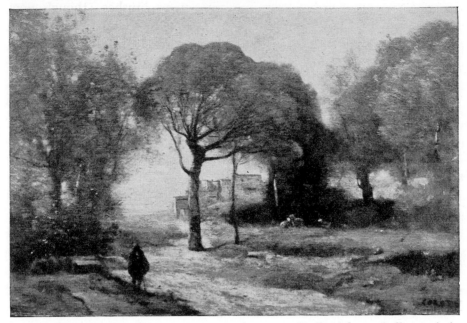

Corot: Villa of the Parasol Pine. *William Rockhill Nelson Gallery of Art, Kansas City*

shimmering leaves of the aspen act as "texture interest," preventing the eye from pushing too deep into the background space. The trunks of the willows carry the eye along linear tracks, or form a pattern-framing of deeper space, or mark successive planes of penetration. Little patches of rose or madder or vermilion, seemingly touched in by chance, "bring up" areas just where the path should be "forward" in space.

Let it be added that beside this instinctive or studied achievement of a plastic organism, Corot kept devotion to good old-fashioned draughtsmanship, making hard-pencil studies of landscape structure before he laid out his picture. To the end of his life he was a hard worker, driving himself to detailed study; the exact drawing is there, veiled, not neglected.

The sounder qualities sometimes disappeared along with the actual shapes of the tree trunks and the architectural edges when Corot became carelessly repetitious, or perhaps when friends needed money and he hurried through variations of his crepuscular pieces, in the period 1855–1870. He became too widely known as the painter of the mysterious moods of nature, of limpid waters and caressing vapours. He gave wings to the

idea himself, saying: "I have only one aim in life, to paint landscapes." But at this time he was painting, on the side, as it were, a series of admirably hard and organic figure-pieces; painting them "for himself," his friends said.

He kept his figure-paintings in his studio, face to the wall oftener than not. Perhaps they were closer to his heart than the landscapes of the same years. The old man, touching seventy in 1866, never lost his conviction that the artist should be pushing on continually, discovering new things in life and nature, new ways of expression. To the public this was an unknown Corot. But two generations later the figure paintings are to represent best of all his claim to a place among the moderns. In the 1930's museums and millionaires were to bid for his long-neglected studies of women reading, or at their toilet, or at the piano or easel, as keenly as rival collectors had once contended for the lyric landscapes.

In his old age (never was a man younger in spirit) Corot saw the rise of a new school, and was witness to a series of controversies among youthful and sometimes intolerant artists. In 1861 Manet showed at the Salon for the first time, Puvis de Chavannes came to notice, and Cézanne arrived in Paris. By 1862 Monet, Pissarro, and Renoir were all there, and Whistler was painting the first of his "arrangements," *The White Girl,* perhaps the earliest indication of a counter-rebellion against Courbet's still novel realism. Eighteen-sixty-three was to be the year of the historic Salon des Refusés and the beginning of the public quarrel over "the atrocities" of Manet and Whistler. In the years 1861–1870 Corot might easily have felt himself threatened, even challenged. He might have let himself be led into taking sides. With controversy all around, he continued to go his own way, happily and graciously, adding animation to his own work, being as "advanced" as Manet or Degas or Renoir.

Eighty years later one may hang a Corot figure-study with the most colourful of Manets and the most luminous of Renoirs and feel no discordance. The Corot is likely to seem as fresh as these others and probably will be better constructed. The landscapes had been a link between the luminism of the English pioneers and that of the French impressionists, by reason of their shimmering light. But Corot's inclination toward the modern is most proved in the plastic or constructive element in such pictures as *The Interrupted Reading* at Chicago or *The Reader* at the Metropolitan Museum. However true to nature, there is in these pictures a living architecture, an organization within which each element plays its part. They

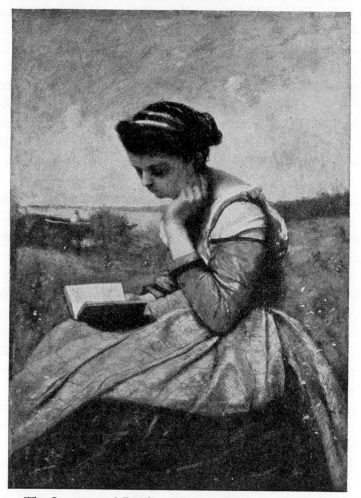

Corot: The Interrupted Reading. About 1867. *Art Institute, Chicago*

have plastic system, quite unlike the lax compositions of his friends Rousseau and Daubigny and Dupré.

There are pictures too in which one finds remarkable examples of use of one or another plastic means, in accordance with principles codified and clearly understood only after the twentieth-century experiments to determine the nature of *form* in painting. Thus texture or patterning is used for plastic weighting in *The Portrait of a Girl* and in an *Odalisque*, quite as Cézanne or Matisse might have utilized the device. Patterned stuffs had been copied into pictures many times in the past, as in Ingres's *Turkish*

Women at the Bath or Delacroix's *The Algerian Women*, but casually or ornamentally, without regard to the backward-forward movement values within the canvas induced by the device. It was only with Cézanne's generation that the dynamic pull of colour or texture was to be recognized as a formal resource. Corot *felt* these values, and in the matter of textured areas used for plastic effect he foreshadowed the experiments of Cézanne and van Gogh. Though few great painters have been so reserved in the use of colour, such colour as Corot has may be studied with more profit by the twentieth-century student than that of the lavish but disorderly colourist Delacroix.

The Corot of the final twenty years was a patriarchal figure, called by his friends, whether artists or models or peasants, "Papa Corot." Cheerfully and gladly he helped his fellow-painters meet the problems of public apathy and critical unfairness and wartime want. That he gave great amounts of money to artists, especially to his Barbizon familiars, is not to be doubted. Sometimes he could accomplish this only by indirect buying of their works. Whatever he did, he did in the kindliest possible way, knowing only that he had been favoured, late in life, with money that could turn starvation if not poverty away from his friends' doors. Hearing, in his isolation, that the Germans were threatening to take Paris in 1870, he bought a musket, then decided he would not be much of a soldier and instead sent a basketful of banknotes to the defence office. Once a stranger who had bought a counterfeit Corot brought the picture to him for authentication, and the old painter was so distressed at the man's disappointment that he borrowed the canvas and painted a picture of his own over the false one. When Millet died, Corot took ten thousand francs to a picture dealer and told him to give the sum to Millet's widow. "Make out you had pictures to that amount from him."

Corot painted until he was nearly eighty. He woke one morning in 1875, with no taste for his breakfast. "It's no use today," he said; "le père Corot breakfasts above." He had time to look again at one of nature's effects. "It seems to me," he said, "that I have not known how to paint a sky. That out there is much pinker, deeper, more transparent. How I should like to set down for you the grand horizons I see!"

Throughout his life Corot had insisted upon two things: that the artist should be himself, should not be carried away by "influences"; and that he should always keep his eyes open for new horizons. "Have an irresistible passion for nature," he said; but he warned that nature must be seen with

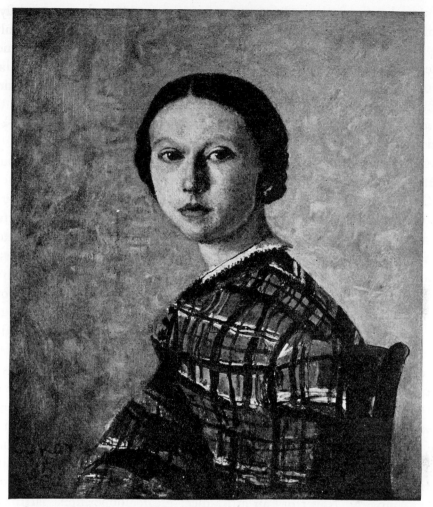

Corot: Portrait of a Girl. *Collection of Chester Dale, New York*

the eyes of a visionary, of a discoverer. Among his rare notes upon painting is this: "Follow your convictions. . . . It is better to be nothing than to be the mere echo of other painters. When one follows somebody, one is always behind. . . . Sincerity, self-confidence, persistence."

Barbizon is the name of a village at the edge of the Forest of Fontainebleau, not far from Paris. Fontainebleau had been the haunt of artists for a long time, but it was in the eighteen-thirties that a determined group of

painters began to copy nature as seen in the forest, and succeeded incidentally in immortalizing the village. Barbizon became the name of a school of painters and of a world-wide movement in art. Fifty years later the public, whether French, Scandinavian, English, or American, counted the Barbizon painters the very greatest of "modern" artists; and it has taken another fifty years to place the school in perspective and to prove that the novelties of faithful landscape delineation might fairly be considered a late variation of Renaissance realism, and therefore not at all modern in the twentieth-century sense.

It is strange that a man so imaginative, so sunny, and so serene-minded as Corot should have had as friend the dark-minded Théodore Rousseau. "A born revolutionary," he was called often enough; which is a little hard upon the makers of revolution, who need not be wholly tragic or contentious or unimaginative. Rousseau was insistently rebellious, loud, personal, unfortunate.

By 1830, when he was eighteen, he had alined himself with insurgent, some would say subversive, social groups, and soon afterward he was leading a band of mutinous art students. "For the new society, a new art," they proclaimed. A certain bitterness of mind, developed in these student days, never left Rousseau. Nor did he get over a tendency to press his ideas, to force recognition. Seventeen years later Delacroix makes this note in his *Journal:* "Dupré and Rousseau came in during the day. They repeated a whole lot of arguments in favour of their celebrated society. But I had made my decision and I expressed to them my complete aversion for their project." Thus another rebel, one still outside the Academy and the Institute, fastidiously stepped aside, joining the conservatives in opposition to Rousseau's "project." Never did an artist meet greater opposition, partly as a result of his own nature and his mistakes, partly because he was an admirable rebel.

Rousseau's insurgency in the practice of art led him to wash his hands of all that contemporary painters were doing, and all that earlier generations had done. While the idea of being "natural" was very much in the air, virtually no French painter had ever gone direct to nature in the raw. Classicists and romanticists alike, he noticed, were studio painters. They were, moreover, bound up in rules about composition, about handling, about peopling their landscapes to render them "human." Rousseau literally walked out into the open and began to paint from the trees and rocks and streams. Better than any other artist he accomplished the task Constable

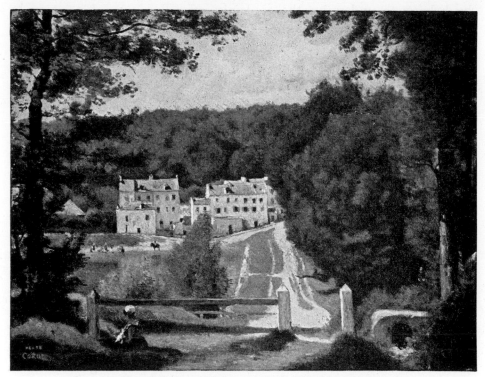

COROT: The Cabussud Houses at Ville d'Avray. About 1850
Collection of Christian Lazard, Paris
(Courtesy M. H. DeYoung Memorial Museum, San Francisco)

had said he set for himself: "When I sit down to make a sketch from nature, the first thing I try to do is to forget that I have ever seen a picture."

No countryman would ever have thought of painting country scenes. The city-dwelling artists had lost the country, its loveliness, its tonic freshness, its closeness to God. The landscape had to be seen nostalgically, as a memory of one's lost youth, before its desirability as painter's material could be realized. But once Rousseau had returned from Paris to the country, from his urban exile, he steadfastly remained an out-of-doors painter. He left behind even the formulas he had picked up at first through museum study of the Dutch landscapists Ruisdael and Hobbema. Constable alone remained as an influence, as an example.

Rousseau became, in the unfolding and shaping of French art, an ally of Courbet rather than of Corot and Daumier, and therefore his services to modernism are negative rather than creative. He helped clear the way,

by helping to undermine the academic, officially powerful painters, by opposing artificiality and the museum approach and the literary touch. He was a realist of the most literal sort, over on the side toward naturalism. Painstaking and exact in his seeing, he seldom freed himself from slavery to casual detail. Later his canvases were to seem excessively photographic. He learned the anatomy of nature, the structure of rocks, the morphology of root, trunk, branch, and leaf, as no one before him had done. But he was unable to forget this knowledge in a visual synthesis, a formal invention. Sometimes he painted a picture in which every nature-lover can take spontaneous pleasure, the transcription of an impressive view so faithfully rendered that the observer lives again a too seldom-roused delight in cathedral-like forests, or latent memories of patriarchal trees, of shadowed pools.

The effects are sombre, and in the handling there is a rich heaviness. On rare occasions the picture may have true grandeur, particularly if it be a portrait of a monumental storm-resisting oak. Continually Rousseau vacillated between the desire to show all that his prying eyes saw and the impulse to express the immensities, the mystic reaches, that natural beauty evoked in him. His equipment was such that he grasped little beyond the surface view. To do so much was to mark one as a startling innovator in 1840.

In one of his famous pictures, *The Oak of the Rocks*, Rousseau's biographers have found the symbol of the man. Storm-racked, rock-bound, solitary, the oak stands above the lesser personalities of the forest. In seriousness, largeness, strength, Rousseau stands above all his fellow-landscapists of the Barbizon brotherhood.

After his one early stroke of luck, acceptance of a picture by the Salon jury of 1834, he was excluded from exhibiting for fourteen years, through unbelievable intrigue and persecution on the part of the Government-favoured artists. His became a *cause célèbre*. His works were so often refused admission that he had the slender consolation of being known everywhere as *le grand refusé*. The Revolution of 1848 opened the doors of the Salon to all who cared to exhibit, and Rousseau then for the first time knew a period of prosperity. But old enmities and his own jealousy and limitations carried him again into controversy and misfortune.

A second period of prosperity, during which he bought a picture from the starving Millet, hiding his generosity behind an invented "rich American," preceded his final decline into embitterment and ultimate near-

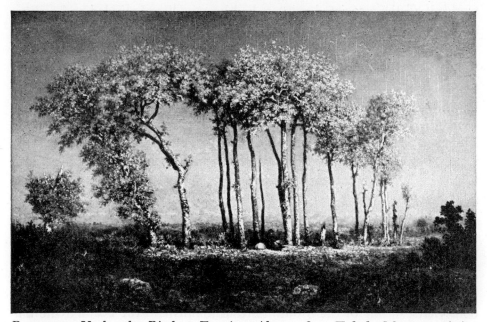

Rousseau: Under the Birches, Evening. About 1842. *Toledo Museum of Art*

insanity. (For years his wife had been actively insane.) Toward the end he wholly lost his slight hold upon the larger compositional elements, and his painting became coldly scientific and naturalistic. He died in 1867.

Rousseau's tragedy was that of the artist who apprehends deeper life-values but is cursed with the naturalist's eye, the materialist's mind and hand. He once said of artists: "With our unfortunate passion for art, we are marked for perpetual torment. We are eternally striving after a truth that escapes us."

It was in 1848 that Rousseau bought a studio-home in Barbizon and settled there as a year-round resident. But many years before, a canny peasant had built hut-studios to rent to the Parisian artists, an old barn had been made over into a common meeting-place, and a considerable company of painters was accustomed to frequent the adjoining woods and fields. All were intrigued with the new idea of the *paysage intime*, but each one brought his own way of mirroring or interpreting nature. Each was an individual, with peculiar temperament and differing vision. "Barbizon" would have a more exact and a more logical meaning, as a label in the art

world, if all the associated painters had been as literal-minded and as limited in imagination as Rousseau. But Diaz was temperamentally a poet, viewing the forests and fields subjectively. Against Rousseau's strength, solidity, and plainness he set a lyric sweetness, a moody romanticism, a sometimes specious charm. Jules Dupré took a ground between the two, being sombre like Rousseau, and inclined to melancholy effects, but in romantic lighting, with plenty of moving clouds, and with men and farm animals or a sailboat or a church adding a softening emotional touch. Daubigny returns toward Rousseau's ground, but is not austere or anatomical. He sees nature with a kindly eye and portrays her as hospitable and grave.

At some time in the eighteen-thirties it may be that an old painter named Georges Michel went to Barbizon to see what all this talk of landscape-for-its-own-sake was about. He had been a landscape painter, over in Montmartre, for fifty years. If anyone had known about him, had listened to him, he might have been a pioneer of the movement. His outdoor views, mostly of the Montmartre windmills and the near-by countryside, were very little tinged with the picturesque. They were, in general, remarkably honest, though perhaps a little too darkened in the Dutch manner. Michel is not known to have sold a picture during his lifetime, and he was probably little more than a Sunday painter. It is likely that he worked at something else, for he had married a washerwoman when he was fifteen, and had five children before he was twenty.

Born in 1753 and living until 1843, Michel saw the whole drama of the Revolution, the Consulate, the Empire, and the restored Bourbon monarchy, and the coming of neo-classic art, then of romanticism. That he was swayed very little by the two revolutionary movements is indicated by his saying: "The man who cannot find sufficient subject matter for his painting within a four-mile circuit of his home is not a real artist." And he asked: "Did the Dutch painters run from one place to another?" This was at a time when the romanticists found it necessary to take their sketchbooks to Venice or Morocco or the Orient. In his ninety years Michel almost never went more than a stone's throw from Montmartre.

Michel was destined to be rediscovered in the twentieth century, and he appears, modestly but certain of tempered appreciation, in leading art museums. The Barbizon masters, after fifty years during which critics and public, not to mention picture dealers, lauded them as immortals and as the peers of Raphael and Velazquez, have lost stature—except Millet. It is

MICHEL: Landscape. *Museum of Fine Arts, Boston*

seen that, after all, Rousseau's and Daubigny's art is transcriptive art, resulting from an extension of the Renaissance scientific search for natural truth. Diaz and Dupré are accepted as minor romantics. The work of these men is important in the chronicles of modern art because they served to carry forward in France, centre of the next phase of advance, the impetus of Constable. They completed the work of Delacroix in claiming liberty of individual expression; and they paralleled the work of Courbet in returning painting to a new starting point in natural observation. But the pure landscapists of the group are hardly in the line leading to Cézanne and Seurat, except as they carry on the study of light.

Dupré had been in London and had become a disciple of Constable. But it was the group as a whole that paved the way for impressionism. How perfectly some of the Barbizon pictures illustrate a transitional phase between the Englishmen and Monet is to be seen in Daubigny's *Springtime* at the Metropolitan Museum. The sensuous colouring, the shimmering light, the atmospheric freshness mark the moment at which the last master of the Barbizon school was feeling those impulses which were already

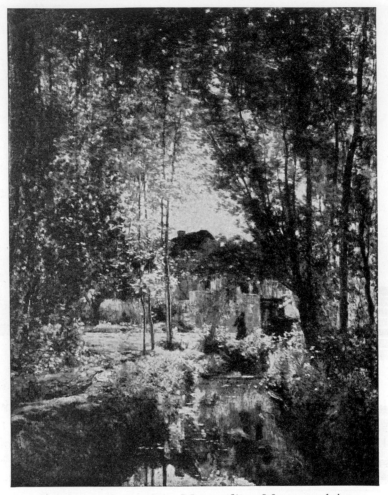

DAUBIGNY: Springtime. *Metropolitan Museum of Art*

leading Pissarro and Monet into the full expression of *plein-airiste* impressionism.

One Barbizon master refused to subordinate all else to the landscape. Jean-François Millet, peasant-born, was a farm labourer in his early years, starved of all art, and imperfectly educated. Sent to Paris from Cherbourg by public subscription in 1837, at the age of twenty-two, he found orthodox art instruction useless, even offensive. To pleas that he must "see and paint as Delacroix does," he could only answer: "But I hear the cry of the earth." In later life he similarly answered, with independence and finality,

MILLET: The Quarriers. *Toledo Museum of Art*

those who would have had him imitate Ingres and the neo-Greeks. "Theocritus makes it clear to me," he said, "that a man is never more Greek than when he simply renders his own impressions, come from what source they may."

Since he had to make a living by his picturing, he attempted for a few years to do the passable, expected thing, even to imitative nudes, and then shop signs or five-franc portraits—anything. But in 1848 he took time to express himself, to return to the themes he knew, and painted *The Winnower,* and it turned out to be his first success. The following year he

resolved to quit Paris and to renounce fashionable painting for good. Having heard of the Barbizon painters, he took his wife and three children on an omnibus to Fontainebleau. The next day the painter and his wife walked the rest of the way to Barbizon, in the rain, carrying their children. The artists welcomed him as a brother, and he never visited Paris again except for the briefest business calls. Nor did he ever again paint anything but the close-to-the-earth themes that interested him.

He paid dearly for his independence. For days together he and his family went without food. In winter he painted his pictures in an unheated barn, with his feet bandaged and a horse-blanket over his clothing. He took time from his art to cultivate a farm-patch in an effort to feed his ever-growing family. Fortunately he lived to be sixty, and toward the end enjoyed wide public esteem and freedom from financial troubles. He even saw one of his paintings, which he had been glad to sell for one hundred and fifty francs, resold for thirty-eight thousand. Had he lived another twenty years he might have seen The Angelus sold for almost as much as the world had paid to him for his entire lifetime's work.

Millet was obsessed with the earth and with the men and women who work close to it. There was no intellectual motive behind his return to the country. And in a certain mystic attitude toward nature there was none of the literary-intellectual impulsion of a Thoreau or a Jefferies. As he was most a peasant of all the Barbizon brotherhood, he best understood the earthy aspects of nature and most deeply felt delight in every manifestation of life. He said that he had heard the trees speaking; and in the splendours of the night he became "conscious of the infinite." But the men and women interested him most, and he increasingly devoted himself to portraying them in relation to "the fundamental condition of human life, toil." As he was over-burdened, so he held especially to their burdens, their problems, their exhaustion, and the simple pleasures that made toil supportable. "The gay side of life," he said, "has never presented itself to me. I do not know where it is. I have never seen it. The gayest thing I know is the calm, the silence, that is so sweet in the forest and in the fields."

It is Millet's greatest merit that in painter's language he brings this calm, this sweetness, into pictures with a grave and beautiful simplicity. He is the only artist of Barbizon who has a measurable amount of the monumental element in his treatment of figures; of that sculptural largeness that makes his contemporary Daumier the greatest painter of the period and a worthy forerunner of Cézanne and Picasso. Millet's work as a whole may

MILLET: The Woodcutters. *Victoria and Albert Museum*
(Crown copyright reserved)

be illustrational and not without a sentimental tinge, but considered merely
as formal organization it yields examples above anything created by Rous-
seau or Daubigny, or, for that matter, Delacroix. Like Daumier, too, Millet
painted familiar subjects and working people, and by his earnestness and
sympathy advanced what was considered, until the twentieth-century wars
made the phrase scarcely tenable, the modern conception of the brother-
hood of man.

Millet, once he escaped from Paris, was independent, original, instinc-
tively democratic. He avoided, in general, the specious appeal of the pic-
turesque; he was seldom misled into the realm of the pathetic. The pretty
country girl has no place in his gallery of types. His is a record of feeling
about a certain way of life. In creating this record he intuitively grasped
at means which had been unknown to the greater part of his contempo-
raries. Seemingly up out of the earth he took energies that expressed them-
selves through his hand as pictorial vitality. The bodies, large and stat-
uesque, are placed with something of the relation of sun and planets,
volumes poised in tension. The silhouettes of the sombre figures, whether

of the *Sower* or the *Reapers* or the *Woodcutters*, add to a pattern of rhythmic movement. In these larger elements, in a simple way, Millet contributed to the modern search for a new dimension in art. Where the Barbizon landscapists did little more than advance the study of light, moving a little nearer to the culminating luminosity of the impressionists (without, however, contributing rainbow tinting), this lone figure-painter among them, who was accused in his time of being the limner of brutality, is recognized, nearly a century later, as one of the great borderline figures, putting into his canvases just enough of elemental plastic order to be hailed by the moderns as comrade and example. Van Gogh was to profit by Millet's utter honesty of statement, his primitive directness, and Cézanne and Seurat and the *fauves* may have found something to study in the heavy volumes and rhythmic silhouettes.

Peasant that he was, Millet had a shrewd mind when he cared to use it, and he could express himself about art in epigrammatic phrases. Of the fashionable painters he said: "When they set out to make art natural, they succeed only in making nature arty." All the faults of the contemporary school of romanticists were suggested in his one bit of advice: "Keep away from the theatres!" He believed that "one can start from any point whatever and arrive at the sublime, can express the sublime by means of any subject matter, if one's aim is high enough." In this last declaration Millet foreshadowed thousands of later discussions of the purpose of art. He seemed to be saying, with some of the latest groups of moderns, that "it doesn't matter what one paints, only how—and how much of one's self one puts in." But it is well to remember, in interpreting him, that although he renounced "attractive" subject matter, he was a spiritual man expressing the spirit of the life he witnessed.

While the easier path of modernism to trace is that of a gain in formal significance, there is another, a more difficult phase of the search, illustrated in the works of those artists avowedly seeking ways of spiritual revelation in place of material representation. If the painter could evoke the spirit of the subject, could re-express it as imaged through his own spiritual perception, at the same time bringing enrichment out of what may be termed the spirit of the painting art, he might arrive at the same goal as those others who consciously, and intellectually, seek primarily a formal or plastic mode of æsthetic statement. Millet went a little way on the spiritual or mystic road.

V: DAUMIER, A GIANT OF MODERNISM, LIVES AND DIES NEGLECTED

DURING the decade 1845–1855 a truly modern movement in art was at last taking direction in France. Where the old art and the new met, Corot and Millet were outstanding painters, sufficiently creative to have foreshadowed modernism. With them, on the new side, was a single towering figure, Daumier. From him, Millet had been accustomed to learn. Moreover, Daumier was to teach, by example, Courbet and van Gogh, and above all Cézanne.

DAUMIER: The Uprising. *Phillips Memorial Gallery, Washington*

The advance of modern art in the eighteen-forties was along lines not perceptible to the classicist or to the romanticist, or, for that matter, to the realists who were to come to power in the fifties. The great revolutionaries of 1850–1890 were to be revealed especially as searchers for the mysterious thing called "form," without which, they proclaimed, the painting art becomes mere illustration, photographically or sentimentally important but æsthetically shallow. The form-seekers believed that subject painting should be fortified with "plastic vitality"—as Oriental art had always been. They were to go on in the thirty years after 1900 to attempted isolation of the form-quality, in abstract painting, in a series of adventures by the tough-minded but musically sensitive artists known as cubists and purists. Long before that, however, the transition from illustrational painting, plastically weak, to the picture formally animated, fortified with plastic rhythms, had become the central, revolutionary fact of the advance from old to new painting.

Daumier is important to the formalist revolution because he was the first artist of nineteenth-century France to endow his painting consistently with plastic aliveness and spatial organization. But he equally scored within a second territory embraced by every tenable definition of modernism. Not all painters see abstraction as a goal. It is only necessary to *build in* formal excellence, not to abandon all else in the search for form, the moderate modernists have said. And so, though no picture is at home in a modern gallery if it does not have controlled plastic movement or formal vitality, its modernism may be the more or the less intense too by reason of the social awareness shown in choice and interpretation of the subject matter.

In 1840 the official and the insurgent painters alike were choosing themes without significant relationship to the tides of change that had swept human ways of living and social institutions. Since 1789 life had been ahead, art lagging. If there was growing up what may be called a conscience of the century, stirred by aspirations for liberty, brotherhood and an enlightened humanity, artists had known little of it. The Davidians had tried to adjust their vision to changing social conditions and they had succeeded in picturing certain events of the Revolution, and then the martial and civil exploits of Napoleon; but the canvases were hardly more than enlarged book-illustrations, and the painters had soon retreated again to classic themes. The romanticists began with horse-races and battle scenes but retreated to literature and the Orient.

Millet and Daumier were the first painters to dedicate themselves

DAUMIER: The Theatre Box. Lucas Collection, Baltimore Museum of Art

wholly or substantially to contemporary or "common" themes in nine-
teenth-century France, the one painting peasant life, the other the life
of the workers and the *bourgeoisie* of Paris. Both achieved for the task
a painting method sufficiently simple and primitive, even heroic. The one
may be said to have painted without social intent: he simply portrayed
the peasants he knew and loved, but his pictures so exposed their misery
and he so suggested his brotherhood with them, that the world was stirred
to sympathy and to socialistic thought; and he was even attacked in the
press as an agitator. The other was a trained social commentator, a car-
toonist by trade, and he carried over to his painting his interest in the
contemporary scene, and at times his barbed criticism and satire. His pic-
tures of washerwomen and blacksmiths and street singers are sympathetic
if not "ennobling," and he caricatured the predatory lawyers and the cor-
rupt courts so subtly that his paintings rouse ultimate anger over official
injustice.

There will be more deliberate attempts to ennoble labor during the

following eighty years, and efforts will be made at intervals to mark the "socially conscious" painter as the truest modern; but Daumier will still be, in 1940, the unrivalled master of common-theme painting and of political satire. He is not the less a master because he not only satirizes social and political institutions but also shows up the foibles, the weaknesses and the pretensions of the individuals who make up society, who sometimes blame it for their weaknesses and mistakes.

For those who do not count ennoblement or commentary a significant part of the painting art, there is in Daumier's œuvre a wide range of merely objective presentation, of subjects seen at the print-sellers' shops, on the street, in the theatres, in the railway carriages and omnibuses. There is a series of paintings on the Don Quixote theme. There is an occasional proverb illustrated, or a Biblical figure. Through it all is evidence of that other mastery, an instinctive command of the plastic means that endow painting with formal excellence.

Honoré Daumier was born February 26, 1808, in Marseilles, to the wife of Jean-Baptiste Daumier, a glazier who fancied himself a poet. After seven years the family moved to Paris, in order that the father's literary abilities might have wider scope; but very little is heard again of his verses and certainly nothing financially consequential. Of the life of the boy little is known except that the family lived in substandard lodgings on crowded streets, and that he drew incessantly and went to prowl and brood in the Louvre as he liked. The sculptures there attracted him more than the paintings. Of professional training for art he had practically none. In failing as a poet, the father did not succeed in any practical calling. Expensive schooling of any sort for Honoré was out of the question.

At eighteen, stifling his ambitions, the youth became usher and errand-boy bound to a bailiff of the law courts. The only gain was insight into the devious processes of law, and knowledge of lawyers, clients and judges, all subject-material for the painter of thirty years later. Rebelling, when he had become a lawyer's clerk, demanding any change from the dismal legal routine, he was put into service with a bookseller. He quit that job unceremoniously, and told his parents he wanted to be an artist and nothing else. By a happy chance his father was advised from high quarters to give the boy his way and he was placed in an orthodox art school.

This too proved insupportable and the youth went over to a lithographer's studio and learned the craft of print-making by crayon on stone.

DAUMIER: At the Theatre
(Courtesy Durand-Ruel Galleries, New York)

Before he was twenty-three he was doing professional work. Within an-
other year he was contributing political cartoons to *La Caricature*, and
had entered that life of servitude to journalism which prevented him from
painting seriously during the following seventeen years, and thereafter
yielded him only marginal time, and no peace of mind.

In 1831, when Daumier joined the staff of *La Caricature*, the govern-
ment of Louis Philippe was attempting to be liberal and tolerant. But
Daumier tried its patience by a not very nice cartoon of the political ma-
chine taking in bribes at one end and discharging decorations, commis-
sions and favours at the other. He was sentenced to six months' imprison-
ment and a fine. A stay "during good behaviour" was cancelled when he
displeased high officials again a few months later, and he was incarcerated
in Sainte-Pélagie.

During the six months in prison Daumier drew a great number of portraits of his fellow convicts. When he was released in January 1833, just before his twenty-fifth birthday, he had learned about another segment of society, and he had greatly improved his command of the crayon. No artist, realist or romanticist, ever got down the collective physiognomy of a nation as Daumier has caught the French. He was to become shortly one of the greatest masters of draughtsmanship of all time, surpassed by only three or four Western artists—Rembrandt and Michelangelo most notably—and by the Chinese and Japanese masters.

He returned immediately to his cartooning. A year later, at twenty-six, he contributed to *La Caricature* as a supplementary plate his print *Rue Transnonain, le 13 avril 1834*. It showed the interior of a worker's home after Government troops had massacred the inhabitants during social disorders. Its straightforward statement, free of the melodrama a romanticist might have added, proved that a new master of the crayon had been born, and was dedicating himself to the republican cause. Suppressed too late, the one print made Daumier's name a byword in France. Almost as celebrated is the lithograph, of the same year, entitled *The Legislative Belly*, or, as some translate it, *The Vile Body of the Legislature*, in which the law-makers are lined up on their benches, as it were, for public inspection, and their characters, their hypocrisies, and their dishonesties portrayed in their faces with only the slightest exaggeration. In the following year *La Caricature* was suppressed. Daumier went over to the journal *Charivari*, for which he did the greater number of his political and social drawings. For the rest of his life he depended upon this "hack work" for his meagre living. He gained an immense audience, found esteem among the greatest figures of the time (outside official circles), and knew fame that would have made many of his contemporaries happy.

But Daumier wanted to be a painter. At a time undetermined, he began to work in oils. (Nearly all his canvases are undated.) Many critics believe he only turned to serious painting in 1848. In that year censorship cut down the amount of journalistic work he could do, and the enforced leisure gave him opportunity to experiment. It may be, however, that the greater proportion of his painting was done after 1860, after his fifty-second birthday.

Daumier felt that, as regards his art, his early and middle years were wasted; but it is not to be inferred that he was so long unhappy. He was a man of good heart, even-tempered, generous, though grave and sparing

of words. His experience of courts and prisons might have made him bitter; but there is no malice, no unfair advantage taken, in his long series of drawings of court life and character. Merely the truth carefully observed, beautifully set down—and toward the end presented with all the power and cunning that mastery of the plastic means can add to painting. Even his cartoons are reserved and generally good-natured. He never stooped to lampooning.

Heart-burning he must have experienced once he acknowledged to himself that nothing but success as a painter would justify living. Yet the artist who has turned commercial, to buy bread, is usually philosophical about it up to his middle years. Daumier was unworldly, and did not greatly miss worldly rewards. He was happily married and had an unusual number of friends. To the barely furnished attic studio over his apartment on the Quai d'Anjou came writers and artists, known and unknown, to sit on the floor and talk and drink and examine prints.

But after 1860, when his vogue as print-maker and social commentator had passed, when therefore he became actually the painter he wanted to be, poverty hampered him cruelly and he also suffered the consequences of his democratic opinions. The great Baudelaire was one of the first to value his genius, but efforts to praise Daumier in a popular magazine in 1860 met a stone wall of prejudice, and Baudelaire's article appeared only belatedly, in book form, in 1868. He spoke of Daumier as "one of the most important figures, not only in caricature but in modern art." It is one of the few true estimates of Daumier's position to appear before 1900. For the most part he was ignored as a painter, except by a very few friends, to the very end. Blind, poor, with a roof over his head only by grace of Corot's generosity, he died in 1879.

Any estimate of Daumier's paintings should begin with reminders of his independence. If he had antecedents they are to be found as far back in time and as distant in place as Rembrandt and Michelangelo. There had been absolutely no sign in earlier French art to account for him. His painting is his own, as removed from that of the recognized leaders, from Ingres and Delacroix, as from the popular Couture and Meissonier and Flandrin. He was known to his contemporaries by reason of his lithographs (unlike the almost totally obscured Blake, and the wholly overlooked Michel); but the few who valued him, like Corot and Delacroix, apparently could do nothing to win recognition of his genius. The commoner

attitude was that of Couture, who, late in the fifties, displeased by the independent ways of his student Manet, exclaimed: "My dear boy, you will be nothing but the Daumier of your time!"

Daumier painted wholly from memory. There is never a suggestion of the posed model. His memory stored up an amazing gallery of faces and figures, and he got these down with supreme livingness, in movement. The characterizations are sensitive, penetrating: the old actors who have come down to street-fair stunt-playing, the bourgeois drinkers and singers, the countrymen and -women in the third-class carriages, the lawyers who are sometimes like rats, sometimes like vultures, the bewildered clients and the Pharisaical judges.

Sensitive as his draughtsmanship is, where sensitiveness is needed, there is no loss of vigour, of largeness. Daumier is the most heroic of all the moderns. His figures occupy space with Michelangelesque amplitude. Even his slightest sketch is likely to be sculpturally voluminous and virile. When Daubigny went to Rome and visited the Sistine Chapel, he looked up at the great Italian's murals and mused: "It looks as if Daumier had painted here." If art may be divided, as some would have it, into the monumental and the intimate, Daumier gained more than he lost by turning in the direction of largeness and power.

But these were not qualities that the French critics and the French public knew how to value. Daumier had none of the cold purity of line of Ingres and Flandrin, none of the velvety brushing of Couture, none of the exactitude and finicking correctness of Delaroche and Meissonier, none of the bonny faultlessness of Bouguereau. Painting had been rather thoroughly feminized, and Daumier was heedlessly masculine. Although he never painted a picture that offends taste—he is incurably middle-class in all that touches upon morals—he was unrefined and lacked polish. Although he believed passionately that his paintings were what counted, and marked down his cartooning as mere routine bread-winning, official art circles and the public continued to treat him as a great cartoonist mistakenly attempting to paint.

He was not a school man. Perhaps that is the whole story. The doctrinaire classicists, of course, loathed his sloppy execution and his addiction to unrefined subjects. The romantics, who were the revolutionaries of his formative years and to whom he was somewhat indebted for his free method of painting, disowned him. Romance, they believed, lay in the long ago and far away, not in the streets of Paris. They thought his subjects

DAUMIER: Don Quixote with Sancho Panza Wringing His Hands. *Collection of Mrs. Charles S. Payson, New York* (Courtesy C. W. Kraushaar Art Galleries)

necessarily carried him over into the ranks of their enemies, the realists. Yet if realism is the matter-of-factness of Courbet, the label is not big enough for Daumier. His monumental simplifications, his distortions for pattern effects, his deliberate playing with volumes and planes, his unnatural lighting deny the rules built upon scientific observation and rational presentation.

For three decades after his death the historians did not try to "place" him, noticing him only as a caricaturist. The strange divergence of opinion among twentieth-century historians throws light upon the originality of his painting, indicating how he over-rode the schools. Élie Faure in his *History of Art*, John Rothenstein in *Nineteenth Century Painting*, Clive Bell in *Landmarks in Nineteenth Century Painting*, and Frank Jewett Mather, Jr., in *Modern Painting* have treated Daumier as a romantic. But Haldane Macfall in *A History of Painting* writes that "Daumier created French realism" and that "he was always a realist." And Ernest H. Short in *The Painter in History* treats Daumier unreservedly as a realist.

What really has happened at this point in the history of painting is

DAUMIER: The Emigrants. W. Van Horne Collection, Montreal
(Courtesy The Hyperion Press, New York)

that a figure has appeared too big for traditional labels. Without losing
the essential truth to life which is at the heart of realism, with neverthe-
less a full measure of the human warmth, the spirited movement, and
the concentrated drama which should characterize romanticism, Daumier
goes on to some more inclusive classification. There are critics and his-
torians who still would wait for a more acceptable word to name definitely
the nineteenth-twentieth-century modernism; already there are others
who call Daumier the first great expressionist.

Daumier painted three pictures entitled *The Emigrants*. In them he
meets the romanticists on their own ground. One can search the galleries
of the romantic leaders and find no picture more immediately dramatic,
none with depicted movement so integrated into a movement pattern,
few so freshly evocative of sympathy. As regards the emotional aspect of
the subject, the observer in the world of the nineteen-forties might better
meet the title translated as *The Refugees*. The word carries implications
of danger, of peoples uprooted, of blind flight. Daumier has achieved
perfect co-ordination of treatment and subject feeling in these paintings.
Even the lighting is tragic, without slipping over into the field of melo-
drama. The contrasts of light and dark are moving, even disturbing. The
atmosphere is one of hopelessness.

In the Don Quixote series, constituting Daumier's one excursion into

DAUMIER: The Lawyers. Collection of John Nicholas Brown, Providence

literary romanticism, he outdoes all the men of the Delacroix school who painted enlarged illustrations of Shakespeare and Dante, of Byron and Goethe. The scene, the characters, the moment of drama are simply and powerfully set out. The painter re-creates Spain, more Spanish than the country itself. He re-creates and shamelessly enlarges the two questing characters. He enlarges emotion by the contrasting chiaroscuro, by the deformation of rock and sky, by the foil and counterfoil of poise and swift movement.

Daumier's realism no less beautifully fulfils the conditions established by the realists themselves. If it is the penetrating realism of character that is in question, one may study for psychological truth *The Lawyers*, or any one of the many paintings of theatre audiences, or a whole gallery of street singers, actors, beggars. If it is the realism of exact record of a way of life, one may find it richly achieved in the illustrations of the law courts. If detail is lost in the study of *The Towman*, does it not still tell more of the essential truth of human toil along the canals than a dozen photo-

DAUMIER: The Towman. *Collection of Richard Samson, Hamburg*

graphic records could? Yet always it is representation, transcription, achieved within some larger intention, within a synthesis, a formal creation.

There are not lacking those who, without violating the essential meaning of the labels, would set up the figure of Daumier as bestriding all the divisions into which the æstheticians had parcelled out the field of art in the nineteenth century, as covering realism, romanticism, *and* classicism. There is reason to believe that better than the avowed neo-Greeks Daumier fulfilled the basic requirements of the "simple, harmonious, and proportioned" style. Jacques Lassaigne in the only book of any stature in English upon Daumier writes: "Daumier's painting seems to stand above Time, above the accidents of events and without connexion with the exterior world. Having thus reached a convention that is entirely classic, it is accessible to every age."

It was not until the second quarter of the twentieth century, however, that Daumier's name was brought forward by the post-cubist moderns as that of a creative pioneer. It was necessary that the experiments of Cézanne be understood, that the theories of plastic vitality, of dynamic movement

D<small>AUMIER</small>: Corot Sketching. Water-colour. *Metropolitan Museum of Art*

and spatial organization, be co-ordinated, before the exceptional modernity of Daumier's achievement could be felt. The verdict of the moderns was this:

Of all the nineteenth-century artists before Cézanne, Daumier best succeeded in formally organizing pictures. Among those few painters who, instinctively or consciously, groped for values beyond those of transcription or illustration, he best succeeded in making each picture a living formal entity, with inbuilt and self-sufficient plastic vitality.

Four decades later Seurat was to speak of "the canvas hollowed out."

DAUMIER: Soup. Drawing. *Louvre*
(Courtesy Metropolitan Museum of Art)

Daumier better than any other can be called upon to illustrate indicated
(and controlled) depth within the picture-frame, to illustrate space hol-
lowed out and bounded, and figures (or mere volumes) organized in poise
within that space. Further, he used planes more knowingly than any artist
before Cézanne, for movement-direction within space, to step back or bring
forward the eye. Of the several plastic means, he used colour most spar-
ingly and with least formal effectiveness; but occasionally he seems to
have utilized colours consciously to bring up an area or to set back a volume,
within the organized composition.

At its lightest his grasp of the formal means yields a thing that is pat-
terning at its best, as, say, in the water-colour *Corot Sketching*. At its
profoundest it yields ordered compositions of magnitude, with a rich
interplay of the several plastic elements. There is not here the achieve-
ment of symphonic form of a majestic grandeur, as in the case of that old
master who, though isolated in time, fulfilled so many of the aims of the
moderns—El Greco. But even in so simple and hasty a sketch as *Soup*
there is a hint of elemental grandeur.

DAUMIER: The Beggars. *Collection of Fritz Hess, Berlin*
(Courtesy Museum of Modern Art)

Among the pictures of the other artists who appear upon the first courses of the modern slope, most notably Goya, Turner, and Corot, it is necessary to search carefully for canvases that might illustrate the several ways in which the plastic means are used to achieve a formal effect. But there are a half-hundred paintings by Daumier that might be chosen to demonstrate manipulation of space and volume, of planes tilted for direction of movement or overlapped to induce ascent or descent, of chiaroscuro contributing pattern interest. The flattened figures, the pyramidal grouping, and the squared, sharp-edged planes of the background in *The Beggars* are reminiscent of the mathematical laws educed by the cubists out of their practice based upon Cézanne. Built upon the same principles but in less elementary arrangement, *The Uprising* shows how the plastic means, cunningly manipulated, may at the same time support the theme and intensify emotion. Plane, line, and volume contribute to movement; and

DAUMIER: The Horsemen. *Collection of Harrison Tweed, New York*
(Courtesy Museum of Modern Art)

in this case movement in the pictorial or formal sense means movement
in the thematic sense, leading to emotional excitement.

Other canvases may be set out as showing one or another of the ele-
ments separately. *The Horsemen* illustrates that "pull" between volumes
in space which is a basic means of poising the movement structure. The
placing of the horses in the rectangle of the picture field, the way in which
the superior heaviness of the horse in the background "ties in" the bulkier
ones at the front, the weighting of the lower left corner with a plane, all
this affords material for study where students seek understanding of the
modern language of plastic design.

The Laundress (which might be analysed for the fidelity of observation
shown in the movements of the short-legged child and the stooping ges-
ture of the burdened mother, and for the perfect fitness of treatment to
theme) affords a notable example of simplification by the breaking up of
the picture into a very few strongly marked planes. It is usually a dan-
gerous expedient to place the figures of principals so far forward in the

DAUMIER: The Laundress. *Museum of Modern Art, New York*

"hollowed-out" space and then to leave vistas beyond; but Daumier has perfectly controlled penetration of the eye into deep space, through manipulation of the across-the-river background as a single plane, like a curtain dropped to close the spatial field. The generalization of a whole row of buildings and a sky into a single plane is a favourite device of Daumier's (to be seen among the illustrations again, with slight linear reinforcement for "pointing" purposes, in *The Uprising*).

For one who recognizes the signs of plastic orchestration—as a listener at a symphony may note how beautifully the wood-winds are introduced

DAUMIER: The Market. Drawing with water-colour.
(Courtesy C. W. Kraushaar Art Galleries)

at a certain point, without losing anything from larger musical enjoyment—even so slight a drawing as *The Market* may, upon analysis, illuminate a formal method. Note how the basket and shadow at the lower right form a plane marking the picture front; how the central figure and its shadow mark the next plane of penetration; how the next is in the woman and small boy who together form a single plane almost paper-flat; and how a fourth plane, subdued and hardly meant to attract the eye, but rather to act as a buffer, is formed by the shadowed man and woman be-

DAUMIER: Crispin and Scapin. *Louvre* (Archives Photographiques)

yond. The specialist in analysing movement effects will explain that the
eye has been led from the front right corner to the point of deepest pene-
tration, at the left back, by this conscious expedient of four planes descend-
ing into picture space. The observer's eye then naturally moves up, across,
and down to the woman with baby and market basket on the other side,
and so back to the central figure, and to the point of rest.

So great, then, was the mastery of the devices today considered modern,
in the work of a man scorned as painter in his own generation and ob-
scured until the moderns of the twentieth century had found their audience
and taught it appreciation of formal pictorial beauty. In his day Daumier
was a giant lost among excellent painters, some, like Corot, destined to
live by reason of a lesser grasp of the modern means, others to be known
only as late practitioners within the dying academic traditions.

There are Daumier-lovers who, without being form-blind, remain un-
convinced about the structure of theory raised by the post-war moderns,
who discount talk of plastic vitality and form-as-movement and paths-for-

the-eye. They ask why it is not possible to see Daumier's pioneering in simple terms as rhythmic design, as achieving interesting "shapes." A recent writer upon Cézanne's art has pointed out that his first departure from orthodox realism showed in experiments with natural objects twisted into pattern-like areas of dark against light. In the famous early portrait *Uncle Dominique* at the Museum of Modern Art (page 212) the beard, the tie, and the rest build up into a geometric form that seems consciously contrived. The "shape" is interesting on its own account. If there is a precedent for the device anywhere it is in the paintings of Daumier. Note the silhouettes of the shadows, particularly the washes of the darker areas, in *The Market* and *Corot Sketching*. Or study the oil painting *Crispin and Scapin* to find the perfect parallel to Cézanne's method. If one prefers to sum up the whole matter as explained in the phrase, "he paints rhythmically," the perfect illustration can be studied in *The Towman* (page 110), in which the main rhythm is unmistakably emphasized and the answering rhythms plainly marked. In *Stairway of the Palace of Justice* a line traced around the two central figures and the crowds above would form a centred but asymmetrical design, in itself interesting.

Paris in Daumier's time saw the spread of that Bohemianism which was to nurture a certain number of moderns, to engulf others and drown their talents or genius in dissipation and licence. Daumier, Corot, and Millet, the great creative figures of the era among the French—Ingres, too—were as removed as the Englishmen Constable and Blake from the Bohemian atmosphere, the café-and-brothel libertinism which is sometimes paraded as a necessary part of artist freedom. There is something of integrity, dignity, and solidity in the works of these men that derives from personal character and poise. The quality is not to be discerned so easily when the impressionists begin their adventure, or in the days when the *fauves* and the cubists make of Paris a confused battleground, crowded with the art-conscious youngsters of a score of countries, and the riffraff of mere moneyed art students and poseurs and vagabonds.

The story of Daumier cannot be considered complete without the chronicling of that incident which lightened the darkness of his late years. There had come a time when calls for his services as cartoonist or illustrator had almost ceased. There was no market for his paintings. Having moved to a cottage at Valmondois in an effort to bring expenditures within range of his small earnings, Daumier found himself months behind with

DAUMIER: Stairway of the Palace of Justice. Drawing with water-colour.
Lucas Collection, Baltimore Museum of Art

his rent, facing blindness, and threatened with eviction. Then one day he received a letter from his devoted friend Corot:

My Old Comrade,

I have taken over, at Valmondois near the Isle Adam, a little house, and I cannot think of any use for it. The idea came to me to offer it to you; and as I found that idea as good as any, I went through the legal steps of deeding the place to you.

It is not so much for you I am doing this. I wanted to annoy your landlord.

<div style="text-align: right">To you—</div>
<div style="text-align: right">Corot.</div>

Foreseeing objections on Daumier's part, Corot had bought the house secretly, and presented the matter as a *fait accompli*. The day after he sent the note he went down to Valmondois to lunch. Daumier, unable to conceal his tears, broke his accustomed silence to say: "Ah, Corot, you are the only one from whom I could accept such a gift and not feel myself humiliated." The two old men embraced.

Corot died in 1875. Daubigny, also a devoted friend of Daumier's and a neighbour at Valmondois, died in 1878. In that year the Durand-Ruel Gallery in Paris held an exhibition of Daumier's paintings, but it was not a success. On February 11, 1879, Honoré Daumier died, in the arms of his wife. There was no money for a funeral, so the state buried the body, at a cost of twelve francs. Some of the newspaper commentators, remembering the caricaturist, the agitator, the jail-bird, thought the expenditure unwarranted, and upheld the mayor of Valmondois, who had refused to do for the body what was done for respectable paupers. Thus ended the life of the first Frenchman among the giants of modernism. When he had gone, not half a dozen people in France considered him a competent painter.

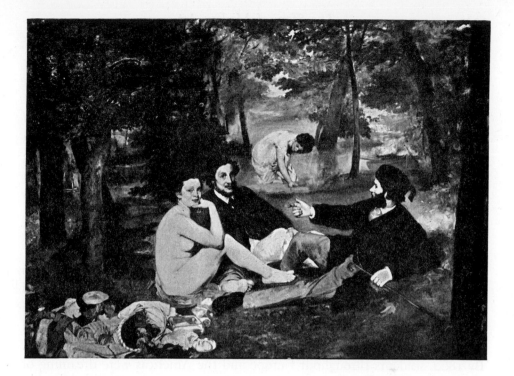

VI: TRIUMPH OF THE REALISTS OF
PARIS

A HIGH-SPIRITED but inarticulate student of art, named Paul Cézanne,
went up from his native town Aix-en-Provence to Paris in the spring
of 1861. During the preceding two years, under the surveillance of a father
who was a successful money-maker, the youth had studied law, then bank-
ing, in a vain effort to fit himself for one or another of the respectable
vocations. He had written much verse, but his ambitions in the direction
of poetry had diminished steadily as his passion for painting had grown.
Perhaps he had recognized, in 1861, that the influence of a devoted friend,
Émile Zola, also given to dreams of literary success, and already in Paris,

MANET: Luncheon on the Grass. 1863. *Louvre* (Archives Photographiques)

had carried him along rather than an aptitude for writing. It was the art of painting that took him to Paris, that was actually to obsess him for the rest of his life. Of the two youths, it was Zola who was destined to become a recognized "revolutionary" first, achieving, in literature, a spectacular if stormy success, in the name of realism. But it was Cézanne who, though obscure for thirty years longer, was destined to serve a major art even more greatly, as founder of a style or school or way of painting that was to give to the whole Western world a new conception of "modern art," a conception beyond realism. From 1870 it is to be, creatively, Cézanne's world—and Renoir's and Monet's—but for the ten years of their student life and novitiate it will be also the world of Courbet and Manet and realism, and of a solitary dissenter, Whistler.

It was natural for Paul Cézanne to turn his eyes toward Paris, while he idly scratched sketches on the margins of his father's ledgers, or attended the dull night classes at the provincial Academy of Fine Arts at Aix. In the mid-nineteenth century Paris was more than ever the home of good painting, and also the exciting centre of new adventure and experiment. By 1860, students throughout Europe and the Americas were dreaming of getting to the capital of art and of Bohemia. Each year hundreds of hopeful and talented youths arrived and entered the studios of the Latin Quarter: English and Scotch, French and German, Balkan and Russian, Scandinavian and American.

Only a half-dozen years before Cézanne's father relented and let his moody son have his way, Parisian painters might have marked the arrival there of an indolent American student, James McNeill Whistler, who also was to be concerned in the march of modernism; while in the same year there had come, from the West Indies, one Camille Pissarro, later to be known as a founder of impressionism. In the very year of Cézanne's appearance at the Atelier Suisse there arrived at the near-by Atelier Gleyre a twenty-year-old youth named Auguste Renoir, who had decided to give up the decoration of porcelain to study painting; and Claude Monet was to come up from the provinces to enter at Gleyre's the following season. These, however, were students and—excepting Whistler—little will be heard of their history-making experiments for another dozen years, until, indeed, they startle Paris with the aberrations of the First Impressionist Exhibition, in 1874.

One should visualize well the Paris of the sixties. Perhaps not since the golden days of the Venetian school, when Giorgione and Titian and

Tintoretto (and an obscure student to be known later as El Greco) were within call of one another, had a single city harboured so many great painters. There were, in addition to that incomparable student group, the two youthful innovators, stirred by the call to realism but taking the first timid steps into the region beyond realism, Manet and Whistler. There was the decorator Puvis de Chavannes. There was the master of realism himself, Courbet. More remarkable and sometimes forgotten, there were still living the master of the French classicists, Ingres, and the master of the romanticists, Delacroix, and those three true independents of the mid-century, Corot, Millet, and Daumier. In a slightly lower range (and sub-urban) were Daubigny, Dupré, and Diaz.

Side by side with the leaders of the elder revolutions, side by side with the creative innovators, a third group painted in Paris: the conservatives, the academics, the safe and obedient painters, the upholders of sanity in art. Their names tend to escape later generations, but in the early eighteen-sixties Couture and Fromentin, Bouguereau and Cabanel, Meissonier and Troyon, were the winners of honours and the overwhelming favourites of critics and public. They form the solid phalanx of orthodoxy against which the revolutionaries shatter themselves; until one day, no one knows how, a rebel pierces the front, establishes a new centre for a new orthodoxy, and in turn shapes a new phalanx.

In Paris, in 1861, within this army of painters that included recognized masters, obscure geniuses, and talented innovators there was one artist whose name was on every tongue. Gustave Courbet was the man of the hour, the painter who "made the headlines"—and certainly the artist who talked loudest. He had challenged alike the not yet defunct classicists, the run-down romanticists, and the academic and fashionable painters. The new art he had brought in, he proclaimed, was realism, which in 1861 was being spelled with a capital R.

Realism! It had in truth, in the larger application of the word, been the normal art of Europe since the days of Masaccio and Leonardo and the introduction of "scientific vision." Certainly it was big enough to include the exactly detailed if severely drawn portraits and illustration pictures of David and Ingres, and the exotic transcripts and literary anecdotes of Delacroix, to which he had added unusual warmth and colour but without ever venturing to distort nature. And it embraced easily the sentimental reporting of Cabanel and Fromentin, and the exact history-recording of Meissonier.

But in the nineteenth century the interest in the artists' *methods* of painting had been so great, discussion had so centred on questions of purity of style and warmth of treatment and choice of subject, that no one seemed to notice that *all* accepted painting had become literal, correct, "reasonably" close to nature as seen by the eye, real. Another generation was to pass before historians and theorists would again apply the label to the several types of art emphasizing observed objects and effects (as against, for instance, the non-realistic art of the Orient or of the primitives, in which nature is bent to consciously formal and decorative ends), and thus to all the model-serving nineteenth-century schools.

Courbet was specific in explaining what *he* meant by realism. "Show me a goddess," he said, "and I will paint one." And he added: "I paint what I see. . . . I give you *real* nature, crudities, violences, and all." He painted some excellent life-like portraits and many not unattractive transcriptive landscapes. Unfortunately he came to be known best by those museum and barroom nudes in which he depicted naked women who obviously have taken too little exercise, in distressingly complete detail, negligently set down in stagy settings of forest and stream. When he had a really beautiful model, even his over-detailing became bearable. In general he was the exponent of realism on the photographic side, in the realm more properly called naturalism. He was a materialist and a copier. Style is humbug, he said.

By 1861 the shock of meeting Courbet's transcriptions and of hearing his talk was less jolting than it had been in 1855, when, excluded from the World's Exposition, he had opened a competing show of his own near by and had put up a sign reading "G. Courbet: Realism." But how confused the situation still was is indicated by the reaction of Émile Zola (who should be an authority on the innovation called realism). As late as 1860 he had written to Cézanne at Aix cautioning him to be an idealistic and poetic painter, recommending that he emulate—of all sentimental, artificial, and trivial artists!—Greuze and Scheffer, in order "to avoid being a realist." He praised Ary Scheffer particularly: "a passionate lover of the ideal, all of his types are pure, ethereal, almost diaphanous. He was a poet in every sense of the word, almost never painting actual things, treating the most sublime, the most thrilling subjects." In a letter dated three weeks later he writes almost grudgingly: "The realists do, after all, create art, in their own way—they work conscientiously."

This same Zola will be seen in 1866 championing the avowed realists,

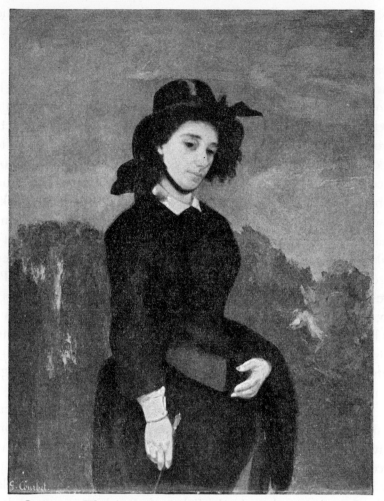

Courbet: The Amazon: Mme. Louise Colet. About 1856
Metropolitan Museum of Art

particularly Manet, acting, indeed, as their foremost literary advocate; and again in the seventies he will be found defending the culminating school of realists, the impressionists. (But he will hide away the canvases Cézanne gives him, and will die in 1902 without having recognized either the prophetic genius or the revolutionary achievement of his boyhood chum, having withheld the encouragement that might have made Cézanne seem successful in his own lifetime.) In 1861 Daumier is, of course, unknown as painter; no one would think of putting him forward as a serious artist, much less as pioneer or prophet. Corot is known for his popular pictures

and keeps his figure-studies out of sight. Realism—in the raw—is the new, the intriguing, the controversial thing.

Gustave Courbet had been born in 1819 in the village of Ornans, down near the Swiss border, son of a farmer little above peasant estate. The boy had enough education to aim at a career in law, but decided upon art instead. He went up to Paris in 1840. He was soon widely heard of, though not through official channels. Year after year the juries rejected (after one early acceptance, in 1844) the pictures he wanted to get into the Salon. But he talked and blew his own horn, he bellowed and threatened, and he drew a number of younger students to him. He was egotistical, thick-skinned, bellicose. He got around amazingly and he was self-advertising. In those early days, in the forties, he painted his best pictures. In a few of them, particularly in simple portraits, there is even a hint of that order, that "arrangement," which Whistler will exploit a few years later. Perhaps because Courbet has not yet been driven to issue his manifestos about realism, he paints a series of these things with less insistence upon detail, letting his talent for design control a little his eye for naturalism. But he is painting, too, unembellished transcripts from peasant life, and strong, exact portraits. He succeeds better than anyone before him in painting figures as nature made them, "without correction."

The Revolution of 1848, resulting in a change of government and suspension of the jury-system for the Salon, gave Courbet his opportunity, as it gave Rousseau his. At the Salon of 1849 Courbet received a medal of the second class for a naturalistic picture of Ornans life, an important victory because holders of medals had the privilege of entering Salon pictures free from jury action. At the Salon of 1850 his monumental canvas, *Funeral at Ornans*, engendered violent and bitter controversy. Theretofore heroic-sized canvases had been reserved for "noble" subjects. That a painter should show contemporary figures, and common figures, in life size was outrageous, an affront to the archæological and historical painters, and, one would have thought, hardly less than a blow against the foundations of the republic. During the following five years Courbet repeatedly shocked not only the conservatives but nearly everybody else with his "vulgar" pictures, his socialism, his subversive ideas about art, and his boorish manners.

Generations of respectable artists in France had quoted to students a saying of Poussin: "A noble subject matter should be chosen, one free of

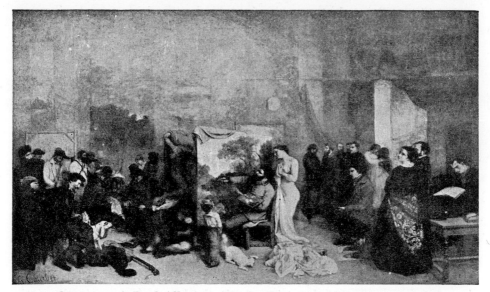

Courbet: A Real Allegory: My Studio. 1855 (Giraudon photo)

workaday grime." Daumier at this time was not recognized as a painter, and Millet still toiled in darkness. Their "lower-class" pictures remained unknown. But Courbet was too shocking and too insistent to be overlooked. Besides, a considerable group of students was being attracted to his sort of thing, recognizing that he was restoring to French art a vigour it had long lacked. There were strength and masculinity here, set up against the tell-tale effeminacy of the neo-Greeks and the polite illustrators. Courbet's wholeheartedness, too, his unreserved vanity, his repeated assertion that he was the only serious artist of the century had weight with the younger generation.

After 1850 the well-bred painters were no longer able to exclude Courbet from the Salons. But when a great art exhibit was planned for the World's Exposition of 1855, the opportunity came to snub the upstart. Nothing daunted, Courbet opened a show of his own in a shed opposite the Exposition gates. Over the door he inscribed "G. Courbet: Realism." Nearly forty canvases illustrated his theory and his progress as a painter. A special scandal was caused by the immense picture entitled *A Real Allegory: My Studio after Seven Years of Art-Life*. It showed, in life-size, the painter at work on a landscape, beside him a nude model, before him a small boy

and a kitten. Ranged at one side were a dozen of his friends, in poses reminiscent of those in which he had shown them separately in his earlier portraits; at the other a mass of figures from his best-known character-pictures, hunter and preacher, peasants and beggars. It was as near an arranged picture, as near fantasy, as Courbet ever came. But it had little formal design, and certainly was heavy-handed as "a real allegory." It served to infuriate both the tender-minded artists and the moralists. A nude woman in a mixed company, realistically shown!

The publicity stirred up by Courbet's exhibition in 1855 gave him position as a public "character," and he was thenceforward the idol of the rebellious students and a front-rank fighter for the young authors who were initiating the realistic movement in literature. Prosperity was withheld from the painter a few years longer, but 1855 is generally accounted the year when the realistic movement became central in the flow of modernism in France.

Courbet went on to other triumphs in the late fifties, and in the sixties received great sums for his paintings, especially for the naturalistic nudes; though at the opening of the Salon of 1866 the Empress Eugénie was so scandalized at one of his displays of naked women that she threatened to close the halls if it were not removed. Such censoring only played profitably into Courbet's game of propagandizing. He had a public success again with his individual exhibit at the World's Exposition of 1867, showing one hundred and thirty pictures as well as sculptures. For a time he was close to Whistler and seemed to be gaining a little of the post-realistic feeling for formal order; but the influence was fleeting.

In 1870 the Emperor offered to Courbet the decoration of the Legion of Honour. Whether sincerely or because acceptance would have less publicity value than the gesture of refusal, Courbet wrote declining the honour. He wrote his letter of rejection at a café gathering, and went out to boast publicly that he had given the Emperor "a biff in the eye." It happened that Daumier, also a staunch republican but a silent one, was awarded the Legion of Honour ribbon in the same year, and he too refused, without public announcement, explaining merely that he was too old for it to mean anything.

Eighteen-seventy was a fateful year for Courbet. As a socialist he was thrilled by the defeat of the Emperor Napoléon III and his surrender to the Germans at Sedan, and more so by the establishment of a republican Government. Under the interim regime—before the Germans bombarded

and invaded Paris—Courbet was appointed Director of Fine Arts. He busied himself with saving as many of the national art treasures as he could. In 1871 he became a member of the Commune, and he resisted as far as he dared the popular cry for destruction of all monuments reminiscent of life under the monarchy; but he did not save, perhaps did not want to save, the Vendôme Column. After the communists were ousted, in "the week of blood," he was held responsible by the royalist-minded Government for the razing of the Napoleonic column. He was fined and put away in prison for six months. The conservative painters in the following year took advantage of his disgrace to have his pictures excluded again from the Salons, as coming from an immoral person and a convicted communist. Then an immense fine was assessed against him for the rebuilding of the column, and his belongings, including his unsold paintings, were seized and auctioned. He fled to Switzerland, and died in exile there, stripped of property, broken in spirit, embittered against his own country. For some time he had not even had interest enough to keep at his painting. This was the artist who had written in the flush of his early popular success: "I stupefy the entire world. I have triumphed over not only the ancients but the moderns. . . . I have thrown consternation into the world of art."

In 1877, it is said, no artist in France was greatly concerned about Courbet's death. To the eternal conservatives the episode of his triumph had been an aberration, the man himself a figure in a nightmare. It and he had passed, and now French art would settle back, doubtless, into normalcy and classic-traditional calm. On the other side, the radicals and the young progressives had no more need of Courbet's sort of insurgency. At a critical moment he had come forward, brutally strong, to blast open the road for a new type of art; but since 1863, when the Salon des Refusés had shown the varieties of ways in which a new generation might develop an art beyond realism, the master who had taken painting back to a new beginning in nature had been unneeded.

Perhaps Courbet was as well off exiled in Switzerland, those last years. A young painter named Manet had usurped his place as chief of the rebels and as purveyor of scandals, and he was developing a type of realism that would become more palatable to the public than Courbet's; and that same Whistler who in the sixties had painted side by side with Courbet had created the series of "arrangements" that marked the first conscious advance into an anti-realistic æsthetic, producing pictures marked by "order" of a sort incomprehensible to the materialist-realist.

Since the critics and the public are usually thirty years behind in appreciation of creative art, Courbet's works rose to a new height of international popularity in the final quarter of the century, and dealers were able to extend the vogue a decade or two longer. But once it became apparent that the epochal change to a twentieth-century art was to pivot on the men who abandoned literalism and sense reality, Courbet was bound to lose stature. It had been gradually recognized that his service to the moderns was similar to that of David and Delacroix, not that of a Daumier or a Cézanne. As David had cleared the field of the last vestiges of the old ornamental court painting, so Courbet's onslaughts swept away the pretentious but flimsy inventions of David's weakened progeny. As Delacroix had challenged the neo-classicists, winning the right to paint as he wished and contributing warmth of movement and colour, so Courbet opened the way again, just before the historic decade of the sixties, for independent men to express themselves in paint; and he set an example of virility, masculinity, power. But, after a promising beginning, his work had become entangled in his own materialistic philosophy. He blundered through to some profitable basic truths; but he was blind to one-half of the artist's world—the half variously known as vision, imagination, or inspiration.

Part of Courbet's service to the moderns was in his written protests and proclamations. "The museums," he proclaimed, "should be closed for twenty years, so that today's painters may begin to see the world with their own eyes." But in the next breath he admits that *he* likes Ribera and Zurbaran and Velazquez—and he might have added Guercino and Caravaggio—and thus had been influenced toward the very type of painting, naturalistic and showy (and done in blackened paint), least congenial to the coming generation. His stand for art as transcription of nature's beauty, as against the values arising from the artist's power of imagining, was unequivocal: "Beauty lies in nature. . . . The painter has no right to add to this expression of nature, to change the form of it and thereby weaken it. The beauty afforded by nature stands above all artistic conventions. Such is the very foundation of my beliefs about art." He wrote also that "Phidias and Raphael have hooked themselves onto us. Our century is not likely to recover from the disease of imitation by which it has been laid low." To this a hundred later artists have answered that it is no better to imitate *nature* slavishly than to imitate a favourite painter; but the warning was timely in 1855.

Courbet put even more of cogent truth into certain lines of one of his

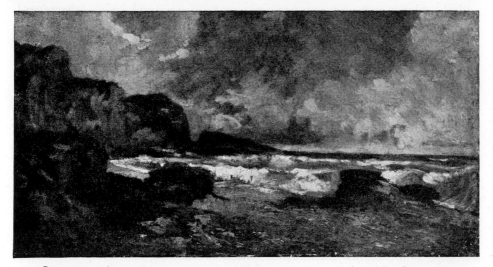

COURBET: Coast Scene. *Smith College Museum of Art, Northampton*

manifestos, about immediate subject matter, about the independence of the artist and about democracy, though arriving at a doubtful conclusion: "The most precious of all things for the artist is his originality, his independence. Schools have no right to existence; there should be only painters. Without being of any school or party I have studied the art of the ancients and of the moderns. I have no more wished to imitate the one than to copy the other. . . . By gaining knowledge I wanted only to perfect my own individual power—power to transcribe the manners, ideas, and look of our time according to my own understanding: in a word, to produce living art, not only as a painter but as a man. I am not only a socialist but a democrat and a republican, a supporter of every revolution. Moreover, I am a sheer realist, that is, I adhere loyally to actual verity.

"The principle of realism means denial of the ideal. In line with the negation of the ideal, I arrive at the emancipation of the individual, and at democracy. Realism in its essence is democratic art. It exists by representation of things the artist can see and handle. Painting is a wholly physical language and what is abstract or hidden does not belong to it. Painting in the grand manner is out of keeping with our social conditions, and religious painting is out of keeping with the spirit of the century. It is nonsense for the talented painters to dish up subjects in which they have no belief, belonging to other epochs. It is better to paint railway stations

and the places one sees when one travels . . . engine-houses, mines, and factories, for these are the saints and miracles of the nineteenth century."

Courbet *was* independent, finely so. With Millet and Daumier he helped to introduce the subject matter of the industrial age, of the world of labour. But after eighty years, proponents of democratic art began to question that realistic painting *is* in essence democratic art. To divide men into classes, to say that any class must subsist upon materialistic art, to deny poetry and imagination to democracy: all this came to seem sheerest folly.

The Salon des Refusés was opened, by decree of Napoleon III, in 1863 as a test of the sincerity and quality of those artists who had been rejected by the Salon juries, who were justly indignant or merely disgruntled thereby. The occasion is sometimes cited as marking the birth of modern painting. Certainly it brought to light, besides a great deal of second-rate imitational work, certain artists who were destined to make history; and the publicity given to unorthodox painting, even if it consisted chiefly of abuse and ridicule, was ultimately profitable. The storm centred especially upon Édouard Manet, whose offence was considered moral as well as artistic; it engulfed too the more truly revolutionary Whistler, who, however, knew how to profit by abuse and notoriety.

Édouard Manet was destined to become the greatest of French realists, displacing Courbet as exponent of the idea that what presents itself to the eye is important as subject matter of art, without regard to literary connotations, drama, symbolism, or personal emotion. Manet made objective realism attractive. Paradoxically he became the greatest realist by moving a little away from naturalism, from observed detail, and from Courbet's lightless, material transcripts; away a little toward concern with light around the object, a little toward patterned arrangement, a little toward sheer delight in "painting quality." But he *was* an objective painter, treating all subjects as of equal importance, keeping up with this or that group of moderns *en passant* but returning always to his own type of studio-made transcripts from life around him. As he lived in the gay atmosphere of elegant Paris, among the well-to-do pleasure-takers, the *boulevardiers*, the racing set, so his is a gay realism, prettily textured and superficially eye-pleasing.

Manet was ambitious and seriously concerned to be a revolutionary, and he picked up now and again the idioms and devices of the moderns: at

one time a hint of the plastic competence of Goya (but more of Goya's forthright realism); at another a modicum of Japanese compositional arrangement; at another a considerable mastery of light effects, as inheritor from the Constable-Corot succession. For a time he joined with the avowed impressionists, went with them into the open air to paint, seemed to be leading them in their search. But while they were still outlaws, he went back to his own studio, to regular appearances at the Salon, and to a more substantial sort of realism than theirs; not all the way to Courbet's brutal verity, or to Courbet's manner of setting the object out immobile and emphasized in bituminous shadow. Where the Master of Ornans had badly blackened his shadows, his Parisian successor reduced them or even abolished them; where the one had painted his trees static, with never a leaf moving, without surrounding air, the other learned to dissolve foliage in an envelope of light and to give animation to every passage in the canvas.

Manet was the typical Parisian, the fashionable man of the drawing-rooms, the studios, the salons. He was an elegant, a scion of the upper bourgeoisie aspiring to the aristocracy. It was his dandyism, his money, his fastidiousness, that removed him a little from the hard-working, often poverty-stricken revolutionaries of the impressionist and post-impressionist (to be) groups.

Manet was born in Paris in 1832 of well-bred parents. His father was a prominent magistrate. The boy early achieved an ambition toward art and at sixteen threatened to run away to sea if he were not allowed to attend art school. His parents considered the one alternative hardly so compromising as the other, and sent him off with their blessings to work his passage on a voyage to South America. Returned, he renewed his pleading, and at eighteen he entered upon a six-year period of study in the studio of Couture. He could not please that academic master, and left smarting under the now-celebrated reproof that he would probably turn out no better than Daumier.

More and more he studied independently the great masters in the Louvre. A trip to the Low Countries and to Germany yielded new treasures for study and copying, and Hals in particular influenced his use of the brush. He visited Florence to see the Italian masterpieces at first hand. But it was the Spaniards, especially Velazquez and Goya, who determined the manner of his first mature group of pictures (though they were painted in his Paris studio, from local dressed-up models).

The Salon accepted in 1861 Manet's *Spaniard Playing the Guitar*. It was rather in 1862, when he painted *Lola of Valencia*, Spanish in subject as well as in manner, that a new turn in the development of French realism was clearly marked. A single figure was set out, almost backgroundless, and made decorative with richness of texture and subtle tonal harmonies. The darkness of the pictures of his immature days, inherited partly from Courbet, partly from Hals and Ribera, had then given way before a pervading grey, reminiscent it might be of Corot or of Velazquez and Goya. The picture drew abuse. On the other hand a freshness in it, and in other works exhibited at the Galerie Martinet in 1862, attracted to Manet the men who were to be the insurgents of the following ten years, Monet in particular, Renoir, Pissarro, Bazille. In print Baudelaire was already Manet's champion.

In 1863 the Salon favourites over-reached themselves and lost the ear of the Emperor. The rejections by the jury were so numerous, and the rejected artists were in so many instances obviously the victims of political or studio prejudice, that Napoleon III was led to intervene. He decreed that in the same building with the Salon exhibit of that year galleries should be opened to as many of the *refusés* as might wish to show their rejected works.

Naturally the exhibition included a great deal of second-rate and third-rate work, which was rightly being denied space on the Salon walls. On the other hand it included the most vital and the freshest art that was being produced in France, the art of the painters who were inventive enough to go beyond academic procedures and conventional subject matter. At the Salon des Refusés, in the midst of the general ridicule and vituperation, the small number of artists, students, and art-lovers who were open-minded could find the new tendencies and enjoy the impact of original solutions.

Manet contributed to the Salon of Reprobates, as the Paris mobs came to know it, the outstanding scandalous piece. He had called it *Le Bain*, but the public renamed it *Le Déjeuner sur l'Herbe*, and so it was known ever after: *The Luncheon on the Grass*. A party of four picnickers is shown, two fully dressed French gentlemen of the day and two women, one nude, the other bathing in a pool at the back, in an undergarment. A huge outcry broke out against the "monstrous" picture, from the bourgeois moralists; and to their execrations were added the ready abuse of the artists and critics who did not like Manet's manner of painting anyway.

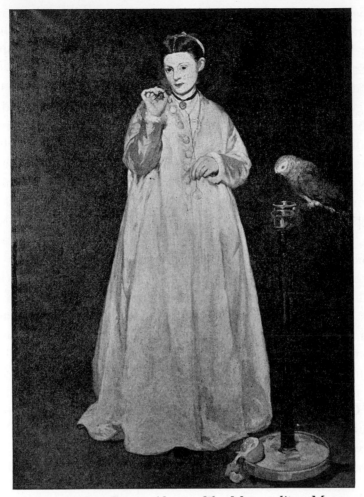

MANET: Woman with a Parrot. About 1867. Metropolitan Museum of Art

Giorgione had composed a similar picture, from which perhaps Manet got the idea for his, but had invested his figures and scene with a sort of classic nobility. Realistically presented, clothed men with nude women were simply shameless, disgusting, and intolerable. Apparently the artists and the public overlooked certain virtues in the canvas: the beautifully handled still-life study of clothing, basket, and fruits in the lower corner, richly textured and itself a harmony in blue-greys; the novel way of laying up the strapping nude flat, without shadows, as if the figure were lighted full-front from a source not affecting the rest of the picture; the grace of

the far figure and the way in which it completes an elementary pyramidal composition. The woods of the background are, unfortunately, mere "filling," hardly beyond the abilities of any mediocre designer of décors.

The Salon of 1865 no sooner opened its doors than the word went forth that Manet had produced another shocker. Again the picture had to have guards to protect it from destruction by irate citizens and to keep the mob beyond spitting distance. The respectable painters, too, were profoundly shocked by the flat tonal painting that accorded with neither classic nor romantic canons. This time Manet, who perhaps had found notoriety not without a sweetness of its own, had portrayed a typical Parisian kept woman, stretched on her bed nude except for a neck-ribbon, a bracelet, and slippers. Beyond, her Negro maid is seen disclosing an admirer's bouquet, while at the foot of the bed a Baudelairean black cat arches its back. The public elected to find even the cat obscene. Somehow everyone overlooked the fact that Manet had avoided any show of sympathy in his portrayal of the *demi-mondaine*, that he had avoided idealization of figure and face, and the usual rosy, caressing technique that might have made Olympia alluring.

Some time since, he had been attracted by Goya's realistically beautiful *Maja Nude*. Now he had manufactured his own version, but with a less healthy model, without Goya's obvious zest for physical loveliness and without Goya's sheer pictorial ability. The *Olympia* was taken as a character-study in a field known to exist but never publicly acknowledged. The woman was a person. That sort did lie naked, then, on their beds. Black serving-maids did exist, and bring in flowers from Someone. But if so, when was licence given to mention, or to picture, these things in places frequented by respectable people? It was this exhibition that elicited the complaint that a mother could no longer safely take her daughter to the Salon (just as, two generations later, daughters were to find it impossible to take their mothers to the plays of Ibsen and Shaw).

The public detested the thing, and its freely spoken abuse, added to that of virtually all the influential artists and critics, came near making a national issue of "wholesome or degrading" art. Manet was heartened, however, by the way in which the young radicals flocked to him and called him leader. (It was, really, because he too was being persecuted for unorthodoxy, and not because his aims were identical with those of Monet and Pissarro, Cézanne and Renoir.) The inarticulate and still unknown Cézanne was so stirred that he enlisted his friend Zola in the cause. Zola

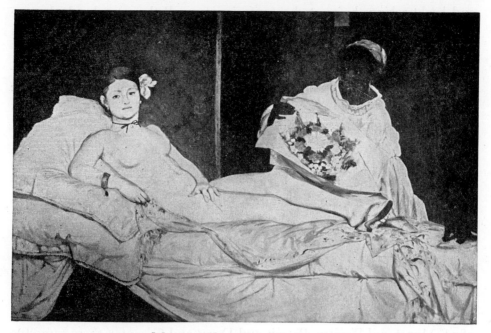

Manet: Olympia. 1864. Louvre

wrote in 1866 for *L'Événement* a series of articles in which he mercilessly attacked the "old-fashioned" artists who dominated the schools and the Salons, defended realism, and unstintingly praised Manet. Maddest of all his madnesses, he predicted that *Olympia* would some day hang in the Louvre (where it seems so tame today). Of course his post as art critic was taken away from him, not, however, before a certain solidarity had been given to the group of young agitators who were to be the impressionists and the independents of the seventies.

But Manet felt the criticism and the coolness in the circles in which he normally moved. Even his friends seemed shaken and uncertain of his sincerity. There came over him then the mood of puzzlement and resentment that more or less persisted until his death.

Thrown into the camp of the radicals, almost automatically made their leader by the accident of a storm of abuse breaking over his unorthodoxy (a storm provoked by his supposed moral anarchism rather than by his mild artistic heresies), Manet alternately went forward with the younger group and returned to his own special province. By his alternate sallies

and backtrackings he created a confusion over all those roads which were leading, with indirection enough, into the modernism of 1875–1890. Thus he will be counted by one historian almost a twin of Whistler, by reason of his devotion to Spanish painting and his momentary homage to the conventions of the Japanese print; by another he will be announced as the founder of impressionism, only to be contradicted by a third who makes him out a temporary and half-hearted follower of Monet and Pissarro. Manet found his audience (after his death) before the realer impressionists, because his pictures were less revolutionary than theirs. Although in the late sixties he stood as leader of the radicals, actually he became neither the originator nor a thoroughgoing practitioner of the impressionist technique.

From 1866 to the time of the coming of the Germans in 1870, a circle of young Parisian artists and literary men met continually at the Café Guerbois in the Avenue de Clichy. There they talked out the questions and the theories that rose in the collective rebellious mind of the day. There came the men who were to stage the impressionist exhibition in 1874, Monet and Pissarro, Renoir and Degas and Cézanne; there came too the less subversive Fantin-Latour and Guillemet and Alfred Stevens. There came the writers Zola and Cladel. Théodore Duret, who was to write the first and one of the best books on impressionism, was a habitué. He has written that "Manet was the dominating figure; with his animation, his flashing wit, his sound judgment on matters of art, he gave the tone to the discussions. Moreover, as an artist who had suffered persecution, who had been expelled from the Salons and excommunicated by the representatives of official art, he was naturally marked out for the place of leadership among a group of men whose one common feature, in art and literature, was the spirit of revolt. . . . Manet and his friends strengthened one another in their views, to such purpose that not all the opposition, abuse, ridicule, and even at times the actual want which they had to suffer, caused them to waver or to deviate from the path in which they had chosen to go." The war put an end to the meetings, and they were never resumed regularly because the real outdoor painters deserted Paris for good. Only Manet returned to the boulevards, and then to daily appearances at the Café Tortoni, a rendezvous too elegant for the poorer artists.

After the turbulent showing of *Olympia* Manet visited the Spain from which had come so many paintings important to the formation of his style. Again Velazquez and Goya thrilled and inspired him, and he brought

home pictures with hints of Ribera and El Greco in them. At the gatherings around the tables at the Guerbois he must often have defended his Spanish teachers (and here, doubtless, the light of Velazquez and Goya joined a little with the light of Constable and Turner and Corot, in preparation for the emergence of full French luminism in the seventies).

Manet on his side could not but gain from the experiments and enthusiasm of Pissarro and Monet. In the period 1866–1870 he developed fully the manner of painting in tone, with little shadow, called *peinture claire*, which some critics have counted the basic technical advance of the nineteenth century. He took away from the object its solid qualities, abolishing sculptural rounding of forms. He minimized the role of line, only sketchily or vaguely outlining the contours. Silhouettes were merely the boundaries between fields of colour. Instead of paying cautious attention to gradations and transitions of tones, he laid his colours on in flat areas, and proceeded to gain his colour harmony by matching certain sets of hues, most notably the greys and blue and rose of Velazquez and Goya. He learned gradually to light the face or figure from the front; and most of the shadows of the older painting disappeared.

All this was startling enough to the eye of the gallery-goer of the sixties, accustomed to dense shadows, to linear accentuation, and to colour used as an accessory in carefully graduated transitions. Manet's pictures were at once gloriously fresh and outrageously bright. The lights instead of the darks predominated. (It was this that gave validity to the name *peinture claire*; this and the fact that the older painters actually worked up or out of the shadowed parts to the highlights, whereas Manet began with the "clear" passages and worked down to the darks.) In 1862–1866 Manet had gone farther along this road of brightened painting than any other artist; and he suffered the penalty of critical and public attacks for it. But his innovations were only a step on the way to the radical substitution of colour harmonies for "solid" painting which the impressionists were to accomplish before 1874.

Of all the great contributors to the development of a modern technique, Manet was most a borrower from other artists. What he took he often enough failed to assimilate, so that *The Bull-Fight, Execution of Emperor Maximilian, The Balcony,* and several other celebrated pictures bring to mind immediately the paintings by Goya that served as models, and in each case comparison of the Spanish original with Manet's derived composition shows Goya as the greater master of plastic invention. In the

same way the influence of Japanese prints is evident in details of many a
picture, but usually as something appropriated; not, as with Whistler or
Degas or van Gogh, a method or a spirit ultimately assimilated and fused
in one's practice.

Even the *Olympia* can be believed to have had a Japanese-print origin
as well as a model in Goya's *Maja Nude*. Manet thought it out, apparently,
as an "arrangement," in the sense in which one uses the word to describe
a Hiroshige print or a Whistler tonal landscape; but then he lost the
arranged "order" in his final rendering of detail and accessory (the cat so
ill placed, the over-accented painting of the lower corners, the disappear-
ance of structural lines). The proof lies in a portrait of Émile Zola painted
five years later. In the background appears, beside a Japanese print, a
sketch or reproduction of the *Olympia*, with a surprising "patterned"
aspect, with structure and planes clearly marked. It would seem to repre-
sent Manet's compositional conception of the picture better than the
large version; he had lost out of that, in labour over wrinkled coverlet and
pillows, over flesh and flowers and maid's dress, the larger rhythm and the
structure.

Late in the sixties and early in the seventies Manet went to the out-of-
doors with his impressionist friends. But he never totally lost his sense of
the object as an entity, as of more importance than the surrounding
atmosphere. It is impossible to know how much of his freshness and
colour he gained from them, though it is certain they all gained from him.

During the Franco-Prussian War of 1870 the group was separated; in
1870–1871 Monet and Pissarro were in England, where they were making
the most of an opportunity to study Turner's pyrotechnics and Constable's
shimmering light. Cézanne went to Provence and evaded the draft. Manet,
Degas, Bazille, and Renoir (and others as yet less known: Redon, Henri
Rousseau, Rodin, and Gauguin) saw service in varying capacities, and at
varying risk. Bazille was killed in action. Manet served as an officer, and
curiously enough his commander was the tight-bound academic painter
Meissonier, who had led the fight against Courbet's "common" realism.
No friendship resulted from their association. If there was a score to settle,
Manet managed it some years later when he described a celebrated battle-
scene picture of Meissonier's in a much-quoted line: "Everything in it is
of steel except the armour."

In the year of the World's Exposition, 1867, Manet, taking the cue
from Courbet, set up an exhibition of his own in a shed outside the fair

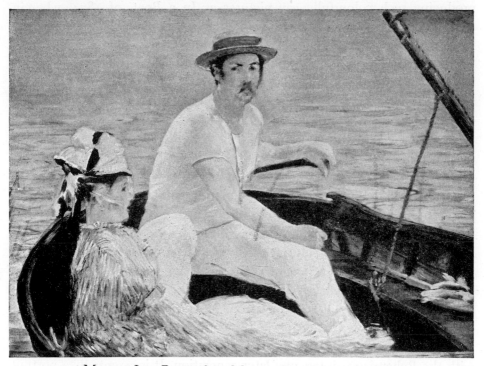

MANET: In a Boat. 1874. Metropolitan Museum of Art

gates and showed fifty pictures. But he failed utterly to break through the wall of apathy and hostility that had been raised against him. At the Salon of 1873, however, he scored a genuine popular success with *Le Bon Bock*, a realistic portrait of a fat and jolly barroom character with a clay pipe and a glass of beer, in the Hals tradition but with a modern lightening of means. In view of this success he let his friends dissuade him from exhibiting at the independent show of 1874, which was to be known later as the historic First Impressionist Exhibition, although he had helped plan the exhibition with Monet, Pissarro, Renoir, and the others.

For several years Manet remained friendly with the radical group, but progressively returned, in his own painting, to the "high-class" objective realism which had been typical of him before he met Monet and Pissarro. He knew only that he wanted to paint the scenes and people he saw around him, at the cafés, in the studios, at the races, in his own way. He did not want to idealize life or to moralize about it. He adopted more at times of the fresh colouring and the staccato touch of the impressionists,

producing such colourfully gay pictures as *In a Boat*, of 1874, wherein there is something of impressionism and a hint of Japanese arrangement, but in a composition with Manet's own sort of flat solidity. He found studio painting more to his liking than the outdoor sort, and he was never happier than when painting at his own easel in a room filled with admiring friends. It is likely that those friends admired the man rather than the painter; or at least were unappreciative of those original qualities in the paintings that were later to entitle Manet to a place among the pioneers of modernism.

Especially admired was the Salon picture of 1881, the *Portrait of Pertuiset, the Lion-Hunter*, a rather loose piece in which an excellent portrait of the hunter, gun in hand, is inserted into a stagy woodland background, with a dead lion, studied obviously from a parlour rug, as a prop. Of Manet's best work is a painting of a simpler sort, in another medium, pastel, *Mme. Manet on a Sofa*, of 1878. But he could not often compose so simply, abbreviate so effectively. In general the later canvases embrace too much territory—very far is Manet from Goya now—and are pulled apart by too much detailed reporting in the corners. The tendency culminated in *The Bar of the Folies-Bergère*, a *tour de force* in a genre to be popular with the Bohemian painters of a later generation. It is essentially a portrait of a barmaid with a panoramic background in which are seen a balcony filled with men and women, a great crystal chandelier, lights, bottles, and a mirrored view of the barmaid's back, and—unforgivable pictorially—a full-sized man's head in the very corner of the canvas. Some critics insist that the picture was painted from a photograph. In any case it is one of the documents of modern realism, and a sort of final test of Manet's power to paint brilliantly, to give animation to every part of a picture, to be vigorous and factual without descending into Courbetesque materialism.

Manet died at the early age of fifty-one, in 1883. He died unhappy about his work. He had coveted critical acceptance and public acclaim. He had been original enough to alienate the public and to outrage the ultra-conservative painters and the critics who served them. He had yielded occasionally, had painted *Le Bon Bock* for the crowd that appreciates a jovial face and a familiar characterization. He had gone round the circle: painting to please, painting to shock, painting (more usually) what seemed to him worth painting without regard; and in his lifetime he failed to find his place. He had made good as a brilliant realistic illustrator of his par-

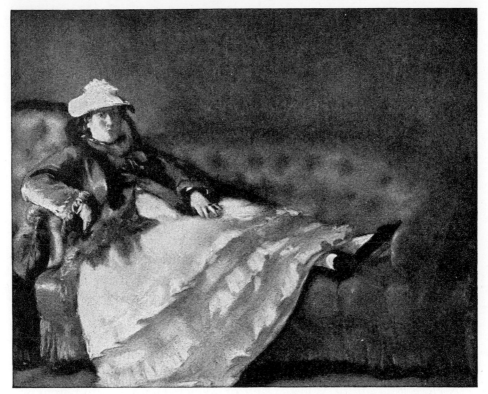

MANET: Mme. Manet on a Sofa. 1878. Pastel (Giraudon photo)

ticular boulevard-world, and as a pleaser of the (advanced) eye. But on the ground where the moderns were staking their claims he pushed about uneasily, uncertain. He went a little way with the devotees of Hiroshige, then retreated. He started as if to play with the rainbow-tinting of the impressionists, even showing them a trick or two on the way; then returned to portrayal of the object itself. He followed Goya to the borders of the realm of plastic improvisation, then turned back, with only Goya's actuality and Goya's colour to show. He was at his normal best when he was following Courbet, modernizing casual realism, banishing the bituminized shadows, subordinating chiaroscuro as a method, adding gaiety of light and colour.

In the years during which Manet was thus bridging from mid-century static realism to impressionism, there were other mildly revolutionary painters who accepted Courbet's faith in common materials, who rejected

with him the belief in the ideal, then proceeded along diverging roads. The Belgian Alfred Stevens played about in Manet's upper-class world and portrayed its women with exactitude and delicacy, but without Manet's impersonal attitude toward his subjects. The Belgian's is a modish realism; he is fully aware of the loveliness of the cultivated Parisiennes whom he paints; his pictures at once mirror and are a part of their fastidiousness; he delights in their beautifully textured clothes and their opulently furnished rooms. But he does not revert to the fashionable fluency and superficial brilliancy of Lawrence. Nor does he fall into the moralizing vein (as do the British and the Germans of the period) or into anecdote painting. It is realism, but of an elegant and precious sort because he found all his models in the *chic* feminine world.

Théodule Ribot was at the very opposite pole, as man and artist. Poor, knowing only the life of the labourer and of suffering, more at home in kitchens and garrets than in boudoirs and drawing-rooms, he struggled through to a considerable success with pictures often sombre but generally life-like. With Courbet he reverts to the earlier Spaniards, to Ribera especially. But occasionally he puts into a canvas more of plastic ordering than Courbet ever did. His *In the Studio* has qualities of arrangement found in few works of the avowed realists of the mid-century.

A close associate of Whistler and of Manet, Henri Fantin-Latour was a realist who went part way with the innovators but always turned back. He was perhaps a traditionalist whose reason told him that he ought to be going forward with Manet and Whistler or Pissarro; yet his lack of originality and inventiveness allowed him only the semblance of novelty. There was a moment when he might have reconciled something out of Delacroix's method with the later tendencies; but his *La Féerie* at Montreal, painted when he was only twenty-seven, seems to have touched the highest mark of which he was capable in that direction. It was among the rejected works of the Salon of 1863, and it went over to the galleries of the Salon des Refusés and there served to mark Fantin-Latour as, temporarily, one of the outlaws.

But his style hardened and he became an accurate and appealing historian-realist, specializing in portraiture. His group-portraits of his friends among the artists and writers of Paris are simplified photographic documents, with an endless human interest for later generations. When he attempted to compose his pictures with Whistler's Orient-derived formalism he betrayed his lack of feeling for plastic orchestration as such.

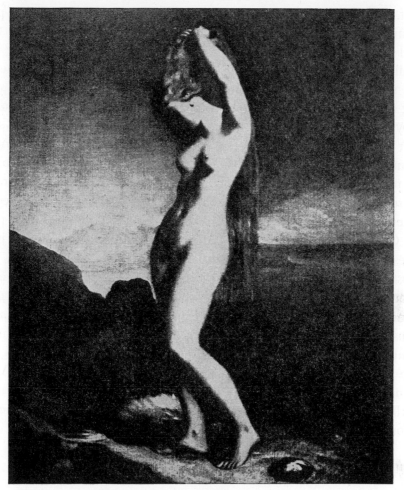

CHASSÉRIAU: Venus Marine. *Louvre*
(From *Théodore Chassériau*, by Léonce Bénédite)

Another contemporary, Carolus Duran, affected the Whistlerian way
(which had been Velazquez's way) of setting out a single figure against
an almost empty background, with telling contrast of muted colours; but
when he added the background or foreground accessory that should make
the arrangement right, he failed to bring about the plastic adjustment,
the perfect poise of all the movement factors. Curiously enough, he passed
along to his American-French-British pupil Sargent a student interest in
formal organization; but Sargent soon fell victim to a fatal facility with the

brush, and served only to carry on into the twentieth century a type of portraiture in which Courbet-like honesty compromised with the traditional brilliancy of Lawrence.

Still another Frenchman tried, in the eighteen-fifties, to unite the two main streams that had flowed in French art before Courbet, with something of Courbet's honesty of vision too. Théodore Chassériau was romantic by temperament, but his style was chastened in his years of study under Ingres. While he never lost a classic discipline, a Greek purity of statement, he went on to adventures under the stimulation of the battles over romanticism, and doubtless felt also the impact of Courbet's robust materialism in the late forties. When other men—the ones considered the greatest of the day—were setting up inflated easel pictures as mural paintings, Chassériau was learning to flatten his backgrounds and to tie in his figures with something of architectural order. His decorations have been almost completely destroyed or lost; but there are critics who believe that he touched a higher mark than his pupil Puvis de Chavannes. There are fragments that are instinct with plastic life. His nude studies such as the *Venus Marine* in the Louvre, although over on the classic side, exhibit a warmth and a melodic composition unknown to David and Ingres. And there are observers of art and of life who would swear that this *Venus* of Chassériau's is more like reality than the "more real" naked women of Courbet. Unfortunately Chassériau, who had been born in the same year as Courbet, died untimely in 1856, at the age of thirty-seven.

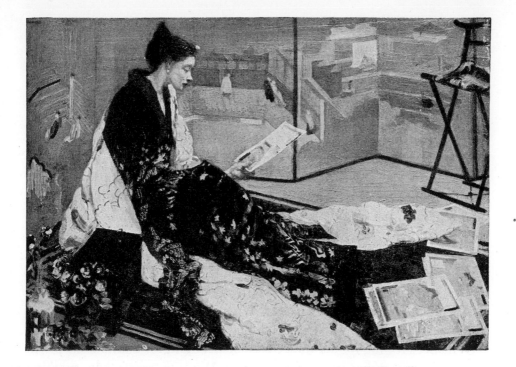

VII: A PARISIAN AMERICAN ARRANGES ART MUSICALLY, IN UNMUSICAL ENGLAND

IN PARIS in 1859 the Salon jury rejected the usual number of offerings by unknown and struggling artists. François Bonvin, a peaceful realist, who had graduated from being a policeman to being a painter, having come to a mild success with his quiet studies of nuns and children and vegetables and topers—in the Chardin and Dutch-interior tradition—in that year decided that he would aid certain of the rejected painters. In his own studio he set up a minor Salon des Refusés (this was four years before the official show of that name) and invited artists and students in to inspect the works of four of the disappointed ones. Bonvin's judgment was excel-

WHISTLER: The Golden Screen: Caprice in Purple and Gold No. 2. 1865. *Freer Gallery of Art, Washington*

lent. Of the four—Whistler, Fantin-Latour, Ribot, and Alphonse Legros—not one was to fail to make his mark and to find a place in art histories; and one, Whistler, an American who had been studying painting in Paris for five years, was destined to set the English by the ears over modern art through forty years and to become in France a forerunner of post-impressionism (in the same sense in which Constable and Turner had been forerunners of impressionism). Whistler's rejected picture was an interior study and portrait of his half-sister and her child, entitled *At the Piano*.

Among Bonvin's guests was Courbet, and he pronounced Whistler's canvas admirable and original. The praise, coming from the master who then was the idol of the immature generation of Parisian painters, encouraged the young American more than a Salon acceptance could have done. It may have helped him to preserve a certain solidity, a Courbetesque devotion to natural substance, without which his somewhat fragile talent might have run off into an over-precious formalism. But he did not let the master's advice and praise affect for long his independence and his vision.

Whistler's feeling for decorative arrangement and for harmonious plastic animation was unlike that of any other Western artist then painting, though only within the year there had died in Japan an Eastern master, Hiroshige, from whose colour engravings he was to learn much about form arrangement. In 1859 he was already starting along a road directly away from Courbet's literalism and materialism. This much he gained from Courbet's friendship and example: he determined to present what presented itself to his eyes, and disregarded thenceforth the remote and noble subjects of the neo-classicists and the exotic and literary subjects of the romanticists. Courbet's frankly illustrational tendencies and method were to be detected in two paintings of 1860 and 1861, *The Thames in Ice* and *Wapping-on-Thames*. But the more distinctive picture was *At the Piano*. Though it had about it something of student self-consciousness, it introduced qualities of decorativeness and order that marked it as a beginning point of consciously post-realistic painting in Europe. Bonvin by his hospitality to the *refusés* had helped to open one of the roads to the future.

James Abbott McNeill Whistler was born in Lowell, Massachusetts, in 1834. He spent his early boyhood in Stonington, Connecticut. His schooling was interrupted when he was taken, at the age of nine, to St. Petersburg, because his father, an engineer, had been invited by the Government to help construct the first Russian railway. Four years in Russia and a

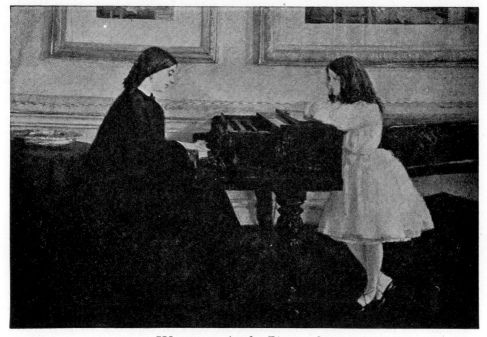

WHISTLER: At the Piano. 1859

year in London with his half-sister, who had married Seymour Haden, gave the boy a taste for travel and cosmopolitanism. A certain broader outlook gained through contacts during his visit abroad, and through mastery of other languages than his own, unfitted him for the routine schooling to which he returned in 1849. Two years at a school in Pomfret, Connecticut, and two at West Point Military Academy failed to make either a fair scholar or a promising military officer out of him.

Whistler produced his first celebrated art work with the etching needle on the margins of a topographical plate he was etching for the United States Coast Survey in Washington in 1854. His superior officers were unappreciative, and he did not care for routine draughting anyway. He had made up his mind he would be an artist. About this time he read Murger's *Scènes de la Vie de Bohème*. He had in him a strain of Puritan inheritance, with the usual subconscious desire for escape, and something of Irish impatience with restraint; and Murger's picturing of the Paris of the artists fascinated him. He had seen enough of Europe to know that

the centres of art abroad offered more, in return for his talents, than Washington—of all places!—or any American city.

An innate fastidiousness was to keep him aloof from much that in the reading seemed attractive in Murger's highly coloured accounts of Bohemia. But in the summer of 1855, in his twenty-second year, he became a student in the Latin Quarter. He never returned to the United States. He studied five years in Paris and returned there at intervals throughout his life for brief or extended visits. He went to London to live in 1860, and took active part in the art life of the English capital during a quarter-century thereafter. Upon the question of his artistic "nationality" a great deal has been written. There was little in his mature work to connect him with any development in America. Least of all has he any affinity with British art. He is almost as much a stranger to the French tradition, except in those characteristics shared with Manet (largely Spanish-derived). He remains, indeed, an internationalist, one of the great independents.

As a student in Paris he found himself inclined to disagree with Gleyre, at whose studio he enrolled, on all questions, and his attendance was irregular. To increase his small income he took to copying, for pay, works in the Louvre. It was there that he formed a close friendship with Fantin-Latour. He could not but be stirred by the controversies over Courbet's heresies, and Bonvin helped him. But there is little in the school years 1855–1859 to account for the originality of *At the Piano*. The picture was painted during a visit to the Hadens in London in the summer of 1859.

When Whistler painted *At the Piano* he foreshadowed his whole career as artist. The woman in black, in profile, the silhouette of her hair and dress forming, with the piano, a main compositional motive, is the first instance of that decorative formalism which will culminate in the *Mother* and the *Carlyle*. The child, in a white dress (placed arbitrarily across the main axis), is like a trial sketch for *The White Girl* of a few years later. The use of fragmentary strips of pictures on the wall merely as divisors of space is a compositional device which will become familiar in Whistlerian interiors in the sixties (a device equally characteristic of early portraits by Fantin-Latour). On the table behind Mrs. Haden, subdued but compositionally important, is a bit of Chinese porcelain, hint of the interest that will influence his painting in a kimono-and-blue-porcelain period.

Already there is reliance upon flat painting, within an artificially restricted tonal scheme. Already the harmonies are those which will be isolated and separately exploited, in the later symphonies and nocturnes:

the black and white, the grey, green, and gold, the muted reds and madders. The young artist, under twenty-five when he painted the picture, fixed in it the directions in which his genius would grow (although one knows that in his maturity he would have simplified the background still further, and that he would have found a way to tie the somewhat obtrusive piano leg into the formal structure). It is to Courbet's credit that when he saw the canvas in Bonvin's studio on a day in 1859 he recognized the originality and importance of it.

Whistler took *At the Piano* back to London and it was accepted for showing at the Royal Academy Exhibition of 1860. It was bought by an Academician. Partly because this encouragement augured better than the official hostility of Paris, Whistler decided soon afterward to make London his home. Although he came to loathe what he deemed the art-stupidity of "the Islanders," he was to consider London his headquarters until 1892.

In 1860–1861 he gave a great deal of his time to etching, an art in which he came to a mastery considered second only to Rembrandt's. In 1862 he painted in Paris *The White Girl*, a further step in "harmonization," and the beginning point of his conscious composing within an æsthetic parallel to that of music. Submitted to the Salon jury of 1863, it was rejected and went to the historic Salon des Refusés. Next to Manet's sensational *Luncheon on the Grass* it was the most talked-of exhibit. But *The White Girl* found as many defenders as detractors, and some of the leading critics confessed themselves pleased and moved, even haunted by the strange beauty of the picture.

In London, from 1863 to 1870, Whistler etched and painted, independent of all current schools, whether French or British, but influenced, in painting, by the vogue for Japanese prints. He was perhaps a leader in introducing Hokusai and Utamaro and the others to London artists and collectors, though in Paris he had been only one of many devotees. *The Little White Girl, The Gold Screen, Die Lange Leizen of the Six Marks*, and *La Princesse du Pays de la Porcelaine* showed the Oriental influence in various degrees. Fuller colour came into his painting, and his decorative sense found its fullest play. But it was the one period when the artist was least himself, most the practitioner within a mode found outside and admired, and not fully assimilated to his own talents.

Whistler and others at this time began the process of ridding Western painting of certain conventions which had been considered valid and bind-

ing since the high Renaissance. Whistler above all challenged the convention of photographic perspective, and with Manet he helped to destroy the almost universal method of laying out the picture as primarily light-and-shade. More consistently than Manet, he opposed to realistic representation the values of arranged plastic elements, the decorative composition, the studied colour harmonies, the disposing of isolated objects at controlled intervals in space, the playing of patterned areas against linear rhythms and tone-filled space.

Certain conventions he took definitely from the Orientals: the high angle of vision (yielding a high horizon line in the landscapes and seascapes, and adding, in the portraits, what seemed to orthodox painters and critics an exaggerated view of the floor); a way of emphasizing space divisions by means of panelling or screens (so obviously used in the celebrated *Portrait of Miss Alexander*, where the upright member dividing the background is so vital to the compositional adjustment); and the device marking, for the observer's eye, a front plane from which the movement-path starts, by means of a spray of flowers, a flattened figure (in the beach scenes), or the butterfly signature. These conventions sometimes added up to a picture too obviously Oriental, and therefore strange to Western eyes. But again the elements were assimilated into Whistler's own style.

The artist himself denied that in accepting Eastern compositional devices he was departing from the main tradition of the painting art. Art, he said, is eternal and unchanging. If one widens current practice by incorporating any known way to make its means effective, one is not being revolutionary, or opposing tradition, but only widening, healthfully, the central path of tradition. The series of Whistler's major paintings of the eighteen-sixties marks more clearly than any other phenomenon the point at which the convention of realism, central in European painting since 1500, began to be challenged and invalidated, in favour of a modern æsthetic broad enough to explain both Western and Eastern art.

During 1866 Whistler went to South America, upon a somewhat quixotic mission, eager to fight for Chile and Peru in their war for independence from Spain. He saw some action at the bombardment of Valparaiso. More important, he returned to London with the first of his nocturnes. In the *Valparaiso Harbour*, now in the Smithsonian Collection at Washington, there are strong evidences of Japanese influence, but there is a harmonious modulation of the colour that is essentially Whistlerian. Within a year or two the artist was painting the series of Thames noc-

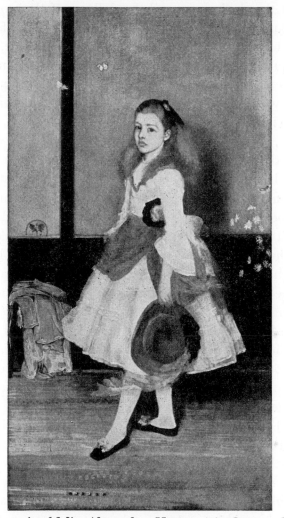

WHISTLER: Portrait of Miss Alexander: Harmony in Grey and Green. 1872
National Gallery, Millbank, London

turnes that forms one of his most characteristic expressions. It became
an influence later upon a considerable number of painters, especially in
America, where artists as important as Davies, Marin, and Carroll were
affected.

Whistler was already involved in those controversies wherein he was so
often artistically right and so diabolically clever with his tongue, while
outrageously the poseur. He knew he was right about the importance of

art, and about the shallowness and the dullness of the works the English artists were turning out around him. He was sensitive, fastidious, finely strung. With his friends he was warm-hearted, responsive, and loyal. But in public he put on a mask, defied almost every leader in the art world, and refused to retreat a single step from the ground he had taken. His intelligence, his wit, his intuition were acute. He slew innumerable enemies with quotable lines.

At the time, the enemies seemed often to prevail, he was so outnumbered. But in the end it has come straight, has gone into history (except when written by the British, perhaps, for the smart is still there), that Whistler was fighting on the side of creative art, of invention and vision and ultimate beauty; and that his opponents betrayed, in their ridicule and their venom, a spirit on the shallower, the meaner side. As early as 1867 his own brother-in-law, Seymour Haden, succeeded in having him expelled from the Burlington Fine Arts Club, after a quarrel. He unfortunately quarrelled and broke with the friend of his student days in Paris, Alphonse Legros.

By 1870 he had passed through the intensely Oriental phase and was returning to the manner of that earliest success, *At the Piano*. In 1871 he painted the *Portrait of the Painter's Mother*, and a year or two later the *Portrait of Thomas Carlyle*, finest of the "silhouette" series and, abstractly considered, one of the most beautiful "arrangements" in the galleries of Western art. The *Mother* portrait was submitted to the Royal Academy, and the word went out that it was to be rejected. A small group of Academicians threatened to resign and stir up a scandal over the rejection. Whistler's enemies reconsidered and the picture appeared at the Royal Academy Exhibition of 1871. It was the last time Whistler's work was seen at an Academy show.

The mid-seventies were marked by growing controversy over Whistler's art and his actions. As though to prove that he could score in diverse fields, he varied his work, and even abandoned the manner of his silhouette portraits. An incident which excited interest, bitterness, and the wildest rumours occurred during an excursion into pure decoration. A millionaire shipowner, F. R. Leyland, had acquired Whistler's *La Princesse du Pays de la Porcelaine* and had hung it in a leather-lined room of his London mansion. The artist found the picture and its surroundings inharmonious (the house is described as being richly furnished with objects and materials from Italy, Portugal, medieval France, Tirol, and old Eng-

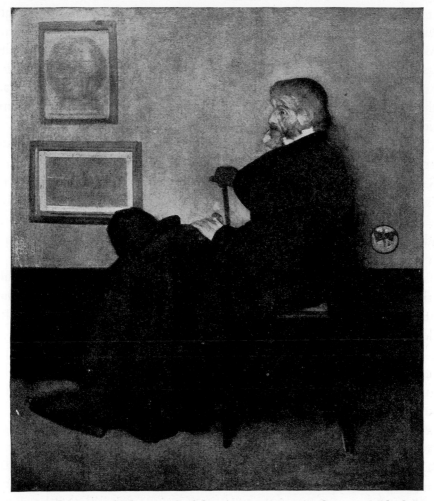

WHISTLER: Portrait of Thomas Carlyle: Arrangement in Grey and Black No. 2.
1872. *Corporation Art Gallery, Glasgow*

land). He arranged with the owner that he should redecorate "around the picture." Leyland having imprudently absented himself, Whistler proceeded to interpret his commission very broadly, and gradually made over the entire room, bringing into existence the celebrated "Peacock Room." (It was later taken entire out of the London mansion and transported to Detroit, and it is now a feature of the Freer Gallery of Art in Washington.) Adopting a scheme of blue-and-gold colouring, and choosing the peacock as the motive for the panel designs, the artist created a rich and consistent interior as unique as his own paintings. Appearing Oriental at first glance,

by reason of its opulence and flat method, it really is a work of the utmost originality.

Whistler created other and simpler works of decoration which had a lasting influence upon modern design, in interior architecture, and in the minor fields of book-making, monogram designing, and picture-framing. He began, too, the de-cluttering and redesigning of picture galleries which continues—oh, so slowly—seventy years later. But nowhere else did he exhibit such a luxuriant talent for ornamentation as in the making over of the room to "surround" his *Princesse* picture.

The Peacock Room controversy led to fantastic rumours about Whistler's high-handedness and his demands upon the owner. It was said that the architect whose decorations he had destroyed was found in his house mad, gilding his floor and then arranging blue-and-gold peacocks upon it.

Whistler had approached the problem of decoration as he would approach the painting of a picture, and he insisted upon calling the whole work "Harmony in Blue and Gold: The Peacock Room," and he explained that the peacock was chosen as a motive merely "as a means of effecting a desired arrangement of colours." His enemies were quick to point out the discrepancy between the artistic harmony and the discordant protests of the owner, who quarrelled over payment for the work, feeling naturally that he had been let in for greater expense than he had authorized. Whistler memorialized the quarrel, not too subtly, by designing the final panels with a motive of *fighting* peacocks. But they are beautifully conventionalized and in the most harmonious colours.

The "pure decoration" of the Peacock Room was only one departure from his earlier types of work. In the seventies he painted many portraits outside the conventions of the silhouette series, and without the devices obviously adopted from the Japanese. He developed his theory of harmonization and arrangement, and he went back over his past work and renamed his pictures; so that the earliest *White Girl* became *Symphony in White, No. 1*, and the portrait of the artist's mother became *Arrangement in Grey and Black*. It was these titles that, seemingly, most enraged the critics and the public at the time of Whistler's first one-man show, held at a gallery in Pall Mall in 1874. He showed there the complete range of his work, labelled as symphonies, harmonies, nocturnes, variations. All of London's art notables, from Royal Academicians down to critics, came to see and laugh and revile, and the public echoed their ridicule and their hostility. Hardly one artist in England recognized that here a path into

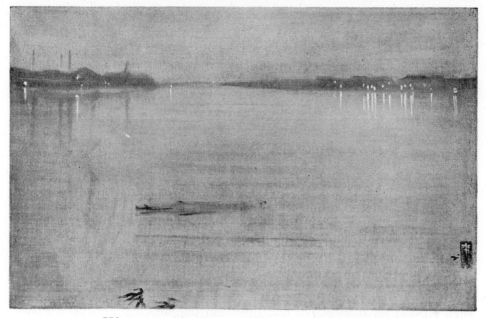

WHISTLER: Nocturne in Blue and Green. 1878.
National Gallery, Millbank, London

the future was being opened. The press treated Whistler as a wilful im-
postor or an insane egoist "showing off."

Among those brought into the fight against the American painter—his
Americanism was held to explain some of his eccentricity and his self-
advertising—was John Ruskin, considered a pre-eminent critic and guide
but tangled in the realistic æsthetic. He saw seven of Whistler's paintings
at the Grosvenor Gallery in 1877. Ruskin could find nothing to praise—
it seems incredible!—in the portrait of Carlyle or in that nocturne better
known as *Old Battersea Bridge*. One of the other nocturnes drew a tirade
from him. In *Fors Clavigera* he wrote in the highest terms of the paintings
of Edward Burne-Jones—later to be recognized as over-detailed, over-
literary, and sentimental. "I know," he wrote, "that these will be immor-
tal." Of Whistler's work, with special reference to a nocturne showing
fireworks in Cremorne Gardens, he wrote: "For Mr. Whistler's sake, no
less than for the protection of the purchaser, Sir Coutts Lindsay ought
not to have admitted works into the gallery in which the ill-educated
conceit of the artist so nearly approached the aspect of wilful imposture.
I have seen and heard much of cockney impudence before now, but never

expected to hear a coxcomb ask two hundred guineas for flinging a pot of paint in the public's face."

By common agreement in the world of art, the critic may go as far as he may be led by his feelings, in praise or dispraise of publicly exhibited works, and, no matter how far he may be led in attack, he is immune from counter-attack on the part of the artist. It is part of the understanding by which men attempt to maintain freedom of the press. But when the critic stoops to personal abuse, calling the artist a cockney and a coxcomb, and when he injures the artist's earning-power by saying that his canvases are not worth the price asked, the artist has both the moral and the legal right to sue him under the law of libel. Whistler found that the few patrons he had depended upon were influenced by the ridicule of the Academicians and the æsthetes of the current Pre-Raphaelite movement, reinforced by the extreme and widely publicized defamatory statement of England's foremost writer upon art. Whistler's struggle to make a living by his painting was made immeasurably more difficult. He sued Ruskin for damages of one thousand pounds.

The trial was a tragic farce. It served to bring out clear statements of Whistler's æsthetic. It brought out witty repartee as well as ill-advised attempts at humour. It was tragic in its outcome for both Ruskin and Whistler; and tragic as a type example of the blindness of justice where an artist's interests are brought to bar before the uncomprehending legal mind and the ignorance of lay jurors.

Had later generations not reversed British opinion of the seventies, the descriptions of Whistler's paintings might still seem as humorous as the press and public then found them. The nocturne *Old Battersea Bridge* was put in evidence. The Attorney General asked the jurors to regard the picture: "Let them examine the *Nocturne in Blue and Silver,* said to represent Battersea Bridge. What was that structure in the middle? Was it a telescope or a fire escape? Was it like Battersea Bridge? What were the figures at the top of the bridge? And if they were horses and carts, how in the name of fortune were they to get off?"

The Attorney General triumphantly asked: "Do you think now that you could make *me* see the beauty of that picture?" Whistler replied: "No!" and then touched upon a matter, blindness to form, which will be endlessly an obstacle between modern artist and the trained-to-realism public: "Do you know, I fear it would be as hopeless as for the musician to pour his notes into the ear of a deaf man."

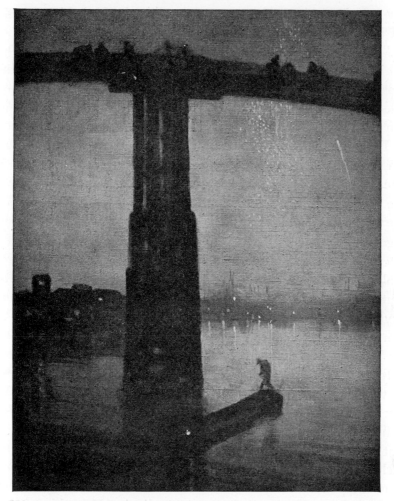

WHISTLER: Old Battersea Bridge: Nocturne in Blue and Gold
National Gallery, Millbank, London

Whistler admitted that he had spent only two days painting the libelled nocturne. "The labour of two days, then, is that for which you ask two hundred guineas?" "No," Whistler replied, "I ask it for the knowledge of a lifetime."

Two witnesses, Albert Moore and William Rossetti, testified that in their opinions the nocturnes were works of art and that two hundred guineas was not an excessive price. On the other side two of the most celebrated artists of the Victorian period gave testimony. Edward Burne-Jones was cautious in condemning *Old Battersea Bridge:* "simply a sketch";

"a day or a day and a half seems a reasonable time in which to paint it"; "good in colour but bewildering in form, and it has no composition and detail." Of the other nocturne he said definitely: "It would be impossible to call it a serious work of art. . . . The picture is not worth two hundred guineas." W. P. Frith of the Royal Academy, a popular illustrator of over-crowded everyday scenes, with a photographically realistic technique, was certain that Whistler's painting was not art. A leading journalistic critic, Tom Taylor of the *Times*, testified in the same vein. The Attorney General in summary took the line that one should be lenient with Mr. Whistler after all, since his paintings had given England so much to laugh about.

The jury, wholly beyond its depth, yet wishing to stay within the spirit of the occasion, found Ruskin guilty of libel but fixed the amount of damage at one farthing. If the verdict were to be taken seriously it would be interpreted as branding Ruskin technically guilty, while the jurors put the value of a farthing on Whistler's painting, thus endorsing Ruskin's estimate of its worthlessness as art. The record of the trial, going into history books, was to do more than anything else to discredit Ruskin's opinions, and to bring him into perhaps greater disrepute than he deserved.

For Whistler the verdict was more immediately tragic. He had court costs to pay. The judge, exercising his prerogative, and doubtless wanting to show where *he* stood, in spite of the verdict of guilty ordered Whistler to pay the costs of his side. His market, of course, was gone. His house furnishings, his collections, and even his etching plates were seized and sold at public auction. It was the lowest point in a life often turbulent and seldom easy.

Thus stripped of everything material that an artist might value, but bowing not one jot in his defiance or his dignity, Whistler left England to etch a series of plates of Venetian scenes. However the British people might deride his paintings, they appreciated still his mastery of the etching needle, and the Fine Art Society, a commercial firm, thought to aid both Whistler and itself by commissioning him, at a handsome figure, to produce a dozen plates. He was away from London more than a year. When he returned and the set of prints was published, the critics and artists of England fell upon him with new fury. He was trying, they said, to palm off on them inferior plates, not nearly so good as those of the famous Thames series.

What Whistler had done was to put himself into the mood of Venice; and because he did not make Venice look like London, or like the Venice

known through the descriptions of romantic writers—he scorned above all else "literary" picturing—he was again mercilessly attacked in every art column in the land. Even French connoisseurs of the print joined in the chorus of disapproval. He had shown a Venice neither nobly ornamental nor peopled with doges and masquerading ladies and gentlemen; rather a Venice somewhat decayed—as it doubtless was in 1879.

"Mere sketches," some critics said. "Another crop of Mr. Whistler's little jokes," said Henry Labouchere in *Truth*.

But this time the "authorities" failed to ruin Whistler's market, as they had done in the case of his paintings. For some years he gave a great deal of his time to printing from his own coppers, painstakingly working up each print with a perfection of inking that no commercial printer could approach. Collectors appreciated this characteristic sort of thorough craftsmanship, disregarded the critics, and bought generously.

In 1883 Whistler held a major exhibition of his etched work and published a novel catalogue in which he got back at his detractors by quoting word for word what the critics had written about his prints. This time the public liked the exhibits, and when they looked under the number and name of the print and found a quotation from a well-known "authority" damning the work as a "disastrous failure," or a blanket denunciation such as "Whistler is eminently vulgar," their sympathy turned back to the artist, who had, indeed, been libelled and abused as much as any creative figure in history.

The only sort of painting that Whistler might thereafter look to as profitable was portraiture. For a few years after the Ruskin trial no one but an eccentric would think of sitting to so discredited an artist. The French writer Théodore Duret was one of those who ventured to pose, in 1883, and the portrait now in the Metropolitan Museum was the result. It combined those qualities of naturalness and of decorative harmony and order that were the special objects of the artist's search at this time. He abhorred the sort of detailed realistic painting that is commonly called naturalism, but he wanted his subjects to appear natural in some larger sense.

The Duret picture grew out of talks the artist and the writer were holding upon the "dressed-up" portraiture of the time. Men's black evening suits were considered dull and inartistic, and no portraits in that dress were known. Whistler saw the problem as a double challenge, to make an acceptable picture of a subject considered too "common" and to

do it within a harmonious arrangement of plastic elements. The one concession he asked of the sitter was that he bring along a pink domino or cloak. The resulting picture, though not one of the artist's masterpieces, is natural and appealing as portraiture; and the black figure on rose-grey ground, with the pink of the cloak that is thrown over the man's arm, forms perfectly the *Arrangement in Flesh-Colour and Black* of Whistler's title.

Duret has told how at the first sitting, without preliminary drawings, Whistler marked on the canvas the limits of the figure, then touched in the colours of the "arrangement." The picture grew slowly from that beginning, with elimination of detail demanding apparently as much effort as building up the design. Another sitter, the Count de Montesquiou, testified to "sixteen agonized sittings," and told of the slow progress of the picture by considered strokes or accents, of which "none was corrected or painted out." Against the opinion of the critics who judged Whistler capable of "sketches" only, his works of this sort testify to a mind bent upon perfection of finish and a unique harmonious completeness. His acceptance of the "musical" ideal in painting, of a harmonious decorative order, confined him within easily marked limits, so that his achievement is slighter in body than that of a Daumier or a Turner or a Cézanne; but it is complete and perfect of its sort.

In the mid-eighties he found himself more accepted. A paper opened its columns to him, a few patrons gathered, he was invited to social affairs. In 1885 he delivered a public lecture on art, surprising the public with the serious truth of his pronouncements, and at the same time paying his respects to the critics. He repeated the lecture at Cambridge and Oxford, and in 1888 published it under the title *Ten O'Clock*. It has since taken its place as one of the most lucid statements made by those moderns who oppose art that serves as preaching or education or sentimental reminder.

In 1884 Whistler had been made a member of the Society of British Artists, an organization not without prestige but then badly run down and in need of new blood. The veteran fighter brought unexpected life into the old body, and in 1886, partly in gratitude and partly as a publicity *coup*, the more progressive members elected him president. He served the Society exceedingly well, by bringing in younger artists and by securing a charter through which the group became the *Royal Society of British Artists*. But distressed by the number of mediocre works offered for exhibition, Whistler separated out those of exceptional merit and

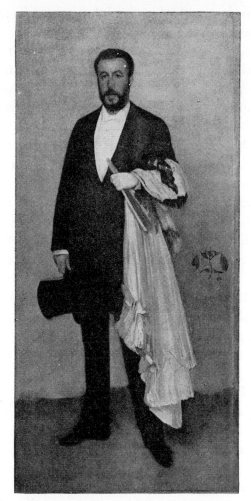

WHISTLER: Théodore Duret: Arrangement in Flesh-Colour and Black. 1883.
Metropolitan Museum of Art

especially those of younger men, and at the Society's exhibition in 1887 showed them in specially designed rooms.

There was, of course, a rebellion, and when Whistler failed of re-election to the presidency in 1888, his faction walked out in a body. His summary was cruel but had considerable truth in it: "You see, the Artists have come out, and the British remain." As for himself, he pointed out that the right man was no longer in the wrong place. Only once again was he to try to advance art's interests through an organization, when in 1898, at the age of

sixty-four, he was made president of the International Society of Sculptors, Painters, and Gravers.

His enemies, though fewer or quieter, were by no means idle during the late period, and in 1886 they continued the abuse that had grown out of Ruskin's condemnation of the nocturnes. The nocturne destined to become later the most praised of all, *Old Battersea Bridge*, came up at auction at Christie's and the audience hissed it. In the same year Whistler was led to answer his old enemies of the Royal Academy, writing of the members: "They all belong to the excellent army of mediocrity. . . . They are commercial travellers of Art, whose works are their wares, and whose Exchange is the Academy." In 1890 he collected, as if in preparation for a major change, all his writings, including the *Ten O'Clock*, his catalogue prefaces, and his letters to the press. Characteristically he entitled the volume *The Gentle Art of Making Enemies*. In 1892 he moved to Paris.

In 1867 four of Whistler's paintings and a series of his etchings had been exhibited in the American section at the Paris Exposition, and the French Salon had shown works of his in 1865 and 1867. Then for fifteen years he submitted no pictures, though he continued to have more friends among the French artists than among the British. In 1882 he sent a full-length portrait of a Mrs. Meux, which found some appreciation; but it was the *Portrait of the Painter's Mother*, shown at the Salon of 1883, that won him a wide reputation and popular acclaim in France. The jury awarded him a medal.

When the portraits of Miss Alexander and of Carlyle were shown at the Salon of 1884, Whistler was for the first time widely recognized as a great artist and as one of the leading innovators among modern painters. From then on he considered Paris his centre for exhibition. In 1889 the French Government conferred on him membership in the Legion of Honour, and in 1891 raised him to the rank of Officer. In 1891, moreover, the Government bought the portrait of his mother for the Luxembourg, an honour seldom accorded to foreign artists. About this time American collectors, long swayed by British opinion, took heed of the French chorus of praise and, more important, became buyers. Even in England the critics at last modified their abuse, and at the one-man show in London in 1892 there was tempered appreciation.

When he moved to Paris in 1892 Whistler felt that he was returning to his artistic home. The atmosphere of success and appreciation that surrounded his exhibitions, and the pleasure found in contact with other

WHISTLER: The Little Rose of Lyme Regis. 1895. *Museum of Fine Arts, Boston*

artists, formed an extraordinary contrast to his past life in London. But he was not to settle down happily for long. An illness of his wife brought about a return to London in 1895. After her death in 1896 he went again to Paris, painted and etched, set up a short-lived school, and enjoyed increasingly the attentions of a group of devoted friends. At this time he was continuing the series of full-length portraits. But perhaps the most appealing work of his later years is in that group of studies of children made in 1895 at Lyme Regis, including *Lillie in Our Alley*, *The Little Rose of Lyme Regis*, and *Pretty Nellie Brown*.

In everything he ever did in life or art Whistler showed a scrupulous respect for womanhood, and throughout his life his portraits of girls had a special delicacy, a characteristic fragility. *The White Girl*, *The Little White Girl*, and the gravely lovely *Miss Alexander* had been pictures characterized by a certain fullness and decorativeness not found in later series. But *The Little Rose*, with its thin-pigmented painting and its great simplification of means, is no less masterly and, in its reticent way, no less colourful. And it is, too, so distinctively Whistlerian that it could not be mistaken for the work of any other artist in history.

Whistler returned to England when he became ill in 1899, in order that he might have the care of his sisters-in-law. When his health was improved he went abroad to sketch, and he spent the winter of 1900–1901 in North Africa and Sicily. He died in London in the summer of 1903 a few days after his sixty-ninth birthday.

The forty years of Whistler's creative life had extended through that period when the art of the Western world was being reshaped into the thing that is today called modern art. In the years of his earliest exhibited works, 1859–1861, the brutal realism of Courbet had challenged the romantic and sentimental realism of the followers of Delacroix and Ingres. When Manet modified Courbet's naturalism, toward impressionism, Whistler was a fellow-innovator, along a divergent road. He was a contemporary of the succeeding impressionists, and of Cézanne, Seurat, Gauguin, and van Gogh. Yet by no stretching of accepted critical terms can he be termed a realist or an impressionist or a post-impressionist. He arrived at certain of the principles which explain post-impressionism; but he arrived at them before impressionism was invented. He was an independent revolutionary, as much outside the schools as Daumier or Turner. But his accomplishment was nearer the heart of the modernist æsthetic than that of any earlier painter. His pictures had *form*, in the modern sense, as something abstract, intangible, living, and indispensable in the work capable of evoking the æsthetic experience.

"Arrangement" seems a weak word upon which to hang all the implications of formal excellence which the moderns have discussed, and tried to name, in their analysis of plastic orchestration, expressive form, and spatial order. But it *is* formal excellence, it *is* plastic order, that Whistler defended when he called his pictures "arrangements," against those who wanted nature shown "as she is" and those who demanded that she be

WHISTLER: The Little White Girl: Symphony in White No. 2. 1864.
National Gallery, Millbank, London

shown as stimulus to our memories or our pity or our benevolence. Again
he used the word "harmony"—Seurat's word, too, in 1890—to designate
all that is furthest from the casualness of nature, from the ideas of mere
illustration or instruction in the work of art. The harmony of his pictures
is explainable in terms of two or three elements that enter into the full
plastic ordering: colour, which he keeps within a scheme unfailingly
lovely but subdued; tone, which he plays with as has no other of the mod-

erns, modifying colour brightness to achieve his foreseen tonal harmony; and line, which he uses sparingly but creatively for rhythmic variation.

"Arrangement" is the better word for his ordering of the weightier elements. The volume arrangement, the placing of the main volume in pictorial space or the pull of two volumes upon each other through space, is masterly. Whether it is *The White Girl* of 1863 or the middle-period portraits or *His Reverence: Richard Canfield* of the late years in Paris, the volume placement is arranged for plastic effect. In the use of that other primary instrumental means of abstractly ordered design, plane organization, Whistler was foremost among the mid-century moderns. Arbitrary manipulation of planes was evident in the immature *At the Piano* of 1859; but it was the Japanese example, no doubt, that led to his use of emphasized flatness of planes to mark the ordered journey of the beholder's eye through the picture space.

The effect is unmistakably Japanese (though originally Chinese) in such decorative arrangements as *The Little White Girl* and *The Balcony*. It becomes Whistler's own in the series of silhouette portraits and in many seascapes in water-colour. At times a spray of flowers or a bush-top is introduced—i.e., arranged—at the very front of the canvas, marking a "front plane." Again the butterfly device or the flattened figure (in the calligraphic beach-scenes-with-bathers) serves notice, as it were, that "here the plane arrangement begins." Of course in the sixties and seventies not one gallery visitor in five hundred would recognize that, beyond subject interest, a picture is endowed with formal order (or disorder) and that formal order is achieved by conscious or intuitive manipulation of volume, plane, line, colour, and pattern or texture. (The feelings of a vast Anglo-Saxon audience were summed up by a reviewer in the Liverpool *Courier*, who had been especially put off by the nocturne subtitled *Battersea Reach*: "Under the same roof with Mr. Whistler's strange productions is the collection of animal paintings done by various artists for the proprietors of the *Graphic*, and very refreshing it is to turn into this agreeably lighted room and rest on a comfortable settee while looking at *Mother Hubbard's Dog* or the sweet little pussy cats in *The Happy Family*.")

That any artist should obtrude a sign to the eye as Whistler did with the butterfly device in the *Carlyle*, and in the *Marine* at Cincinnati, or with the sprig of leaves in the Frick collection's *The Ocean*, was idiocy. It was as outrageous as labelling one's picture a symphony or a harmony.

The distinctive Whistlerian orchestration of plastic elements, to be sure,

WHISTLER: Marine. *Cincinnati Art Museum*

is within a limited range. There are no El Greco effects of storm and flame, no Michelangelesque grandeur, no suggestion of Daumier's monumental figures and vital plastic movement. The picture depth is strictly limited. The effect, if it be described in musical terms, is melodic, not symphonic. In the range of formally excellent art, it is quietly decorative, restful, unpretentious.

"Decoration" is a third word employed by Whistler in setting off the field of consciously arranged art from the field of realism. Whatever the

subject, or without regard to subject, the picture should, he said, be self-sufficient as decoration. Arthur Symons, in *Studies in Seven Arts*, pointed out the revolutionary nature of a return to decorative painting in the world transformed by industrialism. Of Whistler he wrote: "Of all modern painters he is the only one who completely realized that a picture is part of the decoration of a wall, and of the wall of a modern room. When pictures ceased to be painted on the walls of churches and palaces, or for a given space above altars, there came into the world that abnormal thing, the easel picture." And tracing to the Japanese Whistler's theory of the picture as decoration, he continued: "At the present day there is only one country in which the sense of decoration exists, or is allowed to have its way; and it was from the artists of Japan that Whistler learnt the alphabet of decorative painting. His pictures and his black-and-white work are first of all pieces of decoration, and there is not one which might not make, in the Japanese way, the only decoration of a room."

Wherever Whistler went he redesigned rooms and backgrounds, and every public exhibition of his pictures was an occasion of despair to the gallery men, because he insisted upon making over the walls in harmony with his pictorial aims. He was fastidious in small things; he had an eye for perfection and consistency in the ensemble; and in a society and a period self-consciously crude, and guided in matters of art by intellectualization rather than feeling, he was considered eccentric if not effeminate and "precious." A full half-century was to pass before a new style of architecture and of "interior decoration" emerged, wherein the idioms of the machine age were implicit: sheer surfaces, long unbroken lines, simple colour harmonies, precise proportional adjustments. Whistler's name has sometimes appeared as that of a prophet who forecast the simpler expressions of this style. It is a measure of his modernism that one of his paintings will fit perfectly, and better than any other produced in the era of the sixties and seventies, into a modern interior. More significant, each picture is in itself precisely ordered, rhythmically pleasing, formally designed "to pleasure the eye."

One of the sources of Victorian distrust of Whistler was the cleverness of his writing and the wit of his tongue. The soundness of his fundamental contribution was so little understood, and his fluency and assurance in writing were so alarming, that he was likely to be put in the class of the dilettanti and poseurs, or at best with such *fin-de-siècle* cleverists as Oscar

WHISTLER: His Reverence: Portrait of Richard Canfield. 1902.
Cincinnati Art Museum

Wilde and Aubrey Beardsley. Beyond the wit and the banter, however, beyond the pose and the conceit, there was solid truth about art, beautifully expressed in the *Ten O'Clock* and the catalogue prefaces. The man who might so easily have become a slave to his first influential friend, Courbet, set down this answer to the credo of the realists: "Nature contains the elements, in colour and form, of all pictures, as the keyboard contains the notes of all music.

"But the artist is born to pick, and choose, and group with science, these elements, that the result may be beautiful—as the musician gathers his

notes, and forms his chords, until he bring forth from chaos glorious harmony.

"To say to the painter that Nature is to be taken as she is, is to say to the player that he may sit on the piano.

"That Nature is always right is an assertion artistically as untrue as it is one whose truth is universally taken for granted. Nature is very rarely right, to such an extent even that it might almost be said that Nature is usually wrong; that is to say, the condition of things that shall bring about the perfection of harmony worthy a picture is rare, and not common at all. . . . Seldom does Nature succeed in producing a picture."

Like all crusaders warring for an unpopular cause, Whistler over-stated his case: purely abstract painting would have been his only refuge had he acted upon the apparent logic of his words; but even his over-statements are instructive. Of a figure in a *Harmony in Grey and Gold* he said: "I care nothing for the past, present, or future of the black figure placed there, because the black was wanted at that spot." Protesting against the public that sentimentalized over the *Arrangement in Grey and Black*, the *Mother* portrait, Whistler wrote that art "should stand alone, and appeal to the artistic sense of eye or ear, without confounding this with emotions entirely foreign to it, as devotion, pity, love, patriotism, and the like. All these have no kind of concern with it; and that is why I insist on calling my works 'arrangements' and 'harmonies.' Take the picture of my mother, exhibited . . . as an *Arrangement in Grey and Black*. Now that is what it is. To me it is interesting as a picture of my mother; but what can or ought the public to care about the identity of the portrait?"

This sort of extreme stand led to the branding of Whistler as advocate of an impossible thing known as "art for art's sake." Intellectualists (including the social-message people) made out that, in being decorative, Whistler was leaving out the body of art, purveying only an empty pleasing shell, a pretty envelope. Modernism has since moved so consistently toward concern for formal means that no answer to those detractors—who were form-blind—is necessary. It is now universally felt that creative art implies creative formal means. The resulting work may, as Whistler's does, appeal to the æsthetic sense first; but it is notable that Whistler never abandoned objective subject matter, and it is inevitably true that objective subject matter evokes its own response in addition to that evoked by the formal or decorative values. The truth would seem to be that the most fortunate observer is he who is sensitive enough to the formal orchestration as such

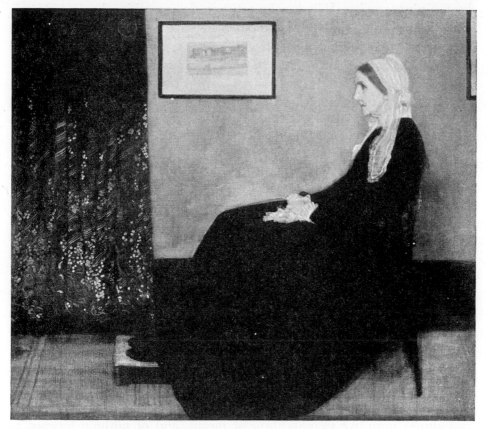

WHISTLER: Portrait of the Painter's Mother: Arrangement in Grey and Black.
1871. Louvre (Courtesy Museum of Modern Art)

to respond to that, in the first flash of seeing, before the mind awakens to
the subject interest, without prejudice to later appreciation of the intellec-
tual and emotional over-values.

In its not very profound way Whistler's portrait of his mother affords—
the artist's protest notwithstanding—the double appeal. The trained eye
is instantly "pleasured" by the "arrangement"; but no less surely the mind
notes the perfect expression of the universal mother idea, and takes a
second pleasure in the fitness of method and subject. Whistler himself
unbends and admits a valid response beyond the æsthetic in at least one
quoted saying, even while again attacking the mere realist: "The imitator
is a poor kind of creature. If the man who paints only the tree, or flower,
or other surface he sees before him were an artist, the king of artists would

be the photographer. It is for the artist to do something beyond this: in portrait painting to put on canvas something more than the face the model wears that one day; to paint the man, in short, as well as his features; in arrangement of colours to treat a flower as his key, not as his model."

There came after Whistler many seekers for form, for decorative design, and as they experimented and worked through to differently expressed formal order Whistler's example was sometimes forgotten. The *fauves*, the "wild men" of nineteen-five, who wanted their modernism raw, the cubists of nineteen-ten, who approached pure abstraction, and the socially conscious groups of the nineteen-thirties, who wanted "message" in art whether the plastic virtues survived or not, all did their best to discredit him as a pioneer of modernism. The very perfection of his technique, the lovely sensuous charm of his canvases, the low-keyed painting that seemed an anachronism in a high-keyed industrial era, were tagged as weak and superficial virtues.

But it seems likely that there will never come a time when repose and serenity and sensuous loveliness are a detriment to the truest art. These qualities, gained by Whistler in part from study of Velazquez and the Orientals, resulted in a simplification necessary before modernism might embark upon its own search for order. Whistler definitely limited his range of creation by his devotion to quietness and delicacy of statement. But he accomplished the double service of returning painting to a new and almost primitive simplification of means, and of pushing forward to mastery of form-organization in its simpler, or decorative, phase. He accomplished the miracle of making his work a hymn in homage to beauty— considered an old-fashioned idea in the rough-and-tumble, brutal, period of shaping modernism—even while attaining the plastic vitality which is at the heart of twentieth-century painting progress.

Modern art, like the old realistic art, later had its gross, its brutal phase. A certain native refinement in Whistler's painting, a spiritual adumbration, led to his being suspect in the advanced studios of nineteen-ten and nineteen-twenty. But further study of the nature of form, and the discovery that expressionism may involve a spiritual as well as an emotional genesis and be interpreted as spiritual release and communication, have brought the American expatriate of Paris and London again into the lists of approved pioneers of the modern mode.

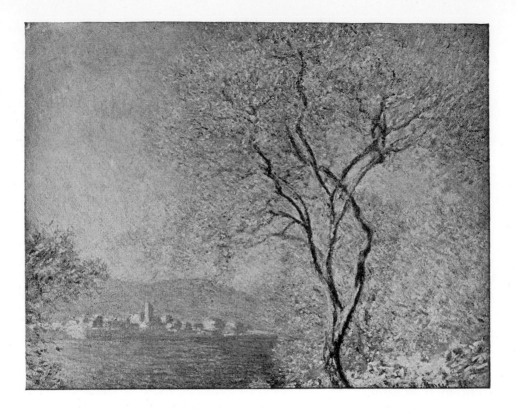

VIII: THE IMPRESSIONIST INTERLUDE,
AND RENOIR

THE Salon des Refusés of 1863, turned by critics and public into a succès pour rire, nevertheless had served to introduce to Parisians the two painters most to be concerned in the advance of revolutionary art during the following decade. Whistler had decided upon London for his studio and his defiant activities. Manet had stayed in Paris, and had become the chief of the insurgents (to Courbet's puzzlement and chagrin) and outstanding purveyor of sensations. But a third phenomenon of the sixties

MONET: Antibes. 1888. *Toledo Museum of Art*

was equally important to the progress of art: the emergence of the founders of the impressionist school.

The name impressionism was not yet invented, and there was hardly a generic likeness in the early pictures of Monet, Pissarro, Bazille, Cézanne, Degas, and Renoir. But these younger men had been thrown together in the years following the Salon des Refusés; and in the meetings of 1866–1870 at the Café Guerbois they arrived at something like a set of principles. Their history and their theories had been entangled at first with Manet's; but even before the war of 1870 the followers had begun to break away, individually, from their leader. It became apparent that Manet was not an outdoor man, that, despite his unpopularity, he was by no means as revolutionary as the *plein-airistes* wanted their leader to be, and that he had ties with a social and aristocratic world to which unpolished or crude youths like Monet and Cézanne could never have access. Thus the war broke up an association already weakened by defections. Manet was to become the studio realist, the logical follower of Courbet. The others, when reunion came after the war, were to establish outdoor impressionism, were then to graduate their own member Cézanne into post-impressionism.

Impressionism proved to be an interruption of the development of modernism. That is, in so far as modernism constitutes a revolution against realism, against the camera eye and transcriptive painting, impressionism added nothing substantially new, and possibly diverted leading innovators into merely a more minute phase of nature-illustration. The founders were entirely outside the progression of form-seeking artists, of those (like Daumier and Whistler) who searched for or intuitively added formal arrangement or plastic vitality at the expense of naturalness. The impressionists, indeed, dissipated structure, lost form in a veil of shimmering colour, and achieved a vitality of a rainbow sort only, on the surface. Yet they served all subsequent painters, including the century-end moderns, in one important matter. They cleansed colour, bringing in that fresh and luminous aspect that so brightens every gallery of pictures painted since the eighties, as compared with pre-impressionist showings. They studied the colour-chemists and colour-physicists, and developed a scientific technique on their way to scientific ends. It turned out that the ends were merely terminal points on the old Renaissance progression toward a scientifically accurate representation of nature; but the technique was passed on to the moderns as a means to purer and more intense expression of their non-

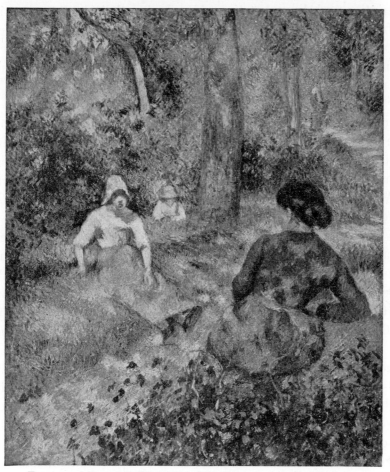

PISSARRO: Peasants Resting. 1881. *Toledo Museum of Art*

realistic, non-representational vision. The "broken colour" of impressionism became a standard painting medium.

Cézanne in a single sentence paid tribute to the most characteristic of the impressionists, Monet, and at the same time suggested the limits beyond which impressionism could not go. "Monet," he said, "is a magnificent eye, but only an eye." Gauguin explained further: "The impressionists searched only with their eyes, and not in the mysterious region of imagination; then they fell back on scientific reasoning." In short, the founders of the school remained substantially within the æsthetic of Courbet and Manet, within devotion to optical truth, within the logic of

transcription and documentation. Abandoning their studios, catching na-
ture fresh and unawares out-of-doors, discovering atmospheres, capturing
rainbow tints and fleeting "effects," they still painted what the eye could
see, and no nonsense about "arrangement" or decorative order, much less
any vague talk of mystic realization.

Two men, Claude Monet and Camille Pissarro, were the active founders
of the impressionist school. Pissarro, with the lesser talent, was born at St.
Thomas in the West Indies in 1831, of a French Jewish father, a hardware
merchant, and a Creole mother. He was educated in France, returned to
the West Indies to serve in his father's business, and went again to Paris,
to study painting, only at the age of twenty-three. He was attracted by the
silvery landscapes of Corot, and he learned more from that master than
from any art school or teacher. A gentle and kindly man, with a warmth of
personality and feeling to be traced partly to his Creole blood, Pissarro
made friends successively with the several younger artists who were to
form the impressionist group, and perhaps served more effectively than
any other of the innovators to make a major movement of the *plein-airiste*
trend.

Corot's example and advice confirmed him in his peculiarity of painting
out-of-doors. He abandoned Paris—insanely, as other students of his age
thought—and worked in country villages, especially Montmorency and
Louveciennes. A landscape of his found acceptance at the Salon of 1859,
but he was seen again only at the Salon des Refusés in 1863. Thence-
forward Manet was to exert strong influence upon him for half a dozen
years, especially in the lightening of his palette. From 1866 to 1869 he
was one of the group of artists who met regularly at the Café Guerbois;
though toward the end poverty and his predilection for the country con-
spired to make his attendance less frequent.

At this time he was painting in accordance with the advanced realistic
trend of Manet's followers, attempting to do in rustic scenes, and in the
open air, what Manet was doing with figure-studies in his city studio. To
be detected in his work was something of Corot's clarity; something too
of Courbet's matter-of-factness, and especially Courbet's abandonment of
the naturally pretty or picturesque scene; and Manet's brighter colouring
and denial of chiaroscuro.

Pissarro had no interest in fighting, and as the Germans approached
Louveciennes on their march to Paris in 1870 he and his wife and two

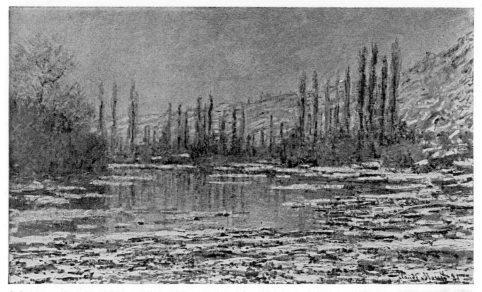

MONET: Ice Breaking Up. 1881. (Courtesy Durand-Ruel Galleries, New York)

children fled from their home, abandoning incidentally hundreds of unsold paintings. The better part of the years 1871–1872 he spent in England, where Turner and Constable determined his future development. Pictures of this period mark perfectly the transitional phase, between the Pissarro of the Courbet-Manet period and Pissarro the impressionist. There is no brilliant colour; there is hardly any colour, one might say. There is no more suggestion of the broken-colour technique than could be found in Constable's pictures of the period fifty years earlier. At this moment a restudy of Constable, and particularly the inspiration of Turner's brilliant improvisations, proved decisive. Monet too was in London, and the two Frenchmen, testing their vaguely revolutionary ideas by the pictures of the two English innovators, saw the vision that was to crystallize two years later into impressionism.

Claude Monet had been born in Paris but had been taken in infancy to Le Havre, where his father, a grocer, set up in business. At fifteen the boy was so proficient in draughtsmanship that his portrait drawings were shown in the windows of a stationer's shop. The marine painter Eugène Boudin saw them and encouraged the youth, taking him out as companion when he painted in the open air. Thus early the most consistent of outdoor

painters learned his *métier*. At sixteen he exhibited a painting at Rouen. Before he was drafted for two years of African service in the army, in 1860, he had come under the remote influence of the Barbizon landscapists, especially Daubigny, Millet, and Troyon.

Invalided home after his army service, Monet found his sensible family still opposed to his ambition, and he then also suffered the first of a long list of official snubs, when the Municipal Council of Le Havre refused him a scholarship for study in Paris on the grounds that he was "not serious." He managed to get to Paris, however, in 1862, after being further encouraged by another marine and landscape painter, the expatriate Dutchman, Johann Barthold Jongkind, who was to be counted one of the marginal impressionists twenty years later.

In Paris Monet studied with Troyon, of the late Barbizon group, and at least learned something of steadiness and honesty. Then came a period of attendance at the Gleyre studio, where the teaching did not impress him. Gleyre said: "Nature is not bad to get themes from in sketching, but it is of no interest otherwise." But in the classes history was made through his association with Pissarro, Sisley, Bazille, and Renoir. Their circle drew in Cézanne, and it was then that they went on to form, with the already celebrated Manet as their leader, the insurgent *bloc* that met at the Café Guerbois. Through Pissarro especially, Monet became a disciple of Corot, and for a time it was Corot's influence that was most discernible in his landscapes. Then admiration for Manet led him to copy that realist's manner. A *Déjeuner sur l'Herbe* followed by a typical Manetesque figure piece entitled *Camille* showed the youth aping the older man's style shamelessly. Manet exclaimed: "The fellow isn't content to steal my name, he takes my pictures too!" But he soon befriended the younger man, and he was later to help save Monet from starvation by stimulating undercover buying of his works.

At this time the several painters who were to found impressionism exerted influence upon one another, so that it is impossible to trace to any one the discovery of the principles or the first practice. The new thing was still Manet's colourfulness and his system of matching tones without serious regard for chiaroscuro. When Monet first appeared at the Salon, in 1865, his two pictures were most like Boudin and Jongkind, with a hint of Manet over all. In other paintings he was still paying tribute to Corot. And in 1865 he hardly could have been untouched by the brutal honesty of Courbet, or the colour harmonies of Whistler.

Monet: Argenteuil-sur-Seine. 1868. *Art Institute, Chicago*

Manet and Whistler were already showing the surface influence of Japanese art, but Monet seems not to have felt the influence in a decisive way until he stumbled upon a collection of the colour prints in a shop in Holland while a refugee in 1870. He had fled, like Pissarro, from the possibility of conscription to fight against the Germans. Shortly he too arrived in London. His pictures up to that time had been hardly more colourful or "impressionistic" than Pissarro's, though the *Argenteuil-sur-Seine*, at Chicago, painted in 1868, has hints of freshness and vibrancy new in French art.

The two returned to France in 1872. They had bathed in the light of Turner's dazzling sea-pieces, and they had found their wildest visions of a colourful art justified. They determined to revolutionize Western painting by rescuing art from the studios, by bringing artists to the worship of light, by enthroning colour.

Their companion Bazille had been killed in action, and Manet had returned frankly to studio painting (and was, moreover, a deserter to a more fashionable café, the sort of place to which poverty-stricken and shabby outcast painters could hardly go regularly). But Renoir and the English-born Sisley were quickly re-enlisted. Monet and Pissarro set up in country villages. Cézanne soon joined them.

At first Monet outstripped his companions in disintegrating objective nature, in losing solids in fluttery, wavering strokes of the brush, and in tentatively disintegrating colour. In 1873 for the first time, perhaps, he went beyond Manet in the freshness of his colouring. Pissarro and Renoir were similarly experimenting, but in that year it was Cézanne who was the most masterly of the impressionists, playing colour harmonies most gaily and creating atmospheric envelopes (though he disintegrated natural forms only in so far as he pleased, stressing instead certain structurally useful elements, and never losing the spine of his picture). Sisley, Degas, and Berthe Morisot, a sister-in-law of Manet, were pushing forward in various individual ways. Manet encouraged this newest insurgent group and helped the members to plan their first exhibition, but he abstained from showing with them.

The exhibition opened at the galleries of one Nadar, a photographer, in the Boulevard des Capucines on April 15, 1874. The newspapers gave the show an impressive amount of space. The opinion of the critics was that a good time, even a hilarious time, could be had by all comers. The people of Paris flocked to the galleries.

It was Louis Leroy, critic of *Charivari*, who gave the impressionists their name. One of the exhibited pictures had been entitled by Monet *Impression: Soleil Levant*. Leroy took the suggestion and captioned his review "*Exposition des Impressionistes.*" What he wrote was calculated to make the impressionists immediately famous: "This painting, at once vague and brutal, appears to us to be at the same time the affirmation of ignorance and the negation of the beautiful as well as of the true. We are tormented sufficiently as it is by affected eccentricities, and it is only too easy to attract attention *by painting worse than anyone has hitherto dared to paint.*"

The first historic exhibition of impressionism covered more than the purist members of a school, since all shades of advanced realism, including the seaside transcripts of Boudin and the Manetesque studies of Berthe Morisot, were represented. But it gave the public its first comprehensive

PISSARRO: Montmartre in the Spring. 1897. Collection of Sydney W. Brown,
Baden, Switzerland
(Courtesy M. H. DeYoung Memorial Museum, San Francisco)

look at the pictures of the insurgent leaders, bringing together Monet,
Cézanne, Pissarro, Renoir, Degas, Sisley, and Guillaumin. It was the con-
sensus that Monet, Pissarro, and Cézanne were the worst offenders.

A second exhibition followed in 1876, in the Rue Le Peletier, and
critical and public abuse was not one bit abated. The critic of Figaro wrote:
"The Rue Le Peletier is an unfortunate street. The Opera House burned
down, and now a new disaster has fallen upon the quarter. There has
opened at Durand-Ruel's an exhibition said to be of paintings. The inno-
cent visitor enters and a cruel spectacle startles him. Here five or six luna-
tics, one of them a woman, have elected to show their pictures. There are
visitors who burst into laughter when they see these objects, but, for my
part, I am saddened by them. These so-called artists term themselves
intransigeants, impressionistes. They take paint, brushes, and canvases,

throw a few colours on the surface at random, and sign their names. In the same way insane persons pick up pebbles on the road and believe they are diamonds."

Thus was that painting which thirty years later was to become the favourite art of museums and collectors received in Paris, the art centre of the world, with a chorus of insults and abuse. It may be noted, however, that the impressionists had found in Durand-Ruel a dealer who, as far as his moderate means permitted, would show this insane new work and even buy some of the pictures.

Monet and his family were near starvation many times in the following ten years, and others of the group, including Sisley, Pissarro, and Renoir, actually felt the pinch of hunger at times. One winter Monet and Renoir came to the point of subsisting upon the potatoes they had themselves grown. Long afterward Renoir confessed that he would have quit painting as a profession then had it not been for the example of Monet's fortitude and faith. In those years a few eccentric buyers besides Durand-Ruel occasionally took canvases, at extremely low prices. There was one who kept a restaurant and would exchange meals for pictures; another was a co-operative colour-seller. Twice, in 1874 and 1877, the impressionists put their pictures up at auction but fared badly, hardly covering sale-expenses.

Persisting because no member of the group had anything to lose, the impressionists put on their third show in 1877. This time the other types of realism had been eased out and impressionism stood naked before the public. More colourful than before, more careless of nature's structure and detail, more "fuzzy," it again drew storms of ridicule. The public came; indeed it had become fashionable to attend these strange affairs and to laugh and scoff. Weight was lent to the popular and critical abuse when the *Chronique des Arts* said of the impressionist works: "One must see them to know what they are like. They provoke laughter, and yet they are lamentable. They display the profoundest ignorance of drawing, of composition, of colour. When children amuse themselves with a colour-box and paper they do better."

Cézanne, who had been absent from the second exhibition, was now picked upon with exceptional bitterness. His sixteen pictures, including ones later regarded as superb examples of his genius, were considered by the critics to mark him as a sort of monster among painters. "Lunatic!" and "Mountebank!" were common exclamations before his pictures. Perhaps by affording the extremest example of non-conformity and daring—

he had already gone beyond the confines of impressionism—Cézanne was serving to make his companions seem a little less outrageous and childish.

And indeed a change was to follow, but not for Cézanne. He was to be absent from all the succeeding shows of the impressionists and was to exhibit only one painting publicly in France during the eighteen years to follow. While he was thus driven into lone exile, with his notions of combining impressionist colouring and creative form-organization, Monet and the others went on to other exhibitions, showing their works each season from 1879 to 1882. In 1880, moreover, Monet held a one-man show and sold a painting, a true impressionist work, for four hundred dollars. It was purchased by a friend, to be sure; but for a painter who had been accustomed to peddle his pictures at ten dollars apiece it was an epoch-marking event.

In 1883 it was becoming apparent that the impressionists had something to say after all, and a few collectors began to buy cautiously. By 1886 the Americans, enlisted chiefly through Durand-Ruel, were buying freely, and the struggle was over for Monet and Pissarro. (Renoir had found moderate prosperity a few years earlier, through portraiture chiefly; he had been re-admitted to the Salons, and had dropped some of the impressionist mannerisms.) Impressionism had been established. The leader Monet was able to buy a home in the country, where he created a garden which became almost fabulous in the annals of early twentieth-century art. He gave up all but landscape painting, and he perfected further the rainbow tinting and the fluttering unsubstantiality that came to spell truest Monet and realest impressionism. Pissarro and Sisley carried on by his side and there were recruits as the popularity of the group increased: the able Dutch painter Jongkind, the French Raffaelli, two Americans who were destined to flirt with impressionism and then turn back to more substantial painting, Mary Cassatt and John Singer Sargent. By 1890 there came the deluge of foreign students who wanted to learn the new way of art, Americans, Scandinavians, Germans, even Italians.

Opposition, even bitter opposition, did not end, of course, simply because the impressionists found both a market and fame. Gérôme, the perfect academician, who was old enough to have opposed Delacroix in the mid-century, and Courbet in the fifties and Manet in the sixties, continued his official persecution of the impressionists until his death in 1904. He visited an exhibition of Monet's canvases in Paris in 1895 and remarked before one picture: "A blank canvas, bought from the dealer and put in

a frame—nothing more! Absolutely nothing! One looks at it, one sees nothing—and you know that sells very dear. It is too grotesque!"

The later story of the impressionist leaders is short and in general pleasant. Monet became greatly prosperous, went when and where he pleased to paint, and lived on in honour and riches until 1926, though he was overtaken by near-blindness in the last years. Pissarro scored his success more slowly, but found appreciation and a fair material reward in the nineties, though he too became nearly blind before his death in 1903. His uprightness, his warm-heartedness, and his patriarchal bearing made him outwardly the co-leader of the movement with Monet; but it became clear that his paintings were destined to a place lower than Renoir's and Cézanne's, and certainly lower, as impressionism, than Monet's.

Sisley fared less well. Born to luxury, he had found himself impoverished during the long struggle to establish impressionism as respectable art. He felt the pinch of hunger even after the others had prospered, in the nineties, and he died tragically in 1899. Ironically, within three months he was posthumously famous through the sale of the pictures he left, a sale that made his heirs rich and provided dealers with material for profitable speculation. Another member of the impressionist group, Armand Guillaumin, who had felt it unfair to starve his wife and children for the sake of art, and therefore had clerked on week-days and painted on Sundays, had the luck in his fiftieth year, in 1891, to win fabulous riches (for an artist) in a lottery. Thenceforward till the day of his death he painted in the lands he had dreamed of during his years of enslavement, on the Riviera, in Holland, in the château country of France.

But French impressionism had been at its best in the early years, from 1873 to the mid-nineties. It had been richest in lasting values when Cézanne and Renoir were of the group, before they drifted away, the one to become the prophet of post-impressionism, the other to score independently as a painter restoring to realism the sensuous glamour and feminine warmth that had gone out with Boucher and Fragonard. By 1880 Monet and Pissarro were the true impressionist masters, and in the following fifteen years they accomplished the best of which the method was capable.

Impressionism had grown slowly. Hints of its coming can be detected in canvases of masters in several countries, of Titian and Tintoretto, of Velazquez and Goya, of Watteau. Corot had been a link. Manet had taken a decisive step in abolishing conventional chiaroscuro and experimenting in colour-harmonizing in the sixties. But essentially the movement

SISLEY: Banks of the Seine. *Phillips Memorial Gallery, Washington*

dates from the years 1870–1871, when Monet and Pissarro studied the works of Turner and Constable in London. In 1873 and 1874 the true impressionist brilliancy becomes apparent. Cézanne has brought in his contribution of colour from the South. Renoir joins in, with a talent already predisposed to fragile colour and light, wavering effects. Before 1880 Monet has gone over fully to the theory of broken colour, and has explored all the possibilities of unscientific divisionism. His railway-station pictures of 1876–1877 are perhaps as fine as any series he ever painted. In the eighties and nineties the colours become fresher, more opalescent. The Vétheuil series of 1880 and the following Étretat series are among the most brilliant and most characteristic, and lead on naturally to the Riviera views of the late eighties, the Rouen Cathedral variations of the nineties, and the famous studies of the London bridges and the House of Parliament of the opening years of the new century. After that, in the interminable garden views and water-lily sketches, even the last vestiges of

pictorial structure are lost, and impressionism appears at its weakest and final ebb.

A paradox of impressionism is that its characteristic tendency (toward vibrating or glittering colour, and toward ephemeral aspects of natural lighting) led away from concern with structural form and plastic vitality; and although impressionism seemed to the critics and the public of 1870–1880 to embrace the wildest sort of unorthodoxy, and to the same people in 1885–1900 to be the fulfilment of France's dream of a modern art, it was really one more bypath in the territory staked out by the Renaissance realists of the fifteenth century. It led its doctrinaire devotees directly away from the paths that were to converge in post-realistic modernism. It became one more phase of scientifically true, nature-bound art.

Monet was bigger than Sisley, Guillaumin, and even Pissarro, in that he found in the pure impressionistic means a sort of binding atmosphere, a unifying harmony of colour, as in the Thames series or the comparatively early series of landscapes and river scenes at Vétheuil. He is the more important, perhaps, because he added to impressionism at times a small measure of formal vitality gained out of those very elements impressionism in general was discarding. At a moment in the seventies when he had been fascinated by Hiroshige and Hokusai he painted Parisian street scenes that indicate a groping toward formal order, a feeling for the effects of patterning and disposition of plane that Whistler had absorbed into his art so beautifully a decade earlier. He adopts too the device of the high horizon line borrowed by so many European artists from the Japanese at this time. There is in certain pictures a suggestion of that quality in Hokusai's work which has led some Western writers to speak of the Japanese master as an impressionist, on account of a disarming spontaneity and subject matter caught seemingly "on the wing," without pose.

But the devotion, on Monet's part, was fleeting, and only in colour is there evidence that he gained permanently from the Orientals. He loses immediately the Oriental decorativeness, the abstract order, the spirit that is suggested where the realist holds to statement. Some of the biographers of Monet have written that he brought to the West the Eastern way of art; but it is only in externals, bright colour and informality of view, that the statement holds. Simply in putting Monet down as greatest of the impressionists, one grants him first place among original and exceptionally pleasing painters; but at the same time one implies strict limits to his creativeness, and exclusion from that small company of Western moderns

MONET: The Gare Saint-Lazare, Paris. 1877. *Louvre* (Druet photo)

who deserve ranking with the Orientals, a company in which Cézanne is central.

The impressionists, then, completed the cycle of Renaissance realism. What Masaccio had dreamed of inventing, in 1425, an art of verisimilitude, an art true to optical law, an art of correct representation and of un-challengeably natural aspect, had been evolved, improved, and refined through four and a half centuries. Leonardo had opened men's eyes to new scientific accuracies, Raphael had somehow ennobled common aspects, Velazquez had shown not only natural objects but an envelope of light, the Flemish masters had traced down circumstantial truth to its last hiding-place in unimportant detail, Holbein and Dürer had accomplished miracles of absolute recording, and most recently Goya had learned to paint something of the sitter's psychology along with the outward features. The immediate predecessor of the impressionists, Courbet, had brought realism back to a matter-of-fact basis, after Ingres and his pupils had

pulled it in the one direction of cold intellectual statement, while Dela-croix and his disciples were pulling it in the other direction of over-heated and dramatic action. From Courbet's fresh (and materialistic) objectivism Manet had moved on to sophisticated lightness of touch. But the impres-sionists capped the progression by carrying the logic of realism to an incon-trovertible conclusion. Objects in nature are seen, they said, only by virtue of the light that strikes them; therefore the search for a true way of visual representation must lead the artist to a primary study of light. Get the lighting scientifically, and you get all. Colours are ways of light, or divisions of light. What the painter had on his palette was an assortment of pig-ments that had seemed to match the local colours on objects. Take the mind off the object, take the mind off pigments. Think of colour as varia-tion of light, think of the picture as a tissue of light-hues.

The name "impressionism," bestowed casually by a journalist, was a misnomer except for its implication of an aspect swiftly caught. There is nothing of sketchiness or short-cutting of means in a Monet canvas. Never did artists strive over a technique of painting more painstakingly than he and Pissarro and Sisley did. A certain slightness of subject obtains, because almost the sole material of the school is landscape, and usually a bit of landscape in a certain evanescent phase of lighting. But every stroke of the brush, every touch of pigment, is put in mindfully, according to a pre-conceived harmony and (if one be truly scientific) a codified system of paint application. It is the nature of this painting technique, its special intent, and its exactness, that the name "impressionism" fails to suggest. The word, in short, is true to the new way of looking at nature, of taking in a scene only as it impresses itself upon the optic nerve, as a momentary sensual imprint; but it wrongly implies a casualness in the painting process, a reliance upon capricious effects, upon a vagarious brush.

Broken colour, the technique of divisionism, was introduced by the impressionists in an effort to give their colour-studies a vividness which had been impossible of achievement under the old order of painting. They observed that colour as light was brighter than any painter with mixed pigments had been able to show it (though Turner in an unscientific way had stepped up brilliancy in sunsets and sky scenes until he scandalized orthodox artists). Colour was known through spectral analysis to be re-ducible to three primary hues, yellow, red, and blue, with orange, violet, and green occurring where these others overlapped. Other hues, less pure, might be obtained by further overlapping or mixing. Painters had tradi-

tionally mixed hues on their palettes, before transferring the pigment to the canvas. Even after the custom of mixing black with the pure colour, to reduce its intensity, had gone out—an advance to be credited partly to Manet—it still was evident that a certain amount of dullness or dirtiness came into most palette-mixed colour. The impressionists discovered that they gained vividness if, instead of mixing blue and yellow on the palette, for instance, to form a green, they placed side by side on the canvas little streaks of blue and yellow, leaving it to the observer's eye to merge the two primary hues into the one derived hue, a phenomenon occurring as soon as the observer stepped back the proper distance. In effect the artist had foreseen the colour he wanted, had decomposed it while putting it on the canvas, and had left it to the observer's eye to recompose it while regarding the picture.

This decomposing of the colours (where they had been ready-mixed on the palette before) gave the technique its name "broken colour" or "divided colour." And it gave painting in general a brilliance, a glittering colourfulness, a chromatic freshness, it had never before known. The impressionists, indeed, came to a rainbow loveliness intoxicating on its own account, and it is little wonder that they occasionally wandered off into colour improvisation of a nebulous sort, giving too little heed to the claims of structure. They played with their new toy and a little forgot that subject does count and that colour is only one of the elements contributing to plastic order, to decorative order. As a matter of fact they followed out their own rules for divided-colour application only in *parts* of their canvases. In the years 1886–1890 the neo-impressionists Seurat and Signac were to reaffirm the importance of broken colour, and to insist upon a scrupulously pure science of divisionism; and they pointed out that the average Monet canvas was more than one-half painted in palette-mixed pigments.

At its best an impressionist painting is not a coloured copy of a scene in nature but a luminous web of harmonized colour, a chromatic veil. No longer are shadows blackened. Shadows harbour the multitude of hues naturally resident there. Forms disappear in atmosphere, light becomes iridescent, solidity fails. So complete was Monet's absorption in the values of light that he painted extensive series of pictures of the same subject, the difference lying in the time of day or the weather prevailing at the moment each picture was projected. His many views of Rouen Cathedral are hardly distinguishable in memory, but placed side by side show subtle variations

of lighting. The effect of light was for Monet the picture. There are serial
pictures of the Thames, of haystacks, of the Seine filled with floating ice,
of water-lilies, etc., all dependent upon minor differences of chromatic
lighting, of mist-veiling and sun-intensity.

The earliest post-impressionist rebel, Cézanne, saw through this innova-
tion and rightly labelled it as merely another variation of nature-docu-
mentation. Renoir and Degas seceded from the school for less profound
reasons. On the side of the artist's way of seeing and in theory, the im-
pressionists had made no advance toward twentieth-century modernism.
But their colour investigations, their push forward to pure colour, had
opened the way for creative use of that element within the full orchestra-
tion of plastic means. Although Cézanne began his search for formal order
before 1870, and was then already distorting nature for formal purposes—
he thus might be said to have been a post-impressionist years before im-
pressionism matured—he could not have arrived at his ultimate creative
use of colour for plastic ends if he had not been a fellow-traveller with the
impressionists in their period of colour purification from 1872 to 1877.

Part of the post-realistic belief is that art's medium should be declared,
not disguised. If colour is one's vehicle, one should proclaim colour as such.
The colourfulness of impressionism lasted over into practically all the
twentieth-century varieties of modern painting. Every stroke or area of
colour, moreover, was then known to have its value as movement factor,
pushing forward from the picture plane or drawing the observer's eye
deeper into pictorial space. The school of Monet and Pissarro, unaware of
this effect, was therefore classed by the moderns as the last phenomenon
of realism. It was noted that there are elements of grandeur and profound
rhythms possible to the painting art which are not to be caught in mere
chromatic transcripts. And neither the subject that is of deep significance
nor the abstract invention that gives art its most moving effectiveness is to
be found consistently out-of-doors.

Painting as an art had needed the tonic of *plein-airisme*. It had needed
a purgation of mud from its colour. And it had needed a corrective for
over-mechanical composition and studio posing. But a tonic and a cor-
rective that left the patient still with the inherent weakness of realism
carried on only a small way toward the reconstitution of art. The cure had
stopped with reform of the artist's eye, with substitution of atmosphere
for solids in nature. Three men who in their early years conspired and

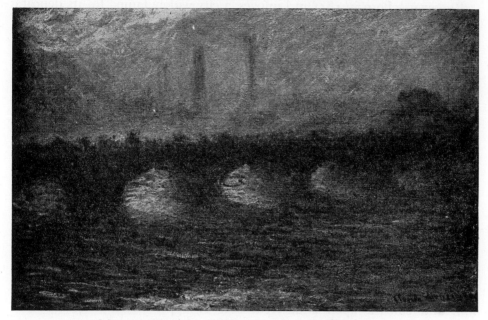

MONET: Waterloo Bridge, London, Twilight. 1904
(Courtesy Durand-Ruel Galleries)

exhibited with the impressionists, Cézanne, Degas, and Renoir, turned back to substantiality—and trained the inner eye as well as the outer to image in new ways.

In the eyes of the devout or pure impressionists, Auguste Renoir was a backslider. His backsliding began in the late seventies, and he was untrue to his sometime companions in various ways from then until his death in 1919. He returned to studio painting, to portraiture and figure painting, and to "solid" composition. He returned to the Salon. He even accepted the ribbon of the Legion of Honour. He had come to the conclusion that he "had wrung impressionism dry." He felt that Monet and Pissarro and Sisley were limiting themselves, keeping self-consciously within a school and a formula. "There is in art not one process, no matter how important, which can safely be made into a formula," he wisely said; and "there is a quality in painting which cannot be explained, and that quality is the essential." Having escaped the formula he went his own way, enriched by the palette of the *plein-airiste* group; and he became a greater artist than any other of the fellowship excepting only Cézanne, who also backslid, into even greater unorthodoxy.

Renoir was born in 1841 in Limoges, a city widely famed for its delicate chinaware. His father, a poor tailor, took the family to Paris to live when the child was four. As soon as Pierre-Auguste, as a boy, showed a talent for drawing, his parents apprenticed him to a porcelain manufacturer, and he spent four years painting floral motives and decorative figures on cups and plates. This early work entailed study of the traditional ornamental painters of France, and the youth formed an attachment for Boucher, Watteau, and Fragonard which affected all his later work. When he was seventeen the use of mechanical methods of printing designs upon porcelain drove his master out of business, and he turned to the painting of fans, where again Watteau and Boucher yielded motives for copying and adaptation. A third business experience, the painting of religious pictures on window shades—mostly for sale to missionaries bound for Africa— proved more profitable. Because of his superior facility in drawing, Renoir was able to earn larger sums than even the most experienced of his fellows. By the time he was twenty he had saved enough to put business behind him and embark upon a different sort of apprenticeship. He entered Gleyre's studio.

There followed the association with Sisley, Bazille, and Monet, and then the meetings at the Café Guerbois. A shy and quiet youth, though sunny by disposition, Renoir was hardly more deeply involved in the café talks than was Cézanne; but in his work he followed the general drift, within the influences of Corot, Courbet, and especially Manet; and he in particular admired and learned from Diaz.

In 1864 the Salon jury accepted one of his paintings, one notable as being the last that he darkened with bitumen. He was represented in the Salons again in 1865 and 1867. Between 1865 and 1870 he went into the open air with the members of the radical group, but he never was able to get the human element out of the landscape as the others did. He was destined never in his life to get far away from that portion of humanity which interested him almost to the point of obsession—woman. Courbet at this time was painting women too, but Renoir shied away from the elder painter's materialism and literalism. Of Courbet he exclaimed to Vollard: "I wish you could have seen the studio he fixed up to 'do' nature in, with a calf tied to the model stand!" Although he adopted the realistic attitude of Courbet and Manet up to a point—"the common things are good to paint"—he was making distinctions in accord with a personal code and a personal taste. Already he was devoted to women, to flowers, to children:

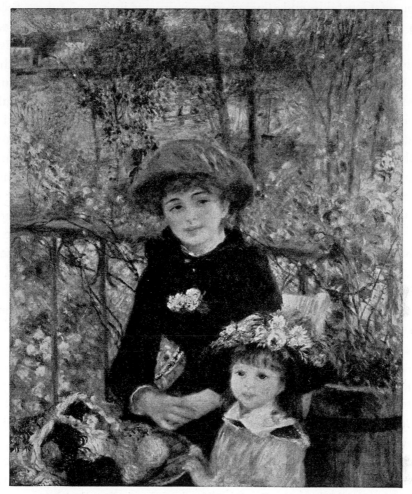

RENOIR: On the Terrace. 1881. *Art Institute, Chicago*

to all that was fragile and effeminately charming. Already there were rose petals in his brush.

In 1870 Renoir served in the army, but far from the battle zone. In 1871 he returned to Paris during the turbulent period of the Commune. Suspected at first, he found privileged security when he discovered that the communist Prefect of Police was a man to whom he had done a signal favour years before. He set up his studio in Paris and was painting happily when the Versaillais ended the Commune and bloodily restored peace. By 1872, when Monet and Pissarro returned from their historic visit to the

shrine of Constable and Turner, Renoir was painting pictures "lighter" than Manet's and already hinting at the rainbow palette which some critics insist was his rather than Monet's gift to impressionism. The *Canoeists at Chatou* of that year, now in the Lewisohn Collection, exhibited an animation of touch and a vibrancy of light unprecedented in French painting.

During the next five years Renoir was a leader in the battle to establish the impressionist school, without quite subscribing to the doctrinaire principles of Monet, Pissarro, and Sisley. At the height of his enthusiasm for the cause, he painted pictures which rivalled Monet's in every impressionistic virtue, while refusing (usually) to be drawn into that sort of compositional vagueness that put first value upon the veil of light over a subject rather than upon the subject itself. A famous series picturing the life of Parisian pleasure-seekers at canoeists' resorts on the Seine culminated in *Breakfast of the Canoeists*, of 1879, now at the Chicago Art Institute, and the more elaborate picture with the same title of 1881, now in the Phillips Memorial Gallery.

Renoir had occasionally made portraits on commission, by way of penance, he said, and in this period he began seriously to cultivate the field, with the painting of the *Portrait of M. Choquet*, of 1875, going on to the lovely and "fashionable" commissioned portraits that drew down on him the suspicions and the mistrust of the one-hundred-per-cent *plein-airistes*. He also did his famous *Le Moulin de la Galette* (1875), and began the long series of studies of girls, seldom in this period completely undressed but with the delicate and light-touched flesh effects which were to lead on to the sensuous nudes of the nineties. Through all these subjects—all objective, it may be noted, without intellectual appeal or moral intent or "idea"—he was perfecting the joyful painting that has made him a distinctive figure in latter-day art, heightening the feeling for gratifying, even voluptuous, qualities of paint and the relish for femininely lovely aspects of nature.

For Renoir 1879–1880 were memorable years. Owing to the financial help of Durand-Ruel and then to the friendship of Mme. Charpentier, who had established a fashionable salon, he was already escaping from the poverty that had hindered him, without seriously depressing him, since his student days. He had a picture at the Salon again in 1879, though there was much wagging of heads over its "wildness"; he married, took a studio in Montmartre, and travelled extensively, to Algeria, to Guernsey, to Venice and Florence and Rome (where Raphael especially delighted

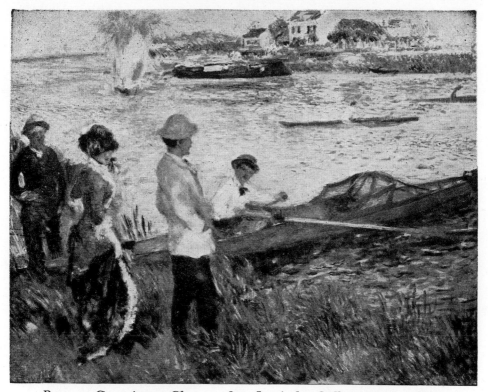

Renoir: Canoeists at Chatou. 1872. *Lewisohn Collection, New York*

him). He threw off the typical impressionist vagueness, although he retained a characteristic soft touch of his own, a distinctive rosiness and caressability. Nevertheless, the critics were to be talking shortly about his "hard" period. In the mid-eighties, indeed, his silhouettes have an unaccustomed exact edge, though there is never an isolated outline. Linear draughtsmanship was no part of his equipment or painting method.

Renoir, unlike Manet, Degas, and Whistler, was little affected by the current vogue of Japanese prints. The general influence, toward colourfulness and toward the utilization of patterning for plastic effect, could hardly be escaped; and one may be sure that the *Portrait of M. Choquet* would not have been so decoratively composed, or *The Loge* so full and rich and so successful as "space-filling," if there had been no Parisian homage to the Orientals. It was characteristic of Renoir that he resisted the

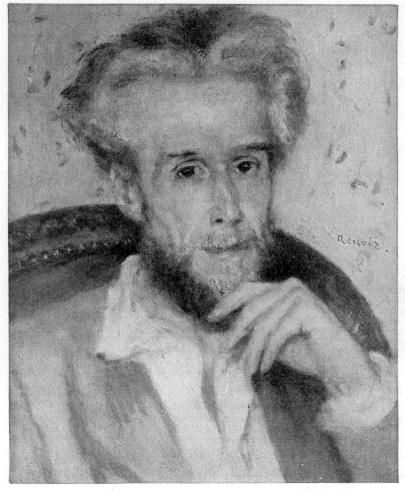

RENOIR: Portrait of M. Choquet. 1875
(Courtesy Durand-Ruel Galleries, New York)

influence, for he always had independent views and a childishly obstinate dislike of efforts to broaden his outlook. In any case, his devotion to Boucher and Watteau, plastically very slack painters, and to what he considered typically French painting, led him to deny the Orientals. In later life he said to Vollard: "Japanese prints are most interesting, as Japanese prints . . . on condition that they stay in Japan. No people should appropriate what does not belong to their own race." And so Renoir remained outside the little group, of Whistler, Manet, and Degas, and later van Gogh and Gauguin, that absorbed the essence of Oriental plastic design,

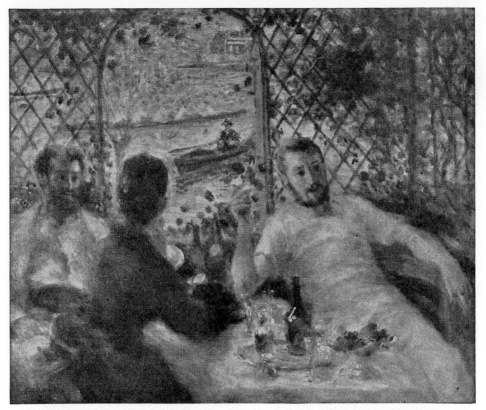

RENOIR: Breakfast of the Canoeists. 1879. *Art Institute, Chicago*

and passed on to the twentieth-century moderns a knowledge of and feeling for decorative rhythm and formal order. Renoir became the most French of the nineteenth-century painters, and became the greatest of the century-end realists; and he came to dislike Degas, Seurat, van Gogh, and others who seemed to him to have gone perversely outside the national tradition.

As his style took shape in the characteristic nudes of the eighties and nineties Renoir might have been recognized (though official French art circles were still blind to him) as inheritor from three major French schools. He combined the fragile, voluptuous spirit of Boucher and the other *fêtes-galantes* painters with something substantial out of the colourist tradition of Delacroix (who similarly rejected linear draughtsmanship, and had a predilection for red); and he added richly out of the technical means of impressionism.

The assimilation and integration of these elements was instinctive rather than studied. Renoir had an eye for seductive colourfulness in nature, a deep personal love of sensuously beautiful textures, and a richness of paint-quality that had grown consistently from the day when he destroyed his last bitumen-blackened canvas. Now in his maturity he showed himself a master within the limited field marked out by his tastes and his instinct for pretty idealization. He is all roses and sunlight and sweet feminine flesh. He spent twenty years, roughly from 1880 to 1900, painting the women of Montmartre, and he set them forth as healthy, radiant, lovely, even innocent; and this was the same Montmartre which Toulouse-Lautrec in the identical years was depicting as tawdry and vicious, the home of degenerate men and gaudy or evil women. There is self-revelation in Renoir's saying, in reference to Velazquez, that "the whole art of painting is in the little pink bow of the *Infanta Margherita* in the Louvre."

Renoir was for years troubled with rheumatism, and finally crippled by it. Early in the new century he went to the South of France to live, and from 1907 he had at Cagnes on the Riviera a home that became a Mecca for admirers and artists. From 1911 he was able to get about only in a wheelchair. His delight in painting never diminished. In the final years his stiffened fingers refused to hold the brush, but a nurse strapped it to his wrist and squeezed colours on a palette, and he painted with the old gusto—nudes, abounding nudes, fat nudes, red nudes. It is only charitable to remember the artist's age and his crippled condition in judging the latest works: a man past seventy, without the use of his hands. The paintings bespeak an iron spirit and a passionate devotion to art. But as pictures they betray faltering powers. Even the most unfortunate canvases of the final years, inferior but bearing a name become celebrated, brought prices in four and five figures, as compared with the ten to fifty dollars asked by the painter for the gorgeous works of the *Canoeists* period.

Renoir died at his home in Cagnes in December 1919. Only a few hours before, he had been talking of another picture he must paint. Three years earlier, when he was seventy-five, he had called his biographer, Ambroise Vollard, into his studio, where he was arranging dahlias, and said: "Look, Vollard, isn't that almost as gorgeous as a Delacroix battlepiece? I think this time I've got the secret of painting! . . . What a pity that every bit of progress that one makes is only a step toward the grave! If only I could live long enough to do a masterpiece!"

The twentieth century has counted as masterpieces many of the can-

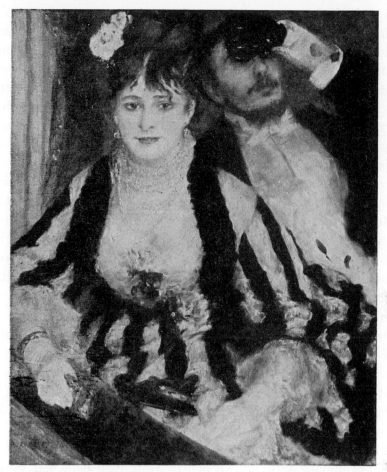

RENOIR: The Loge. 1874 (Courtesy Durand-Ruel Galleries, New York)

vases of the genial Renoir. Even when modernism as a movement seemed to be taking a direction away from his limited field of achievement, few artists or critics cared to deny his stature. His paintings are prominent in every gallery of modern art except those devoted exclusively to the abstractionists. As master of the formal elements, of plastic order, he is the least significant figure among those commonly rated as leaders in modern painting: without the formal inventiveness of a Cézanne or a Seurat, and inferior as regards design even to Degas and Whistler and Gauguin, who sometimes are put down scornfully as "only modern in the decorative sense."

And indeed this accomplished painter of the fascinating aspects of
femininity began as a realist and ended substantially as a realist. His claim
to a place just within the edge of the modernist field lies in a certain syn-
thesizing power, a method of rendering a picture sensuously all of a piece,
in a way unknown to Courbet or Manet or to a thousand followers. By
colour and texture he gave unity to a picture otherwise weakly handled
(as regards the plastic elements). His studies of women and of flowers are
usually harmonies in rose with a multitude of subordinated hues caught
in a tissue beneath. Or it may be instead a harmony in blue, as in *The
Loge*, or *The Swing*, or *Le Moulin de la Galette*. The rainbow aspect of
the impressionist canvas is here restrained within limits of a master hue;
and the divisionist separation of colour is modified so that it is impossible
to say without minutest examination whether the artist mixed his colours
or laid them side by side and half merged. Structure is weak, colour is the
only binder, might be the doctrinaire modern's verdict upon Renoir's
canvases.

This colour synthesis, this quivering, sensuous aliveness, is in the nature
of pictorial creation. It goes beyond all but the most masterly impression-
ism of Monet. It gives joy to the eye trained to "feel" the picture before
comprehending it with the mind. It affords the immediate opulent pleas-
ure felt in the presence of particularly colourful Chinese paintings (though
the Orientals are profounder masters, affording symphonic values beyond
the sensuous, melodic loveliness).

It is loveliness that Renoir has above all else, a loveliness short of beauty,
this side of moving æsthetic experience. More than half, it is transcribed
loveliness. It is women and children and flowers as the artist saw them,
too idealistically for the strong-meat realists, with the true eye of the man
in love. Renoir naturally gravitated toward caressable women, toward
girls and little children, toward flowers and softly textured stuffs. Given
the world as a scene, his eyes came to rest automatically, and contentedly,
on satiny skins, the rounding of breasts and hips, cascading petals, and
luscious fruits.

It is as good realism, perhaps, as any other—quite superior, in many
minds, to that of the camera-eyed misanthrope, the seeker-out of misery,
the reporter of vice and deformity. When transformed into eye-filling
compositions, as joyously painted as joyously seen, it seduces the beholder,
checks his mind, delights his senses. In the eighties there came into
Renoir's canvases too a largeness, an amplitude, that gave weight to the

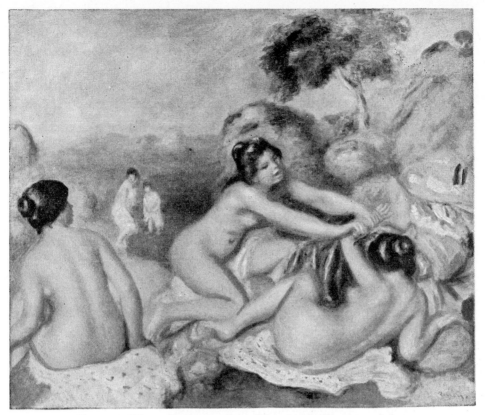

RENOIR: Three Bathers. 1897. *Cleveland Museum of Art*

compositions, that hinted of sculpturesque form. There is no more than a hint of volume arrangement in the profound sense, as one might speak of the massive formal order of Michelangelo or of Daumier; but for a time Renoir at least groped for that hidden voluminous adjustment, as evidenced, for instance, in the *Three Bathers*, now at the Cleveland Museum of Art.

The colour-glow, the warming, sensuous fullness, is assuredly one of the things for which painting exists. Renoir had the most voluptuous brush known in modern times. He is certain of his place. Like the impressionists, he left out of his art all that is important to man in the world of thought, of character, of imagination, of mystic understanding. In the small field of glamorous objective transcription he is supreme. His sense-art is incomparably lush, inimitably soft and caressing. When he went to

the museums he sought out the artists who had painted radiantly, glow-ingly, voluptuously; he came away praising Velazquez and Giorgione and Titian—and he said that he had lived a second life in the pleasure he ex-perienced from the works of the masters. He added his version of paint-loveliness to the world's store, and he asked nothing better of life than that he be privileged to contribute to "the second life of pleasure" for each of us.

Renoir had deserted impressionism because he felt its tenets were too cramping. He uttered one of the wisest criticisms of the *plein-airistes* on record. "If the painter works directly from nature," he said, "he ultimately looks for nothing but momentary effects. He gives up the effort to com-pose, and his work soon becomes monotonous." He went on to praise Corot, remarking that studio painting "did not prevent Corot from in-terpreting nature with a realism that no impressionist has ever been able to equal."

Renoir escaped the dangers of momentary-effect painting. He carried to its culmination the studio realism of Corot and Manet. There have been imitators of his style and his effects in the twenty years since his death. But he may take a place in history as the last of his line. Twentieth-century modernism was destined to open roads leading away from the ter-ritory he charted for his own.

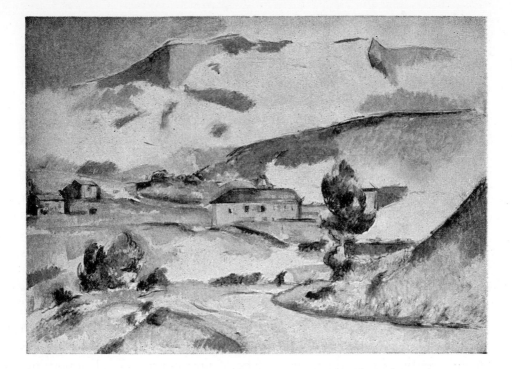

IX: THE GENIUS OF REVOLUTION:
CÉZANNE

REALISM had ended in France by mushrooming out into the varieties of transcription met with in the paintings of Manet, the impressionists, and Renoir, and into the harmless literary and sentimental picturing of the Bouguereaus, the Cazins, and the Bastien-Lepages. A few men were already turning to squalid and vicious subjects, were bringing in slum realism. Zola, the champion of the extreme photographic type of realism known as naturalism, foreseeing the dangers of descending to muck-exploration, in a clinical-minded age, was prompted to say: "Naturalism does not depend upon the choice of subjects. The whole of the social

CÉZANNE: Mont Sainte-Victoire, from Gardanne. 1885–1886. *Marie Harriman Gallery, New York*

structure is in its domain, from the drawing-room to the gin-shop. It is only idiots who would make naturalism the rhetoric of the gutter."

The disputes among the realists continued long after the time of Zola and Monet and Renoir, and indeed through three decades of the twentieth century; and the several varieties continued to appear in the officially approved exhibitions in all countries. But there were no later giant figures to uphold seriously the realistic canon in art. The time may come when historians and teachers will cite Renoir as the last great realistic painter. In his time lived the genius who transformed the way of Western painting. Before Renoir's death the eyes of the creative young artists of Paris had turned for good from the pastures of realism to search in the confusingly unfamiliar æsthetic terrain made known to them in the paintings of Cézanne.

In the quarter-century 1870–1895 Cézanne found and developed the new way of painting that was to give "modern art" a different meaning. He enunciated and illustrated a principle directly opposing that which had been central to European art practice from the beginning of the fifteenth century to his time. In the face of unrelenting official opposition, misunderstood even by his closest and dearest friends and associates, he persisted in a perverse course, even died unacknowledged. Once safely dead he came to be revered as only the greatest masters are. A generation after his death Cézanne is the name heard upon the lips of students and artists more often than any other. His is the type story of the genius misunderstood, of the artist unappreciated in his time but afterward venerated and immortalized.

Cézanne more fully than any other painter added a new dimension in Western art. What Goya and Constable and Corot introduced into their pictures occasionally, beyond the realistic virtues, what Blake and Turner and Daumier intuitively grasped at, without finding disciples or founding a modern school, Cézanne richly achieved. He made a lifelong search for the elusive quality termed "form," exploring the realms of abstract realization and extra-dimensional revelation, and inspiring a succession of experimenters and disciples.

When Paul Cézanne came up to Paris and entered the Atelier Suisse in 1861, he was twenty-two years old. He had fought through the usual parental opposition. "Paul," his father would say, "think about your future! With genius you die; it is only with money you live." His father had

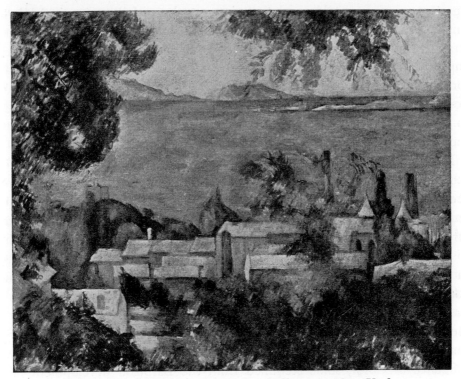

CÉZANNE: L'Estaque. *Lewisohn Collection, New York*

been successful, had climbed through all the stages from workingman to banker and leading citizen of Aix. His son would inherit his home, his business, his position, if only he would show normal shrewdness and would study business ways attentively. But Paul let his mind stray from his courses in law and banking to the more congenial interests of poetry, music, and painting. At school he had been a good student in the fields he cared for, especially the classics. He wrote acceptable verse. But gradually everything else dimmed in his mind before the passion for painting. His friend Zola was already in Paris, and was urging by letter the need to study at the capital of art, where the one-time revolutionary romanticists were being challenged by a strange new cult of "realists." It was in April 1861 that the youth upon whom the mantle of revolution was to fall first saw the Paris which was to hold for him so much of hope and such a weight of trial and disappointment.

Once in Paris—his father and sister had come along to make sure his

quarters were respectable and to point out the pitfalls a provincial lad might come upon in the city—Paul found profit and disappointment strangely mixed. He attended the classes at the Atelier Suisse, and he copied works that interested him in the galleries of the Louvre. He had long talks about art and literature and life with his friend Zola. But somehow neither his painting nor the friendship got along well. He returned to Aix the following autumn, thus setting a pattern for a lifetime to be spent divided between Paris and the Provençal country.

He became involved again briefly in the banking business, but the father soon saw the hopelessness of that, and Paul was off to Paris once more in the autumn of 1862. This time he remained at his studies for a year and a half. He applied for admission to the Beaux-Arts but was refused. He again attended classes at the Atelier Suisse, and there formed a friendship with Pissarro, and later with Guillaumin. Like all the impressionable students in Paris, he was excited by the controversy over the Salon des Refusés in 1863, and he saw, as a revelation, the pictures of "the new men," from the faithful followers of Courbet to the innovators Manet and Whistler. He was soon one of the little band of free-thinking artists and students that was destined to found the impressionist school. Some were under the influence of Corot, some stemmed from the Barbizon development, all had been stirred by Courbet's revolutionary pronouncements; and somewhere along the way Cézanne had felt the deeper values in Daumier's pictures. (Courbet and Daumier were painting in Paris in the mid-sixties, and Corot and the Barbizon leaders were near by in their beloved country villages.)

But soon it was Manet who was the idol and the acknowledged leader of the younger men, and from 1866, when Cézanne met Manet personally for the first time, there were the history-making discussions of the radicals at the Café Guerbois. Cézanne was the shyest and least articulate member of the group, and a less regular attendant than Pissarro, Monet, and Bazille. He was never at ease in the company of polished men such as Manet, and he disliked random talk, was interested only when discussion bore on the one subject of his passion, art. In the midst of the clash of opinion and the impact of idea upon idea he was likely to be reserved, moody, and even taciturn, and when he spoke it was likely to be angrily, even explosively. He simply could not take part reasonably in a general argument, so sensitive was he on the one hand, so opinionated and impulsively voluble on the other. It ended oftenest in his sitting in a corner

and absorbing what he wanted—he could not but gain from the discussions of the aims and the ways of painting—or in his abrupt departure.

He was destined all his life to hate typical Paris repartee and to distrust witty people. He was destined to live a life of withdrawal and silence more than any other important artist of his time. It was one of the sources of his originality and his strength. It also clouded his relationships with his fellow-artists and with all who might have helped him to commercial success or to official recognition. He was not to see a picture of his publicly exhibited until 1874. After a further period of twenty-five years he was to have his first one-man show, the only such exhibition during his lifetime. Nevertheless, he was counted, in the years following 1865, as one of the Café Guerbois group and one of the founding members of the impressionist school.

In 1866 Cézanne sent two canvases to the Salon jury, and they were, not unexpectedly, rejected. Naïvely Cézanne wrote to the official in charge of the state department dealing with fine arts, protesting "the unfair judgment of men to whom I have not given the authority to judge me," and demanding that the Salon des Refusés be re-established or the regular Salon opened automatically "to every serious worker." The only known reply is a notation on the margin of Cézanne's letter, carrying an official statement that the Salon des Refusés had been recognized by the Government as "inconsistent with the dignity of art." Not only was Cézanne cut off then, but he never except once (and then "by the back door") succeeded in getting a picture into the Salon; and he never received an honour or a commission from the French Government.

Success in a monetary sense was not important to him. His father was providing an adequate allowance and the youth could look forward to inheriting more than a modest artist would need. But he—in art matters a natural enemy of authority—for decades clung to the belief that the Government should aid serious creative artists and to the hope that official honour would be accorded his paintings. He recognized himself as *faible* in all affairs of life outside the creative processes of art; and knowing nothing of economics, religion, or politics he left those matters trustfully to his father, the Catholic Church, and the Government. It all worked out well enough except at the point where Government authority touched upon art.

The outbreak of war in 1870 put an end to the meetings of the young radicals and scattered the members. Cézanne, who had been accustomed

to spend a part of each year in Provence, now stayed away from Paris a year or more. He evaded the army draft, as did Monet and Pissarro. Cézanne, however, did not leave France but painted, partly out-of-doors, at L'Estaque, fifteen miles from Aix. Just when he went back to Paris is uncertain, but it is known that his desire to return was sharpened by the presence there of one Hortense Fiquet, who was to be his wife. He set up an establishment with her and their baby son in 1872 at Auvers, a village favoured by several of the younger artists.

Cézanne lived and painted at Auvers for two years, a period in which he outgrew his earlier, heavy style and became a landscapist with more of vibrating colour and sparkling light than any other of the impressionists-to-be. Pissarro after his return from England had settled at the near-by village of Pontoise, and through him Cézanne was kept in touch with new ideas and with the plans of the group of which he had been a member before the war. In the early months of 1874 Manet, Monet, Pissarro, and the others were planning the show that was to bring the impressionists their name and their first opportunity to exhibit as a group.

Up to 1870 Cézanne had painted in veins fairly easy to mark off by reason of the visible influence of one or another master. Independent enough to avoid becoming a "school man," he still, as a student, imitated certain museum painters whom he particularly admired. At first Delacroix was his idol, and the earliest youthful works are heavily painted, full of rounded forms, and of a literary origin. The series culminates in *The Murder*, a somewhat leaden, melodramatic canvas of 1869 or 1870. Beyond Delacroix as an influence were the gods usual to the romantics, Rubens and Titian and Tintoretto. But the immediate influence of Courbet and less notably of Manet acted gradually to exorcize the literary and romantic elements, so that by 1870 Cézanne was ready to experiment independently, as the most original of the group moving toward impressionism.

At a point not determined he had accepted two influences significant to his career beyond impressionism. He had begun to dream over a form-quality hidden in the canvases of Poussin, a sort of plastic structure of which the romantics and current realists alike were ignorant; and he had divined a search for formal order, perhaps of something best described as arbitrary shaping, in the pictures of Daumier. It is Daumier's work that is suggested in the two portraits of the artist's uncle Dominique, of about 1866, now in the Frick Collection and the Museum of Modern Art in New York. The disposition of hood, beard, cross, and hands in the one,

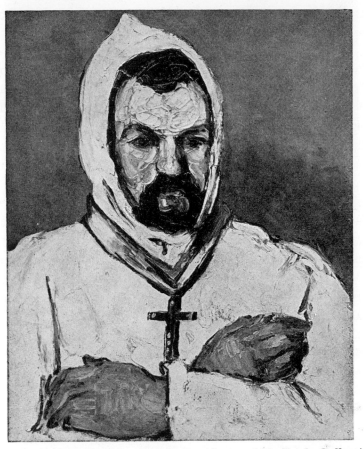

CÉZANNE: Uncle Dominique as a Monk. About 1866. *Frick Collection, New York* (Photo copyright by Frick Collection)

and of beard, tie, and vest in the other, leaves no room for doubt that Cézanne at this time was interested in arranging an arbitrary pictorial structure at the heart of his picture, in a way common then only to Daumier's paintings.

This rather obvious "shaping" is to be considered only a very elementary stage of the form-organization which Cézanne will master so gloriously in later life, but, occurring so early in his career, almost in his student days, it indicates that he, like Whistler in the same years, developed tendencies toward abstract expression, in a direction just opposite to the one he might have been expected to follow after association with the young realists.

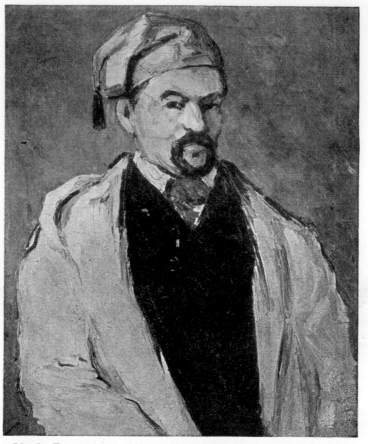

CÉZANNE: Uncle Dominique. About 1866. Museum of Modern Art, New York

By 1870 he was experimenting with plastic organization in less obvious ways, as indicated in *The Black Clock*, a still-life in which the elements of line, space, and volume are manipulated in a manner suggesting further study of Poussin. It is the first notable item in a series of still-life canvases destined to be famous among twentieth-century students. The apparently unconventional but carefully "adjusted" *Portrait of Valabrègue*, of the same period, carries over something of the Daumier-like studies, but the early heaviness, and particularly the use of pigment as a thick impasto, is already disappearing.

Colour had not been a chief resource in Cézanne's painting before 1870, and for this reason it was to be said later that he did not find the

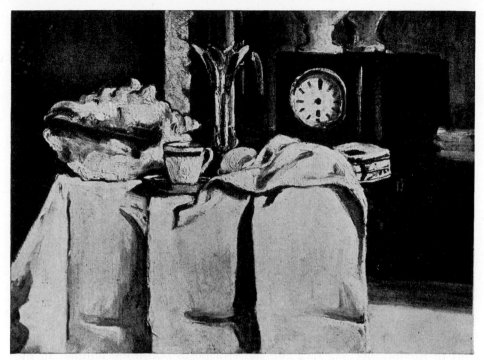

CÉZANNE: The Black Clock. About 1870. *Collection of Edward G. Robinson, Beverly Hills, California*

road he was to follow until he joined the impressionists in their researches of the years 1873–1874. But the mastery of the other formal elements, particularly the elemental ordering and the refinement of structure which link him with Daumier and with Poussin, was to be of the very essence of mature modernist painting as Cézanne arrived at it. There is the fact too (unless the biographer Vollard is mistaken) that during the period of the Café Guerbois discussions Cézanne once boasted to his fellow-painters: "I am painting Valabrègue, and the highlight on the nose is pure vermilion," probably referring to the portrait of 1868. In any case his advance in the use of pure and brilliant colour was rapid in the years spent at L'Estaque and Auvers. When Pissarro brought back exciting word of the pyrotechnic exercises of Turner, and of the sparkle of Constable's brush-point colouring, Cézanne was already inclined toward a brighter palette and cleaner hues. The gentle Pissarro was a perfect companion for him, understanding his silences and his moodiness, forgiving his outbursts

when his paintings baffled him, and keeping him in touch with the activities of Monet, Renoir, and Manet. Cézanne's wife also had much to forgive, and her love and patience must have been grievously strained innumerable times. A bright-minded and talkative woman by nature, she found herself married to a man reserved and violent by turns, who withdrew into himself increasingly. Some obsessive fear prevented him from ever working from a nude model in his own studio, part of a lifelong fear that people, especially women, might "get hooks into him"; and when his friends sat for their portraits he was over-exacting about the pose and interminably deliberate. He would often "feel for the stroke" fifteen minutes before making it, and might require one hundred sittings.

Mme. Cézanne understood his need to work slowly, silently, endlessly, and set herself resignedly to model for his figure-pieces. She had no comprehension of the problems of art, and certainly no glimmer of understanding of her husband's genius. But she wanted him to be happy and was ready to sacrifice her liberty patiently when he needed her; and she seems to have had no resentment or jealousy when she acknowledged that for him his work was his life. She was to arrive, decades later, at a curious sort of immortality, her face and her stiff poses becoming familiar to millions of gallery-visitors, not primarily as transcriptions of a human being but as items in formal compositions.

In the years that might be termed the period of incubation of impressionism, that is, 1872–1873, Cézanne continues the advance toward freedom and colourfulness begun at L'Estaque, and works more in the open air. The freedom of handling of *The House and the Tree* and of *Père Lacroix's House at Auvers* and the fresh, gay colouring of a *View of Auvers* indicate extraordinary strides forward. At this time Cézanne, like Renoir, who also will be considered a traitor to impressionism ten years later, is at the very front of the advance toward sparkling light and rainbow colouring. At the same time he holds to his discoveries in the field of formal structure. The *View of Auvers* is one of the earliest works in which his concern for abstract "arrangement" is obvious, with planes from picture front to point of deepest penetration clearly marked. This typically modern device, added to the impressionistic colouring and "carelessness," doubtless explains the critical reception that accounted him one of the most offensive painters showing at the impressionist exhibition in 1874. His two landscapes provoked a certain amount of irony and ridicule, but it was a figure-piece that elicited from the critic of *L'Artiste* the opinion

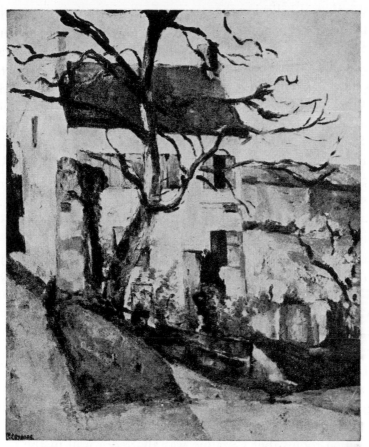

CÉZANNE: The House and the Tree. 1872–1873
(Courtesy French and European Publications, Inc., and Librairie Somogy, Paris)

that "M. Cézanne can only be a sort of madman suffering from delirium tremens when he paints."

Renoir and Pissarro and Monet and Sisley, as well as the more conservative Berthe Morisot, had been seen in Salon exhibitions in earlier years, but for Cézanne the 1874 exhibition of radicals afforded the first opportunity to come before the critics and the public. It was the first opening for a man now thirty-five years old and hitherto rejected in all quarters. The abuse he received from the critics and the obvious hostility of the public deepened the sense of loneliness and irrelation in which he worked. He did not despair; his father still made him an allowance, and

he was steadfast in believing that he was finding a new and important way of art. He was encouraged, moreover, because one of the two exhibited landscapes was purchased, not by a friend but by a bona fide collector who liked it. He would have been even more pleased if he had known that decades later it would find wall space in the Louvre. Thus one of the "impressions," from that show that gave impressionism its name, was lifted out of the fog of confusion and abuse that rose over the exhibition; its sale from the exhibition walls marked the first bit of tangible encouragement given to the most original and the most vilified artist of the nineteenth century; and, like a symbol, it came to rest eventually in France's highest shrine of art.

Cézanne failed to exhibit at the second show of the impressionists in 1876, though he submitted work to the Salon juries of both 1875 and 1876, and was of course rejected both times. He seems in these years, however, to have arrived at a fuller faith in himself and at a more philosophical and tolerant attitude toward those opposed to him. He was struggling to fix on canvases a "realization" beyond the surface appearance of things, and beyond any practice or understanding of the realistic painters. He seems to have dreamed over this secret element especially in the months at Aix and at L'Estaque in the years 1874–1876.

The still radical impressionists, rid now of their more conservative fellow-travellers, held in 1877 their third exhibition, and they featured the works of Monet and Cézanne. Monet's paintings were scattered through the exhibition rooms, but Cézanne was allotted a wall in the central gallery of honour. He showed sixteen pictures, thirteen in oil and three watercolours. His non-conformity was more striking than that of Monet or Renoir or Degas, and again he was singled out for attack and abuse. The now familiar epithets were heard on every hand: "grotesque," "lamentable," "demented," "monstrous."

When he had returned to Aix after the exhibition of 1874, Cézanne had been sought out by the director of the museum there, who asked to see his canvases in order to know whether the new painting was as barbarous as reported from Paris; and Cézanne had told him that his own works fell short of the furthest excesses of the evildoers, that one would have to go to Paris to meet the real criminals. But now there could be no doubt that he was marked down in the minds of critics, art officials and gallery-goers as the outstanding art criminal of France, not merely a charlatan or an incompetent, but an insane egotist, a flouter of laws, a very monster of

rebellion and corruption. The organs of public opinion ascribed subversive tendencies of all sorts to him. So it came about that this reserved and naïvely conservative man, conventional in living, an unquestioning Catholic, and one who trusted government implicitly to those charged with its administration, was publicly branded "anarchistic" and "communistic."

Partly because he felt that the notoriety accorded his pictures could only embarrass the other impressionists, and partly no doubt because he saw his own path diverging from theirs, he refused to exhibit with the group in 1879, and by the time of their next show, in 1880, he had irrevocably set off on the search which he hoped would bring him to an art "in which impressionism will be transformed and given the durability and solidity of the paintings in the museums." He became almost a recluse and lost touch with many of the artists and writers who had been his close friends. He spent long periods in Provence; nevertheless, he was in and out of Paris frequently in the years 1877–1890.

In the Auvers days he had formed a friendship with a Dr. Gachet who was himself a painter when he had leisure. He was in a sense Cézanne's first patron. A little later, through Renoir, Cézanne met a modest collector, an amateur in the best sense, M. Choquet, perhaps the first person to become convinced that Cézanne was a genius. He bought some of Cézanne's pictures (having, however, to trick his wife by pretending that the first of the canvases had been left at their house by Renoir in error), and began a campaign of enlightenment. Vollard relates that whenever Choquet talked with anyone about any artist, he invariably ended the discussion by adding: ". . . and Cézanne?" But he found no dealer who would have anything to do with the "deformed" landscapes and apples of the mad Provençal, and he turned up no collectors to buy.

At this time Cézanne had formed the habit of venting his anger, when his painting went wrong, upon the picture that baffled him or upon any other of his canvases that happened to be handy. He knew they had no commercial value, and he would slash through a canvas with a palette knife, or stuff it into a stove or throw it out an open window. So when he found a colour-dealer, known to the young and impecunious artists as Père Tanguy, and fell into the common practice of trading finished pictures for canvases and paints, he acted to save for posterity many a painting that otherwise would have gone the angry way. For a considerable period the obscure Tanguy had a key to Cézanne's Paris studio and was in command of the accumulated pictures there. Two segregated groups were

offered to customers at fixed prices: eight dollars for any one out of the pile of smaller canvases; and the large canvases at choice for twenty dollars. Cézanne and Tanguy also schemed to purvey art to the buyer who could not come up to these prices; the artist painted on a large canvas (or it may be that these were water-colours on paper) a number of small compositions, and upon demand the dealer would cut out with scissors perhaps two dollars' worth of Cézanne.

Père Tanguy became convinced in his last years that he was letting immortal art slip through his hands in this way and he put away six of the master's pictures. But he died too soon, for at the sale for the benefit of the widow, in 1894, the Drouot auction house knocked down the six at an average price of less than thirty dollars. Tanguy, incidentally, had even more trouble getting rid of van Goghs. It was of more human import that he help the poor and unbalanced artist, in order that he might not starve; and van Gogh's way of painting thick meant a great outlay on colours. The van Goghs piled up, and, like the Cézannes, brought pitiably small prices. At the auction one went for six dollars. By that time Cézanne was no longer the least admired of the revolutionaries.

During the late seventies and the eighties Cézanne moved restlessly from home to home: Aix, L'Estaque, Paris, Melun, Pontoise, and Hattenville in Normandy. He had married secretly, and for a time he was in danger of losing his allowance and perhaps his inheritance if his aged but active and autocratic father found out that the painter had acquired a wife and child. For several months the old man let the son, now nearly forty years old, feel the pinch of a reduced allowance and the apprehension of having to work at something more remunerative than art. But the one's displeasure and the other's discomfiture passed, and in 1879 Cézanne entered upon a period when he knew his family's wants were to be cared for and that he could concentrate upon the search for "realization" in painting. He could work in one studio as well as in another, given a certain isolation, and he found a lift in new surroundings. Hence the seasonal or yearly changes of location. But the aim never changed, and the search— he spoke of his *recherches* rather than of his paintings—never flagged.

For Cézanne 1882 was to be known as the one year when he had a picture in the Salon—the "Salon of Bouguereau" as he called it, summing up at once its official authority, its prestige, and its utter stodginess. He had wanted so long to be in the Salon that he had no ill feeling and no compunction now when the chance came to go in, as Vollard puts it, "by the

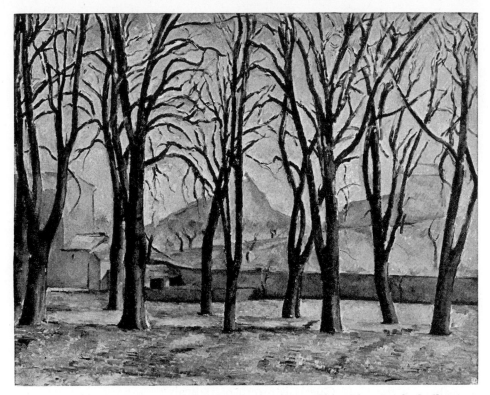

CÉZANNE: Chestnut Trees at the Jas de Bouffan. 1885–1887. Frick Collection, New York (Photo copyright by Frick Collection)

back door." Under the rules then in force each member of the jury had the right to pass one picture without consulting his colleagues, as the work of one of his pupils, "*pour la charité.*" As a deed of *charité* the painter Guillemet, himself conservative and puzzled by Cézanne's painting, entered a portrait by "Paul Cézanne, pupil of M. Guillemet."

The picture seems to have escaped notice, but for Cézanne the event was important: he had exhibited with France's recognized painters. His mother and his sisters were impressed, and perhaps the director of the art academy at Aix, whom he had described as a good fellow but "with professor's eyes." After that the privilege of introducing a charity work was denied the jurors, and Cézanne never again was represented. In 1889 a landscape was hung in the galleries at the World's Fair in Paris, because M. Choquet would not lend another exhibit which the official committee

wanted unless the Cézanne were shown too. That was the last time France officially honoured Cézanne. In Brussels he was represented by three canvases in an exhibition, one of an annual series illustrating "the new painting," at the Modern Museum in 1890. Having been taxed, in the letter of invitation, with having "refused to take part in exhibitions," Cézanne wrote: "I must explain that having achieved only negative results from the numerous studies to which I have devoted myself, and dreading criticisms that are only too well justified, I had resolved to work in silence until such time as I should feel myself capable of defending theoretically the result of my experiments." His pictures seem not to have been particularly esteemed at Brussels, and what scandal and abuse were stirred up centred on van Gogh's entries and not Cézanne's.

The frequent changes of scene continued after 1890. Cézanne's one visit outside the borders of France occurred in 1891, when the family spent three months in towns on or comparatively near Lake Geneva. In the summer of 1896 he painted on the shores of Lake Annecy. But his health had become less secure, and for the last decade of his life he spent more of his time back in Aix. In 1894 Cézanne's name came again into public print, in connexion with the Caillebotte bequest, and official and critical France again had opportunity to show that he rated lowest among the sometime members of the Café Guerbois group of radicals.

Caillebotte was that businessman and Sunday painter who had joined with the impressionist group back in the seventies and had used his wealth to encourage, and sometimes to save from starvation, such radicals as Monet, Renoir, and Sisley. His own paintings enter not at all into the story of modern art; but he sustained the young innovators through a critical period, and he formed a notable collection of their works. When he died in 1894, his will was found to contain a clause bequeathing the major part of his collection to the state, for entry into the Luxembourg Gallery and (he hoped) eventually the Louvre. The bequest brought to a crisis the ill feeling between the academic painters, now thoroughly scared by the inroads of the impressionists, and their modern-minded rivals.

All the impressionists were represented in the collection, together with Millet, Renoir, Degas, and Cézanne. Of the group only Cézanne could, in the mid-nineties, still be considered a "wild man." But the State Director of Fine Arts and the Curator of the Luxembourg were both conservatives, and their efforts to nullify the bequest were the signal for a rallying of the reactionary forces. The old-time artists rushed into print with floods

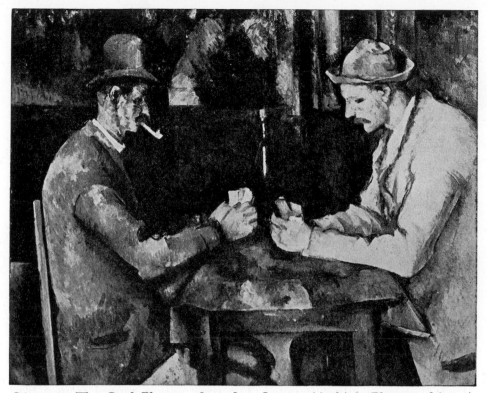

CÉZANNE: The Card Players. 1890–1892. Louvre (Archives Photographiques)

of abuse for "the destroyers of art." The dean of the academics, Gérôme, was one of those interviewed for the *Journal des Artistes*. He said (as translated and quoted by Gerstle Mack): "Caillebotte? Didn't he use to paint himself?—I know nothing about it—I don't know these gentlemen, and I know nothing about this bequest except the name—there are paintings by M. Manet among them, aren't there?—and M. Pissarro and others? —I repeat, only great moral depravity could bring the state to accept such rubbish—they must have foolishness at any price; some paint like this, others like that, in little dots, in triangles—how should I know? I tell you they're all anarchists and madmen!"

Caillebotte's heirs and executors fought rejection of the bequest but finally approved a compromise by which the state took over forty of the pictures, including two Cézannes. In his accounting of the gift the Curator of the Luxembourg valued Cézanne's pictures at one hundred and fifty

dollars each, while each Manet was considered at the same time to be worth thirteen hundred dollars and each Renoir worth one thousand dollars.

There was one fortunate result of the uproar over the Caillebotte bequest. A young art dealer named Ambroise Vollard, who had seen the paintings of Cézanne at Père Tanguy's colour shop, decided that the time was ripe for a one-man show. In the preceding eighteen years only two of Cézanne's canvases had been publicly exhibited in France. Vollard was to become one of the few intimate associates of the artist in his last years and was to write a lively biography incorporating his interviews with the artist. But at first he could not even trace Cézanne to make the suggestion of an exhibition, or find an address, so obscure had the painter become. In the Forest of Fontainebleau he "searched every nook and cranny"; then with a vague clue he inquired at every door on a crowded Paris street. He found Cézanne's son, who communicated the dealer's desire to his father at Aix, and Vollard obtained one hundred and fifty canvases.

It was late in 1895 that about fifty of the pictures went on exhibition at Vollard's gallery in the Rue Lafitte. The first purchaser was a blind man, but there were less equivocal sales; two of the great collections of Cézanne's works, the Camondo (later to be inherited by the Louvre) and the Pellerin, were there founded. The press notices ranged from a blast in the *Journal des Artistes*—"a nightmare of atrocities in oil, going beyond legally authorized outrages"—to understanding and favourable reviews. Gustave Geffroy spoke of the power, sincerity, and subtlety of Cézanne's painting and ventured the reckless statement that his works would some day be hung in the Louvre. Among the visitors to the gallery there were countless ones who laughed and jested, and some who seriously protested. But the real Cézanne was found out by a considerable number of art-lovers and by influential critics.

Immediately after the exhibition Vollard went south to meet Cézanne personally, and thus began a friendship which lasted through the final years of the artist's life and which incidentally gave him standing as a painter with a gallery connexion in Paris. Vollard while in Aix sought out a number of people to whom Cézanne had given his pictures, and he thus bought for a song a representative collection of the master's works. Vollard later in Paris sat to Cézanne for his portrait. He suffered the tortures of sitting rigid through one hundred and fifteen sessions, usually of three and one-half hours, and disgraced himself once by falling asleep and going

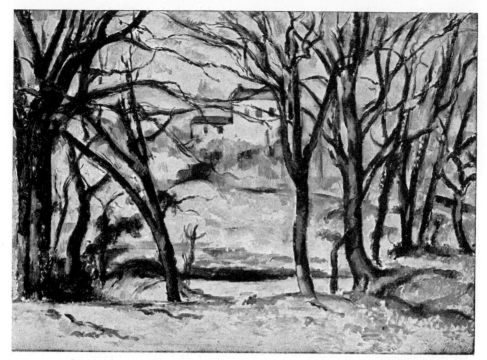

CÉZANNE: Le Tholonet. *Collection of Paul Guillaume, Paris*
(Courtesy Museum of Modern Art)

down in a heap with his chair and his packing-box throne. Cézanne scolded him for spoiling the pose. "You must sit like an apple. Does an apple move?" In the end Cézanne could not finish the portrait to his liking, and set it aside and went back to Aix. "The shirt-front isn't bad," he said, but "the contour keeps slipping away from me."

Even so late in his life, Vollard reported, Cézanne talked of his hope of getting into the "Salon of Bouguereau." If only he could have a "well-realized" canvas favourably placed there, the public would at last come to know, before it was too late, that his was a real art and he a new leader. But from experience he was suspicious of all who "flattered" him, and as always his irascible ways and his fear of people who might get hooks into him turned away some who might have helped. A few friends found it possible to come to a new intimacy with him. One of them, a poet, Joachim Gasquet, was able to understand Cézanne's mind and his aims better than any other, and has left the most revealing of the biographical

studies. The final half-dozen years, after his sixtieth birthday, the artist spent in and around Aix except for one visit to Paris in 1904. He never stopped working arduously, hopefully.

Cézanne coveted the ribbon of the Legion of Honour, that badge so strangely dishonoured yet still so widely honoured. In 1902 Octave Mirbeau undertook to sound out the State Director of Fine Arts, M. Roujon, on the matter. Vollard tells of the almost incredible incident in these words: "Mirbeau had no sooner said that he was pleading the cause of a certain painter for the cross than the superintendent, presuming that his visitor had the judgment not to demand the impossible, reached for the drawer which contained the ribbons committed to his keeping. But the name of Cézanne made him jump. 'Ah! M. Mirbeau, while I am Director of the Beaux-Arts I must follow the taste of the public and not try to anticipate it! Monet if you wish. Monet doesn't want it?' Then, misinterpreting Mirbeau's silence: 'Is he dead too? Well, then, choose whomever you wish. I don't care who it is, as long as you do me the favour of not talking about Cézanne again.'" So Cézanne gave up that hope and returned to his painting, encouraged by the feeling that he was going to "realize" at last. In a sense his water-colours of the final decade did come nearer to achievement of the disembodied, extra-sensual thing that he termed "realization"—far from what he termed "horrible realism"—than did his oils. Yet there are almost abstract, plastically potent oils too.

The one-man show at Vollard's had given Cézanne a certain standing, whatever might be the continuing governmental hostility. In 1899 he exhibited three pictures at the Salon des Indépendants, and in the following five years he contributed to several large group shows in both Paris and Brussels. The Salon d'Automne, organized in 1903, gave Cézanne a room at its exhibition of 1904 (an honour accorded also to Puvis de Chavannes) and there ten pictures were shown. He was to be represented at the Salon d'Automne again in 1906; but to the end the museum in his own town, Aix, like the official Salon in Paris, refused to show his work.

On an afternoon in mid-October 1906 Cézanne was painting out-of-doors at a distance from his home when a rainstorm came on. He was burdened by his easel and knapsack, and his strength was not sufficient to withstand the strain and the shock of cold and wetness during the long walk back. He fell on the roadside and was picked up by a passing laundry cart. Taken to his home, he was put to bed; but the next morning he insisted upon going to his garden studio to paint. He suffered a second

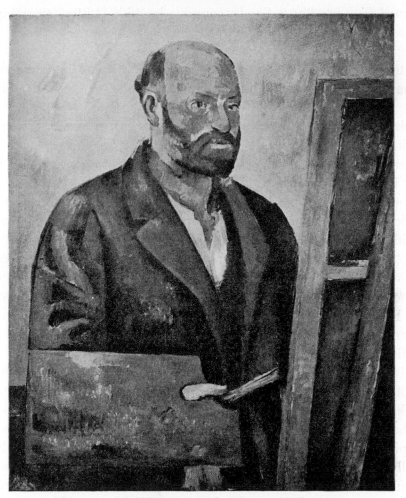

CÉZANNE: Self-Portrait with Palette. 1885–1887.
Collection of Paul Cézanne fils, Paris (From *Paul Cézanne*,
courtesy Oxford University Press, New York)

collapse, and died six days later. He was buried in Aix with a simple ceremony.

During the final years he had been heartened occasionally because young artists had come to Aix to seek him out and talk about art. In his last letter, written to his son on the day of the rainstorm, asking for two dozen new brushes, he added a postscript: "I believe the younger painters are much more intelligent than the old, who only think of me as a dangerous rival." To one of the younger painters who intercepted him as he

returned from mass on a Sunday morning he said: "Listen, everything in nature is a cylinder or a cube." In the year before that of his death there had gathered in Paris a little group of younger painters who were to fall heir to Cézanne's principles, to the abuse of the critics—they were known as the *fauves*, or wild men—and to that remark about cubes and cylinders.

Cézanne was led by Gasquet into discussing the masters whom he admired. Even during the last of his visits to Paris he would spend afternoons in the Louvre, studying, dreaming, copying. He once said: "I like only Poussin, Rubens, and the Venetians." He liked Ingres "in a way," but only for design in a narrow sense. Other of the "dry" painters he liked for design too, Raphael, Clouet, Holbein; but he detected their weakness outside the values to be achieved in line. In painting, linear draughtsmanship "may be beautiful but it is not enough." It may be pure, affecting, ingratiating, but it is thin, not enough *as painting*. David, making a fetish of the quality, had killed painting. Always Cézanne went back to Poussin and Rubens, and to the Venetians, Giorgione, Titian, Tintoretto, and Veronese. He was willing to admit Rembrandt to the company, and Goya "at times."

His likings are eloquent. People who could not fathom his own contributions to the advance of painting, during the quarter-century after his death, could find in a study of Poussin and Rubens and Tintoretto clues to the mysterious abstract thing that the master of Aix had "realized" in his pictures. The conjunction of names appeared strange at first. Superficially the placid, classic Poussin seemed removed whole worlds from the turbulent Rubens. But study brought out that the secret structure, the eternal poise, that Poussin had hidden under his semblant picturing was simply a quieter and deeper manifestation of that formal order which Rubens had introduced intuitively, with a rich and flowing technique, into his most serious canvases. Titian and Tintoretto had felt for the structure (or the hidden rhythm, if one prefer) and had added colour manipulation to the other means by which it is achieved. Study of these masters, and of El Greco, who had been virtually unknown to Cézanne, led to understanding of the task Cézanne had set for himself and to ever-widening enjoyment of the magnificent solutions of the problems of form that he had left.

Because most people were form-blind in that period, and because they tagged as poseurs or charlatans all who claimed to feel a rhythmic extra-

sensual value in a picture, or to detect a form-structure or plastic order which seemed to be the cause of the experience; because most people were form-blind and suspicious of what they could not themselves see, popular recognition of Cézanne's mastery was still slow in coming. A small but growing band of artists, later known as the organizers of the school of Paris, set out in the years 1905–1910 to discover the "laws" behind the phenomenon of formal orchestration. Often enough they muddied the waters for critics and public. But before 1915 the chief countries of the Western world had seen exhibitions of the art of Cézanne and his associates and followers, and it had become clear that the "new art" or "modern art" was to be post-impressionistic and post-realistic, and that its many and confusing varieties could never be explained except by reference to the "form" that had been the object of Cézanne's lifelong search.

The crucial distinction, it came to be seen, was between art that counted representation or "realism" supreme and art that, for the sake of formal excellence, distorted or abandoned likeness to nature. There were other epochal implications in the steps Cézanne had taken. One easily discernible change was that painting had moved toward the simplification, conventionalization, and suggestiveness of Oriental art, which meant a move also toward the qualities that Europe had traditionally considered "primitive" in art. Cézanne had said, when faced with misunderstanding and when baffled in realizing the universal formal thing: "I am the primitive of the way I have taken." But the central distinction was recognized as that between realistic art and form-enriched art.

The form-blind never cease asking: "What has changed in art? Isn't all art transcription from nature? How can they make me believe they see something I can't see in the picture?" The modernist, nevertheless, heartened by the spectacle of armies of people moving over each year from the realistic side to his side, says patiently to these others that something *has* changed in art, that transcription from the beautiful or the picturesque or the affecting in nature *is* no longer considered central in painting; that the observer trained to realism (as we all were until very recently, in our own homes, our schools, our museums, and in the pages of our magazines) must indeed have new eyes, eyes responsive to values in the picture not discoverable on the surface of nature.

In the longer, historical view it is very simple. Here was a world of art committed to realism in the fourteenth century, dedicated to giving back a truthful reflection of objects and events seen with the outward eye, a

reflection made doubly truthful by the researches of science. The scientists had especially served the artist with an exact knowledge of anatomy and with a mechanically true science of perspective. In the course of four or five hundred years the realists had come to an amazing exactitude of representation. The one thing an orthodox painter could not do, at the end of that period, was to distort nature as seen with the science-guided eye. Certain great painters from Giotto to Goya had deviated from transcriptive truth, especially Michelangelo, the Venetians, and El Greco. But Michelangelo's aberrations were forgiven because he was known to be an impeccable draughtsman (when he wanted to be), and Titian's objective distortions for plastic effect were slight as compared with his obvious mastery of representation as such (and it might be that the massively voluminous figures came from his using fat models). El Greco was excused on the ground that his eyesight was defective, and for two centuries he was left out of the list of great painters anyway.

In the final fifty years of the realistic five centuries the revival of classicism had, despite the revolts of Delacroix and Courbet, established Raphael as the highest of masters and a coldly deliberate realism as the standard art. So it came about that in the second half of the nineteenth century the critics of art, the public, and the officially important painters counted a correct representation of the phenomenal world the first duty of the artist. The half-millennium of the age of science had come to climax in Breton and Bouguereau and Meissonier and Gérôme, in Frith and Landseer and Watts.

The simple truth is that a few independent artists, whether out of their own visioning or out of inspiration from the art of the Orient, or out of study of overlooked values in the primitive Giotto or the aberrant Michelangelo or the outlaw El Greco, became convinced that scientific truth and realistic seeing were constricting creative art. Intuitively or by logical reasoning they grasped at formal and decorative values. They were careless of nature. Ultimately they proclaimed that transcription from objective life was of secondary importance, and even that distortion of nature was justified if one "realized" in the realm of plastic grandeur or spatial rhythms. They found converts among the younger artists, a few even among critics and collectors.

When the turn was thus made from realistic art into the pastures explored and cultivated by the form-seeking painters, modern art was initiated. That is the fundamental fact upon which any man's understanding

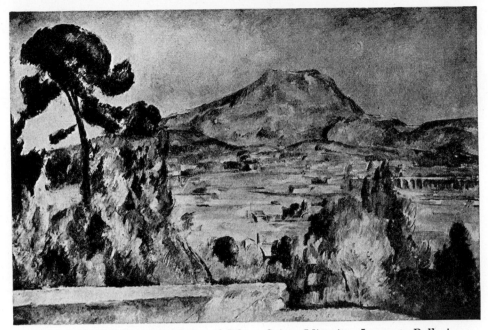

CÉZANNE: The Parasol Pine and Mont Sainte-Victoire. *Lecomte-Pellerin
Collection, Paris* (Druet photo)

and enjoyment of contemporary painting must be based. One must see
clearly the epochal change that took place when leading artists stepped out
of the traditional way of realism to create unrealistically—distortedly, if
you will—with first attention to abstract, plastic, or decorative values. The
statement is an over-simplification, no doubt, but essentially it is true.

Cézanne's importance in the history of art is that more than any other
he is the pivotal figure in the turn from realistic to post-realistic art. Escap-
ing tutelage by any orthodox painter in his formative days (for the Atelier
Suisse was a *free* school), too independent to be caught up and carried
along by his associates in impressionism, forming his own likings among
the museum masters, returning to nature devotedly but never becoming
a slave to nature's casual or visible aspects, he came to image in some
inner chamber of himself compositions that embodied something of na-
ture's hidden structure, of life's hidden rhythms; and he studied, struggled,
and agonized over the ways in which pigments on canvas or paper might
be made to convey, to reveal, what he had inwardly imaged. He was in-

debted to the masters who had incorporated some part of the complex of formal elements into their work, especially to Poussin, who had distributed volumes in space with a mathematical-musical orderliness. But in his profounder researches Cézanne gained, after he outgrew Delacroix's romanticism, from no living painter except the neglected Daumier.

How independent, how original, was his achievement is indicated in the slightness of his debt to the Orientals. He could not have escaped the impact of the vogue for Japanese prints, which was so determining in forming the styles of Whistler and of Degas. Yet not once is there an indication in his pictures that he let himself be influenced directly by the prints. Whistler, van Gogh, Degas, and Toulouse-Lautrec adopted and adapted the stylistic formulas of the Japanese, and even Monet took frankly a series of motives from Hiroshige. Manet, Degas, and van Gogh delightedly copied actual prints into the backgrounds of certain of their paintings. But if Cézanne owed to the Orientals it was because he penetrated to the soul of their art. He is nearer, in the essence of his painting, to the art of the supreme Chinese landscapists.

The commentators upon art, even when they came to *feel* the formal rhythms in Cézanne's canvases (or Seurat's or van Gogh's), could not explain what it was that made the pictures notable beyond familiar values. Thus it came about that when an understanding group of admirers and collectors had been formed, the books and magazine articles seemed only to add to the confusion in the minds of "outsiders." Modern art got the name of being a cultish thing, needing initiation into mysteries beyond common comprehension. Even Duret failed utterly to explain Cézanne's gift, when he so courageously and so competently wrote his books about the impressionists and their associates. That he *felt* a value beyond the transcriptive ones is clear from a passage in the chapter upon Cézanne in *Manet and the French Impressionists:* "From this the picture derives a strength independent of the subject; so much so that a still-life—a few apples and a napkin on a table—assumes a kind of grandeur, in the same degree as a human head or a landscape with sea."

But when Duret attempts to name what it is that endows the picture with "independent strength" and "grandeur," he can only fall back on colour. It is "a range of colour of great intensity and of extreme luminosity"; and "it is the value of the pigment in and for itself, the strength and harmony of the colour." Which is to say that Duret explains Cézanne in

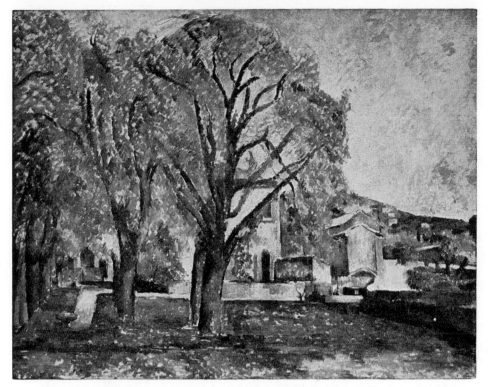

CÉZANNE: The Jas de Bouffan in Spring. 1885–1887. *Museum of the Rhode Island School of Design, Providence*

words perfectly applicable to the innovations of the impressionists; and the "independent strength" and the "grandeur" that mark off Cézanne's paintings as post-impressionistic, what would be termed today their formal or plastic properties, are left unexplained.

It was not until the decade 1910–1920 that a few commentators, basing their studies upon the accumulation of inventive work produced by Daumier, Cézanne, Gauguin, van Gogh, and the *fauves*, and after reappraisal of masters such as Giotto and El Greco and an intensive study of Oriental painting, gave the public clues to the elusive formal values and a vocabulary for discussions of it. The only body of æsthetic theory broad enough to encompass "realization" such as Cézanne's was found to be the Chinese. When Hsieh Ho in the sixth century had written that first of all a painting should have "rhythmic vitality or spiritual rhythm" and "an inner movement of its own"—not a word about imitation or correct drawing or transcribed beauty—he had provided a name as good as any other for the

mysterious element in a typical Cézanne canvas. The Western critics, among them Roger Fry and Clive Bell in England and the American Willard Huntington Wright, have given us other terms to prod our understanding, but Hsieh Ho's "rhythmic vitality" or "spiritual rhythm" is perhaps as acceptable as "abstract order" or "significant form."

The truth is that the *experience* of the thing "realized" in a Cézanne picture or a Sung landscape is of a sort beyond exact analytic terms. It is like the mystic experience, which the realist in life cannot fathom, nor the mystic logically explain. For this reason the wiser writers upon modern art have insisted that the student should have art works familiarly with him before attempting analysis. He should live with the paintings of Cézanne or the Chinese masters or El Greco, or the formally intense designs of Marc or Kandinsky. Exposed continually and open-mindedly to such works, the beholder cannot but respond to the rhythm or order or spiritual vitality hidden within them, just as he responds to the mysterious order or vitality in a Bach fugue, or the unexplainable "essential poetry" in a sonnet by Shakespeare.

After exposure to the works, analysis and deduction may be useful. And indeed, out of the half-century's discussions of the new art have come certain principles or truths that may be considered to constitute a basic platform or specification of modernism. They have at least become so generalized as a theory of modernism that even a book primarily historical must make room for them.

First, it can hardly be repeated too often, the modernist repudiates the Aristotelean principle, "Art is imitation." He denies that the artist's task is primarily the mirroring of nature. He forfeits the appeal of transcribed beauty. He gives up the affecting sentimental incident, and moralizing by literal or symbolic means. Subject becomes secondary to "the æsthetic charge." The painter or sculptor does not often omit nature's materials altogether, but he subordinates natural appearances. He distorts nature at will if thereby he can better serve the purpose of conveying æsthetic feeling through a form-invention.

Second, the artist has learned to transfer his attention from the outward, detailed view of the world and life to the inner view. He gathers his materials less with the eye than with the inner perception. From some fragmentary scene in casual nature he works inward to a region where life is seen whole, in unity, charged with the harmony and rhythm of the eternal universe. To convey the sense of wholeness, the unified order, the sense

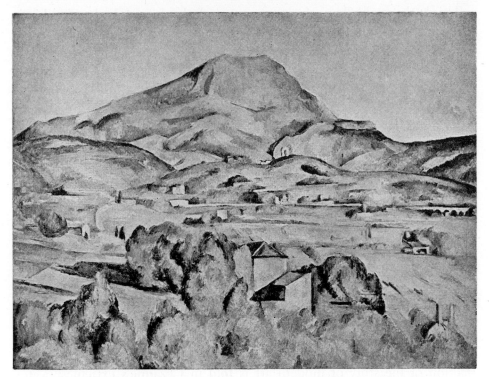

CÉZANNE: Mont Sainte-Victoire Seen from Bellevue. 1885–1887.
Barnes Foundation, Merion, Pennsylvania

of outflowing life, an image is born that transcends the phenomena of nature, an image in which the original motivating fragment is lost. This losing of parts of nature in one's self, and finding the whole that contains all nature, is of the very essence of expressionism. The German school especially, unlike the rationalizing French, held to a theory of mystical origination and heedless emotional outpouring; and some theorists prefer this statement as a starting point for all study and understanding of modern art: that there is a basic shift on the part of artists from objective to subjective creation, from rationally controlled re-presentation to intuitive emotional presentation. It may be added that the approach is justified only when the artist has returned from his mystical experience with the true mystic's apprehension of cosmic order (a reservation necessary because a great deal of disordered emotional outpouring has been paraded in the galleries of modernism, with the plea that it should be considered modern simply because it represents the inner man released).

Third, the main flow of experiment and the largest body of achievement are to be detected where artists have frankly searched for the form, the plastic equivalents, to embody the conceived image. To re-create, to externalize, the image in a way that would convey the spiritual experience was the aim especially of that generation of French painters that founded the school of Paris during the last two years of Cézanne's life. For twenty years thereafter the main channel of advance was kept open by the groups carrying on research in the field of formal values and rhythmic movement. They all but abandoned the realm of correct appearances and semblant truth, working instead for plastic and spatial effects, for form-realization and form-revelation. The most characteristic modern artists are best understood, as a group, in the role of "form-seekers."

Fourth, the form-seeking artists have spread their efforts over a confusingly wide range. At one extreme are the abstractionists, whose aim it is to isolate form "pure," in a realm bordering on that of music. More commonly the modern artist demands merely that a vital abstract structure or a main plastic rhythm or ordered movement lie under the not drastically unnatural objective elements. The abstractionists are the most daring adventurers and the purest creators among modern painters. But only a fraction of the story of modern art is told in Cézanne's extremest water-colours, the exercises of the cubists and the purists, and Kandinsky's non-objective creations. It is rather where the abstract element, the form-creation, is built into a nature-derived (but not transcriptive) picture that major progress has been made.

Fifth, though logical and complete explanation is barred by the very nature of the "form experience," a somewhat useful language of modernism has come into being. It is the artist's secret just *how* he endows the picture with formal excellence. It is done intuitively, not intellectually, and he commonly takes refuge behind a phrase such as Cézanne's "realization" or Kandinsky's "soul-expression." The more helpful terms have come from the side of the appreciator or enjoyer. When Clive Bell became convinced that he felt a supra-sensual element in the plastically vital picture, he gave it that handy but loose name "significant form." Other writers suggested "rhythmic form," or "expressive form" (since the most extreme nature-distorting, form-seeking painters were being called expressionists). Still others wanted to discard the word "form" and went over to discussion of "plastic vitality" and "spatial order." They thus avoided a serious confusion, since "form" has been used traditionally to denote the physical

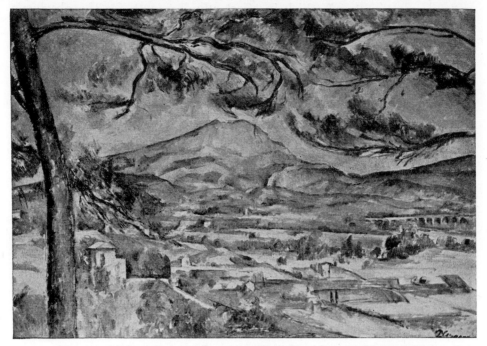

CÉZANNE: Mont Sainte-Victoire. 1885–1887. *Courtauld Institute,*
University of London

fullness, the body and shape, of objects in the picture, as in the common
phrase "form and colour." Nevertheless, most discussions of the intangible,
rhythmic, expressive thing in the canvas that gives the image its power to
convey a sense of order, of poise, of movement, begin and end as dis-
cussions of "form." The appreciator who feels the form in a Cézanne land-
scape or a Seurat port scene, or it may be in an El Greco crucifixion or a
Chinese "mountain and water" picture, is prepared to enjoy the best that
occurs in the whole range of modern art—and probably will not care what
word others employ to name the experience.

Sixth—and this is the final conclusion, out of discussions and quarrels,
necessary to the art-lover—the nature of the form-element, on the ma-
terial side, has been in a way charted and found to have mathematical-
musical orderliness. To endow the picture with form or rhythm or a "life
of its own" the artist employs "plastic orchestration"; that is, he arranges
or orchestrates the plastic elements arbitrarily, placing them in an order
detectable by the practised eye. The plastic elements of volumes in space,
planes, lines, colour, and texture are arranged in a "movement sequence"

or "movement pattern" which in effect affords a path for the observer's eye within the picture space. No eye ever rests for more than a few seconds at one point in a picture. In the merely realistic composition the eye moves casually and without rhythm (content with the older virtues of representation, affecting subject, competence of handling, and all the rest); but in the form-endowed composition it finds pleasure in the rhythmic sequence, and it is this physical pleasure that apparently opens the way to the sense of experiencing, in the soul, the harmony and poise of cosmic order.

Cézanne's supremacy as a painter in modern times is due to the sureness of his orchestration of the plastic elements. He has left innumerable works which can be used illustratively by those who care to make laboratory tests of the manipulation of plane and volume, of spatial interval and sequential rhythms, of line and texture and colour employed for movement values. Seldom is the path for the observer's eye marked so certainly and so subtly as in a Cézanne canvas. (Note, in the version of *Mont Sainte-Victoire* over-page, the accenting of a front plane, by the tree; how the movement sweeps in from the picture base, movement engendered by directing lines and sequences of planes; how the eye is carried around the volume of the mountain; how it is drawn in along a spiral, diverted with minor contrapuntal rhythms, then brought to rest at a complex of accented buildings and trees at pictorial centre.) Not only is it possible to identify, as it were, the ordered movement within a Cézanne picture, as one might trace the structure of a Bach fugue, but it is possible to feel in many works of the Master of Aix some *completion* that is like the echoed rhythm of the universe. Indeed, those who link the achievement of the modern painters with the drift of modern philosophy toward mysticism find in these pictures a warrant of the stability and poise of the cosmos, a hint of the sweet-running, rhythmic continuity of life.

The monumental rhythm, the serene poise, the mathematical grandeur of the *Mont Sainte-Victoire Seen from Bellevue* mark Cézanne's "realization" as at one with that of the seer who has learned to quiet the voices of the clamorous outward world, to penetrate to the silent realm of the over-world. Nowhere else in modern art, or in any period of Western art, is there so moving a revelation of spiritual forces, and of macrocosmic splendours, as in Cézanne's series of landscapes of Mont Sainte-Victoire.

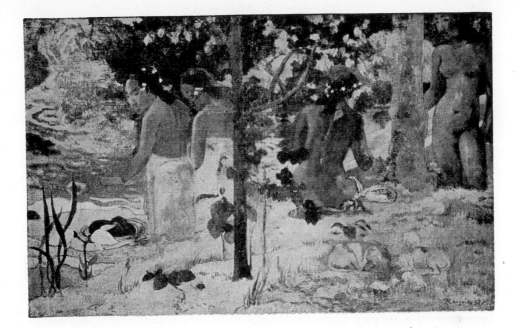

X: FIRST OF THE MODERN SAVAGES:
GAUGUIN

THE winter of 1882–1883 was not a significant one in the history of art, but it saw one quixotic act, on the part of a Parisian stock-broker named Eugène-Henri-Paul Gauguin, which was to bring to the circle of moderns an artist as aggressive as Cézanne was shy, as hardy and adventurous in life as Cézanne was retiring and *faible*. At this time Courbet had been dead five years, Ingres sixteen years. The official Salon of 1882 had in a curious way caught up with the outlaw Salon des Refusés of nineteen years earlier. Now as then the pictures causing the most discussion had been by Manet and by Whistler; but this time both innovators had found understanding and even praise. Nevertheless, Manet was dying and Whistler, sold out after the Ruskin trial, was still in London waging his exhaust-

GAUGUIN: The Bathers. 1898. *Lewisohn Collection, New York*

ing battle against the British R.A.'s and the English anecdote-loving public.

In Paris the season was indubitably the impressionists'. They had held their seventh exhibition and were selling so well that Monet was enabled to plan trips to distant lands; and two sometime members of the impressionist group, Renoir and Degas, had arrived at actual prosperity. Pissarro was still pinched, and Sisley close to starvation, but the impressionist movement (saved now from the embarrassment of Cézanne's participation) could look forward confidently to increasing local appreciation and the coming of American buyers.

Cézanne had made his one bid for attention at the Salon as a charity exhibitor, had failed of notice, and had gone back to Aix and L'Estaque discouraged about officialdom, critics, and public, but determined to make something solid and plastically expressive out of impressionism. He was entering upon one of the most fruitful and also the most troubled periods of his career. At that moment Gauguin, who more than any other contemporary was to gain from Cézanne's ideas and experiments, elected to give up his prosperous stock-brokerage business and to become a full-time professional artist.

There was excitement among the impressionists at the announcement. They had known Gauguin as an amateur, a Sunday painter, and had even let him exhibit modestly at certain of their shows. They had known him more favourably as a buyer of their works. He had sought out these radicals, after encountering their pictures at Père Tanguy's, then at Durand-Ruel's; and from his large earnings he had purchased, for his own pleasure and to aid the artists, a discriminating collection of canvases. All the leading innovators from Manet to Monet and Renoir were represented. More significant, Gauguin had bought two Cézanne paintings and two drawings by Daumier. When this so-valuable patron announced that he would abandon a business in which he was earning forty thousand francs a year, and would thereafter make a living for himself, his wife, and their five children by painting, the gentle Pissarro was pained—even dumbfounded. He pointed out that gifted men such as Sisley could not sell enough to keep roofs over their heads. Hardly one artist in France sold enough to . . . etc., etc. Gauguin nevertheless gave up his business. He was then thirty-five years old. It seems that love of art makes for hardy fools.

Paul Gauguin had been born in Paris in 1848, and was thus nine years younger than Cézanne. His father was a journalist from Orléans. His

maternal grandmother had been a woman of character who publicly preached socialism and was shot, not without reason, by a disappointed husband. Through her Paul inherited some Peruvian blood. Left without a father at three, Paul spent four years of his childhood in Peru, a circumstance held to account for a certain restlessness he felt later in his native France. Returned to Orléans in 1856, he had his routine schooling there. At seventeen he felt the call of the sea and for six years he served as apprentice and seaman on merchant ships and in the navy. At second hand he heard descriptions of certain South Sea islands where Europeans, tired of so-called civilization, might find an earthly paradise.

At twenty-three he entered business life in Paris. Untroubled as yet by thoughts of art, he pushed ahead at the brokerage office in which he had found a position through family friends, speculated profitably, and married a beautiful Danish girl, Mette Gad, who had been visiting in Paris. Children came, and the Gauguins prospered. It seemed like nothing more than a harmless diversion when the successful broker began to occupy his leisure hours with painting and sculpture. There was no radical note in his early works. It interested him to get down the blond beauty of his wife, the comeliness of his children, or the picturesqueness of an enjoyed landscape. So conventional was he that a landscape of his got into the Salon in 1876. He drifted gradually, however, into the company of the impressionists, and began to buy their works.

In 1880 Gauguin exhibited at the fifth exhibition of the impressionist group, and again in 1881 at the sixth. He was now devoting to art all his energies outside his brokerage work, had taken a house with a full-sized studio, and was giving Mette cause for worry that he might unduly neglect reasonable affairs. He spent less time in the company of his family and frequented the cafés where he could talk shop with Manet, Renoir, Degas, and those of the open-air painters who might be in town. In the summer of 1881 he spent his vacation at Pontoise with Pissarro, and in frequent contact with Cézanne and Guillaumin. By 1882 he and his family knew that the case was hopeless. The prosperous businessman had disappeared in the obsessed artist. Mette bowed to the inevitable, and in January 1883, after eleven years in service to finance, Gauguin walked out of his brokerage office a free man, and a professional artist.

Within a year the savings were gone and not a client had turned up to give reality to the dream of living by the sale of paintings. Gauguin had reached the beginning of a road of suffering and humiliation from which

he was hardly to escape during the rest of his lifetime. It seemed best to leave France and go to his wife's people in Denmark. The businessman awoke once more in Gauguin and he took the Danish agency for a patented awning or sun-blind, but he failed miserably to obtain orders. He found himself disliked by Mette's Scandinavian relatives. He loved her for her blond loveliness and her cool reserve, but he found the bourgeois smugness and the Northern coldness of her people intolerable. All the violence of his nature—and he was more Spanish or Latin American than French in temperament as well as in looks—flared up, and he made inexcusable scenes. Mette, not unjustly, considering that she, her improvident husband, and their five children were guests in her mother's home, was inclined to side against her husband.

His painting, which had seemed important and promising in Paris, now seemed a far-away hope, even a futile thing. The gap widened. After a year and a half during which the family's only income had been earned through Mette's venture into tutoring, the break came. Gauguin returned to Paris, taking along his second boy and promising to send for his wife and the other four children when he had mended his fortune. A last-minute sale of his collection of paintings to a brother-in-law provided some funds, which he gave to Mette. He and the six-year-old child arrived in France penniless.

The hardships of the winter of 1885–1886 for the artist and his son were terrible, almost incredible. His pictures did not sell—the words are like a refrain through the rest of his life—and he was too proud to go, a shabby failure, to his old friends in either the world of business or the world of art. He took odd jobs, tried anything, and when there were no jobs, he and his child literally went hungry, and at night they suffered horribly from cold. Both had illnesses that multiplied their trials. In Gauguin pride and resolution fought against bitterness and confession of failure; but the letters to Mette were not free of despair and even unjust reproach. Still, it was many months before he admitted even to himself that reunion must be indefinitely deferred.

Meanwhile, even as early as 1886, Gauguin's paintings began to find favour with one or two advanced critics, especially at the eighth impressionist exhibition, where he showed nineteen pictures and one sculpture. He had renewed association with Émile Schuffenecker, a friend of the old brokerage days who also had given up business to become a painter, but not so recklessly, and this had led to meetings with Pissarro and others of

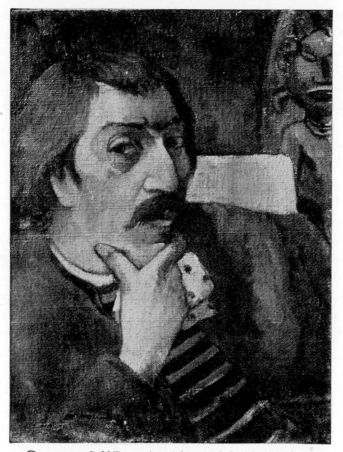

GAUGUIN: Self-Portrait with an Idol. About 1893.
Wildenstein and Co. Galleries, New York

the impressionist group. Sick of Paris, hearing of a *pension* specially run
for artists, at very low prices, by a Mme. Gloanec, Gauguin went to Pont-
Aven in Brittany. He painted there through most of the year 1886. In his
work already there were intimations that he would go beyond impression-
ism—strange hints of abstract arrangement and rhythmic repetitions that
were reminiscent of Cézanne rather than of Pissarro and Monet. (When
he had sold his collection of paintings he had refused to let go his two
Cézannes and one Pissarro.) At Pont-Aven he swore he would not suffer
the privations and indignities of another winter of near-starvation in Paris
and he hinted of suicide. But he went back and endured a second season
almost as sordid as the first. Mercifully the child had been placed in a

boarding-school—but the father could not visit him because the fees were unpaid. Still no one bought Gauguin pictures.

Early in 1887, willing to give up everything in the world except painting, Gauguin decided to leave France. Mette was sent by her Danish relatives to Paris for a not very joyful meeting and to take the child back to Copenhagen. Gauguin sailed for Panama in April 1887. For a time he and a fellow-artist worked as diggers on the canal project, to earn money for transportation to Martinique, the French colonial island in the Lesser Antilles. They thought they had found in the tropical island the refuge and the paradise they had sought; and Gauguin absorbed into his painting qualities of brightness and of broad contrast that were to distinguish his art ever after. But a serious illness of his friend, who also attempted suicide, and then a sickness of his own, led to the admission that the climate made this paradise impossible and they shipped for France. Gauguin worked his passage as a common seaman.

Penniless again, he found a welcome at the hands of Schuffenecker and his wife, and he rather imposed upon their hospitality, not always graciously, while he got his affairs into better shape. He painted ceramic wares for a time, and absorbed from Oriental pottery some of the richness and formalism that later entered into his painting method. He had met during the preceding winter a gallery director named Theo van Gogh, and had been attracted by Theo's brother, an awkward but obviously sincere fellow who had come to Paris from Holland to give his life to art. Gauguin and Vincent—Go and van Go—were as different as two men could be in most ways, but they had been through agony and torture for the sake of the same passion, painting.

At this time Theo van Gogh was manager for a Montmartre gallery, and he arranged there Gauguin's first one-man show. It was a modest affair, in two small rooms, but it might almost have the designation "first post-impressionist exhibition." Gauguin had broken with the impressionist faith and was off in pursuit of something he vaguely called the "synthesis," something as dimly sensed and as obscurely named as Cézanne's "realization," and immensely significant as another point of departure for non-realistic experiment. His observations in Martinique had called for colours and methods beyond Monet's and Pissarro's, and there was this other thing, synthetic and decorative, that the impressionists had wholly missed or dissipated. Later he was to write cruelly but truthfully of his fellow-impressionists: "When they speak of their art, what is it? An art purely

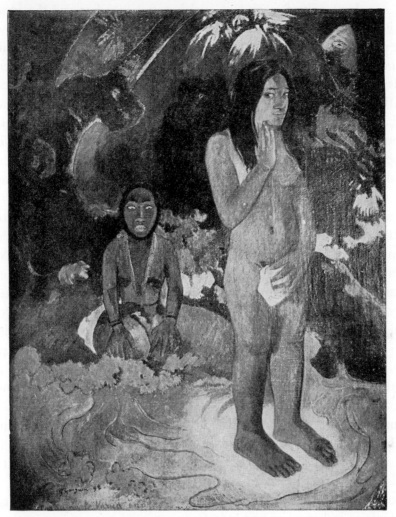

GAUGUIN: Words of the Devil. 1892. *Marie Harriman Gallery, New York*

superficial, nothing but coquetting, purely material; imagination does not inhabit it." In those few words the materialism and the lightness, the realism and the coquettishness, of impressionism are exposed. Gauguin thenceforward followed that other man of imagination, Cézanne, into fields not guessed by Monet, and closed to Pissarro's eager but miscomprehending efforts.

Gauguin sold several pictures from the exhibition, and he wrote to Mette exultingly. At last he was on the verge of popular success! It wouldn't be

long. . . . He resolved to go to Copenhagen to see her and the children. The visit was a failure on all counts but one. His in-laws were in powerful league against him. He was not permitted to see his wife alone. His children were being brought up bourgeois, puritan, and Danish, without even a knowledge of the French language. The one pleasure he found was in the bond that grew between him and his twelve-year-old daughter Aline. He went back to Paris discouraged and baffled, still wanting Mette and family life, but hopeless about any further reunion until he could provide an income beyond any artist's capabilities. He summed up a great deal when he said: "If only Mette had been born an orphan!" Paris, too, soon got on his nerves.

Returning to Brittany, installed again at Mother Gloanec's *pension*, he set out to make his painting pay by "a supreme effort." He found a few congenial spirits at the *pension*, including Émile Bernard and Henri Moret, and Paul Sérusier arrived later; but they were not the ones likely to lead an impecunious painter into profitable fields. There were solidly business-like painters in the house, academicians and illustrators, who could have demonstrated to Gauguin the sort of thing that pleases the officials of art and sells in the public market. But Gauguin antagonized these reasonable professionals both by his painting and by his talk. The "regular" artists ate in the main dining-room, whereas Gauguin's group had a table in their own side-room, referred to by the others as "the lunatic annex."

Gauguin was soon recognized as leader of the lunatic group, being the most forceful, not to say violent, in character, and the most extreme in his insurgent ideas about art. There came into being there a Pont-Aven school which was to be referred to in later histories of French art. There can be no doubt that out of the meetings at Mother Gloanec's certain main lines of influence passed into the centres of modernism in the Paris of 1890–1910.

Gauguin was the spiritual father if not the actual father of "synthetism," a mode of painting not clearly defined by its adherents or advocates, but in general tending toward simplification, subordination of detail, and, in the words of Maurice Denis, the "submission of each picture to one dominant rhythm." Behind this program, which had to do with the *decorative* wing of the modernist advance rather than with Cézanne's search for a purified language of form, there were the several influences that had acted upon Gauguin up to 1888, including Cézanne's own provocative canvases, the stronger arbitrary design quality of Daumier, the study of

ceramic-painting, bringing in probably an influence from Persian pottery and other Eastern wares, and admiration for medieval enamels and stained-glass windows. Japanese prints were still having an effect. To all this Gauguin added his memory of flaming colour out of his sojourn at Martinique.

The others could hardly go so far in exotic colouring as did Gauguin, and in fact few of the Pont-Aven men were to survive importantly the experimental phase of modernism. But Paul Sérusier became a link between the synthetist group at Pont-Aven and the Parisian group known as the *nabis*, in which Maurice Denis, Pierre Bonnard, Édouard Vuillard, and the sculptor Maillol were involved. Later Sérusier gave Gauguin credit for introducing him to the works of Cézanne and van Gogh, with opening his eyes to a new way of seeing the universe "plastically," and with imparting a vision of a painting art in which the "unworthy subterfuge" of light-and-shade would be given up for form, colour, and pattern as a medium of revelation of the inner quality of life and objects. Nature, Gauguin told him, could be violated, should be re-expressed by a sort of sublime distortion in a work of lasting beauty. For 1888 this was extraordinary talk.

At this time Vincent van Gogh was in Arles, painting like mad, supported by his brother Theo, and dreaming of a co-operative community of artists. Gauguin wrote and urged him to come to Pont-Aven. Van Gogh, guessing something of Gauguin's unhappiness, wrote offering half his house and half his food if Gauguin would join him at Arles instead. Van Gogh did not like the idea of an artists' *pension* where he would be expected to discuss art with Englishmen and with men of the Beaux-Arts School. Moreover, he had fallen in love with the Provençal sunshine. He looked forward with enthusiasm, however, to association with an artist passionately devoted to painting and, he believed, of tastes like his own. Gauguin joined him in the autumn of 1888. Theo van Gogh financed the trip, and made an arrangement by which Gauguin was to pay him in pictures.

Thus began one of the strangest and most tragic associations in the annals of art: the mad Dutchman, whose painting was known to no more than three or four persons, and the impoverished ex-broker, separated from his family, by turns strangely humble and violently aggressive; both destined within a year to be creating works among the most original and satisfying in the range of modern art; the two most opulent, not to say extravagant colourists in the whole modern movement; each learning a little from the other, by example and by argument—for they worked to-

gether, talked together interminably, took their leisure pleasures together. It was part of the plan that they should also recover their health together, but after two months van Gogh broke under the strain and had to be put away for a time in an asylum. How he made an abortive attempt upon Gauguin's life and then took out his violence upon himself is part of van Gogh's story, and little important to Gauguin's. Before the end of December the association had come to its end. Gauguin had pushed his painting method a little closer to its ultimate cast. A portrait of van Gogh painting sunflowers is broader, simpler, and more formalized than any earlier one of Gauguin's works; and it shows nature "violated and distorted" for pattern effect with almost Japanese unconcern. Both men had gained in their search for the idioms of a post-realistic style, and, by a hair's breadth, both were still living.

Gauguin went to Paris but stayed only long enough to reorientate himself and to take the lead in setting up an outlaw exhibition of works by "the impressionist and synthetist group" in the uncongenial atmosphere, not to say haze, of a restaurant at the World's Fair of 1889. Most of that year he spent at Pont-Aven, and in the autumn he and Sérusier, dismayed at the influx of bourgeois tourists into their once quiet retreat, moved on to Le Pouldu, a remoter village. There Gauguin spent one of the happiest and most profitable periods of his life. His material wants were fortunately met through a pooling arrangement with another artist, one Meyer de Haan of Amsterdam, who had given up his biscuit factory to practise painting. He had an independent income and it did not bother him that Gauguin never had a franc to put into the pool. Gauguin's reserve and dignity under the arrangement have been particularly remarked: if tobacco or another necessity ran out, he never openly complained or even spoke of the matter, but became excessively sad and thoughtful. He accomplished under the convenient co-operative scheme the finest work of his pre-Tahitian period, and he broke the association to go to Paris only at the end of 1890, when he had decided to seek a new way of life in the South Seas.

At Le Pouldu he moved further toward an Oriental (or modern) conventionalization, coming finally to the almost shadowless rendering of natural objects and the broad-area colouring that distinguish his later painting. He had arrived at a mastery of formal design, at an understanding of the disposition of plastic elements for spatial effect, that only Daumier and Cézanne had already achieved in the nineteenth century (though Whistler,

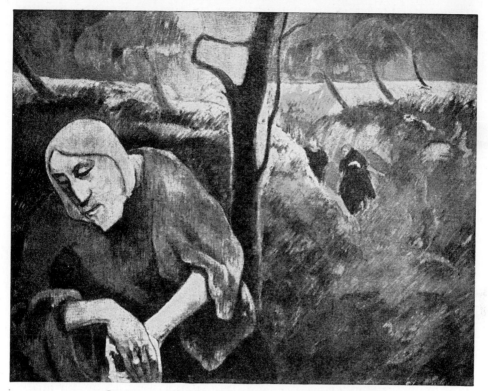

GAUGUIN: Christ on the Mount of Olives. 1889
(Courtesy The Hyperion Press, New York)

in a slighter way, was equally master of linear rhythms, colour harmonies, and plane arrangement). Gauguin painted a series of religious pictures which were to rank with his highest achievements in the field of formal design, canvases preferred by some observers to his later, "softer" paintings. *Calvary, The Yellow Christ, Jacob Struggling with the Angel,* and *Christ on the Mount of Olives* were, however, so far from current standards of religious iconography and of sentimental religious illustration that devout church people were horrified. Gauguin and Sérusier tried in vain to present *Jacob Struggling with the Angel* to local churches.

Perhaps the curés were right; the picture, for all its value as formal experimentation, has a pictorial sophistication, a self-consciously un-Western layout, that makes it more suitable, even fifty years after, for the advanced public that seeks out galleries of modern art. The *Christ on the Mount of Olives,* however, better fused subject-feeling and method. Its

plane and volume arrangement, its plastic rhythms and contrived "paths for the eye," put no hindrance in the way of illustrational presentation or emotional response.

The Yellow Christ might be considered a test of the observer's at-ease-ness with unrealistic art. If he has fully rid himself of the nineteenth-century demand that a painting be first of all true in the camera-lens sense, he will be able to respond—in a flash, as it were—with an upsurge of æsthetic pleasure, and then go on from there to absorption in the meaning values. The colouring and the arbitrary arrangement of the ob-jective materials are likely to put off the observer accustomed to read pic-tures by documentary evidence. But beyond that hazard there is a cunningly adjusted, if summary and obviously decorative, composition of plastic elements, affording an almost musical experience to the eye; and in this case the formal experience leads in harmoniously enough to the comprehension of the meaning, the kneeling Bretonnes, the wayside cru-cifix, and the peaceful land.

While Gauguin was in Pont-Aven he painted a picture of one of the townswomen who took an interest in the visiting artists, entitling the portrait *La Belle Angèle*. He made decorative capital out of every feature of the Breton costume, and he flattened face and hands to accord with the stiff spread-out ribbons and stuffs. He abolished shadows, and instead of a background in perspective he inserted a tapestry-like composition with stray flowers and a sketchily treated exotic vase. The whole picture he suffused with ravishing colour. It is doubtful that any Western artist since the fourteenth century had painted a portrait so purposely decora-tive, so flat, so lacking in depth in the plastic range. It was a *tour de force* in non-realistic, sensuously lovely picture-making, and it might have been marked as opening one of the minor roads of modernism. But la belle Angèle herself was horrified and scandalized. It just wasn't art and it wasn't a proper portrait, and she indignantly refused it even as a gift. Fortunately the painter Degas, who had himself done something toward bringing flatness and mellow colour into French art, took a fancy to the picture, bought it, and held it until his death. La belle Angèle was the more surprised—remembering tenderly the poverty-ridden Gauguin—when the canvas was resold for what would be a Breton fortune. Ulti-mately it came to rest upon the walls of the Louvre.

The other paintings Gauguin produced in that year and a half of eased poverty had the characteristics that foreshadowed his full decorative style

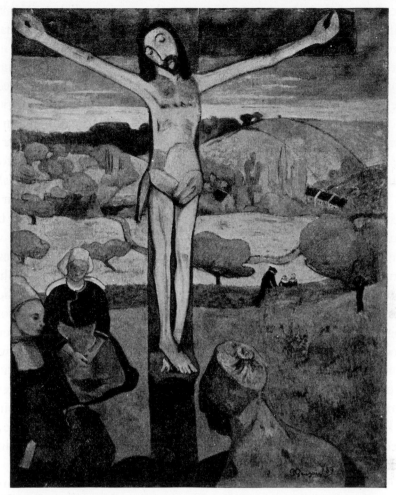

GAUGUIN: The Yellow Christ. 1889. *Collection of Paul Rosenberg*
(Courtesy Museum of Modern Art)

of the Tahitian period. There was no further playing with the impression-
istic fluttery technique, no coquetting in the impressionist manner with
light effects. Perhaps shadows did harbour a multitude of colours. But
a man who had decided to leave shadows out of his calculations unless the
design as such demanded them, who was now accustomed to spread col-
ours in areas where the need for colour-weight or the sensuous exigencies
of tonal harmonies dictated, had no need of Monet's and Pissarro's
discoveries.

In certain of the canvases of 1889–1890 there are parallels to Whistler's simplified form-organizations and to Cézanne's groping for a language of coloured planes (with one portrait showing a Cézanne still-life in the background), hints of Japanese conventionalization and of the flat area-divisions and the heavy outlining of forms practised by the medieval enamel-makers; and something, too, of Eastern tapestries and carpets in the rich colouring. Yet there are such unmistakable Gauguin idioms also that one need be no expert at all to know that these are all from the hand of the stock-broker turned painter. All these characteristics he was to take with him when he left France to find a new home on tropical islands, which he hoped would be less infested with bourgeois imbeciles, "far from this European struggle for money." Even Pont-Aven had fallen before the Americans, was civilized and impossible.

A few months in Paris sufficed to complete arrangements for his escape. Gauguin was seen occasionally at the café meetings of the symbolists, a group concerned more with literature than with new ideas in the field of the visual arts. That winter he felt again at times the pinch of poverty. He made no effort to go to Copenhagen to see his wife and children. He decided that the only way to secure money for the trip to Tahiti was by sale of accumulated paintings at auction. His symbolist friends helped, Octave Mirbeau was induced to write a newspaper article, and a respectable company of buyers assembled at the Drouot galleries. Thirty paintings were knocked down at an average price of sixty-six dollars. The total reached almost the figure of two thousand dollars which Gauguin had considered necessary for his venture.

He sailed from France early in April 1891. At a farewell dinner in Paris thirty artists and writers assembled to do him honour; but neither of the two painters who might have been considered his fellow-pioneers in the modern movement was present. Cézanne, no longer friendly, was in Provence. Van Gogh had died the previous summer. In the company was one Odilon Redon, then a successful lithographer, who may have learned something of enchanting colour through his association with Gauguin.

In Tahiti, looking forward to a new way of living and already discovering fresh sources of delight, Gauguin could look back at his life so far and assess its successes and its failures. In a notebook he kept for his beloved daughter Aline he expressed his hatred for sham and stupidity and for the bourgeois virtues. He did not spare his own weaknesses, but he also

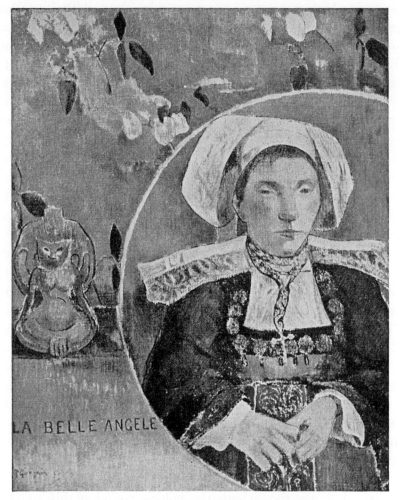

GAUGUIN: La Belle Angèle. 1889. *Louvre*
(Courtesy The Hyperion Press, New York)

was merciless in analysing a society that martyred creative artists. He wrote: "I have known extreme poverty, I have suffered from hunger and cold and all the miseries that follow. That doesn't much matter—one accepts it and with a little effort one even comes to laugh at it. The terrible thing about poverty is that it prevents one from working and paralyses the creative faculties."

He hoped that the escape from civilization had put behind him both physical privations and the senseless distractions from his work that came

in their wake. Unfortunately he had brought along with him his own weaknesses, especially an inability to hold to any money he might have, and an inordinate sensuality. His sensual desires he could happily indulge at will in the amoral primitive society of the Tahitians. He was not, however, content to do so naturally and quietly, but must flaunt his "irregularities" in the faces of the European officials and clergy who were intent upon bringing Tahiti into the orbit of civilization. He was soon in hot water with the authorities and he was a perpetual scandal to the missionaries. On his side he felt only disgust for the "caricature" of European civilization which he found in the colonial capital, Papeete, and he soon moved to a remote district where his only companions were natives.

For brief periods there he found something of that idyllic happiness of which he had dreamed during his days of trial in Paris. His hut was beautifully situated between the mountains and the sea, food was easily obtained, and the native girl he took to live with him brought not only great physical loveliness but a captivating fund of local history and legendry. "Civilization is wearing off little by little," he wrote in his journal, *Noa Noa*; ". . . peace is suffusing me, I no longer am surrounded by unnecessary troubles, I unfold myself normally." Best of all, there was a real accord of the bright simple beauty of the country and its people with the art he had dreamed of achieving. He felt sure he had been right in venturing the innovations that had found so little sympathy at home. He sloughed off, in this land of unashamed nudities and radiant colour, "the old European routines of art, the timidities of expression of the degenerate races." He exclaimed: "Why should I hesitate to put on my canvas all these golden forms and all this joy of the sun?"

And indeed it was the richest, the golden period of his art. He got down the native life in sensuously lovely pictures that never fail to brighten the rooms in which they hang. They are glowing, even enchanting in colour, and they are full of melodious linear rhythms. At their best they go deeper than merely decorative virtues. They are cunningly devised to afford the pleasure to be found in a poised complex of plastic elements. Gauguin's plastic imagination was not deep—he was not a master of symphonic spatial effects of like stature with Cézanne or El Greco—but in the lighter range he was peerless. There is in many of his canvases of the time of *Arearea* a breath of the calm, a hint of the poised order that is felt supremely in Chinese paintings and, in modern Western art, in Ryder and Seurat.

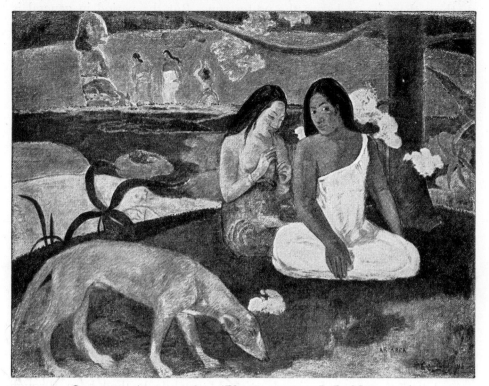

GAUGUIN: Arearea. 1892 (Photo courtesy J. B. Neumann)

It is a quality elusive and difficult to name, a revealed breadth, an organic order. It is a quality seldom found with brilliant colouring, and not at all in the works of those painters who specialize in reflecting the nervous energy and the social conflicts of the industrial age. That Gauguin himself believed that he was catching something of deeper, quieter rhythms in his Tahitian pictures is suggested in his explanation to certain doubting Parisian gallery-goers. Speaking of the luxuriant and even riotous character of the natural scene, and of "a tropical sun that sets fire to everything," he added: "Hence these fabulous colours and this glow of light—but *purified and silent*." Purity and silence are somehow bound up in the experience of poised order, of cosmic rhythm.

Gauguin sometimes, to be sure, was content to endow his pictures with the less profound form-values. He strayed into "merely" decorative fields, let bright colouring and patterning and snatches of the picturesque carry too great a part of the pictorial interest. His simplifications and linear

rhythms then descended to the posteresque. But the period in general is one of the richest in his career. When he returned to France after two years he had established the "primitive-decorative" as one of the chief ways to be explored by the younger groups of French moderns. Something of Tahiti of 1891–1893 is to be detected in the "savage" works of the fauves of 1905.

But Gauguin had not escaped the systems of Europe. Even in an island paradise some money is necessary, and natives buy no pictures. Gauguin had been sending paintings back to the dealers in Paris. The reports, when he got reports, were that his pictures found no buyers. Again hunger and debts came into his life. He fell seriously ill, partly from malnutrition. He spent months trying to find ways to get back to France "and straighten things out," writing bitterly to Mette and to friends to whom he had entrusted paintings in Paris. Yet in the two years in Tahiti he had produced more than sixty paintings and numerous small sculptures. He sailed from Papeete at the beginning of May 1893 and arrived at Marseille at the end of August—penniless.

During the final months in Tahiti, Gauguin had for the first time weakened in his resolve that he would stick to painting as a way of living. Exactly ten years earlier he had walked out of his brokerage office determined to live as a professional artist. Meanwhile he had been through miseries of every sort, had been humiliated by having to accept the charity of his wife's family or of fellow-artists, and had been ground down by a continual battle against debts, the doubts of family and friends, official hostility, and public apathy. He had written to friends in Paris to say that he was ready to drop his brushes and try to make a living again in the way *imbécile* bourgeois society called normal.

Arrived at Marseille, he was able to borrow money to get to Paris. In the capital he settled down in a friend's studio, but so many of the old ties were broken and so many intimates were away from Paris for the summer that he again felt lost and discouraged. Just at that moment, however, fortune elected to strike. An obscure uncle died and the artist came in for an inheritance of more than two thousand dollars. Characteristically Gauguin proceeded to live splendidly—and noticeably. He fitted up exotic quarters in a Montparnasse studio. He decorated the walls in vivid colours, and without much plan or logic mixed South Sea mementoes and Oriental stuffs with French furniture. In this setting he embedded his own paintings and those of Cézanne, Pissarro, and van Gogh. There he installed a

pet monkey and his mistress of the season, Annah, a diminutive Javanese woman who had come to him as a model. His own attire, in studio or street, also was something for Paris to talk about. A great felt hat with a bright blue ribbon, a long frock-coat, also of blue, with a row of mother-of-pearl buttons, a waistcoat of blue with a richly embroidered yellow-and-green collar, yellowish trousers, Breton wooden shoes that he had carved himself, and white gloves made up a costume that attracted attention wherever he went. Further to astonish and shock the bourgeois he carried a heavy cane upon the handle of which he had carved the figures of a man and a woman in an embrace.

He and Annah gave large parties in the studio and many of the great of Paris came, including his lesser painter friends, the sculptors Maillol and Rodin, and the Swedish playwright August Strindberg. Without believing all the rumours that got about, one is forced to infer that Gauguin had descended to being something of an exhibitionist and poseur, and that his regression into a gaudy Bohemianism was a result of both an innate inclination to dramatize himself and a reaction from privation and withdrawal. Everything else had failed. Now he was going to enjoy his inheritance while it lasted. The illusion of splendour was for a time sweet —and his name was getting about.

In November 1893 Gauguin's Tahitian paintings were shown at the Durand-Ruel galleries. There was little of the bitterness and revilement that were to be heaped upon Cézanne on the occasion of his first one-man show two years later, but Gauguin's brilliant colouring, his simplifications, and his occasional deformations of natural objects came in for considerable censure. A red dog and a pink horse were especially remarked. As for sales, the exhibition was a failure. A few art critics and literary men spoke well of the pictures. The public was intrigued by the colour and the exotic subjects but did not believe this was art. Among the painters Degas spoke favourably of Gauguin, but Renoir and Monet were shocked. They scolded, but it was Pissarro who went to Gauguin and tried to point out that his pictures lacked—of all strange charges!—harmony.

In the following year misfortune caught up with Gauguin again. He went to Copenhagen to see Mette and the children, but this time too there was more of unhappiness than of pleasure in the meeting. The inheritance money ran out—literally—and he closed the studio in Paris and went to Le Pouldu, then to Pont-Aven. Annah was with him, and he wore his showy Bohemian costume, carried his sculptured cane, and had the

monkey on his shoulder, and he found himself no longer accepted by the Breton peasants. He had quarrelled with Émile Bernard, who had asserted that the innovations found in Gauguin's works were his own—on no basis discoverable in achievement—and he was at odds with Sérusier, and so there was little of the *camaraderie* of the old days at Mother Gloanec's *pension*. He painted fitfully but there occurred an incident, over Annah, that ended his work for a time, closing a period. A fight arose over an insult, real or fancied, to the brown girl, and Gauguin found himself attacked by ten or twelve sailors. He did well enough until one of them came in from behind and broke the bones in his ankle with a blow from a wooden shoe. Annah deserted and scurried off to Paris, ransacked the studio, and disappeared with every valuable to be found there. Gauguin suffered a long and slow recovery and made his way to Paris, lonely and far from well. Infection from a girl of the streets with whom he sought consolation brought an even worse sort of illness. He went to Government officials to claim help that had been promised him by the Art Ministry. But a new Director of Fine Arts had been installed, and he, the same M. Roujon who was so scandalized when Mirbeau asked the ribbon of the Legion of Honour for Cézanne, threw out Gauguin's claim. After all, Tahiti had no disappointments so terrible as those of his own land. He decided to go back to the South Sea Islands for ever.

He could put his hands on the necessary money only by arranging another auction. This time he would sell not only his paintings but all his effects. There were nearly fifty canvases in the sale at the Drouot auction house in mid-February 1895. The highlight was the sale of a picture for one hundred and eighty dollars, *The Spirit of the Dead Watching*, now in the A. Conger Goodyear collection, New York. The average price was about seventy dollars. The total receipts were little above those from the earlier sale. It was, nevertheless, now possible for Gauguin to plan the final escape from a civilization which he prophesied was headed for ruin.

Gauguin asked Strindberg to write a preface for the catalogue. The great dramatist, being a realist and a literary psychologist, answered that he did not like Gauguin's pictures and could not understand them. But he admitted the vividness of Gauguin's images, which "pursued me last night in my sleep." In his dreams he had seen trees unknown to botanists and animals unknown to the zoos, and people "whom you alone could create," and a sea poured from a volcano. All this and Gauguin's Eves, too, tormented the Northerner in his darkened mind. He complained of

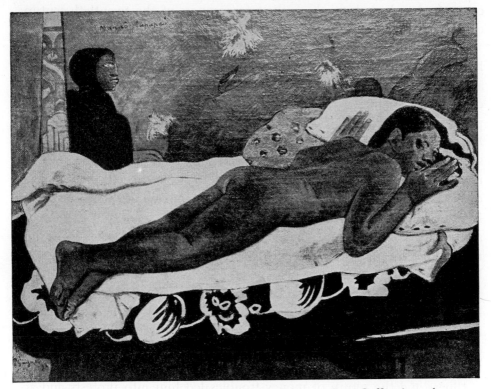

GAUGUIN: The Spirit of the Dead Watching. 1892. *Collection of
A. Conger Goodyear (Courtesy Museum of Modern Art)*

Gauguin as one who "defiantly opposes opinion, seeing the sky red rather
than acknowledge it the blue seen by the multitude." In short he marked
Gauguin as a distorter of nature and a creator of images beyond nature,
who had gone back to savagery to learn to create. Thus the great realist
dramatist expressed his doubts.

Gauguin published the letter in his catalogue in place of the refused
preface, with a letter of his own in reply. He noted that it was civilization
that caused Strindberg to suffer, and so gave him an art of suffering,
whereas it was barbarism that was giving him, Gauguin, new life and
health. He did not use the word expressionist, for it was not yet invented.
But essentially the debate had been between realist and expressionist. And
Strindberg, who had been a leading realist with *The Father* and *Miss Julie*,
soon turned up with *The Dream Play* and *The Spook Sonata*, works later

considered to have been the earliest forerunners of the twentieth-century expressionist drama.

Gauguin arrived at Papeete in the summer of 1895. This time he brought not only a little actual money but the promise of several friends and dealers in Paris that they would send further sums either on accounts owing or for pictures left with them to be sold. At last he seemed able to put to a real test his dream of painting in a carefree exotic paradise. Rather rashly, considering the uncertain nature of promises at ten thousand miles' distance, he spent extravagantly to build a two-room hut on rented land, in an idyllic spot not so remote from Papeete as the scene of his first sojourn. He began to paint. But again miseries multiplied and for long periods he could not take up his brushes, or could not buy canvas and colours. His Parisian friends failed him. For months and months and months not a cent of the money due him arrived. His ankle continued to be very painful, and a complication of diseases kept him weak and unable to concentrate on his work. When he had money he went to the hospital in Papeete for treatment; at other times he tried to wear out the illness alone or attended only by his native-girl companion. When his local credit was gone he and the girl lived on rice and water. He again knew the weakness that results from protracted hunger.

Illness and the return of money troubles led him into protests and actions that were sometimes hysterical and often extreme and ungrateful. In earlier years—he was now nearly fifty—he had shown a certain fortitude and a lack of resentment toward sometimes unreliable friends, despite momentary outbursts. But now his mind became obsessed over the failure of everyone in Paris to carry out promises. He pointed out that an income of only forty dollars a month would provide him with painting materials and living expenses. He begged his friends to find a group of collectors who would each take annually a painting at a cost of thirty-two dollars, on time payments. He said, not unreasonably: "I am sure that this is a fair price and that in future the buyers will not find they have made a poor investment." But a little later he is writing to his representatives to sell anything at any price.

For a time in the second year of his stay his affairs improved. Several remittances arrived from Paris, he paid some debts, he was able to have medical treatment, and he could buy colours. Best of all, he painted a new series of canvases. But when the money was gone, worse blows fell. A brief and unbending letter from Mette said that Aline, the only one of

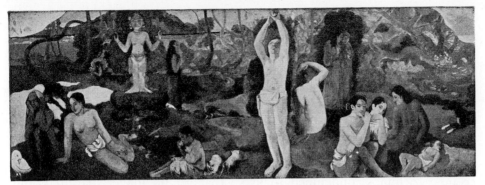

GAUGUIN: Whence Come We? What Are We? Whither Do We Go? 1898.
Museum of Fine Arts, Boston

his children with whom he felt a close tie, had died. He wrote to Mette
bitterly and broke the last bond with his family. The owner of the plot
of rented ground died and Gauguin was under the necessity of moving
his hut. The expense of setting the building up again on new land was
met through a local loan and by the fortunate sale in Paris of several
pictures. There was the promise, too, of further funds from the sale of
two of van Gogh's paintings that Gauguin had left with a friend, at the
magnificent price of eighty dollars apiece.

But illness returned, for months he could not work, and again he found
himself penniless and hungry. Paris was silent. He was ready, he wrote,
to admit at last that his kind of painting "never would earn even a miser-
able living." He was "on the floor, weak, half wrecked in the terrible
struggle he had started." He was bitter enough to wish that his paintings
"being unsaleable would remain unsaleable." He asked at last: "What is to
become of me?" and he began to look forward to "Death that delivers
one from everything." He wanted only to die in peace, "forgotten." He
painted one "last" picture in which he tried to put his thoughts about
life, the mural-like *Whence Come We? What Are We? Whither Do We
Go?* now in the Boston Museum. Having no canvas, he painted the com-
position on sacking.

For a time he was so ill that he thought nature would bring the death
he now desired, that he would escape the "reproach" of suicide. But
nature too failed him. Late one afternoon in January 1898 he went up to
a remote place in the mountains above his hut, took arsenic, and lay down

where he thought the ants would consume his body. But the dose was either too small or too large, the ants did not come in the night, and in the morning he stumbled down the mountain, in terrible pain. Again he had failed. To a friend in Paris he wrote: "Now I begin over again to live as before, on misery and shame."

He actually put away his painting equipment. He went to Papeete and obtained there a position as clerk and draughtsman in the Department of Public Works. For the better part of a year, except on the days when he was too weak to work, he laboured for the Colonial Government. It seemed to him, "condemned to live," that art no longer mattered. But at the beginning of 1899, when money arrived from Paris for sales of earlier canvases, he resolved to return to painting. He took renewed interest too in his home and asked that seeds of European flowers be sent for his garden. In a season of ups and downs he painted some notable works.

In 1901, after quarrels with the Government officials and further illnesses, he decided that Tahiti was being "spoiled" and that he could not serve his art there as well (or live as cheaply) as in some remoter island retreat. He sold his hut and land, and in November 1901 he moved to the Marquesas Islands. Speaking bitterly of the way in which old age had overtaken him (he was now fifty-three), he wrote of his hope that "the savage element there, almost cannibalistic, and the unbroken solitude, will stir me with a last spark of inspiration before my death, will rally my imagination and bring a sort of conclusive achievement."[1]

The final chapter of his life, covering the two and one-half years at Atuana on the island of Hiva-Oa, begins as an idyll and ends as a record of bickering, misery, and frustration. He found the more primitive, the unspoiled environment he had so long sought, and in the woods in a village he built himself a hidden hut. As a painter too he was, he said, "a savage, a wolf without collar in the wilds," and the very antithesis of the civilized, "Grecian" Puvis de Chavannes. Where Puvis *explained* ideas in his art, Gauguin's effort was to paint them direct, without symbols, without literary associations. A virgin holding a lily might represent purity to

[1] The quoted passages are excerpts from Gauguin's letters of this period, or, less frequently, from his *Intimate Journals*. In most instances the author is responsible for the translations, but an occasional phrase or sentence may follow Robert Burnett in *The Life of Paul Gauguin* or the translators of John Rewald's *Gauguin*, in the Hyperion Press series. Where sums of money are mentioned in this and in other chapters treating artists of the pre-World War era, the dollar is given as the equivalent of five francs, as near a fair conversion as can be figured in a world without basic monetary standards.

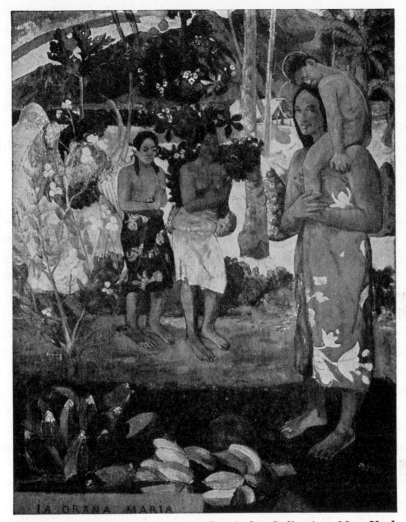

GAUGUIN: Ia Orana Maria. 1891. *Lewisohn Collection, New York*

a knowing age; but a picture suggesting purity by a pure scene and pure painting seemed to Gauguin a preferable achievement. Europe needed to get back to the savage's unliterary and direct approach. Through a long period, Gauguin said, "art has strayed away through devotion to chemistry, physics, mechanics, and over-study of nature. Artists thus have lost instinct and imagination. . . . They are bewildered and frightened when they are left alone." But the strong would seek solitude and find in it strength to act alone.

For a time even now Gauguin painted, but his hand did not always obey as well as it once had done. As in Tahiti during the years before his attempt at suicide, he was troubled because he had to work at each painting through many short sessions; on some bad days he could be at the easel no more than an hour. His method had always been to see the finished picture in his imagination, and to deliberate upon it, before setting up a canvas. Then he would if possible complete it in one sitting, swiftly, decisively, without retouching. "It is preferable," he had said, "to start another picture than to retouch." Now he was reduced to the painter's business of starting and restarting, patching and niggling.

He did not always lose the emotion, the sensation, in the delayed execution—some canvases as fine as the *Native Women in Their Hut* belong to the period—but too often there is indecision in the handling, and an almost cloudy effect in what had formerly been areas of purest colour. In short, this middle-aged man, who had been a professional painter fewer than twenty years, was suffering from an old man's weakened hand.

At last money troubles seemed finally lifted, for Vollard, the Paris dealer who had recently given Cézanne his first exhibition, had made an arrangement for advancing to Gauguin sixty dollars a month against paintings to be delivered, which he was to take in at forty, then fifty dollars apiece. At first the payments were fairly regular, but they soon failed unaccountably, at moments when the failure again meant worry and distraction from painting. There were relapses into serious illness. And as if to give point to those critics who said that he made his own troubles (which he might indeed have avoided if he had remained a stock-broker), Gauguin entered into quarrels with the administrators of the islands in defence of some persecuted natives, and got himself sentenced to a jail term and a fine. It became necessary for him to journey to Tahiti, where alone he could seek an appeal. He had to stop all painting.

In April 1903, when he had made ready to go, he wrote to a friend in Paris about the "scandalous" events, ending his letter, the last he ever wrote: "These affairs kill me." He took to his bed, too weak to make the required trip, and one day shortly afterward he died, unattended. Thus ended on May 8, 1903, a life miserable almost beyond compare, but courageous, and productive of the loveliest decorative painting known to the modern world.

The natives who loved him were too afraid of the authorities to do him honour, though his closest friend, Tioka, once a cannibal, an ex-convict

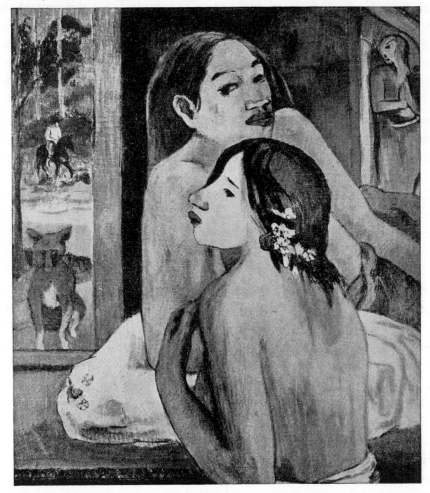

GAUGUIN: Native Women in Their Hut. 1902. *Collection of Paul Rosenberg*
(Courtesy The Hyperion Press, New York)

and recognized medicine-man, tried to bring him back to life by magic
rites.

The officials of the island added some grotesque touches at the end.
The Catholic missionaries seized the body before the Protestant mission-
aries, whom he had equally despised, arrived, and they buried the artist
with all ceremony in a cemetery on the bishop's land. A gendarme took it
on himself to censor Gauguin's belongings and destroyed the carved walk-
ing-stick decorated with lovers. The local authorities sold his minor belong-
ings; and the paintings, drawings, and sculptures were sent to Papeete to

be auctioned, to satisfy his debt to the Government, for the unpaid fine. The French population made a holiday and a joke of the sale. The art works were considered souvenirs of a bizarre "character," little better than a beachcomber, and the prices realized were ridiculously small. Gauguin's last painting, a scene of Brittany, done from memory and imagination, was sold for one dollar and a half. Nevertheless, at this time in Paris first steps were already being taken toward a corner in Gauguin's paintings, toward one of the neatest and most profitable killings in the annals of art speculation.

Gauguin himself wrote that he believed his paintings to be only comparatively good. But he felt that he had dealt decisive blows for liberty and that younger men would profit by his pioneering. "Nobody taught me. What little is good belongs to myself. Who can say that that little will not become a big thing in the hands of others?" A group of young Parisian artists discovered the worth of Gauguin's paintings almost as soon as the speculators did. Unconsciously he *had* absorbed a good deal from Daumier and Cézanne, and even from Corot and Whistler and Degas, all of whom he spoke of as masters. He also incorporated the influences of the East and of primitivism—for which he preferred the name savagery. But he had made the influences his own, and had added out of his individual creative imaging power a personal manner or a style of painting that remains unmistakable.

Certain elements of this manner went almost immediately into the main stream of early twentieth-century revolutionary painting. The shadowless drawing, the heavy outlining (to be traced back to a source in the *cloisons* of *cloisonné* enamels or to the partitions in medieval stained glass), the squared or flattened or otherwise distorted figures, the flattened, tapestry-like backgrounds, and the "exotic" colouring, all reappear in the work of Matisse, from 1905 on; and only less directly, in part, in the painting of the other *fauves*, particularly Friesz, Rouault, and Marquet. Long since, Odilon Redon had gained something in both pictorial simplification and lush colouring from him. Pierre Bonnard also owed his colour and other elements of his personal style more to Gauguin than to any other painter, though the debt came partly by way of Sérusier and the *nabis* group. The Parisian-Italian Modigliani, the German Otto Mueller, and the Swiss Hodler were others indebted heavily to the example of the original savage of modern art.

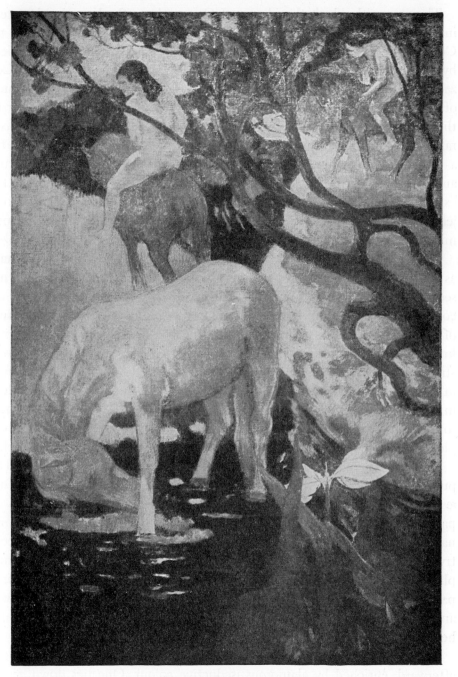

GAUGUIN: The White Horse. 1898. Louvre

The ease with which the idioms of Gauguin's method can be detected in other men's work, as compared with the hiddenness of the debt to Cézanne, is a measure, perhaps, of the lesser place ultimately occupied by Gauguin as prophet of modernism. As the form-organization of Cézanne is more profound, the abstract realization more perfectly a product of all the plastic means, so the mystery of Cézanne's way of mastery is the greater and his method less copiable. He created no style of his own; rather his contribution was the fundamental one of leading all painters to a concern with formal creation. Gauguin, moreover, in escaping literary and moralizing subject matter and in distorting nature, never went to the extreme touched by Cézanne in his near-abstract water-colours. The objective properties of Gauguin's art are always explicit, the meaning recognizable, however arbitrary the arrangement or the short-cutting.

Gauguin nevertheless deserved well the title he was ultimately given, as the second great artist of post-impressionism, second leader of the form-seeking, anti-realistic groups. The plastic rhythms may not be deep as compared with Cézanne's; in the decorator's way, he sacrificed something of depth and profundity for the more easily accessible loveliness of sinuous linear traceries, sensuous colouring, and opulent patterning. But the formal structure, the plastic orchestration, is there. Even the flattened figures are in an adjusted order, serve as volumes in space, acting upon one another in axial relationship. The planes are used in the business of marking a track for the eye. And the colours and patterned areas have place in the complex of elements creating forward-backward movement in the picture field.

In short, Gauguin came to a thoroughly revolutionary way of art. He pushed into the field wherein painters are more concerned to evoke an æsthetic emotion, by means of formal orchestration, than to tell stories in paint or to moralize, or to depict a scene, an incident, or an effect in nature. He shallowed his compositions, flattened his picturing into tapestry-like inventions, and lost thereby the opportunity to achieve the symphonic effects of an El Greco; but he created some of the most ingratiating painting of modern times, of a sort paralleling the art of the primitives and the Orientals, a sort not known in the modern Western world until he mastered his brushes.

It is, of course, the restful, melodic experience that one remembers afterward, enriched by glamorous, seductive colour. One lies down easily in Gauguin's pictures. One abandons one's self to the sensuous glow, the lyricism, the cool freshness of them. One feels the harmony at the heart of

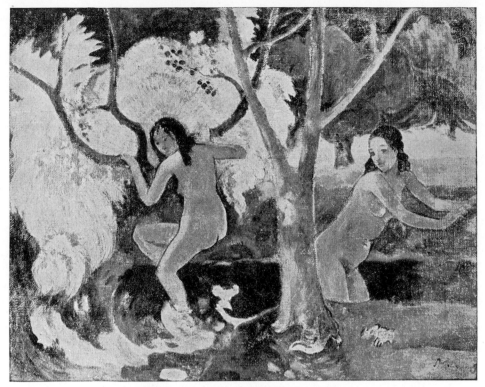

GAUGUIN: Bathers in Tahiti. 1897
(Courtesy Wildenstein and Co. Galleries, New York)

life. In pictorial conventions Gauguin has transmitted to us his own emotion as artist, has fixed in a little arrangement of volumes, planes, lines, and colours the image that formed, imaginatively, within his inner self.

Theorists came to explain some of the specialized ways of Gauguin's fixing of the image. They pointed out in his pictures the avoidance of disturbing recessions into deep space, by the suppression of objective background, and especially the suppression of perspective vistas; the sequences of planes; the absence of chiaroscuro; the weaving of flattened "motifs" into a rich but eye-cushioning "curtain"; the purity of the fresh colours, and the way of laying them in broad areas; and the play and counterplay of linear rhythms. But beyond all that is the interplay of all these elements, the orchestration, the binding of every means into a structure that *is* the form of the picture. Perhaps Gauguin's word for it, the "synthesis," is as good as any. He tired of the word when his followers threatened to

make a formula of it and to found a school upon it, as he tired of every-thing else that smelled of rules and schools and conformities. Neverthe-less, at the end of his life something radiant and moving that he had visioned back in Pont-Aven in the days when he called himself "synthetist" had been given body and flavour and soul in a multitude of painted works. For that the world can afford to forget all the arrogance, truculence, and bitterness of soul which became interwoven with the unfolding pattern of the life of one who wanted to be a savage, in purity and in simplicity, among "civilized imbeciles."

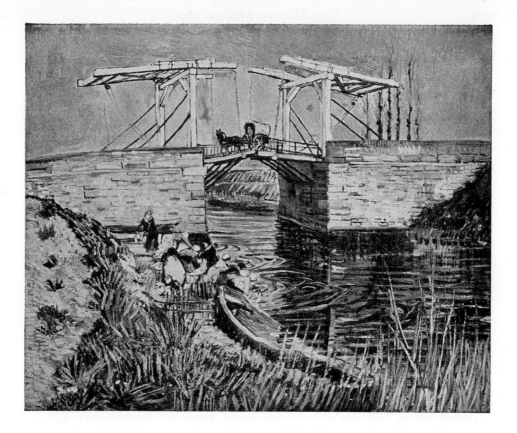

XI: VAN GOGH, THE MAD DUTCHMAN

A YOUNG Dutch fanatic named Vincent van Gogh spent the winter of 1875–1876 in Paris, where he served as a minor clerk at the Goupil galleries. But he was not interested in art. He might have attended, but apparently failed to do so, the second exhibition of the impressionists, the historic event described by the critic of the *Figaro* as a misfortune second only to the burning of the Opéra. In the very month of the exhibition the

VAN GOGH: Bridge at Arles. 1888. *Kröller-Müller Foundation, Wassenaar*
 (Courtesy Museum of Modern Art)

youth lost his job and left France. It was devotion to religion that made him heedless of all else, even the problem of making a living. During the next seven years he was to experience, through his religious fanaticism, the depth of misery and the heights of spiritual exaltation, in a way destined to be curiously significant, after further changes in his life and in art, to the development of modern painting.

In the Borinage, that black district of industrial Belgium, he was to practise in 1879–1880 a form of early Christian communism, giving to the miserable the clothes from his back, sharing his food until he had starved himself beyond possible return to full health, and even giving up his bed —making himself at one with an oppressed and hopeless people, to the furthest depths of their hunger, sickness, and destitution. Broken physically by the experience, and shaken mentally, he nevertheless again in 1883 put to the test the doctrine of unselfish love and self-immolation. At thirty, when he had become an art student, he took into his rooms at The Hague a sickly prostitute, who brought with her one of her five children and was pregnant. He nursed her, paid her doctor bills, and shared food or hunger with her; and he planned to marry her. He quoted to his protesting relatives the unanswerable injunctions laid down by Christianity for self-giving and for aid to the unfortunate.

Frustrated in the end, less by his family than by the woman's incomprehension and restlessness, he nevertheless had set the pattern which his life in art was to follow. For no artist ever gave himself more self-destructively, more fanatically, more lovingly to painting than did the mad Dutchman. The frustration art brought in the end was death, self-inflicted. He had not asked returns from it (though he had been heartened when, during his last year, a critic mentioned his work, and again when one of his paintings was actually sold). But his was the story of the spiritual *exalté* who turned to art as a means of expression, the story of the intense individualist, the story of a consuming emotion poured out in a fire of paint. In that story was the beginning of modern expressionism.

The zealot van Gogh's giving of himself in art lasted hardly more than three years. It was not until he arrived in Arles in 1888 that he found—in the Provençal country and the Provençal sun—something that he could love and serve as he had loved and served the people of the Borinage and the prostitute Sien and her child. He attained again to both exalted happiness and the depths of personal suffering. He gave himself so intensely, so feverishly, that he piled up as many canvases as another might have

painted in a score of years. He wrecked himself by his intemperate devo-tion. As free artist, as confined lunatic, he painted the sun and the sun-colours on the Provençal flowers, trees, and fields. He apostrophized the sun even while admitting that it was destroying his sanity. And in his art he *expressed* it—as no one ever had.

An obsessed and doomed individual in life, an expressionist in art. No wonder when Freud's disciples examined art that they found van Gogh's case a perfect illustration of their darkest theories, of art as a funnel for personal distress, of graphic representation serving as a discharge for psy-chic disorder. Nor did the non-pathological enemies of modern art fail to link the man's insanity with the distorted look of his, and of so much other post-impressionist, painting.

Vincent van Gogh was the son of a small-town clergyman in Southern Holland, near the Belgian border. He was born in March 1853, and was the eldest of six children. At twelve he was placed in a boarding school, but at sixteen he returned home as unformed, sensitive, and asocial as he had gone. Egg-headed, small-eyed, red-haired, round-shouldered, excitable, given to moods of melancholy, he seemed like poor human material. Nevertheless, he worked well for three years as handy boy at the Goupil branch gallery in The Hague, where an uncle was manager. He was trans-ferred, as clerk, to the branch in London in 1873.

Thus he was well on the way to being a cosmopolitan, and could look forward, at twenty-two, to being a successful businessman-of-art, when his life was shattered, as it seemed to him, by the unhappy termination of a love affair. He had come to worship, silently, the daughter of his landlady, and when she rejected him he took the rebuff as seriously, in his com-bined sensitiveness and overwroughtness, as he was to take his troubles in religion and in art later. His work at the gallery suffered and he was trans-ferred to Paris, back to London, and again to Paris, in the years 1874–1875. During the final term of his employment with the Goupil firm, in Paris early in 1876, he neglected his work, and seems even to have conceived an active dislike of the conventional art works he was forced to handle; and he gave all his leisure time to religious study. There developed in him a well of love, of charity, that he was compelled to draw on for unfor-tunate humanity. Finally Goupil's dismissed him.

The following three years saw him buffeted about in the conflicting efforts to make a living and to prepare himself for a life of Christian min-

istry. He taught school in England, employing the opportunity to explore the misery of life in the London slums at the same time; and briefly he held a post as book-seller's clerk in Dordrecht, but was preoccupied and inefficient. Then for a year his family helped him financially while he tried at the University of Amsterdam to prepare himself for the theological course that would gain for him a place like his father's, as minister. Again he failed. There was nothing left but to accept a tentative appointment as missionary, and to attempt direct evangelical work among the people. One after another, every member of his respectable and influential family had washed hands of him.

At Wasmes in the Borinage, where life was blighted by the worst excesses of industrialism, the country withered and blackened, the miners and their families exploited to the last extreme of poverty, destitution, and hopelessness, Vincent threw himself into charitable work. He wisely concluded that preaching had no useful place there—and he knew that at best he could be no more than a shabby and ineffectual preacher. But he could gain the miners' confidence by living as miserably as they did and by sharing whatever he had. He gave away his own clothes and improvised others of sacking and castaways; he gave away the bread that might have kept him in strength; he slept on the ground. He nursed the sick.

Inevitably Vincent failed. He became too much one of the miserable to be successful as a conventional missionary. The church organization dismissed him, with kind words for his spirit of sacrifice but with criticism of his "excessive zeal." He did not give up his ambitions immediately and after a year he returned to the Borinage, to live as one of the oppressed rather than as an evangelist. He came to know himself as a social outcast, a failure, little better than a tramp.

From the University of Amsterdam three years earlier, Vincent had written to his brother Theo that, although he studied theology, he often unaccountably found himself making drawings. As early as his first London days he had sketched a little, for the amusement of his family and friends. The impulse had got lost in the burning fervour of his missionary service, except as he had made drawings and toys for the miners' children. Now his failure as a social ministrant made another way of expression necessary, and at last the artist began to form in the so often frustrated man.

Vincent made drawings of the miners and their life, with Millet-like honesty. Soon he was as feverishly eager to serve humanity by means of

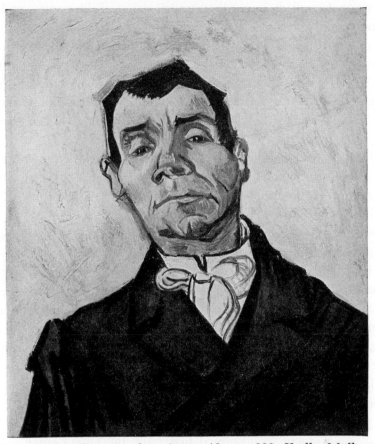

VAN GOGH: Portrait of an Actor. About 1888. *Kröller-Müller Foundation, Wassenaar* (Courtesy Museum of Modern Art)

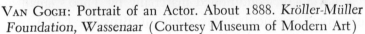

art as he had been to serve by early Christian self-giving. His younger brother Theo, his junior by four years, had been the one member of the family who had understood and sympathized with him through his earlier difficult days. Theo was now with the Goupil firm, at the central galleries in Paris. To him Vincent appealed in his new need; and there began one of the strangest and most touching records of fraternal trust and association known to the world of art.

Out of his own small earnings Theo began to send Vincent money so that he could study and paint. Vincent was enabled, as he tramped the country fields and roads, paying for his bread when he could, begging at

other times, to reflect upon the strange ways of humanity and of art. Love, he concluded, *is* the only way of approach to God's kingdom; but love may unlock too the spiritual chambers of the arts. If one love a great creative artist deeply and selflessly, something of God, all of faith, and a vista of deliverance are opened to one. Perhaps a man seeing this vision, with heart full of love, turning artist, might himself become the instrument of God's design. . . . These truths, he wrote to Theo, one learns quickly from "the free course at the College of Misery." He had, he said, been "for five years—I do not really know just how long—more or less unemployed, wandering here and there"; and he had become homesick for "the land of pictures," for the once-known "surroundings of pictures and things of art."

In September 1880, writing to Theo of a fatiguing trip he had made, sleeping on the road, in haystacks or wagons, he added an almost Biblical dedication. "It was even in that deep misery that I felt my energy reborn, and I said to myself: in spite of everything I shall rise again. I will take up my pencil, which I have forsaken in my great discouragement. I will take up again my drawing. From that moment the world became transformed for me." But in dedicating himself to art he did not immediately forsake humanitarianism. With his other studies he read continually in social literature, from Jesus's sayings to the books of Michelet, Hugo, Zola, and Harriet Beecher Stowe.

The years of study that followed the years of toil and stumbling progress and first achievement, conditioned materially by Theo's small and sometimes interrupted payments, were spent at Brussels, Etten, Amsterdam, and The Hague. These were the years from his twenty-seventh to his thirtieth birthday. For a time at Brussels he tried hard to study in the usual way, model-drawing, copying, perspective, anatomy. He might, if he had not mistrusted authority, have become a great illustrator, a belated realist.

At Etten and at Amsterdam he fell victim to love again—the personal sort—and felt once more that his life was shattered when he was repulsed. At The Hague he sought again to conventionalize his art, this time under the tutelage of a cousin, Anton Mauve, a successful and accomplished painter, realistic in the soft and sombre Dutch manner. Mauve was at first sympathetic and helpful, and he initiated Vincent into the mysteries of oil painting. But soon he was put off by his pupil's waywardness and moodiness, and he washed his hands of the unpromising youth. It was

then that Vincent sank to the furthest depths, as his family saw the matter, taking in the prostitute Sien and dividing with her the scant allowance provided by Theo. For more than a year Vincent lavished on the uncomprehending Sien all the love he had wanted to place at the feet of the two women who had repulsed him, and at the same time he imaged her as a particularization of all the suffering and worthiness of unjustly condemned humanity. For a time his art suffered as his ministrations became more exacting, and as actual hunger returned. Finally the woman took herself off, to resume a life of independence, and Vincent was free—not without regrets, but understanding fully that again he had attempted a task of love beyond his powers.

At Drenthe in the moor region of north Holland, during the latter months of 1883, and more so at Neunen in the south, where his father had taken a pastorate, in 1884 and 1885, he was able to submerge himself in painting and in the life of the people. "I have become so absorbed in peasant life," he wrote, "that I hardly ever think of anything else. . . . It is a real fact that I am a peasant painter. . . ." He recorded the activities of the peasants in the fields, pictured their homes, and especially showed them at their weaving. As art, the drawings and paintings were cramped, illustrational, and over-dark. But there was in them unmistakable strength and utter candour. He had outgrown the Mauve influence and escaped routine Dutch picturesqueness and sentimentalism. He was not without a sense of the poetic—was even romantic in the best sense. He wrote that "the figure of a labourer, some furrows in a ploughed field, a bit of sand, sea, and sky, are serious subjects, so difficult, but at the same time so beautiful, that it is indeed worth while to devote one's life to the task of expressing the poetry hidden in them." And he thought that "an artist need not be a clergyman or a missionary, but he certainly must have a warm heart for his fellow-men." At rare moments he got into his paintings hints of the formal structure that would so notably reappear in the pictures of his year at Arles. But this element was to enter fully only after he had made the discovery of Japanese prints.

At Neunen he suffered again the blighting effect of a tragic love affair, and was driven in on himself, in a way that may have contributed to the mental disorders which were to distort his life increasingly in the five years remaining to him. A woman, older than he, awakened his sympathy, then his consuming love. To escape the fire of his passion she attempted suicide. It was his last effort to find happiness in a permanent love, with one of

whom he could say with his whole heart: "She, and no other." He never ceased to feel himself an outcast when faced with examples of family affection and married devotion. During this year, 1885, his father died. Vincent said: "It is hard to die, but it is harder to live."

The mid-winter of 1885–1886 he spent in Antwerp, the first stopping point on his final journey southward. Symbolically two events there contributed to his development as a painter. He discovered the colour and gay extravagance of Rubens, and he encountered Japanese art for the first time. Spells of illness and near-starvation and brief attendance at a conventional art academy served to accentuate his loneliness and misery. Taking his treasured Japanese prints with him, he went to Paris on a sudden resolve early in 1886. Characteristically he asked Theo to meet him in the Salon Carré, the hall of masterpieces at the Louvre.

Before leaving Antwerp he had written a long letter to his brother that summed up, at a crossroads, the trials, the illnesses, the doubts, of the way he had followed: "Though it is spring, how many thousands and thousands walk about in desolation! . . . When one stands isolated and misunderstood, and has lost all chance of material happiness, this one thing remains —*faith*."

Vincent wrote too of his looks and of his position more vividly than have any of his biographers. "When I compare myself to the other fellows," he wrote in the same letter, "there is something stiff and awkward about me; I look as if I had been in prison for ten years. . . . There are no less than ten teeth which I either have lost or may lose; that is too many, and it gives me a look of over forty which is not in my favour." And: "I have begun to cough continually too. I went to live in my own studio in Neunen on the first day of May, and I have not had a hot dinner more than six or seven times since. I lived then, and I do so here, without money for dinner because the work costs me too much, and I have trusted too much to my being strong enough to hold out. . . . I believe more and more that to work for the sake of work is the principle of all great artists: not to be discouraged even though almost starving." And: "Time must show who is right. Probably the academic gentlemen will accuse me of heresy."[1]

[1] The story of Vincent van Gogh, like that of Gauguin but unlike that of Cézanne, is well documented by his own writings. The longer quotations here are taken, by permission, from *Dear Theo: The Autobiography of Vincent Van Gogh*, edited by Irving Stone, consisting of Vincent's letters to his brother. The author has not scrupled, however, to quote or adapt certain shorter excerpts from other translations when the purpose of a brief running narrative was better served thereby.

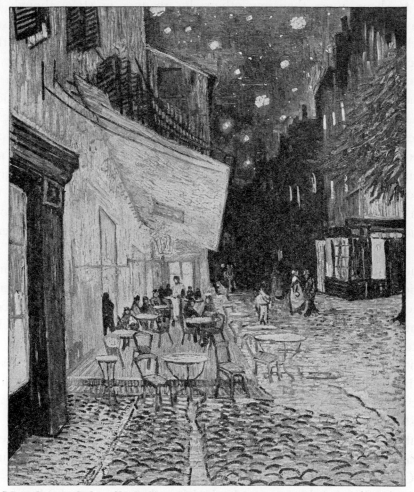

VAN GOGH: Sidewalk Café at Night. 1888. *Kröller-Müller Foundation, Wassenaar* (Courtesy Museum of Modern Art)

In Paris, Theo met Vincent, as requested, in the Salon Carré, under a painting by Rembrandt, another Dutch painter who in his time had been considered a madman by his artist-friends. Soon the brothers were domiciled together in a studio-apartment in the heart of the artists' quarter, Montmartre. At first Vincent was delighted by the picturesque shabbiness of the streets, the cafés, and the surrounding country. He threw himself excitedly into the business of painting what he saw around him.

In the two years of his stay in Paris he absorbed the two influences that

were to shape, more than any others, his manner or style; though the canvases done in Paris were vastly inferior to the characteristic sun-drenched works to be painted in Arles in 1888. The first influence, that of the Japanese prints, was for a long time too little digested. A series of works, ranging from actual copies of Hiroshige and Hokusai, through experiments in Occidental subjects attempted within Japanese conventions of shadowless drawing and starkly geometric composition, to landscape and café-corners, merely simplified and flattened in the Eastern idiom, evidenced his serious study of the prints he had bought in Antwerp and his enthusiasm for the master Hiroshige. At the sympathetic Tanguy's (although he dreaded the "Tanguy woman," a "Xanthippe" and "an old witch") he found more Japanese prints, and there he came into personal contact with the artists who were to exert the second decisive influence upon his painting method.

The impressionists, now accepted and successful, completed his emancipation from the dark manner of the Dutch and Belgian "academic gentlemen." He had written from Antwerp of his radical ideas about colour, atmosphere, and vibrating light, and how his painting had shocked the teachers at the Academy. Now he was in the very heart of the impressionists' territory, and with Theo's blessing he proceeded to absorb into his technique all that Monet and Pissarro could show him of colourfulness, looseness, and spontaneity. He learned to do acceptable impressionistic landscapes and portraits.

But van Gogh perceived, as Monet and Pissarro did not, a deeper formal significance in the distortions and the plastic structure of Japanese and Chinese art. He soon found that his real affinity was not for the impressionists but for three men who had left the company of Monet, Pissarro, and Sisley, to carry the torch of revolt a step further: for Cézanne, who was now generally considered the most monstrous painter among the outcasts, even while he was creating, in 1886–1887, that group of masterpieces of the first Mont Sainte-Victoire series, which has perhaps not been surpassed in the course of modern art; for Gauguin, who was experimenting under the combined influence of Cézanne and of the Orient; and for Seurat, obsessed with the vision of a neo-impressionism in which the recent colour-gains might be preserved within a new formal or architectural structure.

At a moment in the spring of 1887, before Gauguin's "first escape" to Panama and Martinique, three of the four prophets of post-impressionism

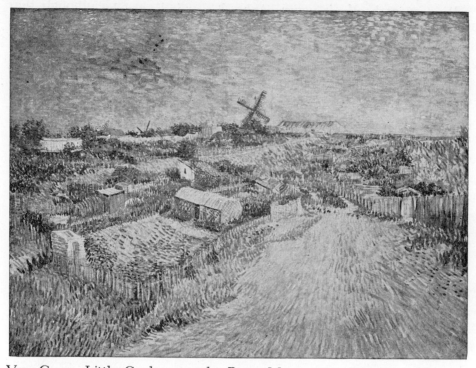

Van Gogh: Little Gardens on the Butte Montmartre. *Municipal Museum,
Amsterdam* (Courtesy Metropolitan Museum of Art)

were in Paris, Cézanne alone having returned to the provinces. Of the
group, Seurat was the only one who ever counted himself a real Parisian.
Four years later he and van Gogh were to be dead, Gauguin, embittered,
was to be on his way to the South Seas, and Cézanne was to be embarked
upon his final years of wandering.

Vincent toward the end of his stay in Paris became convinced that
his brother's position as art dealer (he was still at Goupil's) was being
compromised by his presence. Theo felt a certain obligation to stand by
his brother with encouragement and a show of confidence; but of the
paintings he had taken over, ostensibly in payment for his expenditures
on Vincent's living and his painting materials, not one had ever sold. In-
deed, it was evident that the canvases were an embarrassment to him.
It was all right for Père Tanguy, who had no reputation to lose, to put
one of van Gogh's pictures in his window; but it would be disastrous at
Goupil's. Moreover, in a small apartment the two brothers were inevitably

getting on each other's nerves. A break was indicated by the winter of 1887–1888.

But chiefly Vincent was depressed by the life of Paris. What had seemed gay at first, what had stirred him to feverish activity and ambitious dreams, was turning out to be, when completely explored, superficial, tawdry, and even vicious. Without being a puritan—retaining indeed a comprehensive tolerance with his spiritual innocence—Vincent tired of "painters who as men disgust me." He had come into contact with Toulouse-Lautrec, nobly born and wealthy but morally decadent. Montmartre, moreover, then as later, harboured a flock of painters with the vices but not the talents of Lautrec. Vincent longed for the simple stimulations of nature, and especially for the colour and light of the sun. His heart urged him to escape from Paris. Curiously, it was the town-mad Lautrec who fired his desire to seek refuge in the South. Perhaps Gauguin too had imparted something of his lust for more brilliant contrasts and more resplendent colour than the impressionists had been able to compass. Besides, the greatest of the knowing ones, Cézanne, was a Provençal. Before him even, there had been a Marseillais, Monticelli, who had brought sumptuous colour into his somewhat uncontrolled romanticism.

One day in February 1888, with characteristic kindliness, Vincent cleaned his rooms in the studio-apartment, decorated them with flowers and his own paintings, and disappeared. He had told Theo of his need for tranquillity and poise, and at the same time for a new sort of splendour. He was seeking again the inspiration of direct contact with nature, as well as a new way of artistic life. "I must start all over again. I must go down into the earth, naked. . . . There is wind down there which I long for. I must feel it on my skin, and the warm sweet smell of the ploughed field. In Paris I have lost my sense for the wind altogether." And again: "I could not have stood it much longer." He was escaping and he was leaving Theo free. Nevertheless, he was counting still on Theo's monthly remittances, "until I do better."

In his first letter from Arles he was apologetic but not despairing. It would cost him all of five francs a day to get along. So far "expenses are heavy and the pictures worthless"—but he would not despair, because he found himself at the threshold of new grandeurs. Yet: "I haven't a penny at the moment."

He writes that he has heard from Gauguin (now at Pont-Aven), who

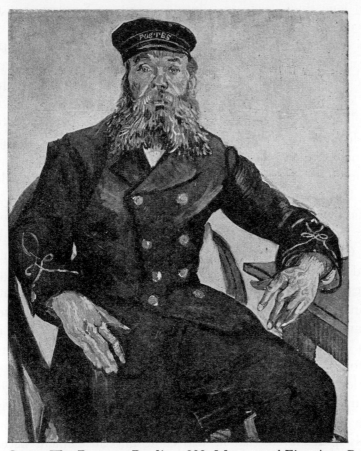

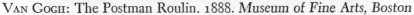

Van Gogh: The Postman Roulin. 1888. *Museum of Fine Arts, Boston*

"feels himself doomed to perpetual beggary." Vincent exclaims: "When will artists see less troubled days?" The thought prompts him to write of a co-operative association of artists he had long dreamed over: an association to which the painters would turn over their pictures, which would then sell them, and "guarantee its members a chance to live and work." The three leading impressionists and Degas and Renoir should be asked, he tells Theo, to take the lead, since they already are finding a market, by reason of "their personal efforts and their individual genius." But they should spread the benefits to "a whole battalion of artists who up to now have been working in continual beggary." Among others he mentions specifically Gauguin, Émile Bernard, Seurat, and himself; and Guillaumin,

who had long since given up painting except on Sundays, but who was to be saved shortly by winning the grand prize in a lottery.

It was of course a frightfully impractical scheme in a capitalistic world, and it was destined to come to nothing; but Vincent was to trouble his head over it often in the short season before madness claimed him. Perhaps he looked forward to a future in which a single painting by Gauguin would sell for fifty thousand dollars. Was it logical that "collectors" and dealers should gain these profits? Why, all three of them, Gauguin, van Gogh, and Seurat, could have lived and worked without worry for their whole lifetimes on the amount a dealer was to gain from the sale of one painting by the least of them.

But the immediate problem for Vincent was how to secure five francs a day for his living and paints, and how to cease being a burden to Theo. He and Gauguin were going through periods of undernourishment, illness, and loss of precious time from their work. Seurat, never in actual want because he could throw himself upon the charity of his mother, was undermining his health by over-work and would die, at thirty-one, within three years. Vincent had even fewer months before him, though he spoke to Theo encouragingly: "Three or four years I have—I must make one more effort."

At Arles he was immersed in the "splendour" he had sought, or at least so much of it that he became as one intoxicated. It was winter still when he arrived, but from the first contact he knew he had found that which his spirit craved; that he had come into an element necessary for the ripening of his art. He exclaimed: "I feel as though I were in Japan!" And he enumerated the delights that had come to his eye. "I have seen some splendid red stretches of soil planted with vines, with a background of mountains of the most delicate lilac"; and he had made his first studies "of a branch of almond already in flower in spite of the snow." In the same letter he enumerated "lots of beautiful things, a ruined abbey on a hill covered with holly, pines, and grey olives . . . a drawbridge with a little cart going over it, outlined against a blue sky—the river blue as well, the banks orange-coloured, with green grass and a group of washerwomen in smocks and many-coloured caps."

Nature newly glorious, humanity newly colourful—these galvanized his sensitivity and gave wings to his brushes. As if by magic his art ripened, was transformed. Always a rapt student and an oblivious worker, he gave himself passionately and heedlessly to painting. Within a nine-month

period he piled up as many canvases as a reasonable artist would do in ten years. Impressions crowded in on him—he must get them all down: the people, the cafés, the streets, the bridges, the farms, the orchards, the flowers. Animating all these subjects was the Provençal sun, giving them gorgeous colour. The gay yellow of the sunflower was echoed in countless blossoms and was spilled in great patches over the fields of grain; it was burnt into the walls of the stucco houses and it bathed the pavements and the river landings with a golden wash. Even that was not enough for Vincent: he often put the disk of the sun itself into his pictures. The reds were hardly less intoxicating to him. The tile roofs of the houses, the poppies studding the meadows, the painted boats, the fezes and trousers of the Zouaves; and if all these things seemed to give not enough brilliancy, he found ways to weave yellows and reds into tree trunks and rocks and clouds, and even faces, where all of tradition should have told him they did not belong.

Vincent descended into a veritable orgy of colour. His soul, born and nourished in the comparative dark of the North, was free at last in the land of the sun. Sometimes when illness or worry returned, or it might be only through impetuous haste, he failed to bring off the image he had conceived. But never did a single year see production of so large a proportion of an artist's masterpieces. Under the spell of Arles, Vincent cast off almost miraculously the confusion, indecision, and weakness that had come over his painting in Paris. The softness of impressionism was exorcized. Overnight he returned to the largeness and simplicity that had been his link with Daumier. He began to draw again with Daumier's heavy outlines and Daumier's ruthless simplifications. What he had taken from the Japanese too came clear, no longer as copied idioms or adapted mannerisms but as part of his own method of frank formalization and structural stability.

From Arles Vincent went on for a few days in June to the shores of the Mediterranean, out of sentiment and to find out if the colour of the Midi held all the way to the sea. The diligence set him down at the village of Les Saintes-Maries and immediately he turned to his painting and drawing. The Mediterranean water fascinated him; it seemed by turns green or violet, blue or rose or grey. He was fascinated too by both the form and the colour of the fishing boats: blue, pink, green, red, orange. He had never encountered scenes so Japanesque, and in his *Sailing Boats on the Beach at Les Saintes-Maries* he exploited, legitimately, the methods of

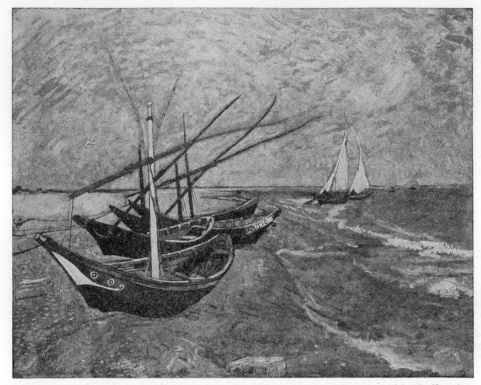

VAN GOGH: Sailing Boats on the Beach at Les Saintes-Maries. 1888. *Collection of V. W. van Gogh, Amsterdam (Courtesy Museum of Modern Art)*

the Oriental print-makers more successfully than any other Western artist had done. He was seeing with a Western eye sharpened for decorative and rhythmic effects by love of Eastern art. The grouping of the boats, the method of drawing, the flat colouring, the playing with textured areas, and above all the concern for a main plastic rhythm: all this parallels Hokusai and Hiroshige, though Vincent could not have adapted or absorbed so much if he had not, like Cézanne and Seurat and Gauguin, gained long since a personal and an intuitive feeling for the painting values beyond realism.

At Arles he painted anything and everything. Along with landscapes attesting his delight in the out-of-doors he produced unique interiors, intense and alive, and one of the most masterly series of portraits known to modern art. The range of his portrait methods was as notable as the improvement of his work over that accomplished in Paris. At one extreme

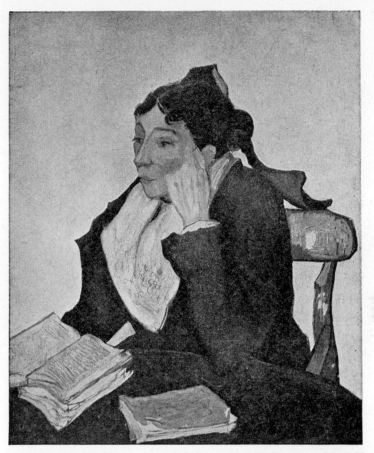

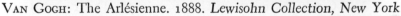

VAN GOGH: The Arlésienne. 1888. *Lewisohn Collection, New York*

was the picture known merely as *The Arlésienne,* now in the Lewisohn Col-
lection, posteresque, unmistakably Japanesque, frankly an "arrangement";
not dissimilar, almost as summary and decorative and broad, the oil study
of Vincent's friend, Roulin, postman, absinth drinker, and philosopher,
now in the Boston Museum; next, the so-called *Portrait of an Unknown*
(identified by some as of Theo van Gogh), more serious, more penetrating;
and finally the stark, uncompromising, distorted *Self-Portrait* at Munich.
A fifth portrait, varying toward caricature, more perversely distorted,
known as *Portrait of an Actor,* is of the same year, 1888, but not certainly
of the Arles period. There were other heads and figure-pieces, of the
peasants, of the Zouaves, of the women and boys of Arles.

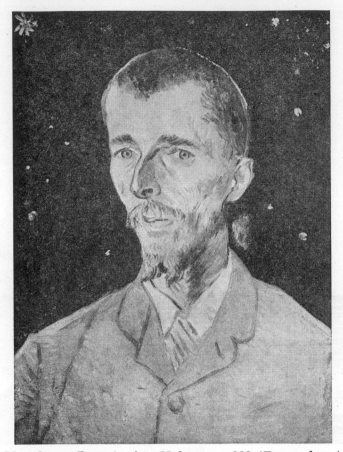

Van Gogh: Portrait of an Unknown. 1888 (Druet photo)

Vincent (he now signed his pictures with his Christian name only) painted too the places that became familiar to him, his own little bed-room, night scenes in the café where he drank absinth with Roulin, the café terrace on the street at night—hauntingly like certain prints of Hiro-shige but unmistakably van Goghish too—the cornfields, the farmhouses, the town promenades, the gardens. Or it might be small things that took hold of his imagination, a pair of old shoes on the floor, or a chair, or a jug of flowers. Impossible as "artistic subjects" in 1888, these things were destined to take on immortality when he transferred them in thick paints, clumsily too it seemed, to canvas. Fifty years later no discriminating seller of prints, no matter how far distant from Arles, would dare be without

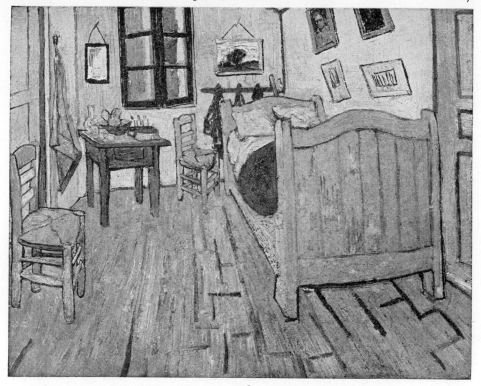

VAN GOGH: Van Gogh's Bedroom. 1888. *Collection of V. W. van Gogh, Amsterdam* (Courtesy Museum of Modern Art)

coloured reproductions of *The Yellow Chair* and the golden *Sunflowers* and the cramped *Van Gogh's Bedroom*; and from all, the buyers were to find the sun of the Midi strangely reflected into their own rooms.

Of the bedroom picture Vincent wrote: ". . . simply my bedroom, only here colour is to do everything. . . . The walls are pale violet. The ground is of red tiles. The wood of the bed and chairs is the yellow of fresh butter, the sheets and pillows very light greenish lemon. The coverlet scarlet, the window green. The toilet table orange, the basin blue. The door lilac. And that is all—there is nothing in this room with closed shutters. The broad lines of the furniture again must express inviolable rest. Portraits on the walls, and a mirror and a towel and some clothes. The frame, as there is no white in the picture, will be white. . . .

"The shadows are suppressed, it is painted in free, flat washes like the

Japanese prints. It is going to be a contrast with, for instance, the Tarascon diligence and the night café. . . . No stippling, no hatching, nothing, only flat colours in harmony." When he wrote to Theo after his first serious breakdown the following winter, he said that of all his canvases the one that seemed best to him was this of his bedroom.

As an artist he had been working theoretically along lines parallel to those followed by the Pont-Aven group. Shadowless drawing, ruthless simplification for the sake of the "synthesis," broad-area colouring, flattened perspective: he was ahead of Émile Bernard, with whom he was in frequent correspondence, and certainly abreast of Gauguin, in mastery of these elements of a new, non-realistic method. But he had no time or inclination to theorize. With him the mere urge to express himself, to paint, was the central, the overpowering thing. *How* he was to paint was a matter of intuition, of trial and error, of exciting pursuit of an experienced image, conditioned by his own emotion and by what he had apprehended from other artists and from the study of pictures he had liked. He could not be bothered to make up a theory, much less to write it out. Least of all did he care who got credit for a new theory if one *was* forming. But his letters were full of accounts of the colours of this picture or that, and they contained generous references to the Orientals and to his fellow-artists.

About Gauguin he wrote to Theo: "I thought, he is on the rocks, and here I am with money while this lad who does better work than I do has none. So I say he ought to have half. . . ." In the same letter he exclaims: "This would be the beginning of our Association! Bernard, who is also coming south, will join us. . . . I should willingly see them all better men than I am."

Vincent rented a house for fifteen francs a month, in preparation for Gauguin's coming. He rashly spent everything Theo had sent him, making over the rooms and putting in beds and chairs and a gas stove. He painted the interior walls himself—this was to be a house of art, the "Atelier of the South," the beginning of an artists' co-operative worthy of the new age. The studio especially he wanted to be a *permanent* home for artists, for him first and for unending successors, and so it should be especially decorated with portraits, "with a feeling of Daumier about it." Finally he painted the exterior of the house yellow: after all, to him yellow was the most important colour in art.

Gauguin, who had to fall back on Theo for fare, arrived in October, and

the two painters plunged into their life of incessant painting and talking. The stimulation of it at first was good for both of them. Vincent learned technically from Gauguin; he learned to "clean up" his canvases a little. But the arguments, in which he undertook especially to defend Delacroix and Rembrandt, Meissonier and Monticelli, were, as he put it, "electric." Gauguin, being the more forceful character and fresh from leadership at Pont-Aven, was inclined to play the teacher. He even sketched in the outlines which Vincent should follow in portraying one of the Arlésiennes.

Increasingly they quarrelled, taunted each other, and drank absinth to excess. A few weeks of the association served to bring Vincent to the verge of a mental breakdown. One evening in the café he threw a wine-glass at Gauguin's head. Gauguin carried him like a child to his room and put him to bed. The next morning he was worried and contrite, and asked forgiveness. But by evening madness was full upon him. Gauguin, walking in the dark street, heard footsteps behind him and turned to see Vincent running after him holding an open razor. A sharp word was enough to send him back to the studio. Gauguin took a room at a hotel.

When he went to the house of art next morning, intent upon taking away his things and returning north, Gauguin found the street crowded with policemen and curious citizens. He was seized and accused of murdering his companion. It fell to him to lead the police through the blood-stained rooms of the yellow house to Vincent's bedroom. There they discovered that the mad painter was not dead but exhausted and seriously weakened by loss of blood. They pieced together—with the aid of reports from a neighbouring brothel—an account of Vincent's actions of the evening before. Failing in whatever violence he had designed against Gauguin, he had returned to the studio, decided to take his own life with the razor, then had been deflected by the diabolical idea of fulfilling a jesting promise made to a prostitute, that he would give her "one of his funny ears." He had sliced off his right ear, had wrapped his head in towels, and had gone to deliver the severed member to the door of the brothel. Then he had gone back to the house of art and fallen into the stupor of exhaustion.

Vincent was carried to the local hospital. Gauguin telegraphed to Theo, then left for Paris. A doctor put Vincent on his feet in a few days, but was afraid of a recurrence of insane impulses. He helped Vincent to get started again with his painting, and finally let him return to the yellow house. Under the doctor's instructions he learned to calm himself when

threatened by over-excitement. He wrote to Theo optimistically about both his health and his paintings. "So many difficulties . . . but I have not given up hope. . . . I am not taking thought for direct sale . . ." but "my tale of pictures is getting on, and I have set to work again with a nerve like iron."

He even dared believe that his *Sunflowers* might be worth a hundred dollars to "one of those Scots or Americans." He marvelled that "you could fracture the brain in your head and recover." He congratulated Theo on his approaching marriage, adding: "You have gone on being poor all the time in order to support me, but I will give you back the money or give up the ghost."

But the precautions he had to take in protecting his temporary sanity were of a sort that harmed his work. He was to discover that it was excitement over nature, overwrought emotion, a passionate fever of expression, that had enabled him to achieve the intense expressiveness of the *Sunflowers* or the *Night Café* or the self-portraits. He had paid for attaining what he called "the high yellow note." For a time he held to his resolve to be moderate and calm. But inevitably the impulse to push on "headlong" with his art brought his nerves again to the breaking point, and one night he accused a restaurant waitress of poisoning his soup, and shattered the bowl on the floor. He was returned to the hospital—it was now mid-February 1889, a year after his arrival in Arles—and was treated by the sympathetic doctor.

When he returned to freedom, the townspeople had turned against him. He found it impossible to paint freely, and finally, goaded by the taunts and jeers of small boys calling for his other ear, he made an unforgivable scene in the square. From the jail he was taken to the hospital, and not long after, in order to save further worry to Theo, he agreed to commitment to a private asylum at near-by Saint-Rémy.

There after a few weeks he was permitted to set up a tiny studio, and to paint as he liked. He found a certain fellowship with the other patients (though there were terribly distressing incidents too). "I think I have done well, for by seeing the actual *truth* about life of the various madmen and lunatics here, I am losing the vague dread, the fear of the thing. And the change of surroundings is doing me good." His mind ran back to the eminent artists who had ended their days in such retreats, and he was comforted that after all he was not to be considered so abnormal, so different. His one greatest worry was the trouble he had caused Theo.

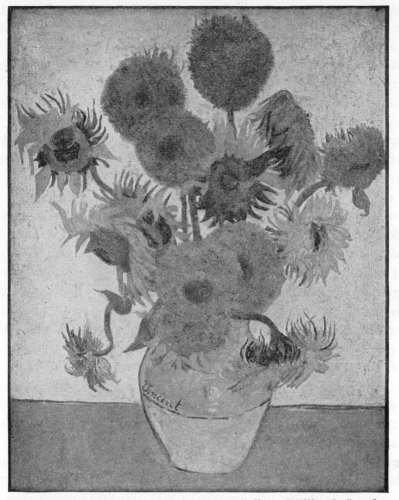

VAN GOGH: Sunflowers. 1888. National Gallery, Millbank, London

He had made his peace with Gauguin by letter. He found himself, in his new seclusion, after reflection, more tolerant of artists with ideas different from his, among both bygone and contemporary painters. "Madness is salutary in this way, that one becomes less exclusive." He wanted to give the impressionists their due, especially for extending the bounds of colour; but not forgetting that Delacroix and Millet even so, without rainbow colouring, attained "more completeness." He had praise for Daubigny, Breton, Whistler, and Puvis. These made him judge his own work of slight importance. Despite the recurrence of spring, and the following

of golden summer, he found that a sombre note crept into his painting, and he began to talk of grey as a basis for his harmonies.

He could not work regularly, but between attacks he accomplished an enormous amount of painting for one so ill. At first he pictured the cloister of the asylum (an ancient monastery), and the immediate landscape surroundings. He was later permitted outside the walls and he found the fields as colourful as those at Arles. But most of all the cypresses came to obsess him. "I have a cornfield, very yellow and very light, perhaps the lightest canvas I have done. And the cypress is always occupying my thoughts. It is as beautiful in line and proportion as an Egyptian obelisk, and the green has a quality of high distinction. It is a splash of *black* in a sunny landscape. . . . I should like to make something of the cypresses like the canvases of the sunflowers; it astonishes me that they have never been done as I see them."

And he painted them as no one else ever had, as personalities, distinctive, compelling, as part of the earth-life. Always he had thought of everything in nature as being of the one universal vitality with himself. He endowed scenes and people and things with a life quality. Now he painted the cypresses of Saint-Rémy and, because he was tormented, melancholy, he added to the cypress quality a flaming torment of movement, of dark colour, of twisting coilings. Sometimes whole landscapes took on the look of tortured convolution. In the pictures of road-menders at work in the village at Saint-Rémy the tree trunks are like writhing monsters dwarfing the workmen and strollers.

Even in the portraits the painting method, always swift and unaccountable, turns nervous, even troubled. The audacious harmonies oftener fail. The feeling for plastic organization, partly intuitive, partly developed through love of Oriental art, progressively disappears. In a sense Vincent is getting more of his art out of himself, from within. He is less bound by nature. Landscapes become mosaics of arbitrarily juxtaposed splashes of colour. But the self from which he is drawing is no longer controlled, is less orderly. His art now is expressionism from the source that the realists like to think gives rise to all expressionism: madness. There are, even up to the summer of Vincent's death, bits that are amazingly truthful, scenes set down with incomparable force, compositions that breathe a fantastic intensity. But where the pictures of the Arles period had, for all their vigour and liveliness and gorgeous colour, come to a poise, a plastic serenity—that is, perhaps what *form* quintessentially is—the paintings and draw-

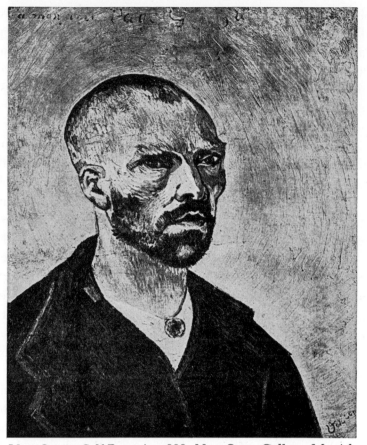

VAN GOGH: Self-Portrait. 1888. New State Gallery, Munich

ings done at Saint-Rémy, and those of the later brief period at Auvers, disavow serenity and often enough lack all formal stability. The exhibit is a *tour de force* of nervous movement, of violence, of twisted power. The old rapture is rooted in torment.

During the year at Saint-Rémy mental crises recurred at intervals, and the doctors would have forbidden Vincent to work had he not made it plain that he would commit suicide if he were deprived of his painting. Between his "better times" he read a great deal, especially his favourite Shakespeare, and Zola; and he made paintings after engravings of pictures by Rembrandt, Delacroix, Millet, and Daumier, improvising the colour. In February there occurred such a change of fortune that the shock might

have brought final ruin to any weakly balanced mentality. A letter from Theo spilled out a check for four hundred francs. One of Vincent's pictures had actually sold. Theo wanted him to use the money to come to a retreat nearer Paris, and one likely to be more pleasant for an established artist, a sanatorium at Auvers kept by that same Dr. Gachet who years before had been Cézanne's first patron.

There came too a telegram that affected Vincent even more: Theo's wife had given birth to a boy and they were naming him after Vincent. It was not only that they cared for him; he had dreamed consistently throughout his younger days of family life and children as the greatest blessings. Finally a third communication from Theo told him that his pictures had been noticed by Albert Aurier in the *Mercure de France*, and not merely mentioned but discussed in three paragraphs. There it was, in black and white. ". . . In his insolent desire to look at the sun face to face, in the passion of his drawing and his colour, there is revealed a powerful one, a male, a darer. . . . Vincent Van Gogh is of the sublime line of Frans Hals. . . . This robust and true artist with an illumined soul, will he ever know the joys of being rehabilitated to the public? I do not think so. . . ."

Vincent's reaction to so overwhelming a change in fortune was mixed. He was flattered by Aurier's notice, but shortly he wrote to Theo: "Please ask M. Aurier not to write any more about my painting, and insist upon this: that, to begin with, he is mistaken about me, since I am too overwhelmed with trouble to face publicity. To make pictures distracts me, but to hear them spoken of gives me more pain than he can know." He wished, too, in becoming a godfather, that he might have been in some other place. . . .

The little flame of public approbation lighted by an uncertain journalist in Paris was destined to grow and brighten too late to shed any warmth upon the "robust and true artist." He went through his final months at Saint-Rémy with little change except that he learned that his mental lapses were recurring cyclically, and by watching the calendar he could know when he would have two or three months free of them. His latest two attacks had taken the form of religious frenzies induced, he believed, by the religiosity of the nuns who served as nurses in the asylum.

In May he wrote to Theo: "I can't stand any more—I must move even for a last shift," and a few days later he was permitted to start for Auvers by way of Paris. Theo met him at the Gare de Lyon, and he enjoyed a visit with the little family and a gathering with old friends. Vincent was

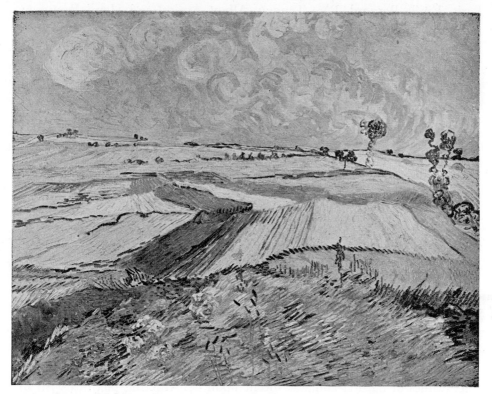

VAN GOGH: Fields at Auvers. 1890. *Collection of Marshall Field, New York*
(Courtesy Metropolitan Museum of Art)

looking exceptionally well, they all remarked, and he behaved himself
meticulously.

After three days he went with Theo to Auvers and met Dr. Gachet.
He felt that he was in the hands of friends and he began to paint, in the
sombre, fantastic mood that had come over him at Saint-Rémy. He did
a portrait of Dr. Gachet, "with the heart-broken expression of these times,"
and a few landscapes and flower studies. But somehow he was dull, weary,
and exhausted. He could not resist the idea that he was finally foundering.

After a few weeks, anticipating the time when his next cyclic crisis was
due, he borrowed a revolver and shot himself. He did not do a clean job.
When Theo came, Vincent said: "I have failed again." He lingered on
two days and died in the early morning of the twenty-ninth of July 1890,
in Theo's arms. Besides Theo and Dr. Gachet, four of his friends from

Paris, Émile Bernard, Père Tanguy, Albert Aurier, and Henri Rousseau, were among those who stood silent as the body was lowered into a grave in the Auvers cemetery. Dr. Gachet planted sunflowers around the grave. The following spring Theo died and his body was brought to Auvers and placed beside Vincent's. It was a bad year for modern art: Seurat died too, while still hardly more than a youth, that same spring of 1891.

The passing of Vincent van Gogh made little difference to the artists who were striving, in various ways, to establish a new way of art. He had been briefly in the councils of the group encouraged by Tanguy and by his brother Theo. But he was not a man to have pupils. It is questionable whether in the ten years after his death he inspired anyone to be his follower. Gauguin was to have imitators and almost a following "school" within a few years. But it was Vincent's less understandable *approach* to art that was to be important. It was, moreover, in the Northern countries first that wide popularity was to come to his paintings.

Van Gogh fitted well enough into a later grouping of "post-impressionist masters" when measured by the chief tests employed in setting artists beside Cézanne. That is, he had been anti-academic and anti-realistic; he had struck back to begin in a new simplicity; he had abandoned the appearance values of nature, and was intent upon constructing pictures with intense "life of their own"; and out of some central imaging power (and out of a study of Oriental works, a study common to all the post-impressionist masters) he had brought up into his pictures, in the all-important Arles period, enough of the precious form-quality, of plastic and spatial rhythm, to mark him as creatively a brother of Cézanne, Seurat, and Gauguin.

In his pictures the form-apparatus cannot be as easily marked as in the works of these others, though at times the volumes are placed in space as tellingly (especially in the portraits) or the planes arranged as effectively in sequential order, as in Cézanne's less abstract studies. In use of colour and texture he is as daring and generally as successful as the others. But in the end it was as intensified emotional expression, as the irrational spilling-over of personal excitement, that his painting prophesied one whole stream of modernism. He let himself go before that bit of nature which at the moment interested him and submerged his senses. His painting became a revelation of a personal identification with forces beyond the appearances of nature.

If van Gogh had fellow-travellers along the trail of self-revelation and emotional intensification, they were less the French painters with whom

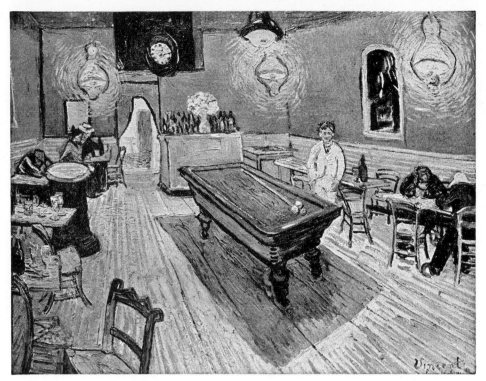

VAN GOGH: Night Café. 1888. *Collection of Stephen C. Clark, New York*
(Courtesy Museum of Modern Art)

he had briefly associated, in the two years in Paris and the one at Arles, than the Scandinavian Edvard Munch, already a creative painter during van Gogh's last years, and a scandal in conservative Berlin as early as 1895, and James Ensor, a Belgian, who in 1890 was a disordered dreamer and a wildly emotional painter, although he was to exert less influence on subsequent developments, being weak on the formal side.

The Germans by the turn of the century were ready to embark upon their special road of experimentation. Munch in 1904 was at the centre of a *Junge Kunst* movement in Dresden. In casting about for sanctions and encouragement within French radical modernism, the beginning expressionists discovered van Gogh as the perfect type-artist of their dreams. Not yet certain of the importance of Cézanne's revolutionary discoveries in the realm of pure form, still suspicious of the over-simplified and perhaps over-decorative idioms of the better-known Gauguin, they took to their hearts

the brooding, burning, vehement art of van Gogh. They felt in him the mystic apprehensions, the intense sympathies, the passionate longing to express the inexpressible, not to say the mental chaos, that churned within themselves.

All the members of the original post-impressionist group had been individualists—it would be hard to name four artists who had painted more individually, with more marked personal idioms, than Cézanne, Seurat, Gauguin, and van Gogh—but van Gogh had been an individualist on the spiritual and emotional side. He had heeded inner voices, had seen visions, had felt in his own veins and in his painting hand the rhythms of the vital universe. Nor did the elements of suffering, of tragic torment, that shone out of the Saint-Rémy canvases seem to the Northern radicals at odds with their impulse to pour out their intensest feelings.

Thus van Gogh came to be the first exhibit in the gallery of post-realistic pictures that called forth the name and the theories of expressionism. The name was to find currency ultimately as almost a synonym of modernism, a label broad enough to cover the several varieties of post-realistic art. But in its first phase, when it labelled only those artists who intensely expressed their inner selves, van Gogh came to be considered its first prophet and pioneer.

He who had sold only one picture in his lifetime might, if he had lived out a normal span of years, have seen his "mad" pictures take their place in the greatest art repositories of the world. Ultimately a leading museum of modern art achieved its greatest popular success with a comprehensive exhibition of his works. Even more surprising, schools all over the world gave space on their walls to cheap coloured reproductions of his once despised paintings. Out of a soul burning with love and the desire to give, out of a super-sensitive temperament, out of a body robust at first, then abused and progressively starved and finally broken, had been born pictures too strange for the artist's own generation but destined to become familiarly loved masterpieces three decades later.

Once Vincent had written to Theo of his sunflower pictures: "It is a kind of painting that changes to the eye, that takes on a richness the longer you look at it." If in 1890 when he died, lovers of art still could not detect that hidden meaning, that increasing richness, fifty years later it had come to seem a part of the normal loveliness of modern art.

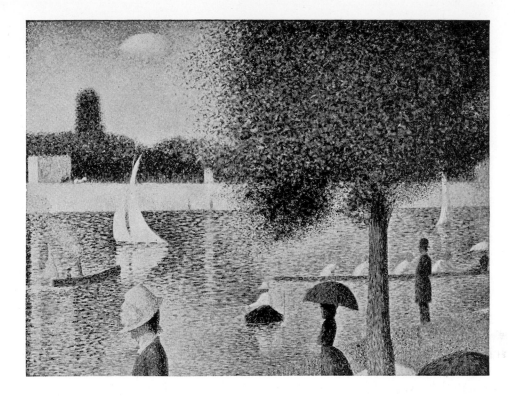

XII: SEURAT, DEGAS, AND THE
BOHEMIANS OF MONTMARTRE

THE romantics of 1830, when they had rebelled against the neo-classi-
cism of the school of David and of Ingres, had bandied about a ques-
tion, almost as a rallying cry. "Who," they asked one another, "will rescue
us from the Greeks and the Romans?" Géricault had died, and the leader
Delacroix had failed to form a school or to launch a movement of sufficient
momentum to crush Ingres and the perennial academics. There had come
the insurgency of Daumier, without the slightest impact upon any con-
temporary but Millet; then the full objective realism of Courbet and Manet;

SEURAT: La Grande Jatte. Detail. *Art Institute, Chicago*

and the final tenuous flowering of realism in impressionism. But all these together, from Delacroix to Monet, had failed to dislodge the Greeks and the Romans from the teaching positions in the École des Beaux-Arts or from control of the Salon.

In the early eighties, a half-century after the struggle between the youthful Delacroix and the party of Ingres, it became apparent that a distinctive French school had arisen, with a credo sufficiently sound and at the same time sufficiently novel to attract painting students in great numbers. Impressionism, still not officially accepted in France, was by 1880 no longer the radical fringe but the main front of progressive painting. And because a few creative artists recognized a shallowness in impressionism, a new cry was heard, especially among the painters who gathered at Tanguy's shabby gallery or at Theo van Gogh's: "Who will save art from the impressionists?"

Four men, known later as the original post-impressionists, responded to the call, not as a group but each in an individual manner: Cézanne, himself an impressionist at the beginning of the movement, seceded to seek those formal values which were to concern school after school of experimentalists in the twentieth century; Gauguin, taught partly by Monet and Pissarro, deserted his early friends and increasingly imposed decorative order upon his brightly coloured pictures; van Gogh, turned impressionist during his two years in Paris, 1886–1888, abandoned all but the surface markings of the style as soon as he plunged into his one great creative year of painting in the South; and finally Georges Seurat, after the briefest of exposures to impressionist influences, gave, in the seven years of his professional life, the completest and most definite answer to the question. Of all the four insurgent masters he left an œuvre that most clearly negates the weaknesses, the spinelessness, and the formal laxness of impressionism.

Unlike his three fellow-insurgents, Seurat was Paris-born, and he lived and painted in Paris almost exclusively. Although lost to recognition for a dozen years after his death, and dismissed as a "neo-impressionist," he was to be brought into lasting fame, alongside Cézanne, as soon as the twentieth-century "school of Paris" took form. It was discovered, indeed, that in his tragically short life he had, even more consistently than Cézanne, re-established the French creative tradition; had answered, for all time, the question: "Who will save art from impressionism?"

Georges Seurat at the time of his death had been twice as successful commercially as Vincent van Gogh, that is, he had sold two paintings in

his lifetime. Fortunately the failure to find a market did not keep him from painting and from experimenting, though it may have had something to do with the feverish overwork that brought physical collapse at the age of thirty-one. He was born in Paris of parents well situated. His father was an attorney and court attaché. Georges's schooling was orderly, and at nineteen he entered the École des Beaux-Arts. As a student of Lehmann he was given thorough training in draughtsmanship, in the strict Ingres tradition. Above all he was admonished to "paint cleanly." At this time he had never heard of, or had not felt sympathy for, the impressionists, who in 1880, the last year of his study at the École, were holding their fifth exhibition. Seurat haunted the galleries of the Louvre, and he haunted also the art-school library, indulging a passion for information about painting methods and especially about colour theories.

For a year he was away for army training. After his return it took him a year or two to get seriously into the routine of art work, though he sketched and studied. It was perhaps in 1883 that he came into contact with impressionism. He had become involved in a searching study of colour, first out of growing admiration for Delacroix, then in a wider field, with attention to the Venetians and to the Oriental print-makers. Finally he turned to the scientists for light on the problem, and pored over the books of the French and American colour-physicists. A drawing of his was shown at the Salon in 1883—no small honour for a youth of twenty-three—and a critic specially remarked it, saying specifically that he had searched for other works by the unknown artist.

Already Seurat was meditating upon a picture that was to be his first major production, *The Bathers*, now in the Tate Gallery. He was developing his personal method of accumulating numerous pencil and crayon sketches, following up with sketch paintings, and finally setting to work slowly and laboriously, with infinite care for each part, upon the full-sized canvas. Already he had found the scene from which so many of his early subjects were to be taken, the banks of the Seine in the neighbourhood of Courbevoie and the Island of the Grande Jatte.

By nature he was a man serious, lonely, and studious; and he asked nothing better than opportunity to linger through a morning on the river bank, studying effects, sketching, dreaming. Never, apparently, was anything put down hastily or thoughtlessly. Visionary in the profoundest sense, he was nevertheless methodical and painstaking; and the sense of order is felt in virtually every one of the four hundred surviving drawings. What he

drew was, essentially, order—never casual aspect. No one else "arranged" his pictures with quite such artificial precision except Whistler, whose paintings probably came to Seurat's notice in the Salon exhibitions of 1883 and 1884, when the portraits of the artist's mother and of Carlyle were shown.

The Bathers was rejected at the Salon of 1884. Later in the year it was shown at the initial Indépendants show, an occasion historic not only because a new annual exhibition was then established for the refusés of Paris, but also because it marked the debut of the so-called neo-impressionists. The two leaders of that school or movement met there for the first time, Seurat and Paul Signac, and formed a friendship and a professional contact that was to end only with Seurat's death seven years later. The date of the showing of The Bathers came to be considered by some twentieth-century critics as a moment historic and determining, marking the rise of the first effective rebellion against impressionism. It brought to attention a man who, accepting impressionist freshness of colour, reverted to careful adjustment of design, to objects set out in their own right (not merely as takers of light), and to experimenting with the full range of plastic elements in pictorial space.

A sketch for The Bathers, probably of 1883, shows reliance upon the impressionist means, and especially exhibits the sketchy handling and the tendency to merge areas and to lose definition of contours. In the larger 1884 version the volumes take on definition and roundness (though flattened in Seurat's peculiar planar way), and there is a painstaking adjustment of the pictorial structure in space. Not yet, however, has the artist arrived at that method of precise painting in colour "pellets" which is a surface mannerism of all his later years.

In a revealing work of 1885, The Seine at Courbevoie, the transition from the manner of The Bathers to that of the final period is illustrated. Seurat was at this time only twenty-six years old, and frankly a learner still; and it is not to be wondered at that he seemed, on the surface, to have gone back to a Monet-like fluttering touch. But in all else, in the attention to pictorial structure, to sequences of planes, and to sharpness of silhouettes, he had progressed beyond the impressionist masters—directly away, indeed, from their improvised harmonizing and soft-focus views.

For nearly two years he laboured upon the largest of his works, shown in 1886, the Sunday Afternoon on the Island of la Grande Jatte. This painting, of mural size (covering seventy square feet), now at the Chicago Art Institute, marked the painter's arrival at maturity in use of the personal

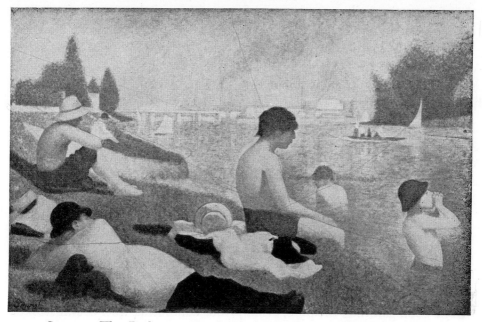

SEURAT: The Bathers. 1884. National Gallery, Millbank, London

method he had invented, and it established the right of the neo-impression-
ists to claim advance beyond anything accomplished by the school of Monet
and Pissarro and Sisley. It was first shown, curiously enough, at the last
impressionist show, held in May 1886. When the exhibition was planned,
it was found that Monet and Renoir, and of course Cézanne, would not be
showing, and Degas was appointed a committee of one to bring in substi-
tutes not too different spiritually from the "regulars." Seurat, Signac, and
Redon were invited to contribute.

The *Grande Jatte* turned out to be the sensation-piece of the show, and
when it reappeared at the second *Indépendants* exhibition in the same year
it stirred ridicule and controversy almost as had Manet's *Olympia* twenty
years before, and, more recently, Cézanne's "monstrosities." Characters
from it, especially the lady and the monkey, became the subjects of café
and music-hall jesting. Critics, perhaps because they listened too much to
Seurat's and Signac's explanations and lived too little with the picture,
put it down as a failure by reason of "too much science and not enough
art."

And indeed never did a painter rise above the limitations of his own

theorizing more brilliantly than did Seurat. He said that he was interested in a painting method and that he had no other aim than to demonstrate it. His mind was seething with excitement over his researches in the field of colour. Apparently he believed that he had developed a watertight and foolproof formula. If any student would take a course in optics, memorize a few rules for juxtaposing colours, and learn to spot colour on in the pellet- or wafer-stroke technique, he would surely be able to practise painting successfully in the modern style. In other words, Seurat had perfected a method, even while leaving out of consideration all of emotion, all of subject matter, all of instinctive feeling for rich use of the medium, and all sense of rhythmic and constructive organization of the plastic elements.

The painter of the *Grande Jatte* may have been lacking in emotional warmth; but in other directions he was, fortunately, a "born painter." Beyond the mechanics by which he set such store, he had exquisite feeling for paint-quality, and his mastery of the unexplainable formal or plastic elements can be compared only with Cézanne's.

The good painting, the pure, clear, joyous composing with colour strokes, is illustrated less in the monumental *Grande Jatte* than in the seacoast scenes done at Honfleur and Port-en-Bassin, at Le Crotoy and Gravelines, from 1887 to 1891. These "port scenes" constitute a series of gaily coloured, freshly pleasing arrangements of stretches of sand and water, distant horizon lines, boats and buildings, as simplified and neatly put together as Whistler's marines, but, at their best, articulated in a plastic structure as delicate and profound as Cézanne's. To come upon one in a room showing a sequence of nineteenth-century French paintings (as the visitor may, for instance, at the St. Louis City Museum) is to experience a start of delight at the purity of Seurat's conception and the fresh loveliness of his way of execution. To live with, to lose one's self in, one of the port scenes is to know the sweetest response to art, is to have bathed the senses and the spirit in an innocent loveliness and a profound quietude.

If the *Grande Jatte* lacks that touch of innocence which makes the less pretentious compositions a delight, it has, nevertheless, in generous measure both the more austere and the more playful virtues of Seurat's style. By its very size and complexity it is richer and affords a more varied interest. Seemingly a comprehensive view of an island pleasure park dotted with Sunday strollers and picnickers, with an amusing touch of caricature in the portrayal of types and customs, it is notable as a thoughtfully and precisely constructed formal composition (so notable, indeed, that a whole

SEURAT: The Beach at Le Crotoy. 1889. *Collection of*
Edward G. Robinson, Beverly Hills, California

book has been published about the one picture). In it, for the first time, Seurat has arrived at full mastery of his precisionist technique and his way of playing complicated rhythms with carefully disposed elements of plane, volume, line, and colour.

Seurat once remarked that the whole art of the painter is in "space hollowed out" in the canvas. In that saying was the key to the problems then occupying the mind of Cézanne (and less directly Gauguin's and van Gogh's), the clue that might, if understood, have made easier the researches conducted by the *fauves,* the cubists, and a host of following schools. Not until the nineteen-thirties were the full implications of the picture as hollowed-out space to be explained. Fundamental in the conception is the truth that the painter no longer thinks of his picture-frame as a window opened upon a scene in nature, with nature's objects and effects, nature's outlines and volumes and vistas and colours, transferred in a more or less truthful way. Instead the frame makes an entity of a certain picture space,

and the problem is to create within that space an organic composition with a formal vitality of its own.

Within the area of the picture there is inevitably the illusion of space hollowed back, between an established front plane and an arbitrarily placed point or plane of deepest penetration. It is the painter's business so to control every element that goes into the "hollow" that a poised plastic structure results (as one modern school has it), or that a rhythmic pattern of movement is indicated, along a path clearly marked for the eye (as a second group explains it).

In addition to the conception of the picture as space set off, then divided, and given plastic bones and sinews, there was a second epochal discovery, at the point where Seurat and Signac abandoned impressionism and initiated what was inadequately termed neo-impressionism. It was that colours and textures, entirely aside from their objective and ornamental values, have potentialities of structure and movement. As structural elements, certain colours are heavy, foundational, while others are weak and tenuous. As elements in the movement pattern or rhythm, as parts of the movement path, certain colours are recessive, carrying the eye into deep space; others are insistent and obtrusive, pushing forward. In the same way, textured or patterned areas may be used to obtrude, to stop the eye, or to invite it to deeper penetration.

Already painters from Daumier and Whistler to Cézanne and Gauguin had used planes in sequence to carry the observer's eye into space and along spiral or other pattern tracks. Now the three newly studied plastic elements—colour, texture, and planes-in-series—were being integrated into the structure or composition, along with those elements of volume and line which had been more fully understood in earlier time.

Any picture—it is an axiom among the moderns—should be enjoyed before any part of it is analysed. Thus one may best come before the *Grande Jatte* feeling a rhythmic flow that is in it, and a classic calm. Not even the great number of separate figures disturbs the essential restfulness and poise of the composition. But it is worth going on to note how the larger rhythm is maintained without being dissipated in the multitude of lesser movement elements. Especially the entire forward complex of figures is bound together by the foreground shadow; there is a distinctly marked interval between this front plane and that formed by the next tier of figures; from there the plane arrangement becomes less simple and less clearly marked, but the task of guiding the eye is taken up by line and volume (note the

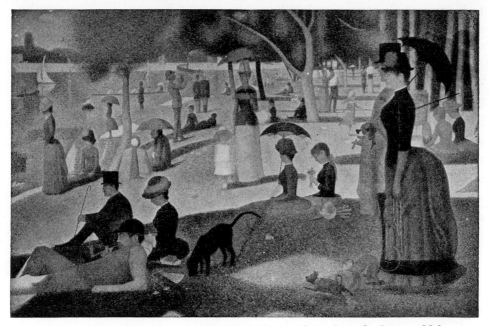

SEURAT: Sunday Afternoon on the Island of La Grande Jatte. 1886.
Art Institute, Chicago

function served by the curved sail in the background left, and by the arcs of the tree trunk at right of centre). At the back of the "space hollowed out" the eye is stopped, and redirected, by the ribbon-like wall lying across two-thirds of the length of the picture; while the uncharacterized tree trunks merely "fill in" the unimportant upper right corner. Within the hollow of the picture there is usually a centre around which the movement is composed, or to which the movement leads. This "point of ultimate rest," as it has been called, this focal point, is here clearly indicated, in the woman and child.

After making this grand tour of the picture space and coming to rest at centre, the eye may go out again to re-enter and pause at this or that figure or group, or to enjoy the flawless painting of a special area. It was part of Seurat's method to compose scores of little studies which later became parts of the final picture, and innumerable "passages" will be found to repay study on their own account. Yet always, let it be said again, a painting stands ultimately by reason of its quality as an organic whole; and the remarkable thing about Seurat is the synthesis arrived at after his patchwork preparation, the completeness and poised unity of each canvas. To return

to his saying, there is complete livingness, a taut integral structure, of the elements spatially disposed in his "hollow."

To the realists Seurat's paintings seemed frightfully unnatural. Although he used shadows at will as devices to mark spatial intervals, natural chiaroscuro had disappeared almost as completely as it did in Gauguin's and van Gogh's work of the same decade. There was no room in his hollowed space for deep perspective of the so-called scientific sort, for angular vistas. From the year of the *Grande Jatte* the roundness of volumes is suggested only by the vaguest turning of edges: figures, tree trunks, buildings are laid up almost paper-flat. The parallelism of planes thus achieved was, of course, a means to create movement within the plastic scheme, for the observer's eye can be made to push back into space in no other way so quickly as by a sequence of parallel planes. It is obvious too that no natural landscape would exhibit so many repeated contrasts of vertical and horizontal lines, with such felicitous occurrence of rare diagonals and arcs, at *just* the points where main transitions are to be desired. Beyond all these departures from the normal, colour was used ruthlessly for movement and pattern values, with only indifferent regard for objective truth.

In other words, here, as in the cases of Cézanne and Gauguin and van Gogh, there came into the company of Western artists a great simplifier, an anti-realist, a creative designer of formal structure, of a sort oftener known, in the past, to the Oriental peoples or to the primitives of Europe.

The impressionists, of course, disowned Seurat and Signac. Here was a caricature, they felt, of their methods of showing nature in an instantaneous mood, a fleeting aspect, harmonized atmospherically and mistily. Signac, nevertheless, chose the name neo-impressionism for the development. Seurat preferred the term "chromo-luminism," which was closer to the scientific theories involved, though it told nothing of the masterly plastic orchestration that he practised out of sheer feeling for formal rhythm.

For a time neo-impressionism was talked about, and generally condemned, as another variation upon Monet's and Pissarro's way of painting nature in chromatic patterns. The story seemed told in a pellet-of-colour technique taking the place of the juxtaposed touches or shreds of colour introduced by the original impressionists. And indeed, points or wafers of colour applied with the tip of the brush were a distinguishing mark of the new school, so that *pointillisme* was the name the French applied to the method of the neo-impressionists.

The new men based their claim of a significant advance, however, chiefly

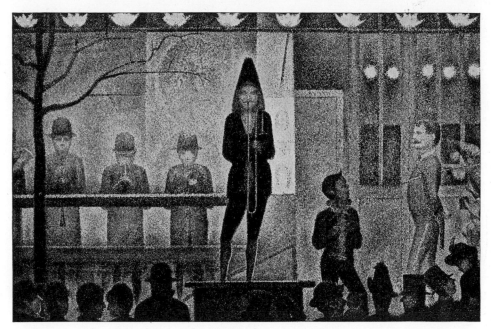

Seurat: The Come-On. 1888. *Collection of Stephen C. Clark, New York*
(Courtesy Museum of Modern Art)

upon the scientific application of the idea of broken or divided colour.
Monet and Pissarro had made much, in the seventies, of the discovery
(based on English pioneering) that colour gave a cleaner, brighter effect
when the painter, instead of mixing his pigments upon the palette, set
shreds or strokes of raw colour of differing hues side by side on the canvas.
The mixing was done in the eye of the beholder. The impressionists amaz-
ingly brightened up the painting art by means of the broken-colour innova-
tion. But they had used the device only fitfully, seldom producing a canvas
without numerous passages in palette-mixed pigments, and they often went
back to the greys of Manet. Moreover, where actual divided colour was
applied, they were unscientific in the separation of hues.

The neo-impressionists claimed to be scrupulously scientific. They
pointed out that the impressionists not only had let the points of colour
degenerate into "commas and dragged-out strokes," but had relied upon
"instinct and inspiration." The impressionists, as one of them said, painted
"as the bird sings."

The neo-impressionists laid down laws for a *"technique méthodique et*

scientifique." All colour must be put on in touches, clean, round, without any mixing on the palette. Thus dirty effects were to be finally eliminated from the painting art. Only six "pure" hues were to be employed: the primaries, red, blue, and yellow, and their complementaries, green, orange, and violet. Observance of their laws would "guarantee a maximum of luminosity, of colour vibrancy and of harmony which had never been attained before." Their manifestos are specific; but of course the best of the neo-impressionists violated their own laws. They shaded their greens, for instance, avoiding mixture of hues only where "dirt" would result from the mixing. Indeed some of Seurat's most enchanting effects were achieved by the exquisite variations in a field full of greens, each variation a slightly different mixture of the primaries. Nevertheless, he always made the point verbally that his art was a matter of science, of law.

Seurat was content, as long as he lived, to lean for his support upon his mother, who had been left well placed after her husband's death. He had a studio of his own; that was enough. Toward the end he had taken a mistress, unknown to his mother or to any friend, and a child was born in 1890. In the years from 1886 to his death in 1891 his known contacts were almost solely those with fellow-painters. There was the group of workers within the neo-impressionist school, including Signac, Theo van Rysselberghe, Henri-Edmond Cross, and two or three lesser men; Pissarro was converted to the new faith and for a time was an assiduous employer of the pellet technique and the six pure colours; and Seurat met van Gogh, Gauguin, Redon, Degas, the *douanier* Rousseau, and others of the progressive-radical movements, at Theo van Gogh's or in his administrative work in connexion with the *Indépendants* exhibitions. So far as is recorded, he never met Cézanne, though he must have known Cézanne's paintings well, since his close associates included the earliest champions of the hermit of Aix.

Seurat produced seven major or monumental works, and forty or fifty pictures of lesser size, of which perhaps one-half are important evidences of his genius. In 1888 he showed at the *Indépendants* exhibition *The Models*, a carefully studied interior with nudes, now in the galleries of the Barnes Foundation at Merion, and *The Come-On* (*Parade*), now in the Stephen C. Clark collection, New York. *The Come-On*, depicting the free show put on for the public outside the doors of a French circus, is one of the most meticulous and most decorative of Seurat's compositions. Ruthlessly flattened, the "hollow" very restricted in depth, it illustrates

SEURAT: The Bridge at Courbevoie. 1887. *Collection of*
Samuel Courtauld, London

perfectly the painter's mastery of the architectonic element in picture-
building. Structure, armature, skeleton are set out, made noticeable, as in
few Western paintings, and planes and spatial intervals are sharply marked.
Students of plastic synthesis, of structural rhythm, have found the picture
endlessly interesting. Even the layman may notice, with help to his under-
standing of form, the backward-forward play of the planes; the heavily ac-
cented, contrasting verticals and horizontals; the patterning with lights
above, with heads below; and the strange part variation of light plays in
the two halves of the picture. As in the *Grande Jatte* the focal centre is
precisely and geometrically marked in a central figure.

Seurat painted other pictures equally illuminating where the modern
problems of form are discussed. It was this that led to the enthusiasm of
the cubists for his works, and to the eventual restoration of his name to
the list of the great pioneers of post-impressionism. In *The Bridge at*

Courbevoie, now in the Samuel Courtauld collection, London, the rhythmic interweaving of lines and planes is clearly marked. More subtle, but no less exquisitely articulated, is *The Beach at Le Crotoy,* while in the more complicated *Naval Base at Port-en-Bassin,* at St. Louis, the main rhythm and counterpoint reveal themselves only when one gives one's self up to feeling one's way into the mysteries of the picture.

Seurat overworked himself cruelly in the final years, painting day and night. Whether through passionate devotion to painting or because he had a premonition of early death, he drove himself without mercy. He was now, of course, an outsider, one of the *indépendants,* and one marked as perhaps the most dangerous and subversive of all. Despite his early training with an *Ingriste,* and despite the "clean painting" that he preserved through all his experiments (unlike van Gogh's and Lautrec's), he was outside the favoured circle that could show at the Salon. (Monet and Pissarro had at this time been judged respectable after all, and appeared on the walls of the exhibition arranged by the Salon officials for the World's Fair of 1889.) Seurat showed only his lesser sea-pieces at the *Indépendants* that year, but in 1890 he exhibited both the large *Vaudeville,* most conventionalized and posteresque of his major works, and the *Girl Powdering,* an utterly simplified and shallowly decorative treatment of the commonest of themes, a *tour de force* in exploitation of his colour-wafer method, verging on the over-pretty and even the rococo.

In 1891 he painted one of the most ambitious and successful of his works, *The Circus* (now in the Louvre by grace of an American collector's generosity, and perhaps contrition because France had been stripped of important Seurat canvases). It shows a little the effect of long intellectual study, is a bit hard and set, without the fresh loveliness and apparent spontaneity of some earlier works. But nowhere is the artist's double mastery of the complete rhythm and of the contributing part more evident. The main design elements, bound together in an upended ellipse, beginning with the clown (who marks "front plane") and centring in the equestrienne, come clear from, yet rest back into, the complex of benches dotted with spectators. But the graceful rhythm of the composition as a whole is no more notable than the perfection of each bit. The horse is the quintessence of all spirited, prancing, decorative horses. The equestrienne is the very flower of gracefulness, femininity, and artificial loveliness. The upside-down clown epitomizes acrobatics. Even each of the twoscore spectators is characterized lovingly, with a touch of tongue-in-the-cheek satire.

SEURAT: The Circus. 1891. *Louvre*

Again the hollow of the canvas may be searched for evidences of abstract mastery. Note, for instance, how the arc over the entryway serves the structural design; how perfectly the zigzag end of the streamer closes the space within the entry, where the eye might wander from the picture field if no cushioning object were there. These are but two instances of seemingly casual additions entering into one of the most complex and most beautifully adjusted plastic organizations in all the range of modern painting.

A few months before his death Seurat explained his art to his biographer

Jules Christophe in a few words. "Art," he said, "is harmony. Harmony comes from placing side by side contrasting elements and similar elements, in tone, in colour, in line." The contrasts of tone might be, for instance, light and dark—with implications of gaiety and sombreness; the absolute contrast of line would be in crossing or right-angled verticals and horizontals; contrasts of colour would be red with green, and so on. By shading down the contrasts, the painter moved toward calmer effects: by balanced dark and light tones, by suppressing the angle of lines and levelling them toward the horizontal, and by avoiding the clash of complementary colors.

One might compose, Seurat explained, with endless variations of contrast and similarity in the three co-ordinated properties. He spoke of dominants, especially the luminous or gay tone dominant, the warm colour dominant, and the horizontal line dominant; and these three are to be found in most of his paintings, giving his work its characteristic freshness and gaiety, with restfulness. He could not explain—he seemed to think it would come for any good painter, as it had come for him—the synthesis, the shaping of the properties or elements, in contrast and in similarity, into the full rhythm, the plastic organism. Like many a creator who came after him, he talked suggestively of the elements of creation but fell short of illuminating the central mystery of "form."

Almost the last recorded glimpse of Seurat finds him at a preview of the seventh *Indépendants* exhibition in 1891. He had worked hard to make the affair a success, and his own *The Circus* hung on the wall. Excitement rose because the veteran Puvis de Chavannes, one of the very few painters accepted by the radicals as well as the moderates, arrived to view the works of the young insurgents. Seurat stood to one side to see what would be the effect of *The Circus* upon the master. Puvis glanced at the picture and then passed on without stopping. Seurat was chagrined and bitterly disappointed.

At this time he already was ill from overwork and from a cold contracted at the gallery. Hardly more than a week later he died, of an infection of the throat. Most of his paintings were still in his studio and they were divided between his mother, his suddenly discovered mistress (the child had caught his father's infection and died), and a few friends.

A memorial exhibition was held in Paris in 1892 but roused little interest and resulted in no sales. Eight years later, while the Centennial Exposition was current in Paris, with, at last, an official art exhibit that did full

SEURAT: The Naval Base at Port-en-Bassin. 1888. *City Museum, St. Louis*
(Photo courtesy Knoedler Galleries)

justice to Manet and the impressionists and Renoir, a second Seurat show
was arranged, and the young painters who were soon to be known as the
fauves had opportunity to see his work in its full range, from *The Circus*
and the *Grande Jatte* to the port scenes and early sketches. But still no one
bought Seurats.

The school of neo-impressionists continued its activities long after
Seurat's death; indeed it would hardly be correct to say that it had dis-
appeared a half-century later, since Signac was still painting, and had not
substantially changed his faith, in the nineteen-thirties. But Georges Seurat
alone had added to the group's technical innovations a creative master's
feeling for pictorial form. The others produced pictures with an iridescent
surface appeal as fresh and disarming as that of the impressionists, with-

out attaining the sort of formal creativeness that would mark them as more substantially on the road to modernism. Seurat had taken the decisive step of stabilizing the architectural structure of the picture, had restored the object in its own right, as an entity in space, had pulled painting out of impressionistic sketchiness, mistiness, and structural disorder.

Signac was at his best, in oils, when closest to Seurat's way of picturing; but in general he reverted to the manner of Monet and Sisley, with hardly more sensitive plastic awareness than theirs. Perhaps the truth is that the name of the school, "new impressionists," perfectly qualifies him; whereas Seurat rose above school lines into an inventive expressiveness for which no adequate name has yet been fixed upon. Signac was more successful in his water-colours, where he somewhat "let himself go." What he lacked was the sense for form-creation. Lacking that, he fell back inevitably toward the impressionist ranks, with only scientific divisionism as an advance.

The neo-impressionists abandoned the rule of point-painting fairly early, and permitted application of the pigment in mosaic-like patches or in wedges. (Signac in an illuminating treatise on the school, *D'Eugène Delacroix au Néo-Impressionnisme*, made it clear that *pointillisme* was not basic to the faith, though scrupulous scientific divisionism was.) Without the form-wizardry of Seurat, dot-painting had resulted in monotony of effect. Theo van Rysselberghe and Henri-Edmond Cross scored ultimately with pictures that exhibit strength above the impressionist average by reason of their juxtaposed swatches of heavy pigment, almost as if the artists had painted with thumb-prints. They failed, however, to add more inner structure and firmness than had Monet and Sisley.

Pissarro, a convert from impressionism to Signac's group, painted satisfactorily for a few years in the purified technique. At an earlier time he had wanted to fathom and parallel the creative magic of Cézanne, and had failed. Now he failed equally to penetrate to the heart of the mystery of Seurat's form. He merely changed his mechanics and produced pictures more vibrant and clear but still characterized by the typical impressionist laxness of structure. In the mid-nineties he reverted to the looser technique, and he made perhaps his finest contribution in the "late impressionism" of the views of Paris of the years 1897–1900, not without recourse to palette-mixed colours, even to a dominant grey. His son Lucien Pissarro went to England to live in 1893, and helped to introduce the impressionist technique, with some neo-impressionist added strength, there. He became better known as a wood-engraver and designer of books than as a painter.

PISSARRO: The Place du Théâtre Français. 1898.
Durand-Ruel Galleries, New York

Other painters were attracted for longer or shorter periods to the Seurat-Signac formula, seemingly so attractively simple. Most of them ended by being merely routine late impressionists. That is, they took over the freshness of colouring and the sketchy method that had obtained from the time of Monet's and Pissarro's experiments in the early seventies, and something of the restored sense of design brought in by the neo-impressionists between 1886 and 1891. But they lost all reverence for the codified laws, and accepted only what they wanted from the experience of the two schools. Obviously Monet, sometime greatest impressionist, had got himself into a very restricted alley. The young men began to see more than the instantaneous impression in nature, more than the opportunity for chromatic improvisation in colour, and even a stabilizing value in good old-fashioned design. Without going very far ahead or very far back, painters such as Maximilien Luce produced pictures well composed, freely

handled, and spontaneous in effect, as a continuation of the schools of mid-century realism and of impressionism, yet suggesting the design-consciousness of a newer generation. (Luce, however, foreran another group of modern painters more notably. He became "socially conscious" and devoted himself to labour and other lower-class themes, and got himself put in prison for it.)

Back in the fifties when Courbet had been France's leading and most vociferous rebel there had been a second unorthodox painter, pushing along a tangent path, who might, if possessed of a little of the great real-ist's force, have opened a way to modern decorative art before Cézanne, Gauguin, and Seurat made their discoveries. Puvis de Chavannes, he who so hurt Seurat by heedlessness in 1891, had then been labouring for forty years to redeem French painting from academic slickness and sentimental-ity on the one hand and from realistic coarseness and drabness on the other. In the end Puvis had failed to escape entirely from a sort of literary yearning for a golden age that had gone. In escaping realism, he had fallen into a too obviously poetic manner. He had drawn inspiration from a wide culture rather than from feeling and imagination. Yet he left works that constitute the finest of French murals of the nineteenth century; works that retain still a remote, sweet charm; that are touched by a magic uncommon in the half-century of Courbet, Manet, and the impressionists, the magic of serenity in design and in colour.

In the mid-fifties, when he was thirty years old, he was already an out-sider, refused three times by the Salon authorities. Setting up a one-man dissident exhibition, like Courbet's, in 1855, he was named by the conser-vatives and the amused public the "amiable madman," as distinguished from Courbet, who was the "raging madman." He aspired—as had Chas-sériau, from whom he had learned much—to combine the best qualities of the painting of the two schools which had been dominant in his student days, the neo-classic and the romantic. His disdain of the matter-of-fact realism of Courbet and Manet—and he came to be accounted a modern to the extent of being one of the earliest consistent anti-realistic propa-gandists—was due to a temperamental inclination toward withdrawal. In his way of life as in his painting he was almost an ascetic, drawing back from full-bodied participation in living as he shrank from Courbet's way of taking art into the street.

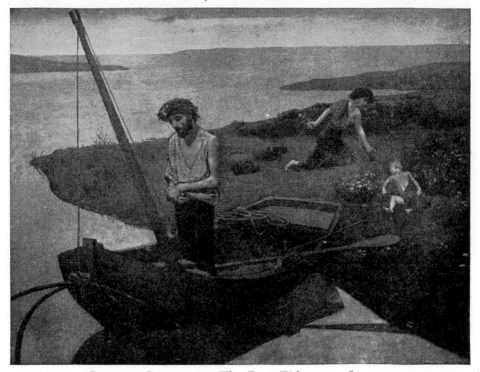

Puvis de Chavannes: The Poor Fisherman. *Louvre*

Fortunately he was one of those who could afford to stand aside from popular and officially favoured groups, without danger of starving. He needed to win no scholarships in order to indulge a desire to study the early Italian muralists at first hand. Once he had modified the vision he had shared with Chassériau, through admiration of Piero della Francesca and Poussin—both constructors of pictures in the modern sense, utilizing geometrical balance, figure arrangement, and spatial division in ways prophetic of Cézanne and Seurat—Puvis became an individualist in the Paris scene and went a lonely way.

He was thirty-seven years old when he made his first sale of a picture, or pair of companion pictures, in 1861. The two panels, *Peace* and *War*, were bought by the state, and the painter was awarded a medal. The placing of the panels as a mural decoration in the Amiens Museum gave wings to his dream of devoting his life to mural art. (He even insisted upon painting, without compensation, companion pieces for the honoured pic-

tures, and was commissioned to add others.) Within a decade he had established his position as leading decorative painter of France.

While the Academy painters napped, while the insurgent youth groups, under Courbet, under Manet, then stirred by the excitement over the innovations of the impressionists, opened the paths to new freedoms, Puvis took his middle way. He had studied with Manet's master, Couture, but where Manet had defiantly rebelled, Puvis wanted sincerely to preserve and to rehabilitate the classic tradition. In 1863 (the year of the furore over Manet and Whistler at the Salon des Refusés) he was still painting Poussinesque compositions, with little hint of the flattened figures, broad spacing, and pale colours of his later characteristic manner.

In 1864 he showed at the Salon, and in 1867 he exhibited at the World's Fair a group of his Amiens murals. Official circles could no longer exclude him, and he was awarded a medal and given the ribbon of the Legion of Honour. From that year until 1898 there was hardly a season that failed to see the unveiling of at least one monumental mural by Puvis de Chavannes. The Marseille series was painted in 1868–1870, walls at Poitiers in 1874–1875, and the Panthéon decorations in Paris in 1877. Another celebrated mural series, and one of the finest, was painted in the years 1884–1886 for the museum at Lyon, where Puvis had been born. The murals at the Sorbonne in Paris are dated 1889, those in the Hôtel-de-Ville 1892–1894. During the final years, 1895–1898, he painted panels gracing the stairway and halls of the Boston Public Library.

The artist's progress toward a style of his own was gradual. The *War* and *Peace* panels of 1861 had been distinctive, but for strength and for reversion to idioms of the Italian muralists and of Chassériau and Poussin, rather than for suggestions of the clear and chaste characteristics of his mature manner. Gradually he eliminated most of modelling, practically all of chiaroscuro, and all deep-vista perspective. In contrast with those fellow-artists who were exploiting bright colour in impressionism, he softened and sobered his colour schemes, and he came to be known as a harmonist on the pale side.

Puvis never learned the fresco process, and there is reason to believe that he introduced into his oil-painted canvases (later cemented to the walls) some of the idioms that belong to fresco or tempera rather than to oils. But he did an immense service to the artists who had so long been restricted to easel painting by proving that there is in the modern world a type of painting suited to architectural uses. He succeeded, partly by

suppressing certain characteristics of the oil medium, in re-establishing the mural conventions of tapestry-like flatness, restful balance, and monumental spaciousness.

Gauguin was the only one of the original post-impressionist group directly and profitably influenced by Puvis de Chavannes, but Puvis was known and respected by Seurat and by Redon. When there came the full tide of vigorous, hurried modernist experiment, of *fauves*, cubists, and expressionists, Puvis, like Whistler, was talked down, even denied. The formal order in his paintings was of a slight, almost a shy sort, and in the excitement over the full-blooded and insistent form-seekers—Matisse, Rouault, Picasso, Kokoschka—students were a little ashamed of admiring his pale, almost ascetic pictures. Nevertheless, the magic of plastic order was there, often in considerable measure, and in the nineteen-thirties it came to seem to some observers that Puvis was destined to outlive a good many of the innovations that had served to obscure his contribution for a generation.

As a decorator he set the example for much (aside from colour) that went into Gauguin's art. He restored those qualities of flatness and simplification that were to characterize truly modern mural painting, from Gauguin to Rivera and Orozco. He was the greatest of the nineteenth-century artists linking Poussin with the latest French schools. He added his own unmistakable touch, for a time drew us into his dream world, played his harmonious compositions on his chosen themes of poesy, peace, repose, and quiet.

Perhaps he succeeded after all in combining the romantic and the classic ideals as Chassériau might have done had he lived longer. The manner is classic, the spirit calm and reposeful. But in the end it is, like romanticism, art that affords escape from the vulgarities of the day. It breathes the air of long ago and far away.

So little of the work of the school of Paris of 1900–1940 invites meditation, admits the dream (except in the Freudian sense), that it is not to be wondered at if some of the greatest living muralists shake their heads at mention of Puvis. But historically, mature art has been serene art, and it may be that it is the immaturity of modernism that still works against admission of Puvis to the lists of the secondary pioneers. The decorative current of modern painting is obviously not the main current—flattened decorative art is, in the view of most critics, less profound than the symphonically deep art of a Greco or a Cézanne. Puvis in his denial of realism,

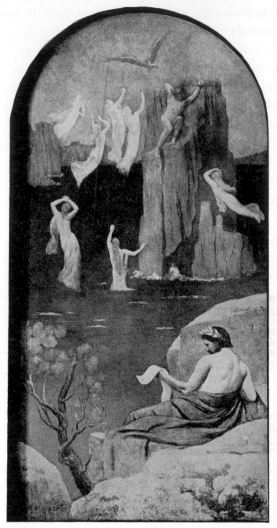

PUVIS DE CHAVANNES: Dramatic Poetry. Mural. 1897. *Boston Public Library*
(Courtesy Trustees of the Public Library, Boston)

in his devotion to order, in his love of peaceful effects, went a little way in form arrangement, hollowed out his canvases only very slightly, and thus limited his achievement of moving, plastic effects. But the low-toned harmonies, the limpid sweetness, and the chaste lyricism of his painting may appeal long after the world has forgotten those who were once considered his successors as the leading muralists of Europe: Baudouin, Besnard, and the rest.

Paris and Lyon claimed the best of Puvis's murals—and he should be judged by the murals mainly, though many of his easel pictures are in the museums; but at Boston the series is thoroughly typical and close to his highest achievement. There one may feel the spacious, the architectural fitness, the simple grandeur, the cool harmony of colouring. Beautifully he simplified, eliminating every unnecessary detail, placing a few figures precisely in space, seldom leaving a suggestion of emptiness, and at the same time he purified his medium, until it was light and clear and refreshing.

Though he had started out as a student of the French "history painters," and from them had worked back to Poussin, in his final works he had arrived at some likeness to Fra Angelico and Giotto. They are ancients whom the moderns admit as kin.

Paris, siren-like in the fascination she exerted on artists, nevertheless had repelled many of the great ones who had learned their craft in her schools and studios. The Barbizon group had deserted to seek their souls in unspoiled natural retreats, and the impressionists had followed them out into the country villages. In the late eighties three of the four great pioneers who were to be known as the post-impressionist masters reacted against the art-life of the capital and found refuge elsewhere, Cézanne in his beloved Provence, van Gogh at Arles, and Gauguin in Brittany. Seurat alone stayed in his city studio. There had been, nevertheless, a continuous succession of Parisian painters, of men of the second range who produced their pictures in Paris and allowed their lives to be formed by Paris. At least three of the great realists of the half-century had dedicated themselves to painting the Parisian scene, to the exclusion of nearly all else: Manet, Degas, and Toulouse-Lautrec.

In the late eighties Manet was already dead, but Degas was at the height of his career, and Toulouse-Lautrec had set up his studio in Montmartre, with no better purpose than to follow in the footsteps of "the great Degas." Paris had much to give the artist, but the artificial life of Paris limited the vision and the achievement of each of these three painters. They were Paris-bound.

Degas was only two years younger than Manet, but he was slower to develop his talent, and in the days of the Café Guerbois meetings of the sixties he joined the younger impressionists in looking up to Manet as master and leader. Through the association he came to be known as one

of the young and irresponsible rebels against authority, and for decades he was classed with the impressionists (with whom, indeed, he exhibited regularly for many seasons). He was, however, a conservative at heart, and he was known as an impressionist only because he arrived, belatedly, at a sketchy technique and fresh colouring. He disliked outdoor painting and vague design and he came to dislike most of the impressionist painters. At a show of Monet's, Degas eloquently turned up his coat collar because the rows of open-air pictures reminded him of nothing so much as draughts. He had become an independent, fixed in a bypath of sketchy realism, but with enough of design sense, derived partly from the classicists and the ancients, partly from the Japanese, to mark him as one of the forerunners of the form-seeking moderns.

Degas was born in Paris in 1834 and christened Hilaire-Germain-Edgar de Gas. His father was a successful banker who had married an aristocratic French Creole from New Orleans, and maintained establishments in both Paris and Naples. As student, and through the early years of his life as painter, Degas was given whatever he needed for a comfortable living and for his work. He studied in Paris, briefly at the École des Beaux-Arts, and became firmly set in the classical tradition, developing an inordinate admiration for Ingres. During a stay of several years in Italy he copied Italian masters and made sketches for large historical paintings in the orthodox, hard neo-classic manner. Though he came to admire Delacroix alongside Ingres he returned to Paris to spend years on the historical works, putting in long hours also as a copyist in the Louvre. It was there that Manet encountered him one day in 1862.

Although he became one of the radical group that accepted Courbet as old master of the new art, and Manet as immediate leader, and though he essayed one race-track picture as early as 1862, Degas was a laggard among the revolutionaries, and his best-known works from the sixties are realistic portraits of members of his family and friends, admirably drawn and proficiently painted, if in general a little hard. As a member of the Café Guerbois fellowship he was shy, not in the uneasy way of Cézanne but with the reserve of the sensitive artistocrat. He was sympathetic to the aims of the group, but doubtful of his place in it. He could be both cordial and witty; but he and Cézanne became known as the silent members of the "school," and Degas was to be less guided by it than any of the others. His reserve and unbending attitude in these years were symptomatic of the melancholy and touchiness that were to fasten upon him in later life.

Already in his mid-thirties, he found himself dissatisfied with, and ready to abandon, the type of painting which he had as a student mastered with academic brilliancy. A certain irresolution was setting in, which was perhaps to be the factor determining that his work would be throughout his life inconclusive—never satisfying to himself, never either clearly old-fashioned or clearly in the modern manner, never more than a sketch of a great painter's output. As he vacillated between witty gaiety and melancholy, so he vacillated in his art between the alluring heresies of the café radicals and the sober fundamentalism of the *Ingristes* who had trained him. Perhaps it was all a part of the self-doubt which ever opposed itself to his pride.

Degas disliked many things that belong in the normal man's life, and many others that the average man finds it easiest to tolerate. He hated his own name Edgar. He came to mistrust and look down upon women. He hated flatterers among art-lovers and medal-seekers among artists, and increasingly his wit turned sarcastic and cruel toward them. He disdained that sort of fame that comes with popular success. He sincerely did not want official honours and they were consistently withheld from him. He disliked flowers on dining-tables, dogs, and forward children. He disliked unconventionality and he loathed Bohemianism, yet he lived most of his life in Montmartre and found subjects in the cafés and even in the brothels there.

In turn three outside influences served to shape his art. First, there was the "probity" of Ingres. Second, there was the realism of Manet. Third, there was Japanese art. In 1863 he had been among the rejected at the Salon, and so was represented in the Salon des Refusés. But unlike the others of the Café Guerbois group he was admitted to the Salon later in the sixties—sign enough that he was still a conformist and considered solid. Nevertheless, he was fast losing the Ingres-derived concern for beautiful or noble subject matter. Aside from his specialty of portraiture, he began to seek themes where Manet was finding his, in Parisian pleasure grounds. After 1870 he would seldom venture away from his chosen group of familiar subjects, race-track scenes, theatre and ballet fragments, laundresses, and women at their toilet. In the sixties, while Whistler was transforming his art under Oriental influence, while Manet was taking some devices tentatively from the Japanese, Degas was little affected; his gains from that source were to come belatedly, in the seventies.

Degas served as a soldier in the War of 1870, and he felt the defeat

more than most artists. Not only had the Germans humiliated and dis-
membered France; the Republic had taken the place of the Empire, and
he was temperamentally anti-republican. It was perhaps this that led him
to embark suddenly for New Orleans, his mother's one-time home, where
two of his brothers were now prosperous bankers and cotton-brokers. He
had something of a vacation, painted at will, and, not too willingly, did
portraits of his relatives, was ill, and found himself longing for Paris. He
dismissed all possibility of painting themes typical of the New Orleans
country with the observation that "novelty both captivates and wearies
one at the same time; our love of art is truly inspired only by what is fa-
miliar." He fled back to the familiarity that was Paris early in 1873. It is
likely that an incident of this time, if not of this visit, led to permanent
bachelorhood and the objective attitude toward women that obtained
throughout the rest of his life. Thenceforward all passion of which he was
capable was poured into his art.

From the months of Degas's visit in New Orleans dates one of his
most characteristic and competent works of the early period, the *Cotton
Market in New Orleans,* now in the museum at Pau. It must have pleased
the artist's relatives to see their offices, themselves, and their clients so
photographically reproduced, and one can imagine the faithful followers
of Ingres exclaiming over the exact draughtsmanship and the "purity" of
technique (though shaking their heads, no doubt, over the devotion of so
excellent a talent to a common subject). The *Cotton Market* was, indeed,
one of the final masterpieces in the neo-classic tradition of clean, linear
painting, with posed figures set out in utmost clarity. Already in this year,
1873, Degas's companions of the café tables were painting disintegratedly,
colourfully, impressionistically. But here is the cool, precise, almost colour-
less art that bespeaks the painstaking training of the historical painter.
There are, nevertheless, certain signs that Degas has seriously studied
Oriental prints. The high angle of sight, so that one looks down upon the
figures, and the device of carrying an architectural member forward to the
very front plane, to afford the eye a starting point for its slide into the
pictorial space, are innovations known in Western art at this time only in
the painting of Whistler.

Degas in the seventies painted a few more pictures in which subject
matter has interest on its own account. There is an admirably handled
story-picture entitled *The Rape.* There is implied drama or comment in
the café scene entitled *Absinth.* But from this time forward Degas is to

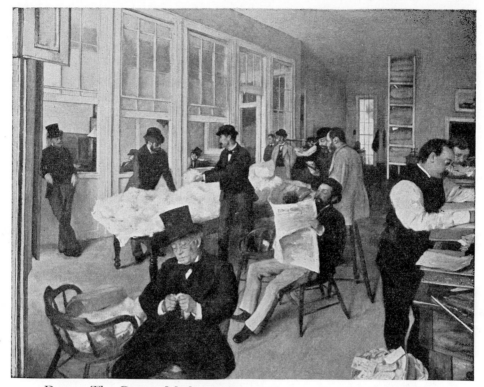

DEGAS: The Cotton Market in New Orleans. 1873. *Museum of Pau*
(Courtesy Metropolitan Museum of Art)

be a realist on the unliterary, casual side. His subjects interest him not
for human, picturesque, dramatic, or moral reasons; increasingly they
become so many devices for exercise of his pictorial inventiveness. They
remain graphic; they are superficially illustrational. But the artist is pleas-
ing his own eye, is getting down primarily a combination of forms and
colours that he has partly seen, partly imagined.

In this final and decisive change in Degas's approach to his art, it is the
Japanese print that is the determining influence. At least it is the influ-
ence that brings most of lasting good to his painting. There is a period in
the mid-seventies when his compositions illustrate as well as Whistler's
the ways in which Eastern formal design fecundated Western painting.
Examination of *Absinth* leaves no doubt that Degas was playing with
lines, planes, volumes, and textures rather than giving his characters the
centre of the stage to illustrate a moral lesson in the orthodox Western

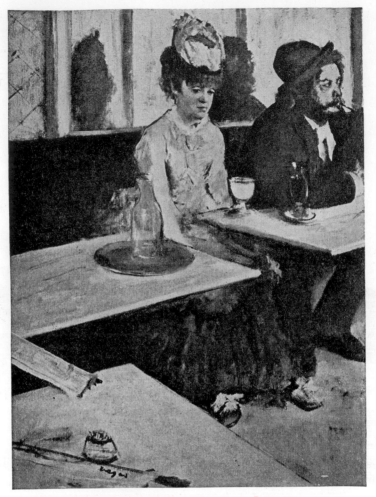

DEGAS: *Absinth.* 1876–1877. Louvre
(From *The Impressionists,* courtesy Oxford University Press, New York)

fashion. The compelling movement values of the table-top planes, the
zigzag pattern value of the table-top edges, in diagonals paralleled in the
line behind the figures but contrasted with the stabilizing verticals above,
and the flattening of the figures: all these devices suggest derivation from
an art more geometrized and more decoratively simplified than that of
Paris in the eighteen-seventies.

Even more eloquent of Japanese sources is the layout of *The Place de la
Concorde, Paris* (also known as the portrait of the Vicomte Lepic and his

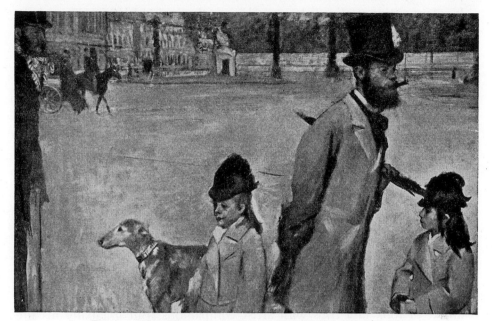

DEGAS: The Place de la Concorde, Paris. 1873–1874.
Collection of O. Gerstenberg, Berlin. (From The Impressionists,
courtesy Oxford University Press, New York)

daughters). The picture is laid up in three planes, that of the four people
and the dog, at the very front, that of the horseman, half-way back, and
that of the backdrop of buildings, wall, and park. The back plane may be
unsuccessfully handled, is perhaps insufficiently simplified, in relation to
the wilfully flattened figures at the front. But no more telling instance
can be found of the effect of the popular Japanese prints upon the minds
of experimental painters. In this line will be found, a dozen years later,
Gauguin and van Gogh, Toulouse-Lautrec and the poster-designers.

As regards colour Degas learned little from Oriental art. Deficient in
colour sense, he had followed at first the Ingres tradition of giving pri-
mary attention to drawing and composition, to which slight colouring of
an objective or ornamental sort was added. Through the period of the
race-track pictures, dating in general from the decade beginning in 1873,
the drawing progresses from hard, precise outlining and generous use of
black to free linear sketching with considerable hatching and trailing. The
colour also is hard and accurate at first, looser and capriciously improvised
toward the end.

In composition of line, plane, and mass the racing pictures are rich in Japanesque pattern effects. The *Carriage at the Races* at the Boston Museum illustrates the borrowed plane-manipulation and at the same time the lingering tendency to hard-edged, exact drawing. The later *Before the Race*, in the Walters Gallery, Baltimore, is typical of the best that Degas accomplished under the influence of the Orientals. It is free and vital, yet controlled within a formal scheme. (It may be added that Degas, in grasping at the Japanese device of stressing planes, often awkwardly cut through figures and objects with his picture boundary. Probably he had seen the effect in the colour prints. It is likely that it was fortuitous there, occurring where pictures had been cut into panels. In other words, an unintentional, even chance effect was picked up by the Parisian painter as part of a method of formal arrangement, as if it were vital to the plastic structure.)

Increasingly Degas moved toward the estate of a recluse. A few close friends asked him to dinner in town. In summer he went to them in the country, or took rare trips with artist companions. But gradually his life became artificial and thin, and the man neurotic. To his rule of avoiding intimate or frequent contact with women he made one exception: he took the American painter Mary Cassatt as pupil. He became a collector of paintings and of prints, and amassed a great number, which he piled unsorted and unseeable against the walls of a storeroom. He joined with the impressionists in their scorn of the official Salon and never again exhibited there. But his exhibits at the impressionist shows, unlike those of Monet, Pissarro, and Cézanne, brought acclaim and a demand for his pictures. He entered into an agreement with Durand-Ruel, who advanced money when needed and became sole agent for the artist. One of Degas's peculiarities was a disinclination ever to let his paintings leave his studio. He was always hoping to make them better at some future sitting, or, as he put it, "less mediocre."

The theatre and ballet pictures began to be a specialty soon after his return from New Orleans in 1873, and they still engaged his attention after the turn of the century. The sketches of dancers in particular served to create for him a world-wide reputation. At first he made drawings from his seat in the stalls, then took to sketching in rehearsal rooms and on the stage. But the finished paintings and pastels invariably were done in his studio. He became celebrated for the spontaneity and verve of his work, and it seemed as if he must have caught each attitude and gesture, each

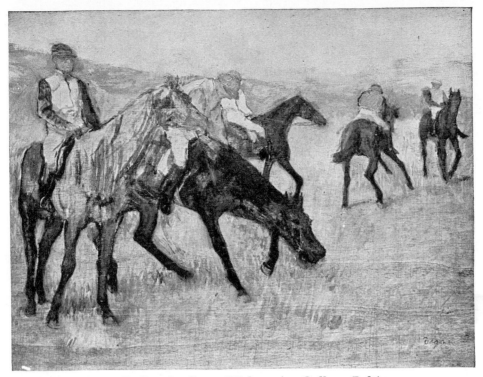

DEGAS: Before the Race. *Walters Art Gallery, Baltimore*

nuance of movement, instantaneously from the stage performance or the dress rehearsal. But the pictures are all studio productions, resulting from hard work. Usually, painstaking drawings of the chief figures exist. (Again it is Ingres's method, the very opposite of that of the "inspirational" impressionists.) In the case of the apparently spontaneous outdoor racing pictures also Degas had taken only "notes" at the tracks. He had a wooden model of a horse in his studio that "stood still in the proper light." In the same way he had ballet dresses and properties in his studio, to which the dancers came to pose.

About 1890, when he had turned to the series of glimpses of women bathing, he had a bathtub specially installed in his studio to afford a semblance of that intimate *milieu* to which he, as a strict bachelor, had not even the slightest chance of access. They are all models carefully posed with a prop-tub, those women seemingly caught unawares at the instant of stepping into or out of their bath-water, or towelling themselves, or

binding up their hair. Landscape interested him no more on its own account than did people. He insisted that he could do landscapes as well in his studio, and he told Vollard: "With a bowl of soup and three old brushes, one can compose the finest landscape ever painted."

How much of frustration may be implicit in Degas's obsession with women as subject in the final twenty-five years is problematical. There is not the slightest erotic note in his gallery of intimate boudoir and bath scenes. Here as in the glimpses of the on-stage and off-stage lives of dancers, and again in two lesser series depicting milliners and laundresses, he is objective and remote. He goes beyond Manet in suppressing character and in eliminating associative interest. Not one of the girls or women shown can be termed beautiful; they are seldom even pretty. And the bodies of the nudes are as likely to be fat or flabby or angular as normally beautiful.

Some critics aver that he was "getting even" with women, as he saw it in his warped mind, by showing them up as common creatures and unlovely. It is more likely that he was interested solely in manufacturing pictorial effects. His eye had been caught by certain possibilities at the theatre, in the dance studios, at the milliners', and in the laundry shops; and it was easy to have the models in while he worked up the subjects at his Montmartre studio. He had become the picture-maker, unliterary, unemotional, professionally preoccupied. He saw arms and legs, heads and torsos, bouquets and ballet skirts, as so many lines, masses, directions, accents. He saw colour, too, as so much pictorial material—unfortunately as so much pictorial glamour, for it was in colour especially that he failed to understand modern plastic means. His colouring is bright, iridescent, ornamental, lovely in itself. But it is often capricious, factitious, seldom within the plastic organism.

Degas made a contribution toward the modern manner of art. His example was helpful to Gauguin among others, and Lautrec's art definitely stemmed from his. For thirty years after 1873 he carried on his experiments in what the Ecole masters termed "unconventional" picture-making. He never lost (until he could see but dimly) the sound draughtsmanship that he had gained out of his early neo-classic schooling, though he seemed often to obscure it after he cultivated the sketchy touch that enlivens so many of the oils as well as the pastels. But it was the unconventionality of the Japanese that persisted and that marks off his contribution as distinctive and, for the West, experimental. "Unnatural" angles of sight, figures

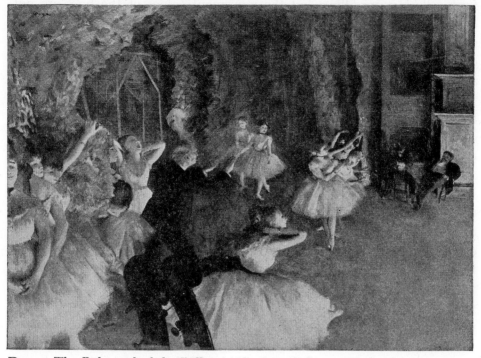

DEGAS: The Rehearsal of the Ballet on the Stage. *Metropolitan Museum of Art*

or furniture or fans arbitrarily placed to mark a front plane, figures (even heads) cut through by the picture's boundaries, repeated linear or planar rhythms: these are all properties of Eastern art rather than of Western in Degas's time.

There is seldom again the extreme flattening of figures and extreme simplification into a few planes seen in *The Place de la Concorde*. There is more of playing with diagonals, more of placing the figures of protagonists unexpectedly in a corner or in the upper half of the pictorial space, more of stringing figures along a bias line or in zigzag formation. Here was Degas's genius as a constructor. He at once surprises and delights the eye with a new yet valid pictorial arrangement. It often looks like sheer improvisation, at first. But study of the planes and lines, of volumes and rhythms, soon shows that the scheme is based on sound plastic principles. There is controlled movement, a pleasurable circuit and coming to poise.

It is the colour that is improvised and unsound. The colouring is

fresh, alluring, eye-filling; but the movement values of the hues are not co-ordinated with those of line, plane, and volume. It is this that gives an air of visual confusion to any late group of Degas's paintings. It also accounts for the unusual fact that many of his pictures are superior in black-and-white reproduction.

The realists count the criticism unfair, even heretical. It is enough for the realists (who came to tolerate Degas as a successful if erratic recorder of fact) if colour is fairly true to nature; the picture is considered especially successful if over and above this it gives an impression of gaiety and glamour, and Degas's paintings are glamorous and gay above most. But in his use, or misuse, of colour to those superficial ends, Degas lost the opportunity to stand in the first rank of creators in his era. No one excelled him ever in the handling of pastels for lush and gorgeous surface effects. But he missed completely the implications of Cézanne's effort to fuse colour and drawing into one process, one purpose.

Degas had increasing trouble with his eyes, to a really serious extent from about 1890 on. It may be that bright colour became for him a refuge when blindness seemed actually to threaten. He had long before dabbled in sculpture, and when he could no longer see well enough to paint even sketchily he took up modelling seriously. The little statuettes of horses and dancers, cast in bronze from his wax and clay originals, are divertingly naturalistic or impressionistic, but hardly profound. As for his paintings, Degas had, before the end, the doubtful pleasure of seeing his early pictures auctioned at a hundred times the price he had originally put upon them. He did not seriously care. It seemed merely one more sign of the stupidity of man in an age when the good old values of living had been lost.

Degas became a legend among the artists of Paris long before his death. Tales of his ill-humour, of his inaccessibility, and of his cluttered and disordered studio went the rounds. But Degas himself, when near-blindness ended his work, tramped for hours on end the streets of Paris, restless and lonely, and was unrecognized by those he met. He had been an elegant in his earlier days, but now he came so near shabbiness that once a shopkeeper handed him a pack of cigarettes out of intended charity. He had to call a gendarme or some passer-by to help him at street intersections. For twenty-five years he had lived and worked in a building on the Rue Victor-Massé in Montmartre, but this was torn down and he brokenheartedly moved to other quarters. A last picture of him is given by his

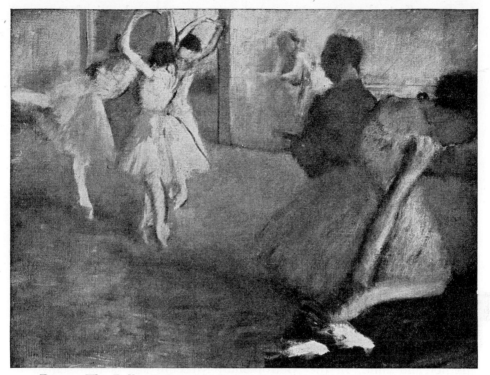

DEGAS: The Ballet Rehearsal. *Collection of Mathieu Goudchaux, Paris*
(Courtesy Metropolitan Museum of Art)

friends, of an old despairing man, walking aimlessly for hours, going finally each day to the place where his home had been, gazing sightlessly into a hole in the ground through cracks in a fence erected by the wreckers. He died at the age of eighty-three, in 1917, in the midst of a war in which he was not interested.

"Nothing in art," said Degas, "should seem to be accidental, not even movement." Thus he defended the painstaking preparations he made for the painting of each picture: the preliminary sketching, the numerous drawings, the arrangement of background properties and accessories—all to the end that he might produce the most spontaneous-seeming and un-studied-seeming art of the century. Degas had two notable followers, Mary Cassatt and Henri de Toulouse-Lautrec. The one achieved in great measure the master's fusion of solid construction with seemingly spon-

taneous effect; the other skimped the preparation and arrived at an art that glorifies sketchiness and often suffers from an obviously hasty approach.

Mary Cassatt painted a great many pictures that are closer to Manet's style than to that of Degas. In other words, the bulk of her work was objective realism of a bright and free sort. But under Degas's influence she went on to an understanding of design beyond Manet's, and in Degas's special medium, pastel, she achieved brilliant and spontaneous effects.

An American girl, of a wealthy and cultured Pittsburgh family, she had gone to France to study in 1868, and she remained an expatriate in Paris until the time of her death in 1926. Unlike other Americans in the European scene, most notably Whistler and Sargent, she fitted perfectly into the contemporary French tradition, exhibiting at the Salon of 1874 and with the impressionists from 1877. She was accepted by the leaders of the movement as one of the foremost creators of impressionistic realism. It was one of her early exhibited pictures that led the retiring Degas to offer her his friendship and aid.

Without losing anything of strength or freshness, Mary Cassatt went back often to a theme which had been over-sentimentalized, that of mother and child. In the Metropolitan Museum she is represented by seven variations of the *Mother and Child* subject, two versions of *A Lady at Tea*, and a portrait of a woman in meditation, a fair sample range of her work. But as in all the late-century realistic art, in the way opened by Courbet, Manet, and Whistler, it is the design element that lifts Mary Cassatt's work to the point of ultimate importance. As design brings Degas into the modern story, so design makes significant the art of the painter to whom he permitted the designation, "pupil of M. Degas." Her work is often fresh, charming, filled with sentiment (but without sentimentality), strong, and free. It is, however, when she adds plastic design, an abstract poised structure, that it is at its finest. She painted pictures as skilfully organized as the Boston Museum's *At the Opera*. It is without the extreme Japanesque contrivances so often noticeable in Degas's theatre studies, but it is frankly flattened, with arranged spotting, and main and minor linear or directional rhythms; and that marks her as a link between the freed realists of mid-century and the form-seeking groups of 1890–1910.

The artist who swallowed Degas whole, without ever becoming his pupil (he seems to have had but one word of encouragement or approval

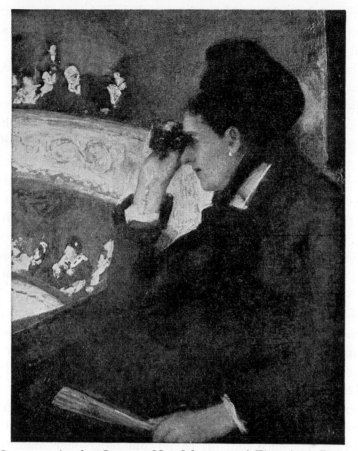

CASSATT: At the Opera. 1880. Museum of Fine Arts, Boston

from the master), was Toulouse-Lautrec. It was he who completed the portrait of pleasure-seeking Paris which Manet had begun. He worked in Degas's Japanese-derived style and, out of his own study of and love for the Oriental prints, mastered the Japanese decorative idioms as even Degas had not done. He aimed at the fresh instantaneity of Degas's effects, and superficially achieved it; but somehow, as painter, he lapsed back to a sketchy and journalistic half-completeness. He designed posters that took supreme ranking; but his paintings were often brought down to the level of poster-art. He embraced Bohemianism, and succumbed to it, dying of dissipation after hardly more than a decade of mature activity. His life is the measure of the utmost that Bohemianism can give to the artist, and of the terrible price it may exact.

An aristocrat, born Henri-Marie-Raymond de Toulouse-Lautrec-Monfa, at Albi in 1864, he came of the illustrious line of Counts of Toulouse. But the Count his father was an eccentric, an obsessed sportsman, and an accomplished pleasure-taker. The sensitive boy grew up in a divided home, heir to his father's instability, shamelessly spoiled by an unhappy and indulgent mother. In his fourteenth and fifteenth years he broke both legs. Complications arose that prevented further growth from the thighs down. Thenceforward he was crippled, doomed to hobble through life on a child's legs. At maturity he presented the appearance of a partial dwarf, with enlarged head, full torso, and shrivelled limbs. Although thus cruelly handicapped in body he was keen of mind. He escaped completely the handicap that hinders so many artists, the necessity to make a living. He was given whatever money he asked for.

He arrived in Paris to study art, and to escape home restrictions, in the spring of 1882. It was the year of the Seventh Impressionist Exhibition, but Lautrec's interest turned instead to the official Salon, where his first teacher, the reactionary Léon Bonnat, exhibited. Soon the youth, now in his eighteenth year, moved on to the newly opened Atelier Cormon, again finding himself under an uncongenial and unprogressive teacher. But he learned from his fellow-students, and soon he was enthusiastically studying the works of Manet, the impressionists, and Degas.

His interest was wholly in people and the life around him. In trying out the impressionist technique, he left aside the impressionists' stock subject, landscape. He once told his friend and biographer Maurice Joyant that "the painter of pure landscape is an imbecile. Nothing counts but the figure. Landscape can be nothing except as accessory." And he pointed out that the figure-paintings of Corot and Millet, and of his contemporaries Whistler, Renoir, and Degas, were superior, more characterful, than their landscapes.

While he was a student, in 1883, while he had the example of Whistler and especially of Degas before him, he chanced upon an exhibition of Japanese art, and from that day he was an avid collector of Oriental graphic art. Thus he gained from Degas, and also from the source that had yielded up much that went to the making of the older artist's style. A draughtsman rather than a colourist, he was indebted, too, to his contemporary Forain and through him to Daumier. In 1886, through association at Cormon's, he came to know Vincent van Gogh, but the Dutch painter was not yet the creative genius he became two years later.

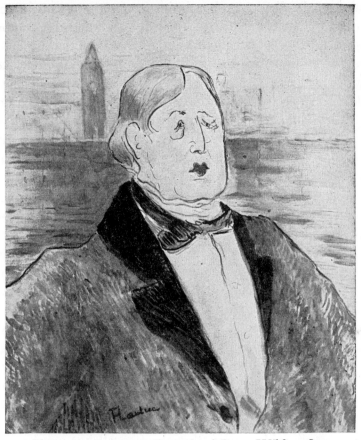

TOULOUSE-LAUTREC: Portrait of Oscar Wilde. 1895
Durand-Ruel Galleries, New York

From 1885 until the time of his death in 1901, Lautrec occupied various apartments and studios, but always close to the heart of Montmartre. (The first one he took purposely on the same court as Degas's.) His life became intricately bound up with the half-world or underworld activities that centred in the district. Within the circle of artists he was known and loved for his wit, his lack of affectation, and his generosity; and because obviously he had a remarkable talent. But he also had sensual appetites that he made no effort to control. Indeed the fact of his physical deformity led him to attempt more than a normal man's prowess in his drinking and other sensual indulgences. He became a common figure at the bars

and cabarets of the district, and an intimate of the women of the brothels. His own bar, on a table in his studio, was a peril and a nightmare to his moderate friends, for he delighted in pouring together at random a dozen potent liquors and insisting that his visitors drink the resulting concoction with him.

He took his subjects, aside from portraits, from the life of the dance-halls, cafés, and "houses" of Montmartre. He made gorgeous posters for the *cabarets artistiques* and music-halls, and for the singers and dancers who appeared there, for the Divan Japonais and the Moulin Rouge, and for Jane Avril, La Goulue, May Milton, and Yvette Guilbert. His paintings oftenest depicted these characters on the stage or dance floor, or scenes among the patrons. The posters are beautifully simple, strong, and colourful. They often owe their structure to Japanese models, but they have the nervous spontaneity of the Western brush or crayon. As is proper for art that is commercial and ephemeral in purpose, they have an air of journalistic unconventionality, an appealing sketchy sprightliness.

Lautrec was already producing some of his finest paintings by 1891, when he was only twenty-six years old. There are few so richly painted and so characteristic as the interior entitled *At the Moulin Rouge*, in the Chicago Art Institute galleries, of 1892. The devotion to Degas and to the Japanese is clearly reflected in the way of formal organization, in the angular layout, in the plane arrangement and linear rhythms. The surface handling and the posteresque method of simplification are typical of Lautrec. Not seriously evident here, though often all but wrecking his painting's claims to profound consideration as art, is a tendency to be content with over-hasty execution. Never is there a sense of repose, of final calm adjustment of the art-values.

Toulouse-Lautrec was living the life of the people shown, observing them sympathetically and candidly, and putting down his impressions re-portorially, without comment of his own. There is no doubt that he wanted to be a painter in the manner of Renoir and Degas, not that of Forain, who could see life only through the lenses of the reformer and the moral essayist. Lautrec wanted, however, to count in the galleries of "high" art. He had started out with the temperament of the objective real-ist, like Renoir and Degas, and he had been blessed with a sense of design beyond that of either of those masters. His failure to rise to a place beside them was due to his failure to take pains in preparation and execution. He was impelled by his nervous temperament, perhaps by alcoholic excite-

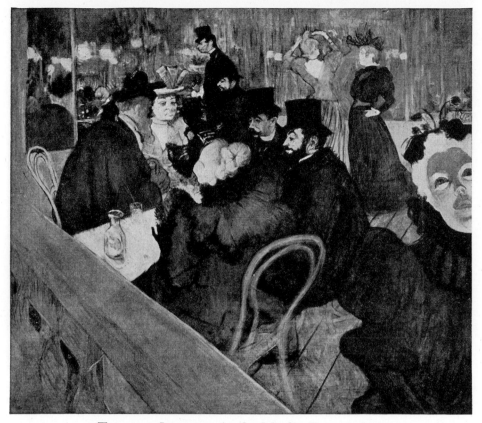

TOULOUSE-LAUTREC: At the Moulin Rouge. 1892
Art Institute, Chicago

ment, to push on to quick completion of each canvas. He produced scarcely a dozen works as finished, as seriously studied, as the masterpiece at Chicago.

What counts, then, beyond the surface interest in unsentimentalized documents from picturesque Bohemian life is the spontaneous pleasure evoked by formally vital pictures. For all their unfinish, their surface sketchiness, their lack of composure, they are characterized by inventive plastic vitality. They afford an experience to the eye. It is seldom profound: the spatial range is shallow. The achievement is on the decorative side. But the evocation is there.

There is evidence that Lautrec had developed his gift for formal arrangement as early as 1891. The photograph exists from which he painted

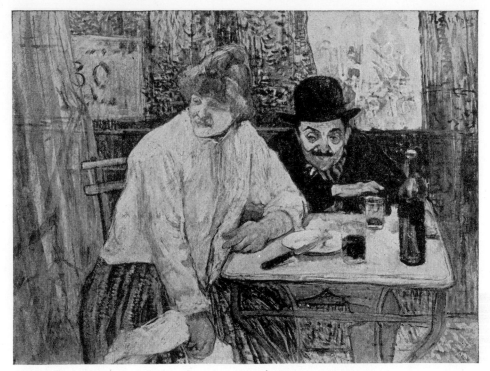

TOULOUSE-LAUTREC: À la Mie. 1891
Museum of Fine Arts, Boston

À la Mie. The picture embraces apparently a glimpse of sordid characters
in a drinking den; but it is really a scene arranged by the artist and posed
by a friend and a pretty professional model. The changes in the finished
painting are instructive to the student of plastic organization. A higher
angle of vision, the lengthening of the woman's arm, the introduction of
the off-vertical curtain at the left, the addition of the knife on the table
(with its directional function), a change in the too like contours and
direction of the heads, and the introduction of texture interest in fore-
ground and background were all alterations made in the interest of dy-
namic or harmonious plastic organization.

Gradually in the years 1891–1900 Lautrec added to his gallery of "char-
acters," in oil, pastel, and lithograph: friends and acquaintances of studio
and café, singers and diseuses of the cafés-concerts, eccentric dancers of
the music-halls, roués and cocottes, perverts and prostitutes. Never did a
gallery of art contain so great a proportion of materials found among the

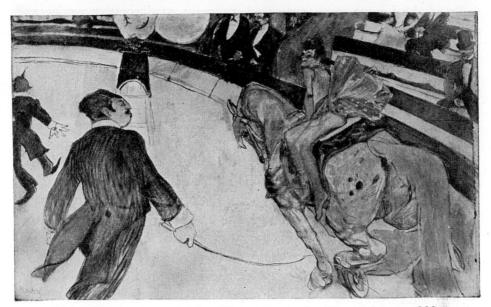

Toulouse-Lautrec: At the Cirque Fernando: Equestrienne. 1888
Art Institute, Chicago

gaudy and the vicious. Through it all ran the thread of the artist's creative genius, too often all but obscured behind hasty improvising or too easy "effects," but occasionally coming clear in a brilliant and lastingly vital portrait or interior. Sometimes he let the note of satire creep in faintly. In general it is "straight" illustration. At times the people and scenes of the circus interested him, and he produced notable drawings and paintings of clowns, acrobats, and equestriennes, in the ring or off-stage. The finest of the paintings in this genre is, perhaps, the earliest, *At the Cirque Fernando: Equestrienne* (known also as *The Ring-Master*), of 1888, now at Chicago. For vigour and directness of statement it is unsurpassed, and it shows the influence of Japanese conventions as eloquently as does van Gogh's *Boats at Les Saintes-Maries* of the same year, or Whistler's *Portrait of Miss Alexander*, of nearly a quarter-century earlier.

Lautrec was to return to circus themes in 1899, when he was under restraint in an asylum, and to produce from memory a remarkably true-to-life series of drawings. In 1895, moreover, he painted two curtains for the side-show wagon of La Goulue, who had then descended from the estate of queen of the Montmartre dance-halls to the position of Oriental dancer at street fairs. The curtains, which ultimately found space on the

walls of the Louvre, were conceived, properly, as decorative works, and they indicate how well Lautrec had learned the essentials of Oriental "space-filling." The one known as *The Moorish Dance* is especially rich, full, even lush. It is of exceptional documentary interest, since it portrays in the foreground a number of the artist's and La Goulue's half-world friends. In 1895, too, Lautrec painted that finely simplified, cruelly revealing portrait of Oscar Wilde that marks at once the best that he achieved in portraiture and the limitations beyond which he could not go.

Ten years of dissipation, reaching the point of depravity and utter debauchery toward the end, wrecked his health and impaired his mind. He gave himself especially to the brothels in the years 1892–1895, from which period a half-hundred paintings of prostitutes survive. He told Yvette Guilbert that he lived (as he did for weeks at a time) in the "houses" in order to observe "the essence of prostitution." Alcoholism took its toll increasingly. With drunkenness came delusions, and finally the dipsomaniac slipped into being the irresponsible rebel against any control. After a few hours' sleep, a rest sadly shortened by the revelry of the night before, he would be up and at work feverishly on painting or lithography till late afternoon, then would plunge into the round of sense-indulgence again. Oftener and oftener the police brought him home from some street disturbance or café brawl. A trip to London, where an exhibition of his was considered by the critics to be genuinely French, of "the cult of vulgarity and ugliness," helped temporarily (though for years Lautrec had voiced his dislike of England, "the land of drunkenness"). Early in 1899 he was carried to a private asylum at Neuilly.

Deprived of liquor, he showed immediate improvement, and in less than three months he was well enough physically and mentally to be released, though placed under constant surveillance of a guardian. After a brief period of good behaviour he drifted back to the old life, the old associates, the old indulgences. The stream of art production dried up. He died in September 1901, attended by his still devoted mother. He was not yet thirty-seven years old.

With the death of Henri de Toulouse-Lautrec an era closed. With his passing a phase of modern art ended. The impulse to realism which had been initiated by Courbet in mid-century, forwarded by Manet, and given a modern form-conscious aspect by Degas, was carried to a conclusion and blind end by this wilfully sensual painter. The realist, in a period of

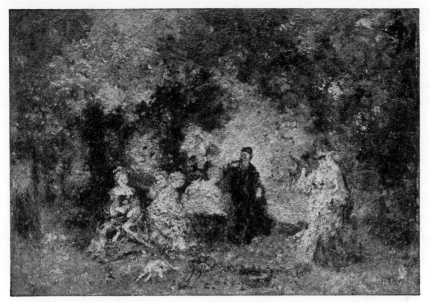

MONTICELLI: Court Ladies. *Metropolitan Museum of Art*

rapid changes in art, is driven to search in the haunts of the strange and the vicious for ever-stronger food for his nerves. Lautrec, predisposed to self-indulgence and the pursuit of strong sense-stimulants, gravitated naturally to France's centre of Bohemianism and moral licence. He became the very incarnation of *fin-de-siècle* instability and animalism.

Physically unsound by birth, he pursued a course of progressive moral degeneration. Those who later argued that an artist's way of living should not affect judgment of his creative works have failed to argue away two facts: first, that in so far as the observer finds interest in subject matter, he finds a great many of Lautrec's pictures unpalatable by reason of associative ideas of gluttony, bestiality, and vice; second, that after painting in the first few years of maturity a number of creative works, the artist's powers progressively declined as his way of life crystallized into its sensual pattern. What might have been a genius profound enough to carry Degas's innovations into the main stream of formal creation flowing from Cézanne, Gauguin, and Seurat, turned out instead to be a talent for duplicating, sometimes more tellingly, Degas's special decorative effects.

Lautrec's contribution, in the last analysis, is seen to be in a marginal eddy of the main modern stream. When he died, symbolically in the

first year of a new century, something like a school of Paris was forming, and it looked to another source—the one uncovered by Cézanne.

If realism was no longer to be central in the French tradition, romanticism was equally displaced before the century's end. Delacroix and Géricault had served the moderns, but there had been no continuing school to keep alive the romantic tradition. As if to mark the end of the line there had died in 1886 one Adolphe-Thomas-Joseph Monticelli, a painter of Marseille who had capitalized upon all the surface virtues of romanticism. His art had been opulent, brilliant, colourful; it had been sylvan, idyllic, visionary. It deserves a word in connexion with modernism if only because it once had fascinated van Gogh. But soon after 1901 it was to be clear that realism and romanticism had had their days in France. Already "modernism" signified something else.

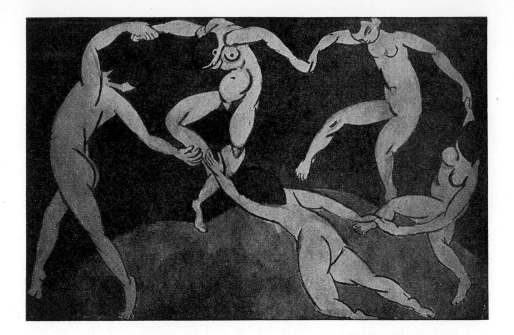

XIII: THE SCHOOL OF PARIS AND THE MODERN PRIMITIVES

AT THE Salon d'Automne of 1905, held in the Grand Palais, the public of Paris was admitted to a room especially dedicated to a group of youthful painters. The names of the artists were unfamiliar. They included Georges Rouault, Henri Matisse, André Derain, Raoul Dufy, and Georges Braque. A few of these young men were already known to conservative officials and to the Parisian schoolmasters of art as radicals and agitators, but they had not been widely publicized. Up to that moment they had been but loosely associated.

Within a few days of the Salon's opening, however, they had a collective name, and apparently a collective mission. This mission was, accord-

MATISSE: The Dance. 1909. *Museum of Modern Western Art, Moscow*
(Druet photo)

ing to one's point of view, the destruction of whatever of sanity and beauty remained in art or the carrying on of the torch lighted by Daumier, Cézanne, and van Gogh. The name given them was "the *fauves*," the wild ones, and the room of their paintings at the Grand Palais was commonly referred to as the *cage aux fauves*.

The collective showing of the *fauves* in 1905 signalized the opening of a new era in the development of modern art. With the turn into a new century the era of individual rebellion, of giant personalities and heroic personal sacrifices, had closed. There were to be no more lone insurgents fighting single-handed, and often tragically, against the forces of reaction and public misunderstanding. Instead the fight was to be carried on by organized and widely recognized groups or schools. Although France will lose leadership before the generation of the *fauves* has passed, although the French contribution will be watered down in the flood of influences from resident and visiting foreign artists, the international school will be known as the school of Paris. There will be provocative, not to say sensational, incidents and trends revolving around the Spaniard Picasso, the Italian Modigliani, and the Mexican Rivera (rather than Rouault, Matisse, and Derain); but the outstanding change is the emergence of a collective consciousness among the rebels, and an integrated school.

The great creative painters of the nineteenth century, Daumier and Whistler and the four post-impressionist masters, had separately demonstrated a new way of art. But no one had understood the likeness in their contributions. At the turn of the century no artist or critic had detected and charted a main course of modern progress. Cézanne, van Gogh, Gauguin, and Seurat were yet to be classed together under the name post-impressionists. It had not yet become clear that there had been a unity of æsthetic aim in their experiments. Gauguin, it was known, was heavily indebted to Cézanne, and van Gogh moderately to Gauguin, and Seurat somewhat to Whistler; and all were indebted in one degree or another to the Orientals. But it was not recognized that this was enough to constitute the beginnings of a school or a style or a world movement. It seemed, in 1901, that the world of art had merely been disturbed by a succession of rebels, each fiercely independent and each, in general, contemptuous of the others.

In the years 1901–1905, six or seven of the most original of young French painters had gradually drawn together. They had inventoried the separate gains of the individualistic masters. They went on to serve French

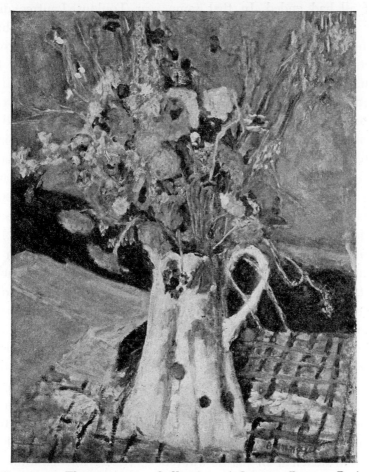

BONNARD: Flowers. 1924. *Collection of Georges Besson, Paris*
(Courtesy M. H. DeYoung Memorial Museum, San Francisco)

art and world art by bringing to focus the efforts and experiments of a half-century. It was they who first affirmed through group organization and group showings that a new way of painting had indubitably been discovered. By 1905 they were strong enough as a group to demonstrate, in the *cage aux fauves*, a collective faith. Historically they became the first group, or class, within the school of Paris.

In 1901 three of the older masters were still living: Cézanne at Aix, Gauguin at Papeete and Hiva-Oa, and Whistler in London and at various European health resorts. But substantially the creative or inspirational

work of all had ended. In that same year Toulouse-Lautrec died. Apparently no French artist was much affected by his passing. The young Frenchmen, sensing that the Manet-Degas-Lautrec line had arrived at a sterile end, were going further back, especially to Cézanne, for their inspiration. The death of Lautrec was felt most by a twenty-year-old student painter, a Spaniard named Pablo Picasso, who was beginning his career by emulation of Lautrec. He was unknown to the *fauves*-to-be; and no one could have guessed that the stranger, near to starvation in Paris, would within ten years wrest leadership of the school of Paris from Matisse.

In 1901 there *appeared* to be an older, soberer group of moderate rebels destined to crystallize the modernism of France. The *nabis*, successors to the synthetists and the symbolists,[1] were certain that they were forwarding the ideals of Cézanne. Maurice Denis, after a sojourn at Aix, painted a document picture entitled *Hommage à Cézanne*. It shows, in a group around an easel bearing a Cézanne still-life, the chief painters, not of the coming *fauve* school, but of the group that Denis and the *nabis* considered the great moderns. Shown are those artists who were to be classed later as within the *decorative* wing of the modern army, who derived as much from Gauguin as from Cézanne: first, the unfortunate Denis himself, who was later able to see just what Gauguin had accomplished and to explain it better than any other in words, all the time sliding down in his own work to an innocuous, form-lacking sort of simplified illustration; Odilon Redon, a revolutionary in wanting to be mystic, to externalize the inner spirit, and author of many charming minor works, but ultimately lacking in force and deficient in plastic awareness; K.-X. Roussel, who rallied a little out of vague impressionism, but without finding the main path of post-realistic effort; Félix Vallotton, who came to the edge of the new stream but failed to plunge in; Édouard Vuillard, an accomplished organizer of decorative interior scenes, not without a real grasp of form-organization, but usually holding it within a posteresque or superficial patterning range; Paul Sérusier, whose best work dated back to the time when he had been working under Gauguin's influence, who is sometimes put down as leader on the backtrack to a "new traditionalism"; and, the one great artist destined to carry on beside the *fauves*, and to establish himself as a leader in the school of Paris, Pierre Bonnard. The list is, in

[1] The *nabis*, unlike the synthetists and the symbolists, chose their name without reference to their artistic aims. The word "nabi" is, apparently, a corruption, possibly of a Hebrew word meaning "prophet," or perhaps of the French for "nabob," signifying leader, governor, or head-man.

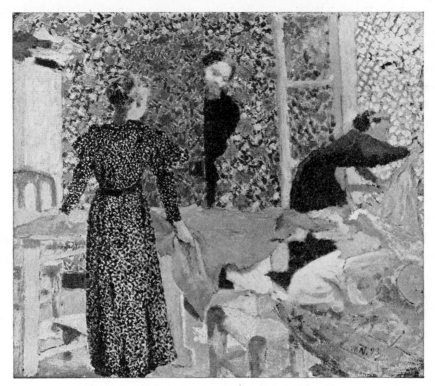

VUILLARD: Interior at L'Étang-la-Ville. 1893
Smith College Museum of Art, Northampton

general, of leading painters in the second rank of progressives, of cautious adapters of other men's innovations; and, aside from Bonnard's name, a list of weak and unadventurous rebels as compared with those so soon to found fauvism.

At the moment of the showing of Denis's *Hommage à Cézanne* the young workers in Paris included Georges Rouault and Henri Matisse, Raoul Dufy and Maurice Vlaminck, Albert Marquet and Othon Friesz. They and not the *nabis* were to form the school consolidating old gains and pushing on to new ones. They were to bring together for the first time in one gallery the works of a group avowedly anti-realistic, preponderantly form-conscious. They were to go further back than anyone had yet done, to primitive beginnings, in order to strike out with the force and uninhibited strength necessary permanently to establish revolutionary

modernism. Essentially they were the continuators of Cézanne's and Gauguin's and van Gogh's insurgency.

Their progress in the years 1901–1905 was halting and apparently unfocused, but in retrospect it may be seen how unerringly all were pushing toward the *cage aux fauves* of the Autumn Salon of 1905. They had seen the first great Seurat show, in 1900, and in 1901 a van Gogh show was held at Bernheim's—and this especially excited Vlaminck. Gauguin was given considerable space at the first Salon d'Automne in 1903. Cézanne's paintings could now be seen regularly at Vollard's, and in 1904 the Salon d'Automne honoured the *maître aixois* by devoting a full gallery to his work. These events had the effect of parading before the younger radicals many of the masterpieces of the pioneer moderns.

The more studious of the newcomers were already going back to the sources whence Whistler, Cézanne, and Gauguin had drawn inspiration. Rouault had studied medieval stained glass (in the footsteps of Gauguin). Matisse had gone to London in 1898 especially to examine the Turners, and in 1903 he went to Munich to revel in the greatest of Western exhibitions of Mohammedan art. He had already re-studied the Japanese. Henceforward the Oriental plastic aims were to dominate his decorative painting. Derain, Dufy, and Friesz, all on the youthful side, were variously enthusiastic over van Gogh and Cézanne, over the Japanese print-makers and the Persian decorators, over medievalism and (perhaps owing to the example of Gauguin) the primitive arts.

In 1903, at the obscure gallery of a Mlle. Weill, which had already shown Picasso, there was held a preliminary exhibition of the *fauves*-to-be. Nearly all of the group had paintings there except Rouault. But it was in 1905 that the work of the new school burst upon Paris. Conceived as a showing place for picked progressives and sincere radicals, the Salon d'Automne was serving upon a ground between that of the over-conservative official Salon and that of the no-jury and standardless *Indépendants* show. From 1903 Bonnard, most creative of the *nabis* group of painters, and Rouault and Matisse of the younger radicals, were inside members of the Autumn Salon group. The directors were progressive-minded, and it was decided that at the 1905 exhibition an entire gallery would be given over to the rising *fauve* group.

A startled journalist by a chance phrase gave the name to the school. Noting an appealing realistic statuette in the midst of so many crude and loud-coloured paintings, he exclaimed: "Donatello among the wild beasts!"

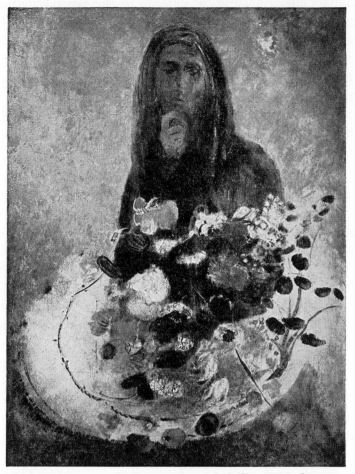

REDON: Mystery. *Phillips Memorial Gallery, Washington*

And the gallery of the innovators, who were to seem so tame twenty years later, became popularly known as the *cage aux fauves*: the cage of the wild men or of the wild beasts, as the translator may prefer.

The exhibits seemed to the conservative critics to go further in irresponsibility and offensiveness than the pictures of Cézanne, Gauguin, and Seurat. Indeed in those others there had been a quality of colouring harmonious and almost chaste, as compared with the flaming audacities of Vlaminck and Derain. The last vestiges of correct drawing seemed to have disappeared from the pictures of Matisse and of Dufy, or to have been brutalized by Matisse and Rouault. The conservative critics were too blinded

by the arbitrary colouring, and too enraged by the general flouting of "the principles of art," to mark these younger men as continuing the revolutionary work of the post-impressionist masters. But the deluge had started. Soon it was pouring over Paris in two streams.

First, there was a succession of retrospective exhibitions, enabling the *fauves* to acclaim their own old masters: Cézanne, Gauguin, van Gogh. Second, there was a consolidation of gains, and a strengthening of forces within the band of *fauves*. They gathered to themselves, around their leader Matisse, a number of young radicals who had been independent experimenters in Paris. By 1907 they had taken in Dunoyer de Segonzac, thus completing a roll that included the name of virtually every painter destined to be known as one of the French masters of the generation 1905–1940. They accepted also Kees van Dongen, a young Dutchman who was enduring the usual years of privation in Montmartre, and the phenomenal Spaniard Pablo Picasso, who had already produced the sensitive masterpieces of his blue and his rose periods without attracting attention.

The early exhibitions of the *fauves* made clear that not only impressionism but neo-impressionism as well (excepting Seurat's transcending canvases) had been renounced by the younger moderns. The hazy composing and chromatic extemporizing of Monet and Pissarro and Signac were vehicles too weak to carry the formal structures demanded by the *fauves*. Year by year it became clearer that Cézanne's example and Cézanne's dicta were the chief animating forces behind the group search for a new formal language. Increasingly, study of primitive epochs of art confirmed the truths learned from the Orient and led the painters to more varied adventures in denying realism and plunging unhampered after plastic expression.

At first it seemed that the decorative methods of Matisse and Dufy were generically unlike the heavily simplified picturing of Derain and Vlaminck and Rouault (and a split in the membership was foreshadowed as early as 1906); but all were experimenting in rhythmic fields central to modernism. The *fauves*, to be sure, produced no technique or style so distinctive and binding as that of the preceding impressionists or that of the succeeding cubists; nevertheless, there was a larger unity in the ruthless simplifications and in the dynamic reach for rhythmic expression.

A painter not himself important as a pioneer modernist, Gustave Moreau, had exerted some of the force that shaped fauvism and the school of Paris. Moreau was not a modern in his way of expression. He lacked a

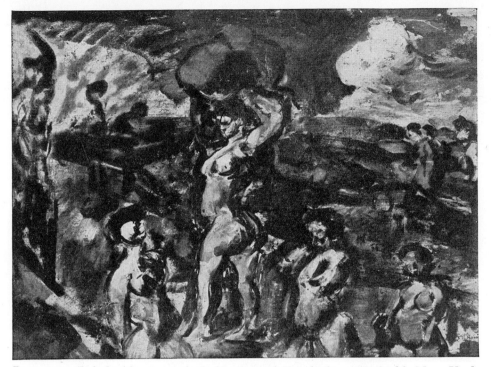

ROUAULT: Babel. About 1906. *Collection of Frank Crowninshield, New York*
(Courtesy Marie Harriman Gallery, New York)

sense of plastic form in the twentieth-century meaning. He was modern in his desire to externalize mystic or spiritual meanings; but he grasped at symbolic and literary means. The many paintings in the Moreau Museum in Paris (he had at one time a host of appreciative converts who transformed his home into a shrine) seem to a later generation insufficiently vital. Nevertheless, this painter was a genius as a teacher. He believed firmly that the independence and individuality of each student should be developed, even while each was made to undergo the discipline of studying the old masters and of copying laboriously the works not only of Raphael and Titian and Poussin but of the more recent masters, Chardin, Delacroix, and Corot. He also encouraged his students to the widest possible speculation upon æsthetic theories and problems, and he asked them to visualize the artist as having high social and moral obligations. He was everything that the Bohemians of Montmartre were not.

Among his students were Rouault, Matisse, Vlaminck, and Marquet,

MATISSE: The Dinner Table. 1897. *Collection of Edward G. Robinson, Beverly Hills, California* (Photo courtesy Pierre Matisse Gallery, New York)

of the inner circle of the *fauves*, and Desvallières and Blanche, who were lesser painters but highly placed among the administrators of the Salon d'Automne and thus instrumental in opening ways of exhibition to the wild men. Moreau himself continued his mystical-mythological painting in the officially approved, meticulously polished technique. But he encouraged discussion of the impressionists, and when a student bought and brought to class two Cézanne paintings the master joined his pupils in appreciation.

Henri Matisse, eldest member of the group of *fauves*, had had varied experience as student and painter before the wild men drew together. Born in Picardy in 1869, he had studied for the law but had been inspired, during a first visit to Paris, to dream of a career in art. At twenty-one he gave up all other plans. In 1892 he won out over parental opposition and went to

MATISSE: The Studio. 1916. *Phillips Memorial Gallery, Washington*
(Photo courtesy Pierre Matisse Gallery, New York)

Paris. After a brief and unhappy attempt to acclimatize himself to the studio of the arch-conservative Bouguereau, he went to Moreau's studio, where he stayed for four years. He copied pictures in the Louvre, for the pay he got and for insight into the methods of the masters. He began early to exhibit, before he had found a manner of his own.

From a derivative realism, partly from Corot, he turned to impressionism and then to decorative simplification in the manner of the *nabis*, under influences of Vuillard, Bonnard, and Sérusier. In 1899 he became owner of a *Bathers* canvas by Cézanne, and thereafter the influences shaping his art came from the Master of Aix, from Gauguin, and from the Ori-

entals. In 1904 he had a one-man show at Vollard's. He was already recognized within a limited circle as a painter with exceptional talents, and he might have gone on to a success among orthodox artists.

The beginnings of his unorthodoxy, his leanings toward revolutionary ideas, went back to the time of his association with Rouault, Marquet, and other students under Moreau. About 1897 a sense of dissatisfaction settled upon him. One day actual revulsion overtook him and he destroyed his latest picture, a conventional academic still-life, although he knew that he could sell it for money actually needed by his growing family. In the following years Derain and Vlaminck, both excited especially by the works of van Gogh, had effect upon his own studies. Gradually, as Dufy and Friesz came into the circle, it became apparent that a school was forming, and that Matisse, oldest in experience and a leader by temperament, was foreordained to be its spokesman and shepherd. Through the years between the sensation of the *cage aux fauves* and the three-way split, about 1909, of the decorators, the neo-realists, and the cubists, he was the acknowledged leader of the wild men. By 1910 he was definitely set in his æsthetic of a decorative plasticism, and was already contemptuous of subject-interest art but no less wary of the trend toward absolute abstraction. He was content to go down a side road diverging from the main way of modern experiment opened by Braque and Picasso. In the midst of the success of the *fauves*, in 1907, he had set up a studio-school in Paris, and through it, for three or four years, he exerted an extraordinary influence upon scores of young painters, mostly from foreign lands. As early as 1908 Alfred Stieglitz put on a one-man Matisse show in New York.

Georges Rouault, born in 1871, was already a student in Moreau's studio when Matisse enrolled there. He similarly copied masterpieces in the Louvre, and he added experience as designer of stained-glass windows, whence came certain elements of simplification, strength, and colourfulness in his style. Unlike Matisse he formed his manner of painting comparatively early. He was the less affected by the Oriental vogue because he had already found a prototype of his idea of modernism in Daumier and in the stronger canvases of Cézanne.

Unlike Matisse, for whom decorative order was enough, Rouault wished his art to speak a second time, beyond formal or decorative significance. He was earnest, religious, Catholic. He was attracted, in Daumier's footsteps, to circus and theatre people and to street characters. He drew on the

ROUAULT: The Judges. 1910–1913. *Portland Art Museum, Portland, Oregon*
(Photo courtesy Pierre Matisse Gallery, New York)

houses of prostitution for subjects, not with Degas's or Lautrec's careful objectivity but in order to castigate prostitution. He developed consistently his sense of plastic design, becoming master especially of the effects of voluminous figures poised solidly in space. He found his colours, brilliant yet smoky, in stained glass and in medieval enamels, with enough of modern brilliance to bring him neatly into the company of those *fauves* who derived their chromatic effects from Gauguin and van Gogh.

When Rouault exhibited in the room of the *fauves* at the Salon d'Automne of 1905 he was already the most "serious" member of the group. Comparison of his works with those of Matisse, Dufy, Vlaminck, Braque, and the others thirty-five years later, at the outbreak of the Second World

ROUAULT: Nocturne. *Pierre Matisse Gallery, New York*

War, shows him in the same relationship to the group, more serious, more profound, speaking as eloquently as they in formal terms but holding to subject interest, or prodding to thought.

Also from the studio of Moreau, Maurice de Vlaminck was of a different temperament. Born in Paris in 1876, he had come to painting later and less whole-heartedly than his fellows. He was something of a musician, and a noted bicycle-racer. His early painting, inspired by a show of van Gogh's, was violent in movement, heavily pigmented, and brilliant, even garish, in colour. Without troubling with the many sources of influence acting upon Matisse and the others, he settled down early in a groove from which he was not to escape in thirty years. Finding, by 1908, that he could do, consummately well, landscapes instinct with movement, appealingly fluent and rich, he has remained substantially the artist he was when the *fauves* were the new group in Paris. It was rather Cézanne than van Gogh whose discoveries in the field of plastic movement, of dynamic organization, he took as beginning point for a facile, bold, washy type of painting. Charming, even irresistible, so far as it goes, it is Cézanne super-

DERAIN: Cathedral of St. Paul and the Thames. 1906–1907
French Art Galleries, New York

ficially understood. Cézannish effects are re-created with bravura and over-emphasized contrast and disarming spontaneity.

André Derain was a younger man than these others, born in 1880. He was, therefore, only twenty-one when the *fauves*-to-be were beginning to find one another. Symbolically Derain, Vlaminck, and Matisse first met together at the van Gogh exhibition in 1901. Impressionable and eager, the youthful Derain absorbed one influence after another. He appeared at the early *fauve* exhibitions with broad, drastically simplified, and highly coloured canvases, with exceptional dependence upon heavy brush-drawn

line; but he abandoned his first set manner when Negro sculpture became a vogue, and was off after the cubists in 1908–1910. He deserted the cubists to go back to that school's source in Cézannish form-seeking. Thereafter he was the great eclectic of the school of Paris, going from manner to manner with extraordinary ease and achieving a high standard of creativeness in each fresh field.

Not himself an initiator, he proved that he could join in any artistic adventure and acquit himself meritoriously. Certain primitive (typically fauvist) traits persisted throughout his career, and in some of the channels of expression opened up during the long armistice he excelled all his fellows, especially in portraiture that vaguely suggests both the Master of Aix and Oriental primitives.

There were other painters who both belonged to the original band of *fauves* and survived as leading figures in the school of Paris as late as the nineteen-thirties: Raoul Dufy, Albert Marquet, and Othon Friesz. None of the three was destined to prove himself the peer of Matisse or Rouault, or even of the versatile Derain. For all three, personal expression became circumscribed, limited in range; yet each scored a distinctive triumph in his narrowed field. Dufy, born at Le Havre in 1878, studied with Moreau. But his personal interpretation of the fauvist ideals of simplification and colourfulness brought him out in a corner of the modern field far from the territory trod by the serious Cézannists, the profound Rouault, or the cubist explorers. Influenced especially by Matisse, Dufy developed a decorative formula, within which he has practised a personal sort of calligraphic drawing, with overlaid patches of pure colour. In this free technique he has produced an engaging reflection of his own child-like delight in race-track scenes, beach scenes, and chance aspects of studio life. It is fauvist, primitively simple art developed with a lightness, a dexterity, and a sketchy prettiness hardly to have been foreseen by the earnest radicals of 1901–1905. It is justified by enough of the form-quality out of Cézanne and Matisse to warrant its inclusion in all the standard galleries of modernism.

Albert Marquet, on the other hand, renounced after 1905 those properties of painting which seem, a generation later, to be at the heart of the modern achievement. He had been born in 1875 and was a companion of Matisse in the student days under Moreau and during the years of trial immediately following. But the qualities of his painting that had brought him into the orbit of Matisse—the posteresque massing, the occasional

VLAMINCK: Snow Scene. About 1927. *Bellier Collection, Paris*
(Courtesy M. H. DeYoung Memorial Museum, San Francisco)

introduction of patterned areas, the clean, strong colours—failed to add up to form-expresssion in the modern meaning. Soon he reverted frankly to neo-impressionism and a sort of posteresque realism. He became one of the most appealing of the Frenchmen practising just on the verge of the freshly opened fields, a little too afraid of "distortion" to stay by the search for form, but honestly spontaneous and decorative.

Othon Friesz, born at Le Havre in 1879, and a close friend of Dufy, showed great strength and a sufficient plastic competence in his years of association with the *fauves*. His failure later to measure up to the stature of the leaders of the school of Paris was the more regrettable because he seemed at one time a companion, in his strength and seriousness, to Rouault.

Other artists joined the movement in the exciting years on either side

of 1905, and some seemed briefly to be in the creative line from the great post-impressionists to the future. But Henri Manguin and Jean Puy, Auguste Chabaud and Charles Camoin, failed to find distinctive ways of expression within the modernist advance, or else fell back from fauvism to mere simplified realism, or to Maurice Denis's type of symbolic-decorative design. Kees van Dongen, born in Holland in 1877 and attracted to the fauvist group later than these others, perhaps served as little to forward the serious aims of the school. But by leaning to seductively rhythmic and facilely decorative effects, not without occasional teasing erotic implications, he attracted a wide and fashionable public. His subjects are preponderantly from the feminine world, dancers, actresses, models, *demimondaines*, social belles. They are posteresquely set out, in a technique studiedly careless, and often they are subtly, even cruelly caricatured. But van Dongen's real achievement was to sensualize and render piquant the surface aspects of fauvism. He carried along some of the new ideas with journalistic verve, with just the touch to assure his success in the way of the sexy magazines.

There came a day when the break between the leader and the school was inevitable. Matisse had been the typical *fauve*; he had been adviser and guide to the younger men; he had taken pupils into his studio, had made it a cradle for a new generation of wild men. Nevertheless, by 1909 some of his radical comrades were complaining that the leader had ceased to grow. He wanted, they said, to hold modernism to a single sort of decorativism. He was settling into his own personal groove. He was, they thought, no longer fit to be their leader. Already in 1908 and 1909 the dynamic and adventurous Spaniard Picasso was recognized as the more original genius and the new breaker of trails. Thenceforward the school of Paris was to be led by a foreigner.

Matisse practically abdicated on the day when he exclaimed contemptuously of a canvas of Braque's: "It is cubist!" He thus gave a name to the group that was to oust him from leadership. It was the spirit of fauvism that brought about the cubist adventure; and that spirit animated many another minor school of experimental painters, in the following era of the 'isms. But from 1910 the forces of the *fauves* were dispersed, and often pitted one against another.

In history the school is not considered for that reason to have failed. On the contrary, it was seen to have done its work well. It had given mul-

VAN DONGEN: The Coiffure
(From *La Peinture Française, XXe Siècle*, by Raymond Escholier)

tiple wings to the solitary ideas of Daumier and Whistler and Cézanne. It had given body to modernism. It had broken the moulds that had been so carefully guarded (and worn smooth by over-use) by the inheritors of David and Ingres and Couture.

Matisse went his way, to become the greatest decorative painter of his time. His ultimate victory was certain, world-wide, and, in his chosen field, complete. He asked no more than an art of lovely sensuous fullness. Rouault equally found his inimitable and potent way of expression, in a more serious *métier*. Vlaminck and Dufy settled into their own grooves.

But a more profoundly experimental group within the enlarged school of *fauves* set out upon the series of explorations that resulted in the twenty-year battle of the 'isms, which enlivened the existence of the school of Paris from 1910 to 1930.

The *fauves*, in summary, served modern art doubly. They effected the focus of revolutionary effort in 1905, consolidating the gains made by formerly separated and lonely rebels, giving body to a school; and, about 1910, they dispersed their members and inspired, in the light of a generalized modern doctrine, the researches and achievements of a dozen related but divergently experimental painting groups.

The freedom to paint as one might wish had been hard-won in France. Foremost among the organizations fostering liberty of expression was the Société des Artistes Indépendants, founded in 1884 by a group of radicals in which Seurat, Signac, and Redon were the leaders. From 1886 the annual salons of the *Indépendants* became a feature of the art season in Paris and continued in unbroken succession until the opening of the World War. The first rule of the society was that any painter, schooled or unschooled, might become a member upon payment of a small fee, and that his exhibit would be hung without the formality, and danger, of submission to a jury. The *Indépendants* shows, like those of the later Society of Independent Artists in New York and the No-Jury Society in Chicago, attracted the legitimately experimental artists, together with hundreds of incompetents, cranks, and Aunt Lizzies. The critics and the human-interest journalists always had a holiday, and the gallery-going public accepted the occasion as a diversion on the comedy side. Nevertheless, the exhibitions did serve to introduce to critics some of the major youthful talents of France, especially among the *fauves*.

In 1912 the free-for-all Independent Salon was victimized. Roland Dorgelès, a reformed painter and a *littérateur* well known in Montmartre, borrowed Lolo, the pet donkey of the proprietor of the Lapin Agile Cabaret, and set about to expose the pretensions of the exponents of the new freedom. He filled a brush with colour, tied it to Lolo's tail, fed the animal carrots to stimulate a favourable wagging, and went behind to hold up a canvas at proper distance to take the paint. The resultant picture, admirably broad and free, was given the title *Sunset over the Adriatic* and was signed with a euphonious name. Under her artistic alias Lolo duly became a member of the Société and had her painting installed on the walls

Rousseau: On the Banks of the Oise
Smith College Museum of Art, Northampton

of the Salon of the *Indépendants*. Her effort was mentioned by the critics.

Freedom of the sort guaranteed by the *Indépendants*, nevertheless, was the only safeguard of artists known as "modern primitives," who produced a body of work later recognized as worthy of place in the most exclusive museums; who were, moreover, an inspiration to the young men of the school of Paris. Chief among these "naturals" was Henri Rousseau, or Rousseau *le douanier*, who had exhibited almost yearly at the *Indépendants* since 1886. In the years following 1905 he became a friend of Braque, Picasso, Delaunay, and others of the fauvist and cubist groups.

The *fauves* in 1905 were discovering those exotic arts that seemed to afford sanction for their own neglect of naturalism and refined technique. They were thrilled, moreover, by the emotional directness and formal richness of certain bodies of art that had been obscured by the historians and relegated by the "authorities" to the museums of science. Delightedly they

had discovered Negro sculpture and the decorative arts of the South Sea Islands. Out of the past of Europe they resurrected relics of the medieval and Byzantine periods; and even the murals of the cave-dwellers came in for praise, as being superior to the works of the Salon and École painters. Chinese and Hindu art were brought out for study beside the Japanese. Everything primitively strong and simple and rhythmic was extolled, and sometimes copied, and made to yield up influences and even specific idioms.

Finally it was discovered, first by the modernists of Germany, that similar qualities and idioms were to be found at home and at present in drawings and paintings by children; that we all begin with certain powers of expression, with command of simple, æsthetically effective means, of which we are deprived by what is called education. From child-drawings the search went on to the pictures of those incorruptible child-men, those simple folk who have never had education or have not been spoiled by it, whose vision remains simple, direct, and unclouded by too much intellectualization; who are above virtuosity, above ingenuities of photographic transcription. In other words, the *fauves* were attracted by men who paint like savages, like Orientals, like children.

Art dies periodically of over-refinement, of sophistication, of knowledge that has dulled inspiration. Every so often the artist must strike back to new beginnings near the source where intuition outweighs training, where feeling is not clouded by tradition, where imagination takes only so much of nature as may be needed to communicate emotion or to evoke æsthetic response. In that the advance into modern art was to entail a major, not to say an epochal change, it was necessary to go very far back, to a new beginning in primitivism. Having gone back, when they started forward again the *fauves* noted, and approved as fellow-travellers along the road of formal creation, a few obscure contemporaries who had never been other than primitive, despite living in the world of intellectual triumph, of machines, of civilized education. Among painters Henri Rousseau was chief of these innocent ones.

For a time, perhaps, Rousseau was over-praised, given chapters unwarrantedly beside those on Cézanne, Gauguin, and van Gogh. His works may be too slight for that sort of canonization. His was a minor talent. But in a world too self-consciously artistic, too feverishly advancing, his canvases were, and are, of an intriguing freshness, with a consoling genuineness and a magically simple lucidity. Here was a man who took short-cuts

ROUSSEAU: Notre Dame. *Phillips Memorial Gallery, Washington*

through all the difficulties raised by knowing artists since the opening of the Renaissance, difficulties of anatomy, of perspective, of camera-truth of volume, contour, texture, colour. His eye saw what was central to an inner image; it rejected what detail failed to serve design and pattern.

The man lived in the Parisian world, but he was detached from it. He invites us with his pictures into his own awareness, his own realm of feeling and inner seeing. As his imagination, or fancy as some would call it, is limited, we cannot go very far, very deep. The world of modern art would be very poor and restricted if it stopped with the achievements of a Rousseau or a Rimbert. But the gallery-goer never fails to be grateful for coming upon one of their quiet, fresh, formally complete canvases in the too strident rooms of modern painting.

Rousseau painted a series of tropical landscapes in which fanciful animals are laid up in flattened tangles of botanically impossible but luxuriant foliage, in pictures lushly decorative. The effect is that of a tapestry, opu-

lently textured, perspectiveless, the execution utterly conventionalized. Other, less ambitious landscapes show urban or suburban bits, reminiscent of real places rather than in imitation of them, shyly put down, as it were, always with trees that make patterns, houses that are like toys, and flat pasted-on humans. The portraits are stiff and posed; but in the frank unreality of the garden or parlour setting, and in the extreme simplification of the graphic means, the posing may be overlooked, is unimportant. There are simple bouquet pieces, prettily decorative, and historical and allegorical compositions.

When intellectualization was more in favour in the halls of art, Rousseau's painting was widely characterized as naïve. Some later critics have combated the idea. Instead of being naïve, they point out, the artist had a very special gift of seeing, a lucid imaging power, and the means to get down his image with exactitude and conciseness. Certainly the intuitive feeling for plastic design is no indication of naïveté, though it is often an endowment of untutored or slightly schooled artists.

But there *is* an unexpectedness in the way in which Rousseau presents his subjects, an ingenuous exposure of feeling, which cannot but strike the conventional-minded observer as naïve. There is, for instance, that most celebrated of his works, and his last, *The Dream*, a large, almost a vast painting, in which he has shown one of the most luxuriant of his imagined tropical forests, with birds and animals patterned in, and at one side the red-plush sofa that was the pride of his household, and on the sofa a chaste conventionalization of a beloved mistress of his youth, nude, and at the centre a piping figure. The juxtaposition of the materials is, in common view, naïve. Rousseau loved his mistress, he loved his sofa, and nostalgically he loved tropical forests; and he expressed himself by putting the three obsessive ideas into one composition. That was, as the Germans reminded us shortly afterward, expressionism at work, on its subjective side, the artist parading his personal feeling, unabashed by common inhibitions.

Art is a convention. It had become, by the end of the nineteenth century, a convention of the upper classes. Recognized art was either realistic and shallow to match the materialism of those classes, or complicatedly experimental along the lines of research instituted by a fringe of intellectual dissidents. The artists known as modern primitives served, according to some critics, to bring painting back to normal, common currency. They and not the École artists have the right to be called "artists of the people"

Rousseau: The Dream. 1910. *Collection of Sidney Janis, New York*

and "artists of the true reality," wrote Jean Cassou of the Luxembourg Museum, for a publication of the New York Museum of Modern Art. "They translated literally the dreams and thoughts of traditional France, a nation of artisans, half-peasant, half-bourgeois, a nation which produces great-hearted and simple men, lovers of flowers, painters and sculptors humorous and diligent."

Perhaps after all it was we who were naïve, we who thought that art lived chiefly among the museums and schools and the educated public, and the official Salon and the consciously rebellious students of Montmartre and the Left Bank. In any case, thanks especially to Rousseau, whatever modern art may essentially be, it has been changed a little from what it would otherwise have been, by the impact of the ever-young primitives.

Rousseau had been born of the people, in 1844, his father an iron-monger. He had common schooling and served in the army, probably in Mexico, whence he is supposed to have brought back the memories of

tropical verdure upon which he drew so freely in the later years of his picture-making. Returned to Paris, he found a minor position in the customs service as a *douanier*. About 1885 he gave up the position and thereafter enjoyed a very small government pension. He was married twice, and he lived like any other half-paid civil servant, in poor but not squalid quarters. He made small amounts of money as a semi-professional musician, sometimes performing in park orchestras or playing the violin for street-corner crowds.

He had taken up painting before he left the customs service, and at that time had only his Sundays for experiment in this new art. Although it was for only a comparatively brief part of his life as painter that he was thus limited, he came to be known as the type figure of the "Sunday painter." And indeed there is spiritual reason for it; there is in his work something of the holiday feeling, of the calm festiveness, of the French Sunday afternoon. He painted pictures of family members or friends, dressed up and lined up in garden or park, of promenaders on the tree-lined boulevards, of empty city streets, and of picnickers or fishermen on suburban lakes and streams.

The *Indépendants* Salon came to be the red-letter event upon the calendar of this eccentric, and year after year he trundled his pictures in a borrowed cart to the exhibition hall. It was enough that he was exhibiting with other artists, and he did not complain when, again and again, he was assigned space on the poorest walls and in the poorest light. If the critics failed to notice him, it was not so with artists. Among those who early discovered his work and spoke well of it were Gauguin (who may have gained some added impulse toward his "synthetism" from the *douanier*), Seurat, and Redon. In his humble rooms he increasingly painted portraits for neighbourhood clients, and he gave drawing lessons as well as music lessons to the neighbourhood children, all at very small fees. Between 1903 and 1910 he painted more ambitious canvases, large in size and imaginative in content, including the finest of the jungle pictures.

It was about 1906 or 1907 that Rousseau became familiar with a considerable group of modern artists, partly through the interest of Guillaume Apollinaire. Thenceforth he was celebrated in the Montmartre haunts of the *fauves*, and was even honoured at a studio dinner by Picasso, Apollinaire, Braque, André Salmon, Marie Laurencin, and Gertrude Stein. About this time Rousseau began to sell pictures outside the circle of his neighbourhood clients, and in the last two or three years of his life he

ROUSSEAU: The Lion's Meal. *The Lewisohn Collection, New York*

enjoyed prosperity. He invited his young artist friends to his rooms for musical and artistic soirées, and entertained them as he did his neighbourhood companions. German, American, and Spanish painters enjoyed his friendship, and through Max Weber something of his influence passed into the modernism then shaping in New York.

In his mid-sixties Rousseau suffered two misfortunes. Twice widowed, he fell in love with an unsympathetic, middle-aged woman and courted her extravagantly, squandering on her the sums then coming in from artdealers, and she encouraged him, only, in the end, to insult him as an old fool and a pitiable artist. Then, made an innocent tool by a swindler, he was tried in court and technically convicted, though the sentence of two years' imprisonment was set aside on the grounds of obvious incompetence and simple-mindedness, as proven by his paintings.

Rousseau died in 1910, at the age of sixty-six. The public and officials being not yet ready to honour him, his friends among the radical artists and writers rented a tomb for him. After another twenty years his paintings

began to appear in leading museums, and by 1940 even the most conservative institutions, such as the Louvre and the Metropolitan Museum, showed examples of his imaginative work.

Rousseau was the only modern primitive whose name entered prominently into the annals of the modern movement when the school of Paris was taking form. The men of a child-like innocence of eye and artless means of statement are by nature solitaries, and usually they stay in their out-of-the-way villages or remain unknown in their humble city apartments. Nor is there any consistency of aim and approach in their ways of painting. Yet there are periodic exhibitions of "contemporary folk art" and of masterpieces of "people's painting"; and seldom a year goes by that the newspapers do not discover an ironworker or a janitor or a rural housewife who seems to fulfil all the conditions of modern primitivism—except perhaps the instinctive achievement of that form-quality which renders the picture æsthetically vital.

The contemporary French "naturals" have been especially talked of, owing to the widespread recognition of Rousseau as an authentic if a minor master. Camille Bombois, Louis Vivin, and Dominique-Paul Peyronnet have been accorded international attention and their pictures are known to the commercial galleries. All came to be Parisians, yet all escaped the sophistication and professional striving and conventionalism of the "normal" art-world.

Bombois, son of a bargeman, has been a farmhand, a professional wrestler, a ditch-digger, and a newspaper pressman. It was in the early twenties that he ceased painting just for himself and sought recognition. Almost immediately he was noticed by the Parisian advance-guard critics. He paints strongly and clearly, without regard to natural light-and-shade, but depicts very literally the details that interest him. His instinct for formalization leads to decorative but not profoundly rhythmic effects.

Vivin, who was born in 1861 and died in 1936, was in service at the Paris post-office for more than forty years. Wanting to be an artist in his youth, though not then or later having traffic with schools, museums, or other artists, he achieved his ambition when he retired from the postal service at sixty-two. Innocent of training and of material ambition, he painted stiffly composed, meticulously detailed panoramic scenes, with a child's interest in animals, trees, and flowers, and in separate windows,

KANE: *Along the Susquehanna. Collection of Mr. and Mrs. William S. Paley, New York.* (Courtesy Valentine Gallery, New York)

gables, turrets, columns, and lampposts. He was at once the most specific and the most dream-like of the group, achieving at the last a haunted lucidity that carried him to the edge of the territory of the surrealists.

Peyronnet, an ex-printer, born in 1872, achieved something of the same remote-from-reality aspects, but with more of finish and within a decorative simplification. He began to paint only after returning from service in the First World War, and, unlike Vivin, who sold his canvases in the streets or at the markets, he exhibited regularly at the Salon of the *Indépendants*. In a technique of minute brush-strokes he builds up broad contrasting areas, each with its special pattern or texture value, and he plays unabashed with the crest-lines of sea-waves, the cottony tufts of clouds and furrows of land.

In contrast to these others, René Rimbert came to a simple, fresh painting style after a considerable acquaintance with art and artists, through his father who was a woodcarver and by virtue of study in the museums of

several countries. He qualifies, however, as a Sunday painter, being a clerk in the postal service. A younger man than the others, born in 1896, he began to attract attention at the *Indépendants* soon after the war. In love with effects of light—he considers Vermeer the greatest of the museum masters—he composes his city and suburban street scenes in broad light-and-shade massings. Though detailing meticulously parts that interest him, as in the foliage and the stone wall of the barn in *Sunny Road at Perpézac-le-Noir*, he has a knowing pictorial sense that leads him to clear extensive areas, for atmospheric effects. When he introduces the human element there is likely to be exaggeration of countenance and attitude, less on the order of the naïve distortion of Rousseau and Vivin than slyly humorous.

Others of the French modern primitives came to notice more as types than because their paintings intrinsically warranted wide advertisement. Thus Séraphine of Senlis, all her life a charwoman and drudge, was a peasant mystic, bringing her subjects up out of a hidden life of the soul, painting differently from all other painters because she was enjoying an inner life and vision that no human being shared. André Bauchant, on the other hand, is a primitive whose seeing is, if unconventional, objective and outward. He takes his subjects from nature and from history, and violates reality only in the way in which he lays up his materials in the picture. He paints himself in his garden, behind him a park with specimen trees, before him a curtain of flowers, each individual bloom distinctly set out and painted. From history or legend he composes mass scenes, with loving devotion to the patterns in tree branches or embroidered robes, and to rhythmic repetitions of tree trunks and of the actors' figures. Marcel Brisset and Jean Ève are other French "people's painters" who never learned to see as professional artists believe they should see, and so have remained themselves and, to a degree, primitives.

Other European countries discovered their own "naturals." Especially rich were the prizes found among Bavarian and Tirolean peasant artists. In Italian churches, and in those of Catholic communities in France, Mexico, and elsewhere, innumerable *ex-voto* paintings were seen to be characterized by the true primitive directness of statement, by disregard of conventional perspective and niceties of anatomy, and by an artless decorativeness. Stripped of all except the central characters, explicit in setting out the record of miraculous intervention, they sometimes owned, by grace of an

RIMBERT: Sunny Road at Perpézac-le-Noir
(Courtesy Museum of Modern Art)

anonymous instinctive talent, not only lucid vision and drama but plastic invention—perhaps also a spiritual expressiveness out of the artist's own faith and ardour.

Of the individual "artists of the people," a Swiss named Adolf Dietrich was especially esteemed in Germany in the twenties and thirties. More truly than the Frenchmen, who after all were mostly Parisians, Dietrich

has been all his life a "natural," living close to nature, winning his bread as a woodcutter and from his garden-farm, and taking as materials the landscapes about him, the animals and the flowers, varied occasionally by portraits of his village friends. A certain calmness and a slow simplicity were at the very pole from the drive and fever of the expressionistic painters who were most drawn to Dietrich's primitive works. It is as a corrective on the quiet side, an antidote to tumultuousness and excessive energy, as an example of serenity, that the modern primitives have served one of their most useful purposes since 1900.

Awakened to the charm and singularity of Rousseau's work, Americans were soon looking into the neglected corners of their own art history, and they discovered a surprising body of primitively simple and naïve painting. Indeed, in no other country had the period 1700–1900 produced so much richly formal anonymous art, and two or three known painters of the nineteenth century, most notably Edward Hicks, a preacher-painter, and Joseph Pickett, a carpenter, were found to rank with the finest untutored artists discovered by international students.

In the nineteen-twenties a Pittsburgh house-painter and carpenter, who had previously been a coal miner, a street labourer, and a factory hand, began to produce oil paintings of scenes familiar to him. John Kane was a Scotsman and had worked in the Scottish mines from his ninth to his nineteenth year, when he came to America. He first exhibited at the age of sixty-seven. His panoramic landscapes, sometimes idyllic, oftener of industrial Pittsburgh, are characterized by the authentic child-like combination of summary short-cutting and painstaking detail-painting in chosen areas. Streetcars, houses, automobiles, horses, might have been studied, devotedly, from children's toys, and human beings are paper-flat conventionalizations. Chiaroscuro, if it exists, is haphazard or arbitrary.

As with so many of the modern primitives, instinctive composition and lovingly patterned areas and arbitrary colouring add up to attractively decorative pictures; and occasionally, as in *Homestead*, the artist's hand is guided by an intuitive feeling for a broader plastic rhythm. John Kane died in 1934, and no other true primitive, untutored and innocent-minded, of like stature has been brought to wide attention. A housewife of upstate New York, Anna Mary Robertson Moses, has come nearest. She began to paint when well on in her seventies, and has produced intuitively decorative landscapes with an engaging child-like freshness.

KANE: Homestead. *Museum of Modern Art, New York*

A number of artists have painted with some of the characteristics of a Rousseau or a Kane, but usually after gaining and overcoming fairly complete school educations. Thus Lawrence Lebduska, born in Baltimore in 1894 and trained in industrial schools of Germany and Czechoslovakia, reverted to the idioms of peasant art and is popularly spoken of as a primitive. In the late nineteen-thirties he emerged as a leading American decorative painter, richly fanciful, with a penchant for brilliant and exotic colour, at a point where the trail of the modern primitives meets the highroad of the Gauguinesque decorators.

A stranger case was that of Louis Eilshemius, who was "discovered" at the Independents' show in New York in 1917. Eilshemius is commonly accounted a modern primitive, because of a disregard for much that the schools count fundamental and a simple picturing talent that somehow gets down the plastic essentials of a scene despite a halting technique. Not

EILSHEMIUS: The Approaching Storm. *Phillips Memorial Gallery, Washington*
(Photo courtesy Kleemann Gallery, New York)

a Sunday painter—for he was born to a wealthy family and never had to work for a living—and in no sense an artist of the common people, he nevertheless arrived at an art method innocently romantic and seemingly artless. Born in 1864, he was given every cultural advantage, a bookish atmosphere at home, travel, a cosmopolitan mastery of languages, European schooling, years at an American college. Then he spent two years in routine art-school drilling in New York, and went to Paris for a like period under French masters, including Bouguereau. He seemed to be firmly set in the safe, conventional, academic path when the National Academy accepted his pictures for exhibition in the years 1886-1888. For a man of his age it was an exceptionally successful beginning.

But shortly Eilshemius was finding his paintings refused in all quarters;

EILSHEMIUS: The Haunted House. *Metropolitan Museum of Art*

he failed equally as poet, and as composer of music. There began a thirty-year period of frustration, obscurity, and wandering from one part of the world, or one part of the country, to another. He did not go on, as painter, to fuller mastery of the recognized values. Slowly he gave rein to some imaginative self within. As the man failed, in the path for which the man had been trained, a child-self asserted itself, and in the pictures appeared the direct but shy, child-conceived values. It was partly a falling back upon another self, an unspoiled self; partly the expression of an authentic lyric gift which school training had been by way of stifling.

Eilshemius disappointed and frustrated became Eilshemius the eccentric, ridiculed by fellow-artists but in his own mind building the legend that he was the greatest living painter. On the one side there was, doubtless, arrested mental development. On another side there was a loosening of the shackles of convention and a pouring forth of "natural" art. But even this development of his art brought only disappointment, in the very place where it should have found understanding; for in 1913 the organizers

GREAVES: Hammersmith Bridge on Boat Race Day. *National Gallery,*
Millbank, London (Courtesy Knoedler Galleries, New York)

of the Armory Show in New York rejected his canvases just as the Acad-
emy had rejected them.

Then there was founded the Society of Independent Painters and Sculp-
tors, bringing at last the opportunity to exhibit before a large public; and
in 1917 the "discovery" of Eilshemius by the visiting French modernist
Marcel Duchamp. Three years later the newly organized Société Anonyme
in New York gave him a one-man show. Slowly his reputation grew among
advanced artists, patrons, even critics. By 1930 he was a known artist, and
already something of a legend. He had, however, been all but broken by
the years of neglect and of unrecognized effort, and he had practically
completed his lifework. He became a familiar figure in the galleries of
Fifty-Seventh Street, as critic, talker, general eccentric; but as those gal-
leries began to show, and sell, his own paintings, life ebbed from him. In
1932 he was injured in a street accident and has never left his room since.

But slowly, certainly, his gentle, lyric art has been accepted into the
halls of "modern" painting, for an unconventional loveliness that has been
breathed into it, for its freshness in a world of too many studied and

ROTHENSTEIN: The Doll's House. 1899. *National Gallery, Millbank, London*

re-studied virtues, and, above all, for the frequent intuitive shaping of the design into plastically alive, rhythmically authentic pictorial organisms.

"Naturals" or "innocents" were little known to the British world of art in the period when Rousseau was becoming famous in France. One artist, however, Walter Greaves, who became a disciple of Whistler's, painted in his early youth a picture unique in the halls of English art, and engagingly unconventional. *Hammersmith Bridge on Boat Race Day* is, indeed, fanciful, unusual, primitively direct in expression—and strangely careless of

camera-truth. But the painter produced no other picture with similar distinction. Nor did any other Englishman between the period of the excitement over Whistler's insurgency in the eighties and the period of the First World War enter importantly into the lists of creative modern artists. The leaders called modern, Brangwyn, Orpen, John, Sickert, and Steer, were ultimately content with progressive phases of realism and impressionism. William Rothenstein painted in 1899 the beautifully composed and decorative *The Doll's House*, as if he had determined to carry on Whistlerian "arrangement" in art; but he too was a realist at heart, and he came to be known for his portraiture, admirably hard and true and economical, rather than for any revolutionary tendencies.

Modern painting, in the era of the *fauves*, had become very special, very strident, very pushing. In discovering the "naturals" the young men of the school of Paris were finding artists endowed on the one hand with the virtues they themselves most sought, in the directions of simple emotional statement and intuitive formal organization; they were finding also painters who escaped what can only be termed the unrest of fauvism. Rousseau and Rimbert painted out of themselves, revealed a sense of order reposeful, breathing peace. It was an example profitable to the French rebels of 1905–1920, who had discovered something of the dynamics of form-organization, without, perhaps, recognizing that ultimately, and ideally, form-movement in the canvas must end in poise, evoking serenity.

XIV: THE GERMANS AND
THE AMERICANS

REALITY and truth are never fully uncovered. Always in art the spiritual elements are susceptible of new revelation. The tangible elements admit of new combinations and profounder rhythmic effects. A movement in art grows as individual creators release their personal and varying contributions along a main line of direction determined by the race consciousness or the æsthetic awareness of a nation or an era.

MUNCH: Landscape with Bridge (Courtesy Nierendorf Galley, New York)

The new form of truth that we of the mid-twentieth century call modern art had been widely discussed and clarified, in its main outlines and aims, by 1910. But more had been foreshadowed and promised in the works of a Cézanne or a van Gogh than was to be discovered in the paintings of the school of Paris of the period 1905–1910. Cézanne and van Gogh and Whistler and Daumier had been great enough and various-gifted enough to augur a world movement rather than a national school. Already, indeed, pioneers had appeared in Germany and in America to speak with voices authentic and commanding.

The German art world especially was shaken by rebellion in the decade 1900–1910, and a sort of fauvism as original, powerful, and unrealistic as the French appeared in that decade. Academies and schools experienced conflict and schism. Secessions and new secessions came into being with alarming rapidity. Youth, too long repressed and forced to practise in the moulds of German nineteenth-century classicism and romanticism, went over in great numbers to the marchers who carried banners variously inscribed *Neue Kunst* or *Junge Kunst* or (a little later) *Expressionismus*. Long before the end of a social era was signalled at Sarajevo, in 1914, German expressionism was firmly established, and attested in the works of masters of the stature of Nolde, Marc, and Kokoschka. No one of these men had upon him more than incidentally the mark of the school of Paris. Germany had discovered thus early its own way of expressing modern æsthetic reality.

Goethe had said that "man's intellect alone cannot compass the creation of art; it must act in union with the heart." And he had gone on to speak of the necessity for enthusiasm, vision, and personal feeling. His brooding and emotional compatriots rushed into the field of modern painting with more urge for emotional expression than regard for formal methods. If the main channel of modern pioneering had been opened by a succession of "form-seeking" artists, the German side-stream flowed in from some separate source. It could not, of course, have joined waters with the French stream, as part of the international flow of modernism, if the artists had not, intuitively or by reflection, had grasp of the implements of formal design, of plastic organization. But the impulse to subjective dreaming and emotional outpouring played a part unknown among the French post-impressionists (except through the inclusion among them of the Northern-born van Gogh). Introspection, mystic contemplation, soul-searching, transcendental speculation: all inner experience fed the urge to self-expression

Corinth: Walchensee. 1927. *Buchholz Gallery, Curt Valentin, New York*

in paint. These German moderns, moreover, felt that longing, sympathy, passion, even drama might give rise to art-expression—a heresy in the eyes of most French moderns, from the objective Manet to the impassive Matisse.

As the emotion of the expressionist increased, the importance of objective truth to nature decreased. Even the wild men of the Paris of 1905, exhibiting in the *cage aux fauves*, seemed less wild than the German *fauves* of the same year. The Northern group, moreover, was to go on, under the same stimulus out of the study of Negro sculpture, South Sea fetishes, and neolithic arts, to a degree of "savage" distortion unexampled elsewhere. That the tendency led to creation of intemperate, even brutal effects comes clear from any comprehensive exhibit of German modernism. But in the hands of masters such as Marc and Kokoschka it expressed itself as a gravely beautiful monumentality.

It was in 1904–1905, when for the first time a group of German moderns

banded together and took a name and a programme, that it became apparent how many forces had been at work in the preceding twenty years to make inevitable the emergence of a school allied with, yet different from, the French. National and racial considerations demanded that ancestors be found in history. Attention was drawn to the affinity of the new men with such Northern masters as Cranach the Elder, Grünewald, Brueghel, Rubens, and Rembrandt, rather than with the Italians and Poussin.

It was even discovered that one of Germany's own painters of the mid-nineteenth century had made a good start down the road of formal experimentation. Hans von Marées had found neither sympathy nor a market in his homeland, and had lived most of his professional life as an expatriate in Italy. But in the early sixties he had painted pictures in a manner as broad, as simple, and as fresh as Manet's, and with more than Manet's feeling for pictorial organization. From the beginning his methods were those of the muralist, and increasingly he flattened figures, suppressed background vistas, and organized the pictorial materials broadly and rhythmically.

At the time of his death in Rome in 1887, at the age of forty-nine, he had failed to fulfil the extraordinary promise of his early work, and for a quarter-century afterward his example inspired no waywardness among the young Germans. But observers coming upon his sensitively composed paintings in the galleries of nineteenth-century realism are struck by the essentially modern simplifications and occasionally by a typically modern form-solution. His subject matter reflects little of the life of his own time. Like Puvis de Chavannes, he turned for his themes to literature and mythology, and his pictures derive oftenest from classical and Christian legendry. He achieved, nevertheless, a power and a monumentality not found in Puvis's work.

From Paris in the years 1880–1900 there had come to the Germans, as to all art-conscious people, the knowledge of impressionism. The pure impressionist manner of Monet, light and fluttery and evanescent, was never successfully transferred to Germany (as it was to Sweden and the United States, for agreeable if not very important reflowering). Rather, an able group of German artists took certain qualities and idioms at once from Manet's realism and from impressionism, and with them shaped a type of painting that was as independent, say, as Degas's contribution and similarly beholden to both parent schools. This realistic-impressionistic group served to bring Germany up to date, and provided a link or a transitional phase

between the old pigtail native art and the startling modernism of 1905. Four painters were significantly concerned.

The eldest, Wilhelm Leibl, born in 1844, was least beguiled from the preoccupations of the realist. He set himself up in opposition to the "German Romans," and depicted everyday people and scenes with strict fidelity. He became one of the world's leading realistic portraitists. But his claim to later consideration arose from recognition of a precise sense of arrangement in some of his canvases, and a feeling for simplification not unlike Ribot's. He also pushed along the line of naturalism to a point where over-detailing became a sort of caricature. Pressing the natural beyond all explored limits, in spots, and playing those spots against bare spaces, he had paradoxically arrived at something unnatural. His digression from realism or naturalism linked later with a special variation of German modern effort to be known as the "new objectivism," or verism, a sort of post-war counter-reformation within modernism.

Max Liebermann, born in 1847, turned out to be a more understandable link between the old and the new. In his own painting he ran the full gamut from beginning Courbet-like naturalism, through a Manet-derived, simplified illustrationism, and through a phase of impressionism stronger than the French, to experiments in unorthodox design similar to those of Degas. With training and associations in France as well as in Germany, and being a Jew, he had less of the Northern feeling. He was, rather, a great internationalist. As such he did more than any other to bring the new world currents before the German people. By the same token he failed to open a way for Germany's own particular sort of modern expression. In the nineties he was the country's most forceful and most cosmopolitan painter. It was he who led the secessionist movement in Berlin in the years just before 1900. But in the end, faced by a radicalism more extreme than his own, he halted, decided upon a substantially realistic credo, and became a middle-way painter rather than one of the moderns. He was awarded many honours and lived to a ripe old age—too long, as it turned out, for in his eighties he fell victim to the Nazi persecution of the Jews.

Two younger men, Lovis Corinth and Max Slevogt, born respectively in 1858 and 1868, owed much to Liebermann, and as they began later—Slevogt studied in Paris after impressionism had been accepted by critics and a section of the public—they went further along the road of post-realistic defection. Corinth particularly discovered the weaknesses of impressionism and took only as much of its clear colouring and atmospheric immediacy

ENSOR: Still Life with Roses (Courtesy Nierendorf Gallery, New York)

as could be assimilated into his strong and impetuous art. While not con-
verted to the utterly wild insurgency of the young painters of 1903–1905,
he developed his own type of post-impressionist statement. His landscapes
in particular are unmistakably modern in their disregard for nature's ap-
pearances; their author was obviously seeking a solution of plastic problems.
They are unmistakably German in their ruthless strength and headlong
attack.

Slevogt was more definitely caught in the mannerisms of the *plein-
airistes*, and like Liebermann he was drawn to the art of Degas. Like Lieber-
mann, moreover, he turned a little aside when the younger generation
insisted, in 1905, upon total war against the old art, the standard, the
substantially true-to-nature art.

In one way or another the four century-end leaders, Leibl, Liebermann,
Slevogt, and Corinth, had helped prepare the way for German modernism;
but only Lovis Corinth really went forward as a creator alongside the ex-
pressionists.

In the days when Brussels had been more receptive than Paris to the

HODLER: Portrait. 1915

works of the outlaws Cézanne and van Gogh, permitting exhibitions of
the whole range of "monstrous" distortions of nature, a Belgian painter
of English and Flemish parentage, James Ensor, had exhibited at the
shows of *Les XX*. Although somewhat deficient in the rhythmic and archi-
tectonic intuition linking together the greatest masters of post-impression-
ism, he showed as early as the mid-eighties all the other qualities necessary
to mark him as a pioneer of modernism. He was shamelessly thoughtless
of natural appearances, he made no concessions to the rules of "good"
technical painting, and he drew upon his imagination for theme and detail.
In denying common reality he oftenest moved over into a realm of fantasy
and dream, in a way that later gave him claims as a prematurely born
surrealist. So wild and lawless was he that the radical-minded Group XX
only missed expelling him by one vote after the showing of his *The Entry
of Christ into Brussels in 1889*. An artist so extreme and impetuous could
hardly be overlooked by the emotional and liberty-conscious young Ger-
mans, and Ensor's fauvism (which had preceded that of the French wild

HODLER: Landscape with Three Mountain Peaks. 1908
(Courtesy Paul Cassirer, Berlin)

men by a decade or more) had something to do especially with the early
radicalism of Nolde and Schmidt-Rottluff.

In Switzerland a solider, less impetuous forerunner of the new Teutonic
painting had come to wide notice in the nineties. Ferdinand Hodler had
none of Ensor's fancy, and he permitted himself none of Ensor's careless-
ness (or apparent carelessness) of execution. A Swiss born in the Canton
of Berne in 1853, he began painting along familiar naturalistic lines, but
moved toward a modern manner by boldly simplifying and clarifying his
pictures. By 1890 he had eliminated backgrounds from most of his figure-
studies, and he was leaning increasingly upon rhythmic volume arrange-
ments for formal effect. He also turned to clear, bright colour, sometimes
raw and over-posteresque.

Hodler's innovations seem to have arisen very little out of passion or

MUNCH: Summer Night. 1907. Buchholz Gallery, Curt Valentin, New York

emotional frenzy. In that, he is in contrast with both Ensor and van Gogh. Indeed his non-realistic "arranging" seems deliberate, guided by intellectualization. There is often pictorial symbolism, with considerable literary and philosophical contriving. Nevertheless, the German advance-guard owned him as a pioneer, and he was much talked of in the years just after 1900, influencing Kirchner and the Dresden group. Perhaps his best work was done *after* the full advent of expressionism, when he went on to larger, simpler, and more powerful picturing, as exampled especially in the rugged, colourful views of the mountain lakes and peaks of Switzerland. He lived on until 1918.

The immediate father of the German revolution in art was still another foreign but Northern-born artist, Edvard Munch. Born in Norway in 1863, trained at home and in France, he developed before 1890 a way of art in keeping with the main trends of post-impressionism, but without losing personal and racial individuality. He had known Gauguin and the members of the synthetist group, and his paintings, with their bold, almost poster-esque simplifications and their broad but shallow spatial effects, mark him as closer to Gauguin than to Cézanne. Temperamentally he was even more akin to van Gogh, and there is a brooding darkness in many of his canvases of the nineties. The storms of nature and the storms of the inner man

alike yielded subject matter, and there was a period of neurotic concern with the difficulties of love, sickness, and death. The catastrophic element, a frequent intruder into German art, is felt as a silent force in many canvases and drawings.

In the period when he first studied and painted in Paris, between 1889 and 1892, impressionism had come to wide popularity. But Munch seems not to have been seduced by it as were so many Scandinavian artists. He followed a road already indicated in his early designs, and preserved his Northern introspective bent. He was one of those who were especially fitted temperamentally to accomplish the about-face from impressionism to expressionism.

From Paris he went not to Norway but to Germany, and he remained there as an innovator and finally as a leader during the years of the formation of the German school. Munch more than any other turned the expressonists-to-be in the direction of a solid, powerful, and ultimately monumental sort of form-organization. Thus, while they were absorbing the heedless emotionalism of Ensor and of van Gogh, they had in their closest mentor a champion of firm-knit design, an advocate of nature-distortion controlled for expressive effect.

Munch, exhibiting in Berlin in 1895, brought about the schism there between the majority in the Academy and the founders of the Secession. In 1904 under his inspiration, at Dresden, the first modernist German group was organized, under the name *Die Brücke*, The Bridge. He was then hailed as the new master who, instead of purveying impressions from nature, revealed feelings through inwardly conceived images, who *expressed* the soul.

Munch's later professional life, after he aided in the founding of expressionism, has been lived in a way that has little to do with the story of modern art; his most original work had been done before 1910. Returning to Norway, he seemed to lose some of his early feeling for rhythmic organization, and to expend undue effort upon the purely illustrational requirements of his art. Nevertheless, he had already taken his place as the greatest of Scandinavian artists of the early twentieth century, and the only one influential in determining the course of modernism.

The *ideas* of modern art had thus been poured into Germany from many sources, through a decade and a half, from France, from Belgium, from Switzerland. There were examples at hand of the work of the French in-

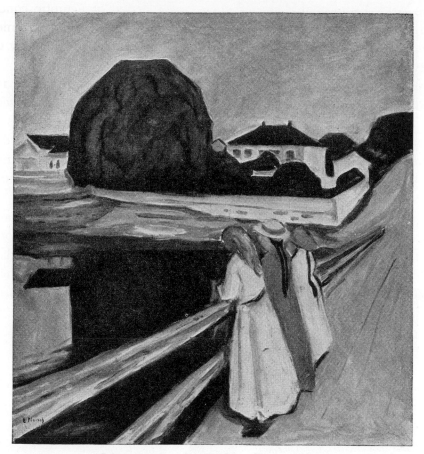

MUNCH: On the Bridge. About 1889
(Courtesy Carnegie Institute, Pittsburgh)

novators, and there was the continued example, not to say irritant, of Munch's local insurgency. At Dresden, in 1904, the ideas took form as an ideology and a programme. As in Paris in 1904–1905, the chaos of new tendencies and individualistic innovations was resolved. A focus of modernism was achieved. A band of young men not only declared for the revolutionary new art but set up a studio and dedicated themselves heart and soul to *Junge Kunst*.

In Germany, the soul had a special contribution to make. Expression of the inner man was talked about before formal problems. Nevertheless, form-values were important to Munch, and he was the idol and guide to the group. Therefore the *Brücke* members got off to a start along the main

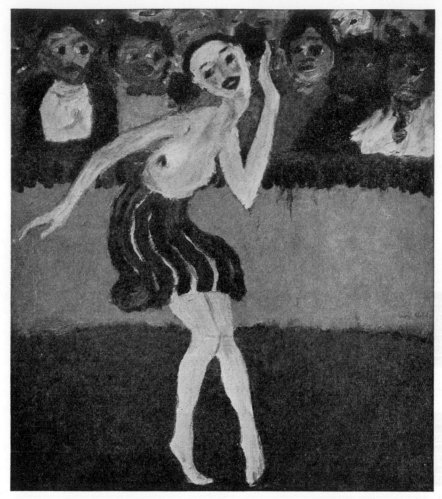

NOLDE: The Young Dancer (Courtesy Nierendorf Gallery, New York)

road of international endeavour. They escaped the dangers of mere form-
less improvising, and they equally avoided the dangers of fantasying and
dream-reporting, which had engulfed Ensor.

The original members of the Bridge were Ernst Ludwig Kirchner, Erich
Heckel, and Karl Schmidt-Rottluff. A year or two after the founding, in
1906, they were joined by Emil Nolde, long since a worker in the modern
manner, and Max Pechstein, a youth who had been affected by the post-
impressionists in Paris. Otto Mueller was a later adherent. These six paint-
ers were to be at the very heart of the German expressionist movement

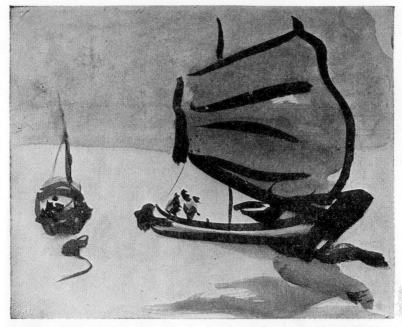

NOLDE: Boats with Red Sails. Water-colour. *Collection of Ninfa Valvo, San Francisco* (Courtesy Buchholz Gallery, Curt Valentin, New York)

through twenty years, and each member in his own way had a grasp upon the central modern problem of form-organization or plastic construction. Nevertheless, the national or racial characteristics, the introspective and spiritual inclination, prevailed in the *approach*. And there were the special German power, thrust, and tumultuousness.

The artists of *Die Brücke* proclaimed a social as well as an æsthetic programme. They lived communally. Even their paints and brushes were considered common property. The phase did not last, but it probably had to do with the more or less consistent nature of later German expressionism. Of course it led to a common study of sources and of newly discovered analogous arts.

Kirchner had become excited in 1904 over the carved figures from Africa and the South Seas which he had discovered in the ethnographic collections at a Dresden museum, and the enthusiasm spread among the young German painters, as it was doing in the same period among the *fauves* of Paris. While the gospel of Cézanne was spread too, it was rather Gauguin, and above all the emotion-mad van Gogh, whom the Bridge members

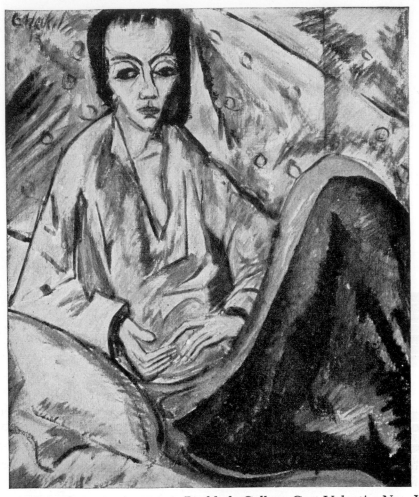

HECKEL: Convalescent. 1912–1913. Buchholz Gallery, Curt Valentin, New York

claimed as akin from the French post-impressionist period. Cézanne's
primitivism had been of a quieter sort, and was destined to influence more
fully a second group of German radicals, especially Marc and a Russian
resident in Germany, Kandinsky. Van Gogh's ecstatic visioning and his
heedless, expressive outpouring were more readily understandable. It was
at this time too that analogies were found in the medieval German arts,
especially in Gothic sculpture, in fourteenth- and fifteenth-century woodcut
illustrations, and in peasant paintings on glass. Children's drawings were
collected also.

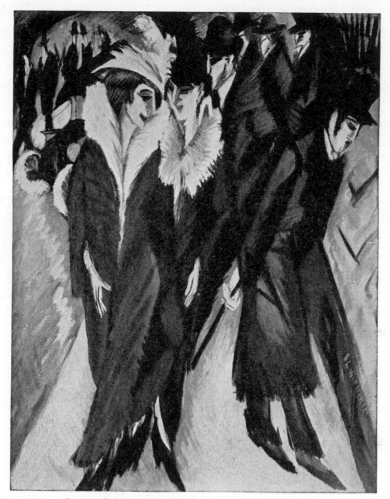

KIRCHNER: Street Scene. 1913. *Museum of Modern Art, New York*

This was literally a youth movement, and the phrase *Junge Kunst* had a double application. Kirchner in 1904 was only twenty-four years old, Heckel was twenty-one, and Schmidt-Rottluff twenty. Pechstein was twenty-three. Nolde alone was a painter of long experience. He had been born in 1867 and was the only one of the Bridge members who had to overcome the handicap of early training in objective realism. He owed the transformation of his aims to the example of Munch.

Nolde disliked academies and cities and he spent years seeking peasant refuges (he was from a peasant family) before he found fellow spirits in

the group at Dresden in 1906. He gained with the others from the study of African and Melanesian masks, and he became one of the most ruthless of the distorters of camera-truth. He employed line freely, heavily, and his washes of colour he put on loosely, with apparent carelessness. He gained a typical expressionistic strength and intensity, often with extraordinary plastic liveliness. It was this vitality that ran through the work of Heckel, Kirchner, and Schmidt-Rottluff too, marking them as of a distinctive school in the period between 1905 and 1913, when *Die Brücke* was dissolved, and persisting in the recrudescence of expressionism after the close of the war.

The breaking of new trails by the group met with the usual opposition from the realists, among artists, critics, and public, with Kaiser Wilhelm taking a personal interest in keeping art sane and wholesome. From an unexpected quarter the young men received a lone and important recruit, in a woman painter who had been exposed, in France, to the art of the original group of post-impressionists. Paula Modersohn-Becker had absorbed the influences of Cézanne and Gauguin more fully than any other German painter of the time, but almost miraculously she retained a native ruggedness and largeness. In a tragically brief career she created a series of highly coloured, decoratively conceived portraits and still-lifes, some frankly, and beautifully, derivative from Cézanne and Gauguin, others individualistically conceived and competently executed within the post-realistic set of idioms. Her straighter portraits had a totally unfeminine strength. Sometimes, in Leibl's steps, she carried local fidelity beyond the point of naturalism, to a degree of over-emphasis upon chosen detail that rendered the work "truer than truth," in line with what was to be known a quarter-century later as verism. Paula Modersohn-Becker died in 1907, at the age of thirty-one.

In 1907 Oskar Kokoschka was accorded his first exhibition in Vienna, and there was proclaimed a wayward talent akin to Nolde or Kirchner. And indeed it was Kokoschka who was to go to Germany, in 1908, to become a moving spirit within German expressionism and ultimately to send his paintings out to the far corners of the world as the most characteristic and the most brilliant examples of Central European modernism.

Born in Austria in 1886, Kokoschka had his art schooling in Vienna. His training there under Gustav Klimt served to forestall allegiance to either naturalism or impressionism. But in adopting Klimt's non-realistic

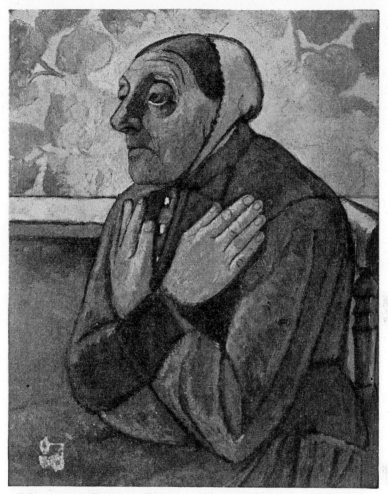

MODERSOHN-BECKER: Peasant Woman Praying. 1906–1907
Collection of Robert H. Tannahill, Detroit
(Courtesy Buchholz Gallery, Curt Valentin, New York)

approach he escaped the neo-baroque master's mannerisms: the posteresque framework and the over-soft decorative filling, and, in more serious endeavours, the pseudo-mystical fantasying and the symbol-blazoning. Instead he developed an independent sort of portrait painting, so personal that it has not in more than thirty years been imitated. Seeming unnatural to the last degree, and therefore inevitably termed bolshevistic in the twenties, it had from the first the virtue of revealing inner truth of character. In those

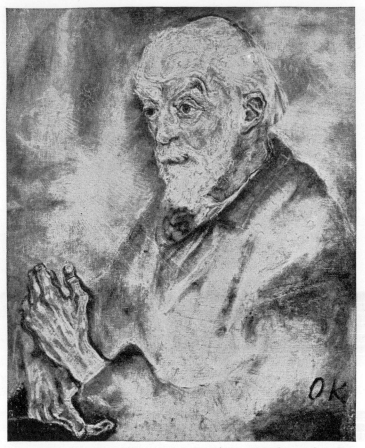

KOKOSCHKA: Portrait of Professor Forel. 1908
(Courtesy Paul Cassirer, Berlin)

first years in Germany, before 1910, Kokoschka painted portraits that have
gone into the galleries of modern masterpieces. Free in the fullest sense,
disorderly in appearance, to the camera-trained eye, but instinct with plastic
order, sensitively penetrating, and psychologically revealing, they are like
so many examples of calligraphic self-expression.

With the adherence of Kokoschka the German school was given new
body and importance. The group had, in a sense, found its own van Gogh.
He was to go on to other types of picturing, and especially in landscape
he was to prove his versatility and his mastery of types of formal organiza-
tion not possible to compass in portraiture. Seldom has nature been treated

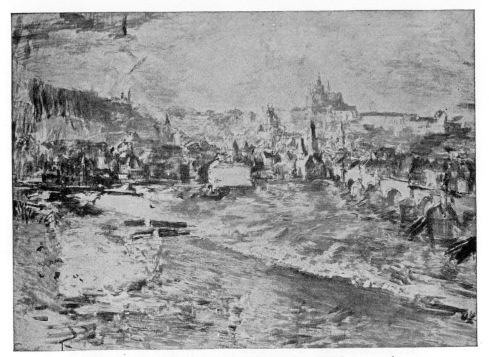

KOKOSCHKA: Landscape (Courtesy J. B. Neumann)

so cavalierly. The searcher for familiar landmarks or for "nature's balms" is disappointed and baffled. But the sacrifices seem justified in the gain of plastic grandeur and structural rhythm. Just as the portraits, in the realm considered by some the last justifiable refuge of the realist, have been stripped of "correct" detail and freed of the devices of idealization and of pretty technique, so the vigorous landscapes violate the truth of the lens, to become pictorial creations, vital arrangements, in which line, colour, volume, space, and plane combine to vibrate in a composition thrilling, even dramatic, to the eye.

When Kokoschka arrived in Berlin in 1908, he helped Pechstein to force a new schism there, resulting in the foundation of the New Berlin Secession. In the following year most of the members of Die Brücke were to be found exhibiting with the Berlin radicals. For that reason 1908 is sometimes recorded as the second red-letter date in the calendar of German modernism. But a greater event, a sort of final affirmation of a Central European gathering of forces, was signalled in Munich in 1911, when the Blue Knights rode into view, with fanfare of trumpets.

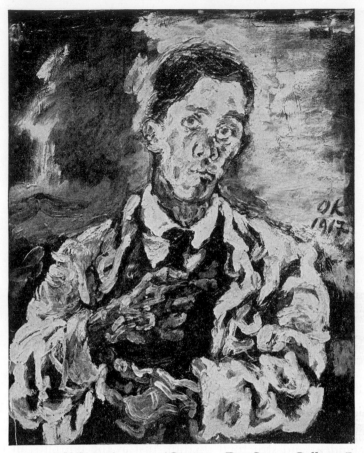

KOKOSCHKA: Self-Portrait. 1917 (Courtesy Der Sturm Gallery, Berlin)

The Blue Riders, or League of Blue Knights, formed one section of a large community of advanced artists who had long been loosely associated in Munich. They became the most creative and the most talked-of group of moderns in Central Europe because they had as leaders Franz Marc and Vasily Kandinsky, and because they set forth a provocative programme and maintained a journal of discussion.

Early in 1909 Munich had seen the founding of the New Artists' Federation, a truly international organization, to which the Germans had welcomed the Russians Kandinsky and Alexei von Javlensky, and the French *fauves* Le Fauconnier and Girieud. Among the German adherents were Alfred Kubin and Karl Hofer. The Federation's first exhibition was

KANDINSKY: Landscape. 1910. *Solomon R. Guggenheim Foundation, New York*

wild enough to provoke the usual public ridicule and critical condemnation. A second exhibition brought to notice especially the great figures of the school of Paris, including Picasso, Rouault, Derain, Vlaminck, and van Dongen. A split developed in the membership over questions of policy, and in 1911 the *Blaue Reiter* as a dissentient group set up a separate exhibition.

It was at this moment that the word "expressionism" was first heard. Kandinsky took the lead in attempting explanation, in words, of the aims of the new art, and he more than any other yielded the materials with which the later Germans built the complex edifice of expressionist theory. To Kandinsky it was very simple. Every work of art, he said, is a child of its own times. If the times are materialistic, if men are given to living objectively and superficially without feeling their way to the eternal heart of life, then art will be shallow and materialistic. But when men penetrate

the outward shell of reality, when they find the soul, art lives as a spiritual activity. Then it will tend toward the universal, the absolute. The art of painting will transcend the objective, the material, as easily as does the least contaminated art, music. The artist will paint only out of an inner spiritual necessity. Within himself, out of his emotion and his spiritual perception and his inner imaging power, he will create the form that is externalized in colour, line, and mass on the canvas. He must heed above all else the total spiritual rhythm, and the harmonies and tensions, the spiritual weight, of each part.

Kandinsky amply illustrated his theory with paintings as uncontaminated as music, without recognizable body or familiar parts. In his Russian days (he had been born in Moscow in 1866, and had been educated for the law there, before taking up painting) he had failed to find himself as artist, though he had formed some attachments and pondered some theories which affected his later development. Wagner's music and the paintings of Rembrandt especially had inspired him. Even as a student in Munich, under Franz von Stuck, at the century end, and during the first years of serious practice up to 1908, he showed promise of little more than a conventional talent. Obviously he had been swayed considerably by the sort of stylization made popular in the periodical *Jugend*, and a little successively by Russian peasant art, neo-impressionism, Byzantine mosaics, and finally his own researches into the realm of mysticism. He especially speculated upon the possibilities of bringing painting into correspondence with music, as a mystically expressive rather than a reproductive art.

In 1908 he had taken the first decisive step toward elimination of subject interest, transferring his attention to abstract values. By 1910 he had arrived at non-objective improvisation. When the Blue Knights rallied around him in 1911 he was prepared with pictures perfectly illustrating one phase of expressionistic endeavour. He was then entering upon one of the richest periods of creativeness in all his career, a period brought to an end by the outbreak of the war in 1914, and his abrupt return to Russia.

Between 1911 and 1914, while he was co-leader of the Blue Riders, Kandinsky became a world figure. Not only the German centres of modernism saw his canvases but Paris, London (where Roger Fry was strangely fascinated by them), and the American cities in which the Armory Show collection was exhibited. In 1911 and 1912 he contributed many articles to the periodical *Der Blaue Reiter*. In 1913 an album of reproductions, with a biographical text, was published by *Der Sturm* in Berlin. Already

KANDINSKY: Landscape with Red Spots No. 2, 1913
Nierendorf Gallery, New York

his theoretical and philosophic work on the spiritual element in art had appeared, and in 1914 there was issued an English translation, under the title *The Art of Spiritual Harmony*. The clear-cut nature of his insurgency, a confidence engendered by his own spiritual certainty, and the *absoluteness* of his theory—especially the aim to parallel music—made him understandable to a wide audience. He found supporters, and stepped into a position of international leadership, more quickly than any other major prophet of modernism.

A great many people believed, in those days before the nations plunged into the most materialistic war of history, that the climax of modern materialism was past, that the world was ready for a renaissance of the spirit. They were willing to believe that the old realistic-scientific art had been the natural accompaniment of materialism; that it, too, would pass. When

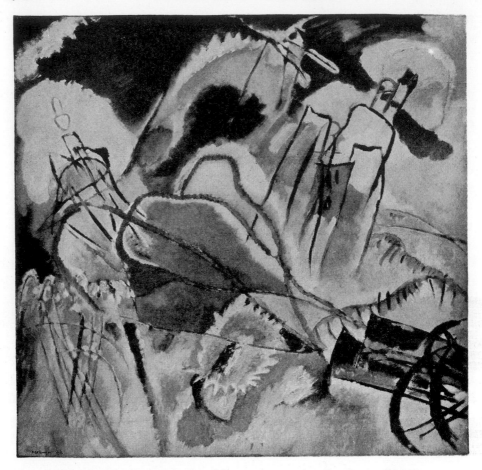

KANDINSKY: Improvisation No. 30. 1913. *Art Institute, Chicago*

Kandinsky talked of an art of the soul, of painting as incorporeal as music, of timelessness in art, of the picture as a world of mystic experience, he found, especially in Germany (where there had been a wave of interest in the Asian philosophies and religions), an immediate response.

There was, moreover, an appearance of purity and grace in his paintings; common people could believe not only in his sincerity but in the truth that the artist approached his work with religious devotion to things spiritual. There were not those deformations and distortions of natural truth that were to be found in the paintings of every other great innovator from Cézanne to Matisse and Picasso and Nolde. Visitors to the galleries might not understand the pictures, but there was no reason to get out the

familiar epithets, "terrible," "monstrous," "revolting." Many of these canvases breathed the spirit of harmony and peace. Abstraction had got off to a favourable start in the Western world.

Kandinsky had really gone further than any other modern. All the pioneers and innovators from Cézanne's time had declared for the inner values and for the unidentifiable formal or abstract values. But none before had cast out nature entire.

While Kandinsky declared for absolute abstraction, he did not always stand by his own declarations. Even when his compositions were pure to him they sometimes suggested to others objective things, or at least the emotional shadows of things. The story of abstract and of non-objective art, however, belongs rather to the post-war period (when Kandinsky will return to Germany to be a creative leader in the movement centred at the Bauhaus); it is sufficient to record here a sample critical reaction of the time when the Blue Riders were first asking for a hearing and an understanding. In 1914 Michael T. H. Sadler, translator of *The Art of Spiritual Harmony*, wrote: "Kandinsky is painting music. That is to say, he has broken down the barrier between music and painting, and has isolated the pure emotion, which, for want of a better name, we call the artistic emotion. . . . The effect of music is too subtle for words. And the same with this painting of Kandinsky's. Speaking for myself, to stand in front of some of his drawings or pictures gives a keener and more spiritual pleasure than any other kind of painting. . . . Something within me answered to Kandinsky's art the first time I met with it. There was no question of looking for representation; a harmony had been set up, and that was enough."

Kandinsky made no demands on his fellow-artists as regards the nature of their painting. Of course he considered mere transcripts of the objective world futile; he asked that each artist "express himself"; he said: "I value only those artists who really are artists, that is, who consciously or unconsciously, in an entirely original form, embody the expression of their inner life; who work only for this end and cannot work otherwise." But among the Blue Riders there was the widest range of non-realistic experiment and achievement.

Javlensky was producing heavily decorative canvases, heads particularly, under French fauvist and exotic art influences. He was orientalizing his painting beyond even the limits touched by Matisse. His highly coloured,

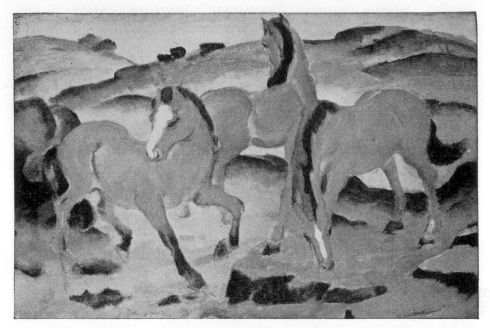

MARC: Red Horses. 1911
(Photo courtesy Buchholz Gallery, Curt Valentin, New York)

posteresquely simplified things, rhythmic and original enough to bring
him solidly within the ranks of important secondary creators, seemed
later too insensitive, too forced, to warrant bracketing his name with Kan-
dinsky's or with that of Marc. Forty-five years old in 1911, he had been
trained academically in Moscow and St. Petersburg, but had been in
Munich fifteen years, absorbing modern influences, though without the
native originality to carry him along as a leader beside Kandinsky. A young
German Swiss with a slight but very original and personal talent, named
Paul Klee, also was one of the inner group, contributing at that time fan-
tastic and somewhat tortured painting-drawings—but his story belongs sub-
stantially to the post-1914 period. Another of the organizers of the group
was August Macke, a close friend of Marc and similar to him in his aims
and even in some of his mannerisms. But his expression was less mature,
and he was killed in 1914, at the age of twenty-seven.

Franz Marc, however, proved himself in every sense a leader. Helping to
found the *Blaue Reiter* group, he also took an active part in its adminis-
tration. Given hardly more than four years of mature working life, he

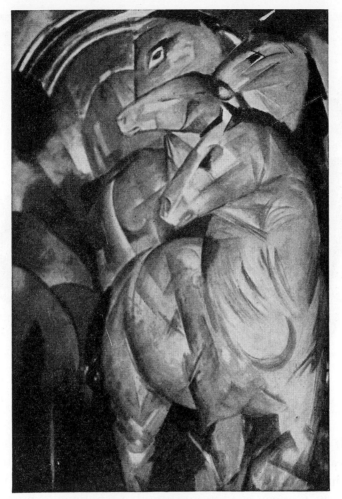

MARC: Tower of Blue Horses. 1912
(Photo courtesy Der Sturm Gallery, Berlin)

nevertheless produced a body of painting that has served to keep his name, in the quarter-century since his death, at the very top of the list of German modern painters.

Born in Munich, in 1880, Marc studied with local academic painters at the beginning of the new century. In Paris while the *fauves* were drawing together, he assimilated not so much their tastes and ways as the influence of an earlier generation of innovators, especially Manet and the impressionists and the fanciers of the Japanese print. It was an influence that

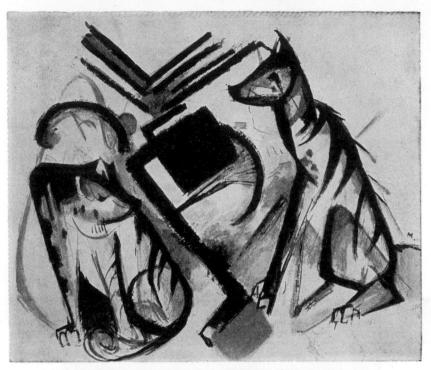

MARC: Black Wolves. Water-colour. 1913
Solomon R. Guggenheim Foundation, New York

served well to fit him for service within the ranks of the illustrators for
Jugend. Searching for a new way of expression, he was not unaware of
what the *fauves* and the cubists were accomplishing in the years 1908–1910,
but he had the German need to find a way of emotional expression, to get
at the thing from the inside. Yet there is no apparent direct connexion
with Nolde or Kokoschka or the Dresden or Berlin revolutionary groups.

In 1911, just when the Blue Riders were making the break from the
parent Federation, Marc appeared with his first original and independently
modern works. *The Red Horses,* in which the rhythmic intention is so
clearly apparent, in which there is evident already the mastery of volume
and plane organization, is of that year. In the one painting Marc showed
his affinity with Kandinsky, in his interpretation of modernism as a search
for harmony and rhythm, and in the attempt to fix in an outward ex-
pression the inner feeling of the artist, his emotion over his materials.

For several years he had been devoted to animals as subjects. When he

threw off thought of further naturalistic representation, when he wanted only to get at the heart of the universe and to reveal its pulse, he found that he could best do so by "sinking himself in the soul of the animal in order to imagine *its* perceptions." How misunderstanding it was, he exclaimed, to paint animals in a landscape *he* had seen! Thereafter the landscape, and all else in the picture, took form from the animal protagonist. There came those pictures, to be paraded again and again as type-illustrations of the expressionists' method, in which Marc portrayed not so much an individual tiger as "the tigerishness of the tiger," not so much a doe at rest as the gentle, pure feeling of the doe, not so much a group of horses as the dynamic rhythms of horsepower. It was another phase of painting from within, of re-creating a universal rhythm rather than the outward appearance.

Marc was no longer painting nature; but miraculously he painted the nature of the animal. Colour, line, volume-space organization, all the elements of formal design were used in service of the one revelation. If each of Marc's major compositions is a complete organic expression, a rhythm sprung, coiled, and closed, it may well be proof of the expressionist's contention that the picture hollow is a spatial field within which the artist creates a microcosmic organism, a little world pulsing with the universal life essence. And he will tell you, no doubt, that the pulse is the same as that animating the horse or the deer, or the tree or the man for that matter; and that the artist has proved himself the true mystic, identifying himself with what Marc termed "the greater oneness within nature's fabric." It is the twentieth-century artist's version of Master Eckhart's "pulse of God."

Marc called the penetrating power "third sight," and he was sure that the artist of the future would exercise this faculty to get at the "hidden" values as readily as the realist had used the scientific discoveries of his age. Matter would become of no consequence; the objective would be merely a bridge to the spiritual world. In all this he was, of course, at one with Kandinsky. He left to his companion the main part in the writing of the manifestos of the Riders, but his letters and a series of aphorisms, sent back from the war front, are filled with suggestive shreds of æsthetic and religious theory.

Kandinsky once said to Arthur Jerome Eddy that the structural forms in his pictures, although they outwardly appear indistinct, are in fact as fixed and rigid as if cut in stone. This strength and this definiteness of

structure run through the work of the great German moderns even more consistently than that of the French (*vide* Matisse, Bonnard, and Dufy). With Marc the formal structure is externalized by his crisp and firm technique. Few painters more consistently give the impression of compact organization, of plastic weight and compensated tensions. For a time he grasped at the devices made known by the cubists of Paris. Marc's aim was to see beyond or through natural appearances, and the cubists' disassembling of planes seemed a possible opening of the way. Then in re-creating the subject, to give more than the conventional camera view, one might well find the intersecting and interpenetrating planes useful. Certainly he employed sequences of planes and arrangements of texture with masterly formal effect.

But Marc did not, like so many derivative cubists, both German and French, lose himself in flat-area exercises and textural patch-quilting. He held by two primary form-elements which had been subordinated by even the best of the Parisian cubists, volume-space organization and dynamic colour orchestration. In a world exciting for its new understanding and harnessing of energy, one needed, he felt, the whole range of plastic elements. He could not have achieved the sense of combined integration and movement, of subtle rhythm and inescapable power, so fully if he had worked with less than the full round volume, or with the dulled colours of the cubists.

The range of Marc's work, in subject, was not large. The pictures of animals predominate. But there are ambitious paintings such as the monumental *The Unhappy Tirol*, of 1913, in which he attempted a panoramic view of the essential features of a country. At the other extreme there is a series of abstract drawings. There are a few landscapes; but in the period of maturity there was not a wide range.

Marc was a man of his time. He recognized the wonder of modern science, of technology, of machinery. He was not withdrawing from the world of science when he sought to develop "third sight" and to express the essences of things. He dreamed over the machines, too, and in his aphorisms he stressed the necessity for finding the hidden "oneness" behind science as behind all else. He was also a servant of his times, and as such he was killed near Verdun early in 1916. Two years before, he had deplored the killing of Macke, writing: "With his death one of the most beautiful and most daring curves of our German artistic organism has been brought down. . . . His work is ended, there is no appeal, no return."

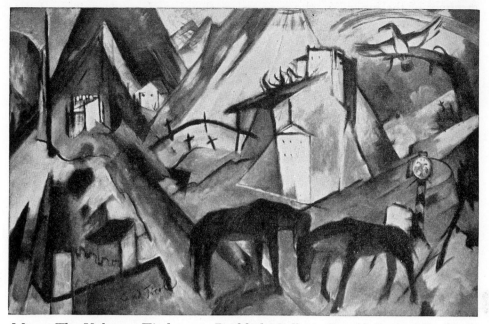

MARC: The Unhappy Tirol. 1913. Buchholz Gallery, Curt Valentin, New York

How much more truly, and more wonderingly, the surviving companions among the Blue Knights might have used the words about Marc's own death! As an initiate into spiritual truth he had no fear of death; but he had written of his intense desire to live in order to put down the pictures that had been conceived in him, that were still unpainted.

The Blue Riders in three or four years had served to bring to focus the expressive art of Central Europe, and to establish expressionism as firmly as fauvism had established itself in Paris. The German radicals, moreover, were to conquer in the schools and the museums much sooner than the French, so much so that in the twenties more than fifty public galleries in Germany would be showing works by members of the *Blaue Reiter* and *Brücke* groups (though destined in most cases to be purged by the so-called National Socialists a decade later). After full credit had been given to Cézanne above all, to Picasso, to Ensor, and to Munch, it was clear that from the association of their own artists, and of Kandinsky and Kokoschka, who had come to them in fellowship, a new way of artistic release had developed. Modernism had been demonstrated as convincingly as in Paris, especially modernism of the sort that seeks out and attempts to express the

essences of the inner life, the modernism that broods on eternity and the cosmic architecture and the mysteries of the human heart.

Walt Whitman spoke of objects and of light "latent with unseen existences," and he wrote that "all merges toward the presentation of the unspoke meanings of the earth." In Whitman's time an American painter lived who gave his life, literally, to the attempt to express unspoken meanings and to create in pictures unseen existences. He was the most successful of American artists, and the creative tradition of American modernism begins in his works. His name was Albert Pinkham Ryder.

He did not find recognition as a pioneer of modernism in his own century, and when the realists of 1908 succeeded in discrediting the then current sentimentalism, he was dismissed as merely a romantic. He was further obscured during the excitement over the innovations brought home by American graduates of the school of Paris, the zealous converts to Cézanne and Matisse and Picasso strangely overlooking the truth that Ryder, by humbler means, had achieved a considerable measure of that "realization," that revelation of order, which Cézanne had so agonized over.

But when the excitement had subsided, when the returns from German modernism as well as French had been studied, when the mystic as well as the technical aims of the new art had been assessed, the hermit-artist was rediscovered and canonized as America's own pioneer. His pictures were brought up out of museum basements and were sought out by dealers from old-fashioned parlours and attic storerooms. Unknown, he had illustrated perfectly that aim of the moderns which had to do with the mystical penetration of nature and with the revelation of an essential architecture, of a fundamental cosmic rhythm. He should, of course, have arrived at this penetration and this revelation only after study of the French post-impressionist advances. But he was an independent pioneer, a solitary, an intuitive without a gift for study, and he gave the successive phases of modernism to America in what seemed a reversed order.

Lacking knowledge of impressionist and neo-impressionist discoveries, Ryder failed to use colour creatively in his form-orchestration. But on other counts he achieved all those plastic ends considered vital and characteristic. He laid down, upon American soil and out of a narrowly American equipment, a body of work formally alive, revealing form-structure with four-dimensional vitality. If there is a thing fairly called abstract plastic beauty, it is to be found richly in Ryder's pictures.

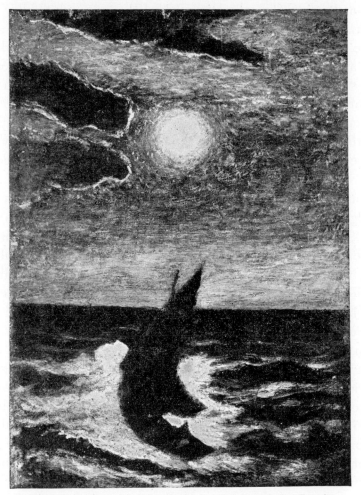

RYDER: Night Clouds. City Art Museum, St. Louis

He did not abandon surface reality, nor did he often radically distort nature; but his themes were less products of observation than distillations from life. They were said by the realists to be inspired by dream and reverie and longing. With Ryder, however, there was no evasion of life. His subjects came up out of the intensest of inner living, out of spiritual experience. He had tended and trained his perceptions and vision exactly as routine artists train their outward visual faculties and their hands.

Albert Ryder was born of old New England stock in New Bedford,

Massachusetts, in 1847, at a time when the community was still sea-conscious. His boyhood served to give him a companionship with all things in nature and a passion for the sea. His family moved to New York in 1867 or 1868 and there he gained his scanty training in art procedures, chiefly through study with William E. Marshall, who was known as both engraver and painter and who had received his academic art education in Paris. A brief attendance at classes of the school of the National Academy in 1871 seemed to bring Ryder little except the friendship of certain fellow-students who were to be prominent in American art circles through succeeding decades, most notably Wyant, Blakelock, and Thayer.

The lack of thoroughness in technical training left Ryder with a deficient knowledge of the chemistry of paints. It made harder his search for ways of expression, and it doomed many of his pictures to near-disintegration. The colour has largely gone out of the artist's œuvre, and unsightly cracks disfigure many of the most inspired of the paintings. But the skimping of conventional education was a matter of temperament in his case, and no more to be wondered at, or censured, than the artist's indifference to eating or his forgetting to go to bed or even to have a bed to go to.

When he set up as a painter—and there seems never to have been any question of other occupation—he simply settled into three dingy rooms, with various inherited and accumulated bits of furniture, useful or broken, and miscellaneous boxes and piles of unsorted magazines and books. In that environment he began a lifelong effort to fix, slowly and laboriously, the visions that appeared before his inner eye. He grew old and grey and unkempt, and still made no move to better his surroundings, nor seemed to care whether he had the things that other men think of as the common comforts and the minimum conveniences. Many stories are told, and perhaps magnified by the journalists, of the squalid surroundings of this visionary: the dark, cluttered, dust-filled rooms, the accumulation of unwashed dishes, of old papers, of squeezed-out paint tubes, even of ashes; the chaos of canvases and unwashed brushes; the atmosphere of decrepitude and confusion of the place. Yet no one ever failed to remark that the man was a light in the darkness, a clean fine spirit that could be touched by no grime, daunted by no disorder. And he himself said of his rooms: "I have two windows in my workshops which look out upon an old garden whose great trees thrust their green-laden branches over the casement sills, filtering a network of light and shadow on the bare boards of my floor. Beyond the low rooftops of neighbouring houses sweeps the eternal firmament with

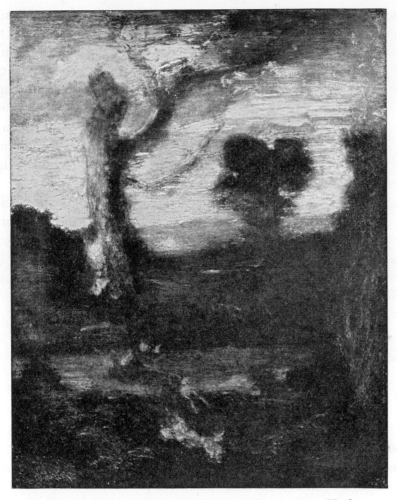

RYDER: Diana's Hunt. *Babcock Galleries, New York*

its ever-changing panorama of mystery and beauty. I would not exchange these two windows for a palace with less vision than this old garden with its whispering leafage."

He was a rapt worker, and never came out of his raptness far enough to see other than beauty and friendliness. Somewhere along the way the National Academy elected him to membership and he took it as all else, as a friendly gesture. A friend wanted him to see the galleries of Europe, and they went across and the painter was duly impressed, and came back and changed his manner of painting not one iota. He had had a wonderful

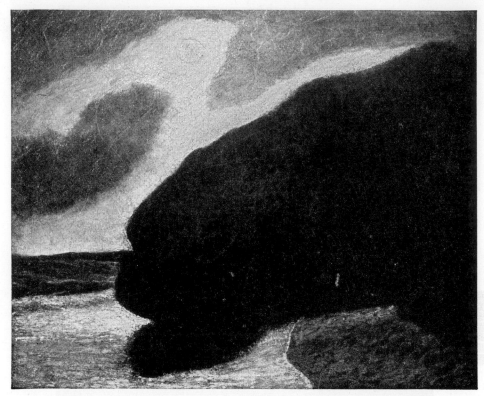

RYDER: Moonlit Cove. *Phillips Memorial Gallery, Washington*

time on the ocean, standing for countless hours at the rail, gazing into
the mysterious spaces of the sea; and the ship's captain became a lifelong
friend.

Ryder had close friends, a very few of them patrons too (enough so
that he could live, having, as he explained, nineteen cents a day), but
mostly a few artists, a young lady artist disciple, young people who trusted
him and looked upon him as a second father, the grocer, the keepers of
the restaurant across the street, the butcher's daughter (at whose wedding
he arrived late, though expected to appear as best man), and the newsboy
at the corner, who expressed surprise when he found Ryder's picture in a
magazine, saying: "I thought you was a bum." They were all friends, all
part of the human environment, shining through unsullied to his con-
sciousness just as did the beauty of the garden outside his grimy windows.

In short, Ryder was an innocent, a saint. He knew that a man could

RYDER: Sailing by Moonlight. Ferargil Gallery, New York

make his own world. For two young married people he wrote a prose-poem about the life of angels as a parable of lovers: ". . . with intuitiveness of inspiration, which is love, they penetrate the wishes of the inner soul, delighted by the wonder of their perception. . . ." On Fifteenth Street, in a grey section of New York, in the era of gilded materialism, Albert Ryder lived like a lover, intuitively inspired, enchanted by the endless wonder of the world as it presented itself to his perceptions.

His method of work was as crude and unrefined as his surroundings. His was not clean painting, confidently applied, not straightforward craftsmanship, but a stumbling method of indeterminate beginnings, slow reworking, paint-coat over paint-coat, scraping and scumbling, glazing and varnishing. Sometimes he laboured over one picture at intervals through ten, fifteen, eighteen years. Always, he hated to let a painting go; one little touch more might add the breath of infinity! But he was not insensitive to "paint value" and he did achieve the sense of a full brush and a rich surface glow. Even the overlay of varnish served a mellowing purpose.

RYDER: The Temple of the Mind. *Albright Art Gallery, Buffalo*

Ryder painted few large pictures. The little canvases are usual, often measured in inches rather than feet. Squares of wood served when canvas could not be afforded. When all else failed he would saw a square out of a walnut panel of the bedstead. He said he did not know what he would do when the bed was used up. Reports of the later years agree that he regularly rolled up at night in a buffalo robe or strip of carpet and slept on the floor.

Old age came, and finally cessation of work, and illness. One who had so continuously lived in friendliness and faith could not but receive care.

Fittingly, the woman who had been his artist-disciple, not to say worshipper, gave him refuge for the final years, with her family. It must have seemed luxury, but he had paid the world well for whatever came to him. Whole-heartedly he had lived in accordance with his own saying: "The artist needs but a roof, a crust of bread, and his easel—and all the rest God gives in abundance."

Ryder died in 1917. He left perhaps three hundred pictures, out of a lifetime of seventy years. In subject matter they are predominantly sea-pieces. The commonest subject is a boat on a moonlit sea, and the skies are likely to be the most eloquent and moving part of the picture. Ryder's skies, like El Greco's, are brooding, heavy with mystery, movement, even tragedy. There are landscapes, and allegorical scenes, and figure-pieces and homely farm scenes. Subject interest is of secondary importance to what may be termed mood interest. It is Ryder's feeling, his inner understanding, that is conveyed to the observer. A sailboat scuds before the wind; but it is the passion of a man for the sea and the sky and the wind that evokes one's emotion. A *Pasture* or a *Sheepfold* simply breathes quietude and restfulness. Wagnerian "interpretations" catch one up in movement, storm, and grandeur. Some of the night scenes seem compounded of sleep, stillness, and moonlight. *The Temple of the Mind*, obviously imperfect as craftsmanship and as representation, somehow externalizes Ryder's own quietness of mind, his serenity and lovingness.

But it is in the sea pictures that he has most fully and most gloriously penetrated to the soul of nature, re-creating the emotion and the pulse and the essential pattern, for others to experience. Here at work is the "third sight" of Franz Marc and the expressionists—two, three decades before Marc—with enough of distortion and heedlessness to identify Ryder as an elder brother of the Germans. Here is Blake's cleansed perception of the infinite. This is the modern as transcendentalist, as seer, as creator. Ryder himself asked: "What avails a storm cloud accurate in form and colour if the storm is not therein?"

No less is Ryder the master in Cézanne's sense, perhaps second to Cézanne alone in his grasp of a formal vitality, a plastic dynamism, within the hollow of the canvas. His design is unfailingly compact, architectonic, rhythmic. It is the thing without name that is there, the thing of which Whitman wrote that it is "not in any dictionary, utterance, symbol. . . . It is form, union, plan—it is eternal life." Sometimes Ryder externalizes it almost as abstraction, as in *Under a Cloud* and *Moonlight at Sea*, in

RYDER: *Moonlight at Sea. National Collection of Fine Arts,*
Smithsonian Institution, Washington

which shapes, directions, movement are everything. The abstract intention
is hardly more hidden under the clearer subject matter of *Sailing by Moon-
light* and *Miraculous Draft*. And so on, to *Night Clouds* and *Toilers of the
Sea* and *Moonlit Cove* and *The Lighthouse*, each having the almost trace-
able form-structure perfectly merged in the illustrative body of the picture.
It is worth pausing over *Toilers of the Sea* to note the extraordinary
dynamic main rhythms, of boat and clouds, with similar yet opposed move-
ment drifts, and the counterpoint of the "lighter" yet no less firmly de-
signed motion-pattern of the waves.

Again and again the hidden path for the eye is so marked in Ryder's
canvases that they can be used to illustrate, beside Cézanne and Seurat, the

RYDER: Toilers of the Sea. *Addison Gallery of American Art,*
Phillips Academy, Andover

characteristic modern plastic synthesis. Equally they have affinity with the
landscapes of the Chinese masters.

Occasionally Ryder strayed over into frank illustration, and once even
into picturing with a suggestion of moral comment; but he made no con-
cessions on the formal side. The moral-bearing picture, indeed, is one of
the most compactly built and dynamically rhythmic of his paintings. En-
titled sometimes *The Race-Track,* sometimes *Death on a Pale Horse,* it
commemorates the suicide of one of Ryder's friends, a waiter, who took
his life after losing his savings on a horse-race. Not only does Death ride
the endless track, alone, but a symbolic serpent is introduced into the
foreground. The landscape is desolate. Even the sky is tragic.

A *tour de force* of movement, of turbulence, is *The Flying Dutchman,*
in the Smithsonian Gallery at Washington. It breathes unrest and stormy

RYDER: The Race-Track. *Cleveland Museum of Art*

grandeur. A second legendary picture, *Jonah and the Whale*, has been characterized as "a lovely turmoil of boiling water." Certainly in both cases the idea of story-telling was secondary in Ryder's mind to the re-creation of a felt experience of the sea. In both pictures the design element is strong, rhythmic, rewarding. It was this element, this inner organism of the picture, one may believe, that he went back to repeatedly, through years and years in many cases, attempting always to crowd into the canvas a little more of abstract design, a more perfect adjustment of the main rhythms and counterpoint, a clearer revelation of essential pictorial-universal architecture.

It is because he was successful, far beyond any other American artist of his time, in seeing mystically and in creating form-equivalents that he stands first on the list of New World pioneers of modernism. It is pertinent to note that America, producing thus only one great seer in the field

RYDER: The Flying Dutchman. *National Collection of Fine Arts,*
Smithsonian Institution, Washington

of the graphic arts, produced, within Ryder's lifetime, pioneers in other arts
destined to lead the Western world to revolutionary new forms: Louis
Sullivan was then fixing the outlines of modern architecture, and Isadora
Duncan was already demonstrating the ideas that were to overturn cen-
turies-old conceptions of the art of the dance.

Between 1870 and 1890 accredited painting in America was a strange
mixture of halting native expression and reflections of foreign develop-
ments. Along with a somewhat independent landscape school there was
a scattered group of belated Barbizon men. There were many academics
who had gone to Paris to study with the safe École masters, and there
were some half-convinced impressionists. There was even a dissentient
German-trained school, partly reflecting Munich, partly Düsseldorf. The
leaders in the art world were, in other words, eclectics. A few pushed out

RYDER: Under a Cloud. *Collection of Mrs. T. Durland Van Orden, New York*
(Courtesy Museum of Modern Art)

of conventional picturing and touched, with an occasional canvas, into
the modern field. Thus there was a moment when John Singer Sargent,
later to be held up as a very bugaboo to the young, as a commercializer
and exploiter of the flashiest values of painting, was influenced by Whistler,
and painted so good an "arrangement" as the *Portrait of Robert Louis
Stevenson*. Sargent was an internationalist, European-trained, in any case.

One of the landscapists of the preceding generation, George Inness, was
more definitely American, though Paris-trained after a fashion, and he
came nearer to an intuitive grasp of formal designing, over and above the
Barbizon-inspired "poetic realism" of his pictures. There are fleeting
hints of structure and plastic movement and rhythm in his least orthodox
pictures. Once in a while he apparently let himself go, and produced so
finely modern a work as the *Coast of Cornwall*, in the Worcester collection
at Chicago.

Most successful, and considered most American, of Ryder's contempo-
raries was Winslow Homer, also a specialist in painting sea scenes. He

INNESS: Coast of Cornwall. 1887. Collection of Mr. and Mrs.
Charles H. Worcester, Chicago (Photo courtesy Art Institute, Chicago)

was a great illustrator and a virile realist. Sometimes in handling water-
colours he let his enthusiasm for the medium and for the immediacy of
his emotion over a scene lead him into forgetfulness of the rules of correct
representation. At those moments he drifted over unknown, as it were, into
the manner of modern expression. But chiefly he is important as bringing
into the field of imitative and sentimental American painting a rugged
honesty of outlook and a native vigour of technique.

There were imitators of Whistler, of course, but almost without excep-
tion, before 1900, they imitated the mistiness and the feminine delicacy of
his marines, and overlooked the elements of "arrangement" that made
valid his version of modernism. Still, some of the "poetic" painters helped
prepare the way, and to this day a picture by George Fuller, Elliott Dain-
gerfield, or Homer Martin, or by John La Farge in a sturdier category, or
by the true romantic Ralph Blakelock, may bring one up short in a museum

SARGENT: Robert Louis Stevenson. *Collection of Mrs. Payne Whitney, New York* (Courtesy Museum of Modern Art)

with the exclamation that *there* was a man who had an inkling of what might come after realism. The important American followers of impressionism were to come late, though Theodore Robinson actually worked with Monet and achieved the characteristic shimmering colour in fleeting light effects. He died, however, in 1896, at the age of forty-four, without quite attaining the mastery achieved in the following three decades by Childe Hassam. Perhaps the greatest of the American impressionists was Ernest Lawson, because he carried the method on with personal additions, with an independence as great as that of Liebermann and Slevogt in Germany, though with less of vigour. Together, Hassam and Lawson gave body to the idea, often expressed, that when French impressionism declined in its own land, American impressionism carried the method on to equally distinctive if equally slight loveliness.

In the nineties a painter named John Henry Twachtman taught the impressionist technique to many American art students, and he was then

LAWSON: Sunset, High Bridge. *Phillips Memorial Gallery, Washington*

classified as an impressionist by the critics and historians. "A mere impressionist" was the way the full-blooded realists of 1908–1910 phrased it, as did some of the moderns after them. But Twachtman put into his art a quality that makes it imperative to place him as the second American master of modernism, close to Ryder. In his day formal, structural values were not easily recognized or considered significant, and he was put down as a school man, particularly admired for the luminosity of his colour and the misty delicacy of his nature effects, but considered to have risen not at all above the routine production of the American followers of Monet and Pissarro. Time, however, has worked in Twachtman's favour, and many museums are discovering that in his canvases they have examples of post-impressionist form-manipulation, and examples that are deeply moving even while fragile and lovely on the sensuous side.

TWACHTMAN: The End of Winter. *National Collection of Fine Arts,*
Smithsonian Institution, Washington

Twachtman, born in 1853, had studied in Munich and therefore began
with brown gravy, or mud, on his palette. Later years were spent with
French academic teachers, and the youth pushed further in the wrong
direction. Then, with a natural gift for composition to steady him, he
passed through the intoxicating experience of discovering, and absorbing,
impressionistic lightness, fresh colour, and spontaneity. He emerged with-
out losing a sense of structure; though often the framework is so fragile,
so exquisite, that it seems lost in the web of palely luminous, harmonious
colouring. Somehow, intuitively, or possibly after an unrecorded meeting
with works of the Chinese landscapists, he went on to the playing of
rhythmic melodies within the fragile composition, achieving form-organi-
zation in its most fugitive and rarest aspects.

Back in America at thirty-two, the young artist failed at first to make a
living, and failed permanently to make a living by painting alone. He
tried farming. As an artisan he painted a great deal of the background for

TWACHTMAN: Lower Falls, Yellowstone. *Addison Gallery of American Art, Phillips Academy, Andover*

one of the most stupendous and offensive of the mammoth cycloramas at the Chicago World's Fair of 1893. He had turned to teaching, at the Art Students' League in New York, about 1890, and continued there to the end of his life. He died before he was fifty, in 1902. He had been made a member of the National Academy, and was considered a "leading" painter, though not because of the qualities recognized by a later generation.

Almost wholly a landscapist, and especially happy in winter scenes, Twachtman was accustomed to lay out his materials in compositions not

TWACHTMAN: From the Upper Terrace. *Art Institute, Chicago*

unlike those of the orthodox impressionists. But what appears at first, to the uninitiated eye, the chance emphasis upon a tree trunk here and a roof-edge there, or the idle tracing of reflections across a pool, or a zigzag repetition of leaf-shadows, resolves itself into part of an adumbrated form-structure, part of a covert but dynamic form-drift. The thing is so implanted, so hidden in faint touches and exquisite colour modulations and accentuations played against reticences, that it is likely to be lost entirely to the casually roving eye. But a moment's contemplative attention, a giving of one's self to the picture, evokes this other meaning, this other pleasure, this rhythmic vitality.

In an occasional canvas, for instance *From the Upper Terrace*, now at Chicago, the artist is found openly experimenting with geometrical elements, playing the linear angles and sloping planes against convex and concave forms, with introduced linear and patterned-area variations. The recessive and forward values of colour too are utilized for movement potency, with an effect not evident in black-and-white reproduction. But the

TWACHTMAN: Rapids, Yellowstone Park. Worcester Art Museum

more usual procedure covers over the mathematical materials that yield the sheer music of the creation, as in *The End of Winter*, in the Smithsonian Gallery, Washington. In some of the waterfall pictures there are hardly more than variations of tone within the main masses, and changes in direction of flow, to mark the existence of the pattern of plastic movement. Indeed no modern artist, arrived at understanding of formal orchestration, has so hidden the extra-dimensional design or hidden it so consistently. But it is as certain, and clear, and pleasure-giving, when one has cleansed one's eyes to it, as the design of a Seurat port scene or a Whistler nocturne. Nor in his time had any other artist in the Western world, except Cézanne,

travelled so far on the road toward absolute abstraction. Certain near-abstractions in the waterfall series take almost complete leave of nature.

In 1908 there came to attention in New York, out of a movement started originally in Philadelphia, a group of virile realists that shocked the sensibilities of academicians, critics, and gallery-going public by painting scenes from everyday life. It shortly achieved wide publicity as the Ash-Can School. More properly the group was known as the Eight. What it accomplished was to purge routine American painting of academic romanticism and sentimental idealism, much as Courbet and Manet had cleansed French art a half-century earlier.

In the seventies there had been challenges, and even demonstration of solidly realistic painting. Winslow Homer, beginning as an illustrator, must be classed ultimately as a realist. Frank Duveneck, who had gone to Munich instead of Paris to study, had come back to teach American students a sort of selective realism in a technique derived largely from Hals and Rembrandt, out of much the same influence that gave Leibl to Germany. But the man who directly opened the way for the Eight was Thomas Eakins.

A Philadelphian, Eakins had studied with two of the most sterile academics of the Parisian schools, Gérôme and Bonnat, but through his own further researches and a medical course, he arrived at the position of foremost American practitioner of a scientifically accurate art. His naturalism, his matter-of-factness, and his insistence upon sound draughtsmanship were excellent medicine where painting was apt to be anæmic and pseudo-æsthetic. He, more than any other, taught American art students to look objectively at the world around them and to realize that subjects abounded in the common life. In his own work he seldom rose above the limitations of the fact-painter, but indirectly his influence passed on to the Knights of the Ash-Can.

The leader of that exuberant band of rebels was Robert Henri. Without being a great artist, Henri became a great teacher, enthusiastic, open-minded, seeing further than he personally could go. He had an immense enthusiasm for living and for getting the sense of the life around him onto canvas. His fellow-illustrators active in organizing the Eight were George Luks, William J. Glackens, John Sloan, and Everett Shinn; and all of these were hampered in the end by the obligation laid upon the illustrator to show life in accordance with observation rather than inner visioning.

SLOAN: In the Wake of the Ferry. 1907
Phillips Memorial Gallery, Washington

Glackens, Luks, and Shinn delighted, as Manet and Degas had done, to picture cafés, theatres, and scenes from home and street life. They did it honestly and competently, but without introducing any of the Orient-derived formalism that had made the innovations of the Frenchmen doubly startling in their time.

John Sloan, however, went on to a wider field, and more nearly outgrew his training as an illustrator. Already in 1908 he had studied through to the sort of simplified, arranged composition to be seen in *The Wake of the Ferry*, which is not without lingering Whistlerian influence. With a work of 1912, *McSorley's Bar*, he touched a high point in American realism as affected by the long train of influences from Courbet and Manet to Eakins and Henri. The panoramic scene in a Bowery saloon affords a parallel, both in approach to subject and in technique, to Manet's café scenes of the seventies, but with a freshness inherited from the impressionists and an American reportorial forthrightness. Destined never to become unreservedly one of the moderns, Sloan was to influence the course of

American painting by fathering the Society of Independent Artists, which has been New York's counterpart of the Paris *Indépendants*, and by his teaching. He has had something of Henri's open-mindedness and has never blocked his students from entry into post-impressionist channels of experiment.

By 1912, the Henri-Sloan group had undermined the accredited American schools. They had made it clear that the United States had not found its way of art in the prevailing landscape and genre painting that reflected academic and impressionist Paris. It had made the "sweet" painters ridiculous. If in its own contribution it brought little more than candid and sometimes racy reports of familiar life, it served to ease the shock of the first descent of anti-realistic modernism upon the American public. It even welcomed and accepted into membership three artists who were to be instrumental in administering that shock by arranging the Armory Show of 1913: Arthur B. Davies, Maurice Prendergast, and Ernest Lawson.

The Eight also took in, as their youngest member, a brilliant pupil of Henri's, named George Bellows, who was a greater painter than any of the founders of the Ash-Can School. Bellows was, indeed, the most distinguished transitional artist between the early-century full-blooded realists and the modernists of the twenties. Vigorous, masculine, individualistic, he began "painting American" along the lines of the illustrators' group, accomplishing such typical reportorial records as the often-reproduced *Forty-Two Kids* and *Stag at Sharkey's* and *Club Night*. A born painter, Bellows was not content merely to photograph the vital life around him. In his treatment of manly and striking themes he carried on the tradition of virile brushwork, in the Sargent-Henri tradition; and he was the first American to combine a third sort of vitality with these others, going on to the study of plastic organization, and adding, toward the end, a sufficient dynamic animation to the composition of each picture. His portraits, among the most masterly in the American line, while yielding nothing of truth of look and character, took on profounder design values; and there was even a series of experiments, a *Crucifixion*, *The White Horse*, and certain landscapes, which indicate a primary concern with plastic problems.

Bellows died in 1925, at the early age of forty-two—a tragic loss to American art. By that time his early associates in the Eight had begotten a considerable school, to be known in historical perspective as the New

SLOAN: McSorley's Bar. 1912. *Detroit Institute of Arts*

York Realists. But Bellows had outgrown both his teacher Henri and his early companions. Nor did he fall easily into any of the categories established after the impact of the Armory Show: the Cézannists, the cubists, the neo-traditionalists. He died a true independent, not quite inventive enough in the new way to be termed a modern master, but the most gifted, forceful, and lovable artist of a transitional period.

In February 1913 New York was invited to attend a show innocently announced as "The International Exposition of Modern Art." It was staged in the Sixty-Ninth Regiment Armory, and from that circumstance has since been known as the Armory Show. The outcry raised by injured academicians, shocked critics, and an enraged public was louder and shriller than any previously heard in the halls of American art. There was an unprecedented wave of journalistic abuse, pamphleteering, and pulpit-

pounding by the moral authorities. The academicians were profoundly scandalized. Most of the critics veered to their side (though Christian Brinton bravely put in strokes for the "madmen").

The organizers of the show spared New York nothing. They included among the exhibitors not only Cézanne, the *fauves*, and the Cubists, but even Kandinsky, Lehmbruck, and Brancusi. They also did a thorough job of illustrating the backgrounds of modernism, picking up the threads with Ingres and Delacroix, and following down through the entire succession of French schools and movements. About eleven hundred major works were shown, by three hundred exhibitors, including the Americans. The foreign sections included the French, the German, and the British, while individual Russians, Italians, and Spaniards were found scattered among the Germans and the French. The American works represented chiefly three groupings of artists: one historical, with Whistler, Ryder, and Twachtman appearing among routine impressionists; the Ash-Can School of realists; and a large showing by the American disciples of the school of Paris. A few independents appeared who could not be classified, particularly men such as Boardman Robinson, Edward Hopper, and John Marin, who had studied in Europe but without losing their individual and American traits.

It was the artists themselves who planned and set up the Armory Show. In those days there was in New York no museum tolerant of, much less devoted to modernism. A growing band of open-minded younger painters felt that America was suffering from ignorance of the advances made by the Frenchmen, and they knew from experience that if they showed the slightest tendency to unorthodoxy they found themselves without opportunity to exhibit. They believed that if they could bring the public and the critics to a comprehensive show of the new art of Europe, they might break through the smugness and prejudice of art's officialdom, and perhaps find friends, even patrons, for the soundly adventurous young Americans.

At first they seemed only to have stirred the country into revolt and protest against themselves. In the end they succeeded in introducing modern art in America to an extent they had not dreamed possible, and with consequences to native painting not to be fully estimated even a quarter-century after the event.

Respectable citizens were warned by the newspapers that the exhibition had been inspired by the "degenerates of Paris" and that the whole thing was outside the realm of beautiful art, was a gesture by the fakers and

BELLOWS: The White Horse. Worcester Art Museum

sensationalists of art. The result was that the public attended in great numbers. They saw the works of Cézanne and van Gogh and Matisse, and the curious and indeterminate puzzle-pictures of the cubists, and thousands of them laughed and joked and scoffed. Somehow an unimportant picture by a second-rank French radical, entitled *Nude Descending the Staircase*, came to typify the show in the public mind, and for two decades the title was a byword in press and schoolrooms. But thousands of people formerly unenlightened had, in the end, become conscious of the existence of a large body of "new" art, and the way of the American radicals was by that much rendered easier. And a few patrons were found. The gains were not sufficient to prevent repetition of France's neglect, and sometimes persecution, of her creative rebels: two of the leading spirits of the Armory Show, Alfred Maurer and Ernest Lawson, eventually accepted suicide as the only way out, and almost incredible hardship and poverty have dogged the steps of other leaders in all the years since. Nevertheless, the Armory

Show did establish modernism in the public mind as a going and to-be-expected movement. Before the opening of the first World War modernism was firmly established in New York, as in Paris, Munich, and Berlin.

The museums were not to awaken fully until many years later. In 1941 there were still "leading institutions" in which a Cézanne or a Marin would be a disturbing factor and a Picasso or a Kokoschka a reason for memorials to the City Council and the Legislature. But the Art Institute of Chicago boldly took over the Armory Show after the New York closing. The reverberations along the Lake Shore were even louder and more alarming than those set off in New York. Certain of the artists and organizers of the show were burned in effigy by students of the Institute school. But nearly a quarter of a million people went to see the moderns. Whether for that reason or others, Chicago became, in official circles, the most open-minded of American cities in regard to contemporary art, and the Art Institute has been known through many years as a Mecca for lovers of Cézanne and Gauguin, Renoir and Lautrec, even for students of the German moderns. When the exhibition was transferred to Boston, though not to the Museum there, the weapon of the scandalized conservatives was icy silence, and the occasion failed of the sort of journalistic and public-attendance success achieved in the other cities.

The men who did the work of bringing to America the first comprehensive showing of internationalism were themselves creators and active pioneers. Foremost at first was Walt Kuhn, who had hardly passed thirty when he set off on the adventure of rounding up Europe's moderns in behalf of a vaguely planned American exhibition. It was Kuhn who induced Arthur B. Davies, already known as a bold but comparatively sane innovator, to take over direction of the show. Together they searched Germany and Paris, and even Holland, for exhibits. Two circumstances played wonderfully into their hands. In 1912 Germany had its first great exhibition of modern painting, with whole roomfuls of Cézannes and van Goghs, at the Cologne *Sonderbund* Fair; and in London Roger Fry and Clive Bell staged the second Grafton Gallery Show. Large blocks of exhibits were procured for the American event. In Paris Alfred Maurer and Walter Pach were drawn into the inner circle of workers, Pach particularly serving on the firing-line thereafter as administrator, lecturer, writer, and public guide.

Of these men, Kuhn turned out later to be the most important artist. Fauvish in tendency in 1913, he developed along the lines of an indi-

KUHN: Acrobat in White. 1913

vidual if somewhat limited vision, and an independent strength. Primarily
a portraitist, in the broader sense, as showing types and "characters" as well
as individuals, he at intervals also produced landscapes, still-life, and even
American genre studies. Unmistakably influenced by Cézanne at first, he
outgrew dependence upon borrowed idioms and settled into the production
of shrewdly observed portrait-themes, lifted to the level of creative art by a
sound plastic construction. Somehow throughout his paintings he man-
aged to convey a sense of his own rugged strength, forthrightness, and
honesty. The men of the realistic school, not recognizing the form-

DAVIES: Unicorns. *Metropolitan Museum of Art*

values in Kuhn's work, since he went along with neither the cubists nor the abstractionists, were perhaps justified in asking by what token he was classed as a modern, when his subject materials were often identical with theirs. But he did somehow put design, form-vitality, first, in a subtle and often unexplainable way. A quarter-century after the Armory event he was still, in a restricted field, one of the leaders among American painters.

Davies, on the other hand, failed to go on to modern expression, even though he overlaid his canvases, for a time, with cubistic plane-intersections and futuristic ray-lines. He was a dreamer, a connoisseur, an ascetic, deriving as an artist from the softer side of Whistler, and inextricably entangled in romantic longings and Arcadian visions. Genuinely hostile to the saccharine academy art, and equally anti-realistic, he found not the modern way but a side-path into classic reverie. He was the American counterpart of Puvis de Chavannes, without full command of Puvis's decorative sense. The best of him is in the harmonious, cool, and reposeful scenes of idyllic nature, peopled usually with troops of slender, lovely women—echoes of a world of withdrawal and imagined perfections. But this ascetic was broad enough, active enough, to direct the affairs of the Armory Show group through two momentous years in the history of American modernism. At a critical time he beautifully promoted open-mindedness.

Of the other artists intimately connected with the Armory event, Walter Pach continued through the years with his three professions of writing,

Du Bois: Waiter! 1910. *Collection of William F. Laporte, Passaic, N. J.*
(Courtesy C. W. Kraushaar Galleries)

lecturing, and painting, guiding a wide public into acquaintanceship with modern art; Alfred Maurer developed a gift for landscapes along substantially Cézannish lines until his death in 1932; and John Mowbray-Clarke became a leader of the new movement in American sculpture. George Bellows was one of the inner conspirators, but continued his independently expressive course.

A later recruit, and very important to the success of the Armory Show because of his recognized position as art critic, in addition to his dubious

WALKOWITZ: People in the Park. *Phillips Memorial Gallery, Washington*

hold as a more or less modern painter, was Guy Pène du Bois. Not altogether committed to form-seeking channels of experiment, harking back
to Forain rather than to the post-impressionists, he had, even in the early
years, a way of taking subjects akin to those made popular by the New
York realists. But under his hands the materials were stripped of all illustrative detail, the main characters were set out in dramatic simplicity, and
the picture as such was given force and vitality. Often, as in *Waiter!*,
there was an added satirical or humorous note. A little aloof, a believer in
conveying effects discovered by observation but reduced to their barest pictorial terms, not given to imagination or to study of abstract effects on their
own account, du Bois fell ultimately on the side of the neo-traditionalists
and parted company from his fellows of the 1913 show.

The important American exhibitors at the Armory Show included, of
course, a majority of painters Paris-trained and steeped in the tradition of
Cézanne, Gauguin, van Gogh, and the *fauves*. Of the company of American disciples of the *fauves*, two were true internationalists, both Jews,

WEBER: Decoration with Cloud
(Courtesy Museum of Modern Art)

both schooled in America, then in France. Max Weber and Abraham
Walkowitz brought back knowledge of the latest methods of achieving
though Marin has been the one American artist willing to sacrifice nature
most drastically for the sake of evoking an intense æsthetic experience.

For his lyric purpose, for intensification of an immediate passion, Marin
found the water-colour medium superior to all others, and he was to turn
seriously to oils only after 1930. In water-colour he developed a distinctive

MARIN: River Effect, Paris. *Collection of A. E. Gallatin, New York*

artists who have been not so whole-hearted in their devotion to Paris. Weber, even in the late nineteen-thirties, went on successfully to new modes of statement, and he has never failed to achieve rich "painting quality," power, and largeness. Walkowitz showed less of versatility in later years but remained a familiar figure wherever modernism was being shown.

Most American of the first group of moderns, an exhibitor in 1913, and still an amazing creator twenty-eight years later, John Marin has shown that the ideals of Whistler, Cézanne, and Seurat may be adopted without commitment to any binding foreign idiom. Like another giant of the American world, Diego Rivera, he went to Europe, absorbed what he wanted from France and from other countries, and returned to form his own unmistakable painting style. Devoted to nature; gaining inspiration from elemental things, sea, mountain, plain and sky; lyrical, even ecstatic in expression, he went further in the years 1910–1940 than any other American in sheer creation, in producing painted equivalents of experienced feeling. Not quite an abstractionist in the absolute sense, he has

MARIN: Lower Manhattan. 1920. *Collection of Philip Goodwin, New York*
(Courtesy Museum of Modern Art)

led all artists on this side of the Atlantic in creative use of abstract form
for expressive purposes.

A typical Yankee, born in New Jersey in 1870, he was educated for
architecture and practised that profession before turning to painting as a
lifework. At thirty he was just beginning specialized art-school training,
though he had previously sketched in many sections of the Eastern States.
At thirty-five he went to Europe for the first time, and was away for the
most part for five years. With an extraordinary gift as an etcher, much
influenced by Whistler, he produced prints at times obviously Whistlerian,
at others strangely original. In and out of Paris in the years between the
first appearance of the *fauves* and the emergence of cubism, he reflected
fleetingly the several influences of the factions within the school of Paris;
but he quickly found his way back to his own manner of statement, to
a style owing, if at all, to Whistler and to Cézanne.

MARIN: Wind on Land and Sea, Maine. Water-colour. 1923.
An American Place, New York

He returned to America in 1911, permanently, and in 1912 he painted that series of turbulently distorted views of the New York skyscrapers which marked his nearest approach to the explosive methods of the German expressionists and the more radical *fauves*. He harked back to the skyscraper theme in the twenties and again in the thirties, but, in general, landscape and seascape claimed his interest. What he saw in nature with his outward eye was seldom more than a stimulation to inner imaging. Yet essentially the Maine islands or the White Mountains or the plains and mesas of New Mexico live magically within the formal organization—post-impressionist effects. Both practised for years in a succession of variations of the form-seeking painting of the school of Paris. Weber had the more of strength, of plastic power, Walkowitz the more of subtlety. For a quarter-century they have been accounted elder masters of American modernism, though by reason of their eclecticism and their internationalism, they have had less influence upon typically American painting than certain

PRENDERGAST: At the Shore. Water-colour. *Addison Gallery of American Art, Phillips Academy, Andover*

shorthand method, a sort of calligraphy of the brush that has affinity with the methods of the Chinese painters rather than with Western tradition. Early in the decade of the twenties he had placed himself in the lead of all water-colourists of the modern movement. He has had imitators, but in essence his art has proved inimitable.

Marin when he returned to America in 1911 had a patron in Alfred Stieglitz, whose modest gallery known as "291"—from its door number on Fifth Avenue in New York—was then the one centre in America to which artists and students might go to see the works of European radicals. While the Armory Show of 1913 first introduced the new art to America widely and resoundingly, Stieglitz had already served by bringing to his gallery the first American one-man exhibitions of Matisse, Rousseau, Cézanne, Picasso, and others. He had also had the courage to exhibit the American radicals, among them the very ones who shortly became leaders of the modernist movement on this side of the Atlantic: Marsden Hartley and Alfred Maurer in 1909, Max Weber in 1911, Arthur G. Dove and Arthur B. Carles in 1912.

John Marin had the first of his one-man shows at the Stieglitz gallery in 1909, and his exhibitions were annual affairs there until the temporary cessation of Stieglitz's activities in 1917. The help extended to artists from "291" included not only the opportunity to exhibit but occasional purchases. Indeed the whole relation of Alfred Stieglitz (himself a superlative artist in an allied field of art, photography) to the struggling creative painters of New York is one of those heartening circumstances too rare in the period of officially outlawed modernism.

In 1916 Stieglitz exhibited the work of a new American painter, Georgia O'Keeffe, who was destined to become, with Marin and Dove, a mainstay of the exhibitions at the post-war galleries carrying on the spirit of "291." But her story belongs to the maturity rather than the birth and awkward age of American modernism.

The Armory Show had brought together an extraordinary group of creative American painters. So thorough had been its canvass of all progressive groups that its list of exhibitors contained the names of most of the artists who were to be considered masters twenty years later. Any rollcall of the leaders in 1933 would of necessity include the names of Marin, Kuhn, Weber, Walkowitz, Robinson, Hartley, Carles, Prendergast, Lawson, Edward Hopper, and Bernard Karfiol. Moreover, a second-range grouping would be found to include many men not especially prominent at the Armory event but listed as exhibitors, and later brought into prominence with the others: Charles Sheeler, Andrew Dasburg, Maurice Becker, Samuel Halpert, Oscar Bluemner, Stuart Davis, Glenn Coleman, Henry G. Keller, and William Zorach. In other words there had been between 1912 and 1915 an epochal event in New York, actually establishing a modernist development, affording a sense of solidarity to the radicals, resulting in nation-wide publicity, discovering to the public artists of more than national significance. Not until the years 1935–1940 was the United States to witness a comparable flowering and a similar eruption of interest on the part of the public.

XV: ART OBSCURED AMONG THE 'ISMS

IN 1816 William Hazlitt quoted, and thereby gave wide circulation to a waggish saying apropos of Turner's paintings: "Pictures of nothing, and very like." A century later, the artists of the advance-guard groups in Paris and Munich had finally come to grips seriously with the problem of "pictures of nothing." In 1914 when the World War opened, abstract painting—dealing with nothing in the sense that music deals with nothing —was "the new art" to the radicals in direct succession from Cézanne, Seurat, and Gauguin.

The moderns of the school of Paris had started their explorations upon the roads leading to abstraction in 1906. Between 1906 and 1940 there was a procession of minor schools of artists across the world stage, each proclaiming its variant 'ism, each certain that finality of abstract reality had been achieved. In that period art itself was often lost sight of in the confusion, and the words, of the battle of the 'isms.

BRAQUE: Beach at Dieppe. 1928. *Museum of Modern Art, New York*

Modern art, nevertheless, gained inestimably by the collective advance. Since it was an abstract value, something still spoken of vaguely as spatial order or form, that was the crux wherever modernism was discussed, adventurous artists could not but gain as a result of the clash of ideas about what it is essentially that counts in the painting that presents, intellectually, nothing. In the end, though cubists and futurists and constructivists and purists had all receded in importance, intrinsically, they had done an enormous service by clarifying the aims of the new art.

A Parisian journalist, looking back upon the earlier proponents of the 'isms, termed them the conscientious objectors of the art world. They seemed to most observers to obstruct rather than to promote progress; yet the next major objective of modern art could not be reached except by their collective agitation, sacrifice, and experimentation. It is not to be overlooked that the artists individually sacrificed much. The lifework of sincere and able men went into cubism and purism in particular. In perspective, nevertheless, it is recognized that the experimenters often mistook the means for the end, and that no one of the schools that tried to isolate the abstract form element seems as important after fifteen or twenty or thirty years as it did during the fierce studio battling of the period 1910–1930.

It was in 1908 that Henri Matisse, serving on a jury that rejected some of Braque's landscapes, defended himself by explaining that they were nothing but cubist pictures. The name was resented at first. The radical wing of the *fauves* sensed criticism and felt that the master should be the first to be sympathetic to new experiment. The end of Matisse's leadership, and the beginning of Picasso's, can be dated from the occasion. The word cubism then came into newspaper and studio currency, though it was not until 1911 that the Picasso-Braque group officially accepted the name and exhibited as cubists.

Gertrude Stein, an American who in 1908 had a home in Paris that was becoming a centre for unrecognized moderns, has told the story of the beginnings of cubism, and she credits Picasso with the creation of the earliest pictures in the manner. The artist returned to Paris with the cubed pictures after he had spent a summer in his native Spain, and she traces the peculiar idioms of his style to, first, his study of Cézanne's water-colours, and, second, the peculiarities of the Spanish landscape, especially the way in which the houses cut across and half disappear into the countryside.

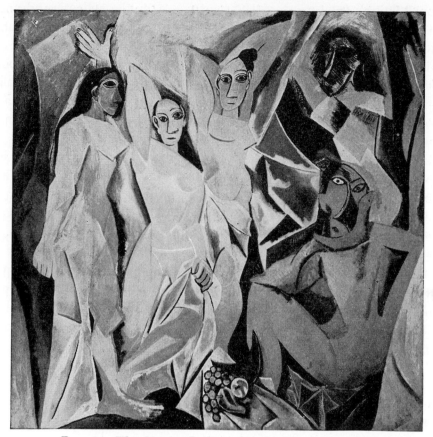

PICASSO: The Young Ladies of Avignon. 1906–1907
Museum of Modern Art, New York

Some of Picasso's figure-paintings and still-lifes of 1906–1907 had incorporated block-form idioms derived, apparently, from Negro sculpture, and the inception of cubism might be pushed back to the earlier date.

Other writers are inclined to accept Braque's claim that he preceded Picasso in squaring up landscape forms and introducing crossing planes; and certainly he produced in 1908 landscapes obviously on the way to geometrical cubism. Derain too was already the author of both landscapes and figure-organizations painted with accented angular intersections and heavy squaring of volumes.

By 1909 the landscape or figure was fast disappearing into plane patterning and frank volume organization. By 1910 the cubists had practically squeezed out the last remnants of observed nature. These secessionists

from Matisse's fauvist group, following the perfectly good fauvish principle
of returning to elemental things, were now approaching an art as absolute
and as mathematical as music.

For all the leading innovators, study of Negro sculpture and of other
exotic or primitive art that approached abstraction and impersonality had
its effect. But central to the impulse was study of the French master, still
most inspiring of the pioneer rebels, Cézanne. In his sayings the cubists
found a perfect text for their activities: "Everything in nature takes its
form from the sphere, the cone, and the cylinder"; and in his paintings,
especially his water-colours, in his realization of what the cubists were
shortly to be discussing as the four-dimensional quality in art, he was in-
spiration and guide. More certainly than any other Western artist before
them, Cézanne had pushed through to the edge of the territory of non-
objective art.

The cubist credos included recapitulations of the ideas put forward by
anti-realistic insurgents from Whistler and Cézanne to Seurat and Kan-
dinsky. Art had too long been studied from nature; now it must arise out
of vision. Before the invention of the camera it had been legitimate to
duplicate the world's outward beauty; now a self-respecting artist could
only leave to the photographers the world as observed and turn to creation
of another, an abstract beauty. The public was, or should be, tired of the
conventional, the normal view of things; the original artist would give a
distillation of all views, the essence as revealed when all appearances had
been brought into order, from the inside and from all sides and not merely
from the ridiculously limited front view.

The cubists did not strike out for absolute abstraction all at once. They
worked back slowly from the object, from natural aspects. They deper-
sonalized the subject, worked it down to its mathematical equivalents, dis-
engaged the planes by which sight operates, and rearranged those planes
in an order more effective than nature's. It required several years to work
back from the *fauves'* concern with the object as such (however summarily
or distortedly portrayed) to the first paintings in which recognizable objects
were wholly dissipated. Nor did the artists even then dare to put forward
the claim that painting might, as music had done, become a disembodied
art.

A certain vagueness, even a blanketing fog, obscured for long the think-
ing and the intentions of Picasso and Braque, and it was not until after the

Cézanne: Mont Sainte-Victoire. *Marie Harriman Gallery, New York*

war that the cubist aims and the cubist achievements had fair appraisal. By 1920 returns were in from German, Russian, and other abstractionists, and Guillaume Apollinaire was enabled to sum up the advance eloquently, writing as apologist for the French cubists but actually stating the case for the international school. "The modern school," he wrote, "seems to me the most audacious that has ever been. It has put the question of beauty in itself. It wishes to visualize beauty disengaged from the pleasure which man causes man, and, since the dawn of historic times, no European artist has dared to do that. . . . It is the art of painting new ensembles with elements not borrowed from visual realities, but created entirely by the artist and endowed by him with a powerful reality."

Again—the quotations are from "Æsthetic Meditations," as translated for the *Little Review* of 1922—Apollinaire wrote: "The new painters do not propose, any more than did the old, to be geometricians. But it may be said that geometry is to the plastic arts what grammar is to the art of the writer. Today scholars no longer hold to the three dimensions of the Euclid-

PICASSO: Still Life with a Mandolin and Biscuit. 1924
(Courtesy Museum of Modern Art)

ean geometries. The painters have been led quite naturally, and so to speak
by intuition, to preoccupy themselves with possible new measures of space,
which, in the language of modern studios, has been designated briefly and
altogether by the term, the *fourth dimension.*

"The fourth dimension would be engendered by the three known di-
mensions; it would show the immensity of space eternalized in every
direction at a given moment. It is space itself, the dimension of the infinite:
it is this which endows objects with their plasticity. . . . Greek art had a
purely human conception of beauty. It took man as the standard of per-
fection. The art of the new painters takes the infinite universe as the ideal."

In 1910 neither Guillaume Apollinaire nor any artist of the cubist circle
could have summed up in words so much of the basic philosophy of the
abstractionists. There is much in the utterance that applies to phases of
non-objective experimentation then little known in Paris. The complete
acceptance of the shift from the world of natural phenomena to a meta-
physical realm had been more talked about by Kandinsky and the Germans.

PICASSO: *Violin. About 1912. Kröller-Müller Foundation, Wassenaar*
(Courtesy Museum of Modern Art)

But between 1910 and 1922 the basic ideas of an absolute art of painting, of an art uncontaminated by reproductive elements from nature, had spread through studios of France, Germany, Russia, Holland, and the United States; and Apollinaire was summing up not only cubist endeavours but the aspirations of a great international group.

If the cubists had never painted a picture of lasting significance, if they

had not helped mark out the path that international abstractionism was to follow, they would have remained notable historically for making clear the nature of the insurgency of Cézanne, Matisse, and other moderns who had not forsaken fully the object in nature. It was Picasso and his fellows who, by analysis and experiment, emphasized the basic significance of *formal organization*. In trying to isolate pure form, they showed how incorporation of form-values within the subject picture, particularly at the hands of Cézanne, had marked the real transition from Renaissance art to modern art. Their own work became a little bloodless, thin, because they were preoccupied with the geometry that is, after all, the grammar and not the essence of the painting. Their very excitement led them into being cerebral in their approach; but as theorists they served the whole world of art.

The original cubists, among whom Picasso and Braque were most creative, carried the cubing process through three general phases. First, they reduced the objects to geometric equivalents, *in situ*, as discovered by the eye; then they began to rearrange the volumes and progressively accented, and repeated in echo, the edges of the planes making up those volumes; finally, they moved on to concern with plane arrangement as such. By 1910 their pictures had taken on the flat aspect of intersecting, superimposed, and interpenetrating planes, which became the thing the gallery-goer visualizes as characteristically cubist. The central problem then was one of composition by means of sequential planes and by arbitrary arrangement of patterned areas. The patterned bits, borrowed from textiles and machines and from such sources as marbling and wood-grains and card-backs, gradually took on greater importance. Because subject interest was negligible, certain familiar images, common and close to hand, were repeated endlessly: guitars, card-figures, vases, tumblers, etc.

The cubist pictures shown at the Salon des Indépendants in 1908 were scarcely noticed among the six thousand exhibits. But by 1911 the school had its own room at the exhibition. It sent its first showing to Brussels that year and also invaded the Salon d'Automne. Derain was already on the backtrack toward subject-art, but the group had brought in notable converts, among them Albert Gleizes, Jean Metzinger, Robert Delaunay, Fernand Léger, and Marie Laurencin, who had been known prior to that time as a *fauvette*. In 1911, Marcel Duchamp came into the cubist circle, and in 1912 one of the most important of the creative members of the group, Juan Gris, a Spaniard, joined, as did Francis Picabia.

Innumerable artists were being influenced by the surface manner of

Marc: Foxes. 1913. *Nierendorf Gallery, New York*

cubism, and many highly original painters adopted, temporarily or permanently, some of the characteristic idioms into their own equipment. Dufy and Vlaminck passed through phases of cubism, but neither one was at his best in so rigid a style. The foremost artist who understood the basic truth of cubism, and richly gained by it without losing his individualism, was the German Franz Marc. A number of American recruits took home the influence, but America was not really to welcome the abstract philosophies until some years later.

There is creative magic of a limited sort in the cubist canvases of the Picasso of the pre-war period. (He deserted his fellow-cubists and was off

on another adventure in 1918, and had faltered in his loyalty even as early as 1914.) There is equally a tenuous charm, not fully apparent at first, in Braque's pictures painted then or later. One gains a quiet, unexciting pleasure from the measured adjustment of plane and pattern, from the carefully restricted movement-design. The creators of cubism had denied the dynamic values of colour, a reversal of the trend of modernism from the time of Manet to the split between the *fauves* and the cubists, a reversal ascribed by Gertrude Stein to Picasso's adoption of the colours of the Spanish landscape, especially dimmed yellows and greens. In any case, the school members limited themselves to a very restricted colour range, chiefly browns, greens, yellows, and greys, and to rigidly restrained colour values. That was only one of the restrictions put upon the doctrinaire cubists. They were almost religiously austere, and thus cut themselves off from the possibilities of achievement, in the field of non-objective painting, as full and rich as that of Kandinsky.

Perilously, as it is easy to see a generation later, the cubists of 1908–1914 had renounced not only one but several of the chief values, in the direction of colour, spatial depth, and volume organization, that make the painting art a thing different from mere decoration. At its least austere and rigid, cubism descended to an almost pretty decorativism. There was a Picassoism, even, that became more important to industrial designers and fashion artists than to the future of painting. The final refuge of some of the members of the school in *collages*, in the pasting-up of varitextured cuttings from paper and cardboard—newspapers, bottle labels, bus tickets, anything —was a last phase of this retreat from painting as such. The impulse found its final expression in dadaism.

The critics and public, of course, pounced upon the cubist painters when they had moved only a very short way toward elimination of subject, pounced upon them with all the old joy at catching artists out where they cannot explain themselves in common sense terms. The equivalent of "very like nothing" was on thousands of tongues, and the galleries echoed with laughter. When the realists heard that some of these artists were contending that a painting should look as well on its side or upside down, they fairly exploded with mirth. As regards the architecture of the picture—and the cubists were after pictorial architecture essentially—there was something in the idea.

Picasso in his own paintings and drawings illustrated all the steps in cubism's development: squared-volume weight-organization, then the vol-

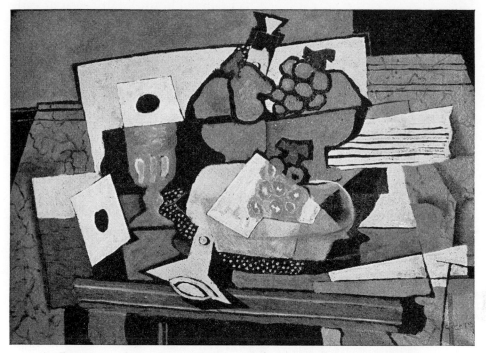

BRAQUE: Abstraction. *Phillips Memorial Gallery, Washington*

ume all but lost in the arrangement of loosened planes, finally the flat-pattern composition, denying the volume (as well as colour), playing a sort of musical-architectural melody in angles, planes, and fragmentary textural snatches. For a time, the pasted-on clippings from newspapers assumed a considerable function in Picasso's organizations, the rigidity of large type-letters affording contrast to the softness of the brushed areas, and columns of news-print affording textural variation. In general the drift was toward utter impersonality and "pure" plastic expression.

The war in 1914 called away all the men of Picasso's group except the leader himself and Juan Gris. During the war none of the important French modern painters was killed, as Macke and Marc were among the Germans; but the years away from their art had a sobering and steadying influence upon many of the foremost experimentalists. Vlaminck, Dufy, Segonzac, and, of course, Matisse settled into their well-worn grooves, as if cubism had never existed. Delaunay and two or three others moved away toward the freedom of German expressionism. Incidentally Delaunay helped to return full colour to French painting. Marie Laurencin retained some of the flat-

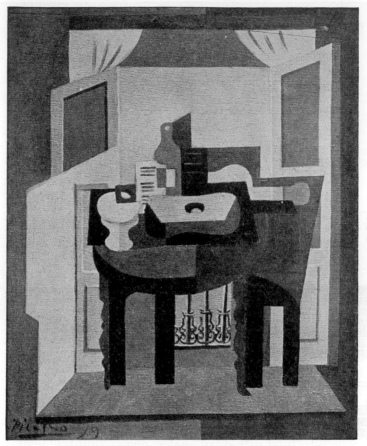

Picasso: Table before a Window. 1919
(Courtesy Museum of Modern Art)

pattern idioms and the subdued colouring in a personal, feminine, prettified style, but in a full return to subject-painting. Substantially the first and main cycle of cubism had closed in August 1914.

After the war and until 1925 Amédée Ozenfant tried to carry the cubist principles to a logical conclusion, in the light of lessons learned meanwhile by Russian and Dutch groups of abstractionists. He preferred not to be known as a cubist, and he and Charles-Édouard Jeanneret (better known as Le Corbusier) proclaimed purism, in which absolute order, precision, and harmonious measure were to be paramount. They began by attempting the burial of pre-war cubism. At least they published a book entitled

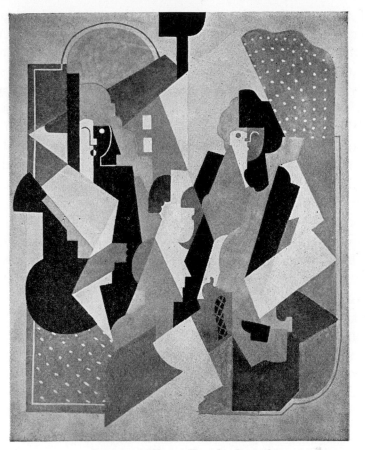

GLEIZES: Three People Seated
(Courtesy Der Sturm Gallery, Berlin)

Après le Cubisme in 1918, and explained wherein the cubists had failed. For their part they were going to hold by the human spirit but learn from the precision of the machine, symbol of modern ways of living.

Order is the only efficiency, Ozenfant said, and precise order must come into painting as it was coming into industrial design and into a new, clean, geometric architecture. The invariable, the organic, the everlastingly static must be the basis of art, not the variable, the accidental, the improvised.

The purists arrived at a type of painting cleaner, more orderly, more elegant perhaps than flat-pattern cubism. They drew away a little from Cézanne to come closer to Seurat and his methodism. They returned toward the object, seldom leaving the observer in doubt as to the material

source of their motifs, and they adopted a less restricted colour-range. Their precisionist technique and their clean faultless colouring endowed their paintings with a special machine-age aspect. But in the end the purists remained a sub-school rather than a school. They lacked pioneer strength and virility. Their work pleases by its fitness to modern architectural surroundings, but it is a little static, even a bit tenuous and washed out.

While the cubists no longer held together as a school, certain practitioners produced some of their finest work independently after the war, most notably Juan Gris, until his premature death in 1927, and Albert Gleizes, chief late companion of Braque in flat-plane—sometimes called "patch-work"—cubism. Others made personal adaptations of the style, in variations inventive and æsthetically rewarding, as in the ingratiating near-abstract improvisations of Jacques Villon, and the compromise "views" of Roger de la Fresnaye, based in nature but patterned on the canvas in geometrical equivalents, with emphasized arcs and squares. There were painters who crossed the principles of cubism with those of futurism, sometimes with engaging if not profoundly significant results, especially the American Lionel Feininger, then practising in Germany, and Marcel Duchamp and Jean Metzinger. Fernand Léger accepted machine-forms as motifs and got into his compositions more of true contemporary feeling, within a technique which he had learned before the war as a cubist, than did the purists, who in purifying cubism had squeezed out something of machine-age dynamism and fullness.

Futurism had burst upon Paris in 1909. It failed in all its main objectives, but it stimulated an enormous amount of talk and provided a certain leavening of clever and amusing art. It also gave the hostile public, and half-educated dabblers in art matters, a cudgel with which to belabour the whole range of moderns, creative and uncreative, sincere and insincere, in the word "futuristic."

The poet, novelist, essayist, and agitator F. T. Marinetti was the leader of those who brought futurism to Paris from Italy. He spoke with the voice of a reformer, a Messiah, a renewer of the life of art. His words, indeed, were far more potent than the paintings his followers brought along to prove that at last the complete revolution had been compassed, modernism made captive. Marinetti painted a word-picture prophetic, passionate, full of blood and flame. His painters on canvas brought along only pictures that were novel, amusing, and provocative.

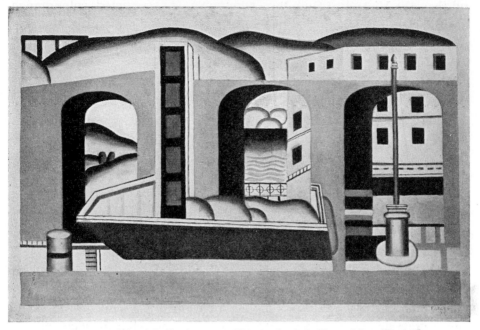

LÉGER: The Viaduct. 1925. *Nierendorf Gallery, New York*

The futurists intended to immortalize the grandeur, the speed, the force of the age. They wanted to sing and paint the spirit of modernism. They began with no nonsense about getting back to the soul or to the mystic heart of the world. They knew nothing of a universal rhythmic order or the fourth dimension. The spirit of modern life was in the *material*, particularly in that product of scientific materialism the machine.

Marinetti opened his first "Futurist Manifesto" with these words: "We will sing the love of danger, the habit of energy and boldness. The essential elements of our poetry shall be courage, audacity, and rebellion. Literature has hitherto glorified thoughtful immobility, ecstasy, and sleep; we will extol aggressive movement, feverish insomnia, the double-quick step, the somersault, the box on the ear, fisticuffs. We declare that the splendour of the world has been enriched by a new beauty: the beauty of speed."

After this generalized beginning, not altogether innocent of bombast, swagger, and Fascism, he goes on to matters of art: "A racing motor-car, its frame adorned with great pipes, like snakes with explosive breath . . . a roaring motor-car that looks as though running on shrapnel, is more beauti-

ful than the Victory of Samothrace. . . . We wish to glorify war, the only health-giver of the world, militarism, patriotism, the destroying arm of the Anarchist, and the beautiful Ideas that Kill; we glorify contempt for woman. We wish to destroy the museums, the libraries; to fight morals, feminism, and all opportunist meannesses.

". . . The daily haunting of museums, of libraries, of academies—those cemeteries of wasted efforts, those calvaries of crucified dreams, those ledgers of broken attempts—is to artists what the overlong tutelage of parents is to enlightened youths, intoxicated with their talents and their determined ambitions."

He spoke glowingly of "the nocturnal vibration of arsenals and work-shops beneath their violent electric moons," of "broad-chested locomotives prancing on the rails, like huge steel horses bridled with long tubes," and of "factories suspended from the clouds by their strings of smoke."

The painters, no less enthusiastic, but faced by the problem of expressing these wonders in pigments on two-dimensional squares of canvas, were more sober in their pronunciamento: "All the truths learned in the schools and studios are abolished for us. Our hands are free and pure, to start every-thing afresh. We declare that there can be no modern painting except from the starting point of an absolutely modern sensation—'painting' and 'sen-sation' are two inseparable words. . . . To paint from the posing model is an absurdity, an act of mental cowardice, even if the model be translated upon the picture in linear, spherical, or cubist forms."

Typical futurist pictures of that early time presented as simultaneous many successive aspects of a scene, as in Balla's widely exhibited painting of a moving dog on a leash, or the compositions of automobile "dy-namics." In their manifesto the painters embroidered upon this idea: "The simultaneousness of states of mind in the work of art: that is the intoxicat-ing aim of our art. In painting a person on a balcony, seen from inside a room, we do not limit the scene to what the square frame of the window renders visible; but we try to render the sum total of visual sensations which the person on the balcony has experienced; the sun-bathed throng in the street, the double row of houses which stretch to right and left, the beflowered balconies, etc. This implies the simultaneousness of the ambient, and therefore the dislocation and dismemberment of objects, the scatter-ing and fusion of details, freed from accepted logic and independent of one another. In order to make the spectator live in the centre of the picture, as we express it in our manifesto, the picture must be the synthesis of *what*

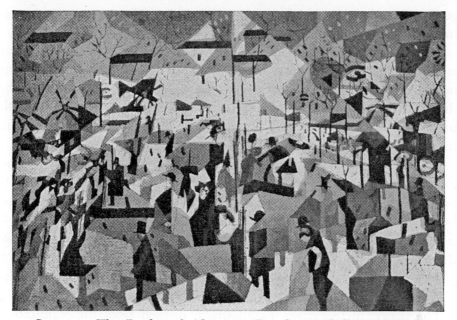

SEVERINI: The Boulevard (Courtesy Der Sturm Gallery, Berlin)

one remembers and of *what one sees.* What must be rendered is the *dynamic sensation,* that is to say, the particular rhythm of each object, its inclination, its movement, or, to put it more exactly, its interior force."

The futurist painters pointed out an error of the cubists, who, they felt, put undue stress upon the "decomposition and deformation" of the object. Instead the futurists were seeking a positive basis for the dynamism of the picture, finding it in a structure of *force-lines.* "Every object," they said, "reveals by its lines how it would resolve itself were it to follow the tendencies of its forces." A sensitive artist could be expected to feel in these force-lines, as seen successively, a sort of "physical transcendentalism." This he immobilizes and immortalizes on canvas, in a fixation of continuity, a prolongation of the rhythm impressed upon the artist's sensibility. Thus, they continue, they succeed in "placing the spectator in the heart of the picture. He will not merely be present at but will participate in the action. If we paint the phases of a riot, the crowd milling with upraised fists and the noisy onslaughts of the mounted police are set down upon the canvas in sheaves of lines corresponding with all the conflicting forces, following the

general law of violence of the picture. These *force-lines* must encircle and involve the spectator. . . ."

It was all very logical, and it led to picturing that was novel, clever, and amusingly illustrative of the surface movement and nervous tempo of contemporary living. But it failed to provide a means for expression of that rhythm beneath life that even the futurist leaders detected. In short, the futurists had adopted technical means that took them back into line with the illustrational artists of the past.

The rhythms of machine-age life, of the actual machine motions, as they caught them and obvious to every observer of their pictures, proved after prolonged acquaintance to be superficial and mechanical. The order created by Picasso and Braque in their paintings of related forms "undetermined by any reality" was seen to be a sounder display of mathematical realization than any to be found in Boccioni's or Severini's or Balla's canvases. And to place a futurist painting beside a Cézanne water-colour or a Kandinsky *Improvisation* was to show it up as empty and journalistic.

The signers of the artists' manifesto, as distinct from the manifesto of the poet-leader Marinetti, were Umberto Boccioni, Carlo D. Carrà, Luigi Russolo, Giacomo Balla, Gino Severini, and Ardengo Soffici. Most of these men (there were no women futurists, of course—contempt of woman, except in the home, being a cardinal principle) were lost to sight after five years of the futurist excitement. Carrà, by exception, was to turn up after the war as one of Italy's foremost creative painters, with a style made over, with hardly a trace of force-line technique, in homage to Cézanne.

The Italians had issued their call and painted their first pictures in their own country in 1909 and 1910. The first manifesto was published in Paris, in the newspaper *Figaro*, in February 1909, but the first public exhibition there took place three years later. It is likely that in the period between the publication of the initial manifesto and the exhibition the futurist artists absorbed some influence from the cubists of Paris, since their home base, Milan, was hardly more than an overnight ride (behind those prancing locomotives) from the French capital. But momentarily, in 1912, the influence worked in the other direction. Albert Gleizes and Fernand Léger were not indifferent to the arresting effects of the skeleton of force-lines and to the ray-lines that could be used to repeat engagingly the accented plane-edges of cubism. Marcel Duchamp capitalized upon the "sheaves of lines" in such pictures as *Nude Descending a Staircase* and *King and Queen Traversed by Swift Nudes*. (At this time other Italian painters were in Paris

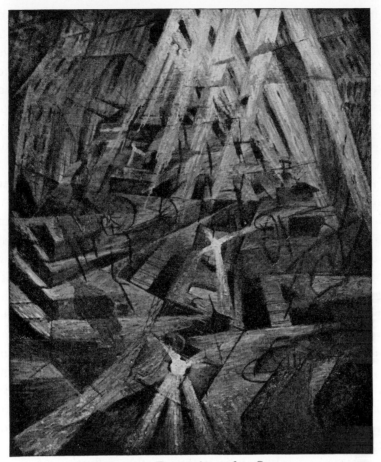

BOCCIONI: Dynamism of a Street
(Courtesy Der Sturm Gallery, Berlin)

and were known where novel ideas were being tried out. Giorgio de Chirico
was laying down a first firm foundation for surrealism, and Amedeo Modi-
gliani was just giving up sculpture in favour of that primitively simple
figure-painting that was to prove him an individualistic if minor master.)

In Paris futurism was, for the public, hardly more than a sensation of a
day. The knowing ones recognized it as less significant than the cubist affair.
The public put it down as one more aberration, to be laughed over and
forgotten. London, on the other hand, when the exhibit was transported
there in March 1912, was profoundly shocked, and there were splits among
the not very numerous British groups devoted to modern experiment. It is

easy to imagine the reaction of the staid English art critics and the English realistic gallery-goers as they faced Severini's *Dynamic Continuity of a Train in Rapid Movement* and *Spherical Expansion of Light, Centripetal,* or Balla's *Dynamism of Dispersion,* or Carrà's *Study for a Picture of a Woman's Shape and Scents.* Half the exhibits were "dynamisms" and "syntheses" and "fusions," varied with occasional "expansions" and "transcendencies."

An English painter, an impressionist at heart, C. R. W. Nevinson, had kept up with the latest movements in Paris. He had been a guest at the Steins', and a friend of Matisse, Derain, Picasso, and the others. Converted by Severini to futurism, and convinced that cubism had ended in "a dehumanized geometrical formula," he took Marinetti and the futurist exhibition to London. It created as great a furore among his fellow-artists as among critics and public. Nevinson himself crossed futurism with his impressionistic realism, and produced some of the most agreeable of Severini-influenced pictures. Nevinson quarrelled, however, with those British painters to whom he had evangelized the new faith, and not long afterward he returned toward innocently illustrational painting.

But a considerable group was corrupted for a time, and vorticism grew up in England as an insular issue of futurism. Wyndham Lewis was the leader in setting up a Rebel Art Centre in London (in Queen's Square, not altogether appropriately) and the two numbers of *Blast* published there in 1914 and 1915 were crammed with pungent, barbed, and sometimes violently prejudiced observations upon art and artists. The illustrations were, however, in final analysis, rather weakly reflective of cubist and futurist models.

The vorticist manifestos tried to reassure the public about the separateness of the British movement. "Cubism means the naturalistic abstract school of painters in Paris, who came, through Picasso, out of Cézanne. The word, even, cubism, is a heavy, lugubrious word. The cubists' paintings have a large tincture of the deadness (as well as the weightiness) of Cézanne; they are static and representative, not swarming, exploding, or burgeoning with life, as is the ideal of the futurists, or electric with a more mastered, vivid vitality, which is the conception of their mission held by most of the vorticists."

Again and again energy, vitality, and the electric are emphasized in the vorticist pronouncements. They express disapproval of the vestiges of impressionism and of Matisse's decorativism carried over into cubism. "We

must disinculpate ourselves of Picasso at once," for, "however musical or vegetarian a man may be, his life is not spent exclusively among apples and mandolins . . ." and "the placid empty planes of Picasso's later *natures-mortes*, the bric-à-brac of bits of wall-paper, pieces of cloth, etc., tastefully arranged, wonderfully tastefully arranged, is a dead and unfruitful tendency."

The vorticists, while praising "the vivacity and high spirits of the Italian futurists," noted regretfully, and with truth, that they never attained to "the great plastic qualities that the best cubist pictures possess." Of the futurist pictures exhibited in London they said: "From their jumble of real and half-real objects a perfectly intelligible head or part of a figure would strike up suddenly. And this head or part of a figure, where isolated and making a picture by itself, you noticed was extremely conventional. It discredited the more abstract stuff around it." In that is the key to any real and lasting good the vorticists may have accomplished. They put emphasis where it belonged—if really the movement was modern—on the importance of the abstract element, on "the great plastic qualities."

The vorticist graphic artists were most successful in black-and-white drawings. Unfortunately there is not a handful of paintings that survives as of more than documentary interest. They are not to be found even in the museums of modern art. In other words, the vorticist leaders, though they placed a little group of English painters upon the road of abstraction, upon which a great deal of pioneer experimentation was to be done between 1920 and 1940, failed to turn up a single first-rate painting talent. Lewis himself, Edward Wadsworth, William Roberts, and Frederick Etchells were the hundred-per-cent British artists concerned; and not one has, even in the quarter-century since the close of the World War and the cessation of vorticist activities, emerged into international importance. The one genius acting with them was the French sculptor Gaudier-Brzeska, who left England to join the French army in 1914 and was killed in action eight months later at the age of twenty-three. On the literary side an American expatriate, Ezra Pound, lent brilliance, beside Lewis.

Even during the war the parade of the 'isms continued, in territories far from the battlefields of France though not always remote from the influences of Paris. No school or group developed that even faintly approached cubism in its significance to the progress of the painting art, and there was no further development so novel, or so well advertised, as futurism. But the Russians in particular started fresh currents that flowed later into the in-

ternational stream of abstract and near-abstract modernism. During the period of the war Kandinsky was in Russia, but he was carrying on as an independent, above the schools and cliques; carrying on, it might be said, as the soul of abstraction in exile.

Moscow was the Russian centre of art, and already before 1914 the collectors there owned scores of the paintings of *fauves* and cubists. A painter named Kasimir Malevitch had been a fellow-traveller with the cubists, but in 1913 a great light had burst upon him. He would free painting not only of the last vestiges of reality as seen with the physical eye but of all associative sensation, symbolic meaning, and emotional mood. He foresaw the world trend to non-objective painting, and he was the first considerable figure, excepting Kandinsky, to dedicate himself to absolute abstraction. He was geometrical, clear, precise, where Kandinsky was expansive, involved, almost romantic.

Malevitch was not, however, clear and precise in his explanations, so far as the public was concerned. He called his art "suprematism," because, he explained not too logically, he painted pictures out of "the supremacy of pure sensitivity." He might justly have appropriated the word "purism"; for this was five years before Ozenfant and Le Corbusier founded the French purist school, and the purgation was more drastic. In fact, Malevitch so purified painting that there was nothing left that the public recognized as art. His earliest pictures in the style were black squares on a white ground. There followed some experiments with perfect circles, then more complex but no less mathematical compositions.

Malevitch set out his creed in a few words: "Suprematism compresses all of painting into a black square on a white canvas. I did not have to invent anything. It was the absolute night I felt in me; in that, I perceived the creation, and it I called suprematism. It expresses itself in the black plane in the form of a square."

Thus the night and the sensitized mind gave rise to suprematism, as later the dream and the Freudian attitude were to give rise to surrealism. If Malevitch's explanations afforded scant comfort to a puzzled public, his pictures and his theories were landmarks on the way to post-war non-objective painting in Germany and Holland. He and one or two followers, especially El Lissitzky, went on to other and less austere modes of abstraction, and their mark was left upon the painting and the industrial design of many countries.

Constructivism was something more easily got hold of, though less based

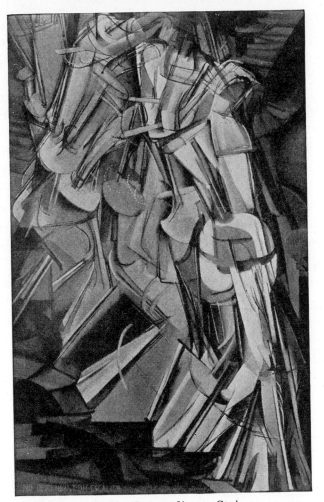

DUCHAMP: Nude Descending a Staircase. 1912.
Collection of Walter Arensberg, Hollywood
(Courtesy Museum of Modern Art)

upon painters' materials. The constructivists emerged about 1917 from a
background in which French cubism, futurist devotion to the machine, and
the individualistic designing of a Russian named Vladimir Tatlin were
tangled. In general the idea was that the dividing line between creative
works of art and inventive machine design should be broken down. Art was
to borrow from the principles of engineering; and shortly art was actually
borrowing the materials that engineers use, gears, levers, and wheels, trusses
and cantilevers, sheet metal, wood, glass, and wire. "Constructions" in these

materials, cunningly articulated and so adjusted that to move a part destroyed a compositional beauty, were common to exhibition halls just after the war. The more valuable impulse passed into the theatre, where constructivist settings had something to do with the passing of illusionistic painted scenery, with the gaining of a fresh start from the bare boards. A second impulse passed into sculpture, along a line that ends, in the early nineteen-forties, in the "mobiles" of an American artist, Alexander Calder.

There were constructions approaching the flat, and thus allied with paintings of the *collage* sort; but the best of constructivism was in the space-constructions of Nahum Gabo and Antoine Pevsner, two Russians, brothers (despite the names), who had studied abroad, the one in Munich, the other in Paris. Their compositions of metal, celluloid, and glass were like purist paintings brought alive in three dimensions, precise, smooth, machine-clean. Through Lissitzky, graduate of suprematism, the concern with the tactile and associative values of materials was transmitted to the German Bauhaus, where students were required to investigate and compose in a wide range of physical substances, glass, metals, wood, paper, plastics, and in plain, roughed, corrugated, and woven textures.

In Holland in 1917 Piet Mondrian and Theo van Doesburg led in organizing a group of artists to publish a magazine called *De Stijl*, and to practise abstract painting and sculpture and a purified, modernized architecture. The movement led on to the school better known as the neo-plasticists. Like Malevitch, the Hollanders began with geometry pure and simple. They too especially fancied the square. Mondrian, who had been in Paris before the war, a disciple of Picasso's, produced paintings divided into rectangular areas of uniform, harmonized colours, separated by black lines. Van Doesburg varied the formula, and was not above finding "suggestions" for his geometrical arrangements in nature, but stuck to rectangles and flat, smooth colours.

Both painters were exceptional propagandists and carried their ideas abroad, Mondrian to Paris, where the manifesto of neo-plasticism was published in 1920 and exerted influence on French abstractionists—Ozenfant and Le Corbusier immediately, Hans Arp and Jean Hélion later—and van Doesburg to Weimar, where he influenced Gropius and the fellowship at the Bauhaus. There was something clean, neat, and calm about the neo-plastic pictures that seemed to grow out of the very life of Holland, and it was an element that worked as a valuable corrective within the sometimes feverish and disorderly international movement. Perhaps archi-

tecture benefited most, from the example of J. J. P. Oud who was an original member of the Leiden group in 1917, and at the hands of the German Mies van der Rohe, who was a convert after the war.

In various other directions the spirit of the Hollanders went out to transform modes of design and decoration, with impetus toward simplification and geometrical tranquillity. Mondrian and Oud of Holland and a Belgian sculptor who was in the original *De Stijl* group with them, Georges Vantongerloo, were able, even on a continent war-torn and embittered, to over-ride boundaries and affect the course of design not only in painting and sculpture but also in architecture and interior decoration, typography, stage setting, and industrial design.

Frederick Kiesler, a Viennese, became a member of the *De Stijl* group in 1923, and after demonstrating the style in Paris came to America, a land that had pioneered in the new architecture with the creative work of Louis Sullivan and Frank Lloyd Wright. He was a link in the chain that connected "absolute" painting in Europe with American industrial design.

When Norman Bel Geddes in 1927 opened a studio for the redesigning of stoves, refrigerators, automobiles, and other mass-produced objects; when streamlined trains began to demonstrate a characteristic machine-sheer beauty to all parts of the country in the mid-thirties; when the new clean-line, flat-surfaced, smoothly colourful "interior decoration" arrived, indicating that at last the Victorian museum-based ideals of home environment had passed; when the telephone, plumbing fixtures, and the clock were brought into line with a machine-age æsthetic; it was sometimes forgotten that if one-half the reason lay in engineering advance, the other half must be credited to a series of pioneer efforts of abstract painters and sculptors. The greatest of industrial designers have been men who inherited from the adventurers in the field of non-objective painting and sculpture; not seldom they have been painters who went over to the industrial-design field. One may well gaze at one's alarm-clock or fountain pen or motor-car and not be aware of a lineage back through American design studios to German, French, Dutch, and Russian beginnings. But had Kandinsky not created the first body of abstract painting in the pre-war years, had the cubists of the school of Paris not progressed from blocked nature to abstraction, had there been no suprematists and constructivists in Russia, no *De Stijl* group in Holland, no centre of abstract study at the German Bauhaus, the objects in one's pocket or on one's bureau or in one's garage would not have just the aspect they have.

In Zürich one night in February 1916, at a Bohemian café, a band of writers, artists, and war refugees opened the pages of a dictionary at random, and found the name of a world movement. Dadaism was born. To this meeting and birth, lines had converged from New York, where Marcel Duchamp, Man Ray, and Francis Picabia had collaborated in some irresponsible designing, from Paris and the scattering cubists, from the abstractionists of Munich, from the frustrated Italian futurists. Frustration in art, despair at the state of the world, the desire to carry wartime destruction into the field of culture, all had to do with the founding of dadaism. No sooner had the proclamations in favour of artistic sabotage and incendiarism gone forth than the wilder adherents of all the earlier 'isms hurried to join the movement. They saw ahead the fun of discrediting every sort of established art. They were the ones who had declared for irrational art, but the ones who, unlike Kandinsky and Marc, had failed to find in their subrational selves anything worth expressing. The leaders especially were second-rate artists. Tristan Tzara, little known otherwise, was the animating spirit; Francis Picabia, of the second range of cubists, was his most active assistant.

With the avowed intention of being perverse and shocking and iconoclastic, the lesser dadaists built up an art at times genuinely amusing, at other times wholesomely cathartic, but in general mediocre and negligible. Because the war had broken down so many standards and had so discredited the pretensions of the human race to being civilized, some of the greatest painters were drawn to dada standards at least temporarily, feeling perhaps that outrage and degeneration had gone so far that to help in the total destruction of culture could only hasten some different social and artistic set-up. Thus the names of Kandinsky, Picasso, Klee, and Grosz became associated with the movement.

Grosz in particular, with an apparently child-like technique, so savagely exposed the pretensions of the German ruling and cultured classes that millions of people were reminded of the insanity underlying the world's sanest institutions. In France the social satire was less bitter though the outrages upon sanity were equally telling. In discrediting the vague æstheticism that had settled upon sections of the Parisian modern scene, in undermining institutions and organizations professing devotion to the advancement of the arts, the dadaists were at their best. A quarter-century later it was to come clear that they did too thorough a job. In any case, the younger French generation that might have gone beyond Rouault,

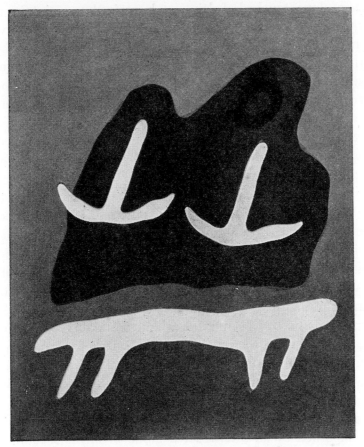

ARP: Mountain, Table, Anchors, Navel. 1925.
Museum of Modern Art, New York

Vlaminck, and Matisse never matured, except in that minor school which inherited a good many of the dadaish characteristics: surrealism.

Immediately after the war it was easy for Parisian dilettanti to carry over certain of the radical modes of painting into parodied or nonsensical versions. For instance, the *collages* became those outlandish whatnots punctuated with pasted-on buttons, photographic snapshots, twine, watch-wheels, bits of fur, and the like. It was easy for the younger men to slide into the dadaish insouciance, irreverence, and insincerity. In so far as they later climbed out onto firmer artistic ground they did so—in the view of most commentators—with a perverted sense of what may be valuable in life as subject matter in art, and without the power of form-creation which would make their non-objective painting important. Of the school of Paris mem-

bers, Picasso alone touched dadaism and survived to paint in masterly ways, even possibly enriched in experience.

In Germany, however, where Berlin, Munich, and Cologne all had dada centres, three masters at least recovered their equilibrium, within limits, some would say, and went on to more constructive work. Klee and Kandinsky, strangely opposed in so many methods and aims, nevertheless became founders of the post-war school of abstract painters in Germany; and Grosz graduated into successive types of form-enriched subject-painting, becoming a leader, first in Germany then in the United States, a leader with an amazing versatility and strength.

The wilful violence, the bitter subversiveness, the anarchism of dadaism passed with the war hysteria. The artful nonsense, the anti-rationalism, and the adolescent sexuality were diverted into surrealism. The brains and the intuitive art that had been temporarily attracted to the dadaist circles went back into the main stream of international modernism, with a Russian-German line of progress definitely established as a counter-movement to the surrealism that had claimed the lesser men of Paris.

In a sense dadaism had been a movement to end all 'isms. It had been willing to suffer self-destruction if it could carry all pretenders to art-wisdom and all established institutions into the abyss with it. No one can know how ill or how well it served its self-appointed task. But it is certain that by 1925 the older 'isms were pretty much a matter of history. At that moment a new integration of all that the various 'ists had stood for was being accomplished by an international group of artists meeting in Germany. All the 'isms had led to one conclusion: the most exciting adventure lying ahead of the world of painters was in the discovery and practice of a non-objective art. The march of the 'isms had ended in a dream, a dream of an art of painting disembodied, like music.

The opening of the next war was to find that dream only marginally realized, was to find the dreamers from the centre in Germany dispersed and only a very small public convinced of the inevitability, or even the feasibility, of a disembodied painting art. But the sequence of 'isms had afforded whatever of continuity and consistency existed in the period 1914–1930; and when creative painters returned to subject-art they carried with them the conviction that, if the abstract form-values could not yet be fully isolated, some sort of form-structure or plastic organism must support or animate the subject-picture from within.

XVI: DECLINE IN PARIS; RESURGENCE
AND ECLIPSE IN GERMANY

A GREAT wave of joyous art had flowed over the Western world in the name of modernism in the half-century before the World War. The character of twentieth-century painting, colourful, unrealistic, form-enriched, had been defined before 1914. Denied at first because it was unfamiliar, modern art had found champions, then a steadily widening appreciative public.

The impressionists, and Degas and Renoir, with their sensuously joyous pictures, found wide acceptance first. After them the decorative painters claimed growing audiences: Whistler, Puvis de Chavannes, Gauguin, and Matisse; and van Gogh of the sun-drenched, decorative period. Finally

PICASSO: Four Classic Figures. Tempera. 1921 (Courtesy Museum of Modern Art)

the artists of the profounder range, the creators of an art that is sensuously lovely and at the same time deeply rhythmic—Cézanne above all—were recognized as the geniuses of the modern movement, and millions of gallery-goers found abiding æsthetic pleasure in their pictures. Just before the war the tide of creation had pushed out in new directions, so that visionary artists such as Kandinsky, Marc, and Picasso had added new types of painting, unprecedented in history, to the world's store of art. But the flow that thus was rich, full, and varied before the war was, after 1918, slowed, and at times all but dammed.

The war to save democracy came to an end in 1918, and the era of chaos began. Not a single thread of continuous achievement in the arts (excepting possibly architecture) can be traced through the succeeding period. Some national schools, especially the French, declined, and others developed where least looked for, as in Mexico. Groups of theorists—sects and cliques and causes—appeared as if spontaneously, held the stage for a day or a month, and disappeared. The larger 'isms split into minor 'isms. There came to be more important arguers about art than important artists. Painters lapsed into being schoolteachers and writers. If certain arts particular to democracy flourished for a time—the claim was made for "socially conscious art," when labour, Socialism, and Communism were recognized "causes," internationally propagandized—they were to be sucked down with all else in the maelstrom of 1939. The triumph of the unimaginative that worked from 1918 to 1939 to prepare half the nations of the earth for a new and staggeringly destructive war brought two decades of vacillation and discontinuous effort, of separated schools and jealous factions, to the arts.

There emerges, to be sure, a certain unity, a certain likeness of aims, even of style in the broadest sense, in the end-products of a dozen countries. But a record of modern art in the period 1919–1941 must chronicle separately the decline of inventive painting in France; integration, growth, and suppression in Germany; sudden flowering and continuous healthy growth in Mexico—the only consistent and continuing episode; and retarded growth, after a promising pre-war start, in the United States, with battling of realists and school of Paris adherents ending, in the late thirties, in something like a flowering.

In France, from the time of Ingres and Delacroix, painting had been, in Élie Faure's phrase, the imperial art. Paris had been the capital of art's

MATISSE: Odalisque with Tambourine. 1926. *Collection of William S. Paley, New York.* (Courtesy Pierre Matisse Gallery, New York)

empire. Modern painting, when the inventions of Goya and Constable had been absorbed, had developed pre-eminently as a French expression, from Daumier and Corot to Cézanne, Seurat, and the *fauves*, with only Whistler and van Gogh bringing in minority contributions from alien sources. Rouault, Matisse, and Bonnard, the masters of the generation of 1905 and the outstanding Frenchmen of 1914, were inheritors from that proud line. But with them, in later life, the line ran out. In the period of the fauvist supremacy, 1905–1909, they had had inventive companions,

men only a little less gifted than themselves: Derain and Vlaminck, and Dufy, Braque, and Utrillo. But when Picasso took over creative leadership of the school of Paris in 1909, the era of French invention was already at an end. Not one French artist emerging after that date turns in a superlative performance.

After the war the *fauve* leaders continue to create gorgeous works of art, even to 1941, but their practice is safely within their established pre-war modes. When the boundaries of modern art are again pushed out, when new and moving ways of expression are compassed, after 1909, it is Picasso and Chagall, Kandinsky and Marc and Kokoschka, Rivera and Marin, who are the innovators. And of the rank-and-file creators, the younger inheritors from Cézanne and Seurat and van Gogh, it is less the French who score than the Spanish and the Germans, the Mexicans, and the Americans of the United States. Paris is left with hardly more than a dubious school of surrealists, and two groups of followers of the earlier masters, the one bound up in inherited cubist or purist formulas—Lhote and Gromaire— the other neo-traditionist—Souverbie, Asselin, Mauny, Oudot, Favory.

In 1930 Élie Faure, dean of art critics of the Western world, published an article entitled "The Death Struggle of Painting—1930," in which he described the confusion that had come into French art and traced the reasons for increasing sterility in the product of native painters. Noting that Paris had become the rendezvous of "artists who are Chinese and Afrikanders, Hindus and South Americans, Japanese and Yankees, Arabs and Redskins, Russians and Spaniards," and so on through ten more categories of aliens, he wrote that "French art has literally been buried under an avalanche." A foreign tide, helpful at first with Whistler and Sisley and Liebermann and van Gogh, had grown until "the gradual inundation has left intact but little more than small lonely islands, which are rather lost among the waters." And he decided, even though forty thousand painters still swarmed in Paris, "that the great French school has virtually accomplished its task, and that the spectacle of Paris since the war demonstrates this with sufficient evidence."

In 1930 Rouault was the most consistently masterly French painter in France. He had been little known in other countries, except as "one of the *fauves*"; but in that year exhibitions of his work were held in London and Munich and in America. Almost every season thereafter his pictures were shown on both sides of the Atlantic, and he was soon accorded a reputation as one of the pillars of the international school. He might well have

ROUAULT: The Old Clown. About 1917. *Collection of Edward G. Robinson, Beverly Hills, California.* (Courtesy Pierre Matisse Gallery, New York)

claimed the distinction as early as 1910, for there was little room left for gain in strength, rhythmic vitality, and monumentality over the pictures of clowns, bathers, and women of the streets produced before that date.

After the war he continued to paint without the slightest lessening of his characterisic pictorial energy and largeness, though he abandoned somewhat the moralistic intention that had led to his early attacks upon the law courts, prostitution, etc. He broadened his field in the twenties to include landscape, and again showed more affinity with Kokoschka and the German expressionists than with his fellow-Parisians. As throughout his career, he continued to paint subjectively, spontaneously, and emotionally. He so

followed his own individualistic way that in France he was often chided for his "violence" and "disorderliness."

Personally unworldly, and given to medieval ideas of withdrawal and of dedication to his craft, Rouault was known as "the monk of modern painting." A native bent toward religion led him to picture in a long series of canvases episodes from the Bible stories. In this he was completing constructively a work he had begun long ago from the opposite approach, in criticisms and exposures of the ills of modern civilization.

After 1931, when he was sixty years old, Rouault in general neglected painting in order to illustrate and to make prints in etching and lithography. His prints are instinct with the vitality and grandeur that first found expression in the larger works. Rouault's total œuvre, despite an apparent deviation toward the Central European expressionists, may ultimately be described as one of the richest expressions of the French temperament, for it is grounded equally in medieval imagery (especially as seen in popular prints and in the cathedral windows) and in the pioneering of Cézanne. No other Frenchman among the twentieth-century painters has been so strong. None other has preserved so fully emotion and the rights of the subject along with gorgeous colour and complete mastery of the new plastic language. A man of integrity, an artist original, colourful, and uncompromising, he has been representative for forty years of the best that the French people have had to give to the world of art.

In the midst of the war period, in 1917, Matisse left Paris to set up his studio in Nice, on the colourful French Riviera. The move did not essentially change his style as it had crystallized in the days of the *fauve* triumphs. His compositions remained impersonal and objective, decorative and glamorous and posteresque. The sun of the South brought a certain lightening of colour and of linear technique, and the semi-tropic Mediterranean atmosphere confirmed the artist in his devotion to effects exotically warm and lush and gay.

Matisse went on, between 1920 and 1940, to phase after phase, and exhibitions of his works became staples of the modern galleries. But always he painted within the one plastically shallow, decoratively lovely range. No artist has been his peer in arranging enchanting colour-and-texture compositions with a few stock materials—a woman, a vase, some patterned stuffs on floor and wall and couch, perhaps a glimpse of sea through the window, all without thematic significance. By 1925 he was acknowledged

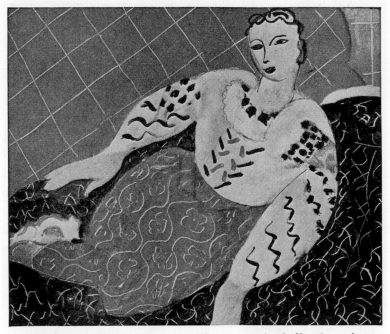

MATISSE: The Roumanian Blouse. 1938. Collection of
Pierre Matisse Gallery, New York

the world's leading decorative painter. As such he has influenced artists in
many lands, but none has matched his mastery and his facility in the
corner of the modern field that he had already in 1910 made his own.
Earlier than any other out-and-out modern, he arrived at material pros-
perity as well as critical acclaim. The French Government honoured him
by purchasing an *Odalisque* as early as 1921. Ten years later he was receiv-
ing for each of his paintings a sum sufficient to support the average artist
through a term of years.

Although Matisse had been undisputed leader of the school of Paris in
its early phase, although he has made an unequivocal success in his chosen
field, there have been few critics ready to call him modernism's leading
painter. In devoting his genius to a decorative type of picturing he has left
out a great deal that art-enjoyers expect from profound painting. He
"pleasures the eye" and he evokes a glow of the senses. His control of the
plastic means is certain so far as he elects to go; but he never affords the
profound rhythmic experience to be attained from canvases of Cézanne, or
even of Rouault.

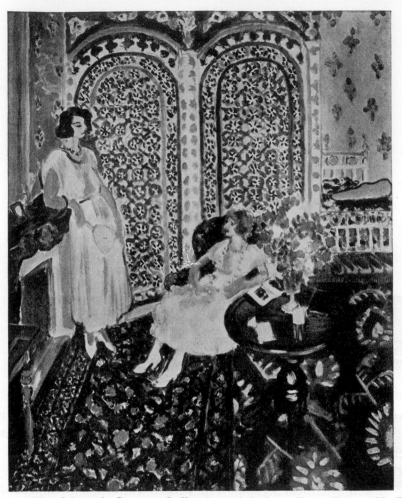

MATISSE: The Moorish Screen. *Collection of Robert Treat Paine, II, Boston*

Matisse carried on certain lines of modern progress, especially those initiated by Whistler and Gauguin. Equally he was inheritor from Manet and the impressionists, doing a surface thing and an objective thing surpassingly well. He has carried to completion the aims of the group of *fauves* that began with impressionism, submitted their pictures to the formalist discipline of Oriental ceramists and print-makers, and emerged as opulent decorative pictorialists. In the late thirties, as if to prove that he had lost none of the verve and ingenuity and captivating brilliancy of his earlier

BONNARD: The Palm. 1927. *Phillips Memorial Gallery, Washington*

style, he reverted to the bright, clean colouring and the posteresque simplifications of the 1925 period, thus reminding the art-lover that he was still, as he had been for thirty years, the Western world's foremost decorative painter.

One other French master, Pierre Bonnard, carried on the gay colouring and surface charm of impressionism. An older man than Matisse and Rouault, a member of the *nabi* group in Paris before the *fauves* were heard of, he had been sympathetic with the wild men of 1905, and his own art had taken on vigour and colour-strength during the decade of early battling within the school of Paris. After the war Bonnard reverted somewhat to capitalization of the surface effects of opalescent colour and rhythmic linear patterning. Like Matisse he has avoided all comment upon life, all subjective revelation, all seriousness of message, all drama.

With an eye sensitized to seductive and subtle colour effects, he has

painted the casual world around him, gardens and flower-filled rooms and glimpses of the sea with yachts, the breakfast table, and the boulevards at theatre time. Women have been a favourite subject with him, but without characterization or attempt to transcribe personal loveliness—they are, indeed, merely items in a charming whole, decorative often by reason of the patterned frocks they wear, or disposed in rhythmic attitudes to complete a plastic scheme.

The plastic order is, with Bonnard, as shallow as in Matisse's pictures, but somehow, perhaps because of the fuller, though not brighter, colour, his pictures seem to have more of body, are less evidently born of a purely decorative intention. He is making an eye-pleasing art of scenes of intimate life relished and transformed, but he neither simplifies nor deforms nature so drastically, in pursuit of formal effect. Detail is not ruthlessly eliminated. And colour suffuses the canvas, where Matisse breaks it up into related and contrasted areas, sharply divided. Bonnard is the truest of those who link the school of Monet, the school that dissolved form in cascades of opalescent colour, with the school of post-impressionists that recovered form and interpreted it as decorative arrangement. Sensuously charming, colourfully harmonious, Bonnard's pictures disarm criticism. They are seductive, enchanting, lazily beautiful.

André Derain, who though younger had also been ranked as an important innovator in the years 1905–1910, was one of those who helped establish the cubists as the most original group of creators within the school of Paris. But he was the earliest to desert the geometric-minded Picasso and Braque. He returned full to subject-painting, and he searched in the backgrounds of modernism to find new starting points for his painting style: at first no farther back than Cézanne, who remained permanently as foremost influence, then to Courbet, Daumier, and Corot, even to El Greco and Giotto.

After the war, as before, Derain passed through a number of easily marked periods. If one evidence of fauvism remained through his transformations of style it was a certain directness, a simple, deliberate largeness derived from a study of the primitive arts. But in place of the more usual informality, even carelessness of statement, he drifted toward an almost classical hardness and clarity. His range of subject matter has been as extensive as his divergencies of style: nudes and still-lifes, portraits and abstractions, landscapes and religious theme-painting. He has made excur-

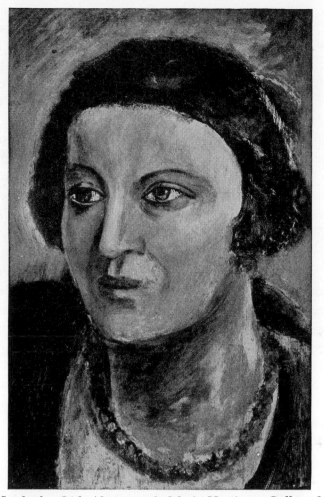

DERAIN: Head of a Girl. About 1918. Marie Harriman Gallery, New York

sions into ceramics, stage design, and sculpture. In every field a master just below the supreme figures, he is modernism's best illustration of a rich and adaptable talent finding success by study and absorption rather than by spontaneous creative invention.

France held to its position of leadership through the twenties and well into the thirties, and through all that time Paris was still a rich hunting-ground for the traveller seeking first-hand experience of modern painting

DUFY: The Studio. Gouache. 1927. Collection of Miss Mary Lewis, New York
(Courtesy Perls Galleries, New York)

(though the German public galleries were incomparably superior). Great retrospective shows of the elder masters became seasonal events, with Cézanne, Gauguin, Degas, and others set forth prodigally at Government museums, and the four reigning figures, Rouault, Matisse, Bonnard, and Derain, to be seen regularly at one-man exhibitions.

To these were added the shows of the gay and charming Dufy, who continued to illustrate life at the race-tracks and the beach-resorts in his characteristic method of staccato, calligraphic drawing, overlaid with washes in areas that only approximated the linear outlines; and the shows of Vlaminck, repeating with growing virtuosity his Cézanne-derived "washy" landscapes, always engaging and always colourful—disappointing only because the man seemed to have rested back upon a formula, capitalizing upon a mannerism over-familiar after twenty years. There were, too, the

VLAMINCK: Houses and Trees. *Memorial Art Gallery, Rochester*

charming decorative canvases of Marie Laurencin, with a quality seductively feminine, but becoming, season by season, successively shallower, more frankly candy-like (though they were mistaken often enough, in the early years, for true examples of modern form-organization). Along with Bonnard there was that other figure from the band of *nabis*, Édouard Vuillard, continuing his painting of interiors, in a decorative manner derived from a crossing of impressionism with a surface Orientalism, but hardly so successful in his late years as before the war.

In 1924 André Dunoyer de Segonzac held his first post-war exhibition and immediately took rank as one of the leading French painters. Younger than the original members of the *fauve* group, he had nevertheless been attracted to the wild men in the years before 1910, and had afterward gone along a little way with the cubists. But after the war a native independence

SEGONZAC: The Marne. 1927 (Courtesy Museum of Modern Art)

of spirit led him to break all ties, and already in 1924 he had formed that powerful personal style that has characterized his canvases ever since. Albeit his independence carried him back a certain way toward the realistic tradition—so that critics oftenest revert to talk of Courbet and Corot in accounting for his *métier*—he had gained enough out of cubism, or out of study of the godfather of cubism, Cézanne, to know the value of form-organization. His pictures, though dependent upon the model, are informed with enough of plastic invention to earn him continued place with the moderns.

Segonzac's design has unfailing strength, and his heavy outlining of forms adds to the sense of vigour and power. In other media, however, he can be delicate, even exquisite. As a draughtsman he has few equals, and as a water-colourist he is as great as any Frenchman since Cézanne. It is because, unlike Cézanne, he has been interested only incidentally in the abstract form-values, in hidden essences, that he has been accorded lower ranking in most exhibitions of the moderns than Rouault or Derain or Matisse.

SEGONZAC: Landscape. *Lewisohn Collection, New York*

When one ventured to ask in the galleries of Paris, say, during the early nineteen-thirties, if there were no new figures of first-rate importance, younger men who were building upon the discoveries of the cubists and on the ground opened by Cézanne and Seurat, the answer was likely to be that Marcel Gromaire and André Lhote gave promise of furthering the new creative tradition. But these painters, stemming direct from cubism of the solidest period, before the extreme flattening process, were recognized gradually as continuators in the intellectual line rather than in the creative line. Both have been eminent teachers, transmitting knowledge of the new plastic means, of formal discipline, but in their own work they seem to have *applied* the principles of modernism rather than to have invented their pictures intuitively. With them what may be termed the apparatus of modernism is too evident. The language is too noticeable for what is said. Yet painters in many countries trace their competence in plastic organization to the teaching at the Atelier Lhote or at the academy over which Gromaire presides in Montparnasse.

Montmartre was no longer, after the war, the centre of insurgent art

effort in Paris, though it long rivalled the Left Bank as a gaudy centre of Bohemianism. The informal café life of the painters centred rather at the Dôme and Rotonde on the Boulevard Montparnasse, in the old Latin Quarter. The Montmartre that had given so much to Renoir and to Degas, but had killed Toulouse-Lautrec; the Montmartre that had nursed Picasso and the late group of *fauves*, that had been the scene of cubism's birth; the Montmartre that had harboured the most spectacular of the alien artists claiming refuge in Paris, Modigliani, and van Dongen, and Pascin— this Montmartre gave way at last to Montparnasse. Just before the war Picasso had deserted to the other bank, the other hill. Gradually his associates had followed.

But Montmartre in the thirties lived again through the brushes of a French painter who had been born, literally, of the Bohemianism of the district. Maurice Utrillo was the son of Suzanne Valadon, a model and a painter. As a boy, in the early nineties, he was permitted to run the streets unrestrained, and as a youth he fell victim to alcoholism. His mother, awakening too late to the dangers her neglect had brought upon him, attempted to reclaim him from his habits and his associations. While she failed to bring back his health, she gave him, in painting, a lifework.

Settling in Montmartre, he became a café character. Continually drunk, perpetually on the verge of a physical and mental breakdown, he yet succeeded in forming a personal and engaging style of painting that brought the art-dealers into pursuit of him. Sometimes the dealers, sometimes the wineshop proprietors, would lock him in a room with canvases and paint and drink, and so secure his pictures in return for their "support." Several times he was committed to institutions, but his Montmartre companions each time contrived his escape. Finally he married and was carried off a virtual prisoner to a villa with barred windows at the village of Pierrefitte-Montmagny. There he entered upon an existence not unhappy so long as he was provided with paints, brushes, and canvases, food and drink, and post cards to serve as suggestive themes. In the mid-thirties he sufficiently recovered to be released, but continued to paint without the embarrassment of knowing his subject at first hand.

The subjects of Utrillo's paintings were largely the buildings, streets, and byways of picturesque Montmartre, or of the suburbs of Paris. But the actual scenes, their lighting and colour, and their life, counted nothing, for he painted indoors, if not from memory then from snapshots or from the post cards. The truth of nature meant little, his own pictorial concep-

UTRILLO: La Rue Saint-Rustique. *Wildenstein and Co. Galleries, New York*

tion everything. And so the conventional snapshot view leaped into life with the vitality of a created image.

There came to be, inevitably, far too many Utrillo canvases of the Montmartre streets; but the best of them are lovely in a simple, appealing way. Not a colourist in the extreme modern sense, Utrillo produces a fresh harmony of restrained colour, in dulled tints. Some of his most attractive pictures date from a so-called "white period," of the years before 1910. So simple are his effects that he has been classed by some critics with the modern primitives. The classification hardly holds, since he is a profes-

sional painter, son of a painter, and intimate of some of the leading artists of his time. A certain infantilism is perhaps a part of the charm of his pictures, but it expresses itself through a technique learned at the heart of the painters' world.

Shy, hermit-like when he was not forcibly confined, unable to paint portraits because he could not make himself look at people, more than a little mad, Utrillo has painted many of the sanest pictures known to the chequered history of decaying Montmartre, the sanest, the most tranquil, and—remembering Lautrec and Pascin in contrast—the healthiest.

For the rest, the story of Paris is of the avalanche of aliens. Even the school to which Paris gives its name takes as leader, from 1909 on, the foreigner Pablo Picasso. And there are others, hardly less individualistic, who advance, in one direction or another, the aims of the post-realistic pioneers. Van Dongen continues, after the war, to capitalize upon the showier and easier effects of decorative-plastic organization, and becomes one of the fashionable painters of Paris. A Pole, Moise Kisling, achieves a popular success by carrying some of the freedom and largeness of the new painting to what is, after all, a fairly realistic portrait-record; and he has been but one figure in a considerable group of Polish expatriates. Kisling, Modigliani, and the Russians Chaim Soutine and Marc Chagall formed the centre of a large international group of Jewish artists in Paris, to which some French critics have attributed the more violent excesses of expressionism evident in exhibitions during the twenties and thirties.

Soutine especially carried the appearance of violence and disorder into his painting technique, his broken, twisted brushstrokes matching the tortured forms into which he has distorted his chosen subject matter. He has an instinctive feeling for pictorial organization, but the combination of confused and melancholy themes with extreme untidiness of execution has worked against public acceptance.

Chagall, on the other hand, is disorderly or perverse only in the arrangement of the elements he takes from life. His effects are likely to be gay, in the fashion of Russian folk art, and his colour is fresh and winning. Some explain his fantastic pictures as illustrations of Jewish and Slavic fairy tales. Others say merely that he has the mind and imaging power of a born expressionist. Human figures walk the sky, heads float over bouquets of flowers, buildings diminish and huddle like toys, girls sprout wings, and animals read.

CHAGALL: Paris through the Window. 1913. *Solomon R. Guggenheim Foundation, New York*

Chagall's is childishly emotional art with Freudian overtones—and of course the German expressionists and the French surrealists successively claimed him as fellow-spirit. Forced to flee Paris at the opening of the World War, he returned in 1922 to establish his permanent home there. Until the German invasion in 1940 he was a conspicuous independent and, some would say, a conspicuous eccentric. Original, imaginative, gay, he added more of joyously creative art to the output of the school of Paris than any other artist of the Jewish group.

It was violence, not fancy, tragedy, not joyousness, that ruled the lives of two other outstanding artists of the group, Jules Pascin and Amedeo Modigliani. Truest internationalist of all, born in Bulgaria of Italian-Serbian and Spanish-Jewish parents, art student in Vienna, Munich, and

Paris, legally an American citizen, Pascin had a native gift for painting that might have placed him in the main succession after Cézanne and the moderate form-seeking moderns. But he was vagrant by nature, unstable, and licentious. In his post-war years in Paris, where he committed suicide in 1930, he lived sensually if not riotously, never quite taking time to come to grips seriously with art. He made a specialty of portraits of prostitutes, and of frothy bits of satirical illustration, though he was as ready to be irreverent or morbid about history or religion, or about his own associates and activities. Few modern canvases suggest as well as his portraits an understanding of Cézanne's formal aims; for he organizes a figure and a few accessories into a composition with plastic vitality and rhythmic sequence. The effect is, however, nervously alive, sensitively animated, rather than vital with the profound order of movement achieved by the Master of Aix.

It was late in January 1920 that the cafés of Montparnasse and Montmartre turned out their idlers and vagrants and artists to do honour to Amedeo Modigliani. He had died, at the age of thirty-five, of an illness brought to crisis by dissipation, starvation, and cold. He was being buried with honours unknown to him in life. For the first time in many years he lay calm, at peace with the world. He left behind him more than three hundred paintings, of a sort calculated to make easy the gallery-goer's approach to modernism, by reason of their decorative rhythms and melodious passages. Had Modigliani not destroyed pictures recklessly, in fits of resentment because he had not been accorded recognition, or when he was crazy-drunk, or because he had been turned out of his studio, he might have left twice the number. Yet nothing surviving or lost could ever change the fact that a great talent had been half wasted, that one of the potential geniuses of modern painting had been betrayed by his own indulgences, had never really got down to the work he had dreamed of and planned.

Modigliani was born in 1884 in the ghetto of Leghorn, Italy. His parents were poor but not destitute. One grandfather was a banker. The boy was delicate and suffered serious illnesses at fourteen and again at sixteen, and he was badly spoiled by an indulgent and romantic mother. After desultory art training at Capri and elsewhere, the youth went at nineteen to Venice for a year of study. Given money for the adventure by his mother, he spent more time in rounds of pleasure than in classes at the Academy.

CHAGALL: Country Fête (for *Fables* of La Fontaine). 1930–1932
Solomon R. Guggenheim Foundation, New York

Three years later, in 1906, he went to Paris, possessed of funds inherited from an uncle. He took luxurious rooms and set up as an æsthete and a dandy, in emulation of Beardsley, Wilde, and the dilettanti of the *Yellow Book*. Some further lines of influence might have been traced from d'Annunzio and Nietzsche.

Sensitive and introspective on the one hand but aggressive and sensual on the other, the youth let his first months of life in Paris set the pattern for all the following years. He had found it easy to surpass other students and to take school prizes when he cared to apply himself to his studies, but he had preferred to pose as one superior to classroom routine; now he came to despise artists who worked. Establishing himself in Montmartre, meeting Picasso and the other leaders there, he began the cycle of dissipation, enforced rest, recovery, and more dissipation that was to be his way of life to the end.

Failing to make his art pay, and finding the remittances from his mother and brother inadequate for luxurious Bohemianism, he gradually sank to the estate of a café character. Sometimes he had a studio retreat of his own, at other times he simply bunked with Soutine or Kisling, or was deposited unconscious in a room behind a café. He became "Modi" to the Montmartre crowd, though always he stood on his pride when he met strangers inclined to be over-familiar. Handsome, with a finely chiselled face, virile, a good talker, he was popular in all the artist haunts.

With the others he deserted Montmartre for the cafés of Montparnasse in 1907 or 1908. Passionately fond of poetry, he attached himself to the literary groups as well as to the artists. By this time drink and drugs were bringing on serious instability, and Modigliani's painting and drawing became increasingly a hasty exercise designed to raise enough money to assure immediate drink and—less important—food. He would take his portfolio to the cafés and sell enough drawings to cover the evening's needs.

Attractive to women, he let his life become a succession of affairs, many casual, others lasting for months, when someone hopefully undertook the mission of reforming him. By 1910 he was in dire need of reformation. Dissipation had weakened him, tuberculosis had developed, he was repeatedly evicted from his studio-quarters (though he would punctiliously leave drawings to cover the amount of the unpaid rent), and his drunken spells, and his aggressiveness in them, were making him unpopular where he had been most welcome before. Increasingly excitable and tempestuous, he was thrown out of his favourite cafés, which were still the only marketplace for his art.

For a time a poet named Zborowski, who through the experience became an art-dealer, tried to grubstake him, selling his own household goods in order to supply Modigliani with paints and canvas and food and drink. But the artist was beyond possibility of returning to a stable way of life. He would talk still of his early ambitions, especially of his plans to make an intensive study of colour. He had begun with idealism, with fire and poetry, even with a mission—vaguely bound around a notion that the primitives of his native Italy, the Sienese muralists and Giotto, might afford common grounds with the more remote primitives for a union with Cézanne's modernism. But he had been unfitted for study or sustained work. He had given up sculpture, in which he had made a promising start, carving direct in stone, in 1912, because of the ill effect of the marble dust upon his lungs.

MODIGLIANI: Reclining Nude. 1917. *Solomon R. Gugguenheim Foundation,*
New York

From 1915 he settled into physical and moral vagrancy, and into repetitions of the characteristic posteresque portrait painting. He sank at times to hack work: copying, repairing, sign-painting. He even peeled vegetables (alongside Utrillo) for Rosalie, proprietress of an inn that gave him shelter when he was carried drunk from his other haunts. Toward the end he found a woman companion who was like a guardian angel to him, so far as any one could be. She sacrificed her life for him, bore him a child, and suffered cold and hunger with him during the last winter. It was she who threw herself from a window when friends tried to console her the night of the day he died.

Only in the last five years of his life did Modigliani seriously practise painting, and he would have been the first to avow that he had accomplished only a sketch of what his output might, under other circumstances, have been. His work became exclusively portraiture (including nudes) and his portraits are all in one or two veins. Influences upon him ranged from Leonardo da Vinci, Botticelli, and Duccio to Gauguin and Picasso and Cézanne. Especially primitive art, savage art, affected his way of painting, determining the utter pictorial simplification, the dominance of one rhyth-

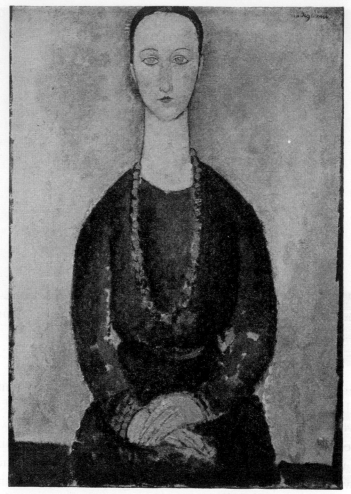

MODIGLIANI: Woman in Blue, Red Necklace. About 1917
Knoedler Galleries, New York

mic motive, and the solving of the complex problems of plane and volume
by means of a few graphic conventions.

Like all the decorative moderns—Whistler, Gauguin, Matisse—Modi-
gliani loses something in comparison with Cézanne or Daumier or Marc.
Then it comes clear that his devotion to form-values is on the lighter,
shallower side. He is content to leave to others the search for ways to reveal
profound order. His plastic solutions are melodious and captivating rather
than symphonic and deeply moving. There are obviously pretty linear
rhythms, melodic runs, and effective contrasts. The figure is elongated,

and the oval of the face, the swan neck, and the in-curving hands have place in an artificial synthesis. If there are background accessories, these echo the main rhythm. The colour is in a limited range but rich in a restrained way. Light and shade are eliminated.

Whenever Modigliani was asked to what school of art he belonged, he would reply: "Modigliani." And truly he created a style, a way of statement, that was his alone. He was a personal expressionist. His work is modern by reason of its departure from realism, of its frankly decorative intention. In the manner of the original post-impressionists, nature is distorted, light and shade are neglected, and a form-organization is created with elements of line, plane, volume, and texture. But the suave disposition of these elements, the rhythmic lilt, is Modigliani's alone. There is something restrained, even classical, in his nudes, a sort of severity that is played effectively against the seductive flow of the body silhouette, a reminder of mathematical order under sensuous display.

The rebellious Italian Jew, the spoiled child, the charming talker, the self-indulgent man, the artist all but lost in dissipation, left this record of his vision, one-sided and limited, but captivating and original. His was a genuine if fragile contribution to modernism.

Picasso had tacitly taken over leadership of the school of Paris in 1909. In the more than thirty years since, it has been in his orbit more than any other that the adventurous young painters have moved. Sometimes their company has included the important, the creative men. More usually the satellites have been imitators, followers, lacking the master's insight and sensibility, and his instinctive command of plastic statement. There has been a company of imitators so manifold and so preposterous that Amédée Ozenfant, who praises Picasso's originality while deploring his waywardness, has devoted a chapter of his *Foundations of Modern Art* to the painters he calls "Picassoids."

The French have been puzzled by and sometimes resentful of the commanding position so long held in Paris by the amazing Spaniard. And indeed Picasso has been by turns a startlingly original creator and a mere virtuoso. He has shown himself a genius but one not above assuming periodically the role of clown or occultist. In any case he has for thirty years held firmly to the position of leader of the school of Paris—because he has been the world's foremost laboratory-artist, greatest of modern explorers in the field of practical æsthetics. In 1909 he had already proven himself

capable of producing magnificent paintings. In the three decades since, he has repeatedly given proof of astonishing originality and versatility.

Pablo Picasso Ruiz was born at Málaga, Spain, in 1881. His mother was an Italian Jewess of a Genoese family named Picasso, his father a Spaniard of Basque descent. The boy learned drawing from his father, an art teacher, so proficiently that already at thirteen he was entering upon his career as painter. Before he travelled to Paris for the first time, in 1900, at the age of nineteen, he had become something of a figure as a precocious painter in Barcelona. In Madrid during the following winter he became known as editor of an art magazine. During a second and more extended stay in Paris in 1901 he attracted the attention of Guillaume Apollinaire, Max Jacob, and Maurice Raynal, who became helpful and influential friends. In 1902 his first one-man show in Paris was held at the little and remote gallery of Mlle. Weill, at a time when Picasso himself was again painting in Spain. The show was so far overlooked that the *fauves* failed, even three years later, to recognize the young Spaniard as a fellow-spirit or to invite him into association with them. He went to Paris to live permanently during the winter of 1903–1904.

During his earlier visits Picasso had been intrigued especially by the paintings and posters of Toulouse-Lautrec and of Steinlen, and the influences of these artists and of the impressionists are easily traced in his early pictures of the cafés and characters of Montmartre. But soon he got back to the real founders of modernism, to Daumier and Cézanne especially, and to Gauguin and van Gogh. There was some influence too out of his Spanish background, from Goya and El Greco. From 1902 to 1905 he was painting in Barcelona and Paris, taking as subjects beggars and street urchins, women of the streets and the girls of Montmartre, and the acrobats and harlequins of the circuses and their families. At this time he had already gone over from realism to a concern with pictorial organization as such. Backgrounds are suppressed, figures are simplified and arbitrarily placed, and there is pronounced though not extreme distortion, as in certain elongated figures and in enlarged hands or feet.

The subjects frequently give the impression of emaciation, and there is an air of sadness about the whole œuvre of these years, created partly by the pervading blue of the colouring. The period 1903–1905 is known as Picasso's "blue period." It may have been the lack of brilliant and clashing colour that led to the failure of Matisse and Rouault and Derain to see

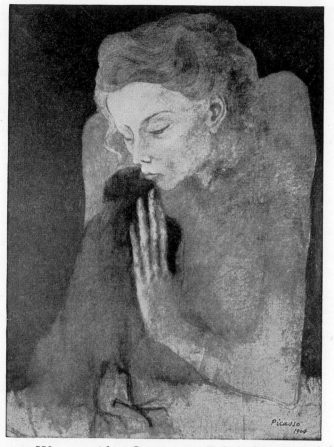

PICASSO: Woman with a Crow. 1904. *Toledo Museum of Art*

Picasso as an ally at this time. In the long view he was creating modernist masterpieces as significant as any produced by the emerging *fauves*.

In 1905 Picasso went to Holland, and coincident with the change of scene the *triste* and attenuated elements began to go out of his painting. A "rose period" followed the blue. The figures thereafter became more substantial, more voluminous, with almost a classical monumentality. The last traces of impressionistic method disappeared; the forms are outlined lucidly and concisely. At this time Picasso, only twenty-five, was already proving himself, in exquisite and expressive drawings, one of the greatest of modern draughtsmen. He was beginning to find a market, moreover—this too may be held to explain the gayer note in his painting.

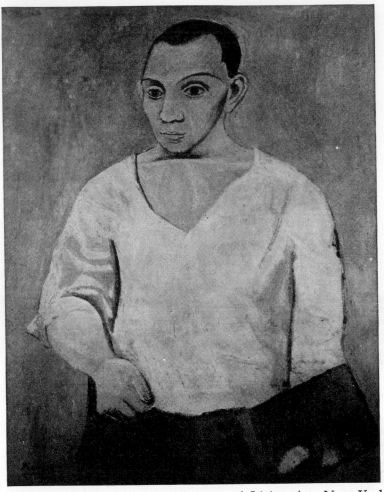

PICASSO: Self-Portrait. 1906. Museum of Living Art, New York

The adventure of cubism began essentially in 1907, when the sculptures of African Negroes led Picasso to experiments in patterning by means of line and plane organization, about central motifs of heavily distorted faces or figures or objects, as in *Les Demoiselles d'Avignon*. In 1908 the accentuated plane-edges appeared in compositions of arranged volumes, and soon there came the definitely geometrized Spanish landscapes. Thence there was the descent into the series of experiments with disassembled and rearranged planes, known as "analytical cubism," and so on to the textural

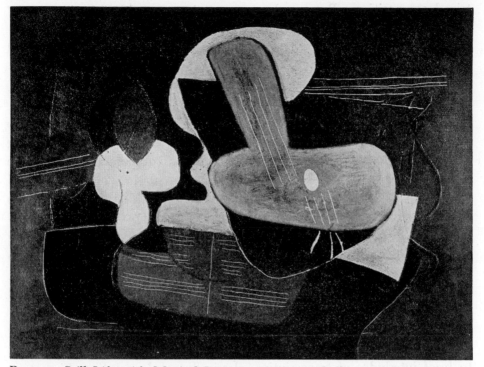

PICASSO: Still Life with Musical Instruments. 1923. *Collection of Mrs. Patrick C. Hill* (Courtesy Museum of Modern Art)

patchwork designing. How much Braque and Derain originated and contributed may always remain a question to be disputed, but that Picasso was the most inventive figure and author of the most significant body of cubist paintings (as well as some of the most trivial) is hardly to be gainsaid. While cubism only moved *toward* abstraction, never in the pre-war years aiming at a purified non-objective art, Picasso did more than any other painter within the school of Paris to make clear that what Cézanne had tried to isolate, what Seurat had crystallized as the organic fabric of his art, what the *fauves* had aimed to fix within their variously rhythmic pictures, was the abstract element, the form element.

From 1918 on, Picasso periodically abandoned his flat-pattern cubism and reverted to representative, even photographically exact painting from nature. In an attempt, apparently, to recapture the interest of the subject, while at the same time creating formal arrangements effective in themselves, he experimented with naturalistic figures within decoratively con-

trived compositions. By 1919 he was entering upon his "classic period," and for a year or two he produced voluminous compositions, obviously arranged for plastic vitality but executed with consideration for traditional ideas of correct representation. There are minor distortions of natural aspect, especially in the over-heavy rendering of arms, legs, hands, and feet, in contrast with dwarfed heads.

The drawings and paintings of this post-war classic period seem to carry on from the point at which Picasso had put aside representational painting in 1907, but there is at once a gain in plastic competence, due to the understanding of pictorial vitality gained from cubism, and an increased respect for exact and revealing draughtsmanship. In his researches Picasso turned back to study thoroughly the one master most likely to be considered at the far pole from the cubists, Ingres, champion of exact drawing as the probity of art. Concurrently he gained from study of an ancient who had distorted at will and had broken all the rules of classicism, El Greco. Out of these elements and out of his own inventiveness, Picasso produced in the years 1919–1925 masterpieces that stand with his best.

During the years that followed he often reverted to the one or the other of the extremes thus established, to further experiments in near-abstraction, to brief interludes of transcriptive, classically ample painting. Each turn was likely to be marked by the discovery of some new idiom or means of expression, a manner of laying out planes (as in a period of curvilinear cubism as against rectangular), a new textural resource, or a form borrowed vaguely from nature—like the "bone" of one of the "bio-morphic" periods. For a time he played with subconscious images, and so entered upon a period of surrealist association. Again he was beguiled away from painting altogether, contributing to the advance of modern stage designing, or again to experimental sculpture. His gifts as illustrator have been unsurpassed in recent times. In view of this record he has with some justice been called the chameleon of modern art.

Almost the last sustained series of paintings in which Picasso avoided extremely distorted or grotesque subjects was a sequence of still-lifes produced in the mid-twenties. Decorative, brilliantly coloured, rich with patterning and texture-interest carried over from *collage*-cubism, they please a wider public than the earlier near-abstractions or the later perversely unnatural compositions. By 1927 the artist is in full pursuit of some plastic reality that he can attain, apparently, only by use of natural forms contorted, of anatomical features separated from their normal placing, de-

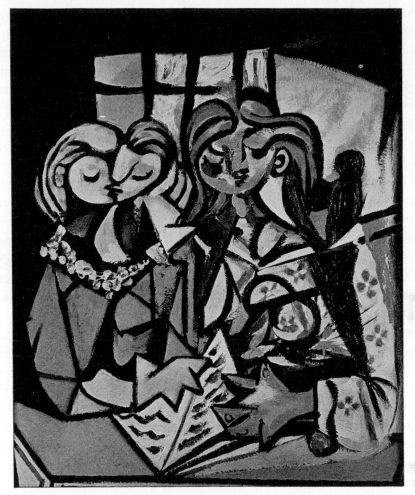

PICASSO: Two Girls Reading. 1934. *Collection of Mrs. John W. Garrett*
(Courtesy Museum of Modern Art)

formed and twisted into plastic entities. Achieving by this means an extraordinary effect of pictorial energy and dynamic movement, Picasso yet alienates most beholders by the violence he has done to normal anatomy.

Even the observer who has arrived at appreciation of cubism, or of the non-objective art of Kandinsky or Klee, may be put off by the garbled eyes, limbs, and breasts of the malformed figures of 1927 and 1928. Characteristically the artist varies his product with "straight cubist" works; and in 1928 he interpolates a gay group of compositions of bathers, known as the

"Dinard beach scenes," which are made up of figures extremely, even preposterously, conventionalized, but without the distressing deformations common to the anatomical paintings produced just before and after them. A certain softness or flabbiness of the forms gives way in 1929 to the hard definitiveness of the figures of a "bone period." From the fantastically misshapen humans of this sculpturesque style there is a reversion to soft female forms, especially in the lusciously opulent pattern pictures, with selective features from nudes, of 1932. In this as in much of his work since 1925 there are surrealist overtones.

The Picasso of the thirties was thus as versatile and unpredictable as the Picasso who between 1905 and 1910 had travelled the arc from the near-romanticism of the harlequin series to the austerities of cubism. When he found himself deeply moved over the civil war in his native country, in 1937, he plunged into anti-Fascist propaganda, notably with a series of powerful and disturbing aquatint etchings entitled *Dreams and Lies of Franco,* and a mural painting entitled *Guernica,* commemorating the destruction of a Basque town by bombing from the air.

Guernica, a thematically obscure panorama-picture in adulterated cubistic technique, caused as loud a controversy as anything produced during the artist's career. The Loyalists listed the painting as the greatest produced in modern times, and some art critics felt that the combination of modern method and burning subject-significance warranted very high ranking. Others were of the opinion that form-values had been sacrificed before the necessities of the theme, and that conversely the formal method —however suited to still-life or abstraction—detracted from clearness of story and thought.

It seems unlikely that *Guernica* will prove, in the perspective of history, one of Picasso's major creative works. It adds one more proof, however, of the versatility and adaptability of an artist who has consistently been changeable and wayward, but one who has made clear that there is a modern way of art, a creative way not opened by men of other epochs, peculiarly suited to expression of the twentieth-century mind. Incidentally Picasso summed up in a single sentence much of the thought that lies behind the modern painter's intention: "Through art we express our conception of what nature is not."

In 1924 André Breton issued the first "Manifesto of Surrealism." Dada was by no means dead at the time, and the dadaist prejudice against reason,

Picasso: Landscape. 1921

sanity, and idealism cropped up in the first document of surrealist theory. What was new was the insistence upon the importance of dreams as revealing a realer reality than that detected by the senses and logic. In art a superreality was to be developed as clear and unexpected and memorable as the images in dreams.

Surrealism was thus a way-station on the long march from camera realism, and to that extent was a characteristically modern development. But it attempted to reverse the main direction of æsthetic progress when it insisted upon the pre-eminence of subject matter and overlooked the gains of modern pioneers on the formal or plastic side. The surrealists sought to restore illustrational painting, substituting objects and scenes dredged from the subconscious mind for the "natural" objects and scenes of the realists. They succeeded in creating a novel and psychologically interesting form of art; but as illustrators they went off on a road divergent from the main course of international achievement.

A certain indecision or instability of the French painters of the generation after that of the *fauves* is nowhere made so apparent as in the

trooping of talented artists to the surrealists' standard. In the fifteen years between 1925 and 1940 surrealism was the one contemporary art movement in France about which books were widely written and headlines published.

Behind the new school was all the cynicism, irreverence, and irony of dada. Civilization had failed; reason was discredited. Nothing could be more futile than serious effort. Let men drift away from the old logical banal art. In withdrawing from the world of reason these disillusioned ones remembered that other known world glimpsed by men in dreams and hallucinations. In that perhaps the artist might find a fresh impulse, unhackneyed materials.

The dream idea opened exciting vistas. Had not Freud proved the superior reality of the subconscious image? Had he not uncovered a whole new realm in the subrational? So the new movement found its second impulse in Freudianism, frequently in Freudianism as popularly conceived, with conspicuous stress upon the secrets and symbols of sex.

There were other and more wholesome aspects of the plunge into the subconscious: one might conceivably discover the well of creativeness from which children occasionally draw startlingly vivid and lovely images. One might free the imagination from intellectual bonds and open the way for instinctive response to divine urgings. But in general the surrealists got no further than the necessity to empty out their subconscious minds, without restraint. And their subconscious minds—and many of their pictures— were as full of hidden sexual imports as the most worldly of Freudian psychologists had prophesied. The new French school became unfortunately involved, moreover, in the popular mind if not actually, with a lot of things that the average citizen and the average artist abhor, along the lines of personal exhibitionism, sex perversion, etc. This was in line, of course, with the negation of all that had been ordered and revered in the intellectually controlled academic world.

There were, however, men drawn to the movement who were among the most promising and most normal of artists, men who accepted Breton's belief in "the superior reality of certain forms of association neglected heretofore," who sincerely wanted to escape "the meddling of reason." Even before surrealism was made the subject of a manifesto, one or two artists had brought dream-recollection to play upon their pictorial composing. Giorgio de Chirico (an Italian born in Greece in 1888), after training in Germany and association with the cubists of Paris, had painted pictures

CHIRICO: Infinite Languor. 1913. *Collection of Mrs. John Stephan, Chicago*
(Courtesy Pierre Matisse Gallery, New York)

in which he fixed something remote and nostalgic and haunting, with
scenes not so much fantastic as familiarly dream-like, with intensely clear
images set out in pitiless open space. Obviously he had aimed at a lucid
quality that Breton described as the integrity of the dream. There was in
his work the unnatural thing that the new school was calling "the reality
absolute" or "the surreality"—though the artist himself rejected the name
surrealism and scorned the school members. Paul Klee also had achieved
an otherworldliness that led the surrealists to speak of him as brother and
guide.

Some of the leading dadaists came over to surrealism easily, especially
Man Ray and Hans Arp. A German, Max Ernst, was perhaps the most
important creator to go from one group to the other. Originally active in
radical circles in Berlin, he had been leader of the Cologne group of post-
war dadaists, and he went on to become one of the most interesting of the
reporters of the subconscious. His paintings in a free, semi-automatic style
of linear tracery overlaid with wash, full of cryptic forms like those in the
pictures of Picasso's bio-morphic period, are pleasingly fluid and melodious,
and in meaning teasingly puzzle-like, especially in the series that includes
The Kiss and *Night of Love*. He painted a second famous series dealing
with fabulous birds, in a manner at once disarmingly child-like and slyly
sophisticated.

But the most significant of the paintings of the surrealists may be judged
(after fifteen years of practice and exhibition) to be the works of painters
who have paid no more attention to the images found in the subconscious

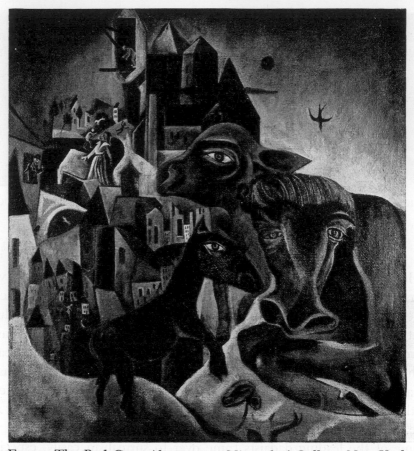

ERNST: The Red Cow. About 1924. Nierendorf Gallery, New York

than to the problems of form-organization. In other words, the most suc-
cessful of the surrealists are those who have been fellow-travellers with the
abstractionists or the form-seekers of modern art. Most creative and most
rewarding has been the Spaniard Joan Miró, who progressed from his
perverse dadaist conglomerates of the early twenties to engagingly decora-
tive improvisations, near-abstract, spontaneous, musical, in the late thirties.
He was accused of deserting the cause in retaining so little of "meaning,"
reasoned or dreamed, in his pictures; but it is of more import to the world
at large that he became an abstractionist worthy of place close to Kan-
dinsky, Marc, and Klee.

André Masson emerged as the most original and fecund of the French

MIRÓ: Flight of the Bird over the Plain III. 1939. *Pierre Matisse Gallery,*
New York

members. His near-abstract improvisations seem definitely in the nature of automatic painting. Reason has been denied as a guide to the hand, but there is only secondary reference to the subconscious as a receptacle of images. This is, indeed, "free" painting in an ultimate sense. Curiously enough Breton, who had adjured his comrades in 1924 to "let your subjective being pour out its content without restraint and you shall be free, wholly free," who had advocated "psychic automatism" as the type method of surrealist creation, undertook to read out of the school in 1929 Masson and Miró, along with many others of the original group. The excommunicated faction retorted that a few dictatorial leaders with a specialized way of pouring out their psychic contents could not restrain others from purging themselves in whatever manner they might wish, and that their output would be surrealism, too.

Hans Arp, who had once been close to the Blue Knights of Munich and then had come under the influence of the neo-plasticists and the dadaists,

MASSON: Woman Pursued. 1932. (Courtesy Pierre Matisse Gallery, New York)

followed, in the surrealist camp, a mode of design similar to Miró's in its simplifications and its cleancutness, though rather severer. His shapes often suggest natural forms but are obviously manipulated and arranged primarily for plastic ends.

Of the members who leaned toward dream-picturing rather than automatism, Yves Tanguy and René Magritte achieved individualistic methods, and Magritte especially put into his strange architectural scenes something of the sharp lucidity and of the sense of spatial loneliness characteristic of dreams. Magritte and the Spaniard Salvador Dali are at the far pole from the semi-abstract Arp and Miró in that they employ a meticulous realism in details of their pictures. It is only the arrangement, the order, that is unnatural, illogical. Dali, with a talent for publicity, believing that the irrationalities of his subconscious self are as significant in the field of artistic materials as a discovered landscape or an arrangement of still-life objects, has kept the perverser side of surrealism in the newspaper headlines for years. An exquisite craftsman in paint, he delights in startling juxtapositions of objects unrelated in nature, in disquieting reversals of normal functioning, and in covert second meanings. (Even the titles indicate his intention: *A Chemist Lifting with Precaution the Cuticle of a Grand Piano* and *The Weaning of Furniture-Nutrition.*) In that he has

MAGRITTE: Mental Calculus. 1931. *Collection of Leon Kochnitzky, Paris*
(Courtesy Museum of Modern Art)

lacked the formal sense of a Miró or a Masson, he has added less to the
world's store of æsthetically potent art.

One sometimes suspects that the apparently illogical and spontaneous
outpourings of a Dali or a Tanguy are not so far removed from purposeful
and pragmatic considerations as the surrealists would have us believe. There
is sly purpose certainly in the very perversity of some of the associated ideas.
Yet when a significantly creative artist of the stature of Miró tells us that
"my painting is always conceived in a state of hallucination created by a
shock either objective or subjective, of which I am utterly irresponsible,"
we can scarcely doubt that he has wholly turned away from those sources
from which painters in the past have taken subjects or inspiration. Miró
adds: "As to my means of expression, I strive to attain more than ever the
maximum of clarity, power, and plastic drive, first to create a physical re-
action, then to reach the soul."

At a point where influences from cubism and surrealism flowed together,
a group of Parisian painters, including the expatriate Russian Léopold
Survage (or Sturzwage) and Jean Lurçat, a Frenchman of Spanish ances-
try, experimented fruitfully in near-abstraction. Lurçat, influenced deeply
and repeatedly by Picasso, expressed himself in distinctive "landscapes,"
notable alike for plastic invention and for a dream-like reality.

LURÇAT: Landscape by the Sea. 1930
(Courtesy Pierre Matisse Gallery, New York)

Of France in the twentieth century it remains only to record that pure abstraction had its champions in Paris, as in Germany, England, and America, in the decade of the thirties. A group called "*Abstraction-Création*" brought together some of the older men out of the neo-plasticist, purist, and other movements and younger artists aware of the general trend toward an art uncontaminated by nature. Jean Hélion in particular developed a clear, simple, "sign-like" type of painting in which colour weighed heavily, thus bringing to culmination the retreat from cubist and purist colourlessness and preoccupation with "shapes." But it was in Germany that abstract painting was coming to maturity, in those years.

In 1933 the leaders of the new Germany began a purge of the elements that they considered degenerate in the national art. Within two or three years they had eliminated from the public galleries most of the creative works of twentieth-century German painters, had made the country unsafe for experiment, and had exiled the progressive merchants and promoters of modern art (whom they stigmatized as Jewish-Marxist dealers and critics).

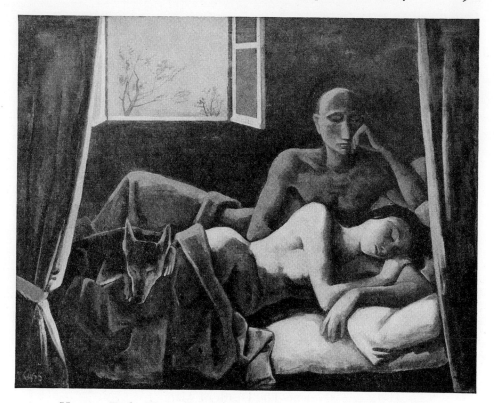

HOFER: Early Hour. *Portland Art Museum, Portland, Oregon*
(Bissell photo)

No more drastic and tragic elimination of the creative elements in a na-
tional culture had been known in history. Two groups of painters especially
were affected: the expressionists, who had carried on the emotional-
expressive aims of the pre-war members of the *Brücke* and *Blaue Reiter*
groups; and the active school of abstractionists, international rather than
specifically German, that had its centre at the Bauhaus in Dessau.

The Nazis termed the period 1918-1933 "Germany's era of shame." In
the first five years of that era modern art had found in the German states
a public and official acceptance beyond that known to other lands. As
against the two or three important galleries open to modernism in the
early twenties in France, England, or the United States, there were fifty
state and municipal museums in the Reich displaying the works of post-
impressionists, *fauves*, and expressionists as the normal contemporary art.

Within a week after administration of the Republic had been taken

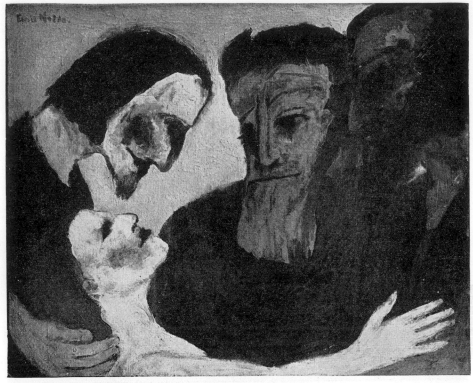

NOLDE: The Death of Mary

over by a Socialist government in 1919, an enterprising museum director
had placed before the leaders a pamphlet arguing that only the new art
could fitly represent the culture of the new German state. From then on
the modernists were powerful in the art life of the nation. Leading radicals
became teachers in the art schools, more than any other country in the
world Germany produced books about and reproductions of the works of
the post-realistic masters, and only in Germany could the traveller discover,
day after day and week after week, exhibitions of the whole range of new
creation, from Daumier and Cézanne to Marc, Kandinsky, and Kokoschka.
For more than a decade the centre of modern experiment and of modernist
interest seemed to have shifted to a point east of the Rhine.

In the years of uncertainty and turbulence between 1919 and 1924 the
artists suffered hardships with the rest of the people of the new Reich. The
expressionists, however, had the satisfaction of seeing their pictures hon-

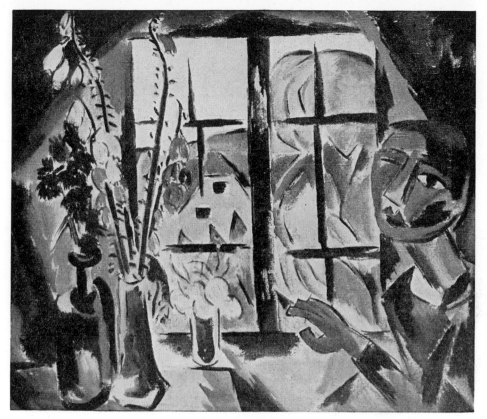

SCHMIDT-ROTTLUFF: At the Window
(Courtesy Nierendorf Gallery, New York)

oured in public exhibitions, and they were the subjects of a flattering number of pamphlets and monographs. The State Gallery in Berlin was but one that opened spacious rooms to *Neue Kunst* displays, with comprehensive permanent collections and periodic one-man shows. The artists honoured at Berlin in the twenties included the members of the 1904–1905 group, Heckel, Kirchner, Pechstein, Schmidt-Rottluff, Nolde; and of the Munich group headed by Marc (already dead) and Kandinsky. Kokoschka was considered a master worthy to rank with the foremost international pioneers, Cézanne and van Gogh and Munch. A few new names crept into the expressionist lists: Heinrich Nauen, Christian Rohlfs, Otto Mueller, and Max Kaus. These were all men fully in the *Brücke* tradition of emotional intensity and impetuous statement. From Munich too there were

recruits not earlier recognized as in the first rank of modernists, especially Karl Hofer, Heinrich Campendonk, and Josef Eberz.

Germany at this time was witnessing its share of the perverse nonsense and subversiveness of the post-war dadaists, and a few artists slid over naturally into surrealism. But a main direction of national advance was maintained along the characteristic expressionistic line, and the foremost painters seemed bent single-mindedly upon the task of achieving plastic power. A critic of the era spoke of their slogan as "strength, courage, force"; and something in the nature of powerful plastic construction was to be marked in the paintings alike of the veterans Nolde, Schmidt-Rottluff, and Pechstein and of the more youthful Kaus and Campendonk.

The same strength and almost overpowering pictorial "drive" may be detected in the works of Max Beckmann, of the older generation (born in 1884) but a comparatively late arrival among the expressionist leaders. One of the masters of plastic orchestration, Beckmann chose to make no concessions to popular or conservative taste, and he slashed through to his pictorial solutions with a heavy hand, often in the service of subjects commonly considered trivial or unpleasant or brutal. And indeed there was a pathological aspect to his work, as if his distortions were less for artistic purpose than to reveal a pervading distortion detected in life about him. It was this that led the Nazis to attack him as one of the worst offenders among "degenerate" painters, and to drive him into exile in Paris, then Amsterdam.

In a sense Beckmann's offence was a too real rendering, in pictorially moving terms, of certain features of German life. A second artist sinned, in the view of the Nazis, even more heinously in that direction. George Grosz, also a master of picture-building in the typical powerful German manner, began frankly as a satirist of life as it was being lived in the Reich during the post-war era. No artist was ever more graphic, more savage, and more disturbing in mirroring hypocrisy, injustice, and vice. In drawings and paintings combining exact naturalism with broad distortion he scathingly accused officialdom and the ruling classes of the crimes bred of personal appetites, political corruption, and a materialistic social order. Without humour, bitterly, he satirized those in power, exposing the sorest spots in a diseased civilization.

Even before the Nazis took over the Government, Grosz's portfolios of drawings were condemned and suppressed; for it was clear that his pitiless delineations of arrogant and sensual officials and profiteers, beside the war-

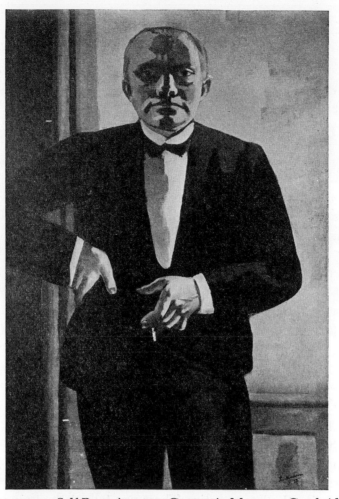

BECKMANN: Self-Portrait. 1927. *Germanic Museum, Cambridge*
(Courtesy Buchholz Gallery, Curt Valentin, New York)

maimed and the poverty-maimed, were calculated to breed social discontent and political bitterness. He carried over into painting something of the same approach and a method similarly combining the greatest naturalness of chosen detail with distortion and elision for plastic effect.

Driven from Germany, Grosz came to the United States in 1932 and began a slow reorientation of his æsthetic sensibility and his plastic powers to life around him. Necessarily, so soon after uprooting, he has left out of his recent work the very elements by which he first became known as a modern master: social awareness, intense emotional feeling, biting satirical

GROSZ: Portrait of Dr. Neisse. 1927
(Courtesy Museum of Modern Art)

comment. But within the limitations of one who still is observer of a new
milieu he has continued to create paintings that have unmistakably a mas-
ter's stamp upon them.

Grosz was one of a group of artists who gained the name of verists in
Germany during the late twenties. There was talk at the time of *die neue
Sachlichkeit*, best translated, perhaps, as "the new objectivism," and it was
pointed out that artists such as Grosz, Otto Dix, and sometimes Beck-
mann embedded in their expressionistic frameworks bits of objective reality
more meticulously exact, more terribly real, than the most naturalistic
passages in the works of the artists frankly photographic in their aims. Leibl
had taken steps in this direction before the turn of the century, forcing the
naturalism of the rustics' faces to an unnatural intensity and precision of
detailing. About the time of the birth of expressionism, Paula Modersohn-
Becker had achieved a similar effect, as in *Peasant Woman Praying*. But
Grosz and Otto Dix carried the method to its culmination, Grosz espe-
cially holding to the extremest post-realistic freedom in his pictorial struc-

Dix: The Artist's Mother and Daughter. *Nierendorf Gallery, New York*

ture and larger layout, while lavishing upon detailed parts a passion for lucid, exact statement.

Grosz made the method a servant to his desire to show a decadent society its own frightening reflection. "The verist," he once wrote, "sets up a mirror in which his contemporaries may see their own grimaces." And he added: "I have designed and painted out of a sense of opposition. I have tried in my pictures to show that the present society is ugly, sick, and hypocritical." Otto Dix, on the other hand, utilized the actuality of verism to present his feeling about a wide range of subjects and objects. Some of

his paintings of the war and of the Communist disorders are as terrible, as shocking, as Grosz's works; but his portraits formed the more characteristic examples of the new objectivism. As Marc had tried to intensify the feeling of the tigerishness of the tiger by his plastic distortions, so Dix tried to intensify the image of, for instance, a child, by dwelling lovingly, and microscopically, upon the golden hair, the smooth curves, and the delicate hands to the exclusion of all else, sometimes in contrast with the wrinkled features and bony hands of an old person.

What really took place under the banner of verism was a joining of a certain larger freedom out of expressionism, manifested in the familiar idioms of distortion and emotional intensification, with a passion for objective, exaggerated detailing in key passages. The expressionist's impetuosity was restrained while the painter became a virtuoso in the field of the close-up. Some critics ascribed the movement to socialistic-minded painters who wished to hold onto the gains in formal design made by the succession from Cézanne to Nolde and Kokoschka, while conveying objectively, in concrete illustration, the lessons of a class-divided, decadent civilization. And certainly as verism expressed itself in Germany, the disillusioned, not to say embittered, artists turned out to be the giants of the movement.

Germany had, of course, many artists socially conscious and eager to advance "causes" by means of their pictures, but in general they reverted to explicit realism. One alone of those normally realistic achieved a worldwide reputation. Käthe Kollwitz drew and engraved and painted the poor and the starving as she knew them in Germany's cities. By reason of her magnificent draughtsmanship and the utter integrity and sincerity of her work, her drawings and prints became known to the peoples of all the continents.

No one since Daumier has put so much of power and of simple understanding into pictures of people of the streets. As she only occasionally achieved the intensity of formal beauty which seemed instinctively to inform Daumier's picturing with crayon or brush, she has taken place upon the edge of the field of modernism rather than at the centre of it. But it would be a narrow definition of modern art that would exclude entirely her moving and monumental record of the tribulations of the poor, of their sicknesses and their meagre pleasures, of their suffering under war and unemployment, and of their futile uprisings. Literally Käthe Kollwitz gave her art-life to the cause of the poor. Stripped of official honours that had been awarded in more liberal times, she was, in 1940, after nearly a half-

Kᴏʟʟᴡɪᴛᴢ: The Outbreak. Etching. *Kleemann Gallery, New York*

century of known Socialism, still in Germany, and was then perhaps the only world-famous radical, still defiant, whom the Nazis had not dared to liquidate.

In Germany as elsewhere the several types of painting from dullest academism to freest expressionism appeared side by side. Occasionally an artist succeeded in fulfilling the new formal aims without distorting nature to the point of alienating the conservative critics and public. Karl Hofer was a temperate modern of that sort. He brought an extreme simplification to his picturing, harked back to Cézanne and the cubists for his knowledge of rhythmic patterning, and emerged as one of the most likeable of moderate expressionists. His paintings in dulled earthy colours, strong and serene, found ready welcome in America, especially in the Far West, and measurably influenced some younger painters. Hofer, incidentally, has managed to escape the displeasure of the Nazis at home. In the

HOFER: Bread and Wine. Nierendorf Gallery, New York

same way bridling his expressionism, but leaning more to the decorative side, was Heinrich Nauen, another of the later recruits to the Kirchner-Nolde group. A lush colourist and a master of surface patterning, Nauen pleased a public that could not go on to Kokoschka and Schmidt-Rottluff and Beckmann.

A considerable school of Germans imitated Matisse, and with one, Hans Purrmann, the results were acceptable as decoration even if not quite original. There was more of individual invention, and of German strength and distortion, in the compositions of Otto Mueller, a painter who seemed to

HOFER: *Village in Ticino. 1930. Buchholz Gallery, Curt Valentin, New York*

stem from Gauguin even while expressing himself in dulled colours and angular figure-arrangements. These all were artists who tempered the characteristic German radicalism, who avoided ruthless deformation of nature and even cultivated refinement of statement. Not so Heinrich Campendonk, a designer with extraordinary plastic powers but given to the most disturbing excesses of distortion and misrepresentation. He was the last great painter to join the group of emotional expressionists—though the German art journals of 1925–1933 were filled with expressionistic pictures by younger and sometimes thoroughly able recruits.

In Germany before the war, abstract painting had been considered a part of the larger expressionistic movement. "Abstract Expressionism" was a common chapter title in books and pamphlets about the new art. When Kandinsky returned from Russia to Germany after the war he joined with a group of artists who were destined to provide the Western world with its

CAMPENDONK: Saturday. Solomon R. Guggenheim Foundation, New York

first considerable school of abstract painters. He and his associates brought to convergence the lines of international development, from France, Holland, and Russia as well as Germany, in service of an independent, non-objective visual art.

Walter Gropius founded the Bauhaus, a school for research in and teaching of typical machine-age design, in Weimar in 1919. He visioned the new contemporary architecture and industrial design as arising at the point where engineers and machine-tenders joined with the painters of abstract pictures and the cutters of abstract sculpture. Three painters were called to the Bauhaus to make their contributions to a machine-age æs-

Mueller: Girls in the Woods. *Kunsthalle, Hamburg*

thetic: Paul Klee, once a member of the Blue Knight group; Kandinsky, co-leader of that group with Marc; and Lionel Feininger, a German-American, who had been in Paris during the incubation of cubism and then had thrown in his lot with the German radicals. Through those and other artists not primarily painters a thorough sifting of the abstract 'isms was accomplished at the Bauhaus, with direct influences flowing in from the Dutch *De Stijl* group and from the Russian suprematists and con-structivists.

As against the larger band of emotional expressionists, still dealing with the phenomenal world, however distortedly, the men of the Bauhaus formed a specialized cult, with limiting notions about clarity of statement and cleanness of technique, and about a desirable complete escape from representation. Just as the new architecture was to be absolutely functional, stripped of every ornament and effect of historical styles, so the new paint-ing would be pure, innocent of nature, disembodied. Under the leadership of Kandinsky, who had been first among artists to proclaim absolute ab-

KANDINSKY: Improvisation. 1912. *Solomon R. Guggenheim Foundation,*
New York

straction as a goal, back in 1911, the group went on to explore, through
half a dozen outstanding talents, the land of non-objectivity.

The Bauhaus organization moved to new buildings at Dessau in 1926,
buildings illustrating admirably the ideals of machine-consciousness and
functionalism. Strangely the painters who had contributed to this demon-
stration of an emerging twentieth-century architectural art shortly found
their own art suspect and slurred over at Dessau. Painters were wanted
there because their principles of design were to be taught to architects and
industrial designers under the new dispensation; but painting as an art (like
the handcrafts) was commonly said to be on the way out, *passéiste*. Never-
theless, the individual painters continued their creative, non-collaborative
work—and fortunately, for no other display of abstract and near-abstract
pictures quite equals, for variety, æsthetic evocativeness, and sensuous love-
liness, that of Kandinsky, Klee, Feininger, and certain younger artists trained
by them.

Kandinsky continued to seek musical expressiveness along the lines fore-
shadowed in his pictures and his writings of the *Blaue Reiter* days. He
progressively deleted the softer idioms of his earlier abstract style, straighten-

KANDINSKY: Emphasized Corners. 1923. *Solomon R. Guggenheim Foundation, New York*

ing and hardening his lines and bringing patches and spots of colour clearer, all perhaps in subconscious response to his new machine-age environment. It is questionable, however, that he ever did better work than that of the years of the pre-war association with Marc at Munich.

Paul Klee went his joyous and inventive way, always limited to a child-like slightness of expression, but pushing into an amazing variety of pic-torial bypaths. Seldom did he, in the years between 1919 and his death in 1940, exclude known objects, or vague suggestions of them, from his paint-ings; yet the object counts so little, the formal arrangement, the plastic melody, so overwhelmingly, that he has been classed, justly, as of the ab-stract school.

KLEE: Landing Boat. Water-colour. 1929. *Buchholz Gallery, Curt Valentin, New York*

Nothing was too inconsequential to evoke within Klee an image to be fixed as a pictorial composition. A tree or a cemetery, a face or a bit of patterned cloth, a machine or a fish, a church or a costume or a bit of musical notation: each started his brushes to moving, semi-automatically, over the paper or canvas. Inheritor from the pioneers of modernism who had especially explored mysticism and fantasy, from Blake and Redon and Ensor, this Swiss artist skirted the edges of all the usual fields of fantasy. The observer of his paintings feels rather that here is a gallery of reflections from a mind whimsically illogical, even capricious, but seldom expressing itself other than harmoniously, in ordered plastic patterns. The inventiveness is not without humour, as in *The Twittering Machine* or *The Musical Family at Dinner*, or again grotesqueness. But in general it is the sheer melodious invention that is of paramount significance. The unexpectedness of the images, the child-like naïveté, the surprise that so little can make a picture, all this enters into the beholder's response. But the ultimate answer is that Klee was a natural improviser in the field of formal organization; there is a touch of formal magic in whatever he put his hand to.

KLEE: Red Columns Passing By. 1928. *Collection of Edward M. M. Warburg, New York.* (Courtesy Buchholz Gallery, Curt Valentin, New York)

The third painter among the Bauhaus masters was the American-born Feininger. Gone to Europe to study music as a youth, he stayed to study painting, in Germany, then in Paris at the height of the excitement over cubism. Curiously, in all his later years in Germany he never quite lost the feeling of angular intersections and crossing planes that he adopted into his painting method while a disciple of Picasso and Braque. He went on to an individualistic way of expression, in picturing that is of a Whistlerian slightness, with something of the thinness of coloured drawing. More than Kandinsky and Klee he held to the subject, taking his themes from architecture, landscapes, and especially the sea and ships. Musician as well as painter, interested in pictorial creation rather than in pictorial transcription, he never leaves a doubt that it is the feeling behind the subject, and the abstract plastic solution, that have intrigued him as artist, that he counts the transcriptive elements as secondary.

Seldom attempting what might be called full-bodied painting, Feininger has produced perfect picture-decorations for houses in the new simplified

KLEE: Landscape with Yellow Birds. 1923. Nierendorf Gallery, New York

architecture, pictures faintly geometrical, cool-coloured, unobtrusive. (It is permitted again, one may believe, to have pictures in modern homes, since the dangers of a too sanitized, too sterilized domestic architecture have passed.) In recent years Feininger has been again in America, hardly of the native group of modern painters but an added individual creator. In New York in 1941, on the occasion of his seventieth birthday, he was accorded a retrospective exhibition, wherein the public was able to see just how much of an individualist he had been, not only back through the Bauhaus days but even in the student years in Paris, and on into the late years in America.

When the Nazis wiped out the Bauhaus as an entity—it had coupled democratic and socialistic aims with its art training, so that its offence was double, involving the teaching of political liberty and social co-operation as well as a liberal attitude in the arts—they drove out of the country all

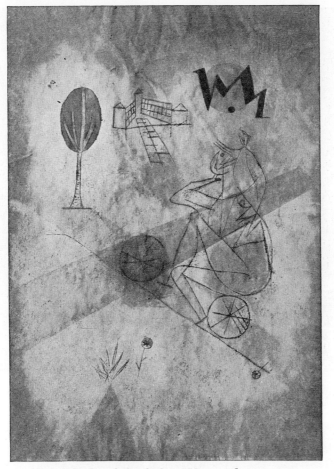

KLEE: Scale of Twilight. Water-colour. 1921.
Collection of James Johnson Sweeney, New York.
(Courtesy Buchholz Gallery, Curt Valentin, New York)

the artists associated in the venture. Klee went to his native Switzerland, Kandinsky to France. All the others ultimately found their way to the United States, where Gropius and Mies van der Rohe turned to teaching architecture. Two others, the designers Ladislaus Moholy-Nagy and Josef Albers, had been known as members of the German school of non-objective painters, and they, like Feininger, in 1941 were part of the vanguard of the forces marching away from realism in America. Thus political upheaval has served to redistribute the leaders of that school of painters which had most

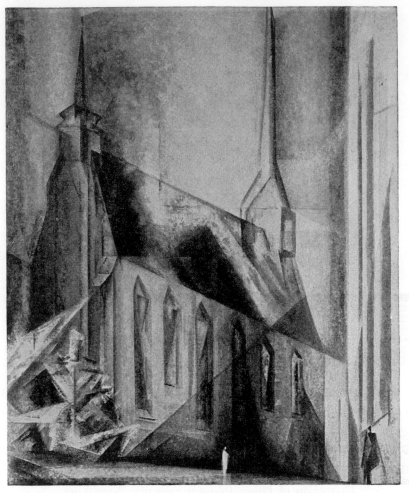

FEININGER: Church. *Nierendorf Gallery, New York*

effectively brought to focus the influences out of three decades of abstrac-
tionist experiment, and America has profited most by the redistribution.

In 1939 New York, already possessing one public museum dedicated to
abstract painting, the Gallery of Living Art, was provided with a second
and more purified shrine for non-objectivism. The gallery of the Solomon
R. Guggenheim Foundation turned out to be, indeed, the world's largest
and more comprehensive show-place of non-representative art. The found-
ers precipitated something of a controversy when they insisted that ab-

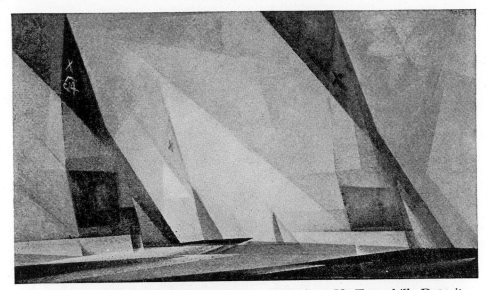

FEININGER: Sail Boats. 1929. Collection of Robert H. Tannahill, Detroit
(Courtesy Buchholz Gallery, Curt Valentin, New York)

straction in painting is not enough, is really a way-point on the road to
non-objectivism (abstraction meaning something taken out of, distilled
from the real or the concrete, something retaining, usually, suggestions of
the objective source). They served to introduce to American gallery-goers
a German artist not formerly known so well as Kandinsky, Klee, and the
French cubists and purists: Rudolf Bauer. They built the foundation's ex-
hibit around his work in particular, showing no fewer than ninety-five of
his pictures, though they neglected no major figure in the march from
expressionism through the stages of abstractionism to the non-objectivists.

Bauer, after he had outgrown his academic training, had been a mem-
ber of the group publicized by the *Sturm* galleries in Berlin, and had then
gone on to independent service in the cause of an art of disembodied paint-
ing. His own works have been most like Kandinsky's, though it has seemed
to some observers that he lacked something of the Russian's intuitive feel-
ing for plastic rhythm.

The theory of abstract painting had been as well set forth by Kandinsky
in his writings of the 1911–1913 period as by any later writer. In America
both the Gallery of Living Art and an artists' group, the American Abstract
Artists, published instructive and spirited defences of non-representative

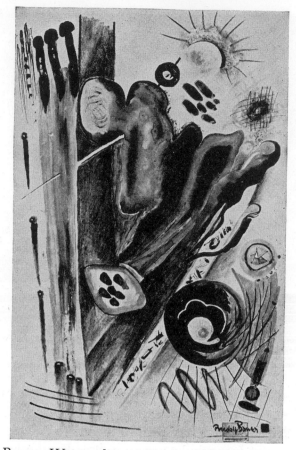

BAUER: Power. Water-colour, tempera, and Chinese ink. 1924.
Solomon R. Guggenheim Foundation, New York

painting, conveying something of the painter's sense of freedom and ad-
venture once he has broken through the bondage of objective and literary
content. The Guggenheim Foundation group has gone further than these
others in claiming spiritual and cosmic significance for the pure non-
objectivists. In fact the foundation's basic proclamation is that "non-
objectivity is the realm of the spirit."

Hilla Rebay, in a publication of the foundation, summed up the case
for the absolutists in these words: "A painted copy of nature, no matter
how charming the texture or interesting the style, is not a real creation.
. . . The purity of space on a virgin white canvas is already ruined by an

BAUER: Orange Square. 1935–1937.
Solomon R. Guggenheim Foundation, New York

objective beginning. . . . Ability to feel refinement in this pure white given space is the first start towards the non-objective picture. Why not use this basic feeling of space given between the four sides of paper or canvas, and bring it to life in a concentric organization with rhythm of form, themes of new invention, and motives of inner relationships? . . . Why not make the intuitive sense of creation as visible as music makes it audible?" And she opened the way to thought upon the obsolescence of realistic art when she wrote that "the child of this century is bored by representations unless they move constantly, charged with unexpected thrills, as offered by the motion pictures. Representative painting formerly was

NASH: Void: On the Ypres Salient. 1918. National Gallery of Canada, Ottawa

necessary to offer to the earthly intellect views of lovely situations with design, light, shadow, and colour. All this now is given by photographs and colourprints, while in addition the cinema offers the nearest perfection for representing natural life in fiction. . . . The non-objective picture stands by itself as an entirely free creation, conceived out of the intuitive enjoyment of space."

In 1939 the leading British art journal, the *Studio*, published a special autumn number under the title *Contemporary Art in Europe*. In an introductory essay Anthony Bertram attempted to pierce the fog of confusion that had settled over the Continent, and he summed up a good deal of his own (and England's) unbelief and doubt in a single laconic sentence: "Europe is growing old." It would be dangerous to enlarge upon the idea; but considered in connexion with Élie Faure's valedictory upon French

NASH: Raider on the Shore. Water-colour. 1940. (Courtesy British Ministry of Information, and Museum of Modern Art. Crown copyright reserved)

painting in 1930 and the even more extreme pronouncements by Herbert Read upon the lack of a characteristic modern art in England, it affords a clue to the indecision and the lack of faith evidenced on the other side of the Atlantic in the period between two world wars.

England's last great modernist was born in the eighteenth century and died in 1851. Since the death of Turner only Whistler's residence in London has linked British art life closely to the revolutionary changes on the Continent. The English have preferred realistic art, and the volume of first-rate art-expression in what is slightingly termed by William Orpen "the Franco-German manner" has been almost negligible. Modernism, in short, never has taken root in England as it has in France and Spain and Italy, in Mexico and the United States, as it once took root in Germany.

As early as 1885 an organization named the New English Art Club promised to bring to flower a British modern painting nourished upon the latest Parisian ideas. But somehow the artist-members never progressed beyond a modified impressionism. Even after the opening of the twentieth century

Wood: Dancing Sailors, Brittany. *Collection of Mr. and Mrs. L. K. Elmhirst, England* (Courtesy Studio Publications, New York)

the attractively free and fresh but formless paintings of P. Wilson Steer and W. R. Sickert were considered characteristic new English art. A little later Roger Fry and Clive Bell aroused all the English-speaking nations to an interest in what they aptly named post-impressionism; but Fry in his own paintings proved that intellectual understanding and enthusiasm could not alone endow an artist with form-creating ability. After the Grafton Gallery Shows of 1910 and 1912 (corresponding to the American Armory Show of 1913) the more radical painters formed the London Group, about which later insurgent efforts revolved; though the vorticist episode during the war years and a foray by an abstractionist group in the thirties, under a banner inscribed "Unit One," enlivened London briefly.

Out of all the organizing, seceding, exhibiting, and propagandizing, only three or four names came into international prominence. Fry was soon forgotten as a painter but gained lasting respect as a sensitive and helpful critic. Augustus John, long praised as England's leading modern, has up-

held his reputation as a great realistic portraitist, with an exceptional talent for liveliness and unconventional grace; but in the end he failed to exhibit that mastery of form-organization which had seemed to be hinted at in his early painting. He barely touched into the territory of modern painting as it is defined elsewhere.

The one artist who achieved a distinctive and authentic personal style was Paul Nash, born in 1889, and therefore an impressionable student at the time of the Grafton Gallery shows. His gift has been somewhat intellectual, and a certain austerity controls his designing. But he is the outstanding English master of the abstract values in painting, and his canvases invariably evoke an æsthetic response. He has been a leader of the group in England that corresponds to the American Abstract Artists, but outside his own country he is best known for paintings picturing phases of war, dating both from the first World War and from the events of 1940–1941.

C. R. W. Nevinson has been the most typical product of the agitation for an English modernism in line with the French advance. Long resident in France, intimate with the leading members of the school of Paris, for a time a disciple of the futurists, an experimenter in various new modes, he ultimately backslid and confessed that at heart he was an impressionist, abandoning all attempt to capture plastic order in his canvases. His most engaging work is that of the period when he succeeded in catching, not profoundly but cleverly, the rhythms brought into painting through the researches of the *fauves*, cubists, and futurists.

The very opposite was true of Christopher Wood, who made the new non-realistic manner his own, in fauvishly simple, brightly coloured pictures touched with the naïveté of the modern primitives. Perhaps the most accomplished and promising of the younger English painters, he killed himself in 1931 at the age of twenty-nine.

In Sweden, in Italy, in Hungary, in Spain, in Holland and Belgium and Poland the modern spirit entered into the younger painters. Some countries sent their most talented men to study, then to stay in Paris. Others saw minor flowerings of the new art at home. The giants in so far as they made history did so within the school of Paris, especially van Gogh and Picasso, where also Modigliani and Chirico, Chagall, and Pascin were to be found. By exception the Russian Kandinsky and the Austrian Kokoschka came to rest within the German schools. There were left at

Stockholm and Budapest and Vienna and Rome rather less than inventive national schools. The new flowerings, after the German, were taking place on the soil of America.

XVII: NEW LIFE IN THE AMERICAS

B Y 1910 Cézanne had become one of the recognized prophets of mod-
ernism, and Ambroise Vollard was accustomed to display one or two
of the master's canvases in the window of his art-shop on a Paris boulevard.
On a day in February of that year there occurred outside the shop an in-
cident not without international significance. Early in the morning an
ungainly young giant, swarthy and obviously foreign, took up his stand
outside the window. He stared immobile at the Cézanne picture, moved
about, craned his neck, came back to stare immobile again. Toward noon
Vollard noticed that the stranger was still there, obviously in a state of
excitation. When he went out to lunch and again when he returned the
youth was there. From annoyance Vollard's mood turned to one of inter-

OROZCO: Prometheus. Fresco. 1930. *Pomona College, Pomona, California*

est. He took the picture from the window and substituted another of the master's works. Throughout the afternoon the performance continued, the dealer placing one superb painting after another on the racks, the youth enraptured still, till Vollard closed the shop for the night. Thus Diego Rivera discovered Cézanne. No other event of his life ever meant so much to his art—unless it was the subsequent realization, back among his own people, that he wanted to paint Mexican, not European.

Diego Rivera was one of thousands of foreign students who had gone to France to seek training in the latest methods of art. The time was at the height of Europe's interest in the primitive expressions, when Picasso and the *fauves* were trying to reconcile Cézanne's discoveries with elements out of Negro and South Sea and neolithic primitivism. Rivera, a Mexican and therefore part Amerindian and partly of European lineage, was ideally equipped to feel his way into a combined primitive and European-modern way of statement. And indeed Mexico more than any other country was destined to produce the finest flowering of post-fauvist, near-primitive painting in the years 1920–1940.

When he stood before the Cézannes in Vollard's shop window, Diego Rivera was twenty-three. He already had behind him a considerable experience of study and travel. Three years earlier, in 1907, he had been accorded a first one-man exhibition at home in Mexico City, then had gone to Spain to study, on a subsidy from the State of Veracruz. From there he had gone on after two years to Paris, and to Belgium, Holland, and England. All his studying and reading and sketching had left him unsettled and discontented. Cézanne's canvases somehow resolved his doubts, put an end to his wavering, and afforded him a vision of a work to be accomplished not out of keeping with the dreams of his youth in Mexico.

After a trip back to his own country, where he was deeply stirred by the beginnings of the Revolution of 1910, he settled in Paris for a term of years, and became conversant with the latest phases of fauvism and cubism. Temporarily he became a cubist, under the impact of a close friendship with Picasso; but it was from Picasso's "classic" paintings that he was to gain most. In the end the three decisive influences upon him, before 1920, were Cézanne, Picasso, and Henri Rousseau.

Still he had not found himself. Imaginative, impressionable, sensitive, he was in those years a follower of fashions and theories. The excitements of the war period, which he spent in Paris except for some months in Spain, stirred him to think of his painting in more than formal and tech-

RIVERA: The Grinder. 1924. Collection of Señor Lic. Emilio Portes Gil, Paris
(Courtesy Museum of Modern Art)

nical terms, and association with political revolutionaries set his mind to working on a possible social art. Then something remembered out of his Mexican background came to seem more vital than all the æsthetic exercises of his years in Paris, and in 1919 he decided upon return to America. He was already dreaming on a mural art, and study in Italy in 1920, where he saw Giotto's wall paintings and Byzantine mosaics, convinced him that he had found his medium. He returned to Mexico in 1921.

If Paris and Italy had given him sustenance on the theoretical and formal sides of his art, his native land was ripe to feed his need for subject materials and inspiration. The natural beauty that he now saw with new eyes, and the stirring stories of revolution, set him to planning monumental murals in endless series. His own insistence and enthusiasm, coupled with the Government's genuine socialistic attitude toward artists, secured for him opportunity to bring his dreams to life on governmental

walls. After a year or two of experimental work he painted, in 1923, the first of the famous frescoes of the Ministry of Education Building at Mexico City and of the frescoes of the Agricultural School at Chapingo.

By 1924, when he was thirty-seven years old, he had arrived at a mature and distinctive painting style. The fumbling uncertainties and the acquired mannerisms are gone, and the Mexican painter, soundly cognizant of what it is that Cézanne and Picasso and Rousseau have contributed to a new æsthetic, but no longer merely a pupil in the school of Paris, is helping to create the recognizably Mexican revolutionary art. When in 1924 and 1925 he paints *The Grinder* and *The Tortilla Maker*, the obvious primitivism seems Indian, of the New World, rather than Negroid or Melanesian by way of Dresden or Paris.

Rivera became a political revolutionary too, an internationalist, a Communist, and his subsequent career at home and in the United States has been punctuated by explosions and enlivened by frequent controversies. But he has succeeded in both countries in setting up series of monumental murals, sometimes more liberal in ideology than the conservatives of the communities might wish, but in general stimulating and serenely decorative.

Rivera's painting style is naturally monumental, simple, and strong. Its vigour, however, does not breed unrest. The colours are full in an earthy way, solid and satisfying. His control of the plastic elements is as certain as that of any living muralist, and the least thing he touches is likely to breathe a sense of rhythmic order. Some of the early frescoes are almost symmetrically composed, with rhythms of volume, plane, and colour so simply arranged as to be too easy, too shallow. Somewhere between these and the late complex, sometimes overloaded political murals lie Rivera's masterpieces, richly decorative, vigorous, and animated, yet poised and serene.

The shy youth who stood all day before a shop window in Paris to feast his eyes on the "realizations" of Cézanne has become thirty years later an almost legendary figure in America's world of art, a man internationally admired though sometimes feared. One sometimes wonders whether the great painters of the school of Paris, the expatriates from Spain and Holland and Russia who have continued to live and paint and discuss art in Paris, the great Picasso and the fashionable van Dongen, and the feverish Soutine—perhaps even the French painters too—do not sometimes wake at night to ponder upon this one-time comrade of theirs; whether they do

RIVERA: Moscow, November 7, 1927. (Courtesy Museum of Modern Art)

not envy a little the place he has made among his own people, expressing not only the æsthetic but the social currents of his country and his time.

His has been a success seldom paralleled in an age when the artist has been suspected as a drone in the workhive that is the industrial world. He has over-ridden criticism and opposition, fair and unfair, that would have stopped an artist of less strength and determination. In the chaotic world of the early forties he is as near the type figure of successful modern artist as any known to Europe or America: powerful as well as sensitive, with a gusto for rich living as well as for art.

When Rivera's pictures were first exhibited in New York in 1921, at the galleries of the radical Société Anonyme, the artist was listed as a "Spanish cubist." No Mexican artist would then have been known in New York. Yet at that time, before Rivera's return from Europe to his homeland, a second Mexican had attained mastery of a painting style

essentially modern. José Clemente Orozco, without benefit of study in Europe, had arrived at primitive simplification, rhythmic organization, and wilful distortion for formal and emotional intensification. He had, moreover, lived through the horrors of the Revolution that Rivera had missed, and his paintings were already being charged with that intensity of feeling and that social import which have since been considered a normal concomitant of Mexican revolutionary art.

Although Orozco, a man three years older than Rivera, had not followed the procession of students to Europe, he had studied at the Academy in Mexico City under artists lately returned from Paris; and he had spent the years 1917–1918 in California. But it was out of lonely study away from schools, out of the realistic experience of cartooning for revolutionary papers in the popular-art tradition, and out of brooding upon the past of the arts in his native country, that he formed the style which so strangely matched the modern primitive of Europe. There is greater strength, greater earthiness, perhaps a deeper sincerity, in his primitively simple, emotionally direct picturing of the period of 1920–1923 than in the derived primitivism of Derain or Picasso or Matisse of those or earlier years.

The World War had failed to inspire any European artist to express his horror and indignation in terms so moving and lucid and dignified as those used by Orozco in his picturing of the Revolution. (The verist paintings of Grosz and Dix are more horrible and more savagely satirical, but they lack the simple human emotion, and also the fullness of Orozco's plastic power.) The school of Paris, immensely important for its pioneering in the search for formal means of expression, had continued to consider subject matter as of secondary significance. No outstanding member of it except Rouault ever acknowledged spiritual or objective content as of co-equal importance with formal excellence. The typical Parisian, whether French or immigrant, was descendant from Manet, who argued that anything seen was of sufficient interest to make a picture. The Mexicans have reaffirmed that, where subject remains, there is a difference between trivial and important content. They have restored magnitude and depth and significance on the thematic side.

The murals Orozco painted for government buildings in Mexico include series as famous as those by Rivera. There is more of the old Mexican people's art in Orozco's painting method, and more of mid-American primitivism. There is, in other words, less reminder of European modern-

RIVERA: The New School. Fresco. About 1923. *Ministry of Education, Mexico City*

ism. Yet the artist loses nothing of the implications of simplification and form-enrichment of the international movement. In the late thirties he even exploited abstraction as such.

Orozco's most characteristic painting, however, is in the main stream of emotionally rich, socially significant mural art. For Pomona College in California and for Dartmouth College in New Hampshire he painted frescoes that are among his most powerful and imaginative works, and for the New School for Social Research in New York City he painted a series

less monumental but no less decorative and meaningful, and charged with social lesson. The walls at Dartmouth are hardly less than magnificent.

The barbarities of war, socialistic propaganda, satire of the rich and the pretentious, pity for the poor and the exploited: all this enters into the picturing of this typically Mexican painter, and he matches the importance, the compulsion of his thematic material with a pictorial power, a plastic competence, equal to that of the overseas leaders of the modern movement. He made his first trip to Europe when he was forty-six years old and already a veteran creator.

The Mexican modern school of art has been national, single, unitarian, as has no other existing school. Its expression has been racial and unmistakable. It has served the cause of international modernism well by proving that the lessons of form-organization learned by the succession of pioneers from Cézanne to the group of abstractionists have a universal validity; that the formal means uncovered in those lessons comprise a typical twentieth-century language of art which can be utilized by painters operating in their own separated territory, whenever they have something important to say. One distinction of the Mexicans is that they *have* had something to say. They have proven the adaptability of a simplified, form-enriched method to themes of magnitude and profundity. They have done this while restoring to common use one of the oldest of painting mediums, murals in fresco. The North American Continent in the early nineteen-forties is richer in modern mural art than any other, and the better part of the display, in quality, is in Mexico.

While Orozco and Rivera have been the giant figures of the Mexican renaissance, there have been other creative painters of both easel picture and mural. Along the lines of socially conscious propagandist painting, one-hundred-per-cent Communist, the most powerful and moving expression has been that of David Alfaro Siqueiros. He has been soldier, labour leader, political agitator, and political prisoner as much as artist. His picturing has the authentic Mexican heavy primitivism, with an extra measure of eloquence born of his aggressiveness and conviction. He is a true internationalist, having lived in California, whence he was expelled for organizing a cell of communistic artists, in Argentina and Russia, and in Spain as a soldier of the Loyalist army.

In 1922 a group of Mexican artists came together in a guild or union known as the Syndicate of Technical Workers, Painters, and Sculptors. Their manifesto declared for the worker, the peasant, and the artist, against

OROZCO: Cortés and the Cross. Fresco. 1932. *Detail of mural, Dartmouth College, Hanover, New Hampshire*

the rich parasites, the politicians, and the bourgeoisie; for collectivism and art-socialism, against individualism; for monumental mural art, against easel art, "which is essentially aristocratic." The Syndicate members' aim, the document concluded, was "to materialize an art valuable to the people," and "to create beauty for all, beauty that enlightens to stir to struggle."

Within the year preceding the manifesto, great expansion in public art works had been planned under a progressive Government, and at that very time Orozco returned from a stay in California and New York, Rivera and Siqueiros returned from Europe, and a young Frenchman named Jean Charlot, who was to become essentially Mexican in his art expression, arrived from Paris. Already on the ground were a number of painters in-

spired to express their progressive or revolutionary ideas through art, and sufficiently alive to modern ways of expression to see eye to eye with the returning radicals. Among those others were Fermin Revueltas, one of the most talented of the younger men (who died at the age of thirty-two in 1935), and Roberto Montenegro, older and broadly trained alongside the Spaniards and Frenchmen in Paris, an eclectic who brought a wide knowledge of modernism to bear upon mural problems.

The stay-at-homes and those newly returned comprised together an extraordinary group of talents—and they found before them an epochal opportunity. Once the Syndicate manifesto had been posted about Mexico City (Siqueiros was the directing spirit, a born manifester and propagandist), the artists besieged the Government for wall assignments, with Rivera's enthusiasm proving especially persuasive. Shortly there were an incredible number of mural projects actually under way. Within two years some of the greatest masterpieces of Orozco, Rivera, and Siqueiros were painted.

The flowering had come swiftly and with promise of persistence. Meanwhile the Syndicate was by way of falling apart. A certain amount of collectivism had been demonstrated in initial co-operative projects; but personalities as strong as those of Rivera and Orozco could not easily yield leadership. The extreme Communism of Siqueiros, the mild Communism of Rivera, and the modified Socialism of the Government bureaux met in an uncollective spirit. Soon art was back on an individualistic basis. But through the individuals the spirit of modernism marched on. As the Government subsequently moved toward the right rather than the left, Rivera increasingly found opportunity and favour.

Along with the actual renaissance of painting there was a movement to liberalize art education in Mexico. Modernist freedom was carried into the lower school grades, and a system of open-air art schools greatly increased the opportunities open to child artists. Exhibits sent out from these primary training grounds have astonished teachers and artists in other countries by reason of the originality shown and the intuitive grasp of fundamental plastic rhythms. Nor have the professional painters emerging in the twenty years since the historic gathering of forces in 1921 failed to indicate a continuing competence, not to say genius, in the field of mural art as well as easel painting.

Julio Castellanos, Federico Cantú, and Emilio Amero, all born after the turn of the century, have shown themselves gifted artists. In Cantú

OROZCO: The Departure of Quetzalcoatl. Fresco. 1932. *Detail of mural,*
Dartmouth College, Hanover, New Hampshire

the influence of long European training and association with radicals of
the school of Paris is marked, while the other two fit more closely into the
specifications fixed by Orozco, Siqueiros, and Charlot. Only a little older
are Rufino Tamayo and Carlos Orozco Romero, both powerful painters
in the neo-primitive line, and, like most of the Mexican moderns, pro-
ficient in print-making.

A Guatemalan who associated himself with the Syndicate in Mexico
City in 1921, Carlos Mérida, has continued as a member of the Mexican
group. He somewhat departed, however, from the national way of expres-
sion, especially in response to training and associations dating from a stay
in Paris late in the twenties. He then abandoned the heavier aspects of
American primitivism and began exercises in near-abstraction. He took
rank during the thirties as the foremost out-and-out abstractionist this side
of the Atlantic, and his sensitive and evocative paintings have found favour,
and clients, in California (long receptive to the Mexicans) and New York,
as well as in Mexico.

Mérida may be said to have added to the distinctions of the Mexican
modern school the one they most lacked earlier, versatility. Some purists

PORTINARI: Morro. 1933. *Museum of Modern Art, New York*

had thought the nationalist expression too heavily freighted with story and meaning. Mérida has a touch as light and incisive as Klee's. His paintings are delicate improvisations, charming and delightful. As such they form a jewel-like addendum to a body of art that has the sterner virtues of social significance and monumental plastic effectiveness.

Artists of the Latin nations south of Mexico have entered less importantly into the activities of modern art. During the nineteenth century the old church-nurtured art gave way to sorts fostered by official academies. Promising students were sent by liberal governments for training to Spain or to Paris. Hardly a nation in South America failed to develop its revolutionary group, reminiscent of European trends and schools. But one artist only made history internationally.

Cândido Portinari was born in 1903 in the coffee country of southern Brazil, of Italian immigrant parents, plantation workers. At fifteen the boy

PORTINARI: The Scarecrow. 1940 (Courtesy Museum of Modern Art)

went to Rio de Janeiro and entered courses at the official School of Fine Arts, under conditions of cramping poverty. A visit to Europe, won as a Prix de Voyage in 1928, resulted in no routine study and in very little painting, but the young artist gained immensely, through the broader outlook and the stimulus of meeting other creative painters and seeing museum masterpieces. Returning to Brazil, Portinari set about painting the life and spirit of his own country in his own way, while earning a living by conventional portraiture. Opposed because his art was unpretty, or distorted, or unflattering to Brazilian esteem, he nevertheless, after 1935, won recognition and prizes; and by 1940 he was internationally known.

Portinari has spanned a wide range in subject and even in technique. He has painted innumerable portraits, honest and cleancut but scrupulously realistic, and Brazilian Scene transcripts, and official murals. He also has painted to please himself, producing sympathetic studies of the

Negroes and other workers—he is socially conscious but not militantly propagandist like the Mexican giants—and pictures in which the pattern-effect is the principal value, and essays in fantastic unreality, such as *The Scarecrow*. In the unconventional pieces he preserves a native, primitive directness and force that link him closer to the Mexican school than to the European ones. But the attention to rhythmic values, the preoccupation with form, mark him as a member, perhaps one of the greatest, of what can only be called the universal modern school.

While revolutionary artists south of the Rio Grande were making history in the decade 1923–1933, art in the United States seemed to have come only to a period of wavering, bickering, and reaction. The early gains of modernism were still in dispute. The Government, as always, was uninterested in the arts. The public and the press were still suspicious of the new-fangled importations from abroad. Some of the most liberal and accomplished of the younger artists were inclined to believe that the influence of the school of Paris had been more for ill than for good. Along with opposition from the academicians, teachers, and critics, the small band of moderns was forced to meet the competition of an illustrational school claiming to purvey a new national art, in "American Scene painting."

The artists of the American Scene soon became the headline personalities in the press and in travelling exhibitions. Even professors were found not only to justify but to glorify them, on the grounds of patriotism and accordance with the American philosophy of democracy and pragmatism. During the late twenties it was they, representing a new and provincial sort of realism, and not the moderns, who profited by the country's boom prosperity and the easy flow of money. Then came the depression, and realist and post-realist went down together into near-starvation.

In 1933 certain state governments took cognizance of the fact that artists are human beings, subject to hunger and cold like others among the unemployed. When the idea of work-relief was tried out, sporadic artists' projects were launched. When the national government took over the problem during the following winter, a small group of idealists drawn to Washington in connexion with New Deal activities opened the way to an extensive Federal Art Project. In 1935 the United States Government put into effect a plan under which, at the peak, 5200 artists were supported while producing in their own fields. From that beginning dates the twentieth-century flowering of American painting.

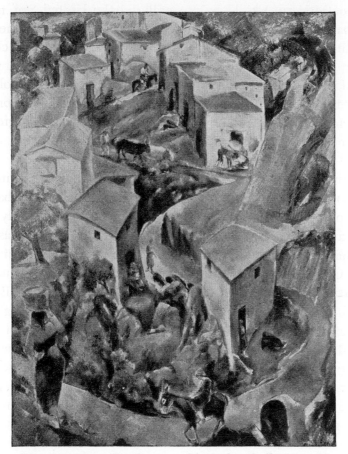

STERNE: The Winding Road. 1922. *Lewisohn Collection, New York*

While art was thus becoming a ward of the Government through the back-door of relief—because the human problem, not the artistic one, was pressing—a second official action gave encouragement and opportunity to the artists. The Department of the Treasury established a bureau for the procurement of art works for the adornment of buildings erected with public funds. It put in charge Edward Bruce, himself an artist (though known in Washington as a respectable and successful businessman), a painter who had been rated as a moderate modernist, partly because of a passionate interest in Chinese art. Bruce, before he went to the permanent Treasury post, had been one of the directors of the W.P.A. art project. That position he yielded to the no less liberal Holger Cahill, of the New York

Museum of Modern Art. Thus, not only did the United States Government embark, in the years 1933–1935, upon two unprecedented undertakings for the good of the artist (and ultimately the public), but by its choice of personnel it ensured opportunity to the liberals and the radicals along with the usually favoured conservatives.

Within the following three years the art life of the country was galvanized into an activity difficult to credit. The volume of exhibitions, the number of new museums and centres opened, the number of art schools established—all leaped forward. Supposedly successful and certainly well-known artists were found on the project along with those five thousand others who had lost all opportunity to work freely in their studios. All were put to work at their own special tasks of creation. An inestimable gain was that artists who had been accustomed to flock to New York were kept in their own communities. Creative centres were established at Seattle, Salt Lake City, Los Angeles, New Orleans, and threescore other cities that had formerly lost their artists to the marketplace New York. Best of all from the modernists' point of view, no line was drawn against the radical because he wanted to paint fauvishly or expressionistically or even abstractly. The Government was interested primarily in the human problem of keeping these people alive and at work in the fields they had been trained for, and it was not interested in upholding the forms of the past as against the problematic ones of the future. In short, the Government officials were gloriously open-minded.

As early as the autumn of 1936 the benefits of the art project were so patent, and the output of creative painting so impressive, that the New York Museum of Modern Art collaborated with Washington in presenting an exhibition under the title "New Horizons in American Art." In 1939 the de Young Museum in San Francisco offered a second retrospective view of painting as fostered under the project, hardly less modern in aspect. If the W.P.A. experiment for the first time brought the American modernists before the public as the important creative group in the national art scene, the years from 1933 to 1941 saw also an extraordinary loosening of lines at even notoriously conservative institutions. From the great museums of New York and Boston to the smaller, younger, and more flexible ones of the Middle West and the Pacific Coast there was evidence that the post-realistic moderns were being increasingly accepted as not only interesting but respectable.

Modernism was well served in the thirties, too, by organizations and

MATTSON: Deep Water. *City Museum, St. Louis*

institutions founded specifically for its advancement. The Society of Independent Artists in New York and the Chicago No-Jury Society continued their activities in the name of liberty and opportunity. In Washington the Phillips Memorial Gallery, devoted wholly to the post-realistic masters, was several times enlarged and its collections signally augmented, until finally it took its place as the nation's most distinguished intimate museum of modern painting.

In 1929 the New York Museum of Modern Art was founded. It embarked at once upon activities of an extraordinary range in the fields of exhibition, publication, research, and instruction. Richly subsidized, it took rank within a decade as the most powerful institution anywhere dedicated to promotion of contemporary creative art. Its own collections have not approached those of the State Museum of Modern Western Art in Moscow or those of the Barnes Foundation at Merion, Pennsylvania, but its activities in behalf of both artist and public have been unparalleled elsewhere. Since 1931 New York has been served too by the Whitney Museum

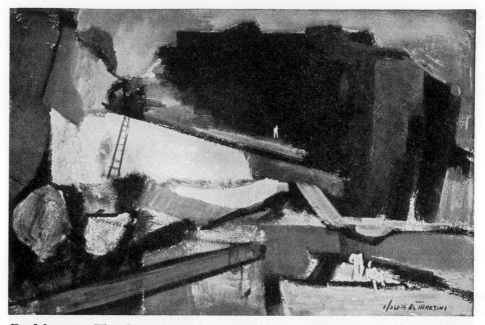

DE MARTINI: The Quarry Pool. Gouache. 1940. Addison Gallery of American
Art, Phillips Academy, Andover

of American Art. It continued in a larger way the work of an earlier Studio
Club, which had introduced unrecognized and sometimes radical artists at
a time when most museums and dealers were deferential to European
labels and neglectful of American talent. At Merion Dr. Albert C. Barnes
has brought to his gallery an amazing array of modern masterpieces, par-
ticularly of the French school. The gallery is administered as one of the
activities of the Barnes Foundation, whose work has advanced modern art,
particularly in educational channels, but the collection has been opened
only to enrolled students.

If it was easy to mark, in the late thirties, the quickening of the art life
of the nation, and to discern an epochal release of creative talent, it was
nevertheless impossible to detect unity or likeness in the mass of paintings
that flooded museums and commercial galleries. Perhaps never before did
the artists of a single country produce an œuvre so various, so hetero-
geneous. The United States, a union of peoples, lately receptive to im-
mense racial blocks from the major European countries, host also to
Orientals, Africans, Mexicans, and South Americans, could hardly be ex-

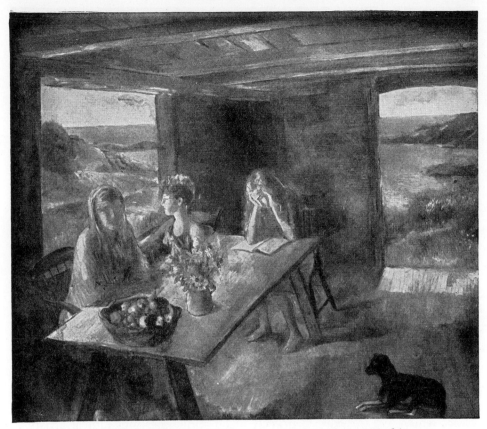

KARFIOL: In Our Shack. *Phillips Memorial Gallery, Washington*

pected to develop a school of expression united and consistent like that of Mexico, or even a school as distinctive and recognizable as the German. Rather it came clear, in the years after 1935, that America had substantially accepted the principles uncovered in the pioneering of the school of Paris, but had then gone on to experiment in all the channels opened by the international insurgents, until every device of modernism was being utilized, every innovation tested, every shade of radicalism from Renoir-like neo-traditionalism to non-objectivity, carried into practice.

Possibly the artists have established idioms, mannerisms, even a style that will be enlarged upon, made widely manifest, and stand to the future as American modernism; but it is too early for the historian to claim so much. What can be said is that in the late thirties American post-realistic

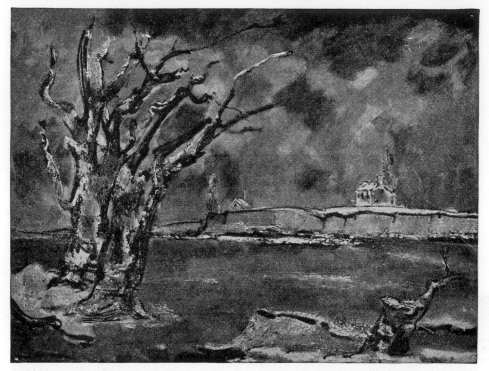

WEBER: Winter Twilight. 1940. Associated American Artists, New York

art has been immensely alive, immensely vigorous, and in spots gorgeously
expressive of American life. Lacking unified direction, it gains by its great
variety, by the extent and flavour of the individualism of its creators, by a
cosmopolitan wealth of invention.

The story of it cannot, then, be fully or clearly told so soon. A few lines
of development can be marked out, some sectional contributions noted,
some still evident racial strains detected. The best way of beginning, per-
haps, is to go back to the time when the French influence was direct and
strong, when young men were returning home enthusiastic and perhaps a
little superior, students at large of the school of Paris, even actual pupils
of Gromaire and Lhote. They found when they returned, even so late as
1930, that the "standard" moderns were the men who had brought French
fauvism to American shores around 1910.

The Jewish internationalists of New York, that sensitively creative group
that had been a feature of the pre-war Armory Show, were still at the

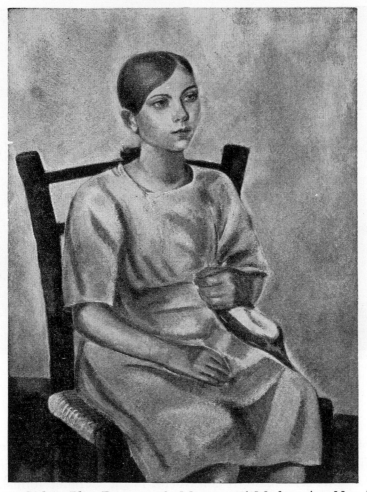

STERNE: Girl in Blue Dress. 1928. *Museum of Modern Art, New York*

heart of the movement, with Max Weber, Abraham Walkowitz, and Bernard Karfiol as leaders—and a new member, Maurice Sterne, fast taking place as the most sensitive and proficient adapter of Cézanne's methods known to the American galleries. But even though Sterne—born in Russia, brought to the United States as a child, and trained in France—might paint his still-lifes and figure-pieces and landscapes beautifully, with exceptional command of post-impressionist plastic methods, as Weber was indubitably doing at the same time, the activity, so close to the French, was hardly to be described as in any sense American. The mark of the

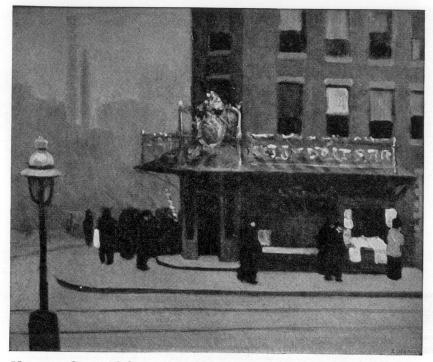

HOPPER: Corner Saloon. 1914. *Museum of Modern Art, New York*
(Courtesy Frank K. M. Rehn Galleries, New York)

school of Paris was equally evident in the canvases of other painters carrying on from the Armory Show beginnings, in the interiors and still-lifes of Henry Lee McFee, a masterly constructor in the Cézanne formalist tradition, and in the hardly less efficient arrangements by Samuel Halpert (who, however, died in 1930). These men were doing an inestimable service to American art in bringing the most authentic and useful methods to this side, sometimes demonstrating them in teaching too, but they were preparing the way for rather than establishing an American school.

There were other French-trained painters who recovered their independence, or perhaps merely reasserted an Americanness held in abeyance during the experience of Paris. Edward Hopper during the twenties had shown an individualistic talent, faintly satirical, for limning empty city streets, gaunt Victorian-age houses, and other nostalgically familiar bits of Americana. By a method of stark simplification, utmost clarity of statement, and subtle emphasis upon a single salient figure or feature, he achieved pictorial

HOPPER: Sunday. 1926. *Phillips Memorial Gallery, Washington*

creations well above the run of illustrational American Scene painting. During the thirties he followed the same distinctive line of urban picturing. In a long series of works of the type of *New York Movie, New York Apartment,* and the street scene entitled *Early Sunday Morning* he has evoked as has no one else the *genius loci,* has distilled the feeling of the place, even while revealing a competent mastery of modern plastic means. In his case the training of France has seemed to be integrated into a mode thoroughly American, suggestive of old New England puritanism and of latterday Yankee forthrightness. Like most of the ranking American painters, Hopper had known early neglect and indifference; before his first successful one-man show, he had sold only two pictures in more than twenty years of painting and studying.

Similar in case to Hopper, Guy Pène du Bois and Walt Kuhn carried

KUHN: The Juggler. 1934. *Collection of Friends of Art,*
Nelson-Atkins Gallery, Kansas City

on through the thirties their distinctive variations of a French-derived, in-
dependently modified painting method. Du Bois leaned more, as time
passed, to a neo-traditionalism, while Kuhn went his unchangeable way,
producing rugged character studies without marked unrealistic distortion,
but with great plastic strength. Morris Kantor, a younger man, immigrant
to America when he was fifteen years old, in 1911, although he had had
no actual training in France seemed at first to have steeped himself in the
methods of the French school until there was little possibility of local

KANTOR: Provincetown Boat. 1937. *Collection of John L. Sexton,
Wilmington, Delaware* (Courtesy Museum of Modern Art)

flavour in his pictures. Later, however, he curiously felt his way into the
American background, until certain of his canvases breathed the spirit of
New York or of New England. In the late thirties he produced a delightful
series of landscapes touched with the magic of the colonial "American
primitives." There has been in his work, too, a hint of the quality of that
most American of modern masters, Ryder.

It has seemed not impossible that Ryder's influence will yet be potent
and direct in determining the central expression of the still forming and
various-directioned American school. Marsden Hartley, known as a leader
as far back as the days of the Armory Show, and after that an eclectic able
to adapt to his own ends all the plastic devices of the international school,
in the years after 1935 turned back to a way of expression as simple, direct,
and—some would say—romantic as Ryder's. His aim has seemed to be that
revelation of the mystic values behind nature which Ryder so magnificently

HIGGINS: Coming Storm. *Kleemann Gallery, New York*

achieved. Hartley throughout his career has held to a simplification and a directness of statement placing him squarely within the primitive-modern development. Coming from territory more to the right, Eugene Higgins has moved toward a Ryder-like, moody expressiveness, especially in his studies of life by the sea.

It was the touch of a beyond-nature reality that first lifted the paintings of Charles Burchfield above "mere realism." Choosing the homeliest of scenes as motifs, painting what appear at first glance to be illustrational records of suburban and industrial America, Burchfield has added a haunting atmospheric truth while painting with a twentieth-century feeling for structural organization. Never approaching abstraction, he yet absorbed in his art training something of form-consciousness. He was one of the first of the great American moderns to have his entire schooling in this country —at Cleveland. His professional experience was all too typical, as lack of appreciation of his work prevented him from giving more than spare time

BURCHFIELD: March. 1922–1928. Frank K. M. Rehn Galleries, New York

to painting until 1930. His particular sort of picturing, drawing on Main Street for subjects, but free from the malice or hint of superiority that implants in most Main Street literature and painting an ultimately unpleasant taste, procured for him finally a place among the most popular of the independent moderns.

Both Hopper and Burchfield showed in their interpretations of American life something like the intensified reality achieved by the German verists. It was not camera truth that they were after, but a concise pictorial record of aspect and spirit. In both cases it is the *feeling* of the subject that comes over to the beholder. Neither man distorts so freely as did Grosz and Dix in their verist days, but the evocation of a mood and an essence is as sharp and true. Coming before the more widely exploited American Scene group of the mid-twenties, Hopper and Burchfield had reason to claim priority as discoverers of the effectiveness of the native scene as thematic material; just as in the thirties those critics who kept their heads were able to see the two as rightly at the top of the roster of American Scene interpreters.

CURRY: Baptism in Kansas. *Whitney Museum of American Art, New York*

About 1925, however, a different group ran away with the name American Scene. The phrase came to mean transcriptions from the life of Midwestern America or from the life of teeming New York, generally satirical or melodramatic or merely picturesque. Three painters, John Steuart Curry, Grant Wood, and the stormy petrel Thomas Benton, immortalized Kansas and Iowa and Missouri for millions who still judge their art by topical interest and pleasing technique; and Reginald Marsh got down lively scenes from Harlem, the Bowery, and the more lurid resorts of Broadway.

In general the output of the American Scene school had no more to recommend it than the earlier transcripts from everyday life by the New York Realists of 1908. In fact a good deal of the most publicized art of the later school was inferior by reason of a sly cruelty, a tongue-in-the-cheek exploitation of honest provincialism. Only when the painters rose above their interest in picaresque character, or local gaucheries, and added essentially pictorial vitality, did they seriously affect the advancement of American painting. Nevertheless, partly because in dealing with local subjects at all they came into contrast with certain over-precious disciples of the school

Wood: American Gothic. 1932. *Art Institute, Chicago*

of Paris, they found editors and gallery-owners ready to hail them as the true initiators of the national modern school.

In the rush of regional realism it was the Midwestern homespun painters who profited most. Grant Wood had risen by sheer ability and hard work to a position as art teacher, had studied in France and Germany, then had returned to Iowa determined to forget Europe and find art-reality at home. From the late twenties he was the most honest, the least flashy of the American Scene painters. His satire is broader and kindlier—though devastating enough in the often reproduced *Daughters of Revolution*, a pitiless

BENTON: The Meal. *Whitney Museum of American Art, New York*

exposé of smugness and false pride. In *American Gothic* the pictorial archi-
tecture is simple and competent enough to bring the picture into line with
modern ideas of composition, and the realism goes beyond mere surface
reporting. In many other pictures the artist seemed to have overlooked
all the gains made in the twentieth century in the name of form-organ-
ization.

Curry and Benton joined Wood in the midwest, to the accompaniment
of blasts about Frenchified Americans and the effete studio art of the
East, and with cheers for a new honest art of the soil. Curry proved himself
a vigorous and honest illustrator of typical dramas of the region, cyclones
and floods and mass baptisms, and hogs killing rattlesnakes. He remained
essentially the realist, with an exceptional faculty for depicting movement.
Occasionally he showed understanding of movement in the deeper sense,
as of something vitalizing pictorial organization.

MANGRAVITE: Rye Beach in Winter
(Courtesy Frank K. M. Rehn Galleries, New York)

Benton, the most vocal of American artists, had already scored with easel pictures and two major mural series, in which he had depicted phases of the national life in a style overcharged with surface movement. Subject and method were alike melodramatic, and perfectly in line with the ideals of "pep" and "snap" set up in boom days. During long tours of the South and the West, in search of pictorial materials, he a little modified the nervousness of this style, even at times bringing his composition to an equilibrium or poise. But in general the canvases have been so loaded with linear movement, and the colour has been so uncontrolled plastically, that he has effectively removed himself from the list of creative moderns. Yet to the press of the nation he has remained the most important "modern" in the country, certainly the most conspicuous and advertised.

There was nothing in the American Scene ideal to prevent creative artists from adding formal values over and above the desired local subject significance. And indeed, just as Hopper and Burchfield had effected some such union before the phrase swept the country, so some later adherents of the school brought into their picturing a genuine feeling for hidden

MILLER: The Atlanta Set, Culver City. Water-colour. 1940. *Ferargil Galleries,*
New York

essences in the subject material and for affective plastic orchestration.
Marsh, leader of the metropolitan branch of the school, showed at times
an excellent sense of major and minor rhythm, and in general surpassed
the Western regionalists in plastic awareness. His record of burlesque
theatre strip-teasers and their audiences, of beach parties at Coney Island,
and of the Negro steppers of Harlem were interesting as social documents,
if often disturbingly gross and faintly obscene. His sort of social recording
led on to excesses of vulgar depiction of city and beach life at the hands
of painters without Marsh's pictorial authority—and it all went into cir-
culation as authentic American genre art.

At the point where truly creative talent flowed over into the near reaches
of regionalism, several significant younger painters came to prominence.
Two men more especially associated with art in California, though not
native to the region nor particularly concerned in recording the California
scene, Paul Sample and Barse Miller, have taken their materials from
familiar life and have, upon occasion, transformed them into æsthetically
moving works. With Sample the urge to Main Street satire is usually
dominant, the formal problem secondary. With Miller the form orches-

Maril: Rocks and Water. 1940. Macbeth Gallery, New York

tration more often comes first, and in his water-colours especially, as in *The Atlanta Set, Culver City*, the handling of the plastic materials is masterly. The colour is full and the rhythm is vigorous yet melodious. Others who have brought more than average ability in picture-building to regional recording are Georges Schreiber, who in 1939 toured the country with sketchbook poised for capture of characteristic Americanisms; Francis Speight, who has found pictorial motives in suburban towns and on R.F.D. routes; and Raphael Soyer, gifted painter of the streets and characters of New York's East Side. Adolf Dehn and Ernest Fiene have interpreted America more broadly, the one ranging from sombre landscape to gay social caricature, the other depicting farms, skyscrapers, and factory slums alike.

It was, of course, impossible to fix exact limits to the territory properly covered by American Scene painting. The leaders of the school argued for truthfully illustrational reporting, and patently favoured journalistic transcriptions from life as lived in the backwaters of American civilization.

MARIL: Winter on a Farm. 1939. *Macbeth Gallery, New York*

It was sometimes argued, on the other side, that "painting American" should be interpreted as including not only what the eye discovers but whatever the American artist can within himself imagine or image. Ryder had painted American, and so had Twachtman; but it was not the local stamp of the flora and fauna, of the architecture, the landscape, and the people, that counted, but the artist's insight, his vision, and the pictorial beauty he created in picture-building. Surpassing the accepted American Scene leaders in permanent interest, because they had got their mastery of form problems before going to nature, a group of younger painters emerged, especially after the aid to free experiment given by the W.P.A., to prove that an artist might hold to the best that the school of Paris had to give, in the way of command of the abstract elements, yet as truly "paint American" as had Wood or Curry.

Herman Maril of Baltimore, in paintings like *Winter on a Farm*, left

Hart: Merry-Go-Round, Oaxaca, Mexico. Water-colour. 1927.
Museum of Modern Art, New York

no doubt that design was to him the first business of a painter, yet lost nothing of the native character of the scenes portrayed. Raymond Breinin of Chicago similarly simplified and arranged the features of Western landscape, presenting at once a distillation of the feeling of the place and a pictorial entity designed to afford an æsthetic experience. Cameron Booth in Minnesota, trained to construct pictures in full knowledge of the plastic devices made known through cubists, purists, and abstractionists, went back to the scenes of the Northwest to accomplish the same dual purpose. Karl E. Fortess similarly reconciled subject-truth with plastic strength and rhythmic order. A painter who died in 1933, George Overbury Hart, better known as "Pop" Hart, had carried over something of the vitality of the New York Realists of 1910, while achieving a measure of Cézanne-like formal enrichment. He worked usually in water-colours, dealing with picturesque localisms, as in *Merry-Go-Round, Oaxaca, Mexico*.

GROPPER: The Budget. Lithograph from the Senate series. 1940.
A. C. A. Gallery, New York

About 1930 it came to public notice that the finest magazine illustration, in line with modern ideals of form-organization, was appearing in political papers to the far left, and that some of the socially conscious artists, painting with frank propagandist purpose, were among the most sensitive and most vigorous inheritors from Daumier, Cézanne, and Kokoschka. It was in this quarter too that agitation for a national mural art had been kept alive—there being, of course, an obvious sympathetic bond with the comrade-muralists in Mexico.

During the following decade the party lines, which at first held together a considerable group of important painters, were destined to be broken and relaid, and the label "Communist," then fairly elastic and applicable to those artists, was to take on a meaning beyond their intentions. But at that time the strong, even passionate convictions of a group of artists were lending to their picturing a vividness, a genuineness, and a strength not apparent in other fields where modernists were at work; and at least one of the truest hewers to the party line, William Gropper, was to take rank, before 1940, in the top grouping of America's moderns. Younger

GROPPER: The Senate. 1935. Museum of Modern Art, New York

men, especially Mitchell Siporin of Chicago, were to go on to creative
mural work under the Federal Art Project, and one or two middle-ground
figures, such as Benjamin Kopman and Howard Cook, were to continue
along broader lines of endeavour. But it was William Gropper who be-
came the type figure of socially conscious painting. In six one-man shows
in New York from 1936 to 1941, he showed himself a forceful commen-
tator upon national life and political affairs, and at the same time a master
of design.

In 1940, when he was forty-three years old, Gropper completed a series
of lithographic studies of life and manners as demonstrated in the United
States Senate, and these were shown in 1941 with paintings and prints
of the Loyalist fighters for Spain, of air bombings during the new European
war, of workers and street characters—a fair sample range of his subject
materials. The Senate studies marked a new high point in cartooning in
America. Certain of the more serious prints indicated that here was a

GROPPER: The Cigar-Maker. 1941. *Collection of Paul J. Sachs, Cambridge*
(Courtesy A. C. A. Gallery, New York)

twentieth-century follower of Daumier, with power and incisiveness equal
to the French master's. A few years earlier Gropper had painted two oils
of the Senate in action, and in both these and the lithographs his use
of the primary plastic elements of volume and plane was in the best post-
Daumier, post-cubist tradition.

In *The Budget* the student trained to detect the formal means at work,
so to speak, can mark the relationships of the sculptural volumes, and
the sequences of planes as employed to induce directional movement.
In the painting entitled *The Senate* the plane arrangement for movement
effect is equally evident, and the least educated eye can note the successful
pattern effect in the placing of desk-tops and chairs, and the striking con-
trast afforded by the three activated figures set in circular relationship
among these geometric planes in series. All that is outside the effectiveness
of the picture as a true record and as satire, but the observer's pleasure
is immeasurably increased thereby. As if to prove his versatility Gropper
painted in 1941 the freely realized but equally well organized portrait,
The Cigar-Maker.

De Martini: Self-Portrait

For a time it had been possible to say with some justice that the artists paraded by critics as the greatest American moderns had taken refuge in landscape, and had thereby avoided a good many of the modes of expression traditional to the painting art. Ryder, Twachtman, Marin— certainly the top names of the list gave substance to the charge. But the decade of the thirties brought conclusive evidence of mastery in other fields, not least in the field most difficult for the form-conscious moderns, portraiture. Placing side by side a half-dozen portraits by representative contemporary painters (as in the pages here and following), one may find striking variety of method, yet discover in each example evidences of an

FRIEDMAN: Unemployable. *Metropolitan Museum of Art*

intention beyond surface realism, an intention to reveal the inner man, and discover also excellent design sense.

Gropper's loosely handled *Cigar-Maker* is apparently at the far pole technically from the austere *Self-Portrait* by Joseph de Martini; the incisive, posteresquely simplified *Unemployable* by Arnold Friedman, wherein all detailing is suppressed save in the face, almost in verist fashion, is in contrast with Franklin C. Watkins's *Boris Blai*. Yet each of these four portraits is essentially modern in both conception and presentation. In each instance camera portraiture is transcended. More of character,

WATKINS: Boris Blai. 1938. Museum of Modern Art, New York

more of humanity even, is revealed than an avowed realist would detect or transmit. And as design, each one bespeaks modern form-sense. It is worth noting, if one is interested in picture-organization, the effect of the enlarged hand, the too small hat, and the rhythmic body outlines in the Friedman work, and, in the de Martini *Self-Portrait*, the geometric-plastic function of the two lines at the upper left corner, or of the straightening of the hair, or of the lengthening of the right hand.

Even greater contrast might be disclosed in placing Philip Evergood's synthetic portrait, *Modern Inquisitor*, beside John Carroll's *White Lace*. The one breathes hardness, inhumanity, the other femininity and grace;

CARROLL: White Lace. Toledo Museum of Art

EVERGOOD: Modern Inquisitor. 1940. A. C. A. Gallery, New York

yet both are distorted, as the realist would see it, each for its own æsthetic and subjective or emotional purpose. The six men who produced these portraits came to the practice of art from backgrounds as varied as their versions of modern portrait-making. Two, Carroll and Watkins, are of old American stock, respectively from the West and the East; of the others, three are Jewish, all born in New York; while de Martini is of Italian descent, born in Alabama. Evergood, incidentally, attained rank as second only to Gropper as a vigorous social-message painter. De Martini has been best known for his powerful and vital landscapes.

CARROLL: Summer Afternoon. Randolph-Macon Woman's College,
Lynchburg, Virginia. (Courtesy Frank K. M. Rehn Galleries, New York)

It was in the early thirties that John Carroll came to wide notice as one
of the great independents, at a time when there was need of creative men
outside the two still warring factions of American Scene and school of
Paris adherents. A typical roving American, born in Kansas, educated in
California, with post-graduate training under Frank Duveneck in Cincin-
nati, teacher successively in New York and Detroit, Carroll developed his
own painting style, unrealistic but with only slight dependence upon ex-
pressive distortion. Under fire from the American Scene group because a
certain refinement in his work, even an elegance, was at the far pole from
their own homely and carefully matter-of-fact picturing, he made the best
of all possible answers by going his own way, painting brilliantly, in a
manner without precedent, apparently, in either Europe or America, and
arriving at success by sheer merit.

Specializing at times in feminine portraiture, Carroll consistently tried
to penetrate to that reality which lies behind and illuminates the seen

CARROLL: Evening. Fresco. 1936. *Detroit Institute of Arts*

features. Working wholly masculinely, he intensified the feminine character of the model, sometimes setting the figure out in space as if in dreamreality. He has, however, been versatile in the decade 1930–1940, producing landscapes, still-lifes, and strange modern allegories of a sailor's loneliness. He uses clear silvery colours expressively, and he is a superb draughtsman. For the Detroit Institute of Arts he painted two murals, distinctly light in character, but engagingly decorative and perfectly representative of his method. In *Evening* particularly he fixed all those personal idioms which he has gradually made his own: the general fragile aspect, the linear rhythms, the subject seeming to float in space, the extensive distortions of nature that become clear only when looked for.

Shortly after Carroll thus made his way into the list of foremost independents a painter who had been a sometime associate of his in the group of artists residing at Woodstock, New York, Henry Mattson, came forward as an individualist of a different sort. An immigrant from Sweden as a youth, a mechanic through his early working years, he suddenly became obsessed with the idea of painting, and went through periods of privation to achieve his ambition. Honours and success came suddenly, and deservedly—for his paintings had splendour and mystic evocativeness and silent beauty. His picturing was different from any known to modernism, yet perfectly in line with certain of the old masters of radicalism, with El Greco, Cézanne, and Ryder. In scarcely more than a half-dozen years

MATTSON: Self-Portrait by the Sea. 1939. *Frank K. M. Rehn Galleries,*
New York

Mattson took his place with the greatest of American painters, in the
direct line from the mystic Ryder.

His subjects were likely to be those Ryder had chosen, landscapes and
seascapes, though he proved himself a thoroughly able portraitist too. It
was especially in painting the sea, as in the superb *Wings of the Morning*
at the Metropolitan Museum, or *Deep Water* at the City Museum in St.
Louis, or in *Black Reef*, that his pictorial design perfectly supported his
feeling for the rhythms of his subject. Few other artists have so tellingly

MATTSON: Black Reef. 1940. *Carnegie Institute, Pittsburgh*

effected a perfect accord of subject-feeling and form-orchestration, an accord which has led to talk of form in art as an echo of the cosmic rhythms, as revelation of cosmic order. Mattson became *par excellence* the mystic painter among the American moderns.

In *Self-Portrait by the Sea* he painted himself in the setting of natural grandeur he so loves, with something of derivative El Greco-like movement of the plastic elements. But the picture is none the less a sincere and moving composition, by a Scandinavian-American who has felt within him who knows how many crossing currents of New World and Old World love of the sea and of the more hidden passion for the arts?

Without direct influence from Ryder, and indeed uninfluenced as few painters have been, Darrel Austin disclosed in his exhibitions in 1938 and 1940 a genius like Ryder's, and Mattson's, in its mystic and intuitive properties. More imaginative, and working in colours of a jewel-like richness, he draws his subjects, his images, from within himself, setting them down not in the self-conscious, reportorial way of the surrealists but in

AUSTIN: Europa and the Bull. 1940. *Detroit Institute of Arts*
(Courtesy Perls Galleries, New York)

intuitively ordered designs. Already by 1941, when he was thirty-four years old, this young Oregonian, who had not yet been to Europe, gave promise of bringing new significance to that rare type of American painting that is personal, mystic, and otherworldly.

American as Plymouth Rock or his beloved Adirondack Mountains, enamoured alike of the lonely spaces of the Far North and of the impending social revolution, mystic in penetration but declaring flatly for a representational art, Rockwell Kent has been likely in any reckoning to fall between the realists and the anti-realistic moderns. To that extent he has been, for twenty years, one of the independents. Never one of the moderns in placing abstract design before transcription, never seriously distorting

AUSTIN: The Legend. 1941. Perls Galleries, New York

the seen aspect, he yet has fulfilled that other requirement of the new school, that the artist shall convey the feeling rather than merely the look of the posing person or the contemplated place. He has made revealing and haunting records of the spirit of the Northern lands. In *The Trapper* at the Whitney Museum and *Adirondacks* at the Corcoran Gallery he found plastic equivalents for the character as well as the contours and lighting of spacious landscapes, intensifying their grandeur and their quietude.

At a moment when a great many artists, both the journalistic American

KENT: Adirondacks. Corcoran Gallery, Washington

Scene men and the more tempestuous moderns, were mistaking depicted movement and animated plastic patterning for pictorial vitality, it was Kent's distinction that he put designed movement into his canvases but brought it to poise. In his finest works he achieved the sense of serene repose after movement that is at its finest in Ryder's seascapes or Cézanne's studies of *Mont Sainte-Victoire*. Kent has been a leader in crusading for recognition of the American artist (against a rooted snobbery among socially prominent patrons and among interested dealers) and for absolute freedom for the painter to express his artistic and social convictions as he pleases.

Still further toward the right, praised often as major moderns but not fully qualifying either by understanding of the form-values typical of modernism or by mystic penetration, three men have notably bettered the realism of their teachers and forebears. Through the decade, Eugene Speicher, Leon Kroll, and Alexander Brook have upheld the ideals of

Kent: The Trapper. 1921. *Whitney Museum of American Art, New York*

"good painting," catching a breath of the freedom of modern methods, even hinting occasionally at a profounder order of composition, but in general paralleling the artists in France or Germany known as neo-traditionalists. Kroll especially exhibits a sense of serene, poised design, along monumental lines, that brings him close at times to Rockwell Kent's quiet authority and grave serenity. Brook has sometimes painted portraits and genre studies that are well within the field of form-enriched painting, but his more usual mode is realistic.

Robert Philipp, after long study and longer residence in Paris, became America's most accomplished manipulator of the stock French subject materials—nudes, flowers, still-lifes—in a finished technique that lacked little of the sensuous charm of Renoir. Just as Philipp has surpassed all other Americans in an alluring if somewhat foreign mode, so Jon Corbino, going further back for inspiration, painted during the thirties vigorous

CORBINO: Flood Refugees. Macbeth Gallery, New York

compositions in the tradition of Rubens, with a unique mastery of move-
ment values. Since Rubens had been a god of some of the foremost pio-
neers of modernism, even of Cézanne and van Gogh, it is not surprising
to find Corbino seeming exceptionally modern in the plastic vitality of his
canvases; though when he has treated the most local of subjects—floods,
farm life, country fairs—there has been, somehow, reminiscence of a method
perfected three centuries ago. Curiously enough the painter, born in Italy
and brought to New York as a child, had his whole training in this country,
absorbing idioms of the Flemish master in local museums.

America did not fail to profit, as France had done, by the abilities of
alien artists attracted by chance or design to her shores. Aside from the
great number of gifted men born of immigrant families or themselves
immigrants in childhood—the list includes such leaders as Sterne, Mattson,
and Weber—there have been those refugees of the chaotic years since
1933, painters so uprooted from and unsympathetic with Europe that they
have come to the United States determined to fit themselves into the social
and cultural life of the New World.

The type figure, and exceptionally important as an influence and exam-

PHILIPP: Olympia. *Kleemann Gallery, New York*

ple because he was indubitably one of the ablest and most original painters of Europe, is George Grosz. His exhibitions between 1935 and 1941 reflected his effort to reorientate himself, and of course lacked any particular feeling of local or national character; but certain universal æsthetic values came clear in the landscapes of 1939–1940 and in a series of figure studies in landscape backgrounds shown in 1941, values so compelling that none but a set-minded nationalist would note any lack of native substance. The coming of one of the leading theorists of the school of Paris, the purist Amédée Ozenfant, in 1937, to teach in Seattle and finally to establish his own school in New York, was a sign of the times. Already the ablest German teacher in the modernist field, Hans Hofmann, had arrived to teach in California and to found his own permanent school in the East. Through his pupils he was able to exert more influence upon the younger generation of painters than any other artist of the international school.

But Yasuo Kuniyoshi provided the most interesting instance of a foreign-born painter entering fully into the art life of the nation, teaching and

GROSZ: Approaching Storm. 1940. *Associated American Artists, New York*

giving out of his own racial inheritance. In view of the debt owed by the great European moderns to the Orientals, it was hardly a matter of surprise that a Japanese, brought to America at fifteen, a student on the Pacific Coast and in New York, conversant with all the phases of international modernism, should have become one of the great independents. From the mid-twenties Kuniyoshi was a contributor to national exhibitions, hailed by progressive critics as an individualistic master.

A little aloof, impersonal in his comments on life about him, he achieved a mastery of form-organization that unfailingly evoked in the beholder a powerful æsthetic reaction. Most characteristic, perhaps, have been the studies of women, beautifully painted, sensuously lovely despite the restrained colouring, set out in compositions that are melodiously rhythmic at the expense of natural detail. For a time Kuniyoshi took something of the direct simplicity and naïveté of the American primitives, crossed it with an Oriental formalism, and produced engaging, childishly unnatural pictures bordering on the range of the intuitive Rousseau-inspired moderns.

KUNIYOSHI: Girl Waiting. Downtown Gallery, New York

A hardly less characteristic crossing of strains was to be detected in the work of Jean Charlot, born and trained in France, painter in Mexico for many years by choice, and a member of the artists' Syndicate and of the socially conscious muralist group there, then immigrant to the United States. He has lived and painted in California and New York. The strangely architectural, primitively simple values of his designing probably grew out of the double experience of pre-war school of Paris training and intensive study of Mexican-Mayan backgrounds. In fitting his equipment to expression of contemporary American themes he has illustrated the roundabout

KUNIYOSHI: Boy with Cow. *Lewisohn Collection, New York*

but not uncommon way in which internationalism has affected cultural life in the United States. Another welcome recruit was David Burliuk, a Russian who became identified with German expressionism before he brought his richly expressive painting to America.

While the one-hundred-per-cent American Scene men have continued to resent and pooh-pooh foreign influences—not without just cause in the economic field—those influences have continued to fecundate and enrich the national art. Without them the output at the beginning of the nine-teen-forties could hardly have been, as it is at last seen to be, one of the two or three most vigorous and inventive national expressions known to modernism.

In the advance of modernism in the United States the mural art has become alive and vigorous as in no other country save Mexico. Except for

ROBINSON: The Club. 1917. Oil and Crayon. *Whitney Museum of American Art*

occasional highly independent achievements such as Carroll's too infrequent frescoes and Boardman Robinson's pioneering, the better American work has leaned somewhat on the Mexicans. Orozco, Rivera, and Siqueiros all painted in the States, not seldom with local assistants, and always with effect upon observing local painters. When the W.P.A. project gave a horde of painters opportunity to try their brushes on public walls, the influence was detected in innumerable cases.

But, in general, up to 1941 the artists concerned were still on their way to artistic maturity, to inspiring mastery of the mural means, and so they belong to the future rather than to history. Boardman Robinson had been the one independent painter contributing to an American tradition before the coming of the Mexican influence, a series in a department store at Pittsburgh proving his mastery of the modern manner in connexion with monumental picturing. Incidentally, Robinson, an exhibitor at the Armory Show in 1913, had been one of the most creative painters of easel pictures

BIDDLE: Whoopee at Sloppy Joe's. Associated American Artists, New York

and an outstanding socially conscious cartoonist in the immediate
post-war years. With no loss of vigour or immediacy he insisted that all
movement in the picture should be resolved into a design balanced and
serene.

While the W.P.A. was putting many relief artists to work on the walls
of schools, city halls, and hospitals, the Treasury Department was inviting
other painters to decorate the palatial buildings at Washington, and or-
ganizing competitions for mural designs to be executed at scattered post
offices and federal court buildings. Some of the foremost "successful"
painters were assigned walls at the capital; but the results were interesting
and encouraging rather than startling. As there had been no revolution or
social cataclysm to stir the souls and imaginations of these men, such as the
one in Mexico, so there was not the conviction or the passion of expression

Poor: The Ascent of Elijah. 1940. *Frank K. M. Rehn Galleries, New York*

in their work. Reginald Marsh painted some excellent illustrational murals for the Post Office Department Building, pretending little beyond realistic virtues; and George Biddle in his Department of Justice series chose a middle ground, tempering a method that had at times run to expressionistic distortion, to fit it to the conservative Washington environment.

Biddle, a crusader for artistic freedom and for social support for the artist, was one of the originators of the Federal Art Project. Independently wealthy in his early days, he had studied in virtually all the countries of Europe. Restlessness took him to the South Sea Islands for two years, and then again to Paris. Returned finally to America, he became one of the solidest of American moderns, with the saving grace of a world outlook. Altogether his mural series, flat, architectural, simplified, is one of the finest painted for the Government. But it lacks something of the freedom and of the grasp of abstract formalism disclosed in certain of his easel pictures.

JONSON: Cliff Dwellings, No. 3

Another of the recognized group of moderns, Henry Varnum Poor, was
less successful in adapting his talent to mural demands. He had in the
preceding decade proved himself a moderate innovator, conversant (through
study in Europe) with the latest ideas of picture-building but preferring
to modify nature only a little to further form-revelation. His attractive
landscapes and certain figure-arrangements of the early nineteen-thirties
showed him a sort of middle-ground figure between the neo-traditionalists
and the frank expressionists. In that range there have been other painters
large in stature, Lucile Blanch, George Picken, Nicolai Cikovsky, and
Ann Brockman, who have seemed at some time well up among the history-
making moderns, yet showing allegiance again to transcriptive realism.

MARIN: Boats, Sky, and Sea, Small Point, Maine. Water-colour. 1932.
An American Place, New York

Abstract art was long considered a foreign movement in the United States, and the advocates of art with American content pointed triumphantly to the "emptiness" of the imported designs of Kandinsky, Braque, and the purists. They succeeded in damning abstraction in painting as the most extreme of the futile 'isms. A few convinced painters nevertheless persisted in experimenting, and in exhibiting when opportunity offered. Agnes Pelton had exhibited abstractions at the Armory Show alongside the European pioneers. For many years Raymond Jonson pioneered at his retreat in Santa Fe, achieving the first considerable body of effective American near-abstract inventions. Arthur B. Carles and Augustus Vincent Tack experimented idealistically along divergent lines. In 1938 a group of painters in New Mexico banded together as the Transcendental Painting Group, and proclaimed aims different from those of both the common abstractionists and the non-objectivists.

Meanwhile the Gallery of Living Art, a museum of non-representative

O'KEEFFE: Ranchos Church. 1929. *Phillips Memorial Gallery, Washington*

painting founded by Albert E. Gallatin at New York University, had in-
fluenced many young painters in the direction of absolutism. In 1936 the
American Abstract Artists organized in New York, and in later years gave
convincing demonstrations of the extent to which the problems of dis-
embodied painting had fascinated American students. At the 1938 exhibi-
tion of the society there were forty-six member-exhibitors. The list included
many competent painters not before known to the general public, along
with a few veterans of the "cause," and at least two adherents formerly
known as members of international groups in Central Europe. In 1939 the
Guggenheim Foundation put on view its permanent collection of non
objective paintings, perhaps the richest specialized collection of the sort in
existence. Yet with so much activity developing—and echoed at art centres
from coast to coast—the historian of modern art must record that, as the
fifth decade of the twentieth century opened, no American painter of the
stature of Kandinsky or Braque or Klee had appeared.

No informed critic doubted, nevertheless, that American artists were
prepared to take their part in what may prove to be the most exciting

SHEELER: American Landscape. 1930. (Courtesy Museum of Modern Art)

search for new modes of æsthetic expression initiated in modern times. Some Americans had long worked creatively at the opposite pole from the realism and pragmatism once considered national traits. Ryder had approached abstract design, and Twachtman was considered to have lost all touch with reality. Two Americans, S. Macdonald Wright and Morgan Russell, had developed in Europe in 1913 a minor 'ism which was a step in the march toward full understanding of the nature of Cézanne's "realization." "Synchromism" disappeared, but its principles of colour organization went into the complex of laws governing plastic orchestration. In California and in Chicago, as well as in New Mexico and New York, pioneer abstractionists had carried on their experiments obscurely toward the burst of activity of the late thirties. The movement, despite the lack of an outstanding creative leader, was still, in 1941, one of the most significant phases of the vigorous and far-ranging advance of the New World moderns.

Back in the twenties a group of artists had become famous with paint-

HIRSCH: Lower Manhattan. 1921. *Phillips Memorial Gallery, Washington*

ings in which a considerable part of nature was sacrificed in the interest of abstract design, but well short of absolute abstraction. Architectural subjects, and particularly machine-age buildings, were, so to speak, reduced to rhythmic designs, almost to decorative patterns. Charles Sheeler especially succeeded in geometrizing, with classical restraint and elegance, factory motifs, combining a seeming realism of draughtsmanship with an austere sense of formal design. He went on later to exactly limned industrial scenes of the sort illustrated in *American Landscape*, painted in 1930. There developed a school of artists working along similar lines, with Niles Spencer emerging as the most sensitive composer of mathematical-musical pictures of buildings and places.

While industrialism was thus being transformed, in æsthetic equivalents, larger architectural panoramas engaged the attention of Stefan Hirsch, who

Driggs: Pittsburgh. *Whitney Museum of American Art, New York*

in the twenties brought his feeling for geometrical simplification to bear in paintings such as the rhythmic *Lower Manhattan*. Hirsch later reacted from the sort of abstracting and careful rearranging there illustrated, and became an exponent of socially conscious painting. One of the foremost muralists, he developed a more personal, expressionistic style and applied it to picturing with social purpose and associative meaning. Ralston Crawford, on the other hand, carried the Sheeler type of skeletonized, mathematical abstracting to a culminating simplicity, preciseness, and lucidity. Elsie Driggs utilized the characteristic forms of industrial architecture as design elements, strongly and clearly, in her *Pittsburgh*.

It had seemed daring when Charles Demuth twenty years earlier had applied the less extreme principles of cubism and futurism to views of architectural and industrial centres. He had played prettily with ray-lines and plane sequences; but in later view his compositions, though engagingly fresh and original, came to seem too slight, even too soft, to fit well the

MARIN: Movement, the Sea, and Pertaining Thereto. Water-colour. 1927.
An American Place, New York. (Courtesy Museum of Modern Art)

austerity and concreteness of the subject materials. His water-colours, especially a series of still-lifes, assure him a place in museums of American modernism, rather than the better-known architectural designs. In the same way another innovator of the war years and the twenties, Preston Dickinson, has taken his place primarily as a sensitive and original painter of still-lifes, though for long he was as well known for his architectural scenes. The still-life group has vitality and strength and is seen to be in the main international line of development from Whistler's and Cézanne's beginnings. Both Dickinson and Demuth died during the thirties, both in middle life, and both revered in memory as artists of integrity and spiritual awareness.

Had there been no flowering of American painting between 1935 and

MARIN: Maine Islands. 1922. *Phillips Memorial Gallery, Washington*

1940, the heritage of the years 1913–1933, between the Armory Show and the beginning of the Government's concern with art, would seem meagre and remote. Taken alone, the paintings of Dickinson and Demuth, of Sheeler and Hartley, formed a somewhat tenuous thread between the full-blooded insurgency of the pre-war years and the depression-burdened radicalism of 1933; and the works contributed by the small school of internationalists, competent and creative but hardly American, did little to convince the public of a full and strong national modernism. In the years just after the Museum of Modern Art opened, two decades after the Armory Show, critics were wont to point out that in general the leading American moderns were still the ones who had been the leaders in 1913.

There was, however, one continuing influence, a focal centre for exhibi-

O'Keeffe: Black Iris. 1926. An American Place, New York

tions and education, in the galleries and the activities of Alfred Stieglitz.
Turning to support of American modern artists exclusively after the war,
he persistently staged one-man shows of Hartley, Demuth, and others; and
three painters he aided in a particularly effective way: John Marin, Georgia
O'Keeffe, and Arthur G. Dove. Marin as creator was the one masterly figure
carrying on with ever-increasing power and sensitiveness through the black
years, and it was the faith and aid of Stieglitz that enabled him to paint
freely and steadily, without compromise for expediency's sake.

Marin stood through those years as the most distinctively American
painter. In 1941 as in 1921 he was painting pictures unmistakably his own,
unlike anything being produced in Europe, essentially modern in their
abstract loveliness and their æsthetic evocativeness. His achievement in
thirty years of individualistic expression has been no less than magnificent.

O'Keeffe: Chama River Ghost Ranch.
1935. *An American Place, New York*

A friend of Georgia O'Keeffe's had surprised Stieglitz in 1916 by forwarding to him without the artist's knowledge a sheaf of drawings, semi-abstract, rhythmic, and strikingly original. Ten years later she had become known, through a succession of exhibitions, as a creative painter no less individualistic than Marin. With him she was one of the figures carrying on inventively and continuously through the lean years of American modernism. When the burst of new activity came in the late thirties, her paintings lost nothing of effectiveness in comparison with the myriad individualistic expressions flooding the galleries.

O'Keeffe's picturing has ranged from absolute non-objectivity through

Dove: Waterfall. *Phillips Memorial Gallery, Washington*

all the stages of abstraction and semi-abstraction to limning of objects and places in a method seemingly camera-exact but subtly controlled for plastic effect. Her painting is strong, cleancut, vital, and feminine only in a special tidiness and precise softness of finish. Certain extended series of canvases became famous, particularly the studies of flowers—"attempting to express what I saw in the flower, which apparently others failed to see"—studies varying from all but abstract interpretations to arbitrarily arranged but botanically correct compositions; a series from the hill country of New Mexico, and another of the adobe buildings of that country; still-lifes with precise arrangements of crosses and skulls and shells and other intriguingly textured things; and in 1939 a series of Hawaiian landscapes. O'Keeffe's

CALLAHAN: Northwest Landscape

paintings have beautifully revealed something of the integrity, the strength, and the sensitive vision of the woman herself, in an *œuvre* at once personal and in the main stream of form-enriched painting.

Once a commercial illustrator, then suddenly inspired to give his life to painting in the field of abstraction, Arthur Dove pioneered at the time when radicalism meant obscurity and deprivation. Persisting in painting "approximations" of objects and scenes, he was regularly accorded one-man exhibitions at Stieglitz's galleries between 1925 and 1941. His aims were nearer to those of the Transcendental Group in the Southwest than to those of the New York groups deriving more directly from the geometrical-minded experimentalists of Europe. He has provided, within American modernism, an example of individualistic creation in absolute, or musical, painting.

In Europe an epoch has ended. Whatever the outcome of the war, whatever the political and economic changes, stupendous but unpredict-

PARADISE: The Storm. Water-colour. 1940. Ferargil Galleries, New York

able, the arts will have been set back. In France as in Germany, the story that began in nineteenth-century visioning and experiment has come to full stop.

But in America all still is activity, surprise, invention. The historian looks dismayed at the month's harvest of art journals, stands amazed as new talents, fresh lines of effort, are disclosed in exhibitions and in news dispatches. Even new schools rise unheralded, regional or based on a teacher's leadership, or because a formerly scattered band of like-minded artists has come together. Within the five years the two major groups of abstractionists, in New Mexico and New York, have emerged as exhibiting societies. In 1938 an association of artists of Buffalo, New York, the Patteran Society, disclosed unsuspected creative talents in a travelling exhibition, and these were supplemented by other surprises at a Great Lakes regional show. Any day the separated and still somewhat furtive American surrealists may come together for a group exhibition and a concerted drive for a place in the sun; or a regional group that centres at New Orleans or

SHEETS: The First Born. 1939. *Dalzell Hatfield Galleries, Los Angeles*

Seattle or Salt Lake City may emerge with distinctively original exhibitions. For twenty years New Mexico has had its artist group centring at Santa Fe and Taos, counting among its permanent members Andrew Dasburg, accomplished veteran of the Armory Show days, and acting at times as host to many of the ranking moderns of the East. The California groups are hardly less distinctive, though more cosmopolitan, the French influence that dominated so long having been modified by currents from Mexico, Germany, and the Orient. The California school of water-colourists especially, since 1938, has outdistanced other regional schools, carrying away prizes at national exhibitions. It has brought to notice not only Millard Sheets and Barse Miller but Phil Paradise, Phil Dike, and Dan Lutz.

Other groupings, non-regional, have provided signs of the drift to certain philosophies of art, as in the case of the American Artists' Congress, founded in 1936 as a left-wing organization. It brought together the young

Jules: The Conductor. 1940. *Collection of Herman Shulman, New York*
(Courtesy A. C. A. Gallery, New York)

extremists of the metropolitan district, a number of moderate radicals, and
pioneers such as Stuart Davis, its national chairman, a distinctive figure
among American abstractionists, and A. S. Baylinson, long a leader in the
Society of Independent Artists and a creative painter in the direct school
of Paris line. The Congress fell apart in 1940 when public sentiment forced
all socially conscious organizations to separate extremists and outright
Stalinists from temperate radicals. During its brief existence it had en-
livened art life in New York, through exhibitions and conventions, more
than any other modern organization. At the far pole from so purposeful
and weighty a group is a scattered band of artists practising close to the
territory of the French Rousseau and the American Eilshemius, painters
who affect a child-like primitivism, though usually with a knowing rather
than an innocent air. Hilaire Hiler of San Francisco has been the most
consistent exploiter of naïve conventions, while Lauren Ford and Molly

ORR: Silence. 1940. *Kleemann Gallery, New York*

Luce in New England have designed their unconventional and remote pic-
tures with less sophistication, in a region whence personal independence
glances back to the colonial primitives and to that prince of unconventional
picturing, Brueghel.

At this point the conscientious historian's notebooks inevitably fail and
shame him. Here at the end, looking back over the chapter, he finds still
omitted names that many consider to have made history, and personalities
that seem central to what modernism was becoming in 1935–1941. One

BARNES: The Storm. *Collection of Mrs. Sigmund Stern, San Francisco*
(Courtesy Joseph A. Danysh Galleries, San Francisco)

remembers uneasily that art history is too often written from New York, with reference to exhibitions on Fifty-Seventh Street. One recalls that history has assuredly been made at Cleveland by Henry G. Keller, an exhibitor at the Armory Show, and later an inspiring teacher and one of the nation's foremost water-colourists. In art education, history is being made not only by John Carroll in Detroit but also by Zoltan Sepeshy at suburban Cranbrook. History has been made at Los Angeles by an extraordinary group of younger painters, and at near-by Pomona where the thirty-four-year-old Millard Sheets teaches in new ways, even while he practises a form of modern painting that has brought him national ranking as a vigorous creator. Locally born, and trained no farther away than the art schools of Los Angeles, he has been a sign of the healthy decentralization of the art life of the nation, a reminder that the student can, without proceeding to New York or Paris or Munich, find the modern atmosphere and modern guidance at places once considered out-of-the-way, at Pomona or Berkeley

MATTSON: Marine. *Whitney Museum of American Art, New York*

or Seattle, at Columbia or Iowa City or Albuquerque, at Minneapolis or Washington or Hanover.

One recalls individuals who have both painted as insurgents and taught a new generation, Karl Knaths and Kenneth Callahan, James Chapin and Frank Mechau and Peppino Mangravite. One recalls outstanding paintings encountered in exhibitions, each seeming to signalize the arrival of a younger painter at mastery of form-revelation, a landscape by Dewey Albinson, localized but capitalizing on the inheritance from cubism; a seascape by Elliot Orr, bespeaking a Ryder-like mystic apprehension; landscapes by William B. Rowe, reminding the beholder that, at the end of one cycle, modern art comes back to a spiritual and formal expression foreshadowed by Chinese artists centuries ago; a satirical criticism of art patrons by Peggy Bacon or a socially weighted propaganda bit by Joe Jones or Eitaro Ishigaki or Mervin Jules, each properly informed with abstract rhythm, yet each

reminding one that among the varieties of American modern art the satirical or socially meaningful is still importantly found. Other masterly constructors of pictures crowd to mind, Aaron Bohrod of Chicago and Arnold Blanch of Woodstock; Matthew Barnes of San Francisco, intuitive and impulsive, and Peter Hurd of New Mexico, intellectually sure and deliberate; Stanford Fenelle of Minnesota; and Doris Lee, De Hirsh Margules, Julian Levi, and Miron Sokole of New York.

In 1941 it is still the superb paintings of a few leaders, of John Marin and John Carroll, of Henry Mattson and William Gropper, of Yasuo Kuniyoshi and Maurice Sterne, the work of artists mature and consistent, work which would appear original and masterly in any company—it is this work that most vividly and concisely proves America's right to a ranking among the three or four nations most productive in post-realistic, form-enriched art. But it is those scores of others, no less creative and sensitive and spiritually aware, adventurous, still pushing into unexplored paths, who attest that on this Western continent modernism is still youthful, resourceful, expanding. Substance is given to the hope and the belief that in this time of tragedy for Europe, when creation has stopped where once creativeness centred, America's moderns will go on to æsthetic solutions unprecedented, will find ways of carrying on worthily, even magnificently, a tradition made important and splendid more than a half-century ago by Daumier, Whistler, and Cézanne, a tradition enriched by the men of Paris and by the Germans, a tradition accepted and made their own by the Mexicans and the Americans of the United States.

FOR FURTHER READING

The present writer believes that no bibliography in the field of the arts should be offered without this word of warning: for every chapter perused the reader should spend an equal period of time in galleries with creative works of art, or, better, should surround himself in his own home with such original pictures as he may be able to afford. Books, even those written by artists, afford no more than hints of what it is that vitally counts in the painting; they can only open the way to the experience of art, never themselves afford it.

In listing, with briefest description or recommendation, a half-hundred books dealing with modern art and the modernists the author has named those which seem to him most informing and most stimulating, where such volumes are at the same time authoritative. With an eye to easy availability at libraries and bookstores, he has listed only works in English.

For an understanding of classicism as related to modernism by far the best available book, absorbing as biography too, is *Ingres*, by Walter Pach (New York, 1939). There is a short study of David entitled *Jacques-Louis David and the French Revolution*, by W. R. Valentiner (New York, 1929). Definitely dated but interesting and revealing is *The Classic Point of View*, by Kenyon Cox (New York, 1911), which takes an admirably broad view of the classic spirit as "the disinterested search for perfection . . . the love of clearness, reasonableness, and self-control. . . ." There are in English no outstanding books upon romanticism in the fine arts and no definitive biographies of the leading romantic painters. One of the rewarding source books, however, and not to be missed, is *The Journal of Eugène Delacroix*, translated by Walter Pach (New York, 1937). The later chapters of *Bandits in a Landscape*, by W. Gaunt (London and New York, 1937), treat in a brief but spirited way of Delacroix and Géricault.

Goya's story has been popularized in *Goya*, by Charles Poore (New York, 1939). More than 600 of the artist's paintings and prints are reproduced in *Goya: an Account of His Life and Works*, by Albert F. Calvert (London, 1908). See also *Francisco de Goya*, by August L. Mayer (London, 1924).

About Constable the most revealing book is *Memoirs of the Life of John Constable, R.A.*, by C. R. Leslie (London, 1843), to be had in reprint in the inexpensive Everyman's edition, or in an edition enlarged and heavily annotated by Andrew Shirlaw, fully illustrated (London, 1937). Excellent too is *John Constable the Painter*, by E. V. Lucas (London and New York, 1924). Pictorially Turner is abundantly represented in *Turner*, by Camille Mauclair (Paris and New York, 1939), one of the Hyperion Press monographs, but the accompanying biographical and critical materials are scant. A second richly illustrated volume, non-biographical, is *The Genius of J. M. W. Turner, R.A.*,

edited by Charles Holme (New York, 1903). The best routine biography, perhaps, is *The Life of J. M. W. Turner, R.A.*, by Alexander J. Finberg (London, 1939). Most of the biographies of Blake are more especially concerned with him as a man of letters; but excellent for the art-lover is *The Life of William Blake*, by Mona Wilson (London, 1927), uniform with the handsome Nonesuch Press edition of Blake's writings. See also Darrell Figgis's *The Paintings of William Blake* (London, 1925) and *The Drawings and Engravings of William Blake*, by Laurence Binyon (London, 1922). Inexpensive and yet richly illustrated is *William Blake, 1757–1827*, a catalogue published by the Philadelphia Museum of Art (Philadelphia, 1939).

Corot and Millet, edited by Charles Holme, with essays by Gustave Geffroy and Arsène Alexandre (New York, 1903), is a convenient introductory volume. *Corot*, by Marc Lafargue (New York, 1926), is a short biography with forty plates. The generously illustrated Hyperion Press monograph *Daumier*, by Jacques Lassaigne (Paris and New York, 1938), is the most attractive book about an artist whose complete life story has never been told in English. *Daumier, the Man and the Artist*, by Michael Sadleir (London, 1924), is excellent but all too brief in text and high-priced.

About the mid-century realists, and the impressionists, their companion Théodore Duret wrote *Manet and the French Impressionists* (Philadelphia, 1910), still an exceptionally interesting book. Manet's work is lavishly shown in the Hyperion Press monograph *Manet*, with a brief essay by Robert Rey (Paris and New York, 1938). *The Impressionists*, a Phaidon Press monograph (Vienna and New York, n.d.), treats of the French painters from Manet to Toulouse-Lautrec, with a generous run of plates. Impressionism as a mode of painting is more fully dealt with in *Impressionist Painting: Its Genesis and Development*, by Wynford Dewhurst (London, 1904).

Of Whistler there is the laudatory and over-detailed but thoroughly interesting *The Life of James McNeill Whistler*, by E. R. and J. Pennell (Philadelphia, 1908). More compact and more readable but touched with the spirit of "debunking" is *Whistler*, by James Laver (New York, 1930). Whistler's own writings, collected under the title *The Gentle Art of Making Enemies* (New York, n.d.), are both entertaining and revealing.

Out of the long shelf of books written about Cézanne three may be chosen as most useful: for authoritative biographical detail, *Paul Cézanne*, by Gerstle Mack (New York, 1935); for a rich showing of the artist's works, the Phaidon Press monograph *Cézanne* (Vienna and New York, n.d.); and for analysis of the paintings, *The Art of Cézanne*, by Albert C. Barnes and Violette de Mazia (New York, 1935). Important also is *Paul Cézanne, His Life and Art*, by Ambroise Vollard (New York, 1937).

The Hyperion Press monograph *Gauguin*, by John Rewald (New York and Paris, 1938), has the advantage of combining a series of large and attractive plates with a considerable biographical sketch (within which are embedded generous excerpts from the artist's own writings). An exceptionally good popular biography, in story form but not fictionized, is *The Life of Paul*

Gauguin, by Robert Burnett (New York, 1937). There is also the interesting *My Father, Paul Gauguin,* by Pola Gauguin (New York, 1937).

Vincent van Gogh, by J.-B. de la Faille (New York, 1939), includes only a brief essay (by Charles Terrasse) as text but illustrates practically all of van Gogh's paintings. At the other extreme is *The Letters of Vincent van Gogh to His Brother, 1872–1886,* in three volumes (London, Boston, and New York, 1927); from this a handy and fascinating selection has been edited by Irving Stone and published under the title *Dear Theo* (Boston and New York, 1937). Irving Stone also wrote the best-seller fictionized life of van Gogh entitled *Lust for Life* (New York, 1934). Perhaps the best full-length "regular" biography is *Vincent van Gogh, a Biographical Study,* by Julius Meier-Graefe (New York, n.d.).

Of the fourth post-impressionist master, Seurat, there is no full-length study in English. Satisfactory so far as it goes but very brief and including only 14 illustrations is *Georges Seurat,* by Walter Pach (New York, 1923). An interesting analysis of a single painting is *Seurat and the Evolution of "La Grande Jatte,"* by Daniel Catton Rich (Chicago, 1935). Of Seurat's contemporaries the following are standard and generally satisfying biographies: *Toulouse-Lautrec,* by Gerstle Mack (New York, 1938), *Degas,* by Julius Meier-Graefe (London, 1923), and (though lighter, even gossipy) *Renoir: an Intimate Record,* by Ambroise Vollard (New York, 1925). Vollard's *Degas: an Intimate Portrait* (New York, 1937) is rather less than a biography, being personal reminiscences, journalistic and readable. *The Art of Renoir,* by Albert C. Barnes and Violette de Mazia (New York, 1935), is a thorough analytical study, sufficiently illustrated. The same authors have written a critical study of the leader of the fauves, in *The Art of Henri Matisse* (New York, 1933).

The story of modern French painting is most completely told (in English) in *Modern French Painters,* by R. H. Wilenski (New York, n.d.), a mine of information entertainingly set out, but in confused order. *Modern French Painters,* by Maurice Raynal (New York, 1934), treats chosen artists briefly, with valuable credos by the painters themselves. The nineteenth-century Frenchmen are paraded in a shrewd and entertaining book, *Landmarks in Nineteenth-Century Painting,* by Clive Bell (New York, 1927), and in the briefer and soberer *Nineteenth-Century Painting: a Study in Conflict,* by John Rothenstein (London, 1932). Both books include chapters on the Englishmen. A more scholarly work, with excellent illustrations, is James Laver's *French Painting and the Nineteenth Century.* The Frenchmen and van Gogh are treated in biographical chapters, readably and in general soundly, in *Rebels of Art: Manet to Matisse,* by George Slocombe (New York, 1939). The Hyperion Press monograph *French Painting in the XXth Century,* by Charles Terrasse (London, Paris, and New York, 1939), provides a lengthy but not uniformly well-chosen set of plates, with brief summaries of the succeeding schools and briefer biographical notes.

A considerable literature has grown up about the Mexican moderns. Outstanding are *Modern Mexican Art,* by Laurence E. Schmeckebier (Minne-

apolis, 1939), and *Modern Mexican Painters*, by MacKinley Helm (New York, 1941). *Diego Rivera: His Life and Times*, by Bertram D. Wolfe (New York, 1939), is a readable and racy biography, partisan but authoritative.

About modern art in the United States the most direct treatment, and critically the soundest, is *Modern Art in America*, by Martha Candler Cheney (New York, 1939). Comprehensive and discriminating, but beginning to seem dated (so fast has modernism developed recently), is *Art in America: a Complete Survey*, edited by Holger Cahill and Alfred H. Barr, Jr. (New York, 1935). A lavish show of American painting in color reproductions, with journalistic text, readable but uncritical, is *Modern American Painting*, by Peyton Boswell, Jr. (New York, 1939). Full-length biographies are rare on the American shelf, but the student should not miss *Ryder: a Study in Appreciation*, by Frederic Newlin Price (New York, 1932), *Albert Pinkham Ryder*, by Frederic Fairchild Sherman (New York, 1920), and *John Marin, the Man and His Work*, by E. M. Benson (New York, 1935).

The general books on modernism, theoretical or historical, are less satisfactory than the individual biographies as described above or the treatments of one or another segment of the field. But the following books contribute significantly in various ways: *Art Now*, by Herbert Read (New York, n.d.), *Plastic Redirections in 20th-Century Painting*, by James Johnson Sweeney (Chicago, 1934), and, old but exceptionally clear and suggestive, *Modern Painting: Its Tendency and Meaning*, by Willard Huntington Wright (New York and London, 1915). Useful and inexpensive, with 274 illustrations and readable journalistic sketch-biographies, is *The Significant Moderns and Their Pictures*, by C. J. Bulliet (New York, 1936). The present writer's *Expressionism in Art* (New York, 1934) treats of the form element in painting and has proved serviceable to advanced students and artists.

For the intricacies of the 'isms the books issued by the Museum of Modern Art in New York in connection with exhibitions are most enlightening, especially *Cubism and Abstract Art* (1936), *Fantastic Art, Dada, Surrealism*, edited by Alfred H. Barr, Jr., with essays by Georges Hugnet (1936), and *Picasso: Forty Years of His Art*, edited by Alfred H. Barr, Jr. (1939). These and other volumes of the Museum series, dealing with van Gogh, Klee, Hopper, and other European and American modern painters, and with phases of French, German, Mexican, and primitive art, include excellent bibliographies.

INDEX

Italic figures, preceded by the letters *ill.*, indicate illustrations (e.g., *ill. 267*). Roman figures indicate text references.